Georgia During the Great Depression

ALSO COMPILED BY ANITA PRICE DAVIS

*North Carolina During the Great Depression:
A Documentary Portrait of a Decade* (2003)

———————————————

BY ANITA PRICE DAVIS AND LOUIS HUNT

Women on United States Postage Stamps (2008)

———————————————

BY ANITA PRICE DAVIS AND MARLA J. SELVIDGE

Women Nobel Peace Prize Winners (2006)

———————————————

ALL FROM MCFARLAND

Georgia During the Great Depression

A Documentary Portrait of a Decade

COMPILED BY
ANITA PRICE DAVIS

McFarland & Company, Inc., Publishers
Jefferson, North Carolina, and London

LIBRARY OF CONGRESS CATALOGUING-IN-PUBLICATION DATA

Davis, Anita Price.
Georgia during the Great Depression : a documentary
portrait of a decade / compiled by Anita Price Davis.
p. cm.
Includes bibliographical references and index.

ISBN 978-0-7864-3395-7
softcover : 50# alkaline paper ∞

1. Georgia — History — 20th century — Sources. 2. Georgia — History —
20th century — Pictorial works. 3. Georgia — Social conditions —
20th century — Sources. 4. Georgia — Economic conditions — 20th century —
Sources. 5. Depressions — 1929 – Georgia — Sources. 6. New Deal, 1933–1939 —
Georgia — Sources. 7. Depressions — 1929 – Georgia — Pictorial works.
8. New Deal, 1933–1939 — Geogia — Pictorial works. I. Title.
F291.D385 2008 975.8'042 — dc22 2008008607

British Library cataloguing data are available

On the cover: "A little spinner in a Georgia Cotton Mill" January 1909
(photograph by Lewis Wickes Hine from the National Child Labor Committee,
Call Number LOT 7479, v. 2, no. 0545 [P&P] Reproduction Number: LC-
DIG-nclc-01638 Library of Congress); cotton©2007 Shutterstock

Manufactured in the United States of America

*McFarland & Company, Inc., Publishers
Box 611, Jefferson, North Carolina 28640
www.mcfarlandpub.com*

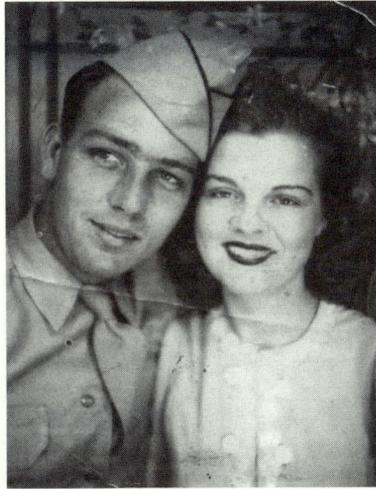

Nell Daves Price Burns and Corporal Arthur Fred Price, September 1943. Both members of this happy couple were products of the Great Depression and were the parents of the author, who was born in March 1943.

With love and gratitude, I dedicate this book to my mother,
Nell Daves Price Burns (1923–1998), and to the memory of my father,
Arthur Fred Price. Like many others of the time, my mother and father
met the 1930s with hard work, pride in a job well done, and dignity.
When World War II came, she sacrificed her husband (my father) to war and to death
on a battlefield in Belgium when I was not even two years old.
In 1944, as a twenty-one-year-old single mother, Mother demonstrated
a will to live, pride, a radiant beauty, and an inner strength.

Acknowledgments

Special thanks go to Katherine Knapp Keena, program manager of the Birthplace of Juliette Gordon Low (Founder of the Girl Scouts), National Historic Landmark in Savannah, Georgia. Her enthusiasm was welcome and her contributions provided an accurate write-up of Low.

The encouragement of Converse College and the support of the staff of the Mickel Library, particularly Wade Woodward, Mark Collier, Shannon Wardlow, and Becky Poole, are always helpful. These individuals located materials for me that seemed impossible to find — and they did it graciously.

Annie and Imogene Dillon shared their photographs, their affection, and their knowledge with me. Jean Bubley, thank you for "introducing" me to your Aunt Esther Bubley, furnishing photographs, and providing information to improve her biography. I treasure your friendship. Deborah Yost, with Aps, Inc.; Jack Anthony at www.jjanthony.com; Robert Watkins; Harry Henning; Agnes Sellars Eberhart and Claudia Eberhart McCurry; Kim Hatcher, with Providence Canyon; Randy Golden, with Golden Ink; Donald R. Hensley, Jr., with the Tap Lines, Southeastern Rail Road History and Photographs at www.taplines.net; James M. Walker; Anne Nettles Stanford, communications manager of the Margaret Mitchell House and Museum; Jane Bozza of St. Simons Island; and Lain Shakespeare, with the Wren's Nest, were attentive and supportive of my questions and generous with their images. Tom Barber at Coca-Cola, your suggestions for text were most generous and astute. Grateful appreciation goes to Melissa Sanford at the Thomas County Museum of History.

Many thanks also go to Louise Hunt, a native of Georgia, a contributor to *Georgia During the Great Depression*, and a cheerleader for my work.

My family, you have survived another book! Thanks to you for overlooking computer cords, ignoring stacks of books and papers, and listening — with interest — to each finding of a new fact or figure. Evan, at age five you are already my favorite copy machine operator and my best pencil sharpener. Buren, you returned stacks of books to libraries when I thought I could not lug one more book to the book drop. Stacey and Robbie, you are my favorite children. Thank you, James M. Walker, for your photographs.

Thanks to my mother and my grandfather for their inspiration and to my dad for the scholarships he left me and for his sacrifice of life in World War II. To my stepfather, I miss you and wish you had been here to advise and share your wealth of knowledge and love.

Contents

Preface

More than 107,000 federal photographs create a portrait of the nation's people and places during the Great Depression. These records from the past were part of a federal effort that Rexford Tugwell and Roy Stryker helped to spearhead. The pair used the film of some two dozen federal photographers to preserve the era, its people, and its regions.

Nine of these federal photographers traveled several times to the state of Georgia, captured more than 2500 images, and preserved an enduring record. Most of their work in the "Peach State" has never before appeared in any publication — until *Georgia During the Great Depression*.

This pictorial album of Georgia during the 1930s uses a selection of these federal photographs and supplements them with picture postcards, with personal pictures and memorabilia shared by unselfish residents, with written records, with interviews, and with other archival materials. This volume documents the despair and pride of the young and old, the rich and poor, the urban and rural, the landed and landless, the employed and unemployed. The aim of *Georgia During the Great Depression* is to present an accurate, complete picture of the people, the problems, the strengths, and the weaknesses of the state at an earlier time.

Many of the descendents of the survivors of the Great Depression heard — and still practice — the admonitions to "Use it up; put it back; wear it out." Even those who rebelled against squeezing the last of the toothpaste from the tube and "saving for hard times" are reminders that the past is still with us in some way. Those products of the Great Depression, then, helped define the nation and shape future generations.

My mother, Nell Daves Price Burns (1923–1998), experienced, survived, studied, and recalled the Great Depression. She freely shared her knowledge and stories as we prepared meals, did laundry, or arranged closets. No television distracted us from each other or from our conversation; if the radio played softly, the music was the relaxing melodies of the 1940s and did not hinder our time together. Mother always ended these stories to her young daughter by gently urging me to write about and, therefore, preserve these experiences, which were indelibly recorded in her mind — and now in mine.

In 2006 I realized that the time was right for me to begin this documentary portrait of Georgia of the 1930s. I had

- discovered the 2500, largely unused, federal photographic images of Georgia during the Great Depression;
- made many personal contacts in Georgia while I was writing two other books about the state;

1

- received the offer of assistance from Georgians who had collected personal memorabilia and were willing to give interviews;
- taken early retirement and was free to travel throughout the "Peach State"; and
- gained access to Georgia newspaper "morgues" and the Georgia Archives materials.

Like my mother, I now had an opportunity to convey to future generations what life was like during the Great Depression, a decade that had tempered a nation and would shape future generations.

My first decision was how to organize the words and the photographs in *Georgia During the Great Depression*. Most historical material uses a chronological arrangement. The photographs and the events of this era, however, did not always lend themselves to a sequential, month-by-month, year-by-year approach. I searched further for a meaningful, effective way to organize the materials, documents, and memories from the Great Depression era in Georgia.

President Franklin Delano Roosevelt viewed the South as "the Nation's No. 1 economic problem — the Nation's problem, not merely the South's"; he often expressed concern about the area and its problems.[1] President Roosevelt appointed the National Emergency Council (NEC) to explore the problems of the South and to find some possible solutions.[2]

The NEC consisted of Lowell Mellett and 22 representatives from the various Southern states. Included in the twenty-three council members were two Georgians: Superior Court Judge Blanton Fortson of Athens, Georgia, and Joseph G. Tillman, a planter from Statesboro, Georgia.

The President requested (June 22, 1938) the NEC to prepare a detailed report; on July 5, 1938, Roosevelt instructed them to report directly to him on the economic conditions in the South. In this letter, he did not discuss the history or causes of the problems; instead he merely identified the major conditions the South — and the nation — faced.[3]

Their final statement, titled *Report on Economic Conditions of the South*, was ready for transmittal on July 25, 1938. The document indicated that those who were "intimately acquainted with their own region and vitally concerned in its welfare" had done the work and that their document contained vital information, insights, and statistics on the South.[4]

It was in this report that I found the basic skeleton — the outline — for *Georgia During the Great Depression*. The same concerns that the NEC had found affected the South in general had, of course, also affected Georgia. By combining certain features and dividing other features, I easily constructed the contents page of *Georgia During the Great Depression*; close inspection of the contents page will show that all the topics that the NEC deemed important comprised an integral part of *Georgia During the Great Depression*.

Georgia During the Great Depression tells through both words and pictures the complete story of the "Peach State" during the decade of the Great Depression. This window through which the reader may view an earlier time is an album of Georgia and Georgians captured forever on the printed page. Readers will find the images that the federal photographers — and other masters of the lens — captured on film are preserved in the way that Tugwell intended: as important human beings with dignity.[5]

This book is also a written collection of spoken words recorded in newspapers of the time; in books like *These Are Our Lives*, a series of interviews recorded by participants of the Federal Writer's Project of the Works Progress Administration; in journals and diaries; on audio tapes; in recordings of *Fireside Chats*; and through first-person interviews with some who remember certain happenings more than half a century later.

Georgia During the Great Depression uses — in addition to the images and spoken words — written words from primary sources like the Roy Stryker papers; letters of the time; personal records; treasured artifacts of the era like NRA decals and campaign buttons; radio transcripts; state and national congressional records; and newspaper accounts of the period.[6]

To serve the contemporary student of Georgia history, those who remember the era, and those who might be interested in the decade in the days to come, I offer this album — the outcome of researching all documents, tapes, film clips, negatives, papers, interviews, primary sources, and memorabilia. Hopefully, *Georgia During the Great Depression* preserves faithfully Georgia's facts, images, sounds, and feelings in a unique, accurate — yet caring — way.

Introduction

For most Georgians and most Americans, the stock market crash of 1929 and the resulting Great Depression of the 1930s were impossible to predict.

The armistice of November 11, 1918, and the signing of the Treaty of Versailles (June 28, 1919) had brought hope to the hearts of both civilians and those directly involved in the "War to End All Wars." Proudly displaying their war trophies, American soldiers returned home from the French battlefields of World War I.

Georgia had played an important part in this Great War. The state had hosted five major federal military installments when the nation entered World War I in 1917. By the war's end, Georgia had more training camps than any other state; these camps included Camp Gordon, which opened in 1917 and was northeast of Atlanta; Camp Hancock, a National Guard training camp located in Augusta; Camp Wheeler, a National Guard training camp located in Macon; Souther Field, a flight school that trained more than 2,000 military pilots; and other specialist training camps scattered throughout the state.[1]

In addition to providing military installments and training camps, Georgia contributed more than 77,000 troops to the 4,734,991 Americans who served in the Great War. Georgians suffered many casualties: 3,319 were wounded; 67 became prisoners of war, and 1,937 died—130 at one time when the *Otranto* sank during a storm. Even after the end of the war, the military was never able to account for an additional 57 Georgia troops.[2]

After the Great War, most of the nation experienced during the 1920s seven years of economic expansion, unprecedented by any other period in American history. The rules of the decade for many parts of the country were personal extravagance, laborsaving devices, materialism, unwise investments, new social codes, chewing gum, and motion pictures.

A dramatic change that returning service personnel discovered was a considerable increase in the number of automobiles in the nation. There was a jump from 548,000 registered cars in 1910 (1 out of every 36.5 households) to 8,132,000 in 1920 (1 for every 3.0 households). The number of cars registered in the United States in 1928 was 21,362,000—almost triple the number in 1920; the 1928 national average was 1 car for every 1.4 households—a sizeable increase over the number just eight years before.[3]

From 1908 until 1927 the Model T Ford dominated car sales in the United States. Model T automobile production was half the car industry's total output in 1918–1919 and from 1921 to 1925. Ford earned more than all other automakers combined for the years

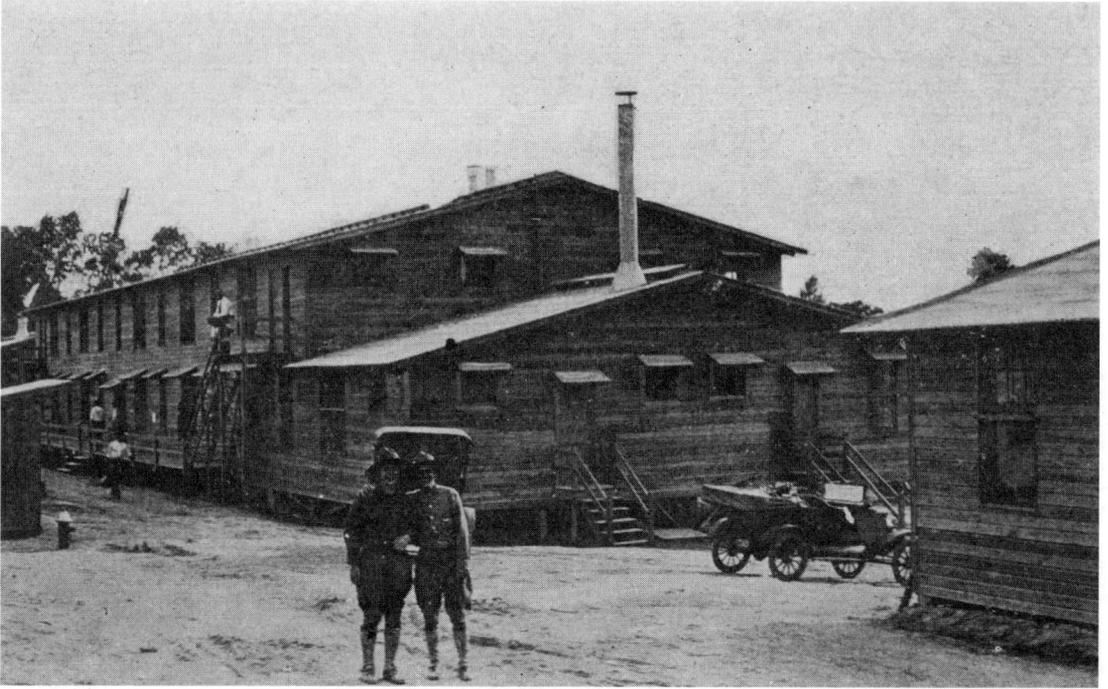

Postcard with caption: "Barracks at Camp Gordon, Atlanta, Georgia."

"Peachtree Street, Looking North from Viaduct, Great White Way, Atlanta Georgia." This postcard was mailed in 1922.

Introduction 7

1911–1915, 1918, and 1921. Ford Motor Corporation set up an assembly plant in Georgia in 1914.

The Model T came in many different models, including roadsters, coupes, coupelets, runabouts, roadster torpedoes, town cars, touring cars, and fordor and tudor sedans. All of these body styles had the same engine and almost the exact same chassis: the Model T. The car had a maximum speed of 45 mph, a gas mileage of 13 to 21 miles per gallon, and a 20-horsepower engine. A ceremony marked the end of the Model T line in May of 1927; Ford had produced more than 15 million Model Ts. When its purchase price dropped from the nearly $1,000 of 1908 to under $300 in 1927, the car stopped being a toy for the affluent and became a necessary vehicle for the masses.[4]

Vehicle production and Georgia had a mutually dependent relationship. The development of improved highways within the state (and nation) and an improved economy in most of the nation and state increased the desire and need for vehicles. Commercial travel via buses increased with the production of more buses and improved transportation routes.

The state's enhanced emphasis on education increased the need for school buses — in the state and nation. In 1927 the world's largest school bus producer — the Blue Bird Corporation — began manufacturing its vehicles in the state.[5]

A network of railroads and commercial bus lines served Atlanta and the rest of the state. On December 31, 1917, the Seaboard Airline Railway inaugurated service on a new rail line between Savannah and Charleston. This Seaboard Airline Railway reduced travel time between the two cities, especially as Georgia

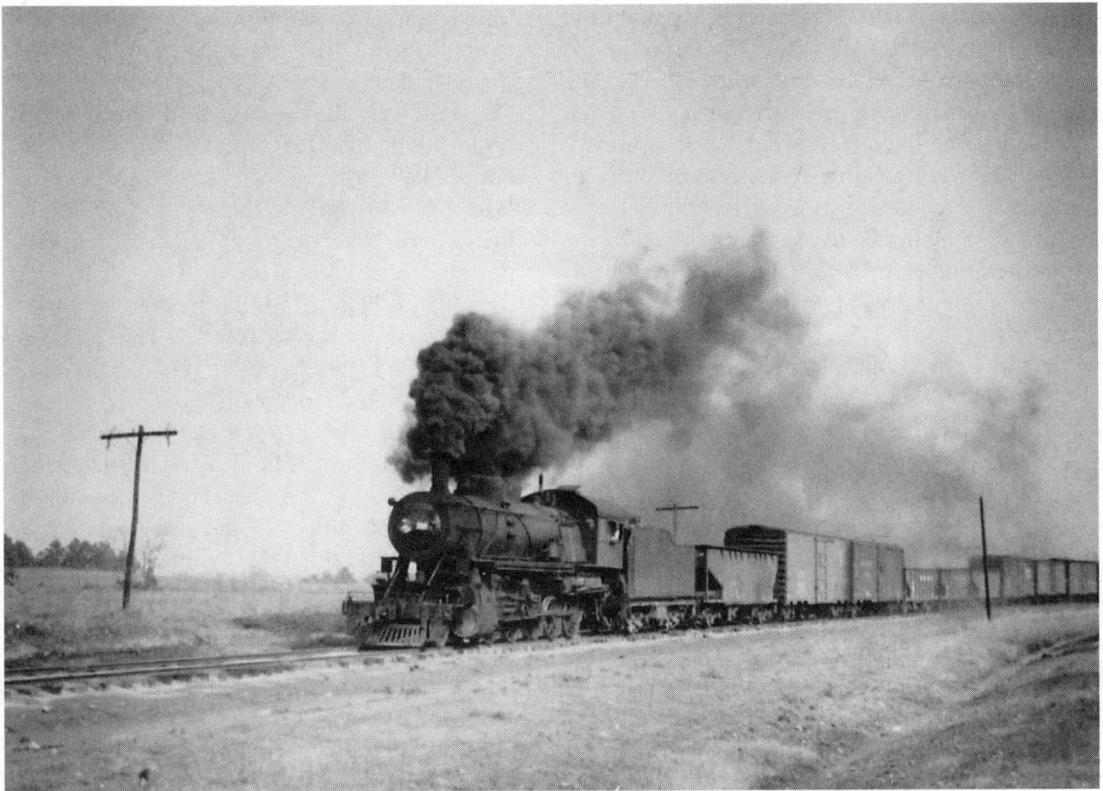

COURTESY DONALD R. HENSLEY, JR., TAP LINES, SOUTHEASTERN RAILROAD HISTORY AND PHOTOGRAPHS WWW.TAPLINES.NET

The Gainesville Midland, from the 1930s, was closely affiliated with the Seaboard Railway. The locomotive is a 2–10–0 "Decapod." Shown near Gainesville, Georgia, this was a mixed train that carried both freight and passengers. The railroad connected at Gainesville with the Southern Railway and at Athens with the Seaboard Railway, the Central of Georgia Railway, the Georgia Railroad, and the Southern Railway.

continued to improve its railways during the 1920s and — later — the 1930s.[6]

Significant also was Atlanta's air transportation initiative. Airmail service between Atlanta and New York became a reality in 1928. In 1929 Delta launched passenger service between Atlanta and New York. The city began to outpace its Southeast commercial rivals of Birmingham and Charlotte.

World War I had provided a great impetus for women's suffrage. During the war, women went to the front as ambulance drivers, nurses, and YMCA workers. On the home front, women had knitted socks, rolled bandages, and performed other essential tasks for those at war. Housewives planted victory gardens and preserved food.[7]

By early 1919 thirty states had granted women their voting rights. Georgia, however, was not one of those. In fact, in 1919 Georgia became the first state to reject the Nineteenth Amendment, which would give women the right to vote. On August 26, 1920, three-fourths of the states ratified the amendment. The passage of this amendment drastically changed the role and the image of American women.[8]

The Nineteenth Amendment read, in part, "the right of citizens of the United States to vote shall not be denied or abridged by the United States or by any State on account of sex." Georgia and Mississippi, however, cited a requirement that one must register six months ahead of an election to vote in that election. Because Georgia's legislature refused to grant "an enabling" act permitting women to vote immediately, white women in Georgia could not vote until 1922.

Passed in 1920, the Eighteenth Amendment prohibited the manufacture, transportation, and sale of alcoholic beverages in the United States. Some veterans began carrying flasks of bootleg liquor instead of rifles, frequenting "speakeasies," where they could buy illegal alcoholic beverages, and even purchasing "moonshine" from unlawful stills. Other Americans may also have secretly violated this amendment.[9]

Atlanta began to organize a nationwide advertising campaign to advance its image. Between the years 1926 and 1929, 679 new firms located in the city. With the firms came the people. The population of Atlanta increased from 200,616 in 1920 to 270,366 by 1930.[10]

The capital city soon became the hub for many insurance, business and banking firms, and, of course, Coca-Cola. During this period of expansion, Atlanta became the convention and cultural center of the South; it housed a symphony orchestra, musical performers specializing in all genres of music, and several colleges—for African Americans and whites alike.

Meanwhile, the "new" woman — the Flapper, with her "devil-may-care" attitude — was emerging across the nation. Bobbed hair, blushed cheeks, and rouged lips called attention to the fact that women were examining their roles and asserting their rights. Dress codes for women began changing drastically across the nation. Short clinging skirts, silk stockings, high heels, and dresses that exposed shoulders and arms were the vogue. Patterns for women's dresses in 1910 had required ten to twenty yards of material; in 1920 only two yards were necessary. Slacks required even less.

Jazz from the backstreets of New Orleans began taking much of the nation by storm, and dances kept time. Songs like "Ain't We Got Fun" blared from Victrolas in parlors across the nation. "The Tango" that Valentino made popular on the big screen, "The Black Bottom," and "The Lindy Hop" were popular dances on floors across America. The song and dance craze "The Charleston" encouraged free and uninhibited movement — even in the conservative Southern states. Dance marathons went on for days. The music was new; the dances were new; the social codes were new.

Georgia, however, did not collectively enjoy the "good times." For some, the Jazz Age soon ended — or failed to begin. In the decade of the 1920s the rural areas especially began to feel the pinch of hard times.

Cotton prices dropped from its price of 35¢ per pound in 1919 to 17¢ per pound in 1920. The price of cotton seed declined from $31 per ton in 1919 to $10 per ton in 1920. Corn prices fell from $1.07 a bushel to 66¢ a bushel. At no time during the next two decades would farm prices reach their pre-war level. For the State of Georgia — primarily an agricultural

state with its textile industry based on cotton — this price drop spelled disaster.[11]

As if the price drops were not trouble enough, the drought of 1924–27 brought further problems and foreshadowed the "Hard Times" to come. The U.S. Geological Service reported that this drought had "a profound influence on industrial and agricultural conditions in Georgia."[12]

Rural Georgia received another blow: the arrival of the boll weevil. First appearing in 1913 in southeast Georgia, the destructive insect began to spread over the state. By 1919 the weevil was devastating the cotton farmers. Thousands of rural families faced hunger and destitution as the insect sought satiation. The drought helped reduce the population of the boll weevil, but the dry weather also reduced crop yields and income from other crops, such as corn.[13]

For more than 100 years, boll weevils wreaked havoc on the U.S. cotton industry. Since its entry into the United States from Mexico in 1892, the insect scientifically known as *Anthonomus grandis Boheman* spread throughout the South, forcing radical economic and social changes in areas that had been almost completely dependent on cotton production. Many experts consider the boll weevil second only to the Civil War as an agent of change in the South. Over the years, estimates of yield losses and control costs due to the boll weevil total more than $22 million.[14]

The female weevils lay their eggs in the flower buds or in the bolls. The larvae that hatch in 2–5 days feed for another 7–14 days. The adults emerge in 4–6 days and chew their way out of the cotton square or boll. The adults continue to feed on the plants; six to seven generations of the weevil may result in a year's time.[15]

Dorothea Lange photographed for the Farm Security Administration a farm boy with a sack filled with boll weevils he has picked off the cotton plants. The scan is dated 1937 — a little later than the 1920s — but the people, the fields, and the boll weevils look the same no matter what the year.

These startling statistics wrought by the insect and the drought of the 1920s are evident in these figures:

Year	Bales of Cotton Produced in Georgia
1919	1,660,000
1920	1,415,000
1921	787,000
1922	715,000
1923	588,000 (Serious war against the boll weevil began with insecticides and reduced rainfall.)
1924	1,002,000
1925–1937	The number of bales remained more than 1,000,000 per year.
1938	The federal crop limitations beginning in 1938 reduced the number of bales to less than 500,000 bales annually.[16]

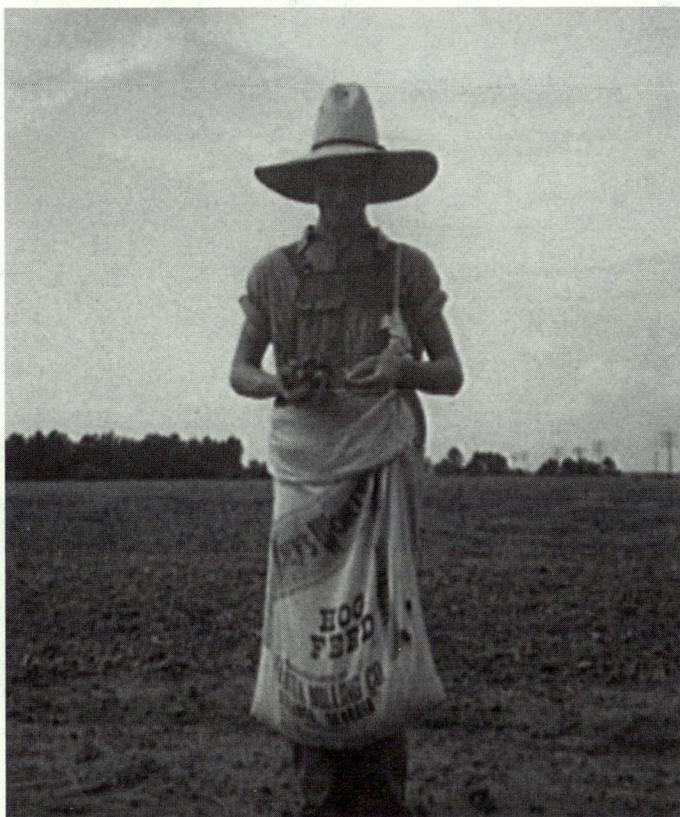

A Georgia farm boy with a sack of boll weevils he picked from cotton plants in July 1937. Photograph by Dorothea Lange, Farm Security Administration.

Mrs. Daisy Thompson of Augusta, Georgia, shared her memories with the Georgia Writers' Project, on February 16, 1940. She spoke of the boll weevil:

> The boll weevil ... got in its deadly work. They practically destroyed the cotton and damaged other crops as well. Prices dropped so low that what little the farmers were able to salvage brought almost nothing and consequently they had no money with which to meet their obligations. Sweet potatoes sold as low as 40 cents per bushel, corn as low as 50 cents, and other products sold accordingly.[17]

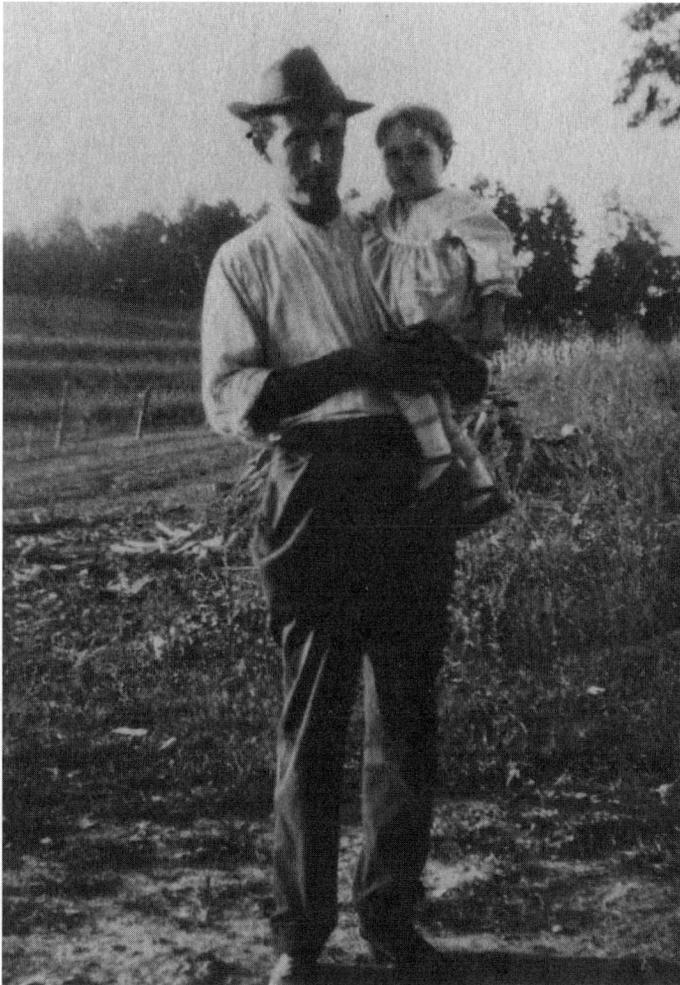

Most Georgians accepted their situations and made the best of their lives. George Hardy appears here with his daughter Georgie. His wife — the mother of their 12 children — died in childbirth; George, a farmer, accepted the responsibility for his family and reared the children successfully. More tragedy came when a son fell off a wagon and died from injuries sustained when the wheel ran over him.

COURTESY ERIN KASCHUB, HIS GREAT-GRANDDAUGHTER

Even the poems and songs of the period reflected the problems with the boll weevil. Below are the first two stanzas of a popular 1920s song/poem with 12 stanzas:

> Oh, de boll weevil am a little black bug,
> Come from Mexico, dey say,
> Come all de way to Texas,
> Jus' a-lookin' foh a place to stay
> Jus' a-lookin' foh a home.
> Jus' a-lookin' foh a home.
>
> De first time I seen de boll weevil,
> He was a -settin' on de square.
> De next time I seen de boll weevil,
> He had all of his family dere.
> Jus' a-lookin' foh a home.
> Jus' a-lookin' foh a home.[18]

Even Carl Sandburg composed his version of a boll weevil song in 1920. One verse of the song reflects the impact of the weevil on all areas of life and reads:

> The farmer said to the merchant
> I need some meat and meal.
> Get away from here, you son-of-a-gun
> You got boll weevils in your field.
> Going to get your home,
> Going to get your home.[19]

Cotton textile mills and the farmer would have done well to examine closely the decreased need for cloth for women's clothing in the Jazz Age. The trend of less consumption of material for fashions coupled with only 7 percent exports helped to create a saturated national market for textiles. Poor strategies for marketing helped make worse an already ailing textile industry. The prescriptions often used for the suffering textile industry were merging the mills, "layoffs," lower wages, and "stretch-outs" that forced employees to tend more machines in the factories at an even faster pace. The future of the textile industry was beginning to be a source of concern to plant owners and workers — but some continued to ignore the symptoms.[20]

There came a time near the end of the 1920s when production of many goods far exceeded national demand, when the American government adjusted tariffs, when the foreign market for American manufactured goods and foodstuffs decreased, when foreign countries did not meet their deadlines for repayment of money borrowed from the United States, when some European countries began to recover and no longer needed aid from the United States, and when other parts of the nation that had prospered in the Roarin' Twenties also began to feel the first pinch of the Great Depression. Many Georgians, however, noticed "nothing new"; lean times had long been with them. Across the nation investors began to take even greater chances. The stock market began to pulsate and tremble. The long, rolling downward slide gained momentum.[21]

The morning of Thursday, October 24, 1929, brought panic to the nation. Traders exchanged more than 12 million shares in a single day. The crash of the stock market followed on October 29, 1929 — Black Tuesday, a sixteen-million-share day. The loss quickly reached more than $30 billion.[22] *The Variety* report on October 19, 1929, summed up the collapse in its headline: "Wall Street Lays an Egg." The Great Depression had officially begun![23]

Following the Stock Market Crash, throughout the nation both laborers and the unemployed were finding their lives and homes threatened from all sides. Citizens responded in a variety of ways.

Some despondent Americans resorted to suicide. Most of these suicides did not occur with the crash of the stock market in 1929, contrary to common belief. The Metropolitan Life Insurance Company reported that 14 people per 100,000 took their own life in 1929; in

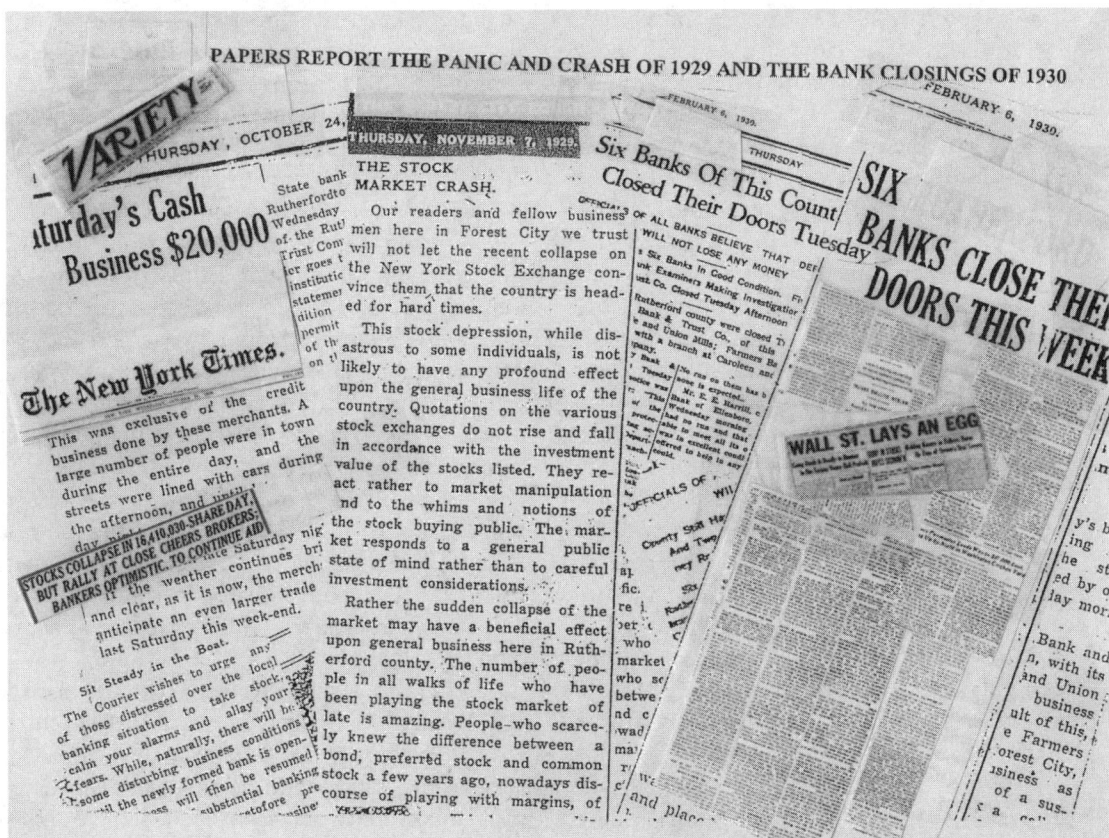

Newspapers across the nation announced the panic of Thursday, October 24, 1929, the crash of the stock market on October 29, 1929 (Black Tuesday), and the closing of the banks.

1931, however, 20.5 per 100,000 took their own life. In 1932, 17.4 persons per 200,000 committed suicide.[24]

The public usually associates Black Thursday (October 24, 1929) with the beginning of the Great Depression in America, but the South and parts of Georgia already knew "hard times." While much of the rest of the nation reveled in "The Roaring Twenties," Southern laborers mired in debt and fought bank foreclosures on their land and assets. Many Georgians were already acutely aware of the "maldistribution of wealth" that McElvaine attributes as a leading cause of the Great Depression.[25]

President Herbert Hoover opposed appropriations for direct federal relief for the nation's citizens; some Americans, however, continued to beg the issue. Hoover, a Quaker, believed that the local level — the communities — should take care of the less fortunate; he encouraged "socially responsible individualists" to take charge. Hoover urged voluntary charity, local aid, and state relief. The President's Organization on Unemployment Relief (POUR) and the Committee on the Mobilization of Relief Resources placed an ad in the *Farm Journal* of December of 1931 urging individuals to "lend a hand."[26]

The nation was even more aware of the arrival of "hard times" with two dramatic occurrences. The first event was in the summer of 1932 when eleven thousand people in the Bonus Expeditionary Force assembled in Washington, D.C., to demand additional government payments from Congress for veterans. Some of these ex-servicemen had brought their families with them and moved into vacant buildings. Others set up shacks outside of Washington.[27] Observers called their squalid, cardboard-and-scrap village "Hooverville." Hooverville was, in reality, much like other such villages that countless homeless people had set up in vacant lots across the country during this bleak period.[28]

Hoover finally offered $100,000 to help the 11,000 veterans with their return home from the capital city, but Congress did not vote to pay additional funds to the Bonus Army. Six thousand of the troops accepted the money, but the others refused to leave. President Hoover called up the troops to help with the eviction.[29]

July 28, 1932, brought General Douglas MacArthur and Major Dwight Eisenhower to Pennsylvania Avenue with the infantry, the cavalry, and tanks. The troops attempted to evict the men from the buildings and to usher them out of the city. One baby succumbed to the tear gas, two veterans died, and two people were seriously wounded. A storm of protest followed. Americans seemed to be losing faith rapidly in Washington. When MacArthur and Hoover attempted to defend their actions, the nation was even more concerned.[30]

On the morning of March 4, 1933, a second event proclaimed further that hard times had arrived. Herbert Hoover and the nation awoke to the collapse of the banking system. When America looked to Hoover for reassurance, he remarked, "We are at the end of our string."[31] Sadly, many Americans—caught with no money in their pockets and foreclosures imminent — had to agree.

The 1920s had symbolized, for much of the nation, a new woman, a new era, and unprecedented economic expansion. The following decade would be a marked contrast for many.

During the Great Depression stocks dropped. Banks closed. Industries failed. Lenders foreclosed. Jobs decreased. Workloads increased. Salaries dropped. Farmers borrowed, accumulated debts, went without, took out mortgages, and sold land and family possessions. They — along with other unemployed Georgians searching for jobs—felt fear.

Even nature seemed to turn on the people. Droughts and floods ravaged the land. Disease and malnutrition escalated. Despair prevailed. Even the well-to-do knew of the pain and suffering about them. Hard times had come.

Franklin Delano Roosevelt, elected in 1932, took the oath of office as president of the United States in 1933. To help with the problems of the nation, and particularly with the problems of the farmers, he persuaded the federal government to create the Civilian Conservation Corps (CCC) and the Agricultural Adjustment Administration (AAA) in 1933.

President Roosevelt's advisers (his "Brain Trust") included Rexford Tugwell. Tugwell came to Washington in 1933 as assistant secretary of agriculture. Tugwell drew many Columbia students with him to the nation's capital and to the AAA. One of his former students was Roy E. Stryker. Stryker eventually worked with the AAA, the Resettlement Administration, and the Farm Security Administration, and the Office of War Information.

One of Stryker's duties was to direct and organize the federal photographers; these men and women captured 107,000 images of the Great Depression — including more than 2,500 in the state of Georgia alone. (Stryker's work at the federal level would later extend to the Office of War Information.)[32]

These important images during the 1930s record forever the despair and the pride, the young and the old, the rich and the poor, the cities and the villages, the landed and the landless, the worker and the unemployed during the era of the Great Depression. The photographs will help to tell the story of *Georgia During the Great Depression.*

Top left: *Rexford G. Tugwell, administrator of the Resettlement Administration. Photograph taken between 1935 and 1937.* Bottom left: *Roy E. Stryker, photograph chief of the Farm Security Administration, Washington, D.C., January 1942. Photograph by John Collier.*

Water, Soil, and Industries Based on Natural Resources

As the twentieth century began, Georgia resolved to be the Southern leader in industry and economic development. For this reason, Georgia—for a while—took the nickname "The Empire State of the South."[1]

In the 1920s and 1930s, Georgia—the largest state in area east of the Mississippi River—was indeed rich in many natural resources, including water, soil, minerals, and forests. These resources and their related industries were important both to Georgians and to the economic health of the state and the nation, particularly during the Great Depression. The industries and resources, however, varied according to the regions.

I. Five Physiographic Provinces or Natural Regions in Georgia

Georgia has 159 counties and five distinct physiographic provinces or natural regions: (1) the Appalachian Plateaus in the northwest corner; (2) the Ridge and Valley Region that joins the Appalachian Plateau and that includes Rome, Georgia; (3) the Blue Ridge Region that makes up the rest of the northern part of Georgia encompasses 5 percent of the state, and includes Clayton, Georgia; (4) the Piedmont Region of central Georgia, that makes up 30 percent of the state and includes

Athens and Atlanta, the capital city; and (5) the Coastal Plain that covers the lower section of the state and encompasses 60 percent of the state.

The Appalachian Plateaus. The Appalachian Plateaus occupy the northwestern corner of Georgia. Lookout Mountain cuts across Georgia's portion of the Appalachian Plateau. Forming the eastern edge of the plateau is Sand Mountain, a 1500-foot high mountain. The province contains both iron and coal deposits. Interestingly, the soil in the plateaus is often rich, but the uneven terrain makes farming difficult.

When people from the mountains of North Carolina and Virginia began to move into Georgia, these immigrants received the insulting name "Crackers." Residents considered "Crackers" as "less than ideal citizens." Other states sometimes referred to the entire state of Georgia with the informal, derogatory nickname "The Cracker State."[2]

The Ridge and Valley Region. Between the Appalachian Plateaus and the Blue Ridge province is the Ridge and Valley Region. As the name implies, both lowlands and ridges characterize this northern region. The valleys of the Ridge and Valley province are suitable for farming; both Rome Valley and Rome, Georgia, are part of this region. Softer layers of rock form the base of the lowland soil. The

ridges of the province often reach elevations of 1500 feet. Resistant rocks mark these ridges. The ridges include Pigeon Mountain and Taylor's Ridge. Forested ridges help to control erosion.

Piedmont Region. The Piedmont Region forms about 30 percent of Georgia. This rolling province lies between the Coastal Plain and the three regions of the north: the Plateaus, Ridge and Valley, Blue Ridge. The altitude of this section rises in places to several hundred feet above that of the surrounding country. The gently rolling land of the Piedmont is suitable to cultivation, but the more hilly sections do not lend themselves well to farming; sometimes forests— often mainly of pine —cover the hillsides.

A prominent natural feature of the Piedmont Region is Stone Mountain, comprised of exposed granite that extends 1,686 feet above sea level. One side of Stone Mountain eventually had a carving etched on its surface.

Chapter seven, "Entertainment," contains more information on Stone Mountain and the lengthy project necessary to achieve the completed sculpture.

Coastal Plain. The Coastal Plain occupies about 60 percent of the state of Georgia. Its elevation rises from sea level to nearly 800 feet above sea level. The extensive salt marshes of the coastal area often become flooded at high tide.

Some geographers divide the Coastal Plain vertically into two parts: the Atlantic Coastal Plain on the east (with Savannah, Augusta, Brunswick, and Waycross) and the Gulf Coastal Plain on the west (with Albany, Valdosta, and Columbus). The Atlantic Coastal Plain generally drains into the Atlantic Ocean; the Gulf Coastal Plain generally drains into the Gulf of Mexico.

A unique area of the Coastal Plain is that of the Okefenokee Swamp. "The Land of the Trembling Earth" earned its name from the

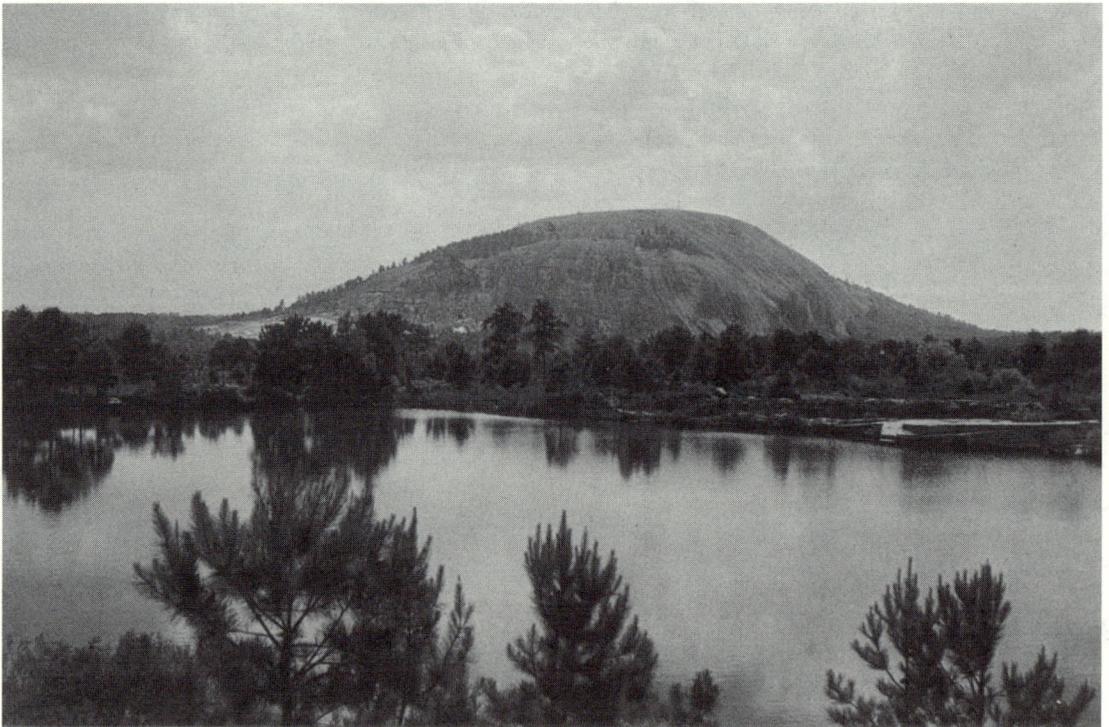

COURTESY STONE MOUNTAIN MEMORIAL ASSOCIATION

Stone Mountain, 16 miles from Atlanta, is known as the world's greatest monolith. The mountain is 700 feet higher than the surrounding plain and more than 1600 feet above sea level. Stone Mountain has 16 billion cubic feet of exposed granite. Seven miles around the base is a carving of the Confederate Memorial.

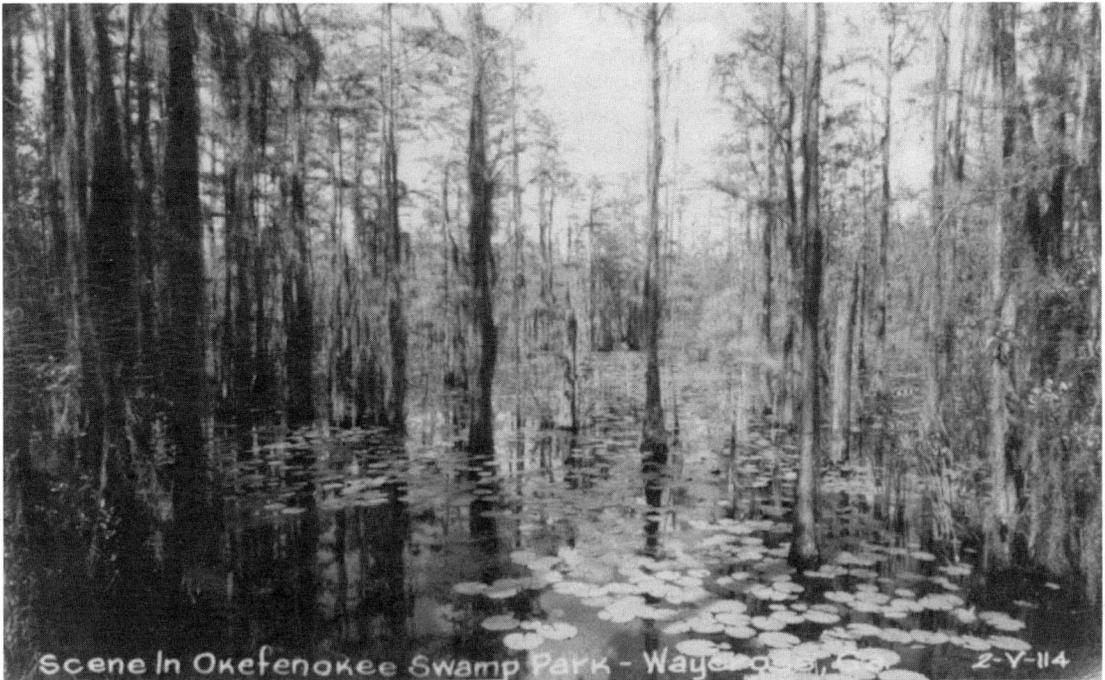

A postcard of the Okefenokee Swamp near Waycross, Georgia.

Indians who once lived in the area. This swamp is a "wilderness of marshlands, floating green lily pads, wild orchids, and bald cypresses draped in Spanish moss."[3] On March 30, 1937, President Franklin Delano Roosevelt issued an executive order creating the Okefenokee National Wildlife Refuge.

II. Water

Roy E. Stryker, who served with Assistant Secretary of Agriculture Rexford Tugwell, organized and directed the federal photographers to capture images of the South and the nation: the droughts, the flooding, the settings, the erosion, and the people. These photographs showing drought, flooding conditions, and destitution helped to document the need for federal assistance to farmers across the nation. Other programs to aid the less fortunate would be forthcoming; Stryker's work directing the photographing of America would continue for more than a decade after 1933.

Rivers. Georgia has many important rivers. Their names often reflect the heritage of the early Indian residents of the state. These rivers were vital sources of food, fish and wildlife habitats, waste assimilation, water supply, power, travel, and leisure-time activities both to residents and to tourists from other areas. The mark of rivers is apparent throughout the state. Most of the rivers of Georgia flow either eastward to the Atlantic Ocean or southward to the Gulf of Mexico. A few, however, flow northward to the Tennessee River, a major tributary of the Mississippi. Most of the rivers of Georgia are navigable as far upstream as Georgia's Fall Line.

Rivers emptying into the Gulf of Mexico. The Etowah River rises in northwestern Georgia. Rising in the northeast portion of Georgia is the Chattahoochee River, which moves southwestward. At a place near Columbus, the Chattahoochee becomes Georgia's western boundary with Alabama. The Flint River joins the Chattahoochee, and they form the Apalachicola; the Chattahoochee-Apalachicola is one of the longest river systems in the eastern part of the United States.

During the Great Depression (1934) Atlanta began the construction of a new sewer

system to help with waste assimilation. Financed in part by the federal Public Works Administration, the new system helped with the environment. This was the largest WPA project in the South; it employed thousands of unskilled workers for months. Prior to its construction, Atlanta dumped half of all its sewage into the Chattahoochee River. The situation was so bad that Gay Shepperson, who administered federal monies to the state of Georgia, wrote:

> Since the bond issue of 1910 the city [of Atlanta] has issued no appropriation for sewage disposal. In other words, the city for a quarter of a century, has stood still.
> Atlanta has escaped an epidemic of typhoid fever by the grace of God and nothing else.
> Atlanta is polluting every stream in every Atlanta water-shed, every hour of the day and every night. This condition creates a menace to the public health which is frightful to contemplate.[4]

The Coosa River and its tributaries from northwestern Georgia join the Tallapoosa River in Alabama. Rivers flowing to the Gulf of Mexico from the Coastal Plain include the Suwanee and the Ochlockonee. Flowing from the Blue Ridge are the Ocoee (Toccoa), Nottely, and Hiwassee, which join Tennessee's Tennessee River.[5]

Rivers emptying into the Atlantic. To the south and to the east of the Chattahoochee and the Flint Rivers is a watershed. This divider separates the streams that flow into the Gulf from the streams that flow into the Atlantic.

The Ogeechee River with its black water and the Canoochee River converge and wind their way to the Atlantic. The Broad and the Satilla find their way to the Atlantic Coast. The Altamaha, the tributaries of Ocmulgee and Oconee, the Satilla, and Saint Marys form part of the state boundary between Georgia and Florida. The Withlacoochee River and those other rivers are important to South Georgia. The Savannah River, Georgia's major river

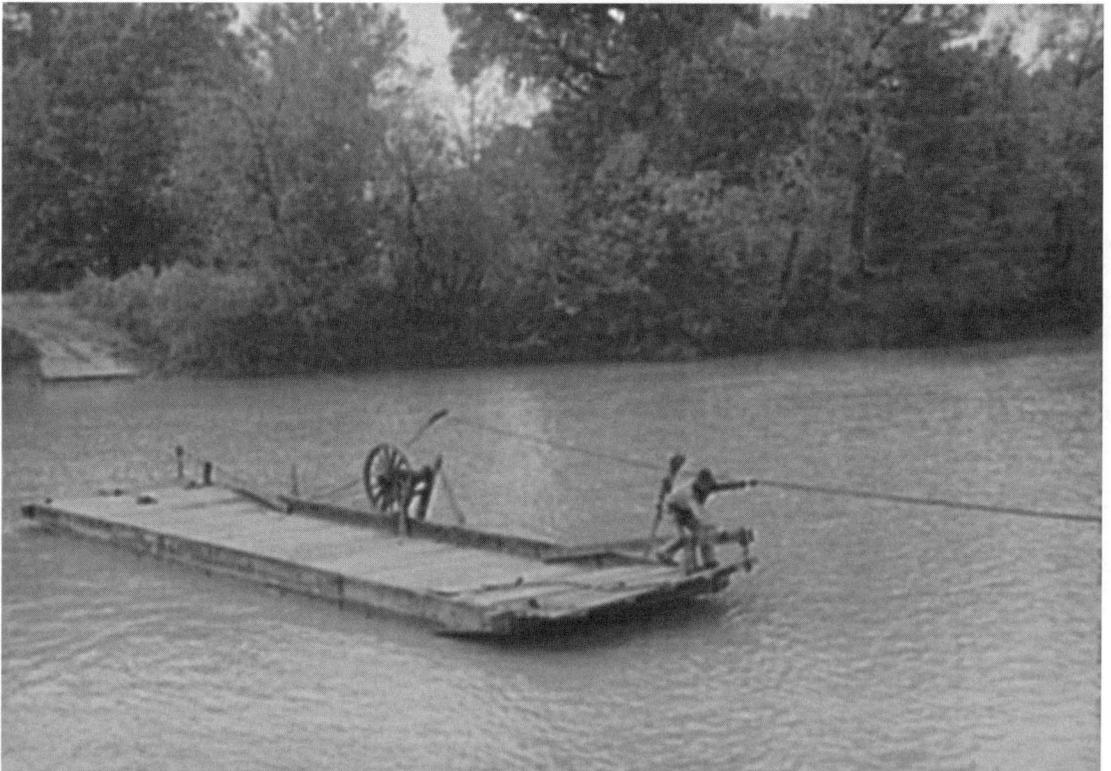

LC-USF34-046369-D. LIBRARY OF CONGRESS, PRINTS AND PHOTOGRAPHS DIVISION, FSA-OWI COLLECTION

Parks Ferry across the Oconee River in Greene County, Georgia, November 1941. Photograph by Jack Delano, Farm Security Administration.

flowing to the Atlantic, helps to define the eastern boundary of Georgia. The Tugaloo River at its head forms Georgia's eastern border with South Carolina.

Bridges were necessary to cross some of these rivers. In other places ferries provided an alternate way of crossing Georgia's rivers for many years.

The Oconee and the Ocmulgee arise from the same springs. The two rivers join to form the Altamaha River, which reaches the Atlantic Ocean and formed part of the Florida/Georgia boundary. At the mouth of the mighty Altamaha are swamps, lowlands, and marshes, which help to refresh and renew the rivers and the ocean.

The Okefenokee Swamp has within its boundaries the origins of the Suwanee, which moves southward across Florida and into the Gulf of Mexico. Also arising within the Okefenokee Swamp is St. Marys; this river, along with the Altamaha, the Ocmulgee and the Oconee tributaries, and the Satilla, form part of the Georgia/Florida boundary forms part of the border between Georgia and Florida.[6]

The Fall Line. A fall line marks the place where the upland region (or in Georgia's case, the Piedmont) and the coastal plain meet. The Fall Line is particularly apparent when a river crosses it because there will often be rapids or waterfalls. River boats often find travel difficult or even impossible at the Fall Line because of rapids and shoals; navigation upstream can be particularly difficult on Georgia's south-flowing rivers.

The Fall Line bisects Georgia. It was here that settlements frequently began because of increased transportation services and a ready supply of water power. The Fall Line, then, helped to define the future of Georgia. Some of the cities to spring up along Georgia's Fall Line were Augusta on the Savannah River,

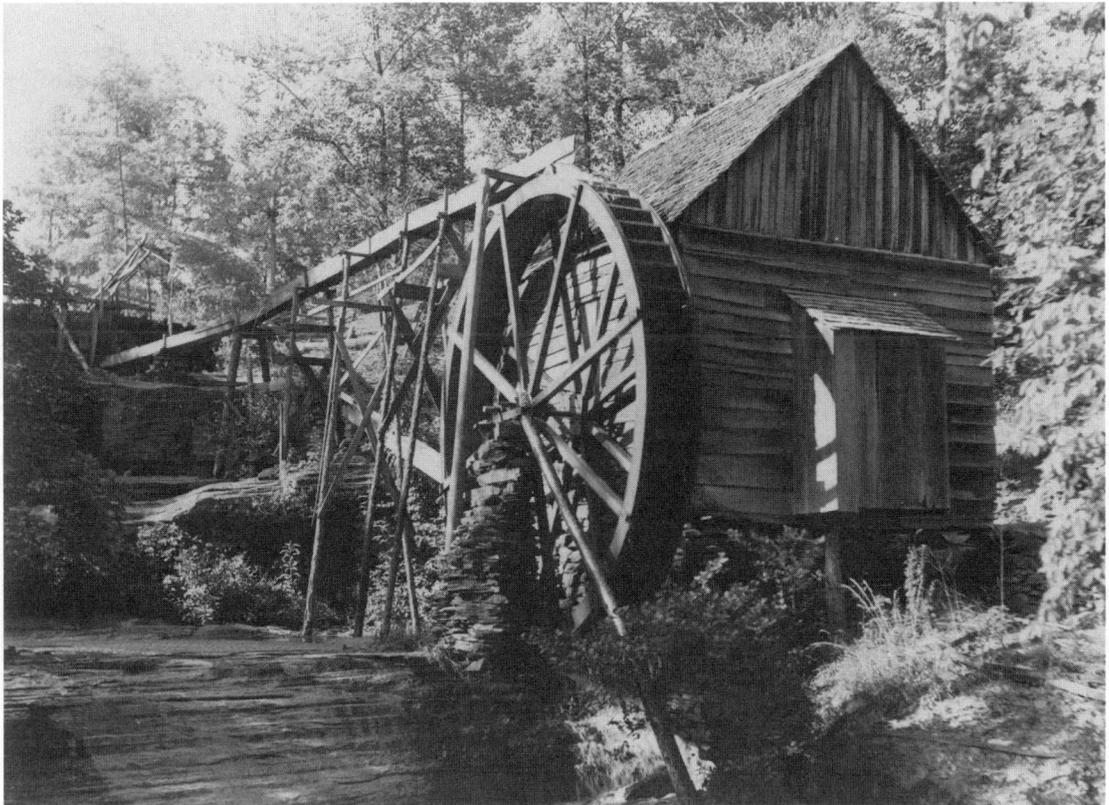

Waterwheel at Logan Maxwell's grist mill, three miles from Cornelia, Georgia, June 1936. Photograph by Carl Mydans, Farm Security Administration.

Milledgeville on the Oconee River, Macon on the Ocmulgee River, and Columbus on the Chattahoochee River. Those who fish for sport, for a livelihood, and for food and those who seek to navigate the rivers and shoot the rapids for recreation find the fresh water at the Georgia Fall Line a challenge.

Georgia industrialists often harnessed the natural water power for mills and plants. Millers, for example, usually placed their businesses near the water and used this power source to turn the wheels of the grist mills.

Factories flourished at the Fall Line; industrialists could use both the rapidly flowing water for hydroelectric power and Georgians as a cheap, plentiful labor source. Some of the Georgia industries at the Fall Line manufactured textiles, paper, paper products, furniture, clothing, wood products, and foodstuffs (corn meal, flour, etc.).[7]

Jimmy Carter, however, is quick to distinguish between Georgia's "divide" and that of the Continental Divide in the Rocky Mountains. He explains that Georgia's divide is not as noticeable because the land was part of the bottom of the seas in the "not-too-distant geological past" and is, therefore, relatively flat. He notes that because of the early ocean sediments and nutrients from plants and animals the land is rich and productive. He describes his town of Plains as being on level land and about 30 miles from the fall line. He said that people had always described the area by saying, "When it rains, the water don't know which way to run."[8]

Waters of the Coastal Plain and the Atlantic Coast. The rivers of Georgia become more sluggish near the Coastal Plain. The upper Coastal Plain is suitable for agriculture; water was generally plentiful enough for the farmer of the 1920s and 1930s.

The lower Coastal Plain, however, has

"Tornado" fence at cotton mill, Atlanta, Georgia, May 1939. Photograph by Marion Post Wolcott, Farm Security Administration.

poorly drained soils. These marshes of the low country provided an ideal environment for rice, an especially essential crop of the colony of Georgia. In the 1920s and 1930s, however, forestry was a more important industry of the coastal area. Pulp wood, pine resin, and other naval products were major products of the area. Industrial development along the coast was strengthened by plentiful water, ports, and proximity to forest productions and other resources.

The Georgia coastline along the Atlantic Ocean is 100 miles long. When all the bays, islands, and river estuaries are measured, however, the coastline is 2,344 miles long. Georgians found many uses for these areas just before and during the Great Depression. The marshes along the coastal region were ideal for nurseries for the commercial fishing industries. Fishing and recreation were common uses for the area.

Near the coast of Georgia are shallow water bodies, or bays. There are about 1,000 bays, which make up some 250,000 acres. These elliptical bays are parallel to each other. Sand rims are on the east and south sides. The Georgia bays vary in size from seven miles to a few hundred feet.

Scientists estimate that all these bays are about the same age and are about 40,000 years old. The bays may have been the result of the impact of the shattered pieces of a meteorite. They recharge the groundwater in the area, serve as habitats for fish and wildlife, provide recreation, and stimulate scientific curiosity. In 1933 Tybee Island became a National Wildlife Refuge, which included a breeding area for migratory birds.[9] Even Franklin Delano Roosevelt enjoyed fishing in the waters of Georgia.

Georgia's Barrier Islands. Barrier islands are the offshore deposits of sediment and sand that parallel the coastline. The current theory

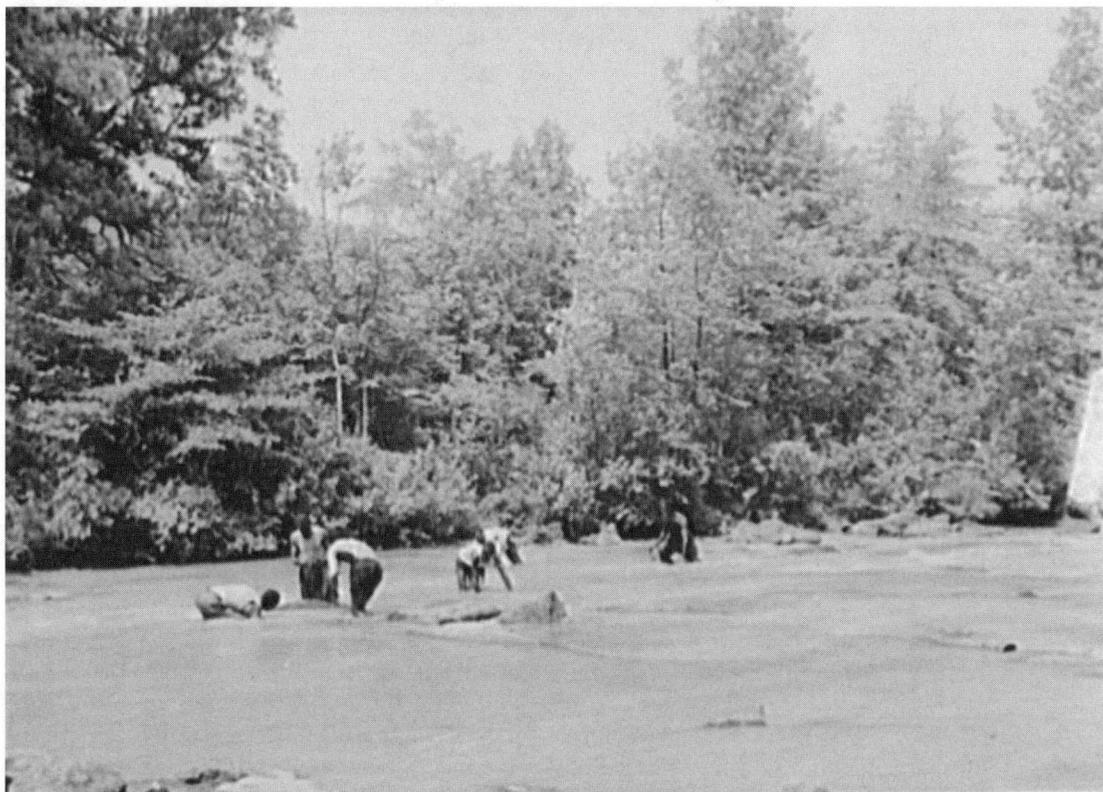

Blacks catching small catfish with their hands to be used as bait in the shoals of Little River, near Eatonton, Georgia, in June or July 1936. Photograph by Carl Mydans, Farm Security Administration.

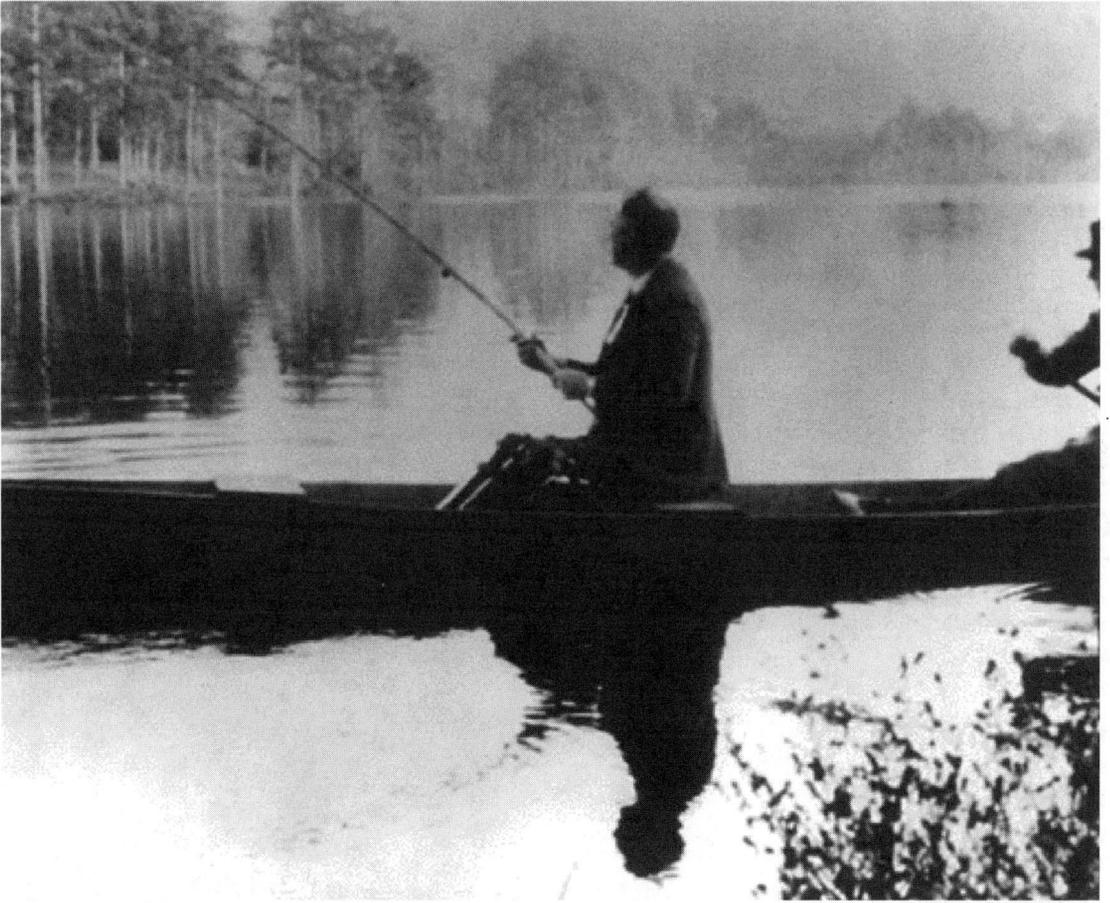

FDR fishing at Warm Springs, Georgia, 1925. Photograph by Basil O'Connor.

of the formation of the older barrier islands is that they resulted from the melting and receding of the glaciers, the rising of the sea levels, and the flooding behind beach ridges. Sediment from the waves and currents along with sediments from the mainland continue to build some ridges even higher. These older barrier islands are usually less than 25 feet above sea level, but Georgia's more newly formed barrier islands have steeper ridges. Barrier islands protect the coastline from storm damage, harbor wildlife, and help to purify runoff from the mainland streams and rivers.

The water that separates the barrier islands from the coast is a bay, a sound, a lagoon. Chains of barrier islands follow the coastline of Georgia. Tidal inlets separate one barrier island from another. Behind the barrier islands is a 4- to 6-mile band of marshland; this marshland contains 393,000 acres. Georgia's barrier islands include Tybee Island and Little Tybee islands, Wassaw and Skidaway islands, Ossabaw Island, St. Catherines, Blackbeard Island, Sapelo Island, Wolf Island, Little St. Simons, St. Simons, Sea Island, Jekyll Island, and Cumberland Island, including Little Cumberland Island.

Tybee Island. Tybee Island is one of the smallest and most northern of Georgia's barrier islands. Tybee Island has 3.4 miles of beach and is more easily accessible than some of the other barrier islands. From 1897 until 1947, Fort Screven on the island was an important part of the coastal defense system of America. Troops trained and stood guard there during the Spanish-American War, World War I, and World War II.

A prominent feature on the landscape is

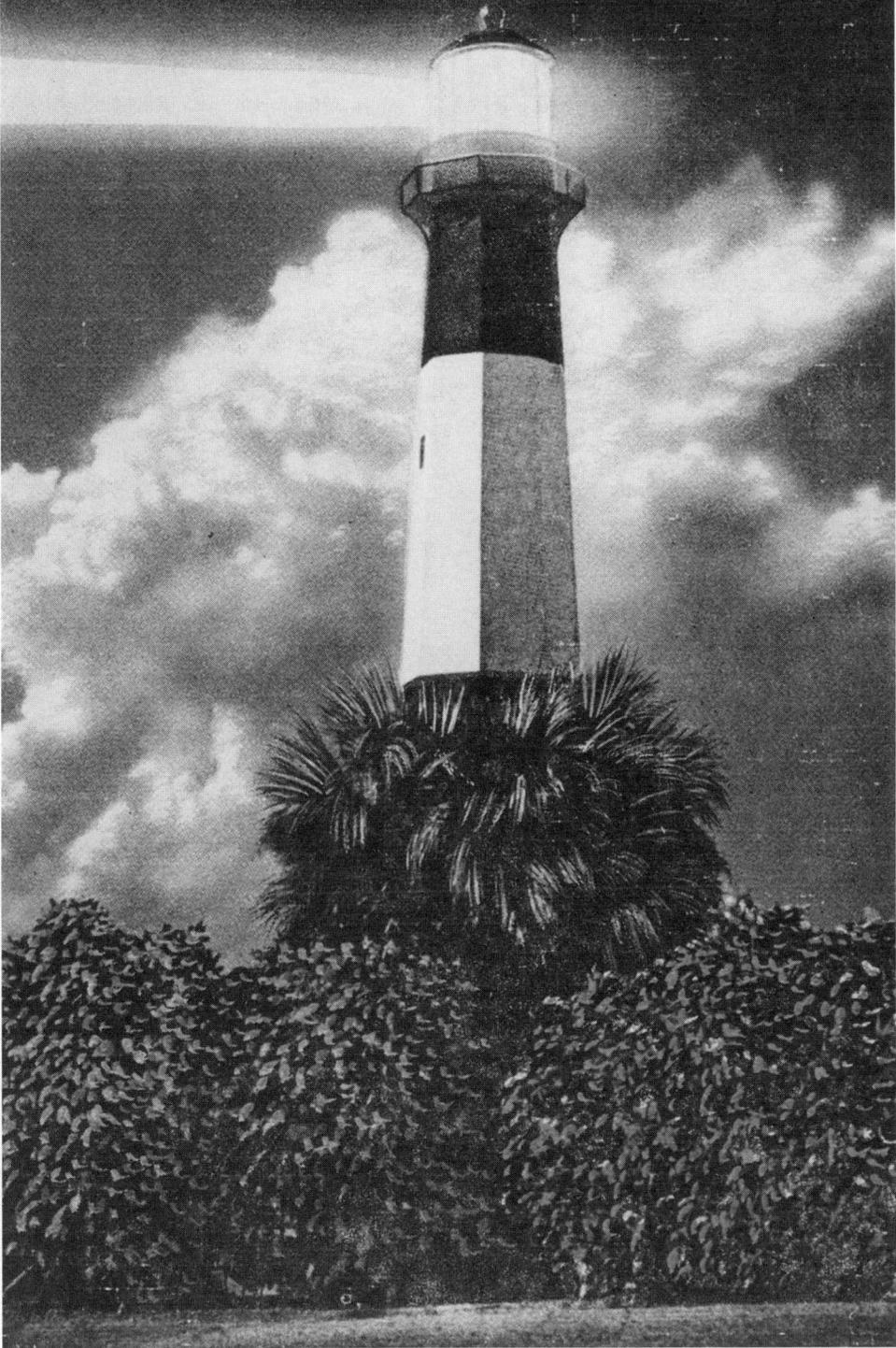

E.C KROPP CARD #32132. COASTAL NEWS (SAVANNAH), CIRCA 1930.

This 1930s postcard shows Tybee Lighthouse, Savannah Beach, Georgia.

the Tybee Lighthouse at Savannah Beach. The history of the Tybee Lighthouse dates back more than two centuries. General James Oglethorpe, governor of the 13th colony, ordered the building of the first lighthouse in 1732. Noble Jones of Wormsloe Plantation directed the building of the octagonal structure of brick and cedar piles. The ninety-foot lighthouse was the tallest of its kind in America at that time. Five years after its construction in 1736, a storm swept it away.

The second lighthouse was complete in 1742. Like the first, it was not far enough inland to survive the seawater for years to come. Another lighthouse was in order. The third lighthouse was completed in 1773. After Georgia ratified the Constitution and became a state, the state ceded the lighthouse to the federal government (1790); the U.S. Lighthouse Establishment assumed it operation. Confederate troops partially destroyed the lighthouse to prevent Federal troops from using it as a guide for their troops.

Authorization of a new lighthouse dates from 1866, and the Lighthouse Establishment began its construction. The bottom sixty feet of the building were intact, so the Establishment made additions to the existing structure. The result was a first order station, made of metal and masonry only; the construction was fireproof. The facility opened in 1867. The lighthouse had 178 stairs and a nine-foot-tall Fresnel lens.

Several changes were apparent by 1933. Tybee Island became a National Wildlife Refuge, which included a breeding area for migratory birds. Electricity — not kerosene — now concentrated the rays of light from the lighthouse effectively; a 1000-watt bulb from the facility was visible at a distance of eighteen miles. A lighthouse keeper no longer seemed crucial, with the advent of electricity. When Lighthouse Keeper George Jackson died, there was no employment of a new keeper. The U.S. Coast Guard took over the operation of the lighthouse in 1939 and maintained the light station until its relocation to Cockspur Island in 1987.[10]

The Little Tybee Islands. The Little Tybee Islands are actually larger than Tybee Island itself. The Little Tybees were primarily in a natural state during the Great Depression.[11]

Wassaw Island. Wassaw Island is one of the most unspoiled of Georgia's barrier islands. Wassaw's forests remain uncleared for cattle, crops, or timber production.

In 1866 George Parsons bought Wassaw and built housing compounds on the island for family and friends; Parsons was a wealthy entrepreneur who dealt in cotton, real estate, banks, and railroads. The houses he built reflect the New England background of the Parsons family, the houses still contain their memorabilia, including a journal that recalls the history of the island.

After 103 years of ownership by the Parsons family, the Nature Conservancy bought the island for one million dollars. The U.S. Department of the Interior purchased the land for one dollar, and it became a National Wildlife Refuge in 1969. Accessible previously by boat, the purpose of the refuge is to maintain and enhance the habitat of the loggerhead sea turtles, migratory birds, and resident and nonresident wildlife; the department intends to continue to protect and preserve this barrier island refuge.[12]

Skidaway Island. Skidaway Island was the site of two Confederate encampments. After the war, the industrialized North had both a financial and political advantage over the South; various Northern interests gained control of the island. Union Bag and Paper Corporation (later Union Camp) consolidated its holding; in the 1940s it used Skidaway for pulpwood production. There was no bridge to provide easy access for cars to Skidaway, however. Union offered 500 acres to Georgia if it would build a bridge to Skidaway.

A lucrative activity in the 1910s and 1920s on Skidaway Island — as well as in the mountains and the Okefenokee Swamp — was moonshining; the operators of the stills could easily hide their illegal activity and transport the final product to boats hidden in the marsh. Park personnel at Skidaway located approximately 30 former still sites. At this printing, the island houses the Skidaway Institute of Oceanography, a park, and a nature trail.[13]

Ossabaw. The third largest of Georgia's

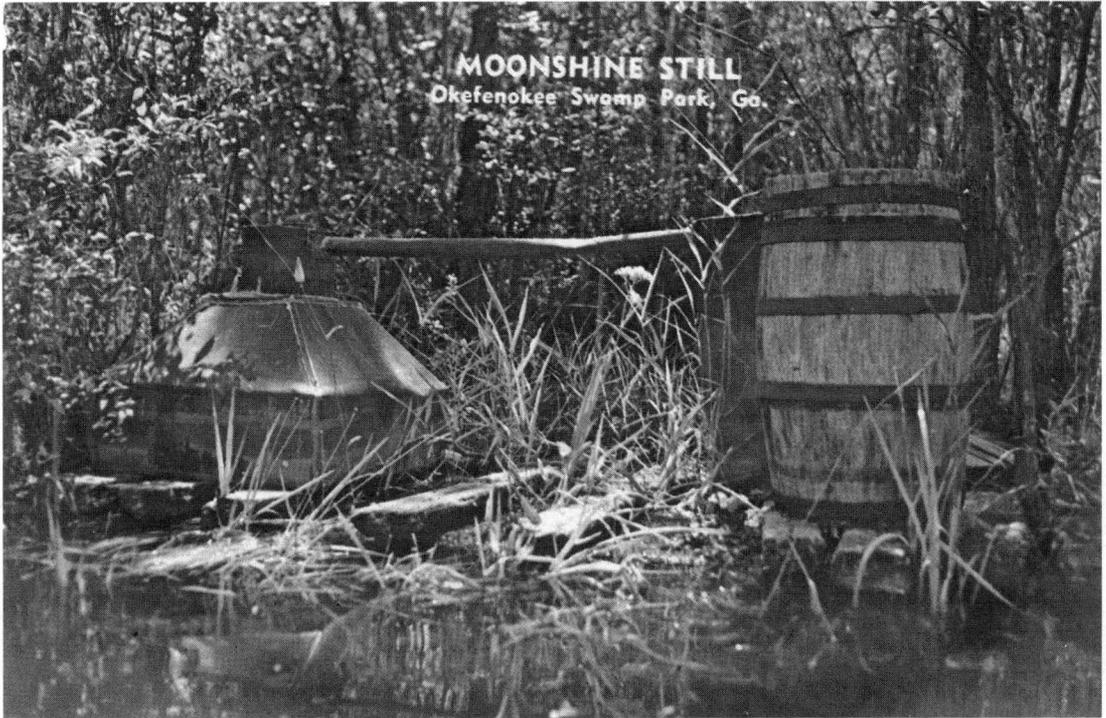

The barrier islands, the mountains, and Okefenokee Swamp were popular places for distilling alcoholic beverages. The sparsely populated areas gave seclusion to the still operators. The postcard caption reads, "The 700 square mile swamp area abounds with wild life of deer, bears, alligators, rare birds, etc. Spanish moss covered cypress trees help to make this spot of wilderness a truly impressive one. The Suwanee and St. Marys Rivers rise in the mysterious depths of this swamp."

SOUTHERN GEORGIA NEWS AGENCY, WAYCROSS, GEORGIA

barrier islands is Ossabaw. Human beings have inhabited Ossabaw for more than 4,000 years. Its rich salt marshes, its freshwater ponds, its forests and beaches, and its dunes have appealed to users for many years. In 1923 Dr. H.N. Torrey purchased the island for a winter residence and passed its ownership down through the family. Henry Ford's was the first signature in the guest book. The Heritage Trust Act of 1975 protects the island from overuse; public access is rare.[14]

St. Catherines Island. After World War I, a Captain Oemler married into the Rauers family, which owned St. Catherines Island. Oemler established an oyster fishery on the island that functioned until the late 1920s.

The Rauers family sold St. Catherines to the New York investors Coffin, Wilson, and Keys. The group retained John Toby Woods as superintendent and permitted Woods to reside in the Oemler house into which he had moved in 1929. Renovations began, but the Great Depression halted many of these improvements. Keys—of Coffin, Wilson, and Keys—bought St. Catherines and allowed the rights to revert to the Rauers family in 1937.

The island has had many uses since the 1930s. Currently the St. Catherines Island Foundation, Inc., administers the island. The American Museum of Natural History oversees research activities on St. Catherines through the Edward John Noble Foundation; this privately-owned Georgia island helps to propagate threatened and endangered species of the world.[15]

Blackbeard Island. The Navy Department purchased Blackbeard Island in 1800 at public auction. The navy harvested some of the live oaks for shipbuilding. Between 1880 and 1910 Blackbeard Island was the South Atlantic Quarantine Station; it housed medical personnel, a wharf, a hospital, and other buildings.

In 1924 the Bureau of Biological Survey received the jurisdiction of Blackbeard Island; the bureau used Blackbeard as a preserve and a breeding ground for migratory fowl and native wildlife. By the presidential proclamation of President Franklin Delano Roosevelt in 1940, the island became a National Wildlife Refuge (http://www.fws.gov/blackbeardis land/history.htm).[16]

Sapelo Island. Sapelo Island is Georgia's fourth largest barrier island. The island is the home of a lighthouse built in 1905 to replace earlier establishments. Made of cast iron, the structure remained in use until 1933. When shipping had declined to the point that there seemed little use for it, the dismantled lighthouse was shipped to South Fox Island on Lake Michigan, where it still stands.

A hurricane in 1898 had left Sapelo's first lighthouse unused on the island. The 100-year-old lighthouse generated interest, and its restoration began. One hundred years after its abandonment (1998), the restored lighthouse continued to be a working aid; its primary function, however, was as a historical landmark. Near the working model is a third, fully-restored lighthouse, built in 1877.

Sapelo is sparsely populated. Only one hundred and twenty-five people currently live on the island. Seventy of these live in Hog Hammock and are the descendents of slaves who lived there.

In 1934 Richard Reynolds established the University of Georgia Marine Institute on Sapelo; the facility operates year round and has served thousands of students, many visiting researchers, and several full-time scientists. The only way to visit Sapelo Island is by a ferry boat that runs only a few times each day.[17]

Wolf Island. The establishment of the Wolf Island National Wildlife Reserve dates from 1930 and includes Wolf Island, Egg Island, and Little Egg Island — all migratory bird sanctuaries. The refuge itself consists of a long narrow strip of oceanfront beach, backed by a broad band of salt marsh backs the refuge. In fact, saltwater marshes make up more than 75 percent of the 5,126 acres. Crabbing and fishing are popular activities on Wolf Island,

but portions of the wildlife refuges are closed to the public.[18]

Little St. Simons Island. In 1908 a representative of Eagle Pencil purchased the Little St. Simons Island with a plan to harvest the cedar trees for making pencils. The trees, however, were not suitable for pencils because of the wind and salt they had endured. Philip Berolzheimer, the owner of the Eagle Pencil Company, was intrigued with the beauty of the island; he bought Little St. Simons as a retreat for family and friends and began a tradition of protection and conservation for the island.[19]

On December 1, 1921, Philip Berolzheimer and a group of seven other men — "The Eight Bandits" — assembled at noon on North River's Pier 36 in New York City. The eight men told loved ones good-bye, boarded a steamship (the *Mohawk*), left comforts behind, and began the first of their annual treks to Little St. Simons Island. Once they reached the island, for weeks they hunted wild game, played parlor games, enjoyed each other's company, participated in outdoor activities, and escaped the responsibilities of everyday life. The group even designed a flag: eight ducks flying over a running deer; a modified version of their flag serves as the logo for the island. Even Georgia's Governor Eugene Talmadge, who served from 1933 to 1937, joined Berolzheimer on occasion.[20]

St. Simons. St. Simons, the largest of the barrier islands, became a subject of interest to Howard Coffin. After creating a retreat on Sapelo Island, the head of Hudson Motor Cars and cofounder of United Airlines paved twenty-two miles of road there in the 1920s. He donated land for an airport and for a Coast Guard station. The steady growth of St. Simons was "hard on the heels of the Depression."[21]

In 1935 the private club "The King and the Prince" had its beginning on St. Simon's Island. The club offered the members fashionable parlors, a bar, card rooms, extravagant floor shows in the garden, and a social atmosphere. The club burned in 1936; after its rebuilding, it burned again in 1937. The hotel that exists today was built in 1939–1940. The private club did not become available to the general public until 1941.[22] St. Simons became a mix of residential and resort areas. Coffin

COURTESY LITTLE ST. SIMONS ISLAND

Philip Berolzheimer and Governor Eugene Talmadge on a deer hunt, 1934.

also purchased a smaller barrier island: Sea Island.

Sea Island. Sea Island, the smallest of the barrier islands, remained largely uninhabited until the completion of the causeway from Brunswick to St. Simons Island (1924); no state or federal funds aided in the completion of this important causeway. In 1928 the Cloister, a 46-room hotel, opened on nearby Sea Island; this resort, managed by Alfred W. Jones, was the culmination of a vision of Howard E. Coffin, founder of Hudson Motor Company. Coffin hoped that visitors to the Cloister might decide to build their homes on Sea Island; his plan worked.[23]

For many years, rooms in the Cloister were available for rental only to the descendents of the original "approved" members. Over the years the Cloister has grown to 262 rooms; reservations are still difficult to obtain.

The Cloister, still under the management of the family of Alfred W. Jones, was the site of the 30th annual G8 Summit, June 8–10, 2004; President George W. Bush selected Sea Island as the meeting place.[24]

Jekyll Island. In 1888 a clubhouse on Jekyll Island was ready for occupancy by the members of the Jekyll Island Club. This club, a haven for successful entrepreneurs, had a limit of 100 members, who were usually the most affluent families of the late 1800s and early 1900s.

At first the primary activity for members was hunting, but later bicycling, tennis, golf, and lawn bowling proved popular. In the evenings members enjoyed multicourse meals. Billiards, dancing, cards, and fireside conversation occupied the guests after dinner. Eventually some of the club members built their own "cottages," which were actually mansions.

In 1942 the club closed; World War II had

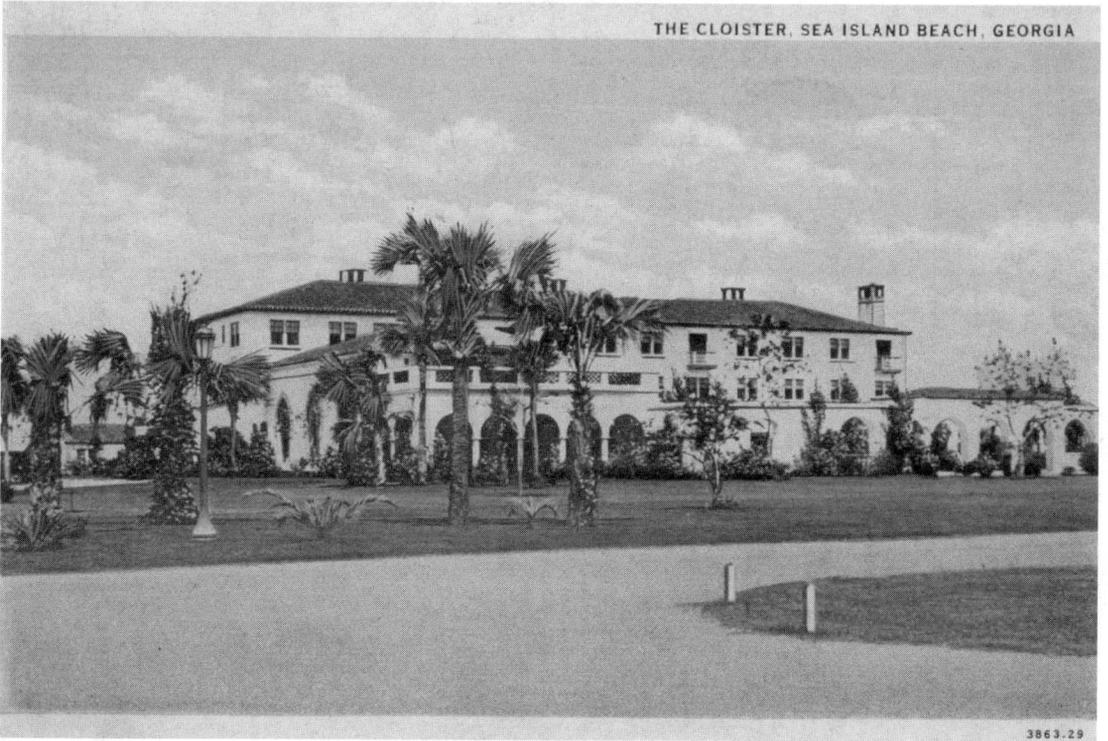

Postcard of the Cloister on Sea Island Beach in the 1930s.

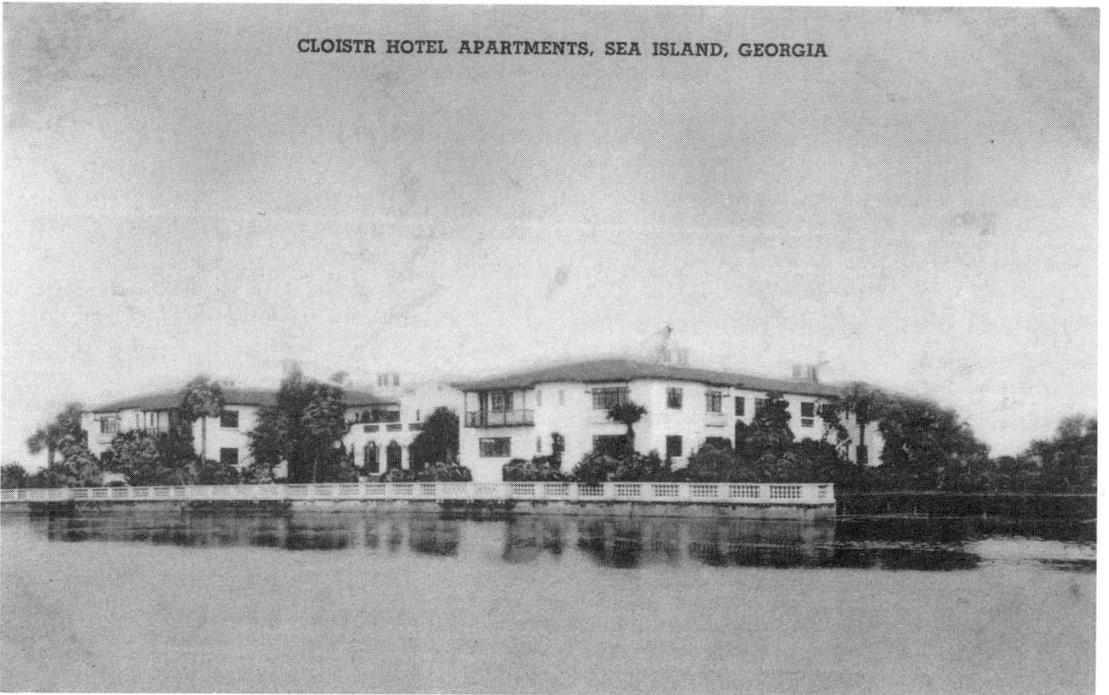

This postcard of the Cloister Apartments on Sea Island Beach has a postmark of 1939.

resulted in drafting some of the members and employees and in rationing the commodities. The state of Georgia purchased the island after the closing. Jekyll Island is now part residential, part state-owned, and frequently used as a public beach and convention center.[25]

Cumberland Island. Cumberland Island is the largest of the barrier islands. It is really two islands— Little Cumberland Island and the island proper —connected by a marsh. A ferry is available for visitors who wish to reach the 15,100-acre Cumberland Island. Only two structures indicate that humans have lived on the island.

One of these two structures is the Dungeness Mansion. Thomas Carnegie built Dungeness on the site of the residence of Catherine Greene, who was the wife of General Nathanael Greene, the Continental commander of the South. The other building was the First African Baptist Church; the slaves of Catherine Greene constructed the building in 1893. Rebuilt in 1930, the church still stands on the island. Originally the island was privately owned, but in 1971 the Carnegie family deeded large areas to the National Parks Foundation.[26]

Cumberland Island is one of the world's largest undeveloped barrier islands. It has one of the largest East Coast wilderness areas in a National Seashore and one of the largest maritime forests in the United States.[27]

The Atlantic Intracoastal Waterway. The 100-mile length of the Georgia coast features the chain of barrier islands. The four- to six-mile-wide belt of tidal marshes separates the islands from the mainland. Running the length of the coast and amid the marshes are waterways known as *the inland passage.*

This natural Atlantic water highway has been important since the earliest years of the European occupation. Being a protected route has enabled smaller craft through the years to avoid the outside passage along the coast. Franciscan friars and Spanish traders used these waterways as early as the sixteenth and seventeenth centuries. Along these routes, Georgia colonists transported their cargoes of rice and indigo to markets in Savannah, Georgia, and Charleston, South Carolina.

With the establishment of the cotton plantations and rice plantations in the freshwater estuaries and on the Sea Islands during Georgia's antebellum period, the inland waterway became increasingly important. Small vessels came to the plantations and loaded the bags of cotton and barrels of rice for shipment. The area's rural nature made these intracoastal waterways crucial for links to the outside world and for receipt of goods, equipment, mail, and supplies.[28]

During the Civil War (1861–1865) it was difficult for the Union navy to apprehend blockade runners and Confederate smugglers in the complicated network of creeks and rivers. The inland passage provided many opportunities for evading the Union troops who were seeking to contain the Confederates.

The U.S. Army Corps of Engineers began dredging the inland waterway off the coast of Georgia during the postbellum period. Sections of the waterway require this dredging periodically; the tides meet behind the barrier islands and cause shoaling, or dividing. Particular sites that often mandate this scouring are the areas between Ossabaw Island and the mainland, the river west of St. Catherines Island, and the sound that is northwest of St. Simons Island.

Dredging also continues to keep the channels open. The work of the Corps of Engineers in 1905 and 1908 helped eliminate navigational difficulties that occurred when the waterways filled with sediment and sand. This additional material in the waterways caused vessels to run aground.

In 1938 the River and Harbor Act "created a federally maintained Atlantic Intracoastal Waterway and authorized the deepening of the mean low-water channel from seven to twelve feet throughout its length."[29] This deepening had become increasingly necessary because of the escalating size of vessels using the waterway and the mounting use of the water by industries in Savannah and Brunswick:

> The opening of pulp mills in the mid–1930s required larger barges to facilitate the shipment of long-haul commerce over the AICW. The Corps of Engineers began regular maintenance of the waterway, including the dredging that is a necessary activity. The corps, in the 1930s and

1940s, obtained from the state of Georgia the marshland rights-of-way along the passage for the disposal of spoil from dredging work.[30]

The Tennessee Valley Authority (TVA). On April 10, 1933, Roosevelt sent to Congress "A Suggestion for Legislation to Create the Tennessee Valley Authority."[31] He suggested that this corporation

> ... be charged with the power of the Government but possessed of the flexibility and initiative of a private enterprise. It should be charged with the broadest duty of planning for the proper use, conservation, and development of the national resources of the Tennessee River drainage basin and its adjoining territory for the general social and economic welfare of the nation.[32]

This project was to develop the Tennessee area (hard hit by the Depression), provide flood control, increase navigation, and furnish power. Georgia would also directly benefit. Congress approved the "Tennessee Valley Authority Act of 1933" on May 18, 1933.[33]

The jurisdiction of the TVA would be most of Tennessee, large parts of Alabama, Mississippi, and Kentucky, and small parts of Georgia, North Carolina, and Virginia. The TVA was the first large regional planning agency of the federal government.

Lakes of Georgia. Georgia lakes are generally associated with sinkholes and with the bays. Sinkholes are often the result of the dissolving of bedrock (such as limestone) near the surface of the land. Caverns or channels result when the rock materials dissolve. During a period of dry weather, the water level may decrease and remove the support from the land surface. When the land subsides, a sinkhole may result. When precipitation returns and when the water levels return to normal, a pond or lake may result. The largest spring in Georgia — Radium Springs in Albany, Georgia — is an example of this process.

In the southern part of Georgia, bodies of water include rivers, swamps, and marshes. These swamps and marshes are present when there are high water tables and poorly drained

WATERFRONT, BRUNSWICK, GA.

89531

This postcard shows the waterfront of Brunswick, Georgia. Its caption reads, "The largest of Ocean going vessels can dock within two blocks of the main business section of the City. Ship is loading rosin and turpentine for Europe."

soils. The largest swamp in Georgia is the Oke-fenokee Swamp, which is within the Coastal Plain. Marshlands, lily pads, wild orchids, Spanish moss, and cypresses characterize the Okefenokee.

Georgia's largest reptile — the alligator — occupies the Okefenokee Swamp and other coastal swampland. Nonpoisonous snakes and the poisonous coral snakes, water moccasins, copperheads, and pygmy diamondback rattlesnakes find havens in the swamplands. Birds—like herons, egrets, wood ducks—occupy the coastal plain; other birds are plentiful throughout the state.[34]

There are no natural lakes in north Georgia. North Georgia is geologically old; the natural barriers that may have allowed these lakes to exist have long since eroded away. There are lakes created by agencies, like the Army Corps of Engineers; these lakes help with power generation, water supply, and flood control. There are also reservoirs in north Georgia.

The Blue Ridge reservoir was a result of the construction of the Blue Ridge Dam on the Toccoa River in 1930; the Toccoa Electric Power Company constructed the dam. At the time of its construction, the Blue Ridge Dam was the Southeast's largest earthen dam, with 65 miles of shoreline on the 11-mile long reservoir. In 1939 the Tennessee Valley Authority purchased the facility for use in the production of hydroelectric power.[35]

The Nottely Dam is located near the north border of Georgia and North Carolina. On the southeastern edge of the Tennessee River watershed, the construction of the dam dates from World War II. The Nottely Reservoir helps with recreation, with power generation, and with flood control.

During the 1920s and 1930s, however, many of these lakes were not ready for use. The list below indicates the name of some Georgia lakes and the approximate date construction commenced:

Allatoona Lake, 1944
Carters Lake, 1962
Clarks Hill (Strom Thurmond), 1946
Hartwell Lake, 1955
Lake Chatuge, 1941

Lake Seminole, 1947
Lake Sidney Lanier, 1950s
Richard B. Russell Lake, 1974
Walter F. George Lake, 1944
West Point Lake, 1962[36]

Fishing. In the lakes and streams of north Georgia and of central Georgia, mountain trout, pike, bream, bass, and catfish are plentiful. In the Coastal Plain one can often find redfish, bass, mullet, drum, shad, and mackerel. Saltwater fish include tarpon, sailfish, channel bass, and spotted weakfish.

Georgia of the 1920s and 1930s, however, had only a minor commercial fishing industry in comparison with other states on the Atlantic Seaboard. In contrast, the town of Brunswick began to increase in its seafood processing and eventually ranked high as a seafood-processing center.[37]

Brunswick Fish Canneries and Brunswick Stew. Brunswick developed a meat and/or seafood dish that chefs and cooks around the nation try to replicate. Brunswick's stew continues to be popular both inside and outside the state.

A "good-natured rivalry" continues between Brunswick County, Virginia, and Brunswick, Georgia, for the claim of originating Brunswick stew. Preparing and eating the stew is a social custom that develops friendship and cooperation in certain communities. The ingredients may vary from recipe to recipe and depend on the foods "on hand" at the time. The Georgian humorist Roy Blount Jr. claims that "Brunswick stew is what happens when small mammals carrying ears of corn fall into barbecue pits."[38]

The basic recipe for Brunswick stew may vary from place to place and stew pot to stew pot. Generally, chicken, pork, and/or beef today replace the squirrels or rabbits of earlier recipes. Any vegetable and any seasoning can become a part of the stew, but onions, corn, tomatoes, and potatoes commonly appear. The following recipe is "a Georgia version":

Georgia Brunswick Stew

1 2-lb chicken
1 lb. lean pork
½ lb. lean beef

½ lb. shelled, deveined shrimp
3 medium onions, chopped
4 16-oz cans tomatoes
5 tablespoons Worcestershire sauce
1½ bottles (14 oz.) catsup
1 tablespoon Tabasco Sauce
2 bay leaves
½ bottle (12 oz.) chili sauce
½ teaspoon dry mustard
⅛ pound of butter
3 tablespoons vinegar
2 16-oz cans small lima beans
2 16-oz cans cream style corn
1 can small green peas
3 small potatoes, diced
1½ cups okra (optional)
Salt
Pepper

Combine chicken, pork, and beef in a large, heavy pan. Season with salt and pepper. Add onions and cook with water. Cook slowly for several hours until the meat falls from the bones. Remove from heat and allow to cool.

Tear meat into shreds and return to stock in the pot. Add shrimp, canned tomatoes, Worcestershire sauce, catsup, Tabasco sauce, bay leaves, chili sauce, dry mustard, and butter. Cook 1 hour and stir occasionally to prevent sticking.

Add vinegar, lima beans, corn, peas, potatoes, and okra (if desired). Cook slowly until thick. Serve in bowls.[39]

Springs. Springs are points of focused discharge of ground water. The source of these springs may vary. Shallow groundwater seepage may feed some springs. Artesian pressure may even discharge deep aquifer water under pressure in other instances.

Many rural families without an icebox or refrigerator might build a box around a spring with cold water. The family could place milk (or other perishables) in containers (often crockery), carry the food to the springhouse, and store the items to be preserved in the springhouse. The temperature there was often cool, regardless of the outside temperature. Butter, eggs, and other items lasted longer in the springhouse.

LC-USF34-046516-D. LIBRARY OF CONGRESS, PRINTS AND PHOTOGRAPHS DIVISION, FSA-OWI COLLECTION

A boxed-in spring on the Jackson farm in Greene County, Georgia, November 1941. Photograph by Jack Delano, Farm Security Administration.

Warm Springs. Groundwater may emerge with a water temperature above that of its surroundings. This is a *warm spring*, and the cause of the increased temperature may vary from place to place. Sometimes this warm temperature results from the mixing of hot-water and cold-water springs, as is the case of Warm Springs, Georgia.[40]

Warm Springs, Georgia. The warm temperature of the springs at Warm Springs, Georgia, is the result of the mixing of hot water and cold water springs. Located in west Georgia, Warm Springs is sixty miles south of Atlanta. This natural thermal spring has water that flows at 914 gallons per minute and has a temperature of 88° Fahrenheit the year round. A resort built near the springs in 1832 helped develop the area that had been a bathing place for the Creek Indians.

Franklin Delano Roosevelt suffered from a severe attack of poliomyelitis in 1921; beginning in 1924 he found relief from water therapy at Warm Springs, Georgia. At the suggestion of his Georgia friends, he frequently exercised in the mineral-rich water. After finding that the waters helped him, he spent $200,000 of his own money to establish the Georgia Warm Springs Foundation. This nonprofit organization became the nation's leading research and treatment center for poliomyelitis.

After Roosevelt began to frequent the springs and became a well-known figure, locals and tourists came to welcome him, particularly after his election to the presidency in 1932. Scientists, government leaders, Hollywood stars, reporters, polio sufferers, and others began to frequent the area. The population of the nearby town of Warm Springs grew from 400 in 1930 to 608 in 1940.

Little White House. Roosevelt even built a home at Warm Springs. This residence received the nickname "Little White House."

Roosevelt worked with Cuthbert native Henry Toombs to build a school, Georgia Hall, which housed the cafeteria and the administrative offices, and a chapel in Warm Springs.

Having visited Warm Springs, Georgia, many times, Roosevelt was particularly aware of the problems facing Georgia and the nation.

Roosevelt was active in raising money for research on and treatment of poliomyelitis. He deeded most of his Georgia property to the foundation. To raise funds for the Warm Springs Foundation and for polio research, he gave Birthday Balls beginning in 1934; these fundraisers later took the name of March of Dimes. The State of Georgia took over operations of the Warm Springs Foundation after Roosevelt's death on April 12, 1945; the name of the institute became Roosevelt Warm Springs Institute for Rehabilitation in 1980.[41]

Precipitation and Temperature. The abundant precipitation coupled with the rich Georgia soils and relatively mild temperature to make Georgia a prime location for farms. Plentiful water usually combined with the rich Georgia soil to ensure agricultural products. Even though Georgia has usually enjoyed abundant rainfall, periods of drought did occur at times. In 1923, for instance, drought threatened Georgia crops, but this drought did provide one advantage: it helped to control the boll weevil that was threatening the cotton crops in the state.[42]

Anna Tutt, of Cordelia, Georgia, in "Blacks in Appalachia," tells of a humorous experience with the boll weevil:

> I've got to tell you this about our boss man during the boll weevil time. You know what boll weevils are? Well, they were eating our cotton crop up, so Mr. Gross sent us some black-and-white molasses in a barrel and some arsenic. He told my daddy to mix the molasses and arsenic together and to make a mop out of some rags tied on a stick. Then dip the mop in a bucket of that molasses and arsenic mixture and go down the row swabbing it on the cotton. Well, we don't mix the arsenic with the molasses. We got hungry for the molasses and ate the molasses up and the boll weevils ate the cotton up.[43]

North Georgia, with its Appalachian Plateaus province, its Ridge and Valley region, and its northwestern portion of the Blue Ridge region, receives a yearly average of 50" to 60" of precipitation; the temperature ranges from about 40 degrees Fahrenheit in January to about 10 degrees Fahrenheit occasionally. In July the average range for the mountains is 74° to 78° Fahrenheit, but occasionally the temperature reaches even higher.

Franklin D. Roosevelt in Warm Springs, Georgia, in 1923.

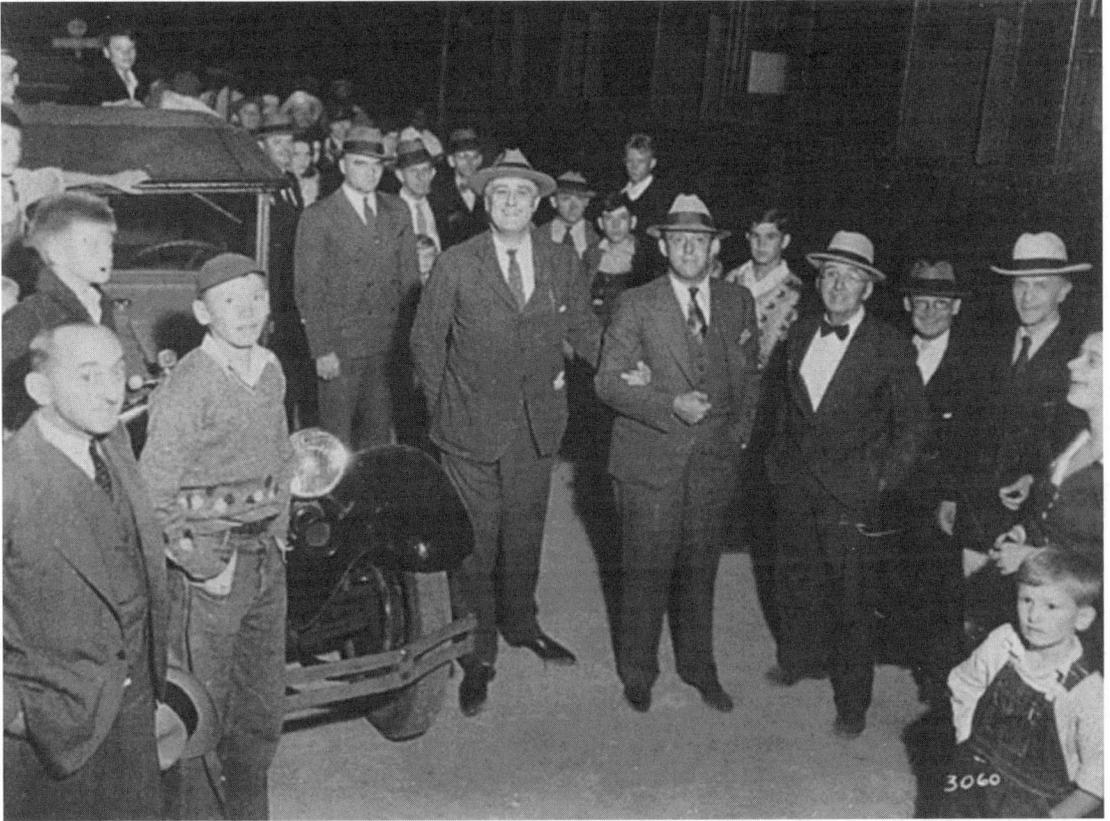

Franklin D. Roosevelt and others in Warm Springs, Georgia, 1932.

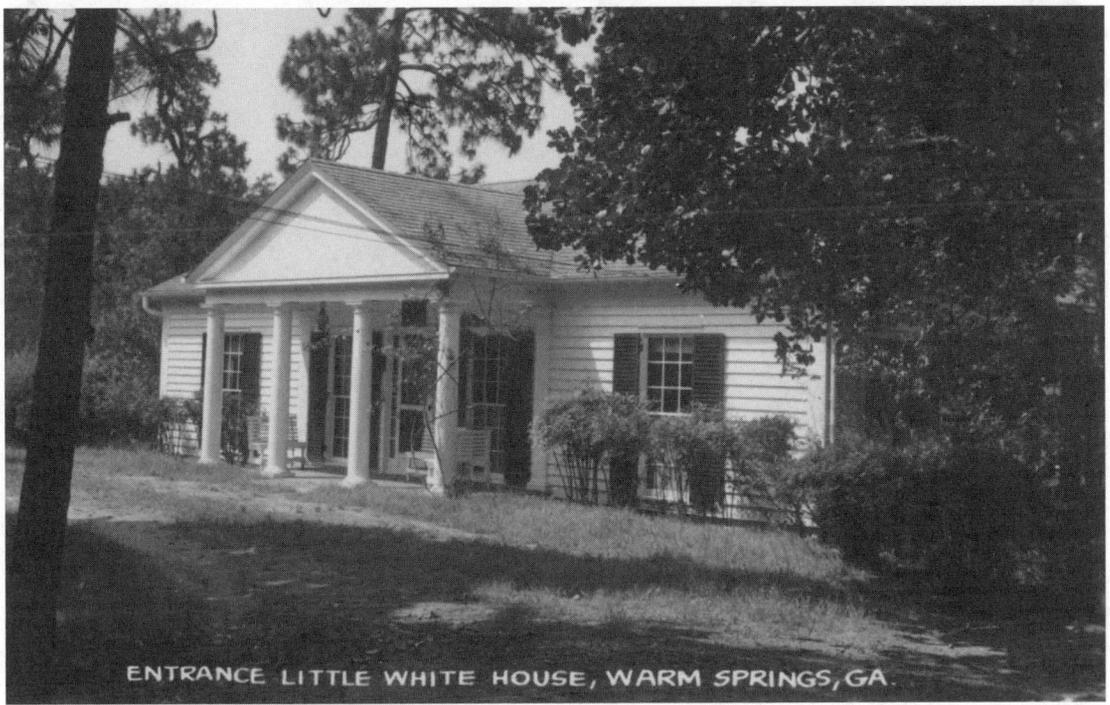

ENTRANCE LITTLE WHITE HOUSE, WARM SPRINGS, GA.

Postcard showing the "Little White House" that Roosevelt built at Warm Springs, Georgia.

This postcard shows the tiny chapel where Franklin D. Roosevelt often worshipped when he visited Warm Springs, Georgia.

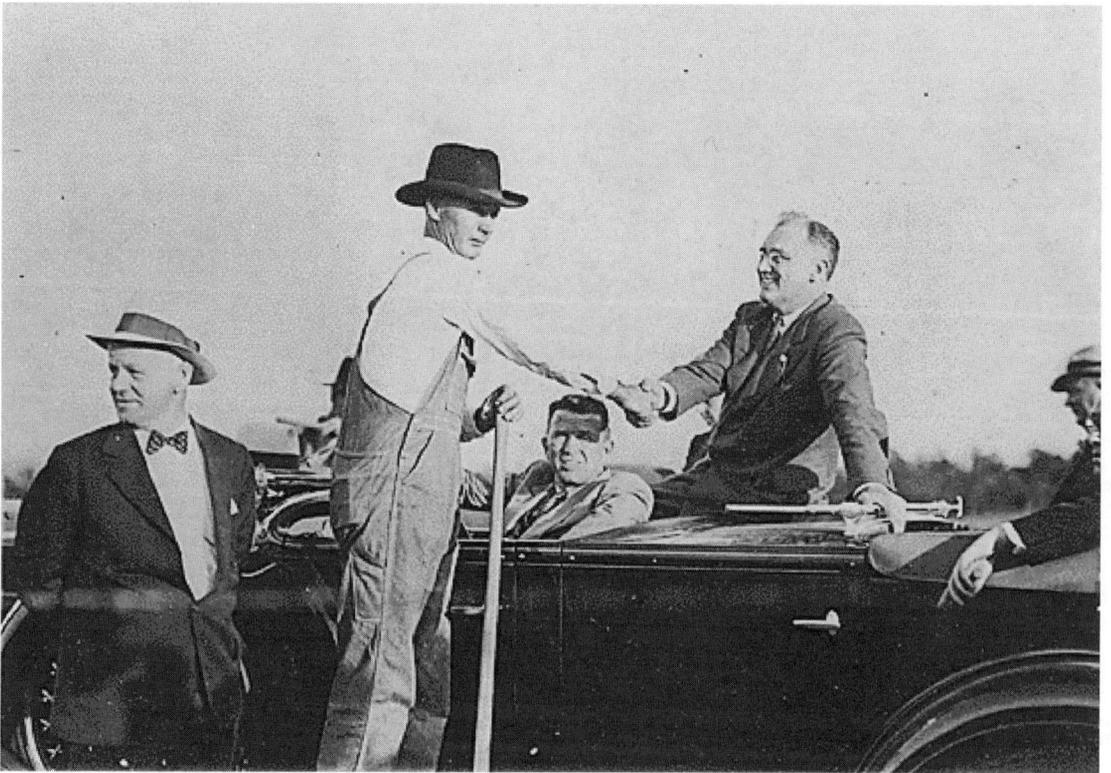

Franklin D. Roosevelt shakes hand with a farmer en route to Warm Springs, Georgia, October 23, 1932.

Like North Georgia, the southernmost portion of Georgia enjoys 50" to 60" of annual precipitation. The northeastern part of the Blue Ridge Province that is closest to the Atlantic annually receives 60" to 80"—normally, the highest amount in the state. The rest of Georgia—most of the middle section—receives 40 to 50 inches. The average temperature in January for the Piedmont and the Coastal Plain ranges from about 44° Fahrenheit in the north to about 54° Fahrenheit in the south. The July temperatures range from about 80° Fahrenheit to about 100° Fahrenheit; occasionally the temperature may reach 110° Fahrenheit. The humidity of the area makes the temperature uncomfortable to most people.[44]

III. Soil

On June 22, 1938, President Franklin Delano Roosevelt requested the National Emergency Council (a group he had appointed) to present to him: (1) a detailed report on the economic problems of the South and (2) possible solutions to the problems.[45] The National Emergency Council reported emphatically that "Nature gave the South good soil."[46] Indeed, Georgia has several distinct types of "good soil"; misuse through the years, however, had caused some problems for the farmers and for the state in the 1930s.

Soils of the Coastal Plains. The soils of the Coastal Plains of Georgia include clays, loams, and gray, sandy soils. The sandy soils are often too dry to be productive and are often too poor in organic matter to be suitable for farming—unless the farmer uses large amounts of fertilizer. Erosion was a problem in the Coastal Plains and elsewhere across the state.

Soils of the Piedmont. The soils in the Piedmont and northern regions vary from the light-colored, sandy loams (under which there is clay subsoil) to reddish clay loams and sticky red clays. Erosion began to affect particularly the hilly sections

of the Piedmont during the 1920s and the 1930s; the erosion of the top soil had begun much earlier.

Soils of the Plateaus. The Plateaus province has loamy soil of a brown or red color. Though the loamy soil is fertile, only the level areas are suitable for farming.

Soils of the Ridge and Valley regions, Blue Ridge province. This region is west of the Blue Ridge Mountains. Past compression forces from the southeast pushed northwestward and formed its ridges and its valleys. The rock layers folded and buckled to form parallel ridges and valleys with a southwest trend. In the northwesterly direction, however, the compression was less, and resulted in uplifting the northwest portion of Georgia—an extension of the Cumberland Plateau. The uneven, hilly land still makes it difficult to farm.

Runoff, erosion, and their prevention. Improper farming methods in Georgia, combined with improper harvesting of timber and the lack of cover crops, created problems such as erosion. When President Franklin Delano Roosevelt took office, he began working to reduce these difficulties affecting the state and

The exposed tree roots show how the land had been washed away on old Wray Plantation in Greene County, Georgia, July 1937. Photograph by Dorothea Lange, Farm Security Administration.

the nation. One of the causes of the erosion in Georgia was the excessive runoff; as rainwater and flood water reached the exposed soil, valuable topsoil was carried away with the water. The estimate in the 1930s was that the Piedmont and Atlantic Coastal Plain alone had lost as much as 5 to 13 inches of topsoil since the colonial era. The hilly, steep land, in particular, combined with lack of terracing, the planting of the same crops in the same places year after year, the improperly harvested timber, and the failure to plant cover crops resulted in the formation of gullies and in fields stripped of topsoil.

A concerted effort began in the 1930s to convert the badly eroded fields to pasturelands or woodlands to combat erosion. Terracing, contour plowing, and crop rotation helped to control runoff and to preserve the fertility of the hilly land under cultivation. Also important was the work of the Tennessee Valley Authority in creating dams to control floods and water runoff.

Georgia farms. Rich Georgia soils encouraged agriculture and a variety of crops in the state. Corn has always been a leading food and livestock crop for Georgia although tobacco, peanuts, and cotton have also long been important to the state. The period between the last killing frost in the spring (February on the southeastern coast to April in the northern mountain valleys) and the first fall killing frost (September in the north and the first of December along the coast) is the *growing season*; with its average growing season ranging between 190 days in the northern mountains and valleys and 300 days in some of the barrier islands, Georgia — as a whole — has a long period for growing crops.[47]

In the 1930s Georgia was a state of small farms. The average size of a farm in the United States was 156.9 acres; the average size of a Southern farm was 106.4 acres. By comparison, the average size of a Georgia farm was 86.4 acres.[48] By 1940 the average size of a farm in the United States had risen to 174 acres. Georgia farms, however, averaged only 109.6 acres; the number of acres of a Georgia farm was up from the 1930 size, however.[49]

Small farms meant that the per capita income of Georgia farmers might be less than the income of those farmers on larger farms. For the years 1920 to 1930, the median annual per capita income for Georgia was $244. The median annual per capita income for all states was $605; the median annual per capita income for New York and Illinois— to which many Georgians migrated — was $852.[50]

Tractors were slow in coming to Georgia and the South. In 1930 only 3.9 percent of Southern farmers owned tractors; the percent for the nation as a whole was 13.5. By 1940 only 9.3 percent of Southern farmers owned tractors; the South did not achieve the 13.5 percent that the nation as a whole had achieved in 1930 until the year 1945. The South was 15 years behind. Georgia was a slow state in changing from mules to tractors largely because of the small size of the farms.[51] In Georgia, the Atlanta mule warehouse sent the animals to the rural areas for the farmers to evaluate and purchase. There was no need for a farmer to secure a truck or make a trip to Atlanta to "shop" for an animal. The Atlanta mule warehouse periodically might come to the farms with animals for the farmers to evaluate and perhaps buy.

"Po' Boy" Jenkins spoke about the "mule business":

> I started in the mule business in 1930, and my last was in 1950.... [In the thirties, most Georgia farmers depended on mules] one hundred percent. They was so damn poor they couldn't buy a tractor. Had to buy a *mule* on credit.... A horse couldn't stand up to this heat. And then a mule's small foot didn't tear your crop down — your cotton — like a horse. See, they grew cotton and corn in this country....
>
> When the Government really bought the mules was the rehabilitation program [the Agricultural Adjustment Act, during the Depression]. That started back in '34 , and in '35 I guess I sold a hundred mules to Farm Security. They had four men here in this country supervising farmers, and I'd sell those mules to 'em. The [farmers] would be down and out, you know, and the Government would loan 'em five or six hundred dollars to make a crop with.... Buy 'em a mule and a few farming tools....[52]
>
> I'd buy them from the stockyard. Bought a few from Tennessee. I bought most of them down in Atlanta. At one time they had the biggest mule market in the world. I bought the mules at Union

Erosion in south section of Heard County, Georgia, in April 1941. Photograph by Jack Delano, Farm Security Administration.

Iola Smith, daughter of Lemuel Smith, a Farm Security Administration borrower, driving cows into the pasture in Carroll County, Georgia, April 1941. Photograph by Jack Delano, Farm Security Administration.

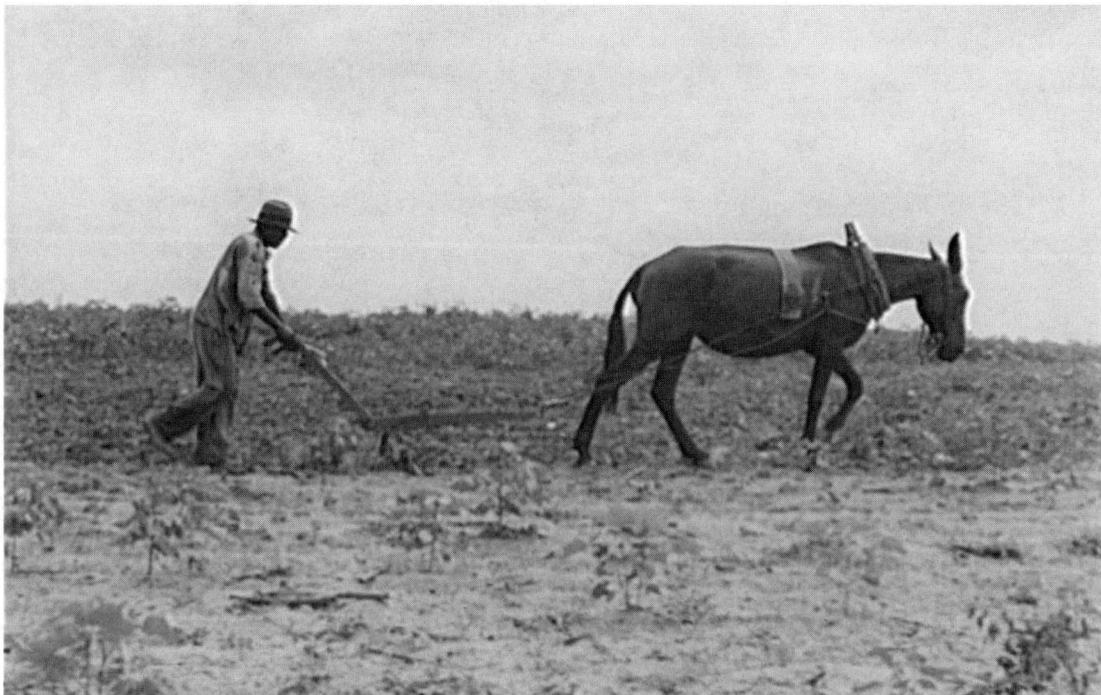

The cotton sharecropper's unit was one mule and the land he could cultivate with a one-horse plow, Greene County, Georgia, July 1937. Photograph by Dorothea Lange, Farm Security Administration.

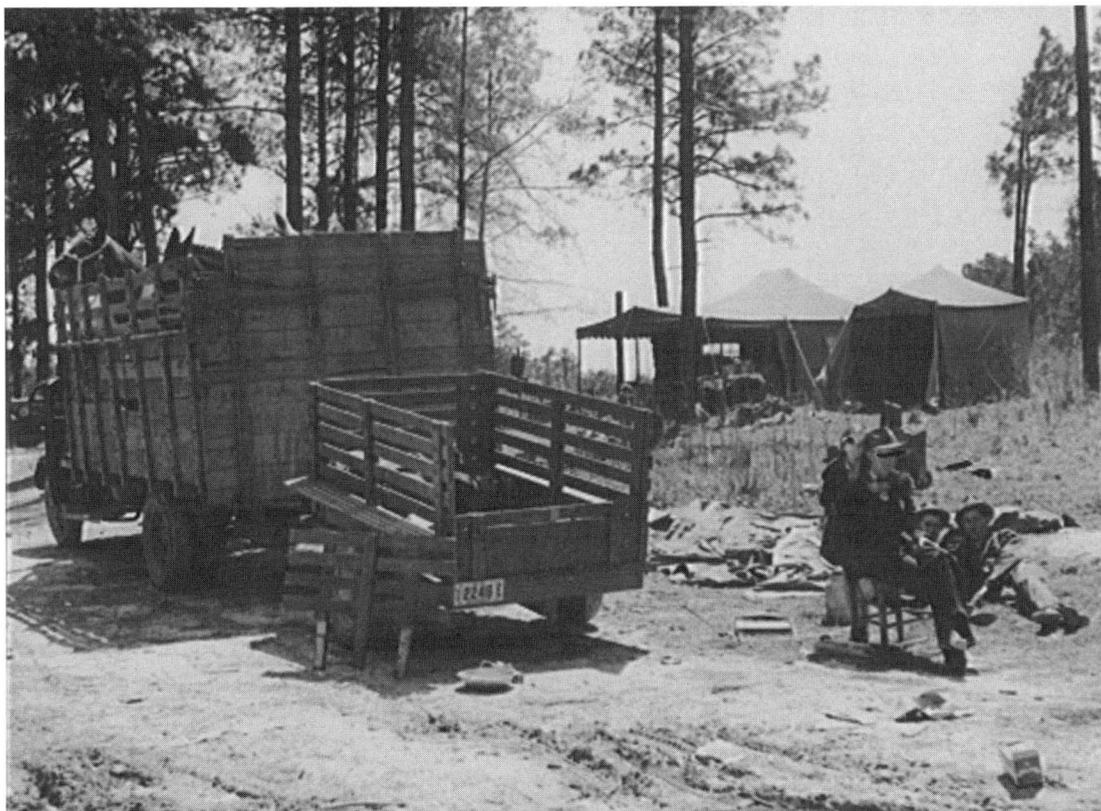

An Atlanta mule warehouse sent a camp into rural sections of Georgia for several weeks at a time to sell mules to farmers, May 1939. Photograph by Marion Post Wolcott, Farm Security Administration.

Stockyard there, and then I'd bring 'em back here. I'd go up there and buy a truckload and bring 'em back here and sell 'em and go back and get another truckload.... I sold 'em over about four or five or six counties around here....[53]

Laborers, sharecroppers, and tenant farmers. In 1930 Georgia had a population of 2,238,192 gainful workers who were 10 years old and older. Of these, 498,941 (more than 22 percent) were agricultural workers. All these people who tilled the good soil of the state, however, did not have title to the land they farmed.

Young children labored in the fields. Using all the family members as unpaid workers was common among farm families; in fact, the census of 1930 showed that 131,249 (more than 26 percent) of the agricultural workers were family members who performed agricultural work.[54] Many landless Georgia dirt farmers worked as laborers, as sharecroppers, or as

tenant farmers during the Great Depression. In 1935, there were 250,000 farms in the state; 164,000 were worked by tenants.[55] Georgia had various forms of the tenancy, sharecropping, and crop lien systems. The distinction among them, unfortunately, was not always clear.

Raper and Reid define *sharecropper* in this way:

For the real meaning of the term "sharecropper" look to such matters as low wages, insecurity, and lack of opportunity for self-direction and responsible participation in community affairs. A share-cropper shares in the risk without sharing in the control. The enforced sales, bankruptcies, foreclosures, and mergers of rural and urban plantations themselves suggest that they, too, do not escape the cost of the sharecropper system.[56]

Sharecroppers might furnish the mule, some of the seeds and/or fertilizer, farm animals, or the use of some of the farm equipment; they often had certain fields for which

they were responsible to the farm owners. At the end of the laborer's year of work, the landowner gave the sharecropper his "due" (portion of money or crop, as previously agreed upon) at harvest time. Sharecroppers might live in a house belonging to the landowner, but this furnished home might be miles from the land that the sharecroppers tilled.[57]

The "interchangeability of the two statuses [sharecropping and tenant farming] is evident in nearly every surviving farm and plantation ledger before the New Deal and the age of evictions."[58] Tenant farmers often had the use of a place to live and "legal rights" to their crops and often had to buy their necessities "on time" until they harvested the crops.[59]

This labor system for the rural areas became "codified in the statute books." Coercion to continue the system of sharecropping and tenant farming came from the contract, from violence, from illiteracy on the part of the worker, and from the laws themselves.[60]

The crop lien system was a slightly different system of providing farm labor:

> Hand-in-hand with sharecropping came the crop lien system. To ensure tenants would pay their debts once the cotton crop was in, the General Assembly passed crop lien laws giving landowners a first claim on the crop. Sharecropping and the crop lien system, together with the almost total dependence on cotton, would mean that the Georgia farmer — the bulk of the population — would remain impoverished until the coming of the New Deal and World War II.[61]

Working as a tenant or sharecropper or as a part of the crop lien system was never strictly a racial matter in Georgia during the Great Depression. Both whites and African

Mr. Bickers, photographed in May 1941, ran a country store near White Plains in Greene County, Georgia, and had an interesting collection of Indian relics found in the area. Photograph by Jack Delano, Farm Security Administration.

Americans worked as tenant farmers, as share-croppers, and as part of the crop lien system.

The tenant system often worked in this manner: farmers who had large farms divided the farm into tenant farms; poor families lived on the small farms. "A family raised the crop and paid a share of it (sharecropping) or paid money (renting) to the owner for use of his land, a 'shack,' and perhaps for supplies."[62]

Georgia native Jimmy Carter recounted one "of the old stories told around the filling stations and stables." The landlord had almost finished settling up with the sharecropper:

> "Well, Jim, you almost broke even again this year. You just owe me twenty dollars." Jim replied, "Boss, I thank the Lord for this good year! I have one more bale of cotton in the storehouse not ginned yet." The landlord said, "Well, I think I forgot about the interest charges. We'll have to figure your account one more time."[63]

Sometimes, however, the farm owner "took back" the shacks of the workers. Daniel notes, however, that the 1930s seemed to have "evicted the tenants" and to have cut off the traditional shelter of both the tenant farmers

and the mill workers. Housing became an increasing problem for the poor.[64]

African Americans who remained in the South and owned no land often served as a source of cheap labor. Landowners paid the laborers by the day or by the week. These workers seldom profited much from their toil. In the rural areas some African Americans—and others, too—sometimes worked as day laborers. Rural life for them was often an endless cycle of work and debt.[65]

Cash crops and land misuse. Because the average Georgia farm was small compared with the average national farm, most Georgia landowners tried every year to use every foot of land for the same cash crops. The landowners encouraged tenant farmers to plant crops all the way to the door of the tenant house each season. This ruling limited the land available for the tenant families to use for garden plots, contributed to malnourishment, and increased the worker's cost of living. Dr. Joseph Goldberger, who researched the cause of pellagra in the 1920s and before, was quite concerned about this use of the land:

Cabins in the corn, South Georgia, July 1937. Photograph by Dorothea Lange, Farm Security Administration.

Cotton, grown to supply the textile mills, was "king" in the South when Goldberger came to [the South].... What disturbed him was seeing cotton rows [or other crops] planted up to the porches of sharecropper shacks, with no room left to grow the foods needed to stop the pellagra epidemic....[66]

Planting the same crops in the same Georgia fields each year tended to "wear out" the soil and reduce the yield.

Lack of cover crops. Another common farming practice was a prime example of soil misuse. Georgia farmers before the 1930s and even in the early 1930s did not usually plant cover crops or use terracing regularly. Erosion was, therefore, frequent.

Using kudzu as a cover crop. To try to combat erosion through cover crops, Georgia was one of the Southern states to plant kudzu. Kudzu came to the United States from the Orient in 1876; its use was primarily ornamental in the beginning. Georgia found that the plant might be useful in other ways. Kudzu provided grazing for cattle, grew quickly, and provided a means of controlling erosion. The plant rapidly spread throughout barren land and the South — especially after the Agricultural Stabilization and Conservation Service provided plants to the farmers during Roosevelt's administration. The Soil Conservation Service even set up nurseries to grow the crop, which was in great demand.

The Soil Conservation Act of 1936 allocated money for flood control and for conservation. The Civilian Conservation Corps (CCC) and the Agricultural Adjustment Administration (AAA) gave aid to the farmer, provided employment to the unemployed, and helped to conserve land in the State of Georgia and in the nation at large.[67]

During the Great Depression of the 1930s, the Soil Conservation Service advocated the use of kudzu to control erosion. Hundreds of young men in the CCC planted kudzu. Farmers received — as an incentive to plant the vine — eight dollars an acre.[68] Georgia found, however, that kudzu was not easy to eliminate. The tap roots reached deeply into the Georgia soil; its rapid growth often smothered other plants.[69] The writer James Dickey (author of

Deliverance) cautions readers that in Georgia there is a legend that one must keep the windows closed at night or the kudzu will enter. He says that, even so, window panes are tinged with green.

Like the motto of the newspaper the *Atlanta Journal* (1883–1939), kudzu covered "Dixie like the dew." Some farmers tried to bale the plant for cows; the secret was to "cut it low and bale it high." Other uses were to fry it like potato chips, add it to scrambled eggs, and make it into jelly. Still the kudzu grew up to a foot a day.[70]

In time, many farmers began to question the use of kudzu. The plant covered houses, fences, trees, and corncribs. Eliminating the plant was almost impossible. Because kudzu was a vine, the farmer could not easily harvest the plants. The plant was not useful for feed for the animals, however, because it could not endure heavy grazing. Many farmers even began to question the value of kudzu to control erosion; they encouraged experimentation

Kudzu vines.

Kudzu growing like a rain forest.

with other plants that seemed superior to the kudzu.[71]

Help for farmers. Ever since it had created the Department of Agriculture in 1862, the federal government had participated in the scientific study of agriculture and the dissemination of information. The local farm bureaus, the American Farm Bureau Federation, state departments of agriculture, Cooperative Extension Services, and private agencies also had tried to improve farming, the use of agricultural products, and the status of those who tilled the soil.[72]

Morrill Act and Land Grant Colleges. The Morrill Act of 1890 subsidized in almost every state a college of agriculture, which gave direct instructions, set up experimental stations, and maintained extension divisions. These public institutions encouraged applied learning, which was often practical for those needing homemaking and agricultural skills.

Georgia, too, had opened two of the land-grant colleges: Fort Valley State University in Fort Valley, Georgia, and the University of Georgia in Athens, Georgia. These two institutions were still operating throughout the 1920s and the 1930s (and beyond) and helped provide the skills the citizens needed.

Advice to farmers. To answer questions and help acquaint farmers with new farming methods and soil conserving techniques like terracing, rotating crops, and the planting of cover crops, most rural residents of the 1930s could rely on the advice of family and friends, the county farm agent, the state, the federal government, and the *Progressive Farmer.*

The purpose of the county agent was to assist farmers with their problems, to bring about a higher standard of living on the farm, to raise the status of the farm family, to increase the productivity of the land, and — especially after the beginning of World War II — to work for national defense. These county agents had been around for some time in Georgia.

The Civilian Conservation Corps (CCC). President Roosevelt was intent upon offering increased federal assistance to rural

A meeting to discuss defense and agricultural problems was held in May 1941 at the county agent's office in Greensboro, Greene County, Georgia. Photograph by Jack Delano, Farm Security Administration.

areas and to the nation; one of the solutions he proposed was the use of the Civilian Conservation Corps. He hoped that this group would help with the "worst environmental disaster Georgia has ever suffered": the

> ...washing away of its topsoil.... Early in the twentieth century nearly 10 million acres were in cultivated row crops, and much of that land was losing soil in every rain. The Piedmont lost an average of about seven inches in its topsoil, but in many places all of it was lost. The resulting red hills were both evidence and the heritage of generations of land mismanagement. In southwest Georgia spectacular gullies, such as Providence Canyon, permanently ruined much of the land for farming.[73]

On the day of President Franklin Delano Roosevelt's inauguration in 1933, he began creating a series of agencies to combat the social and economic problems facing the nation. One of his primary concerns was preserving the nation's natural resources. One agency that had

the directions to help conserve the soil was the Civilian Conservation Corps (CCC). At his third press conference (March 15, 1933) President Roosevelt discussed the idea for a federal agency to help with conservation:

> The idea is to put people to work in the national forests and on other Government and State properties on work which would not otherwise be done; in other words, work that does not conflict with existing so-called public works....[74]

On March 21, 1933, Roosevelt described to Congress his idea for a civilian conservation corps as

> ...simple work, not interfering with normal employment, and confining itself to forestry, the prevention of soil erosion, flood control and similar projects.... [T]his type of work is of definite, practical value, not only through the prevention of great present financial loss, but also as a means of creating future national wealth.... More important, however, than the material gains will be the moral and spiritual value of such work. The

Providence Canyon State Park, Georgia.

overwhelming majority of unemployed Americans ... would prefer to work. We can take a vast army of these unemployed out into healthful surroundings. We can eliminate to some extent at least the threat that enforced idleness brings to spiritual and moral stability.... [I]t is an essential step in this emergency. I ask its adoption.[75]

By Executive Order No. 6101, President Roosevelt started the CCC on April 5, 1933.[76] The act brought about the largest and most rapid mobilization of men in history. Within three months 300,000 men had enrolled and had settled in the 1,468 camps. Every state had some of these camps.[77] Georgia had at least 35.[78] The CCC members cut trees for timber, dug ponds, built firebreaks, cleaned the beaches and installed fences to prevent erosion, built fire towers, restored historic areas, and planted seedlings and kudzu to hold the soil and prevent erosion.[79]

Bradley notes that the CCC

... was designed to wean young men off street corners by getting them involved in shoring up the nation's natural environment. Through the 1930s, youthful CCC workers planted millions of trees across America; they released nearly a billion game fish into the country's rivers and lakes; they built wildlife shelters, created camping grounds, and dug thousands of miles of canals for irrigation and transportation.

But the CCC had a greater function — one that did not fully reveal itself until America went to war [World War II]. It served as a premilitary training experience for some three million boys, many of whom would flood into the armed services after Pearl Harbor. Administered by the Army the CCC introduced its recruits to camp life, to military discipline, to physical fitness, and to a sense of loyalty to comrades and to a cause.[80]

More than 78,630 Georgians participated in 35 camps.[81] The efforts of this agency paid the young men (ages 18–25) monthly about $30 — most of which they sent home to their families. The 200 million trees that the CCC members planted across the nation would be ready for harvest in the years to come. In addition, these trees would help to hold the soil and prevent the prevalent erosion. CCC workers also fought diseases of trees, installed drainage ditches, and built firebreaks.

CCC (Civilian Conservation Corps) boys putting up a fence in Greene County, Georgia, in May 1941. Photograph by Jack Delano, Farm Security Administration.

One observer said that a young man who had a job with the CCC would know how to work![82]

Appalachian Trail. The Appalachian Trail is an example of a CCC project that is still in use. The Appalachian Trail, started in 1937, runs from Springer Mountain, Georgia, to Katahdin, Maine; the trail is 2,159 miles long.[83]

The CCC received many nicknames. One of these was "Roosevelt's Tree Army." Indeed, working with trees was an important part of the services of the CCC in Georgia:

> CCC camps [in Georgia helped with] ... fire protection and suppression.... Lookout towers and houses were built and connected with miles of telephone lines. Truck trails with bridges were built to reach fires sooner.[84]

President Roosevelt found, however, that in Georgia some administrators did not support his policies. Georgia's Governor Eugene Talmadge, who governed from 1933 to 1937,

... wanted the relief money to go only to white families, so he excluded blacks by listing them as employed, in spite of the fact that unemployment rates among blacks were twice those among whites. FDR told Talmadge to begin hiring blacks for the CCC. Talmadge refused the President's request. Roosevelt told him that if he didn't begin hiring blacks for the CCC he would not get a "single penny" of the relief money slated for his state. FDR had Talmadge. Although black CCC camps were disbanded within two years (whites did not like their presence), the damage had been done between Roosevelt and Talmadge. In 1934 FDR refused to let Georgia disburse its own relief funds.[85]

Some administrators, then, had been illegally preventing African Americans from enrolling in the CCC, were receiving the salaries intended for those in need, and were preventing improvements in conservation within the state. Governor Talmadge had vocally opposed paying persons on federal relief at a rate above Georgia's low wages; he wanted the federal wages set at or below the low Georgia wages

to provide an incentive for workers to return to work for private employers. Talmadge called the New Deal programs, "wet nursing, frenzied finance and plain damn foolishness."[86]

Vogel State Park. Vogel is Georgia's second oldest state park. Founded in 1931, Vogel Park is in the heart of the Chattahoochee National Forest; the park now hosts one of two museums in the nation to mark the history of the Civilian Conservation Corps (CCC). Each year the park holds a reunion for the CCC workers. Fifteen structures still stand in Georgia to mark the impact of the CCC on that Southern state.[87]

The Agricultural Adjustment Administration (AAA). To help with the problems of the farmers, in particular, Roosevelt envisioned a second agency — the Agricultural Adjustment Administration (AAA). He mentioned this agency at his third press conference on March 15, 1933:

> The other measure is not only a constructive measure but an immediate one.... That is the effort to increase the value of farm products.[88]

The next day Roosevelt addressed Congress on a "New Means to Rescue Agriculture." He described a step "of definite, constructive importance to our economic recovery." This second measure or agency

... relates to agriculture and seeks to increase the purchasing power of our farmers and the consumption of articles manufactured in our industrial communities, and at the same time greatly to relieve the pressure of farm mortgages and to increase the asset value of farm loans made by our banking institutions.[89]

The Agricultural Adjustment Administration discouraged foreclosures, encouraged the refinancing of farm debts, discouraged planting the same crop every year, helped to develop market agreements, provided benefit payments for certain agricultural commodities, and provided compensation to farmers who limited production of certain crops and who practiced soil conservation, including terracing.

Nonsupport of the Bankhead Act. When the New Deal "plow up" of from 20 percent to 33 percent of the cotton, tobacco, and corn crops came, some landlords chose the fields of the tenant farmer for destruction in the summer of 1933. It seemed to many that the tenant farmers, day laborers, and sharecroppers—"the little folks"— suffered from the actions of the AAA. Even the mules seemed to protest. Mules which had been trained for years to walk between the rows of crops refused to pull the plows that destroyed the crops.[90] Farmers finally devised a plan of hitching two mules together and placing the plow between the two

COURTESY GOLDEN INK

Vogel Lodge (now Walasi-Yi) at Vogel State Park, Georgia. The CCC completed the lodge in 1937; this photograph is from 1939 and shows the building from the south end.

animals; the mules, which had heretofore re-
fused to walk on the rows, now destroyed the
crops by walking in their proper place: be-
tween the rows.[91]

Unscrupulous landowners sometimes kept
all the benefit payments instead of sharing with
the tenant farmer or the sharecropper.[92]

> The structure of Agricultural Adjustment Ad-
> ministration crop reduction programs allowed
> landowners to avoid sharing cash payments with
> tenants. Landlords, themselves strapped by the
> economic depression, often used the government
> payments to mechanize their farms and evicted
> now-unneeded sharecroppers.[93]

**Georgia and the Agricultural Adminis-
tration Agency.** Georgia and several of the
other states had problems with the help that
the Agricultural Administration Agency
(AAA) gave to the small farmer — and the ten-
ant farmer, in particular. First, the states
viewed the regulation of agriculture as a local
activity reserved to them — not the federal
government. Second, the AAA provided
"benefit payments" for farmers who (1) lim-
ited their production of cotton, tobacco,
wheat, and certain other crops and (2) prac-
ticed soil conservation. These actions often re-
duced production of crops and raised prices; if
one's farm was small, however, the increased
prices did not always compensate for planting
less. Third, some states viewed the raising of
money for the payments to farmers as an im-
proper use of the taxing power.[94] Fourth, un-
scrupulous landowners sometimes kept all the
benefit payments instead of sharing with the
tenant farmer. Many deserving people did not
receive the payments that were supposed to
help the poor.[95] Fifth, greedy landlords selected
only the fields of their tenant farmers for de-
struction when the New Deal "plow up"
came.[96] Sixth, the slaughter of 6 million piglets
and 200,000 sows to prevent a glut was, to or-
dinary Americans, an insanity.[97]

Opinions of the Bankhead Act. A Gallup
poll of January 5, 1936, showed that 59 per-
cent of the nation's voters opposed the AAA. In
the South, however, 57 percent supported the
plan.[98]

The Supreme Court on January 6, 1936,
the day after the Gallup poll appeared, struck

down the processors tax which funded the AAA
and, in effect, struck down the AAA also.[99]

**Soil Conservation and Domestic Allot-
ment Act.** President Roosevelt seemed com-
mitted to improving the soil and agriculture of
the nation. On March 1, 1936, Roosevelt signed
the Soil Conservation and Domestic Act. The
new law provided benefits to farmers who im-
proved the fertility of their farms and checked
erosion. Congress provided $470,000,000 for
this program.[100]

Resettlement Administration (RA). The
government's temporary replacement for the
AAA was the already existing Resettlement Ad-
ministration (RA), which both Stryker and
Tugwell joined; this agency continued the fed-
eral photographic endeavors begun earlier
under the direction of Tugwell and Stryker.
Other offices, such as the Farm Security Ad-
ministration and the Office of War Informa-
tion, would later assume full responsibility for
the already begun photographic collection.[101]
The federal government tried through the RA
to provide needed assistance. Its work in meet-
ing the housing needs in Georgia is a part of
chapter five, "Housing."

Bankhead-Jones Act (1937). President
Roosevelt was concerned with the problem of
farm tenancy. Secretary of Agriculture Henry
A. Wallace reported to him on November 17,
1936, that farm tenancy had increased each
year since 1880.[102] On February 16, 1937, after
Roosevelt's message to Congress concerning
the problems of tenancy and the decline in liv-
ing standards, the legislature passed the
Bankhead-Jones Act to aid tenant farmers by
extending loans to purchase land.[103] Chapter
five, "Housing," explores federal aid to hous-
ing in more detail.

Farm Security Administration (FSA).
When the Department of Agriculture assumed
responsibility for the RA, the federal govern-
ment created the Farm Security Administra-
tion (FSA) in 1937 to provide assistance to the
rural poor and the migrant agricultural work-
ers. The FSA continued to produce its docu-
mentary photographs, and Stryker continued
to supervise and organize the work of the
photographers. He directed the work of federal
photographers Arthur Rothstein, Dorothea

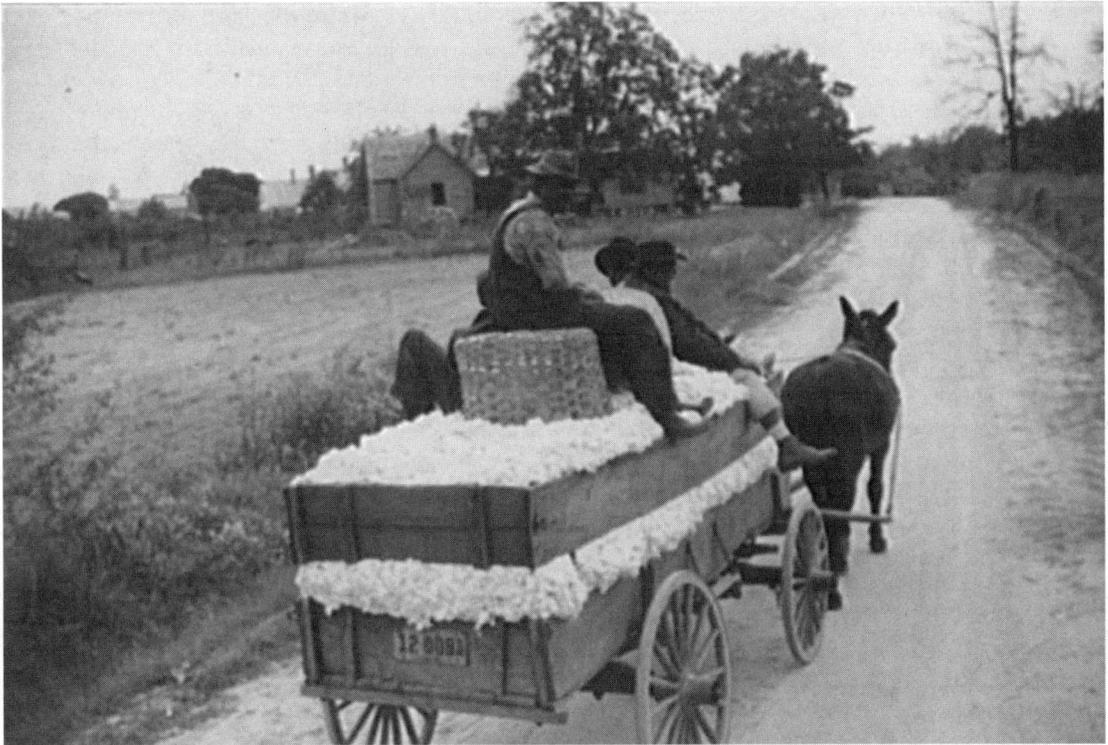

A wagonload of cotton being driven to the gin in Greene County, Georgia, in October 1941. Photograph by Jack Delano, Farm Security Administration.

Lange, Walker Evans, Marion Post Wolcott, Jack Delano, John Vachon, Barbara Wright, Carl Mydans and Esther Bubley — some of the best photographers of the time and all of whom captured images in Georgia. It was through the Farm Security Administration (1937) that financial aid was extended to a selected number of tenants in order that they might become landowners.[104] Chapter five gives more information on the federal aid to housing.

IV. Industries in Georgia

Georgia industries. The number of wage earners in Georgia manufacturing fluctuated during the years from 1920 until 1940. The av- erage number of wage earners in manufacturing in 1920 was 123,441; by 1930 that number had increased to 158,773. The year 1940 saw a slight drop to 157,804.[105]

The number of manufacturing establishments in the state of Georgia declined in the years from 1920 though 1940. In 1920 there were 4,803 manufacturing establishments; this number dropped to 4,179 in 1930 and to 3,150 in 1940. Likewise, the values of the products changed through those years: $693,237 in 1920; $722,454 in 1930; and $677,403 in 1940.[106]

The percentages also changed as shown in the chart below.

From 1890 until 1940 one of the major employment opportunities for lower-income white women was the textile mills.[108]

	Percent of Georgia's Population in Agriculture	*Percent of Georgia's Population in Manufacturing*	*Percent of Georgia's Population in Transportation and Trade*
1910	63.3	12.2	9.2
1930	43.2	20.1	13.7[107]

Textile industry. Cotton production had fallen sharply from 1920 until 1940, but it remained the most important crop in Georgia. Cotton textiles continued as the major industry in Georgia until 1940. Hundreds of textile mills had moved from the Northeast to Georgia and other Southern states. The textile industry had noted the power sources, the mild climate, the proximity to raw materials, the newer machinery, and the absence of labor unions in many areas.

Prior to World War I Georgia mills often produced yarn and cheaper cloth which were sent to the North for finishing. After 1920, however, the Georgia mills began producing more finished products and ready-made clothing. Georgia textile mills were located in both cities and larger towns and in small towns. Often the workers had come to the mill villages directly from the farm. These new factory workers found housing in the mill villages owned by the company; often even the children worked.[109]

Power companies and Georgia industries. Georgia Power and Light Company and other power companies in the state sought to improve the efficiency and production of factories through the use of inexpensive, dependable electric power. The availability of electric power also affected the homes in the state. Chapter five, "Housing," gives more information both on electric power in the state during this important time period and on the role of government in bringing power to the homes and industries across the state.

The liquor industry in Georgia. As an agrarian state in the late eighteenth century, the production of alcoholic beverages was important in Georgia.

Liquor legislation in Georgia. With the concern for temperance that grew up in the late nineteenth and early twentieth centuries, temperance reformers approached both the government to enact liquor legislation and the general public to implement local option powers. By 1907, most of the Georgia counties had

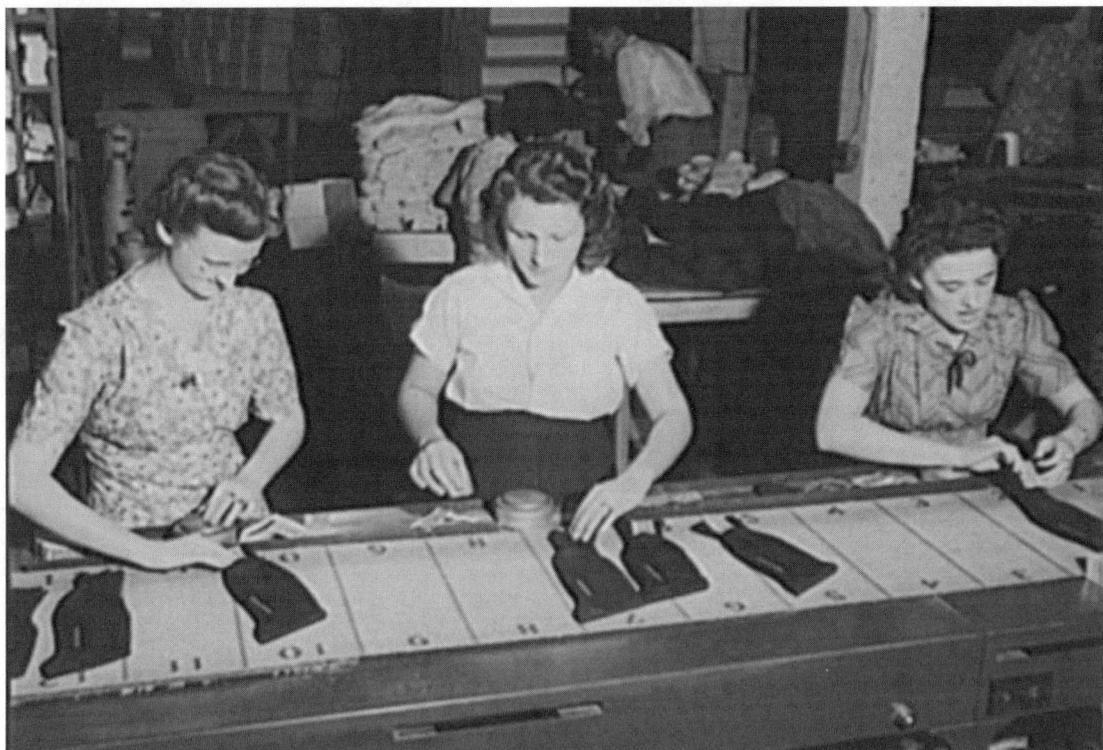

At the hosiery mill in Union Point, Greene County, Georgia, November 1941. Photograph by Jack Delano, Farm Security Administration.

voted themselves dry as a result of this movement; the Georgia state legislature had enacted, by 1908, mandatory statewide prohibition — with some exceptions.

By 1915 the state had closed most of the loopholes, and Georgia officials began their work to ensure that liquor was illegal, that the state had an enforceable law, and that the officials actually enforced the law. Georgia had statewide prohibition that was in effect from 1908 until 1935. This 27-year period extended beyond the national prohibition that was in effect from 1920 until 1933. Georgia did, however, also ratify prohibition: the Eighteenth Amendment. The Eighteenth Amendment and its implementation through the Volstead Act made all alcohol manufacturing and its consumption illegal.[110]

Interestingly, producing moonshine was not illegal in itself, but avoiding the payment of the federal tax was. This battle between the moonshiners and the revenuers received much publicity — and was the subject of some exaggeration. The brutality of some of the moonshiners led the public to favor the revenuers over the distillers who operated illegally. The image of the moonshiner changed from skilled professional to greedy criminal.

The end of national Prohibition in 1933 did not end the illegal production of alcoholic beverages. Residents of some counties that had voted to remain dry still had need of the services of the moonshiner. This illegal industry continued to thrive in certain counties in the state.

Making moonshine. **Moonshine** is illegally-made liquor. Because the 'shiners often secretly produced their product in the dark under the light of the moon, locals began to refer to it as "moonshine." This distillation of apples, corn, or peaches into alcoholic forms was a cottage industry for many farmers and was a ready source of cash or comfort to these producers. To make the liquor, the worker needed a still with 3 basic parts: (1) the cooker, where the corn mash is heated; (2) a copper arm that is attached to the cooker and that tapers off until it is as narrow as the copper tubing; and (3) "the worm," or twenty feet of copper tubing that was coiled, attached to the arm, and run through a barrel of water. To coil the tubing, the producer of the still filled the pipe with sand to prevent kinking, stopped up both ends, and wrapped the pipe around a fencepost. Some people tried to use car radiators instead of tubing, but the end result was often toxic.[111]

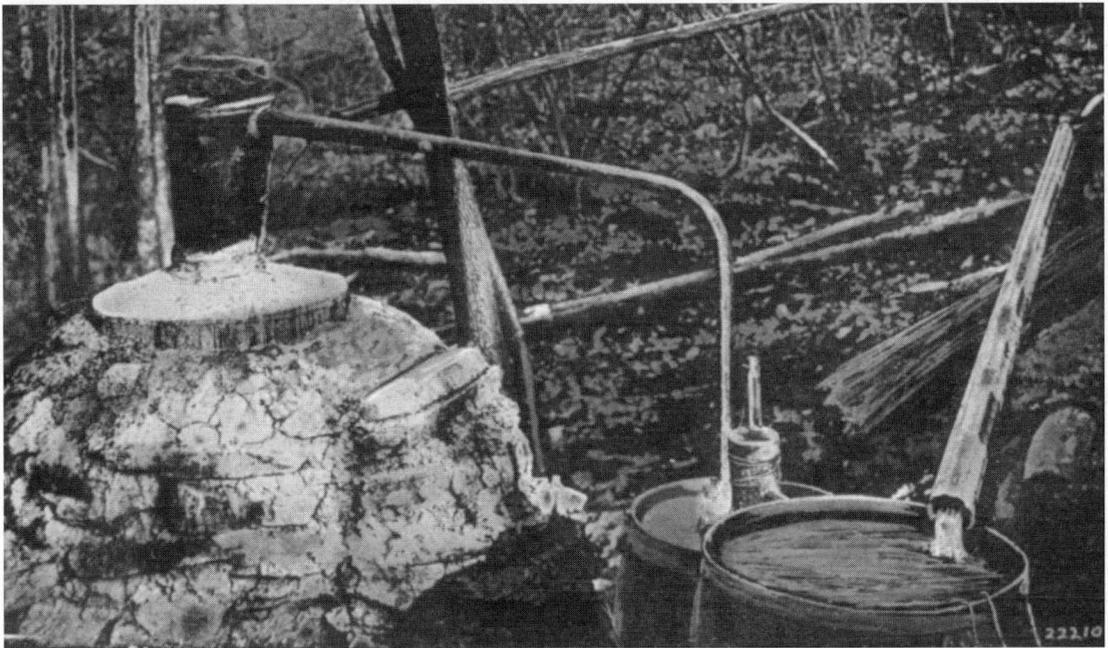

This postcard shows "an 80-gallon Moonshine Still in the Mountains."

ASHEVILLE POST CARD COMPANY

Apples, potatoes, rye, buckwheat, and other foods could be used to make the mash for the whiskey (grain alcohol), but the most common type of mash was corn. To turn the starch of the grain to sugar, the moonshiner placed the corn in a large container with a small hole in it. Added water kept the kernels warm and moist, but excess water drained out of the vat through the opening. Within three days the corn had usually sprouted. The worker dried the sprouted corn, ground the kernels into a meal, added about ½ pound of yeast to 50 gallons of water and mash, and mixed it with sugar — the amount of which varied from recipe to recipe. The moonshiner tried to keep the mixture warm for the next few days. (Corn without yeast would ferment in about 10 or 12 days; at times brewers preferred to omit the yeast.) When the mash quit working, or bubbling, it was time to make the "run." *Smoky Mountain Magazine* describes the liquor at this stage:

> It ain't good to drink at all, so don't even think about trying it out. It will make ya sicker than a dog. It is usually called warsh right at this stage, and it is sour enuf ta make your eyeballs cross a couple of times if 'n ya drinks it. Put yer mash in the still cooker and lights a fire under it ta get it to cooking proper.[112]

As the fermented mash cooked, steam went through the arm and into the worm. Because the worm was placed in a barrel of cool water, the steam inside the worm "dewed" — hence the name "mountain dew." The 'shiner collected this condensation in a container. This collection had to be recycled at least once to get high quality whiskey. To test the strength of the drink, the whiskey maker would usually throw about ⅛ cup of the liquid in the fire and note if the flames leaped. A connoisseur of whiskey could swirl it in a glass container to test for the proof.

> I seen them swirl the shine in the mason jar to watch the bubbles swirl. When they ain't much swirl to it, I mean when you cain't tell they's any water in that there mason jar, then they gits ta being real excited about it.[113]

Poisoning from improperly made 'shine or from hazardous metals — like that in radiators — posed another hazard.

Destroying the illegal stills. One of the jobs of the local sheriff was arresting those who broke the law — including the 'shiners who made and sold the liquor and the runners who transported illegal whiskey. As a part of his duties, the law enforcement officer destroyed the still to prevent further illegal activity. In the 1930s James R. Aswell, a deputy who aspired to someday being "high" sheriff, reported:

> The largest raids or work we usually have now is stills. They's several we've got spotted now to gather in. We'll be going in again in a very few days. Usually we get our tip-off when it's least expected and have to go in all kinds of weather. We almost never find anybody there, but they's always signs of them. The still worm still hot and the mash boiling. But they have time to see us coming and run, no matter how much we try to slip up on them.
> ...You just don't seem to be able to make people quit making liquor. They'll go to jail for it and come out and go right back at it. But still raids is gitting to be pretty tame. The birds is flown usually.[114]

Locations. Illegal consumption of alcoholic beverages was not limited to one region of Georgia; indeed, all sections of Georgia seemed to engage in illegal brewing. Mountain residents, like the Coastal and Piedmont residents, engaged in the illegal "cottage" industry of distilling whiskey. The dense woods, the steep hills, and the valleys on the property of many mountain residents, however, seemed perfect for camouflaging the paraphernalia needed for the production of illegal *white lightning, mountain dew, brew,* or *moonshine.* Little initial investment was necessary to build the still or to secure the corn, jars, sugar, and yeast for the brew. The sparse population in the rural areas meant that few people knew one's business; secrets were easier to keep among the residents who knew and protected each other than in the urban areas where individuals came and went.

Whiskey running. Whiskey runners picked up their illicit cargo of alcohol from the distillers and sold it to the owners of bars or to "middle men." Danger accompanied the manufacture, transport, and use of mountain dew. Jail sentences were typical for those caught by the revenuers. High speeds and curved roads

brought danger to the runners. Violence between competitors and with revenuers was common.

Estimates are that Dawson County moonshiners ran millions of gallons of liquor into Atlanta.

> Moonshiners played a dangerous game of cat and mouse with revenuers. In Dawson, Union, and other counties, so-called trippers designed high-performance automobiles, called "tanker cars" ... to evade revenuers. Such car chases often ended in the death of the moonshiner or the revenuer. Out of these powerful cars and high-speed chases grew the sport known today as stock car racing (NASCAR).
>
> In the process of such blockade running, moonshiners had become reckless outlaws who were concerned only with making money rather than manufacturing quality whiskey. In a full chapter on the subject in his memoir, *The Mountains within Me*, former Georgia governor Zell Miller explains the changes he observed in the business in and around his native county of Towns. Fewer local families engaged in liquor trafficking, and those who did had become "a breed apart from their ancestors to whom making whiskey was a personal custom-sanctioned activity that was incidental to their total livelihood and not a calculated, law-breaking enterprise."[115]

Many Georgia writers mention their own experiences with illicit liquor in their memoirs. Author Rick Bragg, who grew up near the Alabama/Georgia border, talks about his family in *All Over but the Shouting* and *Ava's Man*. Bragg mentions how his maternal grandfather paid the doctor at his mother's birth with a jar of liquor; he also discusses his grandfather's illegal whiskey operations in Georgia. Some of these other Georgia writers include Raymond Andrews, *The Last Radio Baby*; Janisse Ray, *Ecology of a Cracker Childhood*; and Harry Crews, *A Childhood: The Biography of a Place*.

In 1928 Bascom Lamar Lunsford recorded the song "Old Mountain Dew," which he wrote himself. Later, Johnny Cash and Bob Dylan added to and rerecorded the song. Some of the verses tell of the pleasures of moonshine: A short man feels like a giant when he drinks moonshine and a moonshiner makes the liquor so strong even birds flying over the still get dizzy.[116]

Bootlegging. In the vernacular, the sale of the illegal liquor was *bootlegging*. Some people purchased the contraband by going directly to the distilleries; others bought their drinks at illegal bars or "speakeasies." The place one bought one's alcoholic beverage reflected one's class—not the fact that one bought the liquor at all. Lunsford tells of buying jugs of moonshine in his song "Mountain Dew": A buyer puts his money in a hollow tree and leaves. A few moments later, a moonshiner has left a jug in exchange.[117]

Moonshining continued in Georgia and other states long after the end of Prohibition during the Great Depression.

Tobacco. With the weakening of King Cotton in Georgia, new crops began to play an important part in the lives of the rural farmers. Tobacco production increased during World War I and continued to expand in the face of the war against the boll weevil. By 1927 tobacco was a crop on 77,000 acres and was the second most important crop grown in Georgia. By 1939 its acreage had doubled.[118] Georgia was particularly suited to the growing of the binder leaf, which was often used in cigars.[119]

Although those who were more affluent tended to condemn the use of tobacco by the poor, there were reasons for its use. Tobacco was more than a "pernicious habit"; it was many Southerners' "drug of choice."[120] "[T]obacco dulled the pain of hunger and aching teeth and gums, while providing a pleasant, gratifying sensation in the mouth."[121]

Urban Americans began to exchange pipes, cigars, snuff, and chewing tobacco for cigarettes; chewing tobacco and snuff "defined rural Southerners."[122] Plugs of tobacco and powdered tobacco accounted for the "lumped lip or swollen jaw" that travelers often noted in the rural South. During the decade of the 1930s poor people—especially those in the South—were able to buy cloth bags of loose tobacco cut for cigarettes and "roll their own." The cost of these bags was usually five cents. The tobacco counter was a popular one in most rural stores.[123]

Tobacco farming. Much work preceded the actual manufacture of the tobacco products of the factories. Tobacco farming was a job that could require eighteen hours or more a day. First, the entire family planted the tobacco seeds in a bed for two months; to keep

the plants warm, the workers covered the seeds with cloth or with mulch.

After about two months, the workers proceeded to the second step: transplanting the plants into rows in the fields. The third step was keeping the soil loosened and weeded around the young plant. After the plants bloomed came the fourth step: removing the bloom to provide more nutrients to the leaves; this step was "topping." Next came removing the shoots that

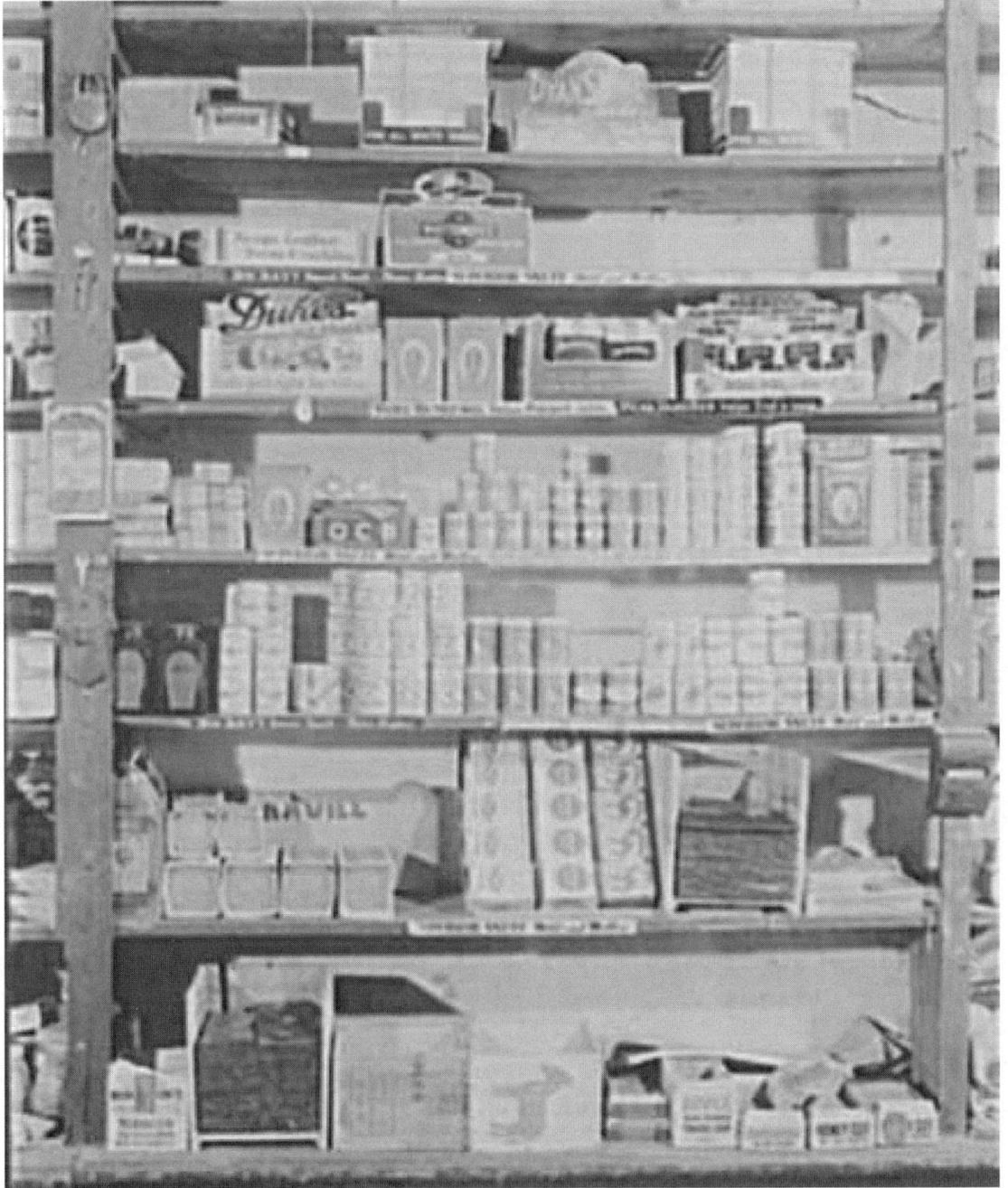

The tobacco and snuff shelf at Mr. Whitaker's store in Greshamville, Greene County, Georgia, May 1941. Photograph by Jack Delano, Farm Security Administration.

sprang up at the side of the plant; this fifth step was "suckering." Removing the ripened leaves was the sixth step, called "priming."

The fieldwork was complete, but other steps followed. Sleds helped to transport the leaves to the barn. In the barn — away from the rain and elements — workers strung the leaves into bunches and hung the bunches on racks to dry in the curing barns with temperatures high enough to cure the leaves. Pipes circulated the hot air from the fires around the barn; the warm air yellowed the leaves, dried the stems so that the juice would not drip, and cured the leaves. To keep the fire all day and night for a week or more required careful monitoring and workers on various shifts. After the drying, there was still more work. The farmer had to sort the leaves, tie them in bundles, and pack the bundles for the auction barn.[124]

All this work did not always yield enough money for the tobacco farmer to "make ends meet." Drought or flooding in an area could ruin a crop for a tobacco farmer and his workers. Many farmers were receiving less for their tobacco than what it had cost them to produce the crops; families often could not pay their taxes or their fertilizer bills. Mortgages foreclosed; the county sold property for nonpayment of taxes. Farmers sometimes just abandoned their land and moved, hoping for a "break" somewhere else.[125]

Other Georgia crops and livestock. With its good soils, adequate precipitation, and labor force, Georgia's crops and livestock are important to the state and nation.

Peanuts. Peanuts, or "goobers," became important in Georgia with the war and with the increased infestation of the boll weevil. In fact, some people began calling Georgia "The Goober State" to call attention to the value of peanuts.[126]

Jimmy Carter described "shaking peanuts" in his book *An Hour Before Daylight*:

> "Shaking" peanuts was especially difficult, because of the heat, dirt, and the constant stooping all the way to the ground. We had to erect pine-sapling stackpoles, nail on cross-strips to keep the crop at least a foot off the ground, plow up the peanuts, shake each plant to remove the clinging

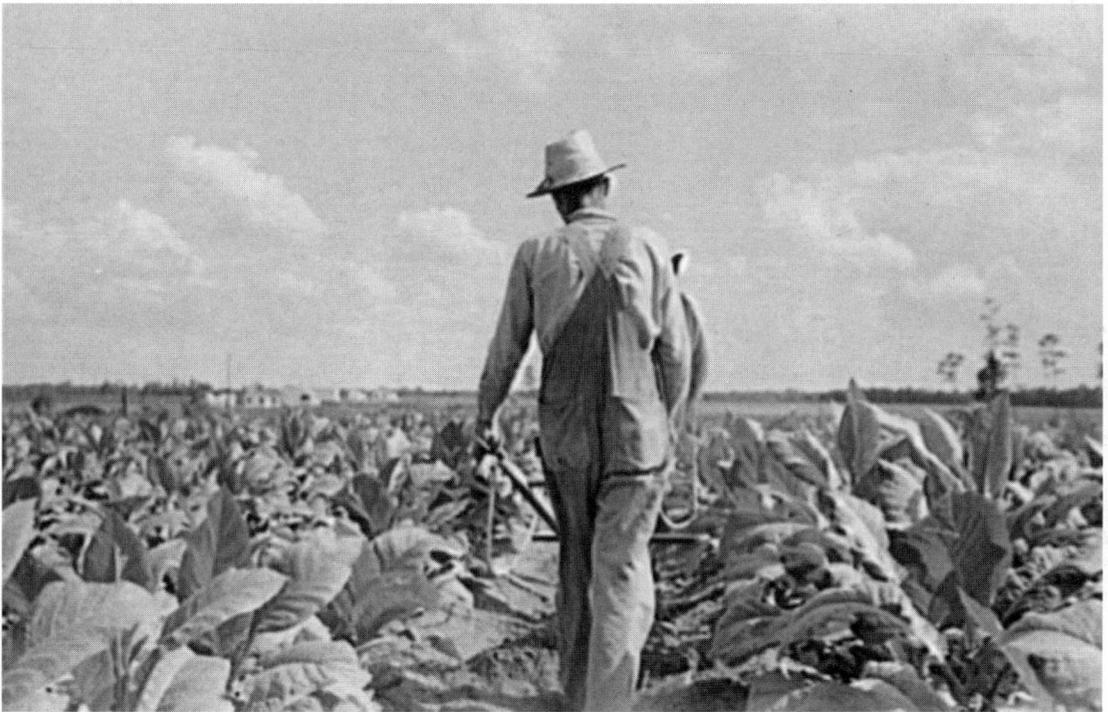

A tobacco farmer in May 1938 in Irwinville Farms, Georgia. Photograph by John Vachon, Farm Security Administration.

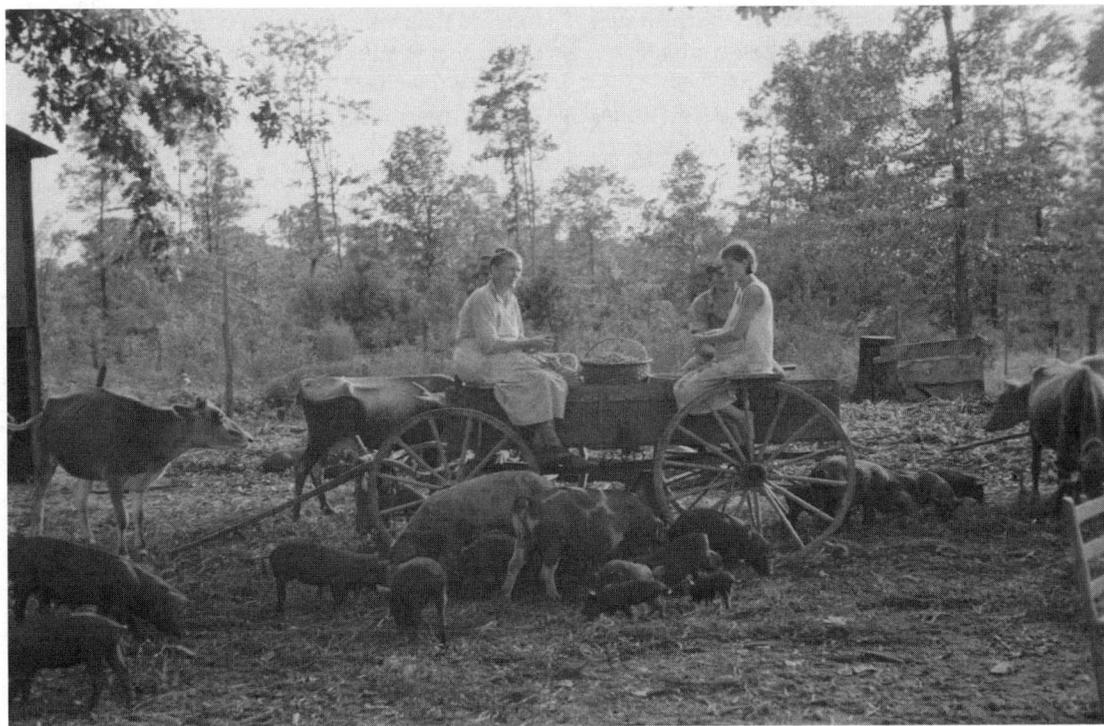

Shelling peanuts, August 1935, Wolf Creek, Georgia. Photograph by Arthur Rothstein, Farm Security Administration.

dirt, and place the root and nuts adjacent to the pole. We put bunches of grass on top of the stack to help shed the rain during the succeeding six weeks or more, while the vines and nuts slowly dried. If stacked properly, the peanuts could wait even into late fall or early winter to be threshed and taken to market.[127]

Pecans. Other crops began to play a larger role in the economy of Georgia. Georgia became the nation's leader in pecan production by 1940; its production had increased from 27,000 pounds in 1900 to 23 million pounds in 1940. Pecans are the only tree nut native to the nation. Even the wood of the tree, a member of the hickory family, is prized for its lumber; furniture, flooring, and paneling are uses for the wood.[128]

Fruits and vegetables. During the first half of the twentieth century watermelons became a major crop for the state. The commercial production of crops such as pimentos, tomatoes, beans, cabbages, cantaloupes, cucumbers, English peas, sweet potatoes, and onions increased after 1920.[129]

The Georgia Pimiento Canners, Inc., began operating in Butts County, Georgia. To remove the outer skin of the pimiento pepper, the company scalded the peppers in oil. When operating at full capacity, the plant could produce 200,000 cans each day. Early records (1924) show shipments to California and to points across the world. The name of the plant became Jackson Pomona Products Company in 1936. The new manager was Joe Lewis. Jackson Pomona Products Company began to can Irish potatoes for the government during World War II. The plant shipped five rail carloads of potatoes daily in 1945. After the war, peach canning became the major concern of the Jackson Pomona Products Company. In 1956 Stokely-Van Camp assumed ownership of the company, which finally closed in 1960.[130]

Peach production in Georgia had dropped considerably after the crash of 1929. From 1890 until 1930, Georgia had led the nation in peach production, but by 1935 Georgia was no longer the leading peach state. In 1943 Georgia ranked only fourth in the production of peaches in the

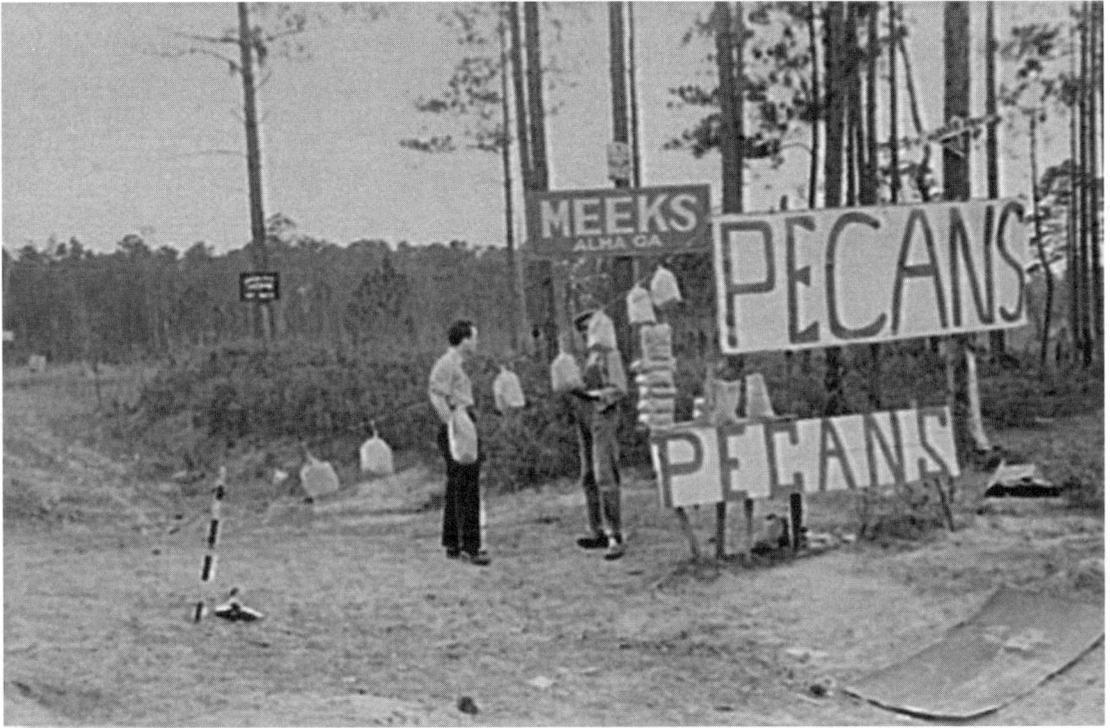

Selling pecans near Alma, Georgia, in January 1937. Photograph by Arthur Rothstein, Farm Security Administration.

Odice Brock's peach orchard, Flint River Farms, Georgia, in May 1939. Photograph by Marion Post Wolcott, Farm Security Administration.

nation; however, the state nickname continued to be "The Peach State" to many people.[131]

Nurseries. Nurseries that shipped plants to the North became more plentiful. Such seedlings as tomatoes, onions, peppers, lettuce, and broccoli were in demand. The production of flower plants, trees, and shrubbery also was important.

Livestock. Largely as a result of the boll weevil, the commercial livestock industry grew. The production of hogs increased sharply after 1920. By 1940 Georgia had over 2,000 dairy farms; the number of dairies and creameries had grown significantly.

Poultry and Eggs. Before World War I, Georgians had produced chickens and eggs primarily for home use. World War I, however, had increased the demand for eggs and broilers nationwide. Whereas many farmers had sold their chickens and eggs locally, they now began to mass produce these commodities. By 1940 Georgia was one of the nation's largest broiler-producing states.[132]

The impact of the transportation on Georgia industry. From 1890 to 1920 the chief means of transportation in Georgia was the railroad. Railroad mileage in Georgia increased from 4,532 to 7,591 during the same period. With increasing competition from cars, trucks, and buses, however, railroad use began to decline. Shipping by truck impacted railroad shipping drastically.[133]

Forests and the forest products industry. With the expansion of the railroads into southwest Georgia, lumber mills and naval stores increased rapidly at the beginning of the 1900s. Lumber operators from North Carolina began to relocate to Georgia when the forest resources declined in the Tarheel State. Turpentine was particularly important to Georgia. Charles H. Herty, a chemist at the University of Georgia, discovered in 1901 a way of extracting turpentine. His discovery enabled the naval stores industry to increase rapidly. By 1928 the leading producer of turpentine, tar, rosin, and pitch for the nation was Georgia. Georgia's

Dairy cows on a farm in Greene County, Georgia, in May 1941. Photograph by Jack Delano, Farm Security Administration.

Georgia farmer George Hardy with a prize hog. The father of a dozen children, Hardy reared the children by himself after his wife's death. The back of the photograph notes that this was only one of his 32 hogs.

A farmer from Greene County, Georgia, came to town on Saturday afternoons to sell his chickens from door to door in spring 1939. Photograph by Marion Post Wolcott, Farm Security Administration.

sawmills provided jobs for its citizens and income for the state. Herty's contributions to the forest products industry continued. In the 1930s he developed a more cost-effective and efficient way of using the Southern pines for paper production — particularly newsprint production.[134]

State nicknames and facts. It was not the pine, however, that received the name of Georgia's state tree. It was the live oak, which flourishes along these coastal plains and on the islands. Its adoption came in 1937 at the request of the Daughters of the American Revolution.

Buzzards are scavengers that Georgia considered a necessary part of the environment. After Georgia passed a strict law protecting the buzzard, many people began calling Georgia "The Buzzard State." Georgia's official state bird, however, is not the buzzard. On April 6, 1935, Governor Eugene Talmadge — by official proclamation — chose the brown thrasher as the state bird. The bird is common in the eastern section of the United States; it

migrates in the summer to the North and spends its winter in the South.[135]

National preserves, forests, purchase units, and parks. The federal government purchased extensive forest areas throughout the country for national preserves during the 1930s. These national forests served to protect the watersheds, to reforest denuded lands, to improve timber stands, to prevent and control fire and disease, to furnish water power licenses, to supply models for private landowners, and to furnish recreational areas. Georgia, too, sold areas as state and national preserves, parks, and forests. Some of the barrier islands, described earlier in this chapter, were sites of these preserves. Chapter seven, "Entertainment," lists other state and national parks, preserves, and forests in Georgia.

Mining. In 1930 the state of Georgia had 3,429 people involved with the extraction of minerals. Most of these (1,986) were involved with quarry operation. As compared with the 497,941 in agriculture or the 233,060 in

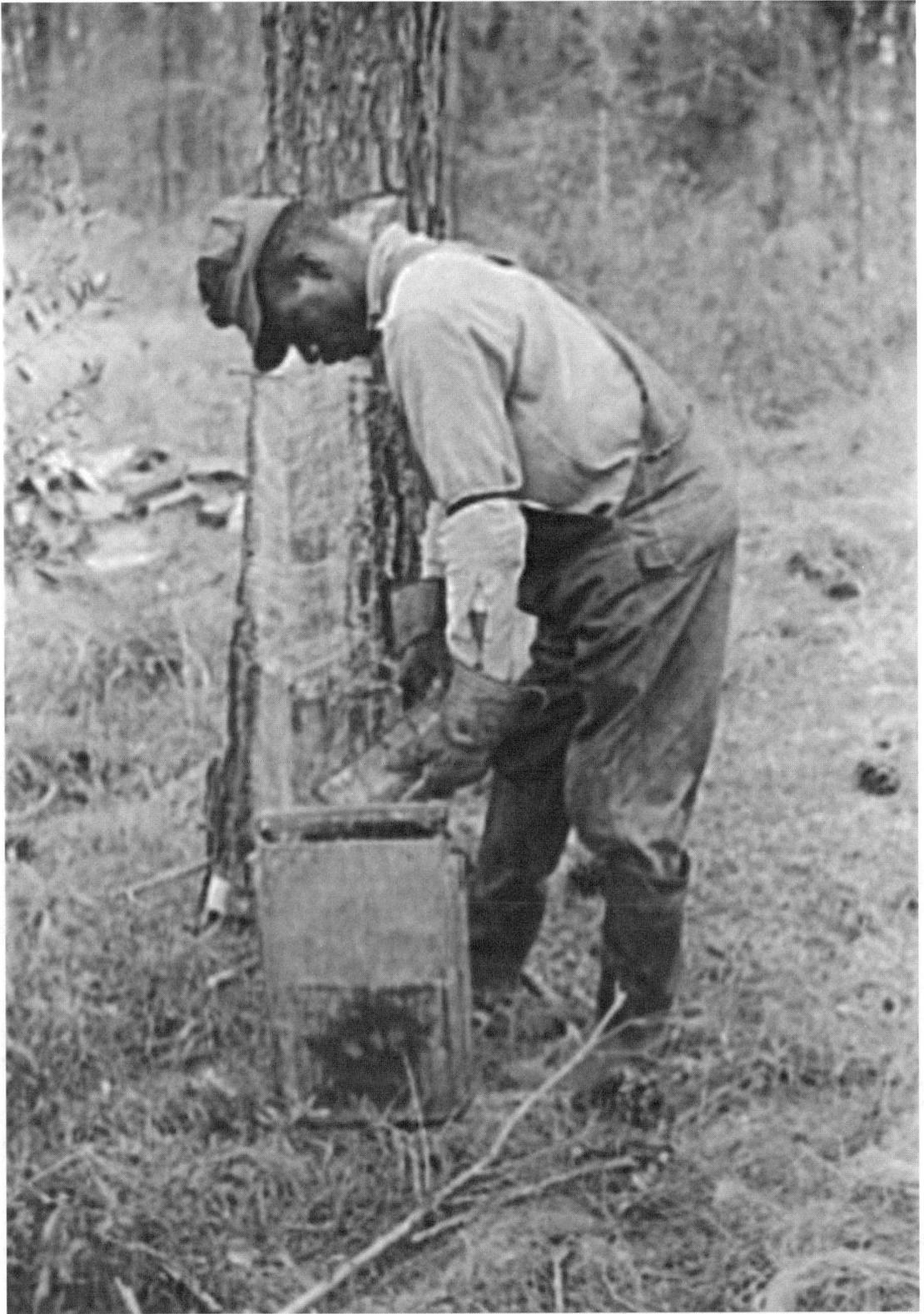

Emptying the turpentine dubs full of rosin into a bucket near a turpentine still in Pembroke, Georgia, in April 1941. Photograph by Jack Delano, Farm Security Administration.

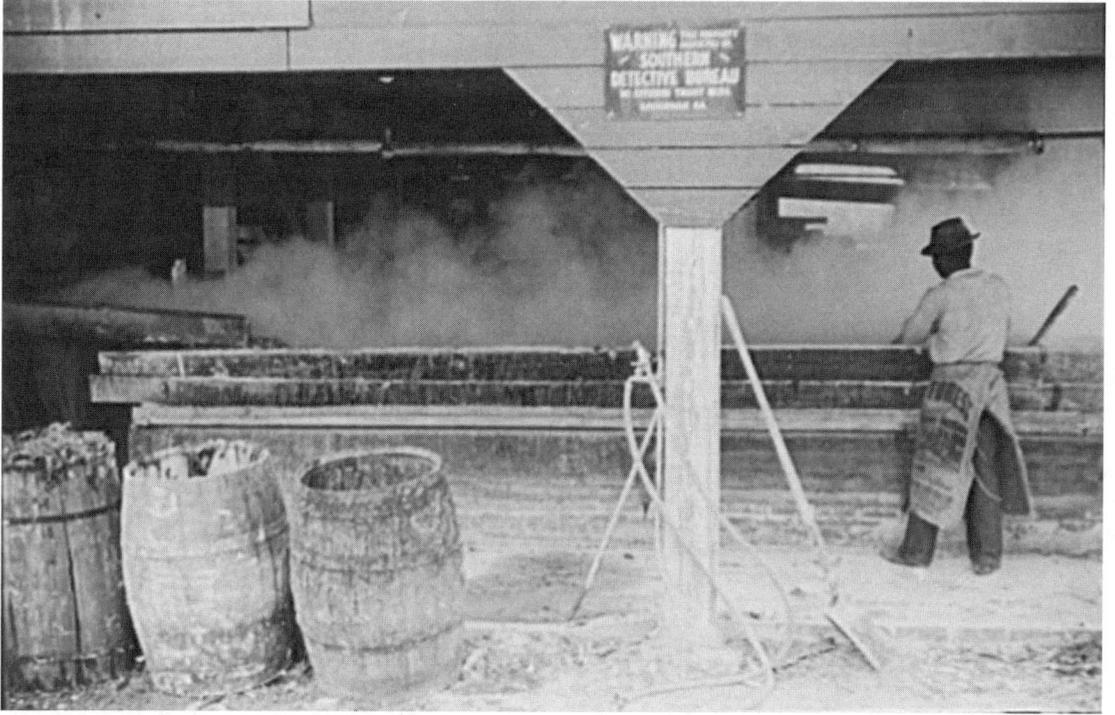

Filtering hot rosin through sieves at a turpentine works in Pembroke, Georgia, in April 1941. Photograph by Jack Delano, Farm Security Administration.

Sawmill in the vicinity of Habersham, Georgia, ca. 1940. Photograph by Barbara Wright, Farm Security Administration.

manufacturing, however, the number seems small.[136]

Granite and marble. About half of Georgia's minerals consisted of stone and clay. Granite and marble were the primary stones extracted from the Georgia soil. In 1937, the granite and marble extracted amounted to 1,737,760 tons, with a value of $3,597,039.[137]

Three different minerals make up granite. The white mineral in granite is feldspar; it is the most abundant material in the rock. The black materials are grains of black mica. The light gray grains are quartz particles.[138]

Marble is compressed and/or heated granite. Unlike granite, however, marble was never molten rock as was granite. It may have been heated and compressed enough to allow the limestone grains to bend and to flow. Only calcite — a relatively soft mineral which also occurs in shells — makes up marble; marble, therefore, is softer than granite.[139]

In the 1920s Pickens County reported that its marble was a part of 60 percent of the monuments in Washington, D.C.[140] One ex-ample of the use of Georgia marble is the 19-foot-high statue of Lincoln, carved from 28 blocks of Georgia marble weighing 175 tons, in the Lincoln Memorial.[141] Other Washington buildings and structures that include Georgia marble are the East Wing of the House Office Building, the National Gallery of Art, the New York Stock Exchange Annex, the Arlington Memorial Bridge, the Federal Reserve Bank Building, the Washington Monument, the Supreme Court Building, and the U.S. Capitol Building.[142]

Kaolin. The clay that proved most profitable to Georgia was kaolin. In colonial days, the use of kaolin, a name meaning "high ridge" and derived from the Chinese word *kau-ling*, was a part of the production of Wedgwood Pottery in England; when England opened its own mines, the shipping of Georgia kaolin tapered.

More than half of Georgia's kaolin production is as an ingredient in pulp for paper and in the coating for paper.[143] Kaolin helps make paper heavier, whiter, and less transparent.

This postcard has a sketch of two men moving a huge block of marble. The caption reads, "Blocks of marble as large as 70 tons have been quarried by the Georgia Marble Company at Tate, Georgia. This sketch shows a large block being hoisted from the quarry floor to the surface."

Kaolin is also an ingredient in rubber products, linoleum, pottery, leather, inks, fertilizers, pottery, and paints. Open pits near Macon and Augusta are important sources of kaolin.[144] The kaolin workers brought 503,732 tons of kaolin from the land in 1937, a value of $3,546,059. This product amounted to about two-thirds of the total production of kaolin in the entire country.[145]

Another use of kaolin: clay-eating. Dirt-eating or clay-eating has long been a practice common among African-American females, especially those who are pregnant. The practice can lead to anemia when the clay (particularly kaolin) inhibits the absorption of iron. The red clays of the South, however, contain high quantities of iron; many eaters consume the clay to ingest the iron that their bodies crave or to help with the problem of diarrhea. The consumer may actually crave the clay.[146]

One can purchase "Georgia Grown White Dirt [Kaolin]" from the Internet. One adver-tiser sells the clay for $10 per pound plus shipping. The Website mentions that kaolin is one of the more common names for the clay and that it can treat dysentery, diarrhea, and cholera; the site lists Kaopectate, Rolaids, Di-gel, Maalox, and Mylanta as products that include kaolin. The site does caution against eating dirt; the producer labels the product "Novelty." There is a warning label: "Not suggested for human consumption."[147]

The practice of clay eating (geophagy) occurred among slaves who brought the practice with them from Africa, where it still occurs. The exporting of kaolin from the South may result from the migration of Southerners who crave the clay.[148]

Jimmy Carter, in his *An Hour Before Daylight*, discusses clay or chalk eating:

> The black women must have inherited information about mineral supplements from their ancestors, because our work wagon never passed an excavated roadside that revealed a chalk deposit

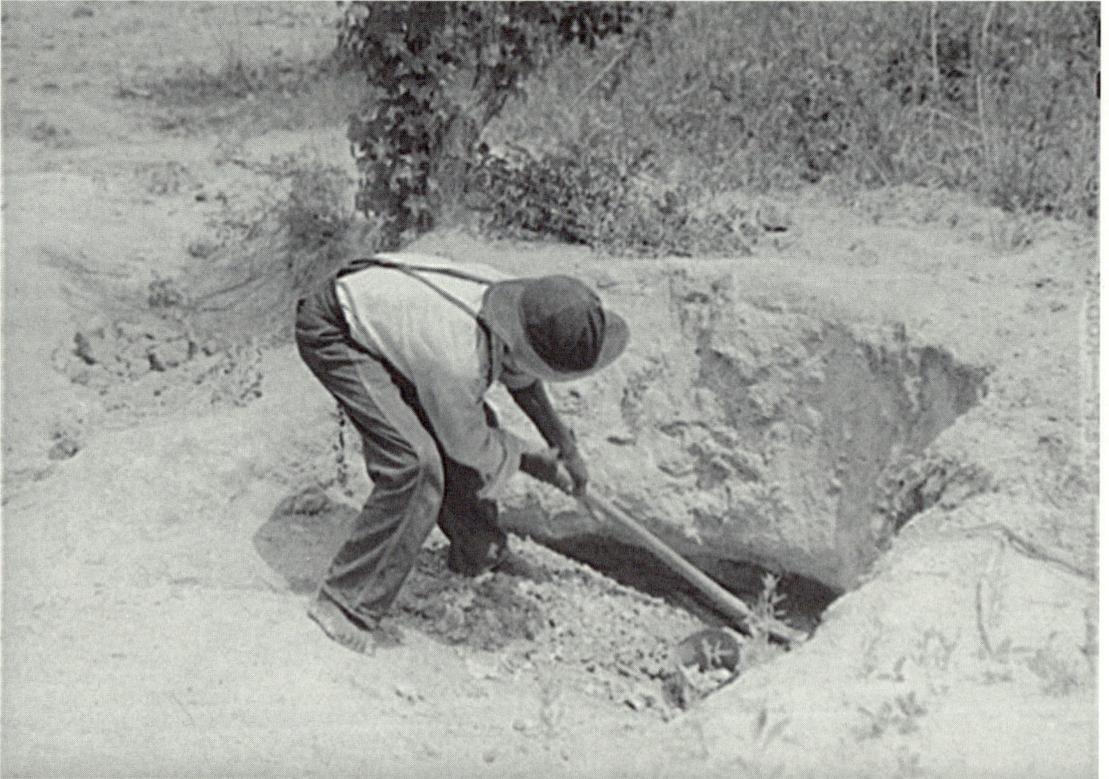

In June 1941, near Siloam, Greene County, Georgia, a worker digs for white clay, which some people eat. Photograph by Jack Delano, Farm Security Administration.

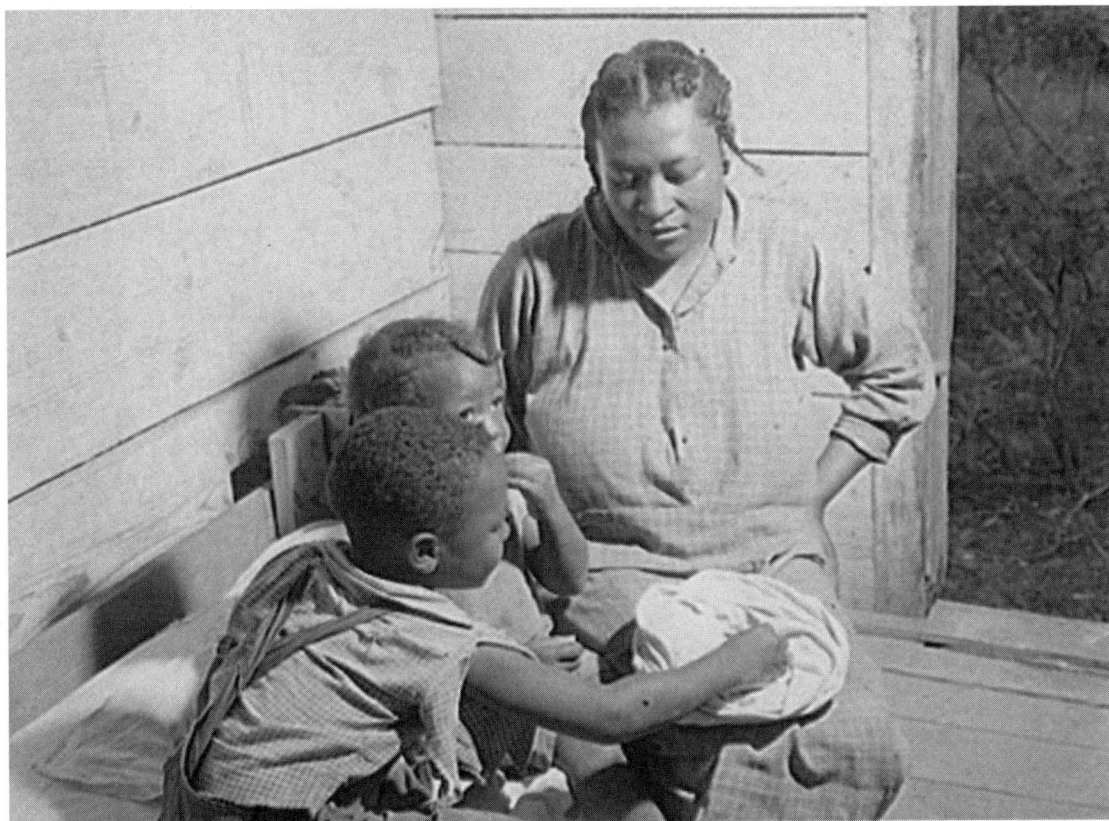

Eating "white dirt," a kind of clay found in several parts of Greene County, Georgia, June 1941. Photograph by Jack Delano, Farm Security Administration.

without stopping. They would eat chunks of the white mineral and fill empty flour-sacks to carry home to their families. It didn't taste bad, except for the grit particles embedded in the soft and almost pure calcium carbonate.[149]

Other Georgia manufacturers. Although textiles, cotton, pecans, peanuts, plants and seedlings, tobacco, forest products, and mining were essential to the state, foodstuffs were also important to Georgia. World War I had led to a demand for these products. Meat-packing plants with modern equipment opened in Savannah, Augusta, Moultrie, and Atlanta.[150]

Fruitcakes. In 1910 the developing agricultural community of Claxton, Georgia, saw the opening of a bakery that would become a national company. Savino Tos had immigrated to the United States from Italy in the early 1900s. After living for a while in New York, he moved to Macon, Georgia, where he worked

for an ice cream company; attracted to the friendly Claxton, which was without a bakery, he opened a bakery shop there.

In 1927 eleven-year-old Albert Parker came to work for him. Albert opened the building each morning, fired the oven before daybreak, and performed other tasks before going to school. He returned to the bakery after school and worked until dark. Albert bought the business in 1945 and began to sell the Claxton Fruitcake nationwide.[151]

Ira Womble, Sr., started the Georgia Fruit Cake Company in 1917. The Womble family continued to participate in the family business. With two bakeries in Claxton to produce fruitcakes, Claxton became "the fruitcake town" in the 1930s.[152]

Cottonseed oil. Animal fats mixed with cottonseed oil made a good substitute for lard. Factories producing the product developed within the state. Cottonseed oil became also a

An early photograph of the Claxton Bakery.

useful product in cattle feed, in rayon, and in soap and the industry began to expand.[153]

Coca-Cola. Coca-Cola® is "the world's largest manufacturer, distributor, and marketer of nonalcoholic beverage concentrates and syrups, operating in more than 200 countries."[154] Coca-Cola's place in the history of American business is noteworthy.

Dr. John Stith Pemberton, a successful pharmacist, developed and sold proprietary medicines. Dr. Pemberton wanted to create the "perfect drink." In 1886, his new drink went on sale for the first time in Atlanta at the Venable soda fountain in Jacobs' Pharmacy. Pemberton decided to make and promote the new drink on a commercial scale, so he created the Pemberton Chemical Company. One of his partners, Frank Robinson, named the drink *Coca-Cola*®.[155] Pemberton received a patent for the new beverage in June 1887; within a year, however, he sold most of his interest in the company. The company's ownership changed through the years, but it eventually became "one of the largest and most successful companies in the country."[156]

By the 1930s the Coca-Cola Company had granted franchises to hundreds of bottling companies all over the nation. The establishment of independent bottlers of Coca-Cola became a part of both small and middle-sized towns throughout America. The formation of the Coca-Cola Export Corporation ensured the sale of the beverage abroad.[157]

Even during the Great Depression, Atlanta's Coca-Cola Company was doing so well that in 1934 it was able to help "bail out Atlanta from its $1 million (plus) deficit by advancing the city $800,000." In 1936, when Coca-Cola agreed to back Atlanta's payroll, the banks honored the city scrip at face value.[158]

The easily recognizable Coca-Cola bottles have changed through the years, but in November 1915 the company received its patent for the popular contour bottle, introduced to the public in 1916. This is the bottle that most customers associate with Coca-Cola.[159]

Automobile manufacturing. In 1907 Ford Motor Company founded its first small sales

Faithful Ford customers Lola Burns (Hamrick) and her brother Robert Ewart Burns pose beside their 1927 Ford Touring Car. The two-seater convertible was a means of recreation and transportation. Lola wears a cloche hat, and Ewart wears a cloth driving cap.

office in Atlanta. By 1914 Ford had decided to place its administration, service, sales, shipping, and assembly for four Southern states in the city of Atlanta. At the Atlanta assembly plant Ford was able to sell 22,000 vehicles annually. The plant assembled Model T's from 1915 to 1927, Model A's (1927–1932), and V-8's (1932–1937).[160] (In April of 1928 Chevrolet set up its own assembly plant in Atlanta. Later the plant had another Georgia location [Doraville], but the plant in Atlanta provided employment for many days to come.[161])

The War Department bought the Ford Motor Company Assembly Plant in Atlanta in 1942. The plant would now function as an army–air force storage depot and as the office of the Third Air Service Area Command.[162] The increased focus on Georgia for the manufacture of automobiles and other vehicles brought about increased jobs for workers. In 1930 the census reported 207 people at work in the automobile factories.[163] By 1939 the census reported 2,019 automobile factory workers.[164]

Related to the increase in the number of automobiles was an increase in the number of automobile repair shops. In 1930 the state of Georgia reported 395 persons involved in the operation of automobile repair shops.[165] By 1940 the state could claim 7,296 persons involved in the repair, storage, and rental of automobiles.[166]

School buses. In 1927 A.L. Luce, Sr., established the Blue Bird Body Company in Fort Valley, Georgia. The idea for the Blue Bird school bus came from Luce's friend, who asked about a bus to transport his workers. Luce created the first Blue Bird school bus and began a highly successful corporation. Still in operation, Blue Bird has 3,000 employees and three facilities in two countries.[167]

Goodyear. Closely related to the automobile industry was the tire industry. Goodyear opened two Georgia textile mills in 1929. The Goodyear Tire and Rubber Company built a large textile mill in Cedartown. The company also established a large residential section of town for its workers— the Mill Village.

After the Great Depression [began], Banning [Mill's] work force dropped dramatically. The 1930 census shows sixty-seven men, women, and children employed at the mill. Thirty-seven were

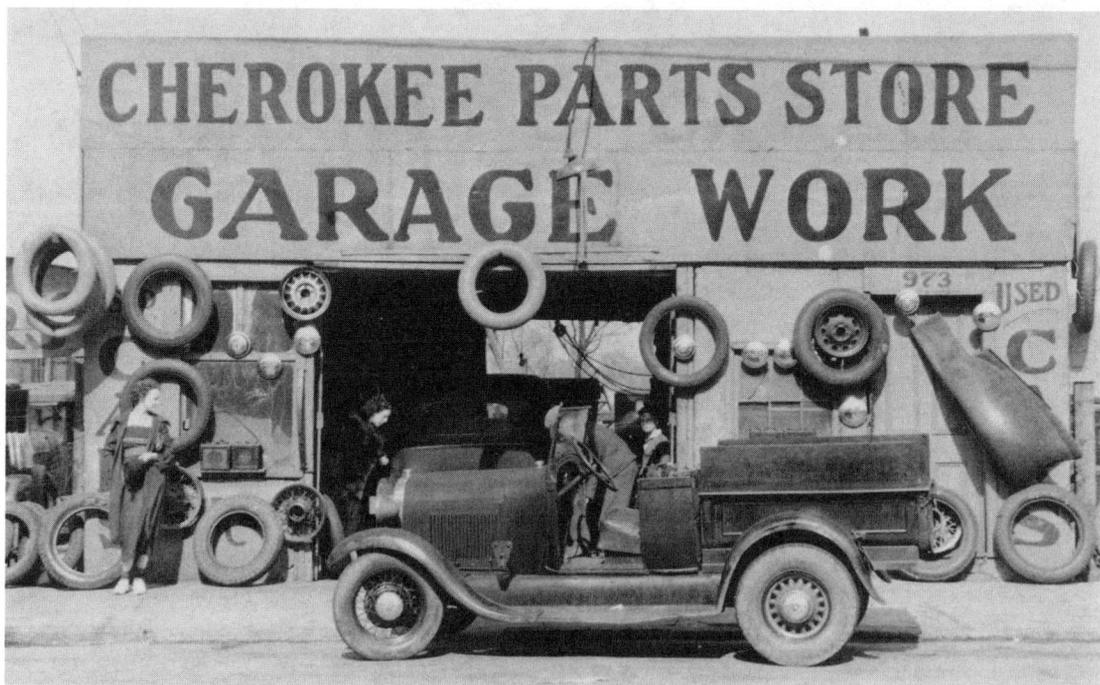

An auto parts shop in Atlanta, Georgia, in March 1936. Photograph by Walker Evans, Farm Security Administration.

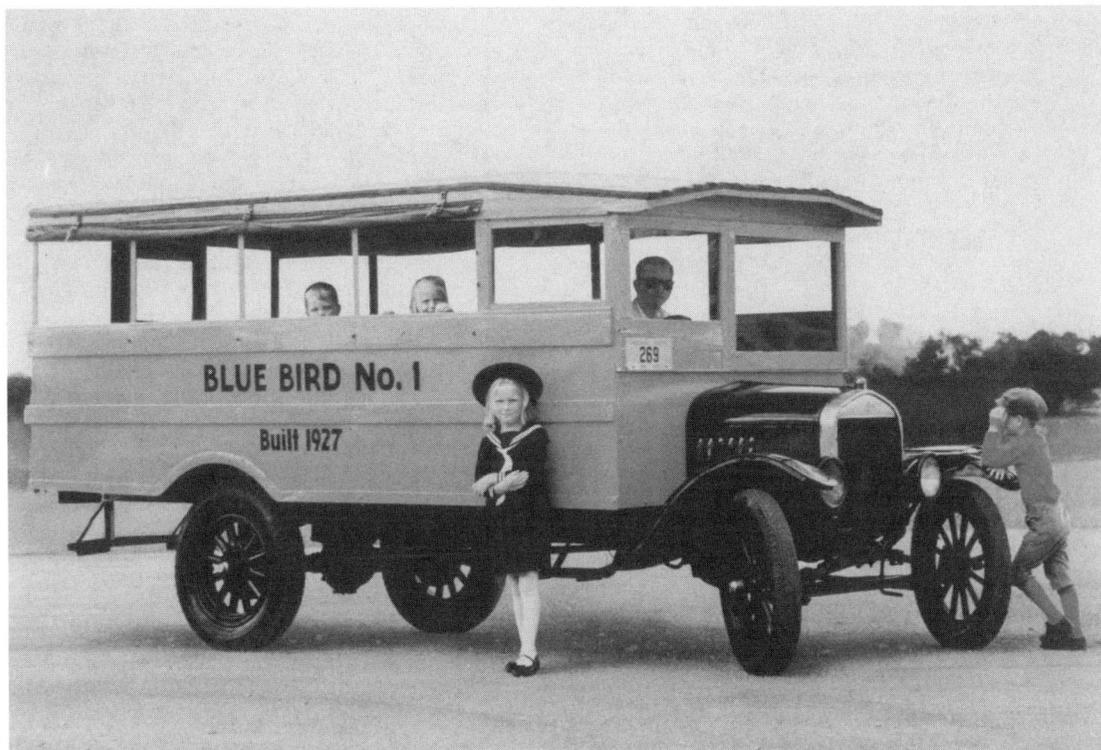

This is the first school bus — Number 1— produced by the Blue Bird Body Company of Georgia.

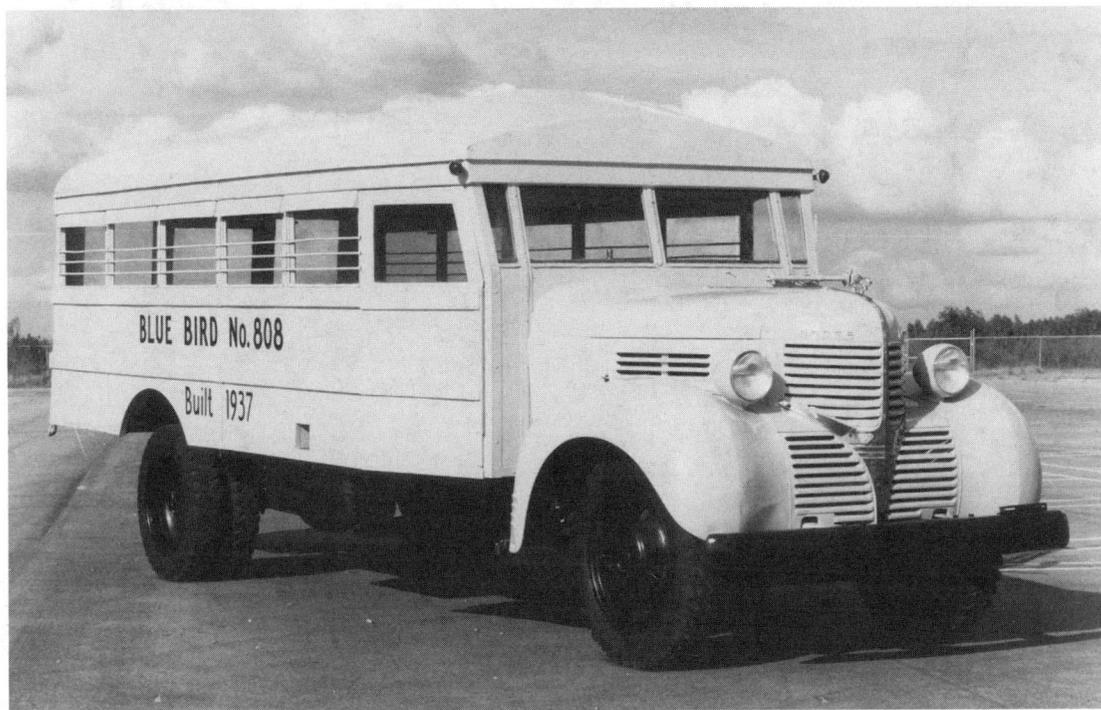

This 1937 Blue Bird school bus was a familiar sight to rural schoolchildren during the Great Depression.

married men, two were widows, and one was a working mother. Men ranged from age fourteen to sixty-seven with a mean of thirty-nine. Out of the twenty-one female employees, the youngest was fourteen, while the eldest was a forty-three-year-old widow. The mean working age for females at Banning was nineteen.

January 1, 1930 — Carroll Free Press reports ... "Several of the mill employees here have moved to Rockmart, Georgia, to work in the new Goodyear mill."[168]

Concerns of the National Emergency Council. President Roosevelt appointed a special group to present directly to him a detailed report on the economic problems of the South. The group, the National Emergency Council (NEC), was concerned about the "difference in freight rates [which] creates a man-made wall to replace the natural barrier long since overcome by modern railroad engineering."[169]

The high tariff policy of the United States. The Council reported that this tariff had forced the South to sell its agricultural products in an unprotected market and to buy goods with high tariffs. The result was that the South

... has been caught in a vise that has kept it from moving along with the main stream of American economic life. On the one hand, the freight rates have hampered its industry; on the other hand, our high tariff has subsidized industry in other sections of the country at the expense of the South. Penalized for being rural, and handicapped in its efforts to industrialize, the economic life of the South has been squeezed to a point where the purchasing power of the southern people does not provide an adequate market for its own industries nor an attractive market for those of the rest of the country.

Moreover, by curtailing imports, the tariff has reduced the ability of foreign countries to buy American cotton and other agricultural exports. America's trade restrictions, without sufficient expansion of our domestic markets for southern products, have hurt the South more than any other region.[170]

The NEC also noted the meager research facilities in the South, absentee ownership of many Southern industries, and the high cost of credit.[171] Jimmy Carter indicated that credit and interest charges in the South averaged about 25 percent during the 1930s.[172]

The Cordele, Georgia, railroad station in May 1938. Photograph by John Vachon, Farm Security Administration.

The tourist industry. Another Georgia industry that related closely to the natural resources of the state was the tourist industry. Evidence for the increasing popularity of the tourist industry was the number of workers involved in hotels and lodging places in 1940; there were 10,090 workers so involved. This was an increase of more than 400 percent[173] over the 671 hotel keepers and managers in the state[174] in 1930 and the additional 2,073 housekeepers and stewards in the motels and lodging places.[175] Chapter one, "Water, Soil, and Industries Based on Natural Resources," gives more information on this aspect.

With the increase in Yankee tourists heading for Florida, Georgia found incentive for more paved roads, restaurants, and service stations in the state:

> Since its earliest days, the state had left road-building to local governments, but the automobile had rendered that arrangement obsolete; good connecting roads between cities became a necessity. After Congress in 1916 established federal aid for highway construction, the Georgia legislature created a State Highway Commission to establish a network of state roads. By 1925, the first urban centers, Atlanta and Macon and Savannah and Brunswick, were linked by paved roads....
>
> In 1925, transportation, which had been at the heart of Atlanta's growth from the beginning, took on a new dimension as the city leased Candler Racetrack for an airfield. The city put up buildings for the Weather Bureau and the Post Office. In 1928, regular air mail service began between Atlanta and New York. The next year, Delta (then based in Louisiana) launched passenger service between Dallas and Atlanta; and in 1930, Eastern added passenger service between Atlanta and New York. Atlanta's initiative in air transportation was perhaps the biggest factor as it outpaced its commercial rivals in the Southeast, Birmingham and Charlotte, after World War I.[176]
>
> After the premiere of *Gone With the Wind* in 1939, Atlanta became a tourist as well as a convention favorite; frustrated northern visitors searched high and low for the fictional Tara and other sites where Scarlett and Rhett cavorted.[177]

Chapter seven, "Entertainment," discusses tourism, tourist sites—including national and state parks—and travel within the state as a means of entertainment.

Summary. In summary, the resources of water and soil and their related industries were all important to the State of Georgia and the nation — particularly during the Great Depression. Many problems, however, surrounded the resources and their related industries. The decades of the 1920s and the 1930s continued the slow process of solving the problems in the state, the South, and the nation.

CHAPTER TWO

Population

Georgia and the South of the 1930s were rich in many natural resources. The most important of these assets, however, was the population, a rich endowment.

During his administrations, President Franklin Delano Roosevelt often expressed concern about the South, its economy, its people, and its problems. He considered the South to be "the Nation's No. 1 economic problem — the Nation's problem, not merely the South's."[1]

I. The Population of Georgia During the Great Depression

To explore the problems of the South and the nation and the possible solutions, President Roosevelt appointed a group that he called the National Emergency Council (NEC). The NEC included two people from the state of Georgia; these two Georgians were Superior Court Judge Blanton Fortson of Athens, Georgia, and Joseph G. Tillman, a planter from Statesboro, Georgia.

Fortson had been openly supportive of Roosevelt's programs. On a radio broadcast on August 17, 1935, for instance, he had delivered an address before the Georgia League of Women Voters. He mentioned that the farm income had doubled since 1932 and openly praised Secretary of Agriculture Henry A. Wallace. As a planter, Tillman had a vested interest in the solution of the problems facing Georgia, the South, and the nation.

These two Georgia figures — Judge Fort-

son and Tillman — joined university presidents, a CIO organizer, a delegate to the AF of L, a newspaper publisher, a bank president, a lumberman, a representative of the Southern Tenant Farmers' Union, a varnish maker, and others to carry out their work on the NEC. All 23 Southerners assembled in Washington with President Roosevelt; the assignment of this group made the front pages.[2]

In June of 1938 President Roosevelt wrote to the group and requested from them a detailed report on the economic problems of the South. He did not ask for the history or the causes of the problems; he asked for a report on the conditions and requested that they deliver the report directly to him.[3] The NEC titled its response *The Report on Economic Conditions of the South*. The report centered on several main topics, including the Southern people — a vital natural resource.

Disapproval of the NEC. The catchphrase "the Nation's No. 1 economic problem"[4] that the President used was offensive to many Southerners. These insulted Southerners preferred to focus on the progress that the South — and especially Atlanta — had made. These critics of the President interpreted his phrase to be

... tailored to the headlines, but so easily misinterpreted as another purblind stereotype of the benighted South. It was almost as if the President had rung a bell that activated the conditioned reflex of the sensitive South. The region had accomplished much in the past seventy-five years, Georgia's Senator Josiah W. Bailey declared

indignantly, because of "our forefathers who rebuilt the South after the Civil War."[5]

Proud Southerners pictured the South — and Atlanta, Georgia, in particular — as the nation's greatest opportunity for improvement and development. These citizens objected to the words of the president; they did not consider the South a problem but an asset.

> In the clamor of that political summer the import of the President's commitment to regional development was lost, and his effort to harness the power of sectional feeling to the New Deal cause failed completely.[6]

Time suggested on July 18, 1938, that the NEC members did not actually prepare the report themselves. Instead the article stated that President Roosevelt

> ... said he had various administrative agencies draw up a statement of the South's economic handicaps and short-comings. He wanted the 23 Southern gentlemen to examine and discuss this, restate it if they liked until it represented "the South's own best thought." Then he would present it to the Congress. To guide the Southern gentlemen's deliberations he detailed Lowell Mellett, director of his National Emergency Council.[7]

Others, however, recognized that indeed the South was facing trials and endorsed Roosevelt's recovery plan.

The population of the South, a prominent feature of the *Report to the President*. The National Emergency Council's *Report to the President* referred to the South as "a huge crescent embracing 552 million acres in 13 States from Virginia on the East to Texas on the West" and as "the most fertile source for replenishing the population of the United States."[8]

The National Emergency Council recognized there were population problems in the South. The NEC considered the problems not to be merely local, Southern problems but

problems affecting the entire nation. The NEC emphasized these population problems in its report to President Roosevelt.[9]

Of the four regions (South, West, Northeast, and North Central) of the nation, the South had the second largest population in 1930 (37,858,000). Only the Midwest region had a larger population (38,594,000) than the South.[10]

Migration. Georgia lost more people to other states than it received from other states. The biggest migration of Georgians to other states came in the 1920s with the devastation from the boll weevil and with the available jobs in other states — particularly in the Midwest and the Northeast. Between 1920 and 1930 the population of Georgia grew from 2,895,832 to 2,908,506, an increase of only 12,674, or .4 percent. The South, however, grew by 14.3 percent, and the nation as a whole grew by 16.2 percent during that same period.

The "Negro population" of Georgia in 1920 was 1,206,365 of the 2,895,843 total population. By 1930, this population was 1,071,125 in 1930, an 11.2 percent decrease over the previous census. The "Negro population" would increase to only 1,084,927 (a 1.3 percent increase) during the decade of the 1930s.

This migration of African Americans to the North may have been a reason for the slower population growth of Georgia in comparison with other Southern states. This relocation forever changed the urban North, the South from which they migrated, and the lives of those who chose to migrate. Many African Americans hoped to find better living conditions and better wages; they could perhaps leave the humility of segregation — and even lynching and the Ku Klux Klan — through this move.[11]

To illustrate the decrease in the percentage of "Negro," consider the following census statistics:

Year	Total	White*	% of Total Population	"Negro"*	% of Total Population	% of Increase or Decrease Since Previous Census
1920	2,895,832	1,689,114	58.3%	1,206,365	42%	+2.5%
1930	2,908,506	1,837,021	63.2%	1,071,125	36.8%	-11.2%
1940	3,123,723	2,038,278	65.3%	1,084,927	34.7%	+1.3%[12]

*The Census Bureau used these terms.

Georgia's percentage of migration during the 1930s was not as great as that of the nation. An indication of this was the fact that only 10.4 percent of Georgia's American-born population was born out of state. Apparently "hard times" sent many Georgians home and discouraged others from leaving home; Georgia's population remained relatively stable. By contrast, 23.4 percent of all Americans during the decade were born outside the state in which they were counted in 1930.

Even during the 1920s, when Georgia farmers were migrating heavily to the cities (within and without the state), Georgia's percentage rate was still half that of the average for the nation as a whole. Georgia's population began moving to urban areas more heavily in 1930; this rate was slightly less than 20 percent. The nation's rate, however, was almost 50 percent during the same time period.[13]

Birthrate in the South from 1930 to 1940. Even though many Southerners had moved to other areas, by 1940 the population of the South (41,666,000) surpassed even the population of the Midwest region (40,143,000). During the 1930s the growth rate of the South was more than 9 percent — largely because of new births. In fact, in the 1930s the Southern region had the highest birthrate in the nation.[14]

Birthrate in Georgia. Though its out-migration was lower than the nation as a whole, Georgia lost more people than the state gained from people moving to the state. Natural increase was the main reason that the state gained in population at all during those years; its natural increase was lower than many other states, however.[15]

Georgia experienced a *decrease* in those younger than 14 years of age from the year 1920 (1,310,914) until the year 1930 (1,009,174); this was a decrease of 301,740, or 23 percent. The number of Georgians 14 years of age and younger in the year 1940 was 957,187 — a decrease of 51,987 (a little more than 5 percent) from the 1,009,174 of 1930. One reason for the decline was that the children were growing older, and the birthrate was declining. The population of Georgia in general increased slightly from 1920 (2,895,832) until the year 1930 (2,908,506). By the year 1940, the total population of Georgia was 3,123,723. The population increases for the state, therefore, were small.[16]

The nation as a whole experienced a drop in births from 1930 (22 births per 1,000) to 1935 (18 births per 1,000). By 1940 the trend in birthrates had begun moving upward again; it would again reach 22 births per 1,000 in 1941 and would reach 25 per 1,000 during the late 1940s and 1950s.[17]

Reasons for the low birthrate in Georgia. Congress had enacted in 1873 the Comstock Law. This law stated that

... whoever ... shall sell ... or offer to sell, or to lend, or to give away, or in any manner to exhibit, or shall otherwise publish or offer to publish in any manner, or shall have in his possession, for any such purpose or purposes ... any drug or medicine,

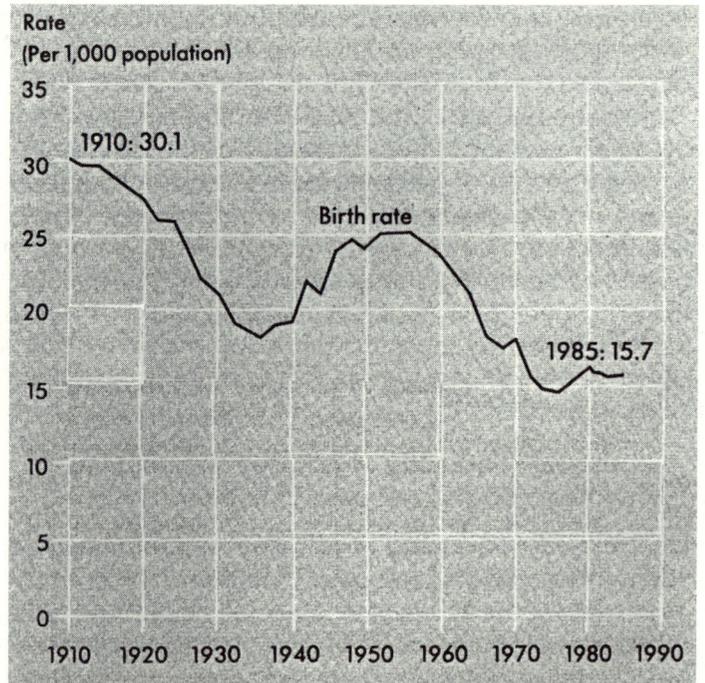

The accompanying chart, adapted from Taeuber's article in the World Book (1989), indicates the declining birthrate during the 1930s.

or any article whatever, for the prevention of con-ception, or for causing unlawful abortion, or shall advertise the same for sale, or shall write or print, or cause to be written or printed, any card, circu-lar, book, pamphlet, advertisement, or notice of any kind, stating when, where, how, or of whom, or by what means, any of the articles in this sec-tion ... can be purchased or obtained, or shall manufacture, draw, or print, or in any wise make any of such articles shall be deemed guilty of a misdemeanor, and on conviction thereof in any court of the United States ... he shall be imprisoned at hard labor in the penitentiary for not less than six months nor more than five years for each offense, or fined not less than one hundred dollars nor more than two thousand dollars, with costs of court.[18]

Until Margaret Sanger opened the first birth control clinic in America in 1916, the Comstock Law remained unchanged. In 1918, the Crane decision—partly as a result of Sanger's crusade—allowed women to use birth control for "therapeutic purposes." In 1935 the U.S. Circuit Court of Appeals deci-sion—*United States v. One Package*—made it possible for doctors to distribute contracep-tives across state lines.[19]

North Carolina and New Mexico were the only two states that had not imitated the Comstock Law. Even though condoms became legal in 1918 (at the end of World War I), it was 1937 before a state was able to offer birth-con-trol services through its public-health pro-gram. The first state to do so was North Car-olina.

The Southern states of Georgia, South Carolina, Virginia, Mississippi, Alabama, and Florida followed North Carolina's 1937 lead. These Southern states offered birth control for medical, social, and economic reasons; they were able to do so, in part, because the Catholic constituencies of their states were smaller than elsewhere. Georgia's willingness to allow birth control may have been one reason the state's population growth did not corre-spond with that of the South and the nation as a whole.[20]

Some people saw racism as the primary impetus for birth control in the Southern states:

A generally high Southern birthrate was higher among blacks. Black families, both urban and rural, were among those hardest hit by the De-pression in the South: they were the first fired, the first evicted, the first foreclosed. Like other poor people they did not respond to economic pres-sure by lowering their birthrates, so the Depres-sion added to the racist fear of being overpopu-lated by blacks....

Although racism in the South was built on seg-regation, it rested on the exploitation and impov-erishment of a large proportion of whites as well, and the continuing arrogance of "good" South-ern families toward "white trash." The demo-graphic characteristics of Southern blacks—high birthrates, not lowered by increasing economic pressure—described Southern poor whites as well, though to a slightly lesser degree. State pro-grams tried to bring birth control to them also.[21]

Johanna S. Schoen, in "Fighting for Child Health: Race, Birth Control, and the State in the Jim Crow South," noted that

Some have held that birth control programs were motivated by racism and a defense of class dis-tinctions. Others have argued that the vulnerable position of black and poor white patients resulted in their exploitation as research subjects. Analy-ses of these public health efforts assume that the birth control program worked to the detriment of black and poor white interests. A closer exam-ination of North Carolina's birth control program reveals, however, that black health and social work professionals as well as black and poor white clients welcomed the services, participated in them, and helped shape the contraceptive pro-grams offered by the state.[22]

Tone observed that African Americans at the turn of the century were not amateurs at birth control; she observed that they had a long history of practicing birth control. Though the size of their families may have been larger, Tone believes that more children may have been a conscious decision and not the result of ignorance of contraception. Tone notes doc-umented use of birth control among early Africans and suggests that they probably brought these traditions with them when they came to America as slaves.[23]

Many people believed that the efforts to fund birth control came when the South began to fear the increasing rate of births among "non-white populations." Burdened with expensive relief payments, these states supported birth con-trol as a means of lessening the cost to the state.

Schoen, however, said that preventing

certain women from reproducing was not in the mind of most health officials; rather they were more interested in helping women space their children to improve their own and the child's health. In fact, Schoen noted that African American women even had more difficulty than white women in getting access to birth control services.[24] Most of the workers in the health departments believed that they had the support of both Franklin and Eleanor Roosevelt. Eleanor had been a board member of Margaret Sanger's American Birth Control League in the 1920s. She had resigned from that controversial position, however, when her husband ran for president the first time (1932).

Franklin Delano Roosevelt depended on the votes both of the Democrats in the South and of the Catholic Church; he refused, therefore, to acknowledge the birth control movement in the South. In truth, however, the New Deal paid nurses in New Deal agencies like the Farm Security Administration (FSA) to take information about birth control and contraceptives to women on the farms and in the migrant labor camps through the FSA county agents. The Birth Control Federation of America (January 1939) began training a nurse (salary provided by Gamble of Proctor and Gamble) to instruct the Southern FSA county agents in April of 1938.[25]

North Carolina had been able to inaugurate the first contraceptive plan into its public health programs with the help of philanthropist Dr. Clarence J. Gamble, heir of the Proctor and Gamble soap fortune. Dr. Gamble donated the first check of $2250 on March 15, 1937.[26]

Although the diaphragm with spermicide was the most effective birth control technique available in the 1930s, it was not the most popular. The most popular method for couples was the condom. The public health departments to which Gamble contributed usually offered condoms and a contraceptive foam powder. When a public health nurse found that the powder was not effective, she wrote to Gamble and suggested using a Proctor and Gamble Product — Dreft detergent — in place of the powder, which seemed unreliable. Gamble refused.[27]

Desperate women of the 1930s needed

inexpensive birth control. The most frequently used female contraceptive of the era was Lysol disinfectant. The manufacturers described Lysol as a "feminine hygiene product" because birth control products could not, at first, be openly advertised as such. There were dangers to using Lysol for a contraceptive. Incorrect dilution could cause burns — or even death — to the user. The product itself was not very effective. Most birth control methods of the 1930s were not very reliable. Even the rhythm method was ineffective because the beliefs about the fertile periods were incorrect.

Despite the fact that family planning services was available in Georgia from the mid–1930s, many women did not avail themselves of the services. Some hesitated to go for "free" services because they considered it demeaning to "beg." Others did not want to visit a doctor because of embarrassment; even the process of inserting a diaphragm in their own home was offensive to them.[28] To carry their information and products for birth control, some health department workers actually went to the homes of the women. This led some to say that the birth control products were going to the mill village alley and to tobacco road.[29]

Women who were eager to limit the size of their families tried many products: suppositories, jellies, foaming tablets, and other "hygiene" methods that were ineffective for birth control. This group of women were "on their own" and did not try the health department for help — even though a Gallup poll of the late 1930s indicated that 77 percent of the people in the United States approved of contraception.[30] There were, of course, many other uses of the health departments. These services were for women and their families.

Age distribution: a factor in Georgia's slower population growth. Another reason for the slower population growth in Georgia in the 1930s was the age distribution of its people. In 1930 those under 14 in the state numbered 1,009,174; those 65 and older numbered 115,122. These figures meant that a total of 1,124,296 of the 2,908,506 people (39 percent) in Georgia were either very young or very old at the beginning of the Great Depression. This distribution is significant because more than

39 percent were not of what is usually considered child-bearing age.

The number of Georgians 14 years of age and younger in the year 1940 was 957,187 — a 5 percent decrease from the 1,009,174 of 1930. The number of those who were 65 and older numbered 159,714, an increase from 1930. The total number of those who were of non-child-bearing age in 1940 amounted to 1,168,888; this was an increase of 44,592 over the number in 1930 and was possibly an explanation for the decline in numbers for the state.[31]

These figures also imply that about 37 percent of the population during the 1930s was not of an age usual for seeking gainful employment; these people often relied on those in the employed portion of the population. This dependence of the very young and the very old on the working population increased the burdens of many Georgians during the Great Depression.

The effect of the infant mortality and the death rate. Still another reason for the low birthrate and the slow population growth in Georgia may have been high infant mortality. As the depression reached bottom in 1933, the Infant Mortality Rate (IMR) for the nation rose slightly in both 1933 and 1934. For the decade of the 1930s, the IMR for the nation continued to decrease.

Infant Mortality Rate Per 1,000 Births

Year	Rate
1920	86
1930	65
1940	47
1950	29[32]

Price V. Fishback, Michael R. Haines, and Shawn Kantor examined the impact of the New Deal relief programs on infant mortality and suicide rates. They found that these relief

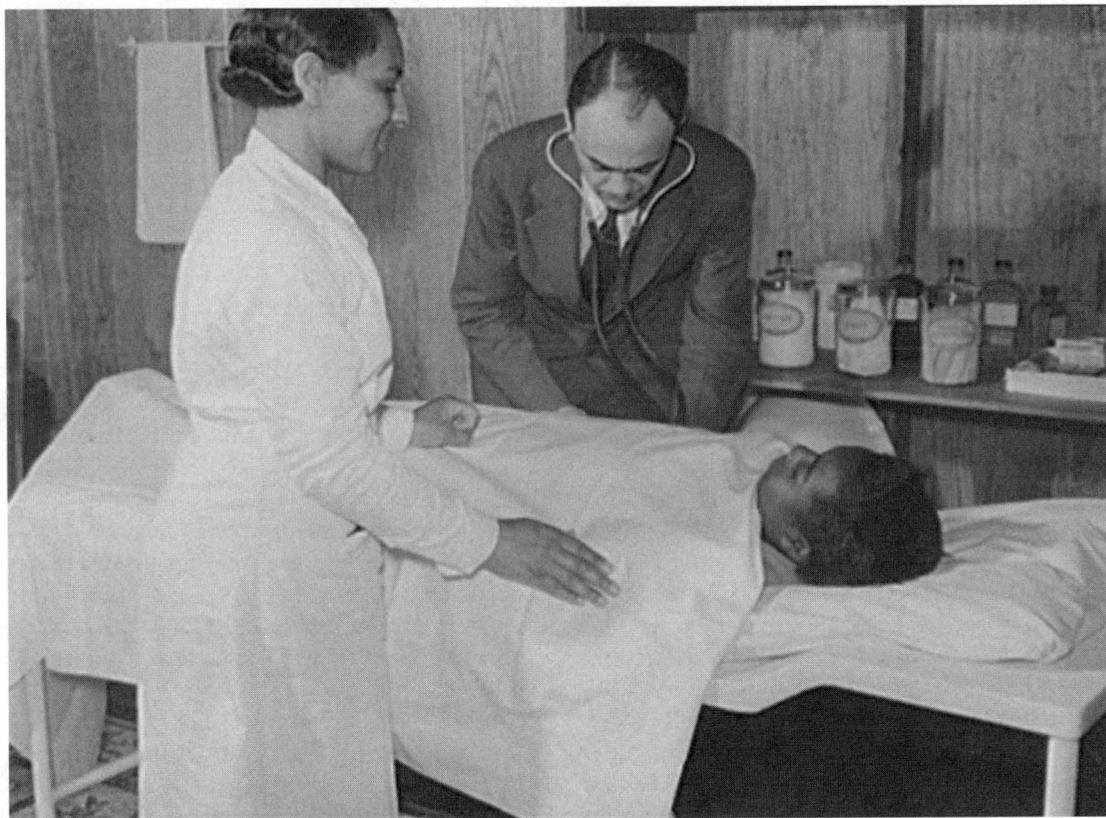

Project nurse Lillie Mae McCormick assists Dr. Thomas M. Adams as he takes Annie Maude Daniels' blood pressure on a table in a health clinic in Flint River Farms, Georgia, May 1939. Photograph by Marion Post Wolcott, Farm Security Administration.

programs helped to reduce both numbers, but the cost in dollars was high. Their estimate was that each life cost $1 to $9 but that all the money was not actually necessary.

The 1930 health conditions for infants in Georgia, in the South, and in the nation left much to be desired. By 1940 the Georgia infant mortality rate was 57.8 per 1,000 as compared to the national 47 per 1,000.[33] Chapter four, "Health," discusses general health for the state during the Great Depression.

Georgia governors during the 1930s. The Georgia governors during the 1930s were all Democrats. The governors included Lamartine G. Hardman (1927–1931), Richard Russell, Jr. (1931–1933), Eugene Talmadge (1933–1937), and Eurith D. Rivers (1937–1941).

Talmadge's campaign strategies included pitting the rural population against the urban population. His promise to reduce the license tags to $3 won him many votes. Governor Talmadge did reduce Georgia's automobile license tags to $3. His actions saved the average person from $5 to $10; it saved some of the large corporations as much as $1,112. This action appealed to the masses, but it did little for them; it did, however, help to give Talmadge the governorship two more times.

Federal relief in Georgia. When federal relief came in 1932, the intention was more adequate aid for all citizens. There were problems, however, with Georgians receiving their intended allotment.

Georgia governor Eugene Talmadge, who served from 1933 to 1937, became an opponent of Roosevelt and the federal relief program; he was one of Roosevelt's most outspoken adversaries in the nation. Talmadge attested that the farmers needed help, but he called the city dwellers "chislers" and "bums." Talmadge's suggested method of handling those who applied for relief was to "line them up against a wall and give them a dose of castor oil."[34] He predicted that "the next President who goes to the White House will be a man who knows what it is to work in the sun fourteen hours a day.... That man will be able to walk a two-by-four plank, too."[35]

Governor Talmadge opposed the National Recovery Administration (NRA) and espe-

cially the wages it paid: forty cents an hour. When one of Georgia's road contractors faced charges on refusing to pay wages by the federal scales, the governor had the state itself begin road building at lower wages.

Talmadge's actions in the state brought about the dismissal of the chair of the highway department and some members of its board, resulted in Talmadge's declaring martial law in an area of the state, tangled the highway board, and resulted in the federal government's refusal to distribute money to Georgia for its roads.[36]

Harry Hopkins, the administrator of the Federal Emergency Relief Administration (FERA), installed Gay Shepperson in 1934 as a state relief administrator for Georgia; Shepperson had been a social worker from the Georgia Department of Welfare. Hopkins removed Talmadge's chosen workers of their positions. Still, Talmadge tried to interfere with FERA's work in Georgia.

Georgians—who "even if they might not agree with the Governor still loved a good fight"—reelected Talmadge in 1934. When the legislature did not pass an appropriations bill, Talmadge declared the old one would remain in effect, but the treasurer and comptroller general refused to pay out funds. Talmadge dismissed them and appointed officers who supported him. Matters became worse with the textile strike of 1934. The use of state troops, tear gas and machine guns, and even concentration camps resulted.[37] The subject of the textile strike is a part of chapter six, "Labor."

In 1935 Talmadge vetoed Georgia's participation in old-age pensions and the unemployment benefits of the Social Security Administration. When Eurith D. Rivers, speaker of the Georgia house in 1935, introduced a series of bills to enable Georgia to obtain federal aid more easily, Talmadge vetoed them all. Talmadge voted against "seven proposed constitutional amendments, one hundred local measures, and fifty-three general bills."[38]

Rivers began his own campaign for the governorship. He knew that Talmadge could not seek reelection because Georgia law prevented Talmadge from running for a third consecutive

term as governor. Still governor when the tornado of 1936 hit Gainesville, Talmadge did accept federal aid for the 200 people killed and for the $5,000,000 in property damages. This tornado may have won many votes for Roosevelt; in the state of Georgia, Roosevelt received seven votes for each vote that Alfred M. Landon won.

Eurith D. Rivers, who replaced Talmadge in 1936, tried to bring change to the state. With his election, Georgia "entered the empire of the New Dealers."[39] Rivers pushed a controversial bill through the state legislature. The bill would expand the Georgia Department of Public Welfare and empower the department to administer the Works Progress Administration and other federal programs. The state legislature, however, would not levy new taxes on liquor or chain stores to provide the matching funds for the federal programs.[40]

At a speech in Barnesville, Georgia, on August 11, 1938, President Roosevelt spoke of his relationship with Eugene Talmadge:

Governor Talmadge [boos]—I have known him in the State of Georgia for many years. His attitude toward me and toward other members of the Government in 1935 and in 1936 concerns me not at all. [Applause] But, my friends, in those years and in this year I have read so many of his proposals, so many of his promises, so many of his panaceas that I am very certain in my own mind that his election would contribute very little to practical progress in government. And, my friends, that is all that I can say about him.[41]

Governor Rivers found that the state would have to scale down its spending to less than 74 percent of the amount appropriated—except for a few items, like salaries for teachers. Rivers decided to "levy on the highway fund," but the highway board chair refused to divert the money. Rivers dismissed him, and the chair of the highway board took Rivers to court.

Rivers declared martial law in a restricted area; the state troops took charge. The federal courts took action, and Rivers found himself arrested. Later, Rivers did obtain the highway money for Georgia's needs and did get out of trouble, but his deficit at the end of his second term was $22,000,000. Georgia law prevented a governor from running for a third consecutive term. Talmadge, however, was eligible to run again, and he was reelected. During his last years as governor, more turmoil arose with the university system.[42] Chapter three, "Education," has more details on these controversies.

Unemployment in Georgia. The unemployment figures for Georgia were not as devastating as those for some other states. In 1930, for instance, Georgia had 11.3 percent of its workers unemployed; 40 states had a higher unemployment rate. The national average was 14.3 percent.

In 1933, the height of the Great Depression, Georgia ranked lowest of all the states in its unemployment rate. With the national average at 34.8 percent and with Michigan's average at 47.2 percent, Georgia's unemployment rate was last with a rate of 14.9 percent.[43]

Three things [falling cotton and tobacco prices, reduction in the workforce, and misuse of the land] combined to chase Georgians from the fields in record numbers. At the end of the ten-year period ending in 1940, less than one-third of all Georgia workers were employed in agriculture.

Economically, urban Georgians suffered less during the Great Depression than their counterparts to the North and West. One reason they had been insulated was the strong industrial base that had only recently begun to form. Coupled with low-cost labor and a dedicated workforce (remember, many had only recently come from farms and did not have the problems of workers in other parts of the country), large Georgia cities did as well as can be expected during this decade.[44]

Segregation within the state of Georgia. Segregated drinking fountains, movie theatres, waiting rooms, restaurants, and restrooms were typical of much of the state during the 1920s and 1930s. Public conveyances had their own rules for waiting rooms and seating in the vehicle itself. Segregation and Jim Crow Laws persisted for years to come.

The biracial society in Georgia was a negative for encouraging migration to the state.

Since Reconstruction, the imposition of white supremacy in Georgia political, social, and economic affairs had visited injustice and violence on black people, stigmatized the white people, retarded everyone's progress, and engendered hostility to anyone inside or outside the state who dared criticize the practice. Racial discrimination naturally brought a continuing out-migration of Georgia's black people.[45]

Discrimination of Georgians toward groups other than blacks was also common. Members of

the Jewish faith often felt the scorn and discrimination of others. Sometimes this discrimination led to violence and even lynching.

Lynching. Georgia frequently led the nation in lynching between 1889 and 1930. The statistics are, of course, unreliable, but the estimate is that at least 450 lynchings occurred during this time period. The victims were usually blacks.[46]

Hepburn reports 531 lynchings between 1882 and 1968 in Georgia.[47] Brundage indicates that there were 441 lynchings in Georgia between 1880 and 1930; 10 of the victims were black women, and 19 were whites. Seven of the 441 lynchings occurred in 1930. Brundage notes that no region of the state was without mob violence.[48]

Between 1882 and 1968 there were 4,742 black lynchings in the nation. Congressman John Lewis calls the period "one of the darkest and sickest periods in American history ... not so long ago."[49] Photographers often recorded the lynchings and sold the images to others, to publications, and to postcard companies for resale. After Allen purchased postcards of the lynching victims, the result was his book *Without Sanctuary: Lynching Photography in America*:

Esther Bubley of the Farm Security Administration took this photograph at a bus station in Rome, Georgia, in September 1943. She was traveling by Greyhound bus from Louisville, Kentucky, to Memphis, Tennessee.

In America everything is for sale, even a national shame. Until I came upon a postcard of a lynching, postcards seemed trivial to me.... Studying these photographs has engendered in me a caution of whites, of the majority, of the young, of religion, of the accepted.... Hundreds of flea markets later, a trader pulled me aside and in conspiratorial tones offered to sell me a real photo postcard.... That image of Laura [Nelson hanging from a bridge] layered a pall of grief over all my fears.

I believe the photographer was more than a perceptive spectator at lynchings. Too often they compulsively composed silvery tableaux (natures mortes) positioning and lighting [of] corpses as if they were game birds shot on the wing. Indeed, the photographic art played as significant a role in the ritual as torture or souvenir grabbing—creating a sort of two-dimensional biblical swine, a receptacle for a collective self. Lust propelled the commercial reproductions and distribution of the

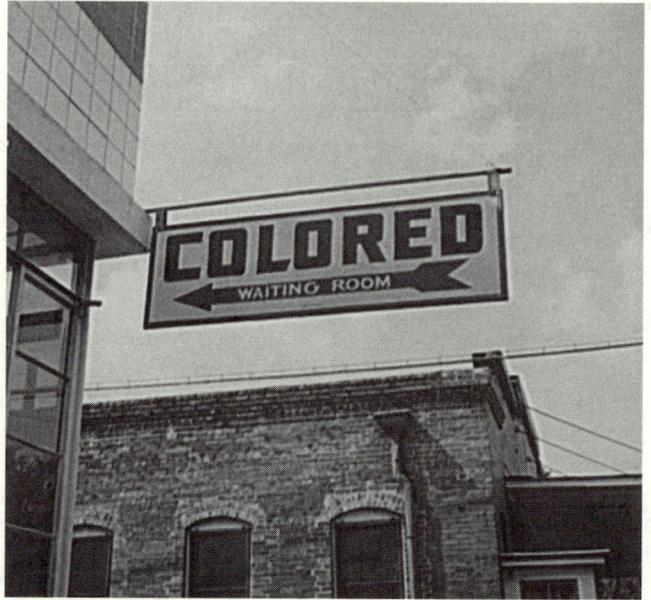

images, facilitating the endless replay of anguish. Even dead, the victims were without sanctuary.[50]

Eleanor Roosevelt openly supported anti-lynching laws. She wrote on March 19, 1936, to Walter Francis White, the executive secretary of the NAACP, about her concerns. Mrs. Roosevelt said in the letter that she had talked with President Franklin Delano Roosevelt and mentioned to him that "it seemed rather terrible that one could get nothing done." The president had responded that

... the difficulty is that it is unconstitutional apparently for the Federal Government to step in in the lynching situation. The Government has only been allowed to do anything about kidnapping because of its interstate aspect, and even that has not yet been appealed so they are not sure that it will be declared unconstitutional.

The President feels that lynching is a question of education in the states, rallying good citizens, and creating public opinion so that the localities themselves will wipe it out. However, if it were done by a Northerner, it will have an antagonistic effect.... I am deeply troubled about the whole situation as it seems to be a terrible thing to stand by and let it continue and feel that one cannot speak out as to his feeling. I think your next step would be to talk to the more prominent members of the Senate.[51]

An enlarged New York World-Telegram and Sun *photograph of Leo Frank.*

Perhaps the best-known victim of a lynching in Georgia was Leo M. Frank, a white, Jewish manager at the Atlanta Pencil Company. Frank was in the state penitentiary in Milledgeville, Georgia; his charge was the murder of a young female factory worker. When the governor changed Frank's death sentence to life imprisonment, twenty-five men took him from jail and hanged him in Marietta, Georgia. The actions of this mob became significant for the state of Georgia and the nation in the days to come; the case of Leo Frank and his lynching "generated the formation of the modern Ku Klux Klan, and produced the Jewish Anti-Defamation League, two organizations that exist to this day."[52]

The Ku Klux Klan (KKK). Leo Frank's death, which has been the subject of many books (including *The Leo Frank Case* by Leonard Dinnerstein in 1968 and *A Little Girl Is Dead* by Harry Golden in 1965), a Broadway play (*Parade*, a musical by Jason Robert Brown in 1998), and a movie (*The Murder of Mary Phagan*, a 1988 television movie with Jack

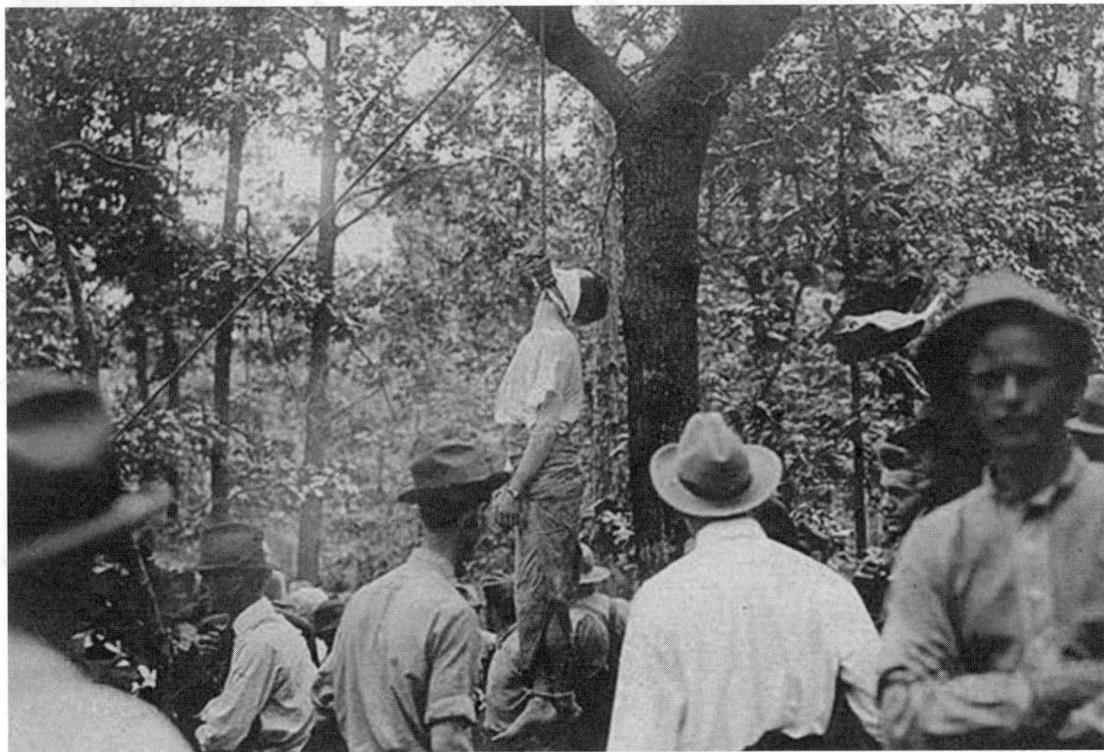

Leo Frank was lynched on August 17, 1915, in Marietta, Georgia.

Lemmon). The lynching of Leo Frank "foreshadowed the 1915 rebirth of the Ku Klux Klan at Stone Mountain."[53]

Seventeen members of the revived Ku Klux Klan ascended Stone Mountain. (More information on Stone Mountain itself is in chapter one, "Water, Soil, and Industries Based on Natural Resources," and in chapter seven, "Entertainment.") At the top of the mountain the mob ignited a flaming cross to announce the rebirth of the Knights of the Ku Klux Klan.[54]

The first KKK had "ceased activities" after the Civil War, partly because of "the restoration of 'white supremacy'" and partly because of federal legislation from the Republican Congress of the United States. Concerned about the loss of Republican strength in the South and outraged by the actions of the KKK, Congress took action after the close of the Civil War.

Congress's first action was reviewing an investigation of the Klan. Next, the Congress passed the Force Act of 1870, the Federal Election Law of 1871, and the 1871 Ku Klux Klan Act. These laws declared that secret societies were illegal. The laws also suspended the writs of habeas corpus "in disorderly areas," increased penalties for violation of the Fourteenth and Fifteenth Amendments, and gave military commanders more control over elections.[55]

The KKK became active again after the beginning of the twentieth century. D.W. Griffith's 1915 film, *The Birth of a Nation*, based on the Thomas Dixon's novel *The Clansman* (1905), appeared in Atlanta in December of 1915. The silent movie presented the Ku Klux Klan as an honorable institution and became popular across Georgia — and elsewhere.

The KKK gradually gained members in 1917 and 1918. Support of white supremacy, anti–Semitism, anti–Catholicism, and immigration restrictions brought many to the KKK; its professed respect for and support of the law, government, better schools, and family life brought more to the folds: "By 1924 the perceived power of the Klan was such that neither major political party was willing to denounce it formally."[56]

There were perhaps 5,000,000 members

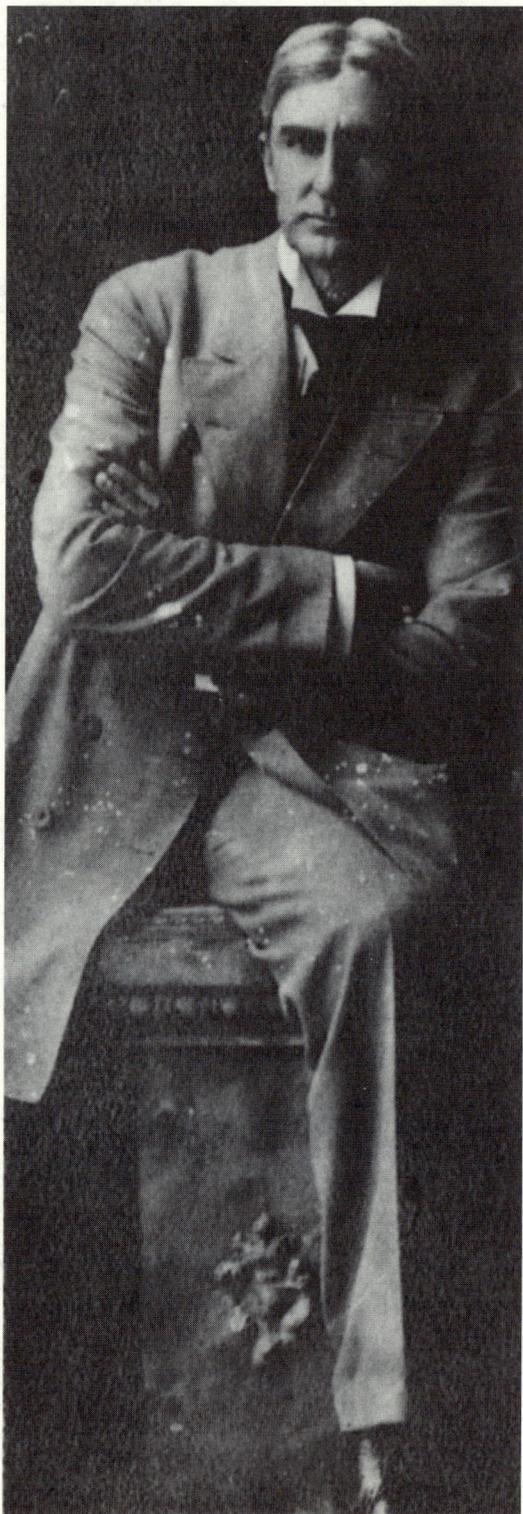

COURTESY ROBERT WATKINS, PHOTOGRAPHER, FOREST CITY, NC

Thomas Dixon, the author of The Clansman, *upon which* The Birth of a Nation *is based.*

in the Klan during the early 1920s. Perhaps this resurgence of the KKK was one factor in the decrease in the black population between 1920 and 1930. The population of blacks in Georgia in 1920 was 1,206,365 in 1920; by 1930 the total had dropped to 1,071,125 — a 11.2 percent decrease in only a ten-year period.[57]

The number in the Klan was dropping also. Its 5,000,000 members numbered only about 30,000 in the 1930s. Georgia's Klan membership declined from 156,000 members in 1925 to 1,400 in 1930. During the Great Depression the Klan still tried to make a showing; in 1939, six hundred Ku Klux Klan members paraded on the streets of Atlanta. The strength of the KKK seemed to be decreasing.[58] Chapter seven, "Entertainment," gives more information on civic, religious, social, and political organizations, including the National Association for the Advancement of Colored People, in the 1930s.

On the move: The road and the rails. Although most Georgians tended to remain in the state during the 1930s, all the people of the nation and state did not do so. People on the road — with and without their own transportation — and on the rails— legally and illegally — marked the era of the 1930s. Many individuals and families sought their fortunes away from their home. More than 250,000 boxcar children marked the 1930s. The boys and girls of the rails were often as young as thirteen. The reasons for their travels were many: crumbling families, job searches, adventure, and desertion by parents. The Interstate Commerce Commission reported that 5,962 "railroad trespassers" suffered death and/or injury in the first ten months of 1932; 1,508 of these deaths and injuries were victims under twenty-one years of age. Kingsley Davis states, "Half a million American boys [and girls] set out to look for the pot of gold at the end of the rainbow. They found it, but instead of gold it contained only traces of mulligan stew."[59]

Unemployed men and women left home to ride the rails, to seek employment, and to find adventure. Of course, many of the travelers of the thirties told of this life on the road

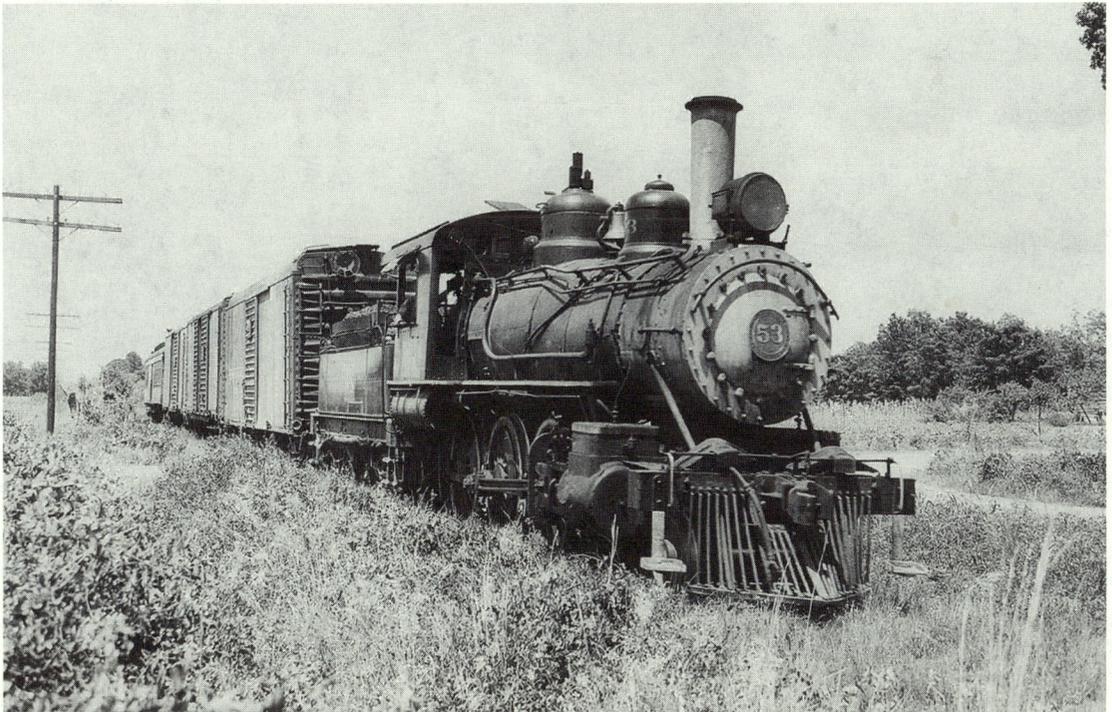

The Louisville and Wadley train near Wadley, Georgia, was typical of the 1930s; it was a mixed train, carrying both freight and passengers. This short line is 80 miles east of Macon, Georgia, and is still active.

and rails, but some of the stories were fictionalized.

For instance, *Tobacco Road* (1932) is Erskine Caldwell's fictional book about a Georgia farming family in the 1930s. Some of the family members decide to migrate to the city; others decide to travel the nation as itinerant preachers. The 1933 Broadway play by Jack Kirkland ran for eight years (3182 performances). Made into a movie in 1941, the film included the stars Dana Andrews and Gene Tierney.[60] Caldwell was married to photographer Margaret Bourke-White. The two collaborated on a photographic portrait of the Great Depression, *We Have Seen Their Faces* (1937).

Bertha Thompson wrote of her life on the tracks in her autobiography, *Sister of the Road* (1988); the fictionalized movie *Boxcar Bertha* records her story on film. All the travelers, however, did not travel alone.

Thompson hints at a reason that hoboes (unattached men and women looking for work), tramps (unattached, penniless people), and bums (those addicted to drugs and drink and who had lost respectability) did not often select Southern cities as ideal destinations.[61] She notes:

> In practically every large city that I have visited, except those in the South, I found hobo colleges, unemployed councils, and radical forums that were run especially for the hoboes and the unemployed. They were nothing new to me.[62]

Thompson discusses the numbers of those who rode the rails in the 1930s. Her estimate is that there were "between five hundred thousand and two million hoboes in the United States, at least a tenth of whom were women."[63]

Family units sometimes traveled by road or by rail seeking work. This was true in Georgia, as well. Georgia tourist camps could oblige those who had the funds to pay.

Charles McCartney ("The Goat Man"). Perhaps the best-known man to travel the

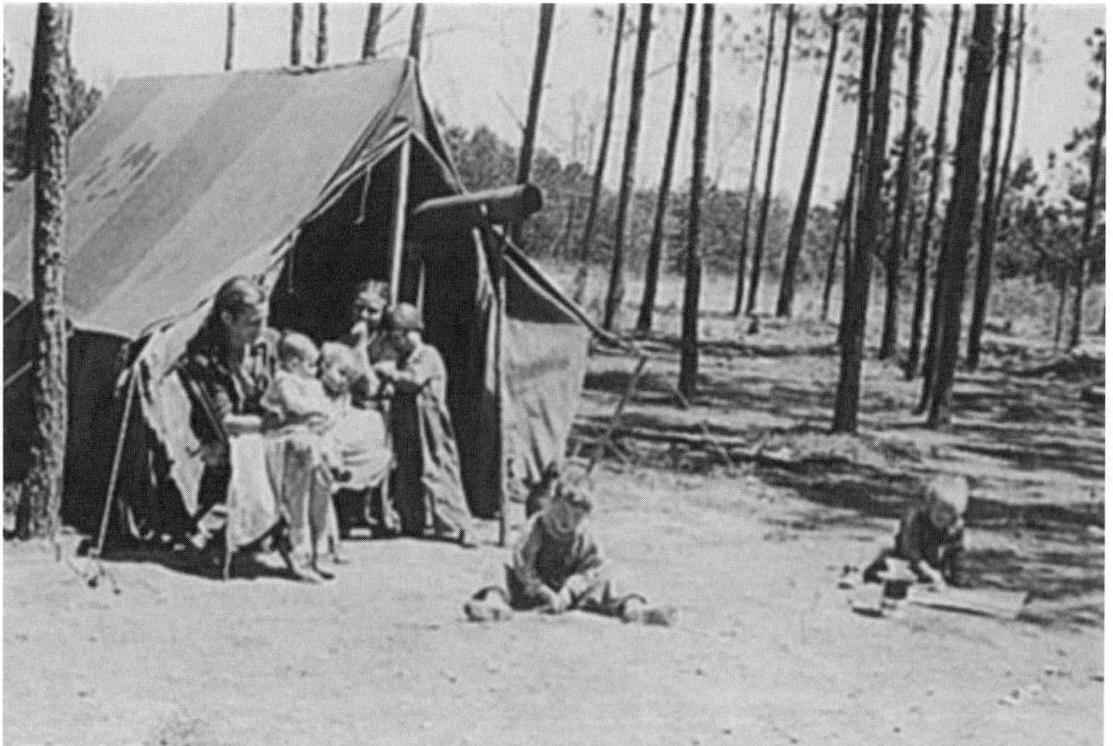

This tourist camp near Atlanta, Georgia, served as a temporary home in spring 1939 to one of two families who traveled and worked together all through the South, repairing stalls, stoves, tools, houses, and performing other odd jobs. Photograph by Marion Post Wolcott, Farm Security Administration.

Georgia roads and the United States highways was Charles McCartney, with his goat-drawn wagon. "Chess" was born in 1901 in Sigourney, Iowa. During the 1930s McCartney had a job with the CCC until a tree fell on him. His rescuers believed he was dead and took him straight to the mortuary. Fortunately the morticians quickly discovered he was still alive, but Chess lived the rest of his life with a crippled arm. It was after the accident (about 1938) that McCartney began his life as a nomad.

Chess McCartney's wagon pulled by goats was a frequent sight on roads across the nation — and particularly on those in Georgia. During his more than thirty years of travel, he reached 49 of the 50 states, but his "headquarters" seemed to be in Georgia — particularly Twiggs County. The postcards of his beloved animals, of his wagon filled with treasures collected from the side of the road, and of "The Goat Man" himself opened the fantasies and wallets of those who saw this unusual troop. McCartney traveled with his wife, Sadie, and his son, Albert Gene McCartney, for many years. He dressed his son in the skins of animals, just as Robinson Crusoe had dressed in the novel that Chess loved.

McCartney later set up a mission in Jeffersonville, Georgia. He did not remain at the mission for long at a time, however. He traveled to California, where he planned to marry a movie star and bring her back to live in a bus. He concluded his travels in 1968 and returned to Jeffersonville. After he sold his wagon, McCartney and Albert Gene lived in a school bus in Easton, Georgia.

Chess spent his last years in a retirement home in Easton; visits from those who remembered him and were able to locate him were frequent. Albert Gene was murdered in his school bus after his father entered the retirement center. Charles McCartney's life ended on November 23, 1998.

Migrant workers. Some Georgians did work elsewhere — and some farms and businesses did at times make use of workers from out of state. These migrant workers knew well the life of the rail and road.

Characteristics of the population of Georgia in the 1920s, 1930s and 1940s. Georgia

Charles McCartney and some of his goats.

THE AUTHOR BOUGHT THIS PHOTOGRAPH FROM K. KELTY, JR., OF ROSEDALE, INDIANA.

Postcard of Charles McCartney, Albert Gene McCartney, and Sadie McCartney.

Migrant agricultural workers traveled from Tennessee, the Carolinas, Alabama, and Georgia to work in packing houses in Homestead, Florida, and lived in overcrowded boarding houses, January 1939. Photograph by Marion Post Wolcott, Farm Security Administration.

had a diverse population in the 1920s, 1930s, and 1940s. Of the 2,895,832 Georgia citizens in 1920, there were 1,689,114 (58.3 percent) who were "White," and 1,206,365 (41.7 percent) who were "Negro."

A census showed in 1930 a total Georgia population of 2,908,506. Of these, 1,837,021 (63.2 percent) were "White," and 1,071,125 (36.8 percent) were "Negro." The "Negro" population had a decrease of 135,240 since the previous census in 1920. By 1940 Georgia had a total of 3,123,723 residents of the state. Of these 2,038,278 (65.3 percent) were "White" and 1,084,927 (34.7 percent) were "Negro." This was a 7.4 percent, increase over the previous census. The white population had increased by 201,167 since 1950. The black population, by contrast, had increased by only 13,802.[64]

Georgia's urban and rural population. Georgia's urban population in 1930 was 895,492, or 30.8 percent, of its total population; this was a 23 percent increase over the previous census. During the decade of the 1930s the urban population would increase to 1,073,808 (34.4 percent of Georgia's total population, or a 19.9 percent increase). Georgia's rural population in 1930 was 2,013,014, or 69.2 percent of the population; the rural population was down 7.1 percent since the last assessment. By 1940 Georgia's rural population was 2,049,915; this was a 1.8 percent increase over the previous census.[65]

Farming population. All the people who tilled the good soil of the state, however, did not have title to the land they farmed. The sharecropper/tenant system seemed a logical system for the South to use after the Civil War. This system, however, resulted in a shifting population and a group of workers who had little concern for the fertility of the soil. Harry L. Hopkins, the administrator of the Works Progress Administration, shared an "often-repeated story of an interview between a landlord and a share cropper" with listeners of WREC, Memphis, Tennessee, on August 5, 1938, and to the morning papers on August 5, 1938:

> *Farm Tenant.* How about fixing that leaky roof over at the place?
> *His Landlord.* Why ask me to fix it?

> *Farm Tenant.* Well, it's your place, ain't it?
> *His Landlord.* Yes, but it's leaking on you.
> *Farm Tenant.* Well, it won't be next year.[66]

In the photograph on page 90, a day laborer moves to another farm. Chapter one, "Water, Soil, and Industries Based on Natural Resources," contains more information on sharecroppers, tenants, and day workers.

Per capita income for the Georgia population in the 1930s. Many facts about the people of Georgia are evident from the earlier information in this chapter. An additional facet of the population gem is per capita income in Georgia as compared to the nation as a whole.

During 1929 the average per capita income of the United States was $700. The average per capita income for a Georgian in the same year was $347; only four states ranked lower. The average Georgian's income was 49.6 percent of that of the rest of the nation.

In 1933, at the height of the Great Depression, the per capita income for the nation as a whole was $373. The per capita income for the state of Georgia was $204. Five states ranked lower. Georgia's per capita income was 54.7 percent of that of the national average; Georgia's income had decreased from 1929, but its percentage of the national average had increased.

By 1940 the average per capita income in the United States had decreased to $595. The average Georgian's per capita income was $337; four states ranked lower. Again, Georgia's per capita income had decreased, but its percentage (56.6 percent) of the national average had increased.

When comparing the years 1929 and 1940, Georgians found that their average per capita income dropped $10 from 1929 until 1940. The per capita income of the rest of the country had dropped over $100.

Georgia, then, had long experienced the sting of the Great Depression. Georgia's percentage of the national per capita income had increased, but the amount of its per capita income had dropped — a reflection of the poor economic condition of the nation as a whole.[67]

Georgia's increased participation in New Deal programs. In 1937 Georgia, after federal stimulus and after the election of

A black day laborer near Madison, Georgia, moved from one man's farm to get work when he wasn't needed any more by his former "employer" in spring 1939. The son of his new employer said his father used to have tenants but that they "skinned" him too often by moving out on him all the time. So his father began hiring only by the day. Photograph by Marion Post Wolcott, Farm Security Administration.

Eurith Rivers to its governorship, increased its participation in New Deal programs. The state created some new agencies to make cooperation with the federal programs easier. The establishment of the Georgia Housing Authority facilitated slum clearance and public housing by making acceptance of federal funds easier. (Chapter five, "Housing," includes more details about public housing and other types of housing in the state.)

The Soil Conservation Authority helped farmers and foresters to curb erosion; the state had about 66 percent of its land in these districts. The development and conservation of Georgia's natural resources was a top priority of the Department of Natural Resources.

To enable eligible Georgians to profit from federal unemployment insurance, Georgia set up the State Bureau of Unemployment Compensation. Rivers made major changes within the State Highway Department; these changes ensured that Georgia complied with

federal standards so that federal highway funds to Georgia would increase.

A 1937 act strengthened the Department of Public Welfare, made county departments of welfare mandatory, and established minimal standards for these agencies. As a result, the benefits for dependent children, the aged, the blind, and the disabled increased.

Rivers persuaded legislators to increase the state appropriations available for public health, which enabled the state to receive matching federal funds. (Chapter four, "Health," includes more information about the health of Georgians in the 1930s.)

Rivers also helped to provide the necessary legislation that would allow the establishment of Rural Electric cooperatives. Chapter five, "Housing," includes more details about the works of the Rural Electric Administration in the state of Georgia.[68]

By 1939 Congress—with the endorsement of the states—increased federal appropriations.[69]

As a result, many of the unemployed had additional funds to help provide for their children, other family members, and themselves.

The National Industrial Recovery Act (NIRA). Perhaps the cornerstone of the New Deal for workers and businesses was the National Industrial Recovery Act (NIRA), which Congress passed in June of 1933, and the National Recovery Administration (NRA), which the NIRA created and which Hugh Johnson led. The NIRA encouraged cooperation among businesses, suspended antitrust laws to facilitate this cooperation, and allowed businesses to fix prices. The ultimate goal of the NRA and the NIRA was the self-regulation of business and the development of fair prices, wages, hours, and working conditions. Section 7-a of the NRA permitted collective bargaining for workers; laborers would test the federal support for their bargaining efforts in the days to come. Chapter six, "Labor," contains more information on the labor force and bargaining in Georgia during the 1930s.

Those businesses that were abiding by the NRA codes received a 5¼" x 7" decal with a screaming blue eagle for display in their window.[70] To demonstrate support of the NRA, businesses displayed the NRA emblem in their windows or on their entrance doors. The federal government encouraged consumers to patronize only NRA businesses that professed, "We do our part." Committed individuals wore metal buttons and badges, which read, "Doing our part."

Public attitude toward the New Deal and President Roosevelt during the 1930s. Despite some opponents, the substantial majority of those in America, particularly working class people, admired and supported President Roosevelt and his plans for a "New Deal" in the early days of the 1930s.[71] Even at the Convention in Chicago, his presence seemed to rally the delegates. To the cheering audience he made his pledge,

"I pledge you, I pledge myself, to a new deal for the American people." The band struck up the Roosevelt campaign song, "Happy Days are Here Again!" and for a moment in Chicago that summer, the pall of gloom lifted from American hearts....

Everywhere the people came to see FDR in huge throngs. They gathered at lonely little railroad crossings in the West just to catch a glimpse of the campaign train; they lined the streets of towns and cities in dense masses; they filled to overflowing the public stadiums and arenas where he spoke. Their faces were grave at first, their eyes searching with quiet intensity the face of the man who might just possibly supply a few answers to agonizing questions. But soon they would begin to smile, to catch the jaunty enthusiasm behind the uptilted cigarette holder, the infectious grin, the voice (it seemed made for radio) which could so well express stern disapproval (of heartless corporations), poke satiric jibes (at humorless Republicans), and speak warmly and directly to people in the language of hope.[72]

Franklin Delano Roosevelt took all but eight states in the 1932 election; he received 57.4 percent of the popular vote. In the 1936 election Roosevelt earned 61 percent of the popular vote and carried every state but two (Maine and Vermont). In the 1940 election Roosevelt received 55 percent of the popular vote; he carried 38 of the 48 states. Promotion buttons for Franklin Delano Roosevelt or his

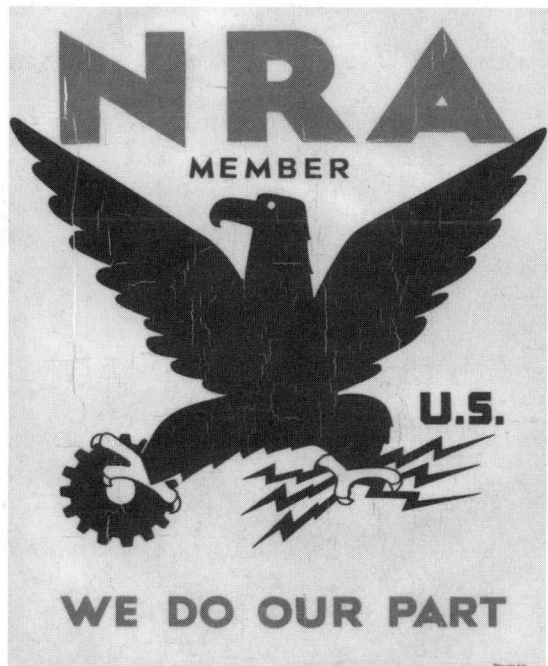

The NRA decal with the slogan "We do our part." A business manager supporting the NRA could place this decal on a window or on another flat surface; both sides had adhesive.

opponents were a part of the attire of many Georgians during the election campaigns.

In 1932 Georgia cast twice as many votes for Roosevelt as it had ever cast for any presidential candidate. Not everyone in the state and the nation endorsed Roosevelt and his plans for a New Deal. To put it mildly, as time passed, "Franklin Delano Roosevelt did not please Governor Talmadge and a considerable number of other Georgians."[73] Some Georgians viewed the president as intruding on their state, which had for years expressed loyalty to the national Democratic Party.[74]

A majority of the electorate deeply resented an outsider — even a highly popular president — coming into their state and telling them how to vote. As one tobacco farmer explained, "We Georgians are Georgian as hell."[75]

New Deal opponents kept up a barrage of criticism. Businessmen damned the NRA as "creeping socialism," while union men called it "business fascism." The Hearst newspapers suggested bitterly that what the initials NRA really stood for was: "No Recovery Allowed."[76]

One attempt to summarize the feelings toward Roosevelt follows: "Ordinary Georgians loved Roosevelt. Georgia's conservative

These two pins indicate that the wearer is a sustaining member of the NRA and an NRA employee.

This first-day cover from August 15, 1933, shows the NRA 3-cent stamp with the inscription, "In a common determination"; illustrated also are workers from various occupations marching determinedly forward.

1933–1936 Election Term
Franklin Delano Roosevelt, President
John N. Garner, Vice President
Herbert Hoover, Republican Candidate

1937–1940 Election Term
Franklin Delano Roosevelt, President
John N. Garner, Vice President
Alfred Landon, Republican Candidate

1941–1944 Election Term
Franklin Delano Roosevelt, President
Henry Wallace, Vice President
Wendell Wilkie, Republican Candidate

1945–1948 Election Term
Franklin Delano Roosevelt, President
Harry Truman, Vice President
Thomas E. Dewey, Republican Candidate

Campaign buttons for Franklin Delano Roosevelt and John N. Garner, his vice-presidential running mate, stand opposite buttons for Herbert Hoover and Alfred Landon. FDR ran against Wendell Wilkie in 1940 and Thomas E. Dewey in 1944; Roosevelt's vice-presidential running mate in 1944 was Harry S Truman.

Democrats needed federal aid but feared for state's rights, a growing southern dilemma."[77]

Letters to President Roosevelt were many. McElvaine reports that in the week following his election, Roosevelt received 450,000 letters; the average remained 5,000 to 8,000 each day. After adjusting for population changes and literacy rates, he concludes that FDR received four times as many letters as the two previously most popular presidents: Wilson and Lincoln. President Roosevelt found it necessary to hire fifty people to answer the correspondence; in past years only one person was necessary. McElvaine found more than 15 million letters in the Franklin Delano Roosevelt Library.[78] Undeniably the dominant personality of the 1930s was Franklin Delano Roosevelt. He was the focal point of the feelings of Americans. Americans either liked him or disliked him; everyone noticed him.[79]

The photographs of the population of Georgia during the Great Depression. The photographs of Georgians during the decade of the 1930s reflect the population: the rural and the urban residents; the young, the middle-aged, and the elderly; the employed and the unemployed; the forester, the industrial worker, the migrant worker, and the farmer; residents of all the geographic regions; whites and African Americans. These portraits of Tugwell's "important human beings" and their environment are an irreplaceable part of the records of the 1930s.

Each of the important population segments — men, women and children — is deserving of further investigation. Separate sections feature these important natural resources.

II. One Segment of the Georgia Population During the Great Depression: The Men

As a Southern state, Georgia was in some respects like its Southern neighbors; in other ways, however, it was unique.

Statistics. Georgia, for instance, did experience a population increase, according to the population census, for each decade from 1920 through 1940. The increase, however, was small

(.4 percent), according to the 1940 census.[80] In Georgia between 1920 and 1940, the number of males and females was almost equally divided. In 1920, for instance, there was a total population of 2,895,832; of this population, 1,444,823 (49.8 percent) were males. The total population of Georgia in 1930 was 2,908,506; 1,473,979 (50.6 percent) were males. In 1940 Georgia, the population totaled 3,183,723, with 1,524,758 males (47.8 percent).[81]

Marriages. The rate of marriages throughout the United States dropped during the early 1930s; the rate per 1,000 in 1930 was 9.2. The years 1931, 1932, and 1933 had rates of 8.6, 7.9, 8.7, respectively; the 7.9 rate was the lowest of the 68-year period from 1920 until 1988. The decade of the 1930s had an average of 9.8 per 1,000.[82]

In 1920, the married population per 1,000 people totaled 12.0; the average for the 1920s — the period of the Jazz Age — was 10.4. The Great Depression rate varied from 10.14 marriages per thousand in 1929 to 7.87 marriages per thousand in 1932.[83] Perhaps the stock market crash was temporarily altering the family unit of the nation and the lives of men, women, and children.

Crime. Crime rates in rural areas have always been below crime rates in urban areas.[84] Not everyone felt safe, however. Prohibition and "hard times" resulted in an increase in crime, particularly in the large urban areas of the United States. In New York City, for example, there were 222 homicides in 1929; in 1930 there were 316. During the first seven months of 1931 alone there were 200 murders. Robberies, looting, drive-by shootings, and other crimes filled the headlines.[85]

To explain this difference in crime between the rural and urban areas, McElvaine describes despair as the dominant mood among the unemployed "little man." He describes those without jobs as being docile; he notes that among the forgotten common people, sullenness — not bitterness — and despair — not violence — were typical. McElvaine sees these victims as blaming the era and becoming dispirited; he notes little violence among them.[86]

A look at the crime statistics for the 1930s for the nation indicates the trend in crimes. In

1933, there were 320,000 persons arrested in the nation; 297,000 were male. The rates continued to increase from 1934 through 1940 with 609,000 arrests; 557,000 of these arrests were male. Unfortunately, the crime rate for the nation continued to rise — even after the end of the Great Depression.

Year	Number of Arrests	Males Arrested
1933	320,000	297,000
1934	344,000	320,000
1935	392,000	365,000
1936	463,000	428,000
1937	520,000	484,000
1938	554,000	517,000
1939	577,000	533,000
1940	609,000	557,000[87]

Difficulties in the prison system of Georgia. One of the charges against Governor Eugene Talmadge and many governors before him was that they bought and sold pardons. To help curb that possibility, a constitutional amendment (1937) set up a Board of Pardons and Paroles in Georgia during Eurith D. Rivers' terms. The Prison and Parole Commission annually would review records of those prisoners seeking pardons and paroles — except in capital cases. During Rivers' 1937–1941 terms, Georgia was also to end its use of sweat boxes, chains, and beatings.

The practice of allowing companies or individuals to pay the fines of prisoners in order for the released prisoners to work for them as servants or peons was a common practice in Georgia in the early 1900s. Without sufficient funds, however, Georgia was not able to enforce the legislated prison reforms or the elimination of the prisoner lease system. This involuntary servitude, a campaign issue in 1906, "persisted, until 1908."[88] Even in 1939 the Georgia Baptist Association charged that in places the lease system was still in effect.[89]

***I Am a Fugitive from the Georgia Chain Gang* by Robert E. Burns and *Georgia Nigger* by John L. Spivak.** A "top-rated Hollywood movie spotlighted the Georgia prison system and helped bring about major social reform throughout the South.... The movie and the book on which it was based, *I Am a Fugitive from the Georgia Chain Gang*, almost single-handedly led to the elimination of chain gangs from the South."[90]

Robert E. Burns wrote the book *I Am a Fugitive from the Georgia Chain Gang* (1932) after being imprisoned for robbing a man of $1.93 — Burns's share of the takings; he received a sentence of six to ten years. Burns served in camps in Fulton County (Bellwood and Sandy Springs) and in Campbell County (now a part of Fulton County). Convicts performed arduous work; they broke rocks into gravel with sledge hammers and spread the gravel on dirt roads. For many years the Georgia prisoners wore chains between their ankles as they worked year-round.

Burns found that a man had to "work out, pay out, die out, or run out."[91] A fellow prisoner broke Burns's chains during the work day and Burns fled. In Chicago, Burns entered the publishing business, married, and achieved social recognition. When he cheated on his wife, she turned him in to the Georgia authorities. Burns negotiated with Georgia prison officials and learned that if he turned himself in, he would receive release after working for 45 days or so in a prison job. He returned to Georgia. Because he lacked the $500 to pay his way out of the situation, however, the authorities sentenced him not to an office job but to hard labor on a chain gang in Troup County: the "worst chain gang in the state."[92]

After his July arrival in Troup County, Burns served 14 months before escaping again in September of 1930; he wrote his experiences — which differed from Troup County's version — as a series for *True Detective Mysteries* in January 1932. Burns stated, "While Georgia may say I escaped from justice, I emphatically state that ... I escaped from injustice." In New Jersey, Burns was rearrested in 1932.[93]

After the release of the Warner Brothers movie *I Am a Fugitive from the Georgia Chain Gang*, Troup County Warden Harold Hardy and others sought damages for the portrayals of their characters in the film. The film portrays them as inhumane in their treatment of convicts. Settlements for $3,000 reportedly resulted.

It was the book and the movie that helped establish the image of sheriffs and prison wardens

in the South as mean, dull-witted, power abusers. The image still abounds in movies, television, and books about the South.[94]

The film *I Am a Fugitive from the Georgia Chain Gang* was a success; Warner Brothers, however, later omitted the word *Georgia* from the movie title. The

> ... theaters could not screen it often enough.... The film was one of the major achievements of 1930s Hollywood.... [It] was named Best Picture of the Year by the National Board of Review of Motion Pictures. [Paul] Muni [the star] and the film received three Oscar nominations. It was remade in 1987 under the title *The Man Who Broke 1,000 Chains* (HBO Films, directed by Daniel Mann). Scenes, themes, and motifs from the 1932 [Mervyn] LeRoy picture also abound in *Cool Hand Luke* (Warner Brothers, 1967, directed by Stuart Rosenberg [and starring Paul Newman]).[95]

In 1937 the new name for the chain gangs became "public work camps." There were 125 county-operated camps in the state. Governor Ellis Arnall appeared with Burns when he appeared before the Pardon and Parole Board (1945). Burns did receive a pardon with Arnall's help. An important reform during Ar-

nall's term was the development of a Board of Corrections and the position of Director of Corrections, who was to help ensure the welfare of the Georgia penal system.[96]

Vincent Burns, Robert's brother and poet laureate for the state of Maryland (1962–1970), wrote *Out of These Chains* (1942) and *The Man Who Broke a Thousand Chains: The Story of Social Reformation of the Prisons of the South* (1968), a memoir of Robert Burns. Some evaluators believe Vincent to be Robert's ghostwriter.[97]

Another book relating to the prison system was published during 1932. Titled *Georgia Nigger* by John L. Spivak, this book, like Burns's volume, presented an argument for prison reform. It was in the 1940s, during Governor Arnall's term, when the beginnings of significant changes in Georgia's prison system appeared. Whipping became illegal. Prisoners wore stripes only for infraction of rules within the prison. The Georgia prison system, then, was beginning to make some changes from punishment and retaliation to a system more focused on reform and rehabilitation.

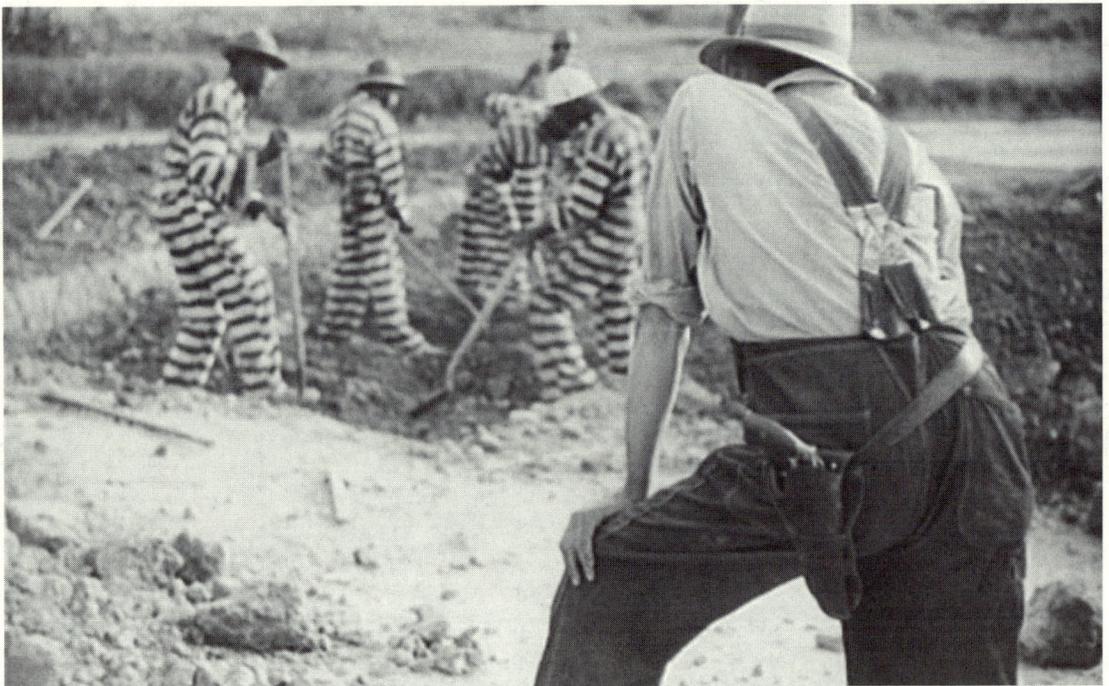

Convicts and guard in Oglethorpe County, Georgia, May 1941. Photograph by Jack Delano, Farm Security Administration.

Employment of men. An often-altered image during the 1930s was that of the man as the chief breadwinner for the family. Some men had to share this role or relinquish it entirely to others in the family. Many textile mills and other industries of the decade chose to hire women instead of men. These employers had found that women and children were often more submissive than men and usually drew lower wages than their male counterparts; such employment practices caused many males to lose their employment.[98]

Another employment practice that resulted in the loss of employment for men was the hiring of children. Child labor undermined the security of some adult males—and some females. In fact, in the South of the 1930s, 148 children out of every thousand (14.8 percent) worked on the farm or in the textile mills.[99]

This practice of hiring children and women in the mills enabled—or required—some men to seek farm labor or other employment while the other family members worked in the factories.[100] The loss of a part of their traditional role was debilitating for some of the men; others took it in stride and helped keep the family unit strong in any way that they could.

Many men, of course, were unemployed. Others continued to labor on the farm, in the sawmills, in the textile mills, or wherever they could find employment.

Below, one can see the drop in the employment percentages of males during these four decades of the twentieth century. At the end of the 1930s, the percentage of employed males had dropped 9.2 percent from the year 1910. Females, on the other hand, had dropped only slightly during the four decades. The next section of this chapter gives more information about females in Georgia during the Great Depression.

Education of males during the Great Depression. In many families during the Great Depression, the boys found it necessary to stop their schooling to help support the family, and these young men dropped out of school. The overall national dropout rate in 1940—at the end of the Great Depression—was 76 percent. Of course the dropout rate at the beginning of the Great Depression (before enforced compulsory attendance laws) was much greater than 76 percent.[102]

In some families the boy with the best "head for schooling" might remain in school. Meanwhile the rest of the family would work in the fields, the factories, the forests, or wherever employment was available. The 1930s for many males—both young and old—was a time to focus on work. There was little time for entertainment, as chapter seven, "Entertainment," attests, but the lean times were primarily a time to make ends meet.

New careers for men. Many men tried alternative ways of making a living during the Great Depression. Occupations became as varied as the imagination and the Georgia land permitted; most of the Georgia men were able to maintain their self-respect as they tried to provide for their families during the Great Depression.

Hubert C. Eberhart was born in Winder, Georgia, in 1923. In the photograph on the next page, he, his mother, Frances Brooks Eberhart, and his sister, Claudia Eberhart (McCurry) pose for the photographer just before the Great Depression began. Claudia and Hubert recalled that their father's work was not highly profitable during the days of the Great Depression in Georgia; their father, Hubert Cochran Eberhart, Sr., sold Buicks and pianos. The children remembered unsold pianos in every room in the house and unsold Buicks on blocks in the back yard.

One Christmas Day during the 1930s the family had one can of Campbell's soup for the four of them to share for their Christmas meal.

Year	Number of Males 14 and Over	Number of Males in the Labor Force	Percent of Males in the Population 14 and Over
1940	1,084,971	889,769	83%
1930	961,270	833,516	86.7%
1920	921,301	810,954	88%
1910	812,234	749,258	92.2%[101]

The Eberharts finally had to relocate; Hubert and Claudia's mother went to work for the Department of Social Services to enhance the family income after the death of the father. To help keep food on the table, young Hubert purchased a bicycle at 50¢ a week and delivered newspapers.

Right out of high school, Hubert joined the CCC and worked for $1.00 a day plus food and shelter. He planted trees and kudzu in the

COURTESY AGNES SELLARS EBERHART AND CLAUDIA EBERHART MCCURRY

Left to right: Hubert C. Eberhart, his mother Frances Brooks Eberhart, and his sister Claudia Eberhart (Mc-Curry) just before the Great Depression. The family lived in Winder, Georgia, at the time of the photograph.

state of Washington. His work helped teach him the responsibility that he needed in the Air Force during World War II.

Agnes Sellars Eberhart — Hubert's wife of more than half a century — also grew up during the Great Depression. Her father, however, worked for the Merita Bread Company. Agnes remembers her father, L.C. ("Bill") Sellars, having no difficulty selling his products — a quite different commodity from pianos and Buicks. Agnes remembered that her father would bring home bread still hot from the ovens and how its fragrance would fill the house. She remarked, "As a child, I did not know that there was a Depression."

Images of men. The federal photographers in their documentation of the nation preserved on film the images of Georgia men at work and during relaxation; their photographs come from all geographic areas. These photographs preserved the diversity of the state for all to see.

III. A Second Segment of the Georgia Population During the Great Depression: The Women

The federal images of Georgia women during the Great Depression are many and ever-changing. Many women of the time were primarily wives and mothers, but the images of the single woman and the working woman are important, too. When times became hard, the Southern woman revealed her true mettle.

Women in the labor force. The number of Georgia women in the labor force remained fairly constant for the decades of 1920, 1930, and 1940.

The Georgia woman was an important part of the labor force. By 1930 one out of every five women — nearly eleven million — worked outside the home.[104] The percentage in Georgia

was higher: almost one out of every three women of employable age was at work. The percentage did not change much from 1920 to 1940.

The roles of women (rural or urban, industrial or agrarian) in the workforce were important to society. Some industries preferred to hire the female; her salary was lower, and she was often more submissive. In those homes where the wife was the sole provider, she often assumed greater family command. Sometimes the result of the working wife and the jobless husband was a greater closeness; other couples, however, became embittered by want, insecurity, and reproaches.[105] Women worked frequently in "female occupations": nursing, secretarial jobs, and teaching, in particular.

Some social reformers encouraged employed women to give up their jobs and stay at home so men could work. These reformers ignored the important fact that many women were the head of their household and had a family to support.[106] The National Federation of Business and Professional Women's Clubs reported that 48 percent of 12,000 female employees surveyed had dependents; more than 17 percent had the sole responsibility for households ranging from two to eight persons. The number of dependents per woman increased between 1930 and 1936 while her average earnings decreased.[107]

Home responsibilities. In addition to any outside employment they might hold, Southern wives and mothers were largely responsible for the housework and the rearing of the children when they arrived home. Women's jobs were not usually complete after a 10-hour shift in a restaurant, factory, or hospital; after the work in the field or office; or after a day of work at a typewriter or cash register.[108]

Informal mutual aid networks and clubs. An important part of Georgia's class structure and social system of the 1930s was the support and mutual aid that women gave

Year	Number of Females 14 and Over	Number of Females in the Labor Force	Percent of Females in the Population 14 and Over
1940	1,147,161	335,915	29.3%
1930	1,006,132	304,795	30.3%
1920	935,635	273,206	29.2%[103]

A fashionably dressed salesgirl in Atlanta, c. May 1939. Photograph by Marion Post Wolcott, Farm Security Administration.

to each other — particularly in difficult times and especially in rural areas. Dr. Melissa Walker recognized this mutual aid in her book *All We Knew Was to Farm*:

> In these crisis years, women's responsibilities did not end with their own families, however. Women were primarily responsible for the complex, reciprocal support that had formed the basis of rural "social services" for generations. In order to cope with the downturn, farm women relied on the same kin, friends, and neighbors as always. They intensified organized efforts to provide community relief. In short, as was the case with urban and suburban women, when economic crisis struck, it was up to farm women to stretch scarce resources so that farm families could survive. Yet even as most of the burden for family and community survival fell on women, men's commercial activities continued to be seen as the highest priority because farm families believed that commercial agriculture was the key to a more secure future on the land.[109]

Rural Southern women maintained the social ties which formed the bedrock of mutual aid networks. Women organized the informal visiting that built ties between neighboring families as well as more formal school and church activities such as Christmas pageants or "dinner-on-the-ground" after Sunday services.... Although maintaining mutual aid networks would later be dismissed as simply socializing, these social ties were crucial to farm families.[110]

Women who had the time and energy formed clubs and bridge groups. The bridge clubs that the federal photographers documented in Georgia usually had restricted memberships. Many women had no time for cards, however.

Home Demonstration Clubs, Extension Classes, and Homemakers Clubs. Some clubs offered instructional programs for women who wanted to preserve food safely, to sew for their families, to socialize with other women, to prepare more nutritious meals for their families, and to practice etiquette. Home Demonstration Agents gathered small groups of rural women to teach them and to allow them to share tips for home food production and for family skills.

By 1935 there were twenty states—including Georgia—with Home Demonstration Clubs. The National Home Demonstration

A home economics and home management class for adults, conducted in May 1939 under the supervision of Miss Evelyn M. Driver (standing in white uniform). Everything they made, including the small handmade looms, utilized materials of local origin including sacks from flour, meal and feed; cane; and cornshucks. Photograph by Marion Post Wolcott, Farm Security Administration.

Council received its charter in 1936. Many of Georgia's Home Demonstration Clubs hastened to join this national organization.[111]

During the lean times the Georgia women especially needed the services of these clubs and classes. Home economics and home management classes—particularly in the resettlement areas—taught everything from weaving and baking to making inexpensive gifts. Many of the programs of the clubs and classes offered suggestions on nutrition, economical dishes, meal preparation, home problems, infant and invalid care, food preservation, and proper table setting. County fairs often featured displays of the clubs for women.

Women's voting and civic organizations. Georgia women had long been involved in groups, such as temperance societies, child labor abolition groups, prison reform leagues, and church organizations. They had not, however, held the right to vote for long. In 1919 Georgia had become the first state to reject the Nineteenth Amendment, which would have given women the right to vote. Later in 1919, however, enough states had ratified the amendment to give American women the right to vote. Georgia's women of voting age exercised their right to vote for the first time in 1920.

Classes and instruction on food preparation, conservation, and preservation. Some Georgia families were able to teach food preparation skills in the home. Mary Louise Hunt (1922–) remembers how her mother, Mary Lou Asbury Hunt (Greene County), taught her to prepare hoe cakes. This pancake-like bread was fried on a hot griddle seasoned with lard (animal fat). Made from cornmeal and

milk with a dash of salt, the thin batter was fried to a crispy texture, not the soft texture of pancakes. Some families used water instead of milk with the cornmeal to make the dish more economical.[112]

The pinch of the Great Depression meant that many already busy wives, mothers, and female workers had to preserve food safely by pickling, preserving, canning, smoking, drying, and curing. Most women baked the bread — often cornbread and biscuits—for the family, and some made their own soap. It was not unusual for a woman to bake and sell molasses, jellies, jams, and other baked goods for additional income. Some communities operated canneries that assisted women who brought their own tins and food and who helped with the canning process.[113]

Pickling was another important way of ensuring food for the winter. Rural women pickled watermelon rinds, cucumbers, beets, onions, okra, and beans. Getty Davis's own recipe for pickled cucumbers required preparation steps for nine days: 5 days the pickles soaked in salt brine and had to be stirred periodically, 2 days in alum with cooking each day, and 2 days in vinegar, sugar and spices with additional heating each day.[114] With many women beginning to work away from the home, however, recipes changed. By the 1940s recipe books began to have titles like *The Quick Dinners for the Woman in a Hurry Cook Book*.[115]

Smokehouses provided a place where the families could store canned food and cured meat — if the family was fortunate enough to have the food to place inside. Families often joined together after the first frost to slaughter a neighbor's hog; the favor would be returned at a later time. The family often packed the hams, shoulder, and side meat in salt and seasonings to preserve or "cure" it; later the family would cover these portions with cloth and hang them in the smoke house. This carefully preserved meat would keep for several months until warm weather arrived. Much of the fat from the pork was *rendered,* or cooked down, for lard. Heated lard was important for frying foods, as a main ingredient in biscuits, and as a seasoning for vegetables.

Some families did not have a smokehouse and stored canned goods under their home or wherever there was available space, such as under a bed or even in the attic. Having a variety of foods in the winter when vegetables from the garden were not available was important to the health of a family. Chapter five, "Health," has more information on the health of people in Georgia.

Ham, fried and steamed until tender, often had as its accompaniment "red eye gravy." The usual method of preparing the side item was to remove the meat from the pan and to add to the drippings some coffee from the pot brewing on the back of the stove. Poured on the grits commonly ground at the local gristmill, red eye gravy was standard fare for a special Georgia breakfast.

Many rural families found, before the advent of electricity to their areas, that the life of cream and butter could be prolonged by using a springhouse, a cement or wooden structure built around a spring. The water where the spring rose from the ground would usually cool the stone or pottery crocks holding the dairy products. Chapter one, "Water, Soil, and Industries Based on Natural Resources," has more information on springs and spring boxes.

Classes and instruction on sewing. Many women, during the depression years, began — or continued — to make clothing for their families. Some tried to make their own clothing — and even hats— if they could afford the material. They attempted to "copy" expensive clothes by using cheaper materials. Some women depended on the help of friends and family. Others had access to classes and clubs for additional instruction.

Longer skirts and more feminine styles began to replace the shorter, more boyish dresses of the 1920s. Slacks, shorts, and beach pajamas began to find acceptance in many communities. Some unemployed, rural, and urban women who were truly experiencing "lean times" sought merely to stay warm and ceased to appear in public because of their worn, tattered clothing. By the mid–1930s, however, skirt lengths began to rise again.[116]

Many women's clubs provided suggestions and patterns for sewing and for making

Mr. and Mrs. Missouri Thomas of Flint River Farms, Georgia, store canned goods and cured meat in their smoke-house, May 1939. Photograph by Marion Post Wolcott, Farm Security Administration.

wardrobe items; not all women, however, had the time and acceptable attire to attend the meetings. Some club leaders shared information with individuals in their homes.

Classes and instruction on crafts, home, and cottage industries. Many women found that they could "let," or rent, rooms to increase the family's income. Some women and their families used their own family homes or purchased large homes for use as an inn or boardinghouse; in this way, they were able to supplement — or establish — a source of income. Pottery, basket making, and weaving were often skills passed down from generation to generation — or even taught in school or classes, in the resettlement areas in particular.

These cottage industries or fireside endeavors helped add income to some families. The items often added some beauty and comfort to the creators' homes and the buyers' homes. Working women sometimes enlisted other family members— the children, the older parents, and grandparents who lived with them — to help with this additional source of income.

The making of quilts and the weaving of rugs in the home were other examples of the creative energies of the Georgia woman. Between the household chores and the care of the young or elderly in their home, many women also worked outside the home and even worked in the fields.

Instruction on etiquette and adult classes. This author was surprised to find that during a time of severe economic hardship women had an interest in etiquette. The women's clubs programs on etiquette were popular even during "hard times." This popularity was evidence of the pride of Georgia women. Many teachers gave classes on etiquette, along with literacy. In Georgia many of the unemployed teachers taught adult education classes. Adult education raised the literacy level of the state and contributed to the income of teachers. Even female teachers began to feel the impact of the Great Depression.

Community service activities were a top priority of many of the clubs for women. Even when the members themselves did not have many monetary resources, they still wanted to

do what they could to help others. These clubs often held suppers and bazaars to raise money; each club member contributed a craft made at home or something baked at home for the bazaar. Many of the suppers were chicken pie suppers; each family contributed an ingredient (eggs, pastry, chicken, potatoes, etc.) for the supper, which had the pie as the main course. The proceeds from the meal often went for a local church project (a piano or stove, for instance), a community beautification project, the polio or cancer campaign, a bookmobile, or whatever was needed for the community, the club, or the women.

Decline of the women's clubs. The needs for these programs presented by the women's clubs diminished with radio and television, with better communication, and with better roads and transportation. When the County Extension Service began to withdraw its work with the clubs, many clubs became inactive. Others re-formed as Homemakers Clubs. The support of women for each other — as evidenced through visits and calls— persisted, however.

African-American women. Segregation and entrenched discrimination circumscribed the lives of rural women. The South's peculiar racial caste system shaped the social lives and responsibilities of Georgians.[117] It was not unusual, however, to see Georgia women — regardless of whether they were African American, white, migrant, immigrant, or Native American — working together in the field, at "hog killings," or in the tobacco barns. In times of death, illness, and family disasters, rural women usually "helped each other out." This womanhood, sisterhood, and motherhood formed a necessary bond in many communities.

Although African-American women had limited access to other than domestic jobs, the strength that many showed in providing for their families was a model for everyone during the "hard times." By the end of the decade of the 1930s, 95 percent of American women ran their homes without the benefit of outside aid or domestic help. This, of course, meant that many African American women lost positions as domestics.[118] Some took washing and

ironing into their own homes, rather than going to another home to perform the labor; working at home was especially convenient if there were young children to care for at home.[119] Migrant women — regardless of color — still had to care for families after — or even during — a day at work.

Domestic workers. Although most families were doing all their own work, some rural and urban families were able to employ outside, inexpensive, domestic help — most often African-American women — to assist with the household work and the care of the children. These African-American domestic workers could use their hands to stir the dough of the family for which they worked; they could lie down with the children at nap time to add security; they could discipline the young people in the family; but they could not use the front door of the house where they worked each day. A social hierarchy with its own peculiar rules and regulations existed in much of the South — and the North, as well.[120] In other parts of the state and in "troubled times," women bound together to help each other regardless of caste, class, religion, ethnicity, or social class; working side by side at the canneries and in the fields was not unusual for these women trying to "make ends meet."[121]

The rural woman. For the rural woman, regardless of color, "the seasonal rhythms of the land and the needs of her family" and others dominated her life.[122]

> The precious, precarious and unpredictable Southern agricultural economy forced women to become experts in doing without, making do, and stretching scarce resources.[123]

When the family earned its livelihood on the farm, the work of the wife was essential. Often she farmed the land alongside her husband, reared the children, prepared meals, sewed and laundered the clothing, cleaned, and maintained the home; her labors helped produce and harvest the crops the family needed to survive. Most farm wives also generated some income selling eggs, milk, butter, and garden produce. Other money-making endeavors included opening stands and novelty stores, raising bees, accommodating boarders or tourists, sewing

for others, taking in laundry, and making and selling quilts, bonnets, and aprons. Only rarely could the rural, agrarian family hire domestic help.[124]

There was a drop of 63 percent in the business of commercial restaurants as families gave up the luxury of "eating out." Despite this drop in dining outside the home, many women were still able to supplement the family income by preparing and serving food to others outside their family. Homes located near a mill or factory seemed ideal for this supplemental income.[125]

Women in the work force. At first the Great Depression did not affect the employment of women workers because employees favored hiring females. As the depression years continued, however, many women, too, lost their jobs; these jobless, now older, women found new employment opportunities difficult to attain.

Women with white collar jobs. Although women occupied many unskilled positions, they worked also in other occupations: secretarial, clerical, teaching, and other "white collar" jobs.

In charge of the welfare work in Franklin (Heard County), Georgia, was a woman, Miss J. Kent. She was still holding the position in 1941 when the federal photographer Jack Delano came to Heard County. An important part of the job of "welfare worker" was to help to identify blind, homeless, crippled, and dependent children who would receive assistance through the Social Security Act of 1935; the Supreme Court had upheld this act on May 24, 1937, and Heard County wanted to have their paperwork in place when assured funds were available. With the welfare workers to help, Miss Kent also identified and certified individuals for "old age pensions."

It is not surprising that it was an unmarried woman who assumed the position in the Welfare Department. The same was true of teaching positions. In 1931 the National Education Association reported that three fourths of all cities were excluding married women from employment.[126] A popular book in the 1930s was *Kitty Foyle* by Christopher Morley; Kitty was a female, white-collar worker, still a

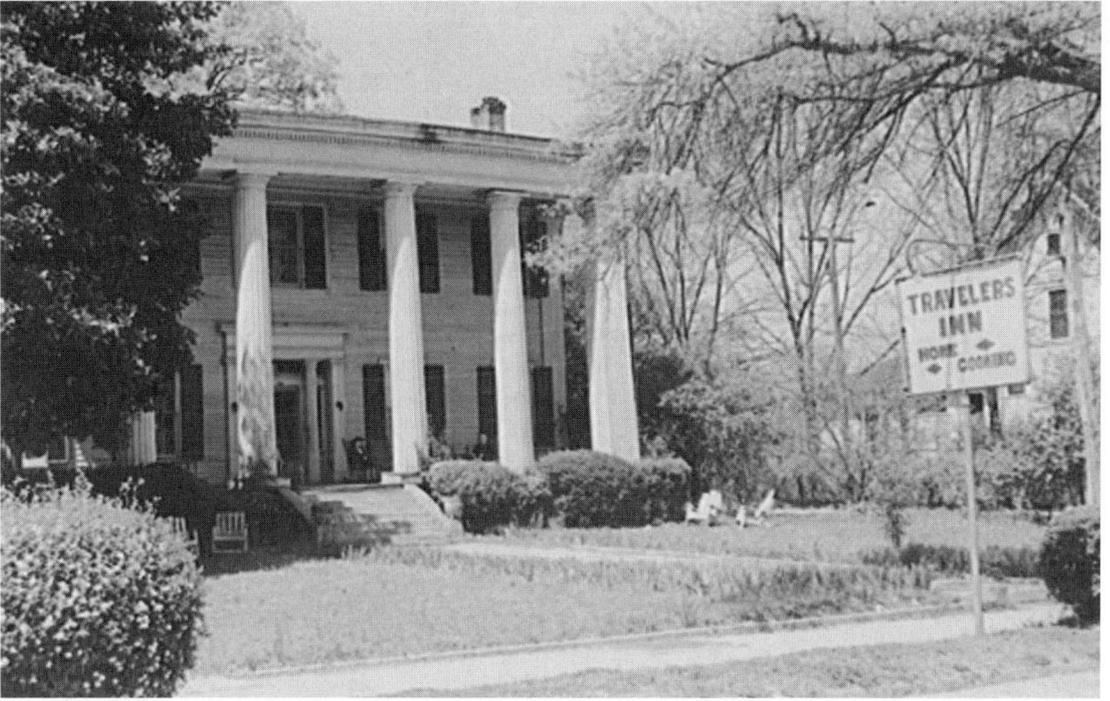

The old Jones home in Madison, Georgia, May 1939, became Travelers Inn. Photograph by Marion Post Wolcott, Farm Security Administration.

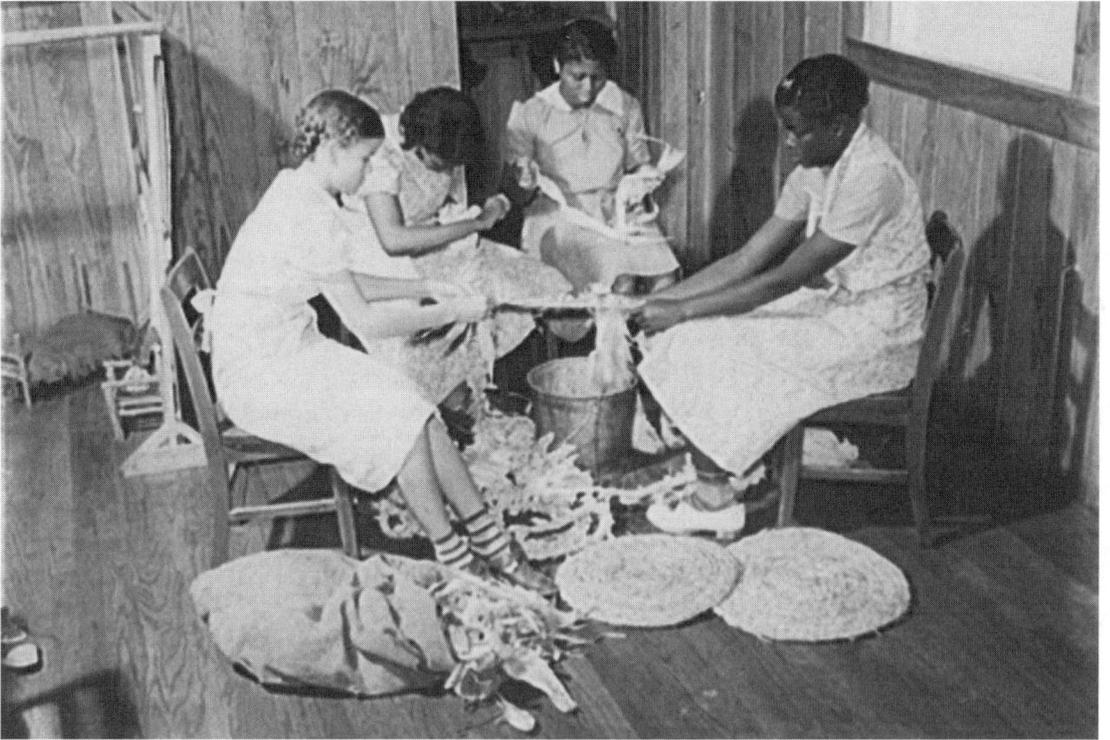

Eighth-grade students Zollie M. Brocks, Susie Vinson, Lucenda Harvard, and Pearlie M. Leurs from Flint River Farms, Georgia, making mats of corn husks, May 1939. Photograph by Marion Post Wolcott, Farm Security Administration.

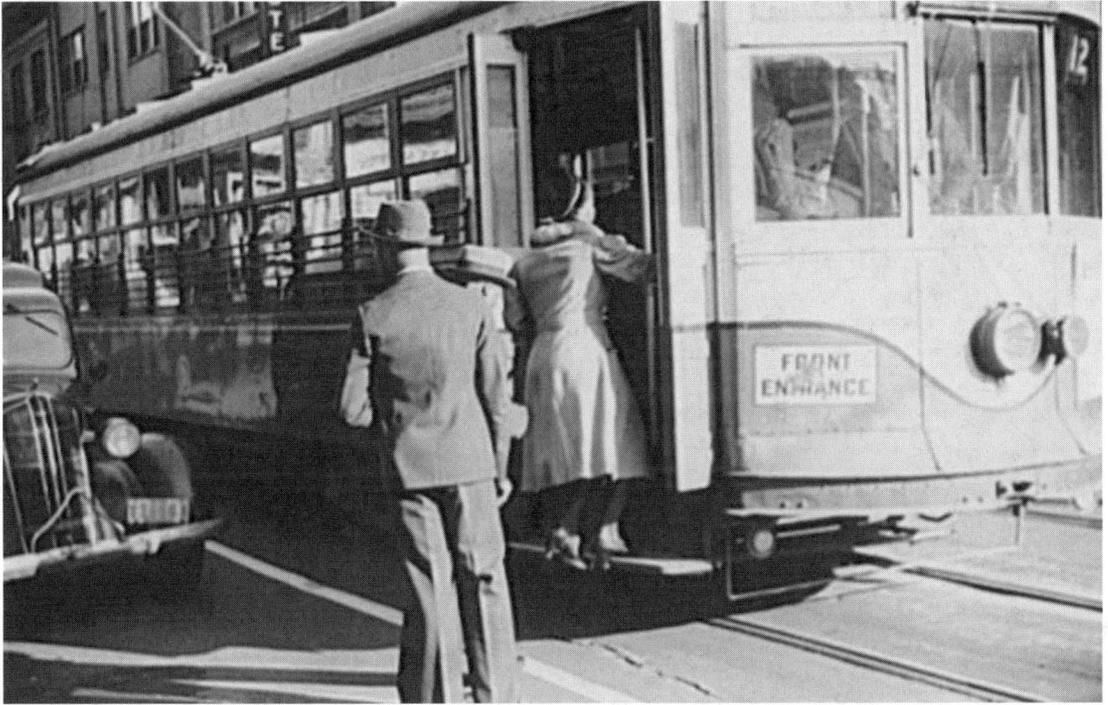

Domestic help boarding a streetcar in Atlanta, c. May 1939. Photograph by Marion Post Wolcott, Farm Security Administration.

Migratory worker from Georgia washing clothes in Belcross, North Carolina, July 1940. Thirty-five people were staying in this house. Photograph by Jack Delano, Farm Security Administration.

Miss J. Kent, in charge of welfare work in Heard County, Franklin, Georgia, April 1941. Photograph by Jack Delano, Farm Security Administration.

novelty at the time. The movie based on the book starred Ginger Rogers, who won the Academy Award in 1940 for her performance as Kitty.

Gender identities. Many of the programs of the government reinforced gender identities. In 1932 the federal government ruled that public service could employ only one spouse per household; the woman was invariably the one who stepped down because of the higher wages paid to men and because of the tradition of the male breadwinner. New Deal legislation enforced wage differentials between men and women and regulated both wages and maximum hours.[127]

Images of women. Fisher noted the images of women captured in the photographs of the Farm Security Administration (FSA). No longer were many women dependent on others. At times their families depended on them during the hard times of the 1930s. In many cases the Great Depression altered the traditional roles of the male and the female.

At times the women in the photographic and written records appear particularly strong, as in the Georgia fields or at the looms in the mills. At other times the women appear tender and feminine, as when they hold their children; these images create a "widely felt nostalgia for a mythic American past...." The photographs of the FSA captured these dual images of women during the decade of the 1930s.[128]

Roy Stryker with the FSA never specifically asked his photographers to emphasize in their photography women and their roles; yet many photographs of women appear. Some photographs show them in poses traditionally assumed by men and in jobs and places heretofore frequented primarily by men. Other photographs show women as teachers and rural mothers, the "universal touchstone."[129] The

Georgia women, then, varied greatly from region to region and from time to time during the decade. They assumed many roles—some simultaneously.

The important photographs of women in their settings—the Appalachian Plateaus; the Ridge and Valley region; the Blue Ridge region; the Piedmont region; and the Coastal Plain—capture the diversity of this important group and depict the oppression, the depression, the dignity, the hope, and the strength that were theirs.

IV. A Third Segment of the Georgia Population During the Great Depression: The Children

The Great Depression signaled the end of childhood for many young people. Others entered the 1930s already bearing a first-hand knowledge of hunger, harshness, poor health, hard labor, and need. Many Georgia children—especially those near textile mills and on the farm—ceased attending school at an early age.

Child labor in Georgia in the 1910s. Working children constituted a grave problem in Georgia and the nation during the 1910s—and later. Children—some younger than ten-years-old—worked for twelve hours each day; their salary for these labors was often as little as 50 cents. These children went to work in the dark and left for home in the dark, as these photographs by Lewis Wickes Hine attest.

To determine if there was a problem and, if so, its extent, the National Child Labor Committee (NCLC) was established in 1904. The NCLC had the mission of "promoting the rights, awareness, dignity, well-being and education of children and youth as they relate to work and working."[130] In 1908 the committee hired Lewis Wickes Hine—first on a temporary basis and later as a permanent employee.

Lewis Wickes Hine. Lewis Hine was one of several NCLC investigators. Hine prepared 30 reports on labor conditions of children; he also examined the impact of this work on the lives of these young laborers. To document his work, Hine included photographs with de-tailed captions. He called his work "detective work." Many of Hine's images came from the state of Georgia. His pictures became a part of many exhibits, reports, folders, magazines, newspaper articles, and lantern slides both of the time and of the present day. His work and the photographs and papers of the NCLC are now a part of the Library of Congress and are in the public domain.

Hine found children who were nine-years-old—and younger—working in the factories and on the farms. He found children younger than nine who were serving as "Dinner-Toters." Each child brought as many as ten lunches to factory workers in the mill for which the children received pay by the week. While the workers ate, the children often tended the machines that continued to run at noon; in this way the children learned the work that they would most likely be doing soon. Hine's photo of the little Georgia Cotton Mill spinner is perhaps one of the best-known photos of child workers from the period.

Hine was one of the first photographers to evoke an emotional response in his viewers. It was after Lewis Wickes Hine's photos that Roy Stryker modeled some of his work. Kaplan described how Hine managed to conduct his assignment despite the suspicions of the supervisors, the business and farm owners, and even the workers themselves:

> Nattily dressed in a suit, tie, and hat, Hine the gentleman actor and mimic assumed a variety of personas—including Bible salesman, postcard salesman, and industrial photographer making a record of factory machinery—to gain entrance to the workplace. When unable to deflect his confrontations with managements, he simply waited outside the canneries, mines, factories, farms, and sweatshops with his fifty pounds of photographic equipment and photographed children as they entered and exited the workplace.[131]

Child labor in the South and Georgia in the 1920s. Even though the General Assembly passed a child labor law in 1914, the law was so weak and so poorly enforced that in 1920 Georgia led the nation in the employment of children between the ages of ten and fifteen. The compulsory school attendance law of 1916 required students who were eight- to fourteen-years-old to attend school for only twelve

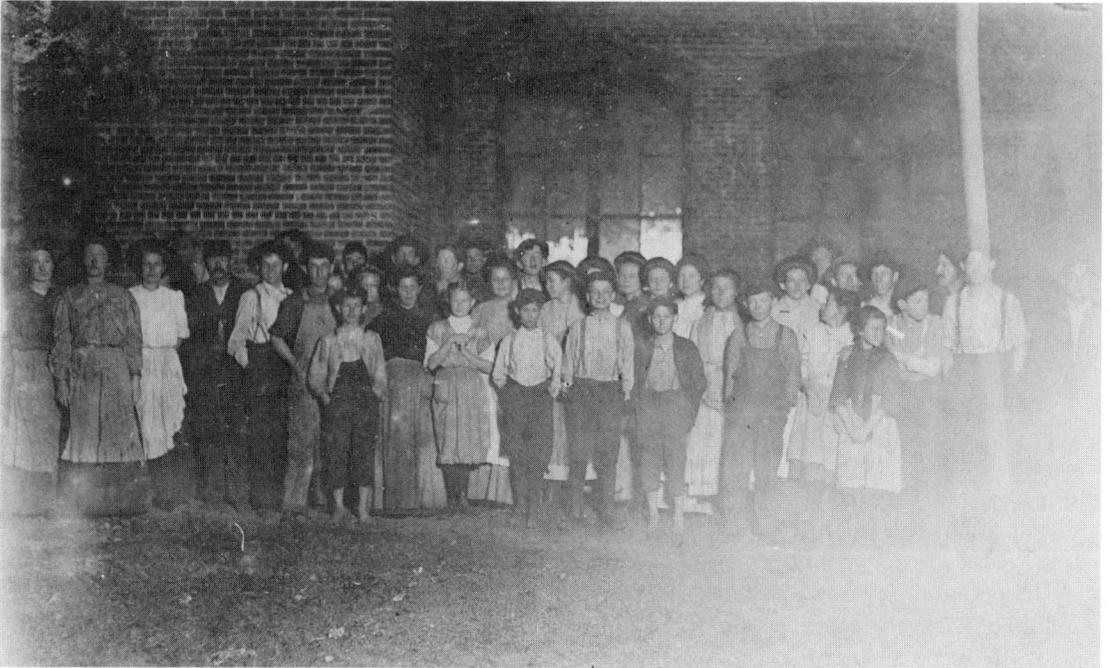

A flashlight photograph at 5:30 A.M. shows part of the labor force (200 in all) going to work in Strickland Mill, Valdosta, Georgia, on the cold, foggy morning of January 23, 1909. A number of children even smaller than these did not get into the photograph. Photograph by Lewis Wickes Hine, National Child Labor Committee.

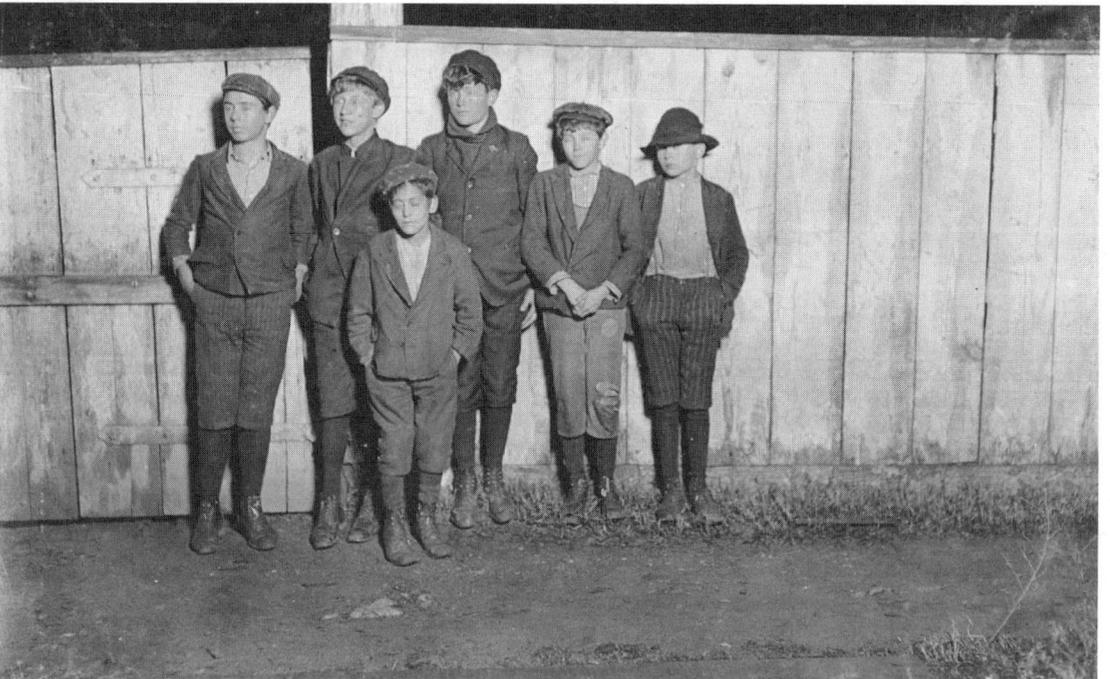

A flashlight photograph at 6:00 P.M. shows boys going home from King Manufacturing Company in Augusta, Georgia, in January 1909. Two of the smallest boys had been working in the mill for two years, and one of the larger for four years. Photograph by Lewis Wickes Hine, National Child Labor Committee.

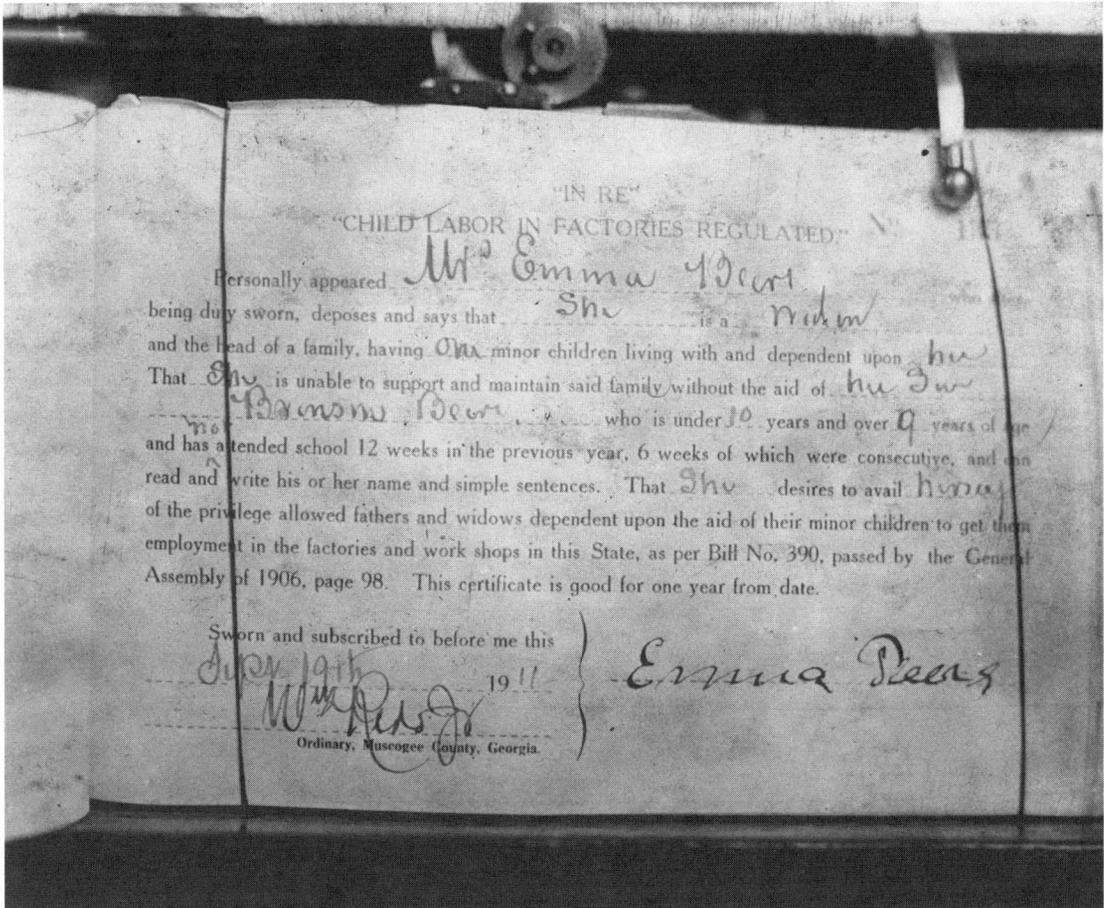

The original caption for this photograph, taken in April 1913, reads: "Photo of Ordinary's Certificate for Bronson Beers, 9 years old (and therefore illegal). The Deputy Clerk told me, 'That was likely a clerical error.' but I found five of these 'errors' issued to children under 10 years old, one for child aged 8. (The latter was later marked 'Void' but none of the rest were.) Rolly's teacher told me the family had moved, but that the boy was a mere baby with a lisp. The issuing of the certificates is very unbusinesslike. (See Vaughn's report, Georgia, 1913.) The Ordinary said, 'I'm a practical Man! The cotton mill people are the poorest paid workers in the country. They have to put their children into the mills.'" Photograph by Lewis Wickes Hine, National Child Labor Committee.

weeks per year. This weak law allowed exemptions by the school board as it saw fit and exemptions were frequent.[132] In 1930, 23 percent of the girls between the ages of fourteen and nineteen in the nation were working. For boys within this age group, 40 percent held jobs.[133]

Both the state and the federal government began work to improve the plight of children. Many Southern entrepreneurs continued to be interested in hiring children, not adults, who commanded higher wages. By 1938 child labor was still a problem in Georgia and the South. The National Emergency Council commented on this problem. The NEC reported that out of every 1,000 children in the South, 148 worked in factories or on the farm; this was 14.8 percent. For the nation as a whole in the same year, the rate was 47 out of 1,000, or 4.7 percent.[134]

Child labor affected the child and at the same time undermined the security of the adult male, the adult female, and families. This practice of selectively hiring children and women in the mills enabled — or required — some men to continue with their farm labor or to seek other employment while the other

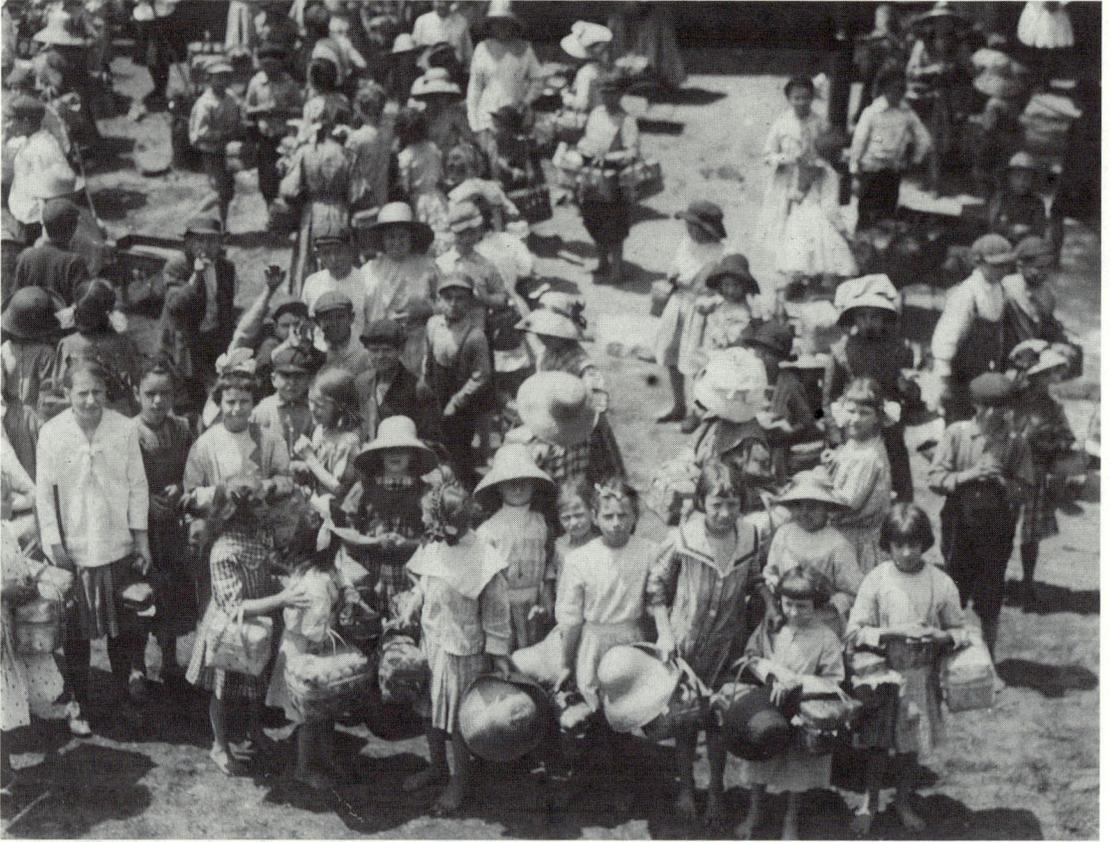

The original caption for this photograph, taken in April 1913, reads: "'Dinner-Toters' waiting for the gate to open. This is carried on more in Columbus than in any other city I know, and by smaller children. (See photos.) Many of them are paid by the week for doing it, and carry, sometimes ren [i.e., ten] or more a day. They go around in th[e] mill, often help tend to machines, which often run at noon, and so learn the work. A teacher told me the mothers expect the children to learn this way, long before they are of proper age. (See also Vaughn's Georgia Report, April, 1913.) Eagle and Ph[o]enix Mill." Photograph by Lewis Wickes Hine, National Child Labor Committee.

family members worked in the factories.[135] Inadequate enforcement of labor laws for children was typical of most of the states at that time.[136]

At the beginning of the decade of the 1930s, jobs for children increased dramatically while jobs for adults decreased. Factories, farms, and small businesses began to look for laborers who would work for low wages and for long hours without complaint; children — and some women — met both qualifications.[137]

By 1933 in Georgia, only 94 percent of the white school-age population actually enrolled in Georgia schools. Only 84 percent of the African Americans of school age had enrolled in schools. Attendance was deplorable. Lam-

entable also were the average daily attendance figures: 76 percent for whites and 74 percent for African Americans.[138]

Wormser estimated that by 1935 there were still over two million children (about 20 percent) laboring in the work force across the United States.[139] By 1940 the 1930 percentages (23 percent for girls and 40 percent for boys) had dropped to 19 percent for girls and 35 percent for boys. The legal restraints against child labor and the better-enforced compulsory school attendance laws had lessened the employment of children.[140]

Child labor on the farms. Dirt farmers sought cheap wage labor also. Because most laws neglected child labor in agriculture, many

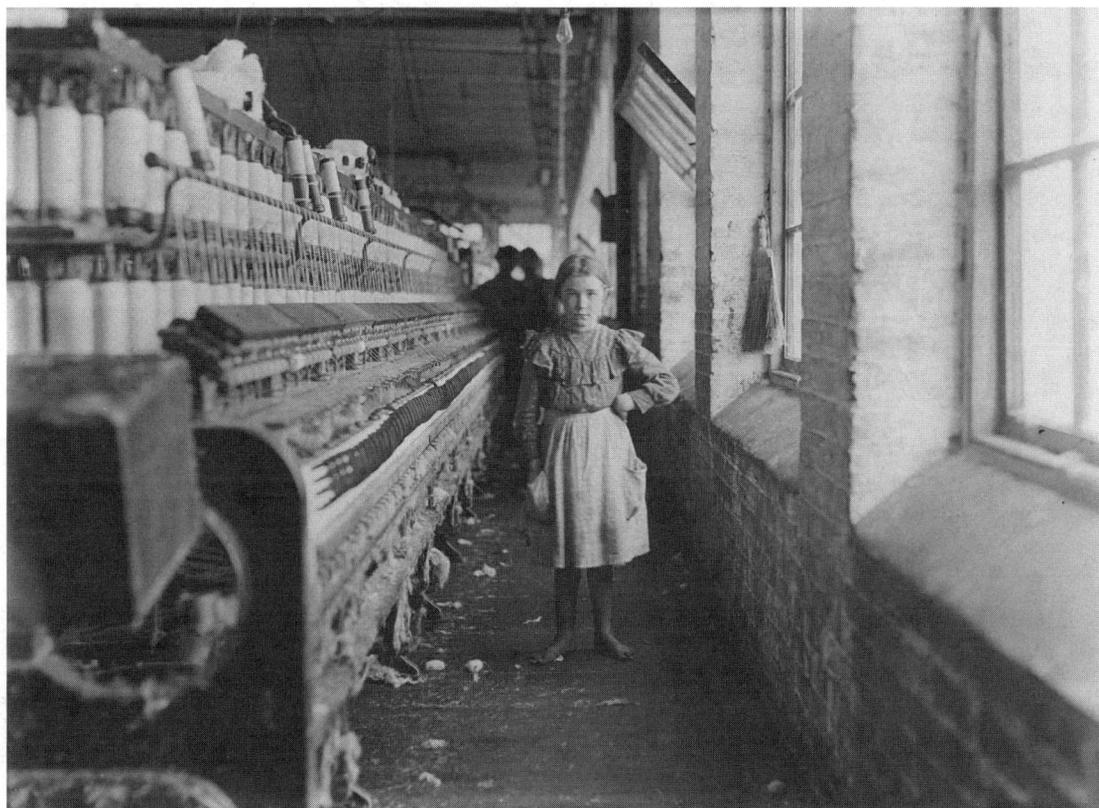

A little spinner in a Georgia cotton mill, January 1909. Photograph by Lewis Wickes Hine, National Child Labor Committee.

landowners leaped at the chance to hire the youth in the area. Estimates are that half a million children between the ages of ten and fifteen worked in the fields. Some children began their toil even earlier.[141]

Two of the field jobs that were most demeaning and brutal for the young were hoeing and picking cotton. Tenant farmers— particularly in the South — needed the work of their children to help them produce the crops and pay their debts. If the landlord noted that one of the tenant farmer's children was not working well, the whole family might have to leave the land — and their shelter. Yet the landlords seldom paid the child laborers; most dropped out of school or attended school around the schedule of the crops. The working day for these young field laborers was from "can see to can't see."[142]

Tobacco farming engaged many child laborers. A broken tobacco leaf could mean the job of a child — and the loss of work and a home for the rest of the family.[143] The work became even more tedious as the stinging tobacco worms called "packsaddles" inflicted their venom on tender young skins and as the temperature climbed to over 100 degrees in some Georgia fields.

The National Youth Administration (NYA). Executive order on June 26, 1935, created the National Youth Administration (NYA) as a part of the Works Progress Administration. In 1939 it fell under the jurisdiction of the Federal Security Agency until its dissolution in 1943. The intent of the program was to help the American youth who were enduring special hardship. The program provided useful work for some of the 2.8 million young people who were on relief in 1935. The NYA was a program with two main goals: to help youths in school (elementary school to graduate school) by providing work programs and

The caption on the back of this postcard reads: "After removing plants from the 'plant bed' they are transplanted in the tobacco field with this hand-operated device, which automatically feeds the proper amount of water for the plants. Greeting from Santa Claus, Georgia."

to help the needy, unemployed youths who were no longer in school.[144]

> To many people, a major achievement of the ... New Deal programs in Georgia was the work of the NYA. Pushed and guided by the first lady, Eleanor Roosevelt, the NYA worked across racial lines to encourage the state's young women and African American teenagers of both sexes to pursue an education.... By the end of 1935 Georgia's NYA had provided work for more than 2,000 students, both black and white, at fifty colleges and universities around the state. In fact, Georgia was second only to Texas, where Lyndon B. Johnson directed the NYA program, in the amount of aid its students received.[145]

About two million students in the nation received an average of $6.00 per month.[146] Mary McLeod Bethune headed the NYA's "negro division."[147]

Letters from and about children written to President Franklin Delano Roosevelt and Eleanor Roosevelt. When President Franklin Delano Roosevelt broadcast his "Fireside Chats," he encouraged the public to write to him.[148] The needy, the poor, and the op-

pressed — regardless of age — often wrote directly to President Roosevelt, and he personally signed most of the replies either because of his concern or to quiet the discontent.[149]

More than 15 million letters to President Roosevelt and his First Lady remain. McElvaine considers these letters to President Franklin Roosevelt and Eleanor Roosevelt to be one of the few and best means available to obtain immediate testimony on the Great Depression. Remembrances can fade. Interviewers of the period too often used their subject's memory and their own interpretation — not verbatim accounts — when they record the conversations. Census figures and statistics are very important, but these actual letters give the testimony one needs for accuracy.[150]

Some of the letters were from children; some were from adults on behalf of children. Some children asked for things for their parents. Some parents asked for help for their children. One such letter came from Rossville, Georgia; the mother is asking for help for her child. She confides that

This photograph is from a miscellaneous lot of photographs for the National Youth Administration (NYA), Works Progress Administration (WPA), and Civilian Conservation Corps (CCC) and was probably taken in Georgia between 1935 and 1945. Photograph by Barbara Wright, Farm Security Administration.

Mary McLeod Bethune, director of Negro Affairs for the National Youth Administration (NYA), photographed between 1935 and 1945. Photograph by Barbara Wright, Farm Security Administration.

... I Cant take my Child to Church on aCCount of having no ClothS. Well Mr. President if you Lend me a helping hand I will be over Joyed and if there Can be Some things I Can do to get Votes for you I will do that well if you think my Child and I are deServeing and help me out of this rut I am in I will never forget. I know the Lord will repay you for any thing you Can do will Cause me to gain a home it is So EmbarreSing to Sign my full name I will Just give my initials....[151]

The Federal Emergency Relief Administration (FERA). The Federal Emergency Relief Administration (FERA), begun in May of 1933, was a program of both work and direct relief. Certain aspects of FERA directly affected children. For instance, the program hired unemployed nurses to tend small children (work relief) and began a free lunch program (direct relief).[152]

The Social Security Act of 1935. The Social Security Act of 1935 made funds ($24,750,000) available for dependent children in need of aid, for maternal and child health ($3,800,000), for homeless and neglected children ($1,500,000), and for crippled children (2,850,000).[153] On May 24, 1937, the Supreme Court upheld the act.[154]

In 1937, under Governor Eurith D. Rivers, Georgians were at last able to participate in Social Security. The state and counties now had authorization to levy taxes and to provide the matching funds required to receive federal public assistance for the blind, the aged, the disabled, and dependent children. Governor Rivers signed the 1937 Welfare Reorganization Act (Georgia's "Little New Deal") and established the State Department of Public Welfare. The federal government was to pay 50 percent, the counties 10 percent, and the state 40 percent to finance the cost of old age pensions and to aid the blind.

The proportions for dependent children in Georgia included 10 percent from the counties, 33⅓ percent from the federal government, and the remainder from the federal government. The new law required the institution of a welfare department in each of the 159 counties; this would help Georgia to meet the requirements of the federal government, which required a uniform administrative structure and uniform criteria for eligibility.

In its first year, the Georgia State Department of Public Welfare assumed all operations of the state institutions for the care of children, the aged, and physically and mentally disabled persons. The department provided in its first year services to 96,638 families; this was 14 percent of the 652,793 families recorded on the 1939 census.[155] Although some viewed the aid contemptuously as "handouts," many Georgians availed themselves of entitlements for themselves and their families. Some even hung Roosevelt's picture on their walls alongside the photographs of family and friends.

The Federal Wages and Hours Act of 1938. The Federal Wages and Hours Act of 1938 governed businesses that produced goods for interstate commerce. This Wages and Hours Act, the Fair Labor Standards Act with its federal child labor law (1938), and state rules and regulations helped many workers— particularly children. By 1939 some states were able to brag that "a child under 16 can't even take a sight-seeing tour through a cotton mill."[156]

Child labor and the mill villages. The consolidation and sale of many of the textile villages, the demise of family labor in the mills, the strictly regulated salaries and hours, and particularly the abolition of child labor convinced many mill owners that they should use their profits for the wages of their employees rather than for subsidizing mill village housing. Federal and state child labor laws, then, helped ring the death knell for subsidized mill housing for textile workers; many Southern states followed the trend of abolishing such villages.[157]

Values learned during the Great Depression. All children were not subject to hard labor, desperation, and exploitation during the 1930s. Some did not experience the dire need that other Georgians took for granted; these children profess not to have known "hard times." This was evidence, indeed, that Georgia did have a multi-class system.

Many adults today who were children of the Great Depression view themselves, their families, and their communities as better for their experiences. These products of the 1930s were proud that they were able to contribute to

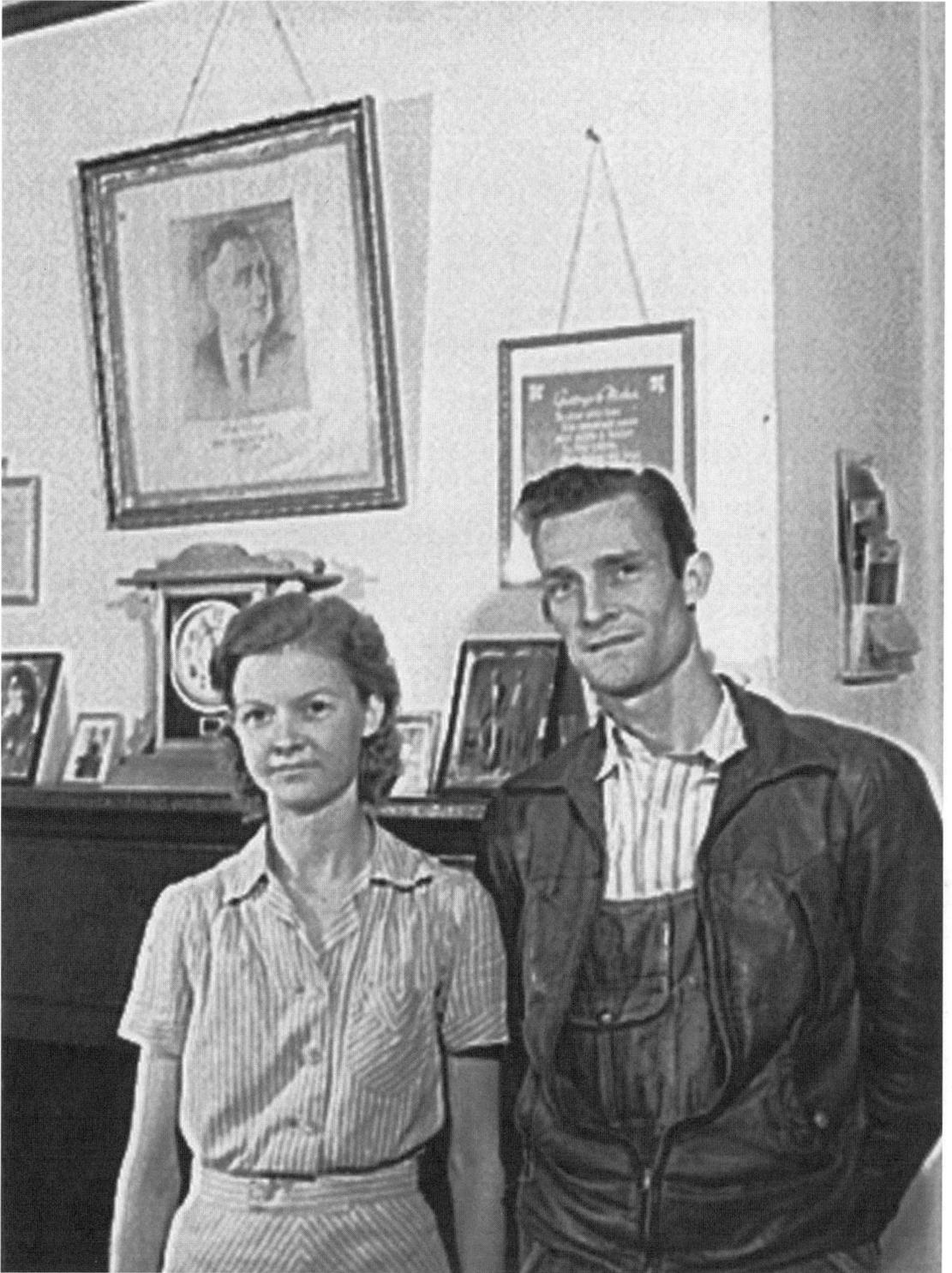

Two mill workers, Mr. and Mrs. Malcomb Mayfield from Greensboro, Greene County, Georgia, stand in the living room with a picture of FDR on the wall, November 1941. Malcomb was a young textile worker at the Mary Leila Cotton Mill. Photograph by Jack Delano, Farm Security Administration.

the family unit or provide some things for themselves; these children gained spiritually what they lacked materially. The Great Depression brought many families closer; families working together sometimes softened the harsh effects of hard times.[158]

The community feeling in some areas helped the young and the old to overcome need and to practice responsibility. This cohesion resulted in a sharing that lessened the oppression and built a trust that permitted many families in certain areas to sleep with open windows and unlocked doors in the summer.[159]

Dr. H.G. Jones, a product of the Great Depression and professor emeritus at the Uni-

versity of North Carolina, stated emphatically that the period taught him the difference between needs and wants.[160] Many saw the Great Depression era as a time to learn the value of family, community, and cooperation. Self-reliance and responsibility were traits that most families encouraged and that many children of the period learned well.

C.A. ("Pete") Hunt (1926–2005) took a job delivering the *Augusta Chronicle* daily in his hometown of Thomson, Georgia; on weekends he delivered *The Saturday Evening Post.* These jobs were not essential to the family income; instead the employment enabled him to supply for himself some of his own personal needs and wants and to learn self-reliance that

COURTESY MARY LOUISE HUNT

C. A. ("Pete") Hunt delivered the Augusta Chronicle *and* The Saturday Evening Post *in his hometown of Thomson, Georgia. Pete's bicycle had whitewall balloon tires, a siren, rearview mirror, bell, horn, headlight, saddle bags, a basket for papers, and a tank on the cross bar for storage and a battery. The bike was a wholesale-distributor version of a well-known brand name; it had an after market rear carrier and chain guard.*

A small child feeds the chickens in Irwinville Farms, Georgia, May 1938. Photograph by John Vachon, Farm Security Administration.

he would need later. Pete's payment was not through a typical salary. Instead, Pete received a catalog of premiums that he could earn in addition to his small monetary income. Pete selected from such rewards as flashlights, knives, canteens, and other attractive incentives.

In the late 1930s bikes began to use whitewall balloon tires. Pete's bike — the fanciest in town — had these tires, a siren, rear mirror, bell, saddlebags, and a basket for papers. On the cross bar was a "tank" for storage and for the battery that operated the headlight and the horn.[161] Pete's bicycle was a wholesale-distributor version of a brand name bike. It differed from the standard brand name because it had an aftermarket rear carrier, chain guard, and numerous accessories. The head badge did not carry the standard brand name on it; this was a typical marketing pattern for bicycles during that period.[162]

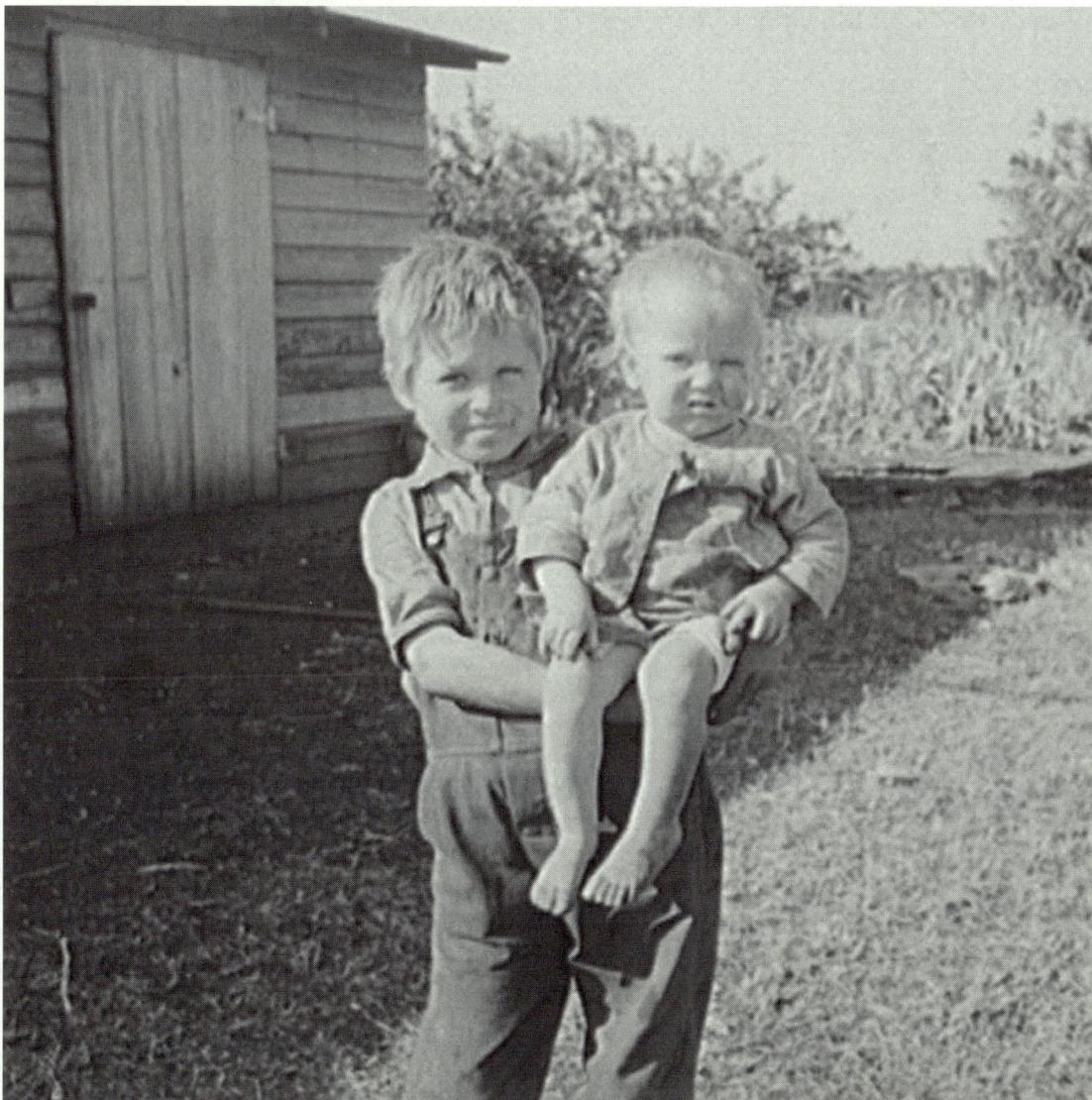

Near Belle Glad, Florida, in April 1939, a ten-year-old son of migrant packinghouse workers from Georgia holds one of his five siblings. His mother was thirty-two years old and had had eleven children (two sets of twins) but only six were living. She lost her job in the packinghouse because they cut down on help after a "freeze-out." Photograph by Marion Post Wolcott, Farm Security Administration.

Chores. Even for children who did not have to labor in the fields or in the factory, chores were typical assignments for even the very young. Feeding a farm animal or taking care of a younger sibling was not an unusual daily task. The children of this era typically expected no allowance or pay for their work.

Diverse lifestyles of children in Georgia during the Great Depression. Many of the children of the Great Depression suffered the worst that the decade could give and yet they still survived. Often they faced their futures with bravery and hope. Some considered these hardships a way to learn perseverance and faith.[163]

Children were instrumental in making Georgia the "Empire State," which produced textiles and tobacco products. The children often began a life of picking cotton, harvesting tobacco, or working in a factory at an early age. Because many of them did not have the money for the shoes that they needed, they put cardboard inside the bottoms of their shoes to cover the holes in the soles. Clothing made from flour sacks or handed down was typical.[164]

Some young people left home to ease the burden for their families. It was a time when some families had to separate, often never to reunite. Some children became ill and even died. All children of the 1930s were affected in some way by the time.[165] Yet many of these children typically maintained their dignity and their belief in themselves. Only a few years later the children of the Great Depression would answer with pride the call of their nation to rally and to fight a world war.[166]

Most found time for some recreation. Chapter seven, "Entertainment," includes ways of entertainment among the Georgia population, men, women, and children.

"The Greatest Generation." Tom Brokaw regards the "men and women [who] came of age in the Great Depression, when economic despair hovered over the land like a plague," as "The Greatest Generation."[167] Brokaw notes how the youth of the 1930s

> ... had watched their parents lose their businesses, their farms, their jobs, their hopes. They had learned to accept a future that played out one day at a time. Then just as there was a glimmer of economic recovery, war exploded across Europe and Asia.... This generation was summoned to the parade ground and told to train for war.... They answered the call to help save the world.... They faced great odds and a late start, but they did not protest. At a time in their lives when their days and nights should have been filled with innocent adventure, love and the lessons of the workaday world, they were fighting.... Without their efforts and sacrifices our world would be a far different place today.[168]

The faces of Georgia's people — its men, women and children — as they worked and as they played are an important part of the portrait of the Great Depression in the "Peach State." Their images tell their own story.

Education

Georgia legislation has long affected its schools. These rules and laws helped determine what the state was able to accomplish with its institutions of education.

I. Elementary and Secondary Education in Georgia: Legislation and Funding before the 1930s

The state constitution of 1777 provided that each county should found schools at state expense, but little was done toward this end until after the end of the war. After Governor Lyman Hall recommended in 1783 that the assembly encourage education, the governing group created three boards of commissioners; these officials were to "layout county seats, sell lots, build academies, and oversee their operation."[1]

The assembly chartered the University of Georgia in 1785; it became the first state institution in America. The governing board had the power to oversee all publicly supported schools in the state. Little happened until 1801, when classes began in Athens, Georgia, in some temporary buildings there. The university received no state monies except some grants for buildings, some public lands, or some other estates. There was no plan for continuing state support. The selling of the landed endowment in 1815, however, provided annual

interest of $8,000, the first regular income to the university.[2]

The same year (1785) as the chartering of the University, Richmond Academy — the oldest school in the state — opened. Georgia had forty academies by 1820. These private schools generally had a classical curriculum, but some included practical subjects; they tried also to become college preparatory institutions and to grant terminal degrees to those ending their education upon graduation.[3]

There were no free schools in Georgia until after 1800; before this time the schools were private establishments. The Georgia Legislature established in 1817 a free school fund of $250,000, the income from which should have established free schools.[4]

A new constitution in 1877 specified the use of state funds for elementary schools, for the state university, and for one college "for education of persons of color." Without the legislation to provide the necessary funds, Georgia had only a few high schools. The early constitution did not make for a strong university; the lawmakers had provided only that they might "from time to time, make such donations thereto as the condition of the treasury will authorize."[5]

The writers of the 1877 constitution were watchful of state funds when they limited the type of educational institutions to which state funds could contribute. These early lawmakers had some doubts as to whether it was even the responsibility of the state to educate its

citizenry — especially if there were local private schools to meet the need. The authors of the constitution saw the private schools as the bridge between the elementary schools and the institutions of higher education. The writers made no provisions for high schools.[6]

Georgia had authorization to use some funds from the poll tax, from a tax on expositions and exhibitions, from liquor taxes, and from dog taxes to obtain funds for its elementary schools. The state would find that additional money was necessary. For its schools, Georgia used half the rental on the Western and Atlantic Railroad, certain stock dividends from the state-owned Georgia Railroad, and wages that prison inmates earned. By 1893 this amount was $1,000,000.[7]

An 1889 law allowed the county school boards to establish the number of school districts that the boards considered necessary. The result of this legislation was the establishment of many small districts, each of which worked for its own interests. By 1890 the state had a system of common schools, which incorporated grades one through seven. The annual school term was five months long at this time.

In 1910 white teachers made an average of $44.29 per month; African American teachers received only $23.23 per month. Only 20 percent of the African American teachers in Georgia had received any pedagogical training; 80 percent of the white teachers, however, had received some formal instruction.[8]

The Georgia country schools of the time were poor and shabby. Lewis Wickes Hine noticed Georgia's poor schools and recorded their images when he photographed for the National Child Labor Committee. He noted the condition of several schools, including one near Valdosta.

The growing recognition of the need for high schools. After 1900 the wealthier school districts had begun improving their schools. Many of these wealthier districts had even established high schools. By 1911 Georgia had organized the Division of Negro Education; this agency helped to ensure cooperation between private philanthropic foundations and public officials. Many foundations were looking at

the possibility of encouraging an increase in high schools — especially for African Americans — and ways to accomplish this goal.

The establishment of agricultural and mechanical arts schools (A and M schools) in each of eleven congressional districts (1906) was significant. These high schools differed from the traditional high schools by offering — instead of foreign languages — both agricultural and mechanical training. The A and M schools were somewhat of a disappointment, however, because they suffered from insufficient funding. After 1911 Georgia began developing more high schools.[9] By 1912 high schools were a part of the Georgia school systems, but in 1914 there was only one four-year, public high school for African American students in the whole state of Georgia.[10]

A spur to the continued development of the high schools came in 1918 when the state public schools became eligible for federal funding of their agricultural programs. There seemed no pressing need anymore for the A and M high schools when additional aid seemed forthcoming.

In most of the "black belt counties" white children had better schools than the large population of African American children. The local school administrators, it seemed, designated most of the state funds for white pupils.[11]

Most rural children — regardless of color — fared poorly. Many walked miles to attend their schools, which were often one-room. The school term in rural areas was divided into two separate time segments. Students began school in the middle of July when the crops had been "laid by," or hoed and plowed for the last time before harvest. For 6 to 8 weeks in the hot summer the schools were open to the students. School closed in the late fall to allow the students to help pick the cotton and garner the other crops. When the students had finished with their farm work, the schools would reopen; the students who were fortunate enough to be able to attend spent the winter months in the schools.

In 1911 the state expanded the responsibilities of the State Department of Education. The department now was in charge of governing policies for the public schools, for the curriculum, for the textbook selection, and for the

certification of the teachers. Over the next years, both the quality of teacher-training programs and the number of persons training to be teachers increased.[12]

II. Higher Education in Georgia: Legislation and Funding before the 1930s

Many Georgians realized the need for higher education. Teachers needed additional training. Women needed opportunities for education at state institutions. Technical instruction was necessary for more people within the state population. The constitution of 1877 specified that the state university must provide these activities. Localism, conservatism, and political favor-exchanging had prevented the university from progressing as much as it could. The state established new institutions across Georgia; lawmakers called these institutions "branches."

Georgia School of Technology. The first institution designated as a branch was the Georgia School of Technology, located in Atlanta. Although there was an 1885 charter, it was three years later before the institution — which cost $100,000 — opened. Women soon gained admission, and the legislature declared (1889) that women could attend all branches of the university.[13]

Georgia Normal and Industrial College. A college for women was set up in Milledgeville, the old capital of Georgia. The legislature awarded $35,000 to the college, named it Georgia Normal and Industrial College, and designated the property with the old governor's mansion as part of the campus. "The Mansion" became a dormitory and a residence for the president of Georgia Normal and Industrial College.

Twenty acres of land ("Penitentiary Square")—containing some of the rubble from Sherman's attack (November 22–24, 1864)— became a part of the grounds for the college. In 1891 the first classroom was complete.[14]

Georgia Normal and Industrial College would include programs for training teachers and studies in

Mt. Pleasant School near Valdosta was typical of the country schools in many parts of Georgia, March 1915. Photograph by Lewis Wickes Hine, National Child Labor Committee.

LC-DIG-NCLC-00247 LOT 7475. LIBRARY OF CONGRESS, PRINTS AND PHOTOGRAPHS DIVISION

... telegraphy, stenography, typewriting, photography, book-keeping, domestic economy, cutting and making dresses, printing, industrial and decorative art in its practical application, and such other practical industries as may tend to fit and prepare girls for occupations which are consistent with feminine refinement and modesty.[15]

The laying of the cornerstone for this college occurred in 1890. The name of Georgia Normal and Industrial College later (1922) became Georgia State College for Women (GSCW).[16]

Georgia State Normal School. In 1891 the

This image of "The Mansion" is from the 1939 Spectrum. *The old governor's mansion became a residence for the president of Georgia Normal and Industrial College and a dormitory for some of the boarding students; the building continues in use. Here some students of Georgia College and State University stand on its steps.*

legislature provided for a teacher's college for men: the State Normal School at Athens. Two years later it, too, admitted women. This college became Georgia State Teachers College, incorporated into the university in 1933.

Georgia State College of Agriculture. In 1906 the legislature established the Georgia State College of Agriculture. The legislature also scattered other A and M colleges throughout the districts. The colleges became branches of the Georgia State College of Agriculture. The number of colleges in Georgia increased until the University of Georgia had some twenty-four branches. All the branches had the misleading name *University of Georgia*.

University of Athens. The legislature did not make periodic donations to the University of Athens (Franklin). Charles McCay, a professor, donated $7,000 to the college; he designated that this sum should be compounded until twenty-one years after the deaths of twenty-five people whom McCay named. McCay predicted that this sum should amount to $2,000,000 by 1979, the estimated year that the compounding would end. McCay intended the money for salaries for professors.

In 1882 Joseph E. Brown offered $50,000 in memory of his son. Brown designated that his money was for needy students. The University invested it and used only the interest. These two gifts of McCay and Brown were an enormous help to the University of Athens.[17]

Higher education for African Americans before the 1930s. Higher education for African Americans moved forward primarily through the gifts of wealthy friends in the North.[18] Most Georgians believed that the concept of separate but equal was important for higher education just as it was for the public school systems. Some legislators thought that the state should develop an institution of higher education for African Americans; others advocated giving aid to an already existing institution. Many did not, because of prejudice, recommend any higher education for African Americans.

Atlanta University. Georgia, however, could not receive funds from the federal land grant fund if it did not provide institutions for African Americans. Finally, in 1874, an agreement with Atlanta University allowed an $8,000 state subsidy, which remained in effect until 1887. Because white students were attending classes at Atlanta University, however, the state denied the funds to the university.

There was great turmoil over the unauthorized integration that had occurred. The legislature received — but did not pass— a bill providing punishment to those who instructed classes with both African American and white students in the same classroom. This controversy over integration foreshadowed the 1940s during Talmadge's term in office and the Civil Rights Movement in the decades to come.

Three other Atlanta colleges for African Americans. The money that Atlanta University had usually received went (in 1885) to Atlanta's Morris-Brown College, which trained ministers. In 1881 Spelman Seminary (also in Atlanta) became important for young women.

Monetary gifts from Elijah H. Gammon of Illinois helped found Atlanta's Gammon School of Theology. Gammon Theological Seminary had begun as the Department of Religion and Philosophy at Clark University (1869). In 1883 Gammon School of Theology opened. After the 1887 official connections between Gammon and Clark dissolved, Gammon provided additional funds; his gifts amounted to $1,000,000.[19] Gammon's intention was "to recruit, support, and educate pastors and leaders for the United Methodist Church."[20]

Atlanta became "one of the greatest centers of Negro education in the world." Governor A.D. Candler declared that all of the white Georgia colleges and universities could not equal them in wealth.[21]

Georgia Normal and Agricultural College (Albany). Georgia Normal and Agricultural College (Albany) received its charter in 1917. Even though it bore the designation of *college*, it remained little more than a high school with courses in industrial education. In 1943 Georgia Normal and Agricultural College (Albany) became Albany State College; the school dropped the agriculture courses and became a four-year teacher preparation institution.[22]

State control of private colleges and universities. The legislature in 1890 exercised its

control over private colleges and universities. It established Georgia State Industrial College for Colored Youths. The state designated this college in Savannah as a branch of the university.

Another school — Paine Institute — began in 1883 in Augusta. The college received its name from Moses U. Paine of Iowa; Paine had made the first gift — a sum of $25,000. In 1933, during the height of the Great Depression, Paine Institute celebrated its fiftieth anniversary with a pageant emphasizing the progress that African Americans had made.

An industrial school patterned after Alabama's Tuskegee Institute began in 1898 in Fort Valley. Georgia gave a small yearly stipend to Fort Valley. Higher education for African Americans was not unheard of in the state of Georgia before the turn of the century.[23]

III. The National Emergency Council's Assessment of Education in the South During the Great Depression

In 1938 the National Emergency Council (NEC) presented a grim picture of education in the South. The *Report on Economic Conditions of the South* denoted factors contributing to problems in educating the South's population.

Factors increasing the problems with education in the South: Population. The NEC observed that the South's population problems contributed to its education problems. Whereas there were 10 adults to 4 children in the North and the West, there were 6 children to 10 adults in the South. Readily apparent was the marked disparity between the number of children that the South had to educate and the means available to educate them. President Franklin Delano Roosevelt often reminded his constituency, however, that these population and education problems were the nation's problems — not just problems of the South.[24]

Factors increasing the problems with education in the South: Economics. A second contributing factor, besides population, to the South's education problems was its economy. The average income in the South was 52 percent of the income of the rest of country. The South's average annual wages in industry was 71 percent of the industrial wages outside the South. These economic conditions impacted the public schools and education.[25]

In 1930 the nation was beginning to slip into the Great Depression. Rural areas across the nation were feeling the economic decline first. Georgia had a farm population of 1,418,000 at the time. Only the Southern states of North Carolina and Texas had more farmers; the schools in these poor, rural areas seemed to have the most difficult time.

The farmers suffered economic loss first with the droughts and boll weevils. Next, the merchants felt the hurt of hard times when the farmers could neither pay their bills nor provide the collateral to purchase new merchandise. Then, the banks began to close. When tax levies failed, the school districts found themselves in debt. Thousands of the nation's elementary schools — primarily in Southern rural areas — closed.[26]

Factors increasing the problems with education in the South: Distribution of students and control. The Southern states were largely rural. This placed a heavy financial burden on the underpaid rural workers to provide schools and education.[27] The Great Depression reversed the trend to localize school funding. "Hard times" brought about greater involvement of the state government in the operation of the schools.[28]

Factors increasing the problems with education in the South: Per capita income. The poorest state outside the South ranked higher than the richest state in the South in per capita income. It is easy, therefore, to anticipate the problems that the South had with financing schools and education for its citizenry.

Factors increasing the problems with education in the South: Assessed value of taxable income. The assessed value of the South's taxable property was only 34 percent of that of the Northeastern states. In other words, the Southern states had one-third the property value yet they had more students to educate

than most other regions. Even though the taxes levied were as heavy as for other sections of the country, the South could not bring its schools and public services up to those of the rest of the nation. It had, in effect, to educate one-third of the nation's students with less funds than the rest of the nation (http://www.sreb.org/main/Publications/Roosevelt/1938.asp).

Factors increasing the problems with education in the South: Collected taxes. The South was able to collect only 56 percent of the amount from state and local taxes that the rest of the nation collected. The federal income tax collections for the South were only 12 percent of the national total; the South, however, had 28 percent of the population.

Factors increasing the problems with education in the South: Time allocated for education. The school dropout rate in the South was high; many students had fewer years in school than did students in other parts of the nation. To compound this problem, in the South—where many students worked on the farm and in the industries—the school term was generally shorter than that in other regions of the nation. The South's employed students attended, of course, even fewer days than unemployed students.

In addition, the upper age for compulsory attendance was often lower in the South than other sections of the nation. Exemptions lessened the effectiveness of these regulations (http://www.sreb.org/main/Publications/Roosevelt/1938.asp).

Factors increasing the problems with education in the South: Illiteracy. The nationwide illiteracy percentage at the 1930 Census was 4.3; as many as 4,283,753 persons who were ten years old and older could not read or write any language. The percentage was such that in 1930 President Herbert Hoover appointed a National Advisory Committee on Illiteracy. This group, with the secretary of the interior as chair, worked as "factfinder and cheerleader, with 44 state branches, to make the nation 'literacy-conscious.'" The group was able to report that 118,000 illiterates in Georgia had received help.[29]

Factors increasing the problems with

education in the South: Overcrowding. Overcrowding in the Southern schools served to lower education standards. These rural states contained one-third of the nation's school age students and had a high teacher-pupil ratio. The average ratio of pupils to teachers in Georgia schools was 38:1 in white schools; the ratio was 50:1 in schools designated for African Americans.[30]

Factors increasing the problems with education in the South: Teacher salaries. Not one of the Southern states had teacher salaries equal to that of the states in other regions. This meant that many of the South's best students might choose a profession other than teaching or move to another state.

Factors increasing the problems with education in the South: Expenditures per student. The amount of spending per school child in the South was about one-half the amount that the rest of the country spent per child. The expenditures for students affected the quality of the education that students received (http://www.sreb.org/main/Publications/Roosevelt/1938.asp).

Factors increasing the problems with education in the South: High school enrollments. Only 16 percent of Georgia's school enrollments was for high school students. The rest of the nation had 24 percent of its students enrolled in high schools.[31]

IV. Georgia Education under Lamartine Hardman, Georgia Governor from 1927 until 1931

By 1930, the Georgia State Department of Education had administrators to supervise rural, African American, vocational, and high schools. The state also established overseers for teacher certification and construction of schoolhouses. Public school control in Georgia was moving to the state from the cities and counties that had previously exercised most of the control. In the early 1930s, when tax levies failed and school districts faced further debt, thousands of American elementary schools—primarily in rural areas—closed. Many of the

poorer districts were unable to operate schools more than six months; these districts began to urge the state to assume more of the financial burdens of the schools.

Teacher salaries during 1927–1931. As the hard times continued, teachers in most states felt the pinch. Teachers in some areas of Georgia went without pay for months. Other districts paid their teachers in scrip redeemable only at local businesses. Teacher salaries in Georgia were below many of the other states. Georgia teachers who were white were receiving $97.22 per month in 1929; this was an increase over the average $44.29 they earned per month in 1910. African American teachers, however, averaged only $38.24 per month, up from the $23.23 in 1910.[32]

Teachers, officials, and civic leaders began to pressure the legislature to assume more responsibility for the schools. The state, they argued, should provide the minimums in salaries for teachers and the minimums in standards for the teachers and for the students.[33]

Administration, finances, and enrollments. In 1931— during Lamartine Hardman's term — the public schools had more than $21,000,000 for expenses. Almost a third ($7,000,000) of this total was state-appropriated. Education in the state, however, still had much room for improvement at the beginning of the decade of the 1930s.[34]

By the 1920s more African American students were attending public schools than in the previous decade; the increase was 73 percent. The number of black secondary schools in Georgia had increased also and African American teachers were receiving more training before beginning their jobs as instructors than had teachers in the past.[35]

Dropouts and illiteracy in Georgia in 1930. The United States Census Bureau applied the term *illiterate* to those over age ten who could not read and write. The 1930 Census determined that 4.3 percent of the national population was illiterate. It is difficult, however, to determine if the rate of illiteracy was higher at the end of the Great Depression than at the

Walking home from school in Flint River, Georgia, May 1939. Photograph by Marion Post Wolcott, Farm Security Administration.

beginning because the 1940 Population Census did not define illiteracy in the same way as it had at the 1930 census. The 1940 census and the reports thereafter attempted to determine the number of years in school (grades completed), rather than using the term *illiteracy* or *nonreaders*.[36]

The state with the highest rate of illiteracy in 1930 was South Carolina, which had a 26.9 percent rate of illiteracy.[37] In 1930 the illiteracy rate of those ten and older was 9.4 percent in Georgia compared to 4.3 percent for the nation; this was more than two times the rate of illiteracy of the nation. Georgia was 41st in the nation.

The percent of African Americans who were illiterate in the state of Georgia in 1930 was 19.9 percent, as compared to only 3.3 percent of whites; this was more than six times the rate of illiteracy among the white population. The percent of males who were illiterate (10.6) was greater than the percent of illiterate females (8.3). The percentage of illiterate African Americans in Georgia ranked the state at 43rd in the nation.[38]

Early consolidation plans. As early as 1919, Georgia began making plans to establish consolidated high schools for the poorer, rural districts. The intention was that the consolidation would help bring the programs closer in quality to the more financially affluent school districts — and would save some of the taxpayers' dollars. The legislature in 1919 set aside $100,000 for the consolidation; by 1930 the allocated amount had grown to $500,000.[39]

Contrived school buildings in 1930. As late as the 1930s many African American students attended school in deserted houses, unused buildings, and even churches.

The scene on the following page shows the interior of a Georgia church; this church doubled as a school during the week. The students sat all day on the hard wooden benches.

One-teacher schools were not unusual for

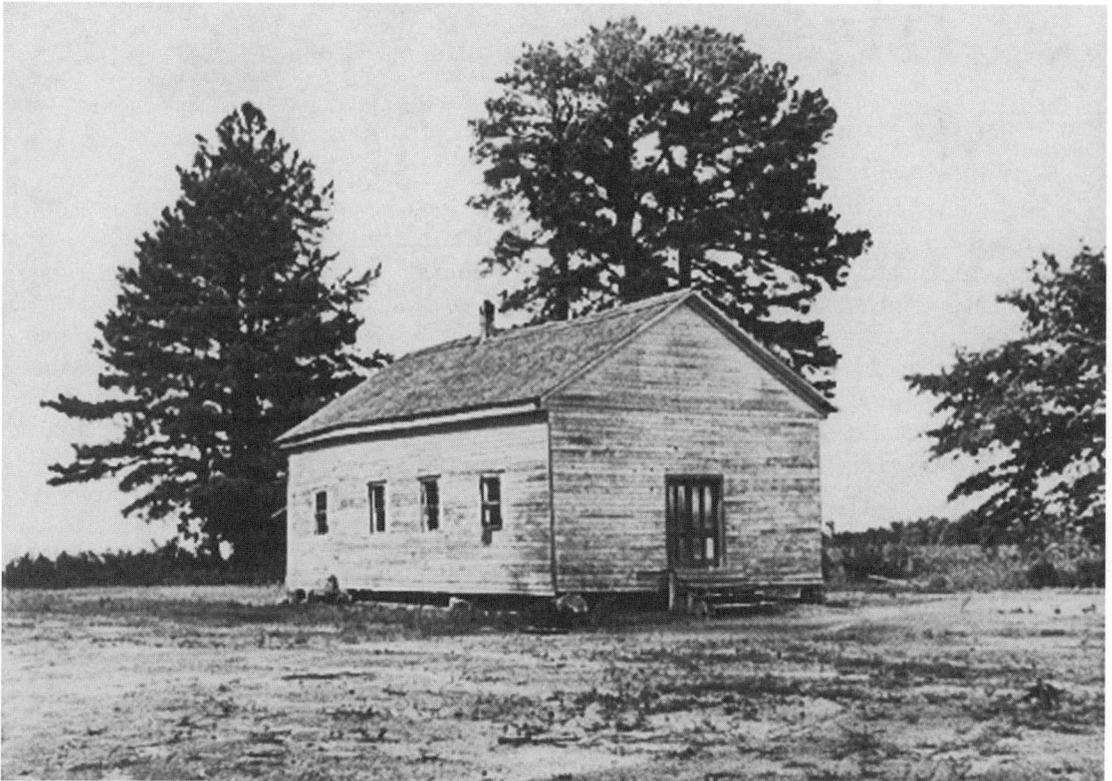

An old church in Flint River, Georgia, also functioned as a school, May 1939. Photograph by Marion Post Wolcott, Farm Security Administration.

Interior of an old church in Flint River, Georgia, that also served as a school, May 1939. Photograph by Marion Post Wolcott, Farm Security Administration.

rural white and African American students, such as these in Greene County, Georgia. This scene is from October 1941, long after the end of the Great Depression; the same educational disadvantages continued into the new decade.

Industrial education. Booker T. Washington urged the introduction of and emphasis on industrial education in the school curriculum — particularly in many African-American schools—from 1890. In 1930 this trend continued, especially in the African-American schools. Such programs encouraged particularly the occupations of blacksmithing, agriculture, carpentry, canning, and housekeeping. The idea of industrial education seemed to fit in with the ethics of thrift and hard work. Many Georgians encouraged the emphasis on industrial education and home economics in all schools. Industrial education, however, seemed to have more emphasis in the schools attended by African Americans.

Some Georgians noted that most of the African-American schools did not have the equipment or the teachers necessary for a good industrial education program. The graduates of these schools became teachers, rather than workers. Many of the programs were becoming obsolete; for instance blacksmiths were no longer vital to the communities. The industrial education programs were on the most elementary level and seemed to be an excuse for inferior education, especially for African Americans.[40] Educational leaders saw industrial programs as

> ... the price that black schools had to pay for white toleration and support. Many whites believed blacks to be capable of only industrial education; others believed it would enable blacks to become more productive while keeping them in permanently inferior positions.[41]

Northern friends of African Americans in Georgia seemed to encourage the industrial

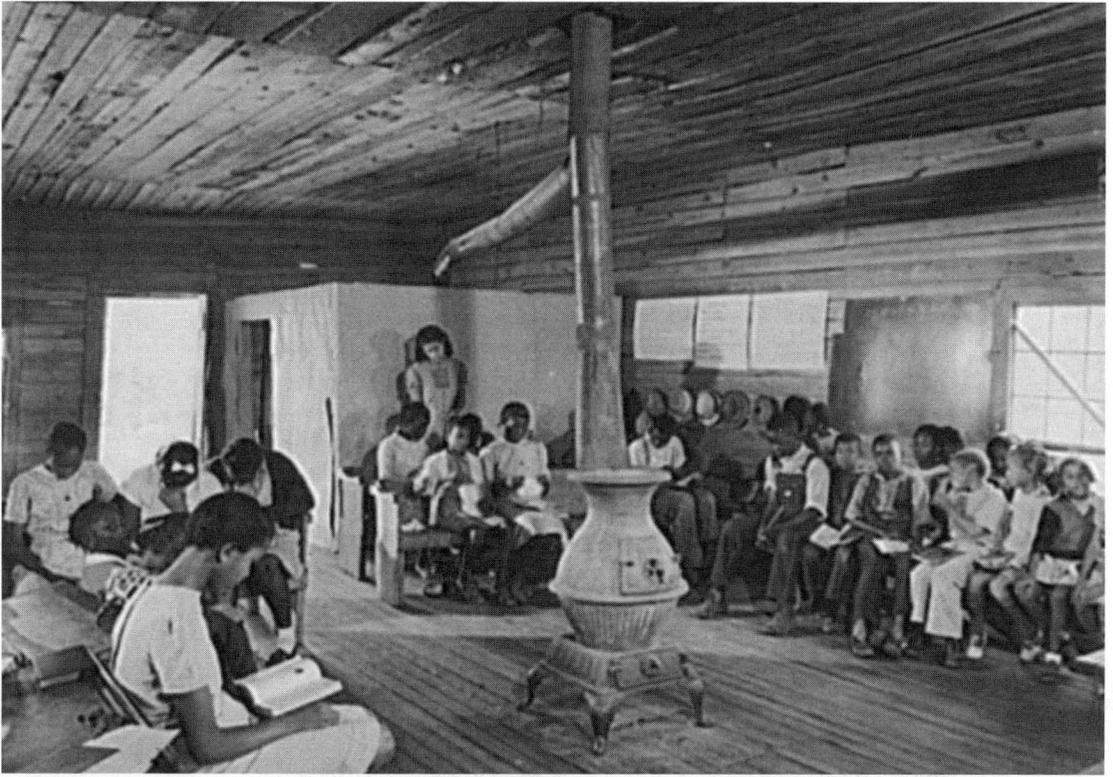

The one-teacher Negro school in Veazy, south of Greensboro, in October 1941. Photograph by Jack Delano, Farm Security Administration.

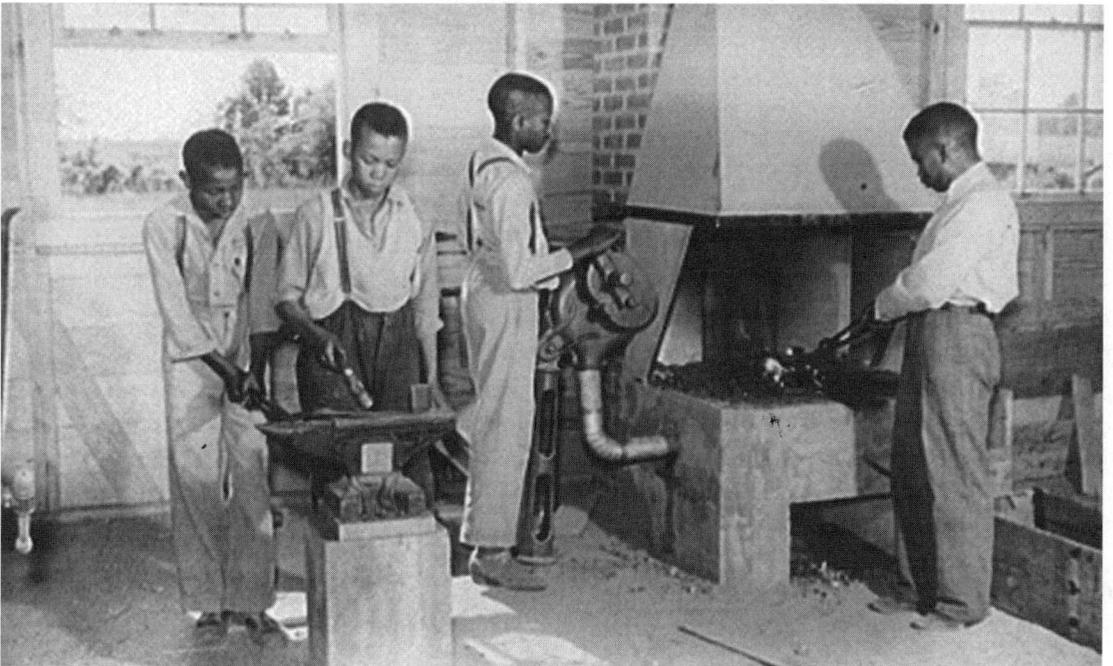

O.C. Cramer, Frederick West, J.W. West, and another student sharpen a plow point at the forge in the school shop in Flint River Farms, Georgia, May 1939. Photograph by Marion Post Wolcott, Farm Security Administration.

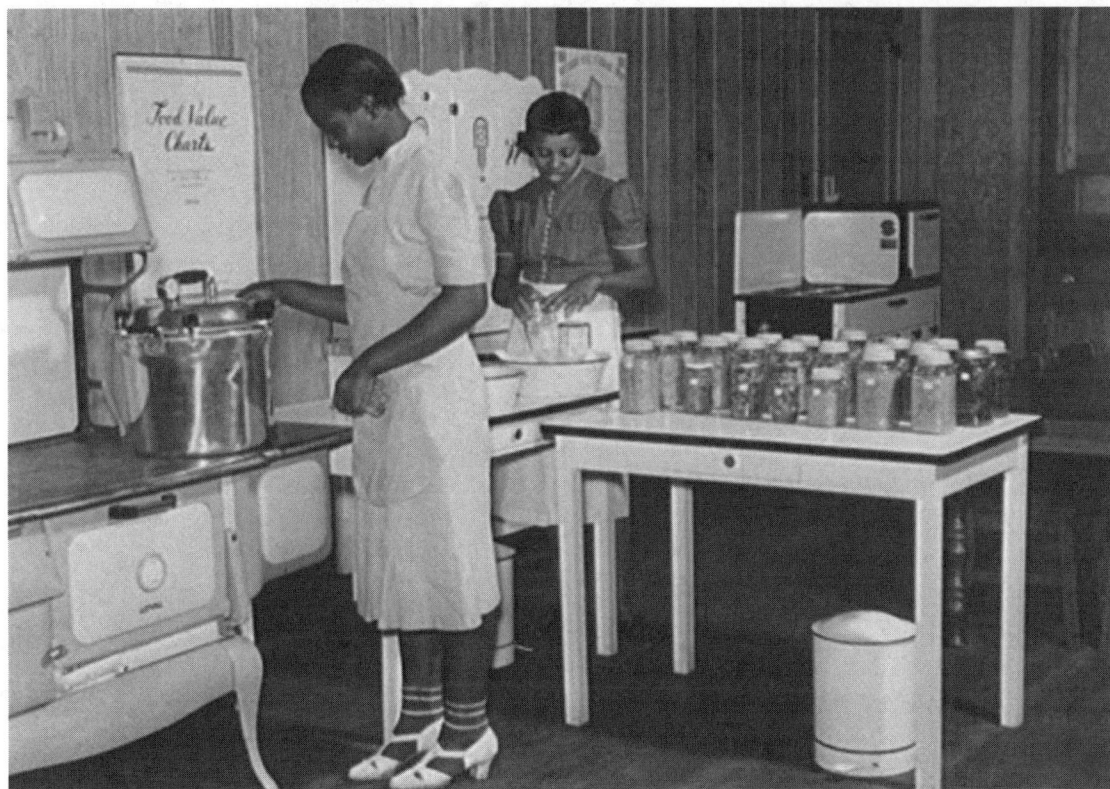

Lucille West, at pressure cooker, and Nancy Engram can vegetables and fruits in home economics class in Flint River Farms, Georgia, in May 1939. Photograph by Marion Post Wolcott, Farm Security Administration.

education programs in the schools. Without these philanthropists, many African Americans would not have received much formal education. Some of the funds that helped with donations to the schools included the John F. Slater Fund, which worked with county administrators to establish advanced industrial education instruction and teacher training; the Anna T. Jeanes Fund, which advocated longer school terms and supplemented teacher salaries especially for those teaching industrial education to African Americans; and the Julius Rosenwald Foundation, which helped to construct over three hundred school and vocational houses between 1917 and 1940.

Higher education in the 1930s. From 1930 until about 1934 the enrollment in most institutions of higher education in the nation dropped. Beginning with the 1934–35 school year, the tide turned.

In 1930 Georgia's public institutions of higher education numbered twenty-eight. Each

had a separate board of trustees. This system changed in 1931 when legislation placed all public colleges and junior colleges under a single board of regents; the group became the University System of Georgia. The Georgia Board of Regents began reducing the number of institutions of higher learning so that a dozen years later there were seven senior institutions, six junior colleges, and two experimental posts. Private colleges continued. Some of these institutions were Mercer University (Macon), Wesleyan (Macon), Shorter (Rome), Brenau (Gainesville), Agnes Scott (Atlanta), and Emory (with campuses at various times in Oxford, Atlanta, and Valdosta).

Martha McChesney Berry founded a private school near Rome, Georgia, in 1902. Designed originally as a school for mountain children, it soon became a boarding school. Each week the students spent some time in manual labor. In 1930 the institution became a four-year college. *Time* reported its enrollment as

1,000 in 1928. Martha Berry received the Roosevelt Memorial Association medal "For Distinguished Service" in 1925; President Coolidge awarded the prize.[42]

Mill village schools. Many of Georgia's textile workers lived in mill villages. The companies owned the houses, sometimes ran the stores, usually built the churches, and even helped to provide school buildings if the company deemed such facilities necessary. In addition, the mill owners might help to subsidize the ministers and even contribute to the pay of the teacher — or teachers—for the school. In Georgia, however, it was not to the plant owners' benefit to advocate school instead of work in the mills. Harriet L. Herring attempted to survey 322 Southern plants. She found that most of the owners of the plants had contributed to the building and the support of the churches; only 28, however, had supplemented the support of the schools.

It was true, however, that children of textile workers often did not attend school. As many of their parents before them had done, these young people, too, went to work at the local mill in order to contribute to their family's income. Later, the state of Georgia would legislate and more strictly enforce attendance laws for its youth and its child labor laws.[43] By 1931 Georgia, like all Southern states, had laws against the employment of children under fourteen and against night work by those under the age of sixteen. Together with the Fair Labor Standards Act (FLSA) of 1938, child labor would diminish.[44]

Money-saving measures, including salary cuts for teachers, in education. During the 1930s the state of Georgia — along with the rest of the nation—faced many problems. Some people in government began to talk of closing more public schools to save money. Many of the schools closed laboratories and discontinued "nonessential" courses; many schools, however, had never had these "frills" in the first place. Some people regarded these money-saving measures as economic policies, not educational policies.

Unique problems of rural youth. Children from rural areas faced unique problems in securing an education. Many had to rise early enough to milk cows, feed farm animals, draw water, bring in firewood, build fires in the wood cookstoves, and perform other chores before going to school. Bus transportation was not always provided; often a long walk was involved in attending school, which was usually in a one-room building.

Classmates poked fun at the smell of those who had worked in the barns before arriving at school. Tattered clothing, irregular attendance based on the maturation of the crops, derisive comments from those who did not live in the country, and inadequate school supplies and lunches were only a few of the hardships, embarrassments, and hurdles many farm children and migratory workers faced in their pursuit of a free public education.

Consolidation. Parents, lawmakers, and educators argued about consolidation of the scattered schools. Consolidation might improve the facilities and the equipment for the schools, but it might increase the average number of students for each teacher. The location of the one-room schools in the isolated areas made consolidation a difficult goal to achieve in the state. Ensuring that students could reach their schools was another serious problem to consider. Georgia faced many thorny problems in education as Governor Richard B. Russell, Jr., came to office.

V. Georgia Education under Richard B. Russell, Jr., Georgia Governor from 1931 to 1933

Georgia had many issues in education during Richard B. Russell, Jr.'s tenure as governor. From 1930 until about 1934 the enrollment in most institutions of higher education in the nation dropped.

Higher education. In 1932 Georgia State College for Women (GSCW) became a part of the University of Georgia. Most people called the students at GSCW "Jessies." In 1938 — with enrollment at 1,500 — a lasting tradition began; this tradition was "The Golden Slipper." The Golden Slipper was a competition between classes to produce and perform the best skits

and dances; "the slipper" became a symbol of the Jessies. GSCW would later carry other names: Woman's College of Georgia (1961) and Georgia College (1967).[45]

Between 1924 and 1933 Georgia abolished some of its agricultural and mechanical arts (A and M) schools in each of the eleven congressional districts. The state changed some of the other A and M institutions to junior colleges.[46]

The Great Depression brought chaos to higher education. Competing for funds from the legislature were the Georgia School of Technology, the University of Georgia, and 24 branches of the university. Some of these colleges were no more than boarding high schools for rural students.

To help remedy the situation, Governor Richard B. Russell, Jr., reorganized the state government in 1931. The reorganization included the establishment of a Board of Regents of the University System of Georgia. From a lump sum appropriation from the general assembly, the board had the power to create, to operate, and to allocate monies to the public colleges. The year 1933 saw the curtailment of the university system to 12 colleges (including one university) for white students and 3 colleges for African Americans. The enrollment in 1933 was 8,035.[47]

Georgia's public schools. The enrollment of the school-age children in Georgia during Russell's term (1931–1933) reached 94 percent for whites and 84 percent for African Americans. Average daily attendance was 76 percent for whites and 74 percent for African Americans. The ratio of pupils to teachers was 50 to 1 in the schools for African American children and 38 to 1 in the schools for white children. Equalization was not apparent in the education of African Americans and white students in Georgia.[48]

Although many Depression era youth dropped out of school, some were able to remain. Even those still enrolled, however, often attended school only sporadically. Reasons for irregular attendance included a lack of sufficient clothing, inadequate school supplies, embarrassment at having no lunch to take to school and at being teased for poverty, laxly

enforced attendance laws, a need to work, and a lack of encouragement from others. Some children lied about their ages so they could secure employment or help at home instead of attending school. Some of the dropouts and some of the other children enrolled still hungered for an education.

Salaries for teachers. The discrimination between African American and white teachers was evident in the salaries. African American teachers in 1933 received an average of $278 per school year; this was 40 percent of the salary of the white teachers, whose average pay was $695 per year.[49]

Adult education. The date of the Federal Emergency Relief Act was May 12, 1933 — about 60 days after the inauguration of President Roosevelt. In 1933 Harry L. Hopkins, federal relief administrator of the Federal Emergency Relief Administration, began the Federal Emergency Adult Education Program. As a result, many states began increasingly to emphasize adult education. This nationwide program, using teachers without jobs to instruct other unemployed groups, had 1,190,131 enrollees by April of 1935 and had employed 43,722 jobless teachers. The Works Progress Administration (WPA) continued these programs when the FERA ended.[50]

With the widespread need and poverty in Georgia during the early 1930s and with the state's support of the Democratic Party, one would expect that the state would support the New Deal programs. Georgia, however, "did not willingly cooperate with many of the early New Deal Programs."[51]

Georgia had long been emphasizing adult education. A survey of the schools as early as 1916 reported the accomplishments of "Moonlight Schools" in Tattnall County. The report indicated that — under the leadership of its superintendent — Tattnall had become one of the first Georgia counties to teach adults systematically. The report indicated that only about 24 white adults in that county could not read and write; plans were to reach those adults before the program ended. The ones reached in 1916 had been "carried as far as the fourth or fifth grades, and some are ambitious to go further."[52]

The survey praised work in all of the

schools in the county for adults. It called attention to one of the largest and most successful programs, "Night Classes," under Professor J.M. Harvey, at Glenville, Georgia; thirty-six adults were in that class. Miss Thompson, at Mile Hill School, had a class that had begun three or four years before; the class deserved particular commendation because they were now doing fourth and fifth grade work.[53] In 1928 *Pictorial Review* magazine awarded Georgia's Cora Wilson Stewart its Pictorial Review Prize for her work in Georgia with her Moonlight Schools.[54] Adult Georgians profited from these "Moonlight" programs and from the available colleges about the state. Unemployed teachers also benefited from the salary, but — again — federal help was not readily accepted by the state.

VI. Georgia Education under Eugene Talmadge, Georgia Governor from 1933 until 1937

Eugene Talmadge renewed and increased his attack on President Franklin Delano Roosevelt and the New Deal during Talmadge's campaigns for governor. In Talmadge's first runaway victory he carried 136 of 139 counties. This landslide

> ... may have caused him to be overconfident; perhaps he either misjudged the sentiment for Roosevelt or ignored it. In any event, opposition began building against Talmadge because of his attacks upon the Roosevelt administration.... He ... vetoed bills providing bills providing for free school textbooks and a seven-month school term.... In response to the governor's vetoes, an opposition faction, which wanted Georgia to participate in New Deal programs, coalesced behind the leadership of House Speaker Eurith D. Rivers. In the hopes of forcing Talmadge to call a special session at which New Deal measures could be reconsidered, Rivers' faction blocked the passage of an appropriations bill. But Talmadge declared, "There ain't gonna be no special session," and proceeded to run the state government on the former appropriations law.[55]

At any rate, Talmadge voted against seven-month school terms and supplying textbooks to the schools. His runaway 1934 victory "may have caused him to be overconfident."

Governor Eugene Talmadge and education. The years 1933–1937 — when Governor Eugene Talmadge was in office — were marked with protracted political battles. School legislation was a particularly heated concern. The legislation guaranteeing funding for an extended school term, free textbooks, and minimum salaries for teachers did not pass during Talmadge's terms (1933–1937). The neighboring state of North Carolina had passed a resolution in 1933 to extend the school term to eight months; Georgia was still using a six-month school year at the time and had vetoed even a seven-month term.[56]

The education of tenant children. Shifting farm tenancy in the Southern states was a problem as late in the decade as 1937. The children of tenant farmers faced unique problems in securing their education. Their lightweight, scant, well-worn clothing kept many away from school on all but the mildest days. Many farm family budgets could not provide even the paper and pencils the students needed for completing assignments. The school attendance of many of these rural children was dependent on the cotton fields, the tobacco fields, and the demands of their families. Furthermore, the moves of tenant families from one area to another sometimes disrupted school attendance.[57] Coupled with jeers from their city counterparts, a family focus on work above education, and little time to study, these rural students had many disadvantages.

Bus transportation. Transporting children from rural areas to the schools continued to be a problem for Georgia families in the 1930s. Even though the Blue Bird Body Company located in Georgia produced the bodies for many school buses for the nation, providing these buses for Georgia's own youth remained a problem.

Buses in the 1930s were safer, however, than when a wooden body was dropped onto an automobile chassis, the forerunner of the modern motor school bus. Passengers in these early vehicles situated themselves on perimeter seating and faced the center of the "bus." The students entered and exited through a door at the rear; this means of coming and going helped to prevent the startling of the

horses when non-motor conveyances were popular.

In 1927 the Blue Bird Company had begun building all-steel bodies for its buses. The company soon added heavy-duty "collision" or "guard" rails to make the vehicles even safer. Not all buses in Georgia had these features, however. Some buses were little more than a truck with a tarpaulin stretched over the bed.

It was 1939 before Columbia University Professor Dr. Frank W. Cyr organized a conference to set up standards for school bus safety. At this time the color *National School Bus Chrome* (later *National School Bus Glossy Yellow*) became the accepted hue for the vehicles; this color enabled the black letters to be more visible in the late evening and early morning light. More about the Blue Bird Bus is in this volume in chapter one, "Water, Soil, and Industries Based on the Natural Resources."[58] Rain slick dirt roads, snow, and ice posed a hazard to the buses, however. This problem persisted throughout the decade and beyond.

Schools and community events. Even though times were hard, funds limited, and many schools deprived of resources, the opportunities that they provided meant much to the children enrolled and to the community, which often attended the events faithfully and used the facilities for plays, programs, adult education, and other social and civic events.

Emergency programs for expanding educational plants were priorities of the Public Works Administration. Six Southern states built 314 new buildings with relief workers; these states enlarged or modernized another 1,225. Georgia was able to build 162 buildings with PWA assistance.[59]

Graduation from school was certainly an achievement during the Great Depression and even into the 1940s. The whole community came out to honor the graduates. Even into the 1940s and beyond the nearest school was important to the community as well as to the students.

A slick country road during a pause in heavy rain near Flint River Farms, Georgia, May 1939. Photograph by Marion Post Wolcott, Farm Security Administration.

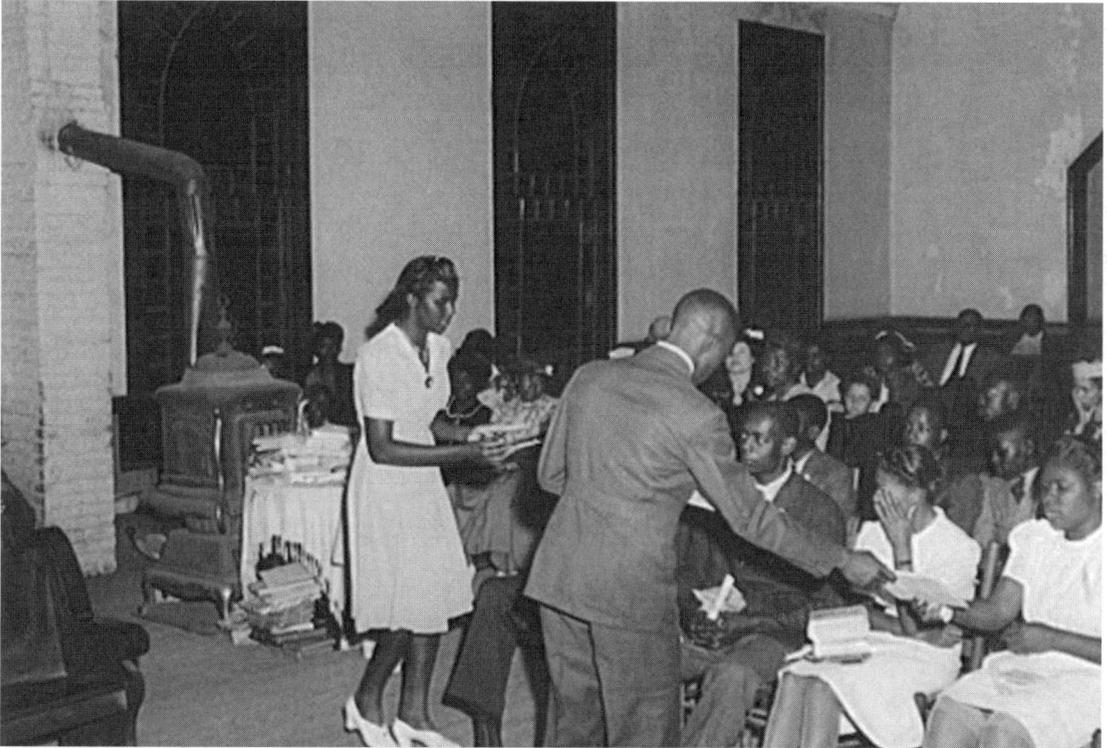

Giving presents to the graduates at the graduation exercises at the Union Point, Georgia, black high school in May 1941. Photograph by Jack Delano, Farm Security Administration.

VII. Georgia Education under Eurith D. Rivers, Georgia Governor from 1937 until 1941

The legislature passed landmark legislation for education and the state of Georgia during the period 1937–1941.

Education legislation during 1937–1941. With the support of Governor Eurith D. Rivers, the state of Georgia finally passed the "Seven Months School Law." This important legislation guaranteed state funding to ensure a seven-month school term for all counties. Included in the package was state transportation for school students.[60] As important as the lengthened school term was, the legislation that provided free textbooks for the students was crucial also. This legislation proved "a turning point in public education" for African American students in particular[61]: new state guidelines and standards, revised textbook adoption policies, modified teacher certification regulations, and adjusted

rules for school transportation: buses and drivers increased costs and the control of the state.

During the period from 1930 to 1940 the state of Georgia had increased its share of school costs from 36 percent to 57 percent. Along with these additional funds, however, came increased involvement in school matters of the Georgia Department of Education.[62]

Accredited high schools. By 1938 the number of four-year high schools for whites had increased from the 169 accredited schools of 1920 to 431 schools in 1938; at least one school was in place in each of Georgia's 159 counties. There were 125 two-year high schools in 1940.[63] In 1940 the number of accredited four-year public high schools for African American students numbered 48 in Georgia's 159 counties. Georgia's investment in grounds, buildings, and teaching aids for each African American child was $35.00; by comparison, the investment was $142.00 for each white child. African Americans in Georgia still had not begun to receive equal educational opportunities.[64] The grounds

Projecting movies in the school auditorium in Centralhatchee, Heard County, Georgia, for those who can't get to town, May 1941. Photograph by Jack Delano, Farm Security Administration.

and buildings—even as late as 1941—indicate the discrepancy in funding.

Financing education. After Governor Eurith D. Rivers took office in 1937, he had widespread support. Rivers did not, however, seek tax increases to fund the programs that Georgia had instituted. By 1938 there was beginning to be some opposition to Rivers and concern about the accumulating debts. The slight tax increases that Rivers did obtain were not adequate to fund the new programs and he barely won the next election (1939–1941).[65]

Rivers failed to secure the sales tax and the tax on chain stores that he had advocated. One source of income that Georgia did not claim was a tax on alcoholic beverages, even though the state consumed a vast amount of alcoholic liquors:

> Some people foolishly felt that it was much better to be hypocritical, violate the law, and lose millions of dollars of income than to compromise with the devil by legalizing the traffic and collecting a handsome revenue. It was a strange turn of fate that lined up the bootleggers with some of the best people in the state in their determination not to legalize liquor.... Twice the legislature, in 1935 and 1937, unwilling to assume the responsibility of legalizing liquor, had passed the question to the people in referendum, and twice by slight majorities the people had voted it down.... In 1938 strictly as a revenue measure the legislature passed a law allowing counties to vote on legalizing the sale of liquors, and soon various counties began acting and going wet.... As a further source of money the legislature sold the rentals of the Western and Atlantic Railroad for four years ahead, getting a little more than two and a quarter million dollars. This method of getting revenue had been resorted to previously by Governor Russell.[66]

By 1939 the Georgia State School for the Deaf had to close for lack of funds. There seemed to be a threat that some of the public elementary and high schools might have to close because of the pressing financial needs.[67] The state had to scale down its payments to 74 percent of most of the appropriations; Rivers did, however, pay the teacher their full salaries.[68]

Between 1936 and 1940 Georgia's expenditures for education rose from $7,948,137.53

Playground scene, Irwinville School, Georgia, May 1938. Photograph by John Vachon, Farm Security Administration.

Recess at the Veasey school for black children in Greene County, Georgia, October 1941. Photograph by Jack Delano, Farm Security Administration.

to $16,083,848.68.[69] The per capita appropriation for higher education in 1939–40, however, was $3.83, the lowest per capita expenditure in the nation.[70] Rivers' efforts to gain money from the highway.[71]

Illiteracy. By the end of Rivers' term, Georgia's rate of illiteracy had decreased to about 2 percent.[72] In 1930 the national average was 4.3 percent. The changing definition of illiteracy made it difficult to compare the two years of 1930 and 1940. In 1930 "illiterates" were those who could not read and write. In 1940 illiterates were adults who had never

completed the fifth grade; the percentage was 13.5 percent. Georgia's 2 percent for 1940 used the definition of those who had not completed the fifth grade.[73]

Jim Trelease notes that the dropout rate for the nation in 1940 was about 75 percent. During the worst years of the Great Depression, however, he concedes that the percentage was probably even higher.[74] These 1940 statistics are, at best, very difficult to compare with the 1930 census where the interrogator asked a different question.

The teacherage. To help teachers make

ends meet and to provide an income to certain families, teacherages sprang up throughout Georgia. These teacherages in homes or in special buildings provided room and meals to teachers for a minimal fee. Teachers might even arrange to have their linens and towels washed for them for an additional sum.

VIII. Higher Education During the 1940s

Turmoil in higher education resulted when Talmadge again came to office in 1941. Governor Talmadge vowed to purge the university system of those who advocated racial equality and communism. He demanded the firing of certain educators by the board. When the board refused, Talmadge replaced several board members and removed 10 of the state's educators from their positions.[75]

Ten days before Pearl Harbor the Southern Association of Colleges and Schools voted to deny the accreditation of 10 of Georgia's public colleges for whites. Ellis Arnall, the attorney general for Georgia, removed Talmadge from the board of regents and changed the organization of the board to prevent political interference in the future; Arnall defeated Talmadge in the next gubernatorial campaign. The war years brought increased income for Georgians and improved public higher education.[76]

Summary. Georgia through the years made much progress. The state constitution of 1777 mandated public education. In 1783 the first government-supported high school opened in Augusta. A "poor school fund" provided limited benefits for those who would not have education otherwise.[77]

In 1866 the state legislature compelled free public schools, but there was no enforcement at the time. Schools were segregated in

Teacherage, community, and school buildings in Flint River Farms, Georgia, before landscaping, October 1941. Photograph by Marion Post Wolcott, Farm Security Administration.

the 1930s. Georgia did not have a seven-month term of free textbooks until 1937–1941. Transition to a twelve-year public school system was not completed until 1954.[78] In 1874 the General Assembly set aside land to endow a public institution of higher education. This was the beginning of the University of Georgia. Private colleges and universities began in various parts of the state.

In 1931 the general assembly simplified the operations of the executive branch of government by establishing the Board of Regents of the University System of Georgia to govern the 26 public institutions at the time. This system remained in effect until the 1980s.[79]

Georgia education had survived the Great Depression. Its education institutions, its youth, and its legislation were even stronger as they entered a new decade. Wecter reported that by 1940 one out of every six or seven college-age students attended some college. This was a record for the nation and the world. The National Youth Administration (NYA) was one of the federal programs that had helped make higher education possible for many in the state and nation during the Great Depression.[80]

Education in both remote and crowded areas, for young and old, for rich and poor, was a goal in the state of Georgia. The numbers and the photographs of the decade show the progress of the state toward this goal. The census was able to report that illiteracy (which was 27 percent in 1870) had dropped to about 2 percent by 1940.[81]

Health

The *Report on the Economic Conditions of the South* described the South as a "belt of sickness, misery, and unnecessary death." The *Report* noted that ill health affected "even the height and weight of school children."[1] Certainly hunger was widespread.[2] Federal photographers in Georgia documented the position of health care in the state.

I. History of Health Care and Public Welfare in Georgia until 1931

Beginning with Hammurabi's ancient codes to present, one criteria of a successful government is the value it places on the welfare of its own people.

Accommodations for those unable to care for themselves: Local responsibility. One of the reasons for the initial founding of the colony of Georgia was the welfare of people. A philanthropic purpose of the new colony was to give the worthy poor an opportunity to earn a living and to support themselves. The Georgia colonists expressed their concern for children by establishing an orphanage at Ebenezer (1737) and at Savannah (1740).

The care of the poor was a local responsibility for the first two hundred years of Georgia's history. This principle had its origin in the 1601 Elizabethan Poor Law, which gave the responsibility of the poor to the parishes. Parishes, then, had to provide the able-bodied with work relief, those who were unable to work with direct relief, children with apprentices, and workhouses for the unemployed. Through these services, the parishes could ideally repress begging.

Georgia's early laws designated the county to be the administrative unit for public welfare. This provision enabled counties to levy a tax to finance services and to purchase a farm for paupers. The people later called the almhouses that many counties established "the county homes"; these institutions served the poor, aged, and otherwise needy persons. Some of the money to support these county homes could come from the taxes raised, but the county could also recover the funds needed from individuals, if possible. The laws clearly established the levels of responsibility for funding. First responsible was the individual; the levels progressed to the immediate family, the relatives, and the county itself.

As the population grew and as material wealth increased, an optimism that common action could work better than the state grew. Reformers led crusades to improve society and rehabilitate the citizens. The causes of temperance, abolition, humane treatment of the mentally and physically ill, public education, and suffrage became increasingly important to Georgians and Americans.[3]

Accommodations for those unable to care for themselves: State responsibility. With increased population, state institutions

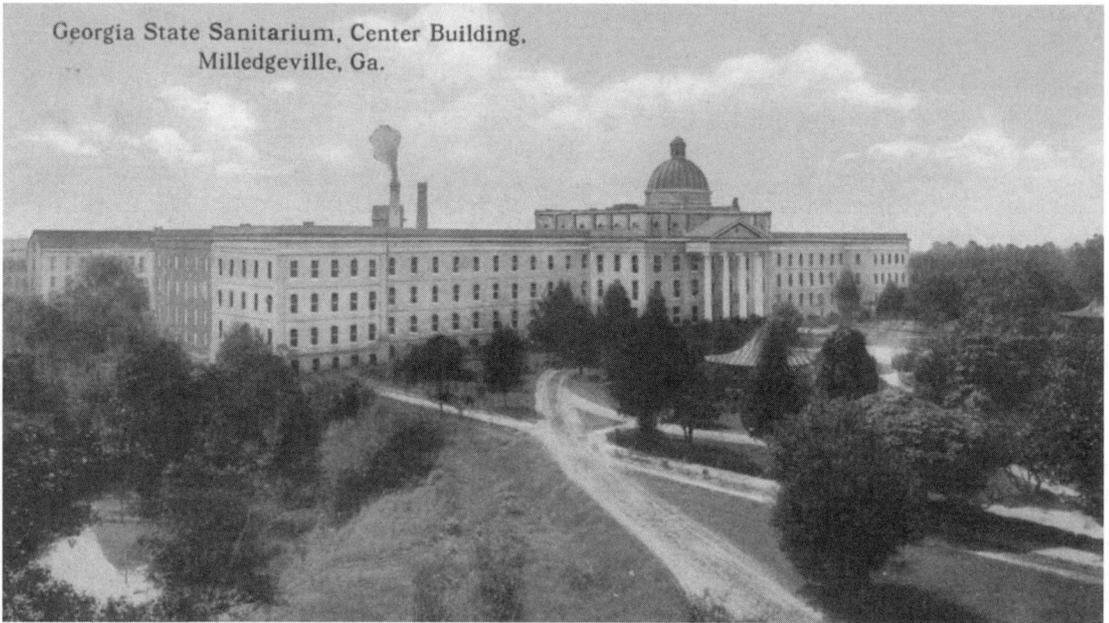

Georgia State Sanitarium, Center Building, Milledgeville, Ga.

C.H. WOOLTEN, MILLEDGEVILLE, GEORGIA. A C.T. PHOTOCHROME CARD.

A postcard of Georgia State Sanitarium, Center Building, Milledgeville, Georgia, mailed in 1914.

became necessary to provide adequate care. Georgia adopted the nation's first criminal code in 1816 and opened a penitentiary for the humane treatment of its prisoners. Some of the radical measures instituted in prisons included Sunday school, yard privileges, industrial activities, and even systems of rewards and punishment. Other of Georgia's state institutions included the Georgia Lunatic Asylum (1842), the School for the Deaf and Dumb (1845), and the School for the Blind (1852).

The state institutions in Georgia were small in the beginning; the state penitentiary, for instance, had only 160 prisoners in 1841. The purposes of these institutions included removing some of the burden from the individual counties and providing specialized care for the individuals. There were, however, those who opposed the establishment of state facilities. The dissenters argued that state responsibility replaced local responsibility and could result in the loss of local control. Another objection resulted from intolerance for those who were different. Many still believed, for instance, that demons possessed the mentally ill, the epileptic, and the retarded. Economic and political changes after the Civil War and Reconstruction compounded the problems.

Restraining government in social and economic matters. The state—for financial reasons—had to abolish the penitentiary and begin a penal system based on convict labor: "chain gangs." More about Georgia's prison system is available in chapter two, "Population."

The Georgia Constitution of 1877 sought to restrain government intervention in social and economic matters. The resulting inadequate financing effectively prevented treatments at those state institutions; old age facilities and institutions for the mentally disabled became places to dump people by the thousands. Abuse, overcrowding, and understaffing of these facilities continued well into the twentieth century.

Georgia Board of Health. A board of health came into existence in 1875, but the legislature voted to discontinue funding in 1877. In 1903, a re-created board of health received $3,000 per year.[4] By 1919 Georgia had nine different state institutions, and many county facilities that operated in a nonsystematic manner. The need for welfare continued, but there was no central administrative board to oversee services needed or already offered.

Central Welfare in Georgia. Georgia was

one of the last of the states to establish a central welfare authority. In 1919 the legislature created a board of public welfare; this unpaid agency visited charitable institutions, collected information on the "dependent, defective, and delinquent classes," and submitted its findings to the governor. The board could only advise and, of course, not mandate changes.[5]

II. Georgia's Health and Public Welfare under Richard B. Russell, Jr., Georgia Governor from 1931 until 1933

In 1931 the state of Georgia, under Governor Richard B. Russell, Jr., began to reorganize its government. Georgia abolished the separate boards of the state institutions and created a Board of Control of Eleemosynary Institutions; this agency had responsibility for general policies for the state facilities. The state itself, however, contributed nothing to the direct relief of indigent individuals, took no part in general relief activities except to encourage counties, and sponsored no general welfare services. The counties and municipalities continued to provide the direct welfare services; organized county public welfare departments remained extremely rare.

The federal government, public welfare, and public health during the 1930s. The Great Depression created social conditions unlike those at any other time in America's past. Under President Franklin Delano Roosevelt, whose inauguration was in 1933, the nation began almost immediately to develop social welfare programs, like the Civilian Conservation Corps (CCC). Further information on the CCC is available in chapter one, "Water, Soil, and Industries." The national government used the CCC to provide relief through Social Security and through work programs to train and hire unemployed workers; the federal programs that hired the unemployed included the CCC, the Works Progress Administration (WPA), and work programs of the WPA. Many of the leaders in Georgia government, however, were reluctant to endorse these programs.[6]

III. Georgia's Health and Public Welfare under Eugene Talmadge, Georgia Governor from 1933 until 1937

Even with the changed conditions in society, many Georgians resisted federal aid. They continued to endorse local responsibility for public welfare. Even with thousands of unemployed Georgians without means of support in agricultural and industrial areas, Georgia's state government did not accept all the federal help offered.

The unemployed masses in Georgia at this time usually had two immediate needs: employment and funds for survival. The numbers and needs of the unemployed and their families increased as the Depression continued. Churches, private agencies, individuals alone, and the local government proved inadequate to help these needy Georgians.

Even with the needs within the state, Governor Talmadge vehemently opposed federal aid.[7] Georgia divided into two factions: Talmadge and anti–Talmadge. The faction that followed Talmadge generally opposed federal and state public welfare programs. In 1935 Talmadge vetoed the amendments to the state constitution that would have allowed Georgia's participation in Social Security.[8]

When Georgia began accepting some monies, Talmadge did not always use the federal funds as designated and was indeed reluctant to accept the monies in the first place. More information on these problems with federal programs in Georgia is in chapter one, "Water, Soil, and Industries Based on the Natural Resources." The federal government appointed Georgia social worker Gay Bolling Shepperson to direct the federal relief programs in Georgia after problems arose.[9]

Organized public welfare departments in Georgia were rare even as late as 1935. Only five of the largest cities— Augusta, Savannah, Macon, Atlanta, and Columbus— had organized public welfare departments; out of Georgia's 159 counties, only 15 had organized public welfare departments. The county commission or ordinary (probate judge) directed the relief

funds; in some cases, one individual might serve as the only commissioner. Even after the organization of the welfare funds, the county commissioner continued to exercise control over the pauper lists and "pauper funds."[10] The size of the monthly pensions "might depend on the financial condition of the county or upon the standing of the citizen who assisted the pensioner in getting on that list."[11] Once an individual "made" the list that person usually remained on the list until death.[12]

IV. Georgia's Health and Public Welfare under Eurith D. Rivers, Georgia Governor from 1937 until 1941

In 1937 the newly elected Governor Eurith D. Rivers led Georgia in a new direction. During Rivers' terms as governor (1937–1941), the state legislature passed laws enabling Georgians to participate in Social Security. Related legislation enabled counties and the state itself to levy taxes to supply the matching funds necessary for the receipt of federal funds for aiding the aged, the disabled, and dependent children. The same year — 1937 — Georgia prison reform began; a new penitentiary opened at Reidsville.[13] More information on prison reform is available in chapter two, "Population."

When Rivers signed the 1937 Welfare Reorganization Act, he authorized the formation of the State Department of Public Welfare. With legislation in place, Georgia was able to begin its participation in federal relief programs. Many referred to the Reorganization Act as Georgia's "Little New Deal." The new legislation stated that Georgia had a responsibility to work with the federal and local governments to provide services to its citizens. To provide services to the blind and aged, the counties were responsible for 10 percent of the benefits, the state for 40 percent, and the federal government for the remaining 50 percent.

The proportions for aid to dependent children were slightly different: 10 percent from counties, one-third from the federal government, and the rest from the state. The "Little New Deal" prescribed that each county have a properly comprised welfare department and uniform eligibility requirements in order to meet federal standards. The administration of the benefit programs was to be through a uniform structure.

The Georgia State Department of Public Welfare, under the "Little New Deal," would assume all welfare functions that the county government and several other state agencies had previously performed. The Georgia State Department of Public Welfare would supervise public aid and assume the operations of the state institutions for the care of children, the aged, and the disabled. In its first year the Georgia State Department of Public Welfare provided services to 14 percent (96,638 families) of the 652,793 families identified in the 1930 census.[14]

V. Georgia and the Three "Lazy" Diseases: Pellagra

Kirby notes the shortened and uncomfortable lives of many Southerners and describes them as "a corn-and-pork-consuming folk":

> Had the corn been leavened with other vegetables, and had the pork been lean instead of fat, they might have been healthy. But tradition, ignorance, and especially economic circumstances permitted in the main a diet only of "white" food — that is, fat pork; corn in the form of bread, or "pone," fried in pork grease; and molasses made from corn or sorghum. This diet was central to what Rupert Vance termed the "cotton culture complex," but it ... [existed] to varying degrees outside the cotton-growing areas, too. During the late 1920s, Vance found, the "maize kernel" constituted 32.5 percent of all the food intake of southern blacks. The figure for whites (which Vance did not report) must have been near this....[15]

Kirby reports that

> southerners of both races relished corn and pork and never apologized to outsiders. "We eat our hogs, fat-back and all," declared a ... sharecropper in 1938, "I like fat-back." He went on to relate a tale of a campaigning politician who promised the electorate beefsteak if he were sent to Congress. "That kind er talk hurt him and lost him the precinct."[16]

Of course, despite Kirby's implications, necessity and the lack of money and availability of other foods made the "white diet" compulsory for many. It was this unbalanced diet that was to cause, particularly in the South, a great sickness: pellagra. Pellagra, however, was not fully understood by the general population of Georgia and the South until later.[17]

Pellagra in Milledgeville and Georgia in 1908. In Milledgeville at the Georgia State Sanitarium in 1908, the superintendent reported that the number one cause of death was tuberculosis. The facility reported forty cases of pellagra and twenty-three deaths in the one year alone; although Georgia State Sanitarium spent only thirty-seven cents per day for each patient, the administrators seemed not to make the connection between the disease and the monotonous, poor diet. The ages of the pellagra victims ranged from six to seventy-five; the dead were primarily female. The superintendent of the hospital wrote that the disease had probably occurred in the past, but there had been no name[18] for the disease of the four D's: dermatitis, diarrhea, dementia, and death.[19] Unsure of the cause of the disease, Georgia State Sanitarium experimented with salvarsan, which caused fevers, chills, and sometimes convulsions. Other experiments treated the pellagra victims with arsenic.

Dr. William F. Lorenz, Dr. D.G. Willets, and Dr. Joseph Goldberger. In 1914 Dr. William F. Lorenz, a physician from the Wisconsin State Hospital, came to Georgia State Sanitarium to investigate the cause of pellagra; Lorenz studied the victims for seven months. The year of his arrival, the sanitarium had 365 cases of pellagra with 190 deaths—an average of one death every other day for a year. Dr. D.G. Willets joined the study after about three and one-half months, and the conclusions of the study were that pellagra caused mental manifestations and that the mental disturbances were similar to that of acute alcoholism. The two concluded that a toxic substance might cause pellagra.

Dr. Joseph Goldberger, the surgeon in the United States Public Health Service, made several trips throughout the South, visited sanitar-

iums, and observed victims of the disease. His first study was at Georgia State Sanitarium in Milledgeville. He found enough evidence of the relationship between improper diet of the inmates and pellagra to announce in 1914 that pellagra was the result of a faulty diet.[20]

In 1915 pellagra at Milledgeville reached a new height. There were 433 cases and 220 deaths from pellagra in that year alone at the Georgia State Sanitarium.[21] Goldberger and his assistant, George Wheeler, conducted "filth parties" to convince the skeptics that pellagra was not contagious. On April 26, 1916, they shot 5–6 cubic centimeters of blood from infected pellagra victims into their own bodies. Goldberger's wife, Mary, even submitted to the inoculations. They swabbed secretions from the noses and throats of pellagra victims and rubbed the secretions into their own throats and noses. They put scabs from the rashes of the victims into capsules and swallowed them. None of the three became infected with pellagra.[22]

By 1920 the Public Health Service—with the valuable help of Goldberger's research—had new information on pellagra. The health care workers experimenting with pellagra had learned "how to prevent it and how to cure it, and, at the Georgia State Sanitarium, they had begun a systematic search for the mysterious missing quantity in the Southern diet."[23] The pellagra preventive (P-P) was a proper diet. One of Goldberger's experiments was to feed inmates in the Georgia State Asylum meat, milk, and fresh vegetables instead of a corn-based diet; the dramatic result was pellagra victims who recovered on the balanced diet. Skeptics called the experiment a fraud; believers talked of a Nobel Prize nomination.

With the hard times in the South in the 1920s the pellagra cases spiked. Goldberger predicted 100,000 cases and 10,000 deaths from pellagra for 1921; his shared predictions of famine and plague for the South were correct. Still the public did not believe.[24]

The year of 1921 was the midpoint of the fifteen year study that Goldberger conducted. He wrote home in late September of 1921 of his conclusions that diet was the cause of the disease: "We have found a road which ... will

come close to nailing pellagra's old hide to the barn door."[25]

Southerners' reactions to the pellagra study. Many Southerners felt insulted by Goldberger's suggestions. They denied the increase in pellagra. They did not like Goldberger's predictions or his pleas for relief, supplies, and hospitalization for the poor: "They believed that Southern pride and Southern prosperity were on the line."[26] Goldberger's findings "challenged the economic and social structures that were the cultural backbone of ... the South."[27] He found a correlation between income and pellagra; the poverty on the farms, in the state institutions, and in the mill villages often accompanied the disease. Pellagra was a disease of the poor. Some enraged Southerners protested that the negative characterization of their area would discourage tourism and investments. Politicians had a vested reason in not emphasizing the problems.

Georgia's Congressman W.C. Wright emphatically said that there is "no grim and gaunt specter of famine ... walking abroad in the Empire State of the South."[28] He noted that any state that had been able to survive the boll weevil and the drop in the price of cotton could solve its problems and did not need outside help. One Georgia city in the southern part of the state telegraphed Georgia senator Tom Watson to say, "When this part of Georgia suffers from a famine, the rest of the world will be dead."[29]

Final results of the pellagra study. Goldberger continued his research to identify the "pellagra preventive factor." He learned that brewer's yeast prevented the disease as effectively as and even more economically than meat, milk, and vegetables. He was not to complete his study, however; he died on January 17, 1929.

It was Conrad Elevjhem who found that a deficiency in niacin — a B vitamin — caused a similar disease in canines. Tom Spies found that nicotinic acid could cure the dreaded disease of pellagra, one of the South's three "lazy" diseases. Tulane University scientists found that an amino acid called tryptophan was a precursor of niacin; their experiments showed that when tryptophan was added to bread, it

could prevent pellagra. These findings helped relieve the suffering of many people — especially Southerners — who were afflicted by a disease of poverty: pellagra.[30] Doctors in the field found that those with pellagra often had other nutritional deficiencies. Nicotinic acid, however, drastically reduced the death rate from pellagra. Nicotinic acid was introduced into the population in 1937.

Pellagra statistics in the 1940s. In 1940 there were 2,040 deaths from pellagra in the United States. By 1945 the deaths from pellagra had dropped to 865.[31] In 1943 Georgia reported 208 pellagra cases and 175 deaths from the disease. Elizabeth Etheridge doubted, however, that "the disease was so much more fatal in Georgia"; he also questioned if the number of cases was accurate for that year.[32] The incidents of pellagra had begun to decrease. In 1940 there were 9,000 pellagra cases across the nation. By 1945 that number was less than half.[33]

The pellagra epidemic lasted from 1906 to 1940, according to Henderson. The South was hit hardest, as were African American residents of the area. The work of Goldberger and others, however, helped bring about relief from the problem.[34]

Planning diets wisely. Even those with some income might not plan their diet wisely. With the beginning of some financial assistance, many Georgians received the first income they had had in some time. Even with this money, many recipients did not know how to spend the money wisely and plan their diet properly; others were able to have variety in their diets.

Jimmy Carter reported:

> I once made a summary of Daddy's old store accounts for 1929 and 1930 and found that the average customer spent fifty-two cents of every dollar on food, of which twenty-four cents went for flour or meal, eleven cents for lard, ten cents for meat, five cents for coffee, and two cents for molasses. For an entire family with an expenditure of less than a dollar a day, this was all they could afford, because they also had to buy kerosene, matches, salt, turpentine and castor oil for medicine, and *always* the snuff and tobacco. Even the poorest bought a can of Prince Albert or Sir Walter Raleigh smoking tobacco, Brown's Mule chewing tobacco, or some CC, Buttercup, or Maccoboy

snuff almost every time they came in the store. Only the more affluent customers who traded with my father bought such luxuries as ready-made cigarettes, cheese, macaroni, peanut butter, grits, canned salmon, tea, starch, socks, or gloves.

More than anyone else in my family, perhaps even including my father, I could understand the plight of the black families, because I lived so much among them. During most of the year they ate only two meals a day, usually cornmeal, fatback, molasses, and perhaps sweet potatoes from our common field. The more industrious families also had small gardens that provided some seasonal corn, Irish potatoes, collards, turnips, and cabbage, with a few rows of running peas and beans planted alongside the garden fence. The combination of constant and heavy work, inadequate diet, and excessive use of tobacco was devastating to the health of our poorer neighbors. With the exception of a few very old women who could no longer do fieldwork, I don't remember any of the tenant-family members being the least bit overweight.[35]

Women's clubs, extension classes, and home-makers clubs helped by providing programs on nutrition. Community canneries and clubs contributed to the improved diets among the population—if women had the time and means to attend. The Home Demonstration Clubs throughout the state helped to guide homemakers in the components of a healthy diet and in how to plan nutritious menus for a family even on a limited income. These clubs helped teach the Georgians how to preserve food safely.

VI. Georgia and the Three "Lazy" Diseases: Hookworm

As late as 1956 Turner reported that hookworm disease (ancylostomiasis) caused by the *Nector americanus* was still a common

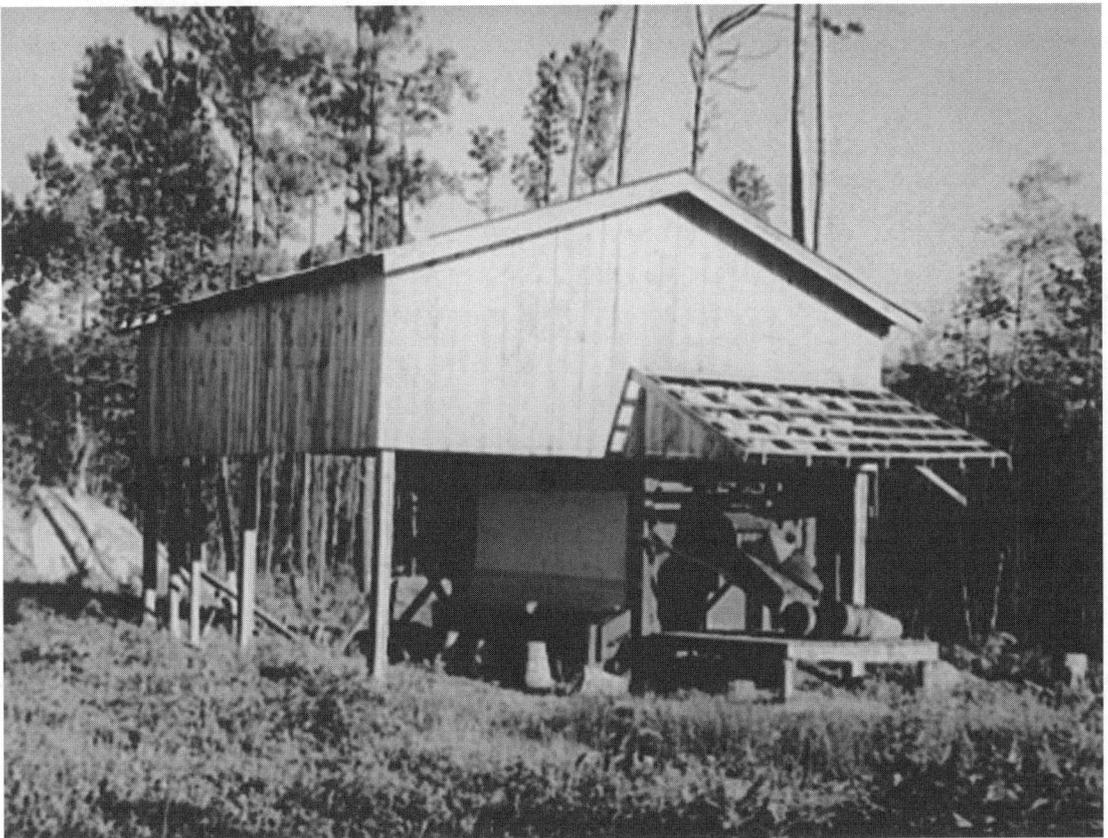

A community canning kitchen in Wolf Creek Farms, Georgia, September 1935. Photograph by Arthur Rothstein, Farm Security Administration.

occurrence — particularly in the southeastern parts of the United States.[36] Its occurrence in the South in the 1930s was a major health hazard, particularly to the children.

Pathology. Infection with the intestinal parasite *Nector americanus* can create serious health problems for newborns, for children, for pregnant women, and for people who are already malnourished. The research on pellagra in the South in the 1910s, 1920s, and 1930s indicates that many Southerners indeed had an inadequate diet for health.

Infestation of hookworm victims came from direct contact with contaminated soil or with the larvae themselves. The most common ways of contamination included walking barefoot through the affected dirt — a common practice in the warm South — or ingesting the larvae through improperly cleaned vegetables grown in the soil, not washing one's hands after working or playing in the dirt, or drinking from an unclean water supply. Proper sanitation provisions were crucial to good health of the citizenry. Tenants and farm families in

the 1930s considered themselves fortunate if they had a privy; many times, however, the family forgot to wash their hands by the time they left the privy and reached a water supply.

In warm, moist, shady soil, hookworm eggs hatch into larvae.[37] These barely visible larvae can penetrate the skin — often through the feet. The site of entry usually produces an itchy rash, which those who are familiar with the inflammation often call "ground itch." The infected person may sometimes develop open sores around the places of entry — usually the ankles or legs. These open wounds seem to appear with no apparent cause and are difficult to cure on the outside of the body.

People in the South often referred to these slow-healing areas as "fall sores" or "dew sores." These common references indicate that the sites often contacted the morning dew and were more severe in the fall after a summer of exposure to the hookworm. "Fall sores" and "dew sores" suggest the explanations that the victims were using for the presence of conditions they did not understand. The small

A tenant farmer's privy in Irwin County, Georgia, May 1938. Photograph by John Vachon, Farm Security Administration.

LC-USF 33-T01-001133-M3. LIBRARY OF CONGRESS, PRINTS AND PHOTOGRAPHS DIVISION, FSA-OWI COLLECTION

parasites, the actual cause of these sores, were unknown to most Southern residents.

What was going on inside their bodies was not as evident to the hosts of these worms. The larvae that entered the body pass through the lymphatic system to the blood stream. After the blood moves the larvae to the lungs, the larvae pierce the walls of the air sacs, pass through the breathing tubes to the mouth, are swallowed, and eventually reside in the small intestine. This long journey takes only a week. If the larvae are swallowed through contaminated water or food or are placed directly in the mouth, their journey is shorter and takes even less time because the larvae go directly to the intestine after being swallowed.[38]

The length of the worms from the larvae are about one-half inch long; these worms attach themselves to the walls of the intestine and suck the blood of the victim. Anemia, abdominal pain, weight loss, diarrhea, appetite loss, difficulty breathing, enlargement of the heart, and irregular heartbeat can result. A common symptom is lethargy — hence the name "lazy disease."

An adult worm can produce thousands of eggs, which the host excretes. If the excretion contaminates the soil and if the conditions are right, the eggs can develop into larvae.[39]

Dr. Benjamin Washburn. Dr. Benjamin Washburn, a Carolina native and traveling doctor in the mountains of the South, gained international recognition in his fight against hookworm. Dr. Benjamin Washburn's first book was *A Country Doctor in the South Mountains*; the book tells of his time in mountain practice before joining the Rockefeller Sanitary Commission to help in its campaigns against hookworm disease. The commission served the state, the nation, and the world.[40]

Washburn later regretted he had not hypothesized more about those whom he treated. He did not realize at the time that the "dew sores" or "fall sores" were actually among the first stages of hookworm, a disease that he would help to eradicate.[41] Dr. Washburn attempted to help his state and nation by sharing his knowledge with others. He organized the Bureau of County Health Work of the North Carolina State Board of Health and be-

came health officer of Nash County, North Carolina; Nash County was one of the first counties of the United States to provide full-time health service.[42]

From 1915 until 1939 Washburn was an officer of the International Health Division of the Rockefeller Foundation and served in the United States, Trinidad, Jamaica, the West Indies, and Central America.[43]

Prevention and treatment of hookworm. Health departments, the Home Demonstration Clubs, doctors and nurses, and publications helped to educate the public as to the cause, symptoms, treatment, and prevention of hookworm disease and to advocate for adequate sanitary provision; these were important in decreasing the incidence of this "lazy disease." Education was important for a populace that had no knowledge of the significance of "ground itch," "dew sores," or "fall sores." A 1937 report showed that only 170 out of 593 incorporated Georgia towns had public sewer systems; only one out of four of the state's rural

Dr. Benjamin E. Washburn (about 1950).

homes had any means of sanitary sewage disposal.[44] With education, sanitation, and improved treatment, and as more people wore shoes, the incidence of hookworm disease began to decline in Georgia, the South, the nation, and the world.

VII. Georgia and the Three "Lazy" Diseases: Malaria

Life — especially in coastal Georgia — includes cold weather. In 1735 Pastor John Martin Boltzius, who lived 20 miles upriver from Savannah, reported about that insects gave "much discomfort" to the people of the Georgia colony. The colonists also suffered from "fever and ague," which were most likely symptoms of malaria.[45]

Incidence of malaria in the South. In a 1938 letter to President Franklin Delano Roosevelt, the National Emergency Council described malaria as being a problem in the South. The letter stated that the disease reduced the South's industrial output by one-third. With more than 2 million Southerners affected yearly by the disease and with a deficit in hospitals, clinics, doctors, and other health workers, the problem was further intensified.[46]

Malaria was one of the three afflictions that Jack Kirby called "lazy diseases" and identified as being of particular concern in the South. During the 1930s and earlier — particularly before the days of insect sprays and bug killers— mosquitoes were very common in Georgia, with its mild, normally moist summers. Many people developed chills and malaria from the bite of the infected *Anopheles* mosquito. The only way at the time to treat the high fevers, quell the chills of the disease, and slow the growth of the parasite contracted from the mosquito bite was to use a bitter medicine called *quinine*. Some pharmaceutical suppliers tried mixing iron, lemon, sugar, and quinine for a more palatable product. [47]

As late as 1940 Georgia was still one of the top three states in deaths from malaria. The disease had affected residents since colonial times, but the state lacked the funds to control

the malaria until the federal government helped with the funding in the 1930s. By 1950 the disease was almost nonexistent in the state.[48]

VIII. Poliomyelitis

The salutary waters in Warm Springs, Georgia, were well known to President Franklin Delano Roosevelt, who had suffered a severe attack of poliomyelitis in 1921; the disease left him unable to walk unassisted. The cottage he had built at Warm Springs took the nickname "The Little White House." The Little White House where he died is now a national memorial. Chapter one, "Water, Soil, and Industries Based on Natural Resources," carries more information on Warm Springs, Georgia.

In the 1930s many victims of polio knew the services of the iron lung. The iron lung was a "difficult, tedious, and frequently frightening" aid for polio victims. No cure was available for polio victims during the Great Depression; no prevention was possible during the decade of the 1930s. Roosevelt established the Georgia Warm Springs Foundation to help other victims of the disease. In 1935 vaccine trials of 17,000 children brought death to six and polio itself to twelve. A vaccine nasal spray developed by Edwin Schultz brought a permanent loss of the sense of smell to many of the 5,000 children tested. Public concern for treatment and prevention continued. The National Foundation for Infantile Paralysis, created in 1938, had as its first president Basil O'Conner and as a radio spokesperson Eddie Canter. Canter coined the term "March of Dimes" and urged listeners to send their dimes to the foundation in the name of President Roosevelt.[49]

IX. Venereal Diseases, or Sexually Transmitted Diseases (STD)

From the time that records have preserved health data, and probably before, sexually transmitted diseases (STD) have plagued

This postcard shows President Franklin D. Roosevelt in his specially-equipped automobile.

AUTHOR'S COLLECTION. A "GENUINE CURTEICH-CHICAGO" CARD.

people. These "prime wasters of manpower" seem to have been particularly prevalent in Georgia during the Great Depression, according to the records of the Census Division of the United States in 1941.[50]

Georgia had long sought to eradicate communicable diseases from the population. By 1883 two Georgia quarantine stations — one at Blackbeard Island and one on Sapelo Sound — were in operation for ships' crews; venereal disease had a high incidence in these crews. The two stations were a part of the South Atlantic Quarantine Region.[51]

The prevalence rates of syphilis per 1,000 of the general Georgia population was 61; this was the fourth highest incidence in the nation. Only Florida, with 77 per 1,000, the District of Columbia, with 68 per 1,000, and South Carolina, with 69 per 1,000, ranked higher than Georgia in disease incidence.[52]

The prevalence rates of STDs among those entering service was even higher than that of the general population. In 1941 the prevalence of syphilis among the first million selectees and volunteers was higher than among the general population. Considering only the STD of syphilis, Georgia had the fourth highest incidence of syphilis in the nation. Florida had a rate of 170.1 per 1,000; South Carolina had a rate of 156 per 1,000; Mississippi had a rate of 143.9 per 1,000; and Georgia ranked fourth in the United States with a rate of 132.9 per 1,000.[53]

Thomas Parran, the chief of the Division of Venereal Disease of the Public Health Service (1926–1930) and the surgeon general (1936–1948), was a strong international and national leader in public health. He used public education as a primary means to fight against venereal disease. His work to strengthen and to extend the research programs of the National Institutes of Health was noteworthy. Parran also helped establish the Communicable Disease Center (later the Centers for Disease Control and Prevention) in Atlanta, Georgia.[54] The reaction to Dr. Parran's attempts at education about "social disease" was shock that he should mention such a topic in public. In 1934 radio executives even forbade Parran to mention STDs on the air.

Still, Parran was determined to get his message across. He published an article on

syphilis in July 1936 in both *Survey Graphic* and *Reader's Digest*. The publishers sold about 2,000,000 reprints of his article. The public became even more accepting of hearing about and considering the problem in the days to come, especially when national leaders— both male and female — supported education and conferences about the topic. *Time* quoted Eleanor Roosevelt as remarking (1937) that she was "very glad to know that women are taking part in the conference on social hygiene." President Franklin Delano Roosevelt's remarks were that "Attainment of your objectives would do much to conserve our human resources and would reduce considerably the present large costs for the community care of the disastrous results of the venereal diseases." Dr. Ray Lyman Wilbur commented in 1937 that victims of the social diseases would decrease only when each generation learned both how to avoid STDs and what to do if infected. [55]

An important first step in the eradication of STDs, then, was an awareness of the disease; the media seemed to be helping create this awareness. In 1939 Dr. R.A. Vonderlehr, who was assistant surgeon general with Surgeon General Parran, wrote a follow-up article three years after Parran's article in *Reader's Digest* and *Survey Graphic*. This follow-up article in *Survey Graphic* commented on the numbers of syphilis patients; the numbers appeared to be on the rise:

> Paradoxically, the increase in patients with early syphilis in the United States during the last few years is good evidence that the disease is beginning to be controlled. It shows that we are getting treatment into the large syphilitic patient load which formerly did not seek treatment at once.
>
> There is more concrete evidence of progress in another form. Facilities for the diagnosis and treatment of syphilis are being increased and expanded all over the country. Blood tests constitute the most important diagnostic measure in syphilis. The number of blood tests performed in state owned or subsidized laboratories rose from 2,400,000 in 1936 to 4,500,000 in 1938 and to 6,200,000 in 1939.... Such a phenomenal increase shows that hundreds of thousands more people are now being examined for syphilis than formerly....
>
> There is a record of about 800 free, pay, or part-pay venereal disease clinics in the United States three years ago, but today there are more than

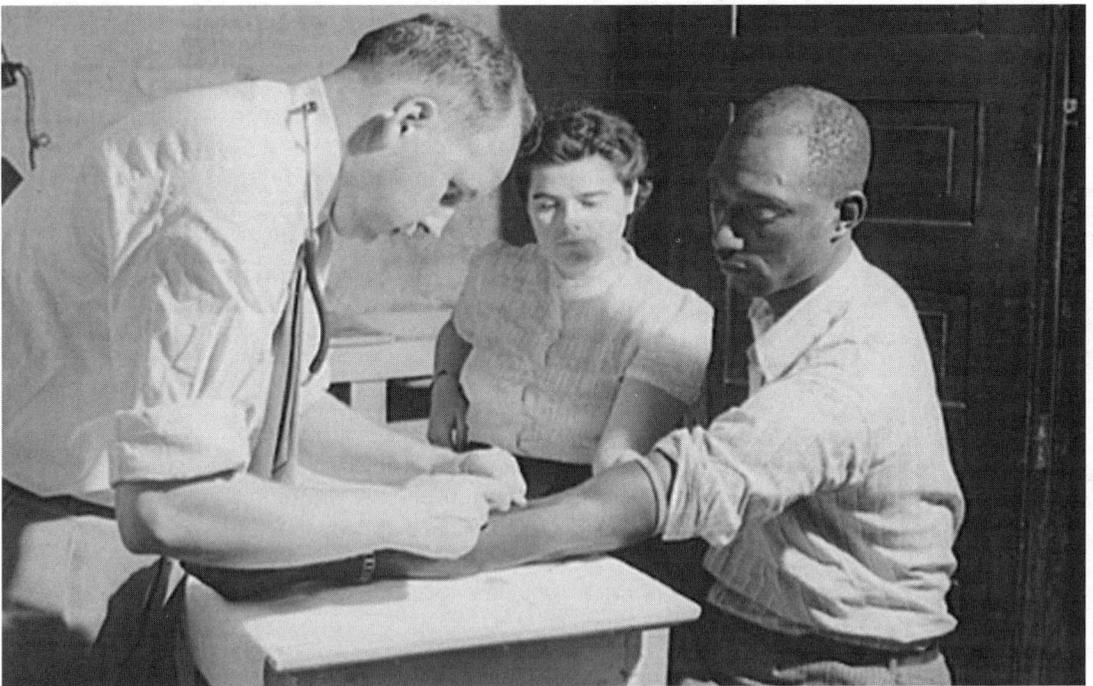

The venereal disease clinic in Union Point, Greene County, Georgia, June 1941. Photograph by Jack Delano, Farm Security Administration.

2400 treatment centers. In 1936, there were 3,350,000 treatments given in these centers, and 64,000 patients were discharged as arrested or cured. In 1939, clinic treatments numbered 8,000,000, and 103,000 patients were discharged as arrested or cured.[56]

In his article, R.A. Vonderlehr commented on a model project in Georgia: a mobile treatment unit in southeast Georgia. The unit had almost tripled the number of patients available for treatment and was much cheaper (one-fourth the cost) than staffing an office in areas with a low population density. Vonderlehr noted that seven other Southern states had followed suit.[57]

Georgia's national rank in syphilis cases remained relatively unchanged for the next 70 years. In 2000 Georgia reported 1,644 cases in the entire state; this gave it a rank of sixth in the nation in syphilis cases.[58] In 2001 Georgia reported 2,011 cases of syphilis, an increase from 2000. Its rank in the nation had moved from sixth to fourth, the same rank as in 1941.[59] The increase in cases of sexually transmitted diseases in Georgia between the years 2000 and 2001 suggests that Wilbur's advice to educate each generation is still important and that further education is still necessary in the twenty-first century. It might also suggest, as Vonderlehr noted, that more people are seeking treatment — a good sign, according to Vonderlehr. In any case, the disease is not extinct in the state.

X. Furthering the Health Care of Georgians

Fortunately, Georgia, the South, and the nation resolved to improve the health of their citizens.

The health of the child laborers of Georgia. As chapter two, "Population," indicates, the state and the nation passed various labor laws and programs that improved working conditions, provisions for caring for citizens, and, therefore, the health of children and adults. The health of children in Georgia had improved since the years following World War I. A reason was

The venereal disease clinic in Union Point, Greene County, Georgia, June 1941. Photograph by Jack Delano, Farm Security Administration.

the awareness and the seriousness of the problem; photography helped document the concerns. Lewis J. Hine helped with the documentation for a national audience; many of his subjects were children in Georgia.

Health care in Georgia. Georgia was

looking to the future, as well as the present, as it began establishing its health care programs. Venereal disease clinics continued into the 1940s. Because sexually transmitted diseases of the parents can affect the child, the clinics in the state attempted to diagnose any sexually

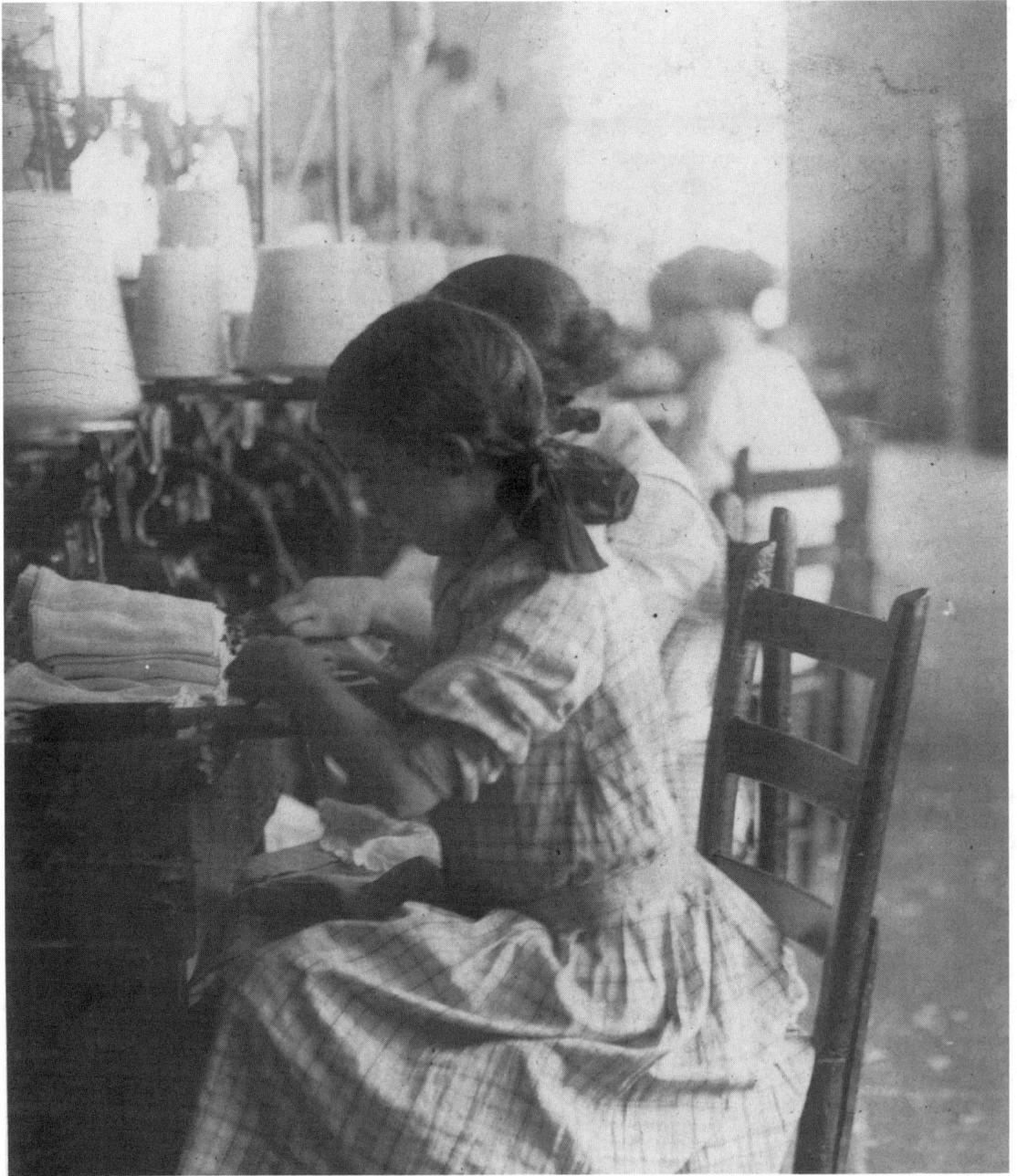

Topper at her machine at Walker County Hosiery Mills in Lafayette, Georgia, April 1913. Photograph by Lewis Wickes Hine, National Child Labor Committee.

transmitted diseases of the child and the parents and to treat any discovered infections. These clinics continued to be necessary.

Physical examinations, inoculations, and advice to families were an important part of the health clinic services. An important source of funds for this health care was the Venereal Disease Control Act of 1939. The United States Public Health Service would administer funds that would aid in the reduction of cases of venereal disease. The service had been making referrals about birth control for some time. The United States Public Health Service began to offer funds for venereal disease treatment and birth control in the 1930s. The Public Health Service said that it would give applications for "child-spacing programs" and venereal disease programs the same consideration that it would give other proposals for health programs in a state.[60]

Doctors. Doctors established offices in some Georgia towns, cities, and villages. Some towns were fortunate to have more than one doctor; one such doctor was Dr. W.T. Lewis. Doctors were less numerous in other towns and villages. In some projects a doctor visited the area only once a week; the crowds on clinic day indicated the need for health care.

Inoculations were a form of preventive medicine that many Georgians were beginning to choose. In some areas, however, house calls were a part of the service that Georgians might hope to obtain.

Midwives. During the 1930s many families used the services of a midwife when a baby was due. Primarily women, these assistants also helped families in time of other health needs or when a family member needed to be "laid out" after death. Midwives had long been a profession for women. In the Royal Period of Georgia (1775–1783) the Trustees had provided at public expense a midwife for Savannah — and later the northern and southern divisions of the colony. This was the only government position funded for a woman. The salary was five pounds per year plus an additional five shillings per "birthing." The requirements stipulated that these government employees must attend to indentured servants and the poor. To help ease the pain at these "layings," the Trustees provided an allowance for wine for women in labor.[61]

Childbed fever rates were lower among mothers who delivered at home than in a hospital. Unsanitized forceps and needles during the birth process and contagion from the sick and dying in the wards increased the infection and death rate at hospitals. There was also danger from "layings" at home. Among those attended by midwives there occurred a "high number of infant mortality and maternal morbidity. Tetanus being one cause of this, made it so that midwives were then forced to take shots and chest X-rays."[62]

By the 1930s midwives began to see changes that indicated that regulations would eliminate their profession. In Georgia licenses began to be available to the midwives. The first "granny midwives" who volunteered their names for the licenses thought the certificate would legitimize and legalize their work. It was not to be.

Classes began to be available. Upon successful completion of these courses, the midwives received a black bag in which to carry scissors, a scale, gauze strips, string for the umbilical cords, silver nitrate for the eyes of the baby, and blank birth certificates; illiterate midwives, however, often had difficulty completing the forms.

Although most midwives believed that completing these courses, obtaining the certificate, and receiving the black bag would provide status and prestige to their services, it began to be apparent that

> ... encouraging midwives to enlist their names was a deceiving method of the [Georgia] Department of Health to track who was practicing and where so they could be closely monitored and eventually retired. This encouraged more (young) women to apply for licenses (between the ages of 25–45). Some were not given a license either because of age, lack of practice, or failure to submit recommendations from two doctors. However, midwives in the most rural areas where there was no threat of competition were allowed to continue their practice without licensure. Of course, these areas were populated by predominantly blacks.[63]

Although many people had a bad image of the "granny midwife," nurses, too, were making home visits and attending births. These nurses often viewed poverty as being "dirty," but they

Dr. W. T. Lewis, one of the doctors in the town of Siloam in Greene County, Georgia, June 1941. Photograph by Jack Delano, Farm Security Administration.

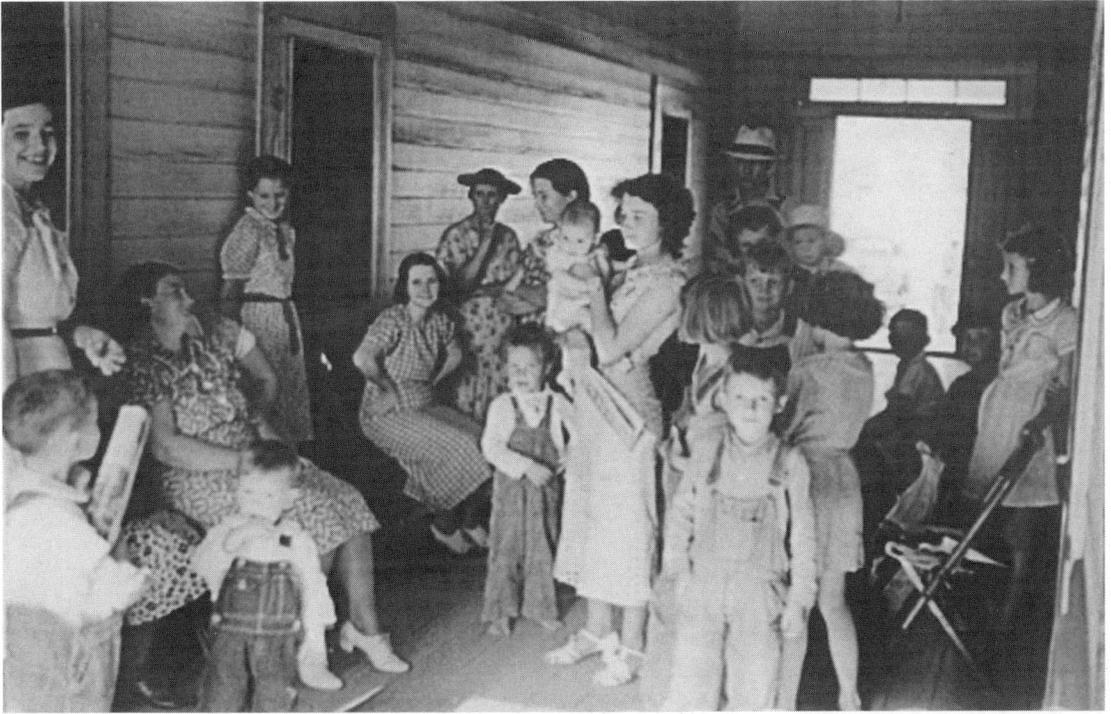

Women and children in Irwinville Farms, Georgia, waiting to see the doctor, who visited the project once a week, May 1938. Photograph by John Vachon, Farm Security Administration.

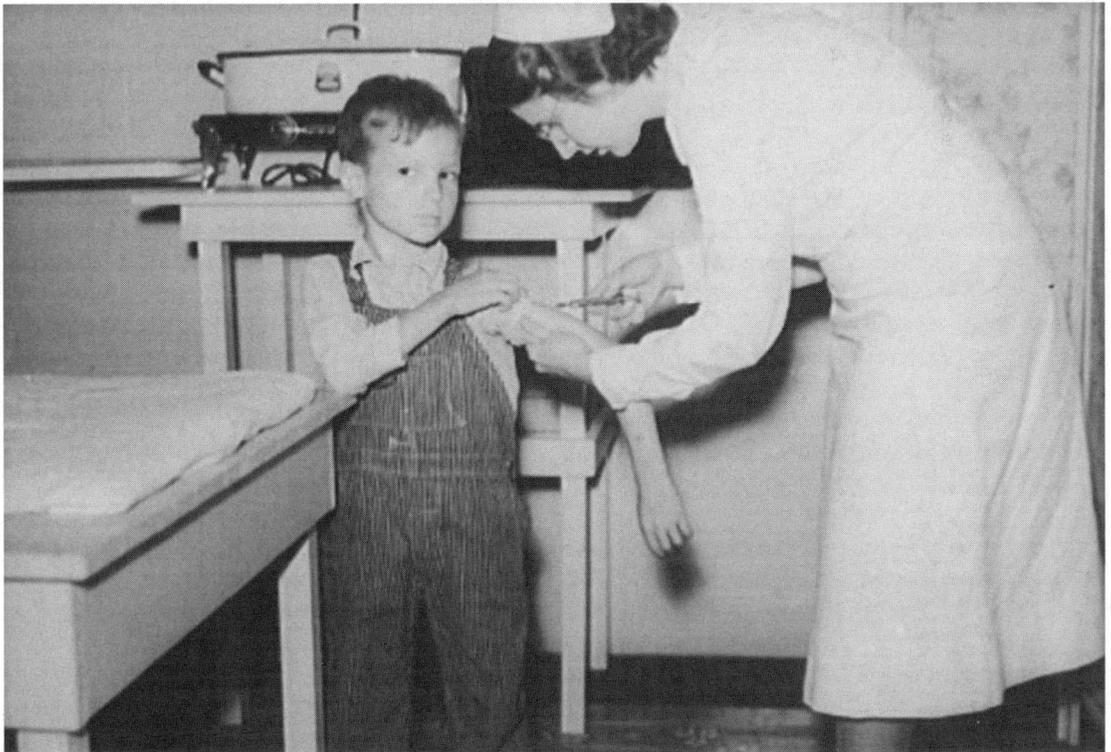

Inoculation for typhoid in the clinic at Irwinville Farms, Georgia, in May 1938. Photograph by John Vachon, Farm Security Administration.

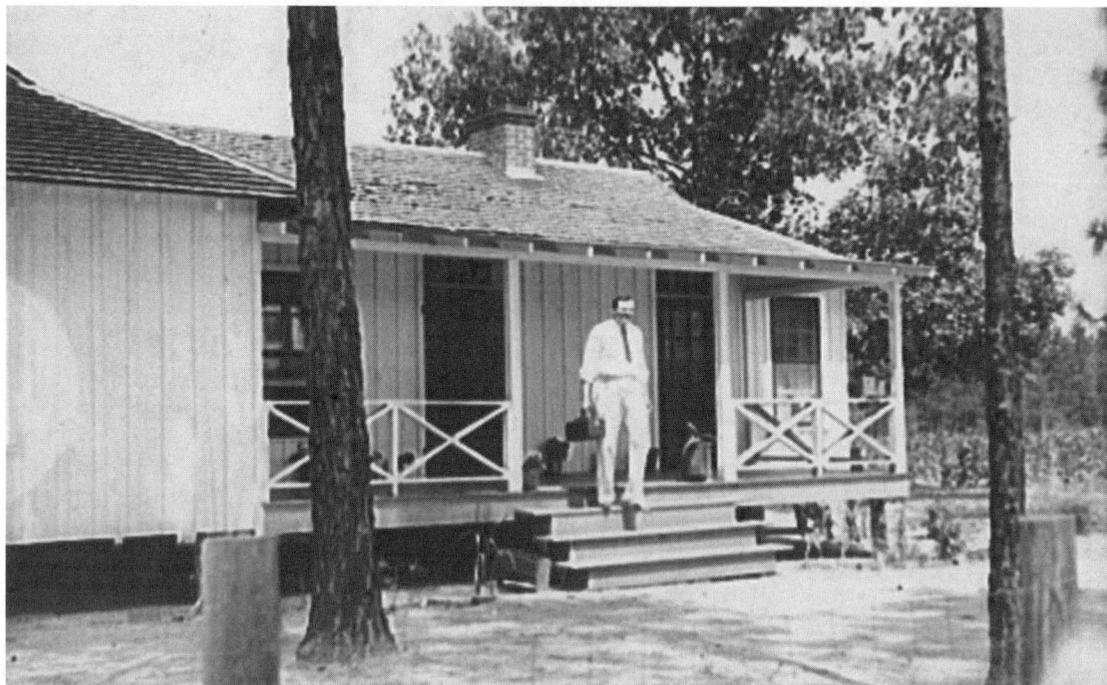

Dr. Herman Dismude of Ocilla, Georgia, leaving Grady Watson's home after treating a child, June 1936. Dr. Dismude, by special arrangement, took care of all residents of the Irwinville Farms resettlement project at reduced rates. Photograph by Carl Mydans, Farm Security Administration.

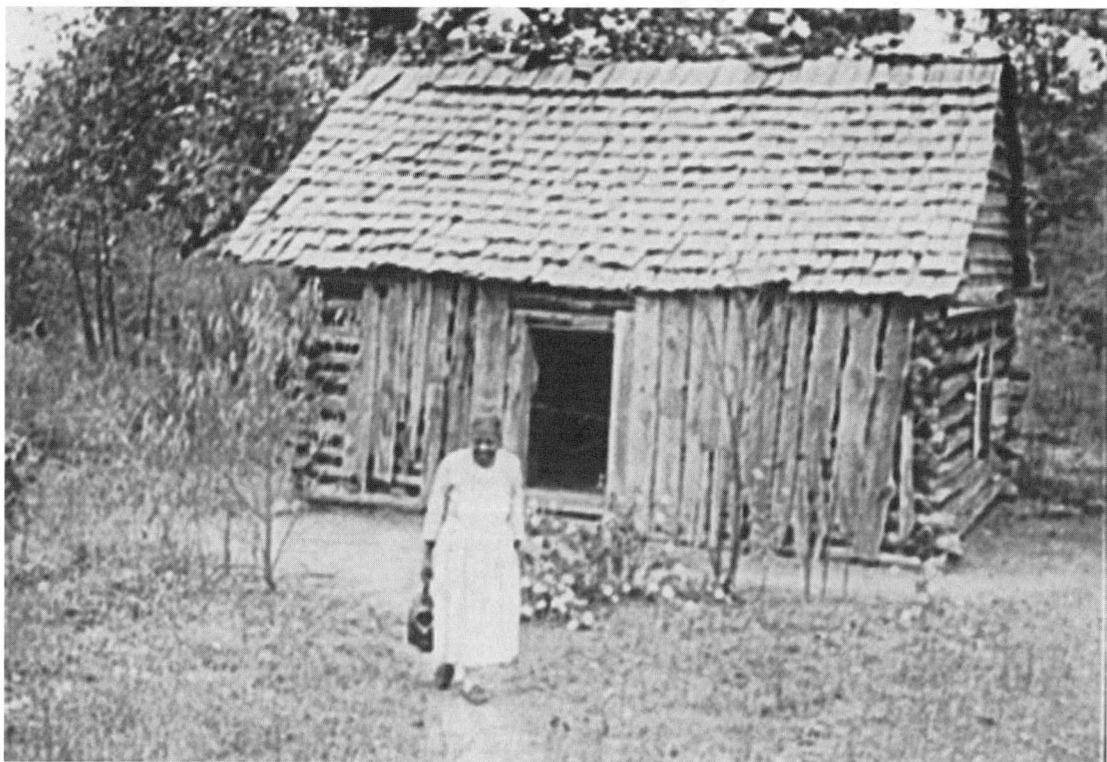

Midwife going out on a call near Siloam, Greene County, Georgia, in October 1941. Photograph by Jack Delano, Farm Security Administration.

soon found that this image in "most cases was not true. Most homes, although they did not have the appearances and the comfort of the other neighboring homes across the tracks, were kept clean and tidy even if newspaper was used to fill cracks in the wall."[64]

Remedies. Most Georgians in the 1930s visited or called the doctor as a last resort. First they usually tried the home remedies of their ancestors, the advice of older residents, the services of the midwives of the area, and the patent medicines before calling — and incurring the cost of — the doctor.

Some of these home remedies did indeed work. Washburn — mentioned earlier in this chapter — describes a case of facial paralysis in one of his patients. In order to obtain the prescription for *Tr. Cimicifuga racemosa* to treat this condition, a member of the family would have to go by horseback to the nearest drugstore, which was more than twenty miles away — a forty-mile round-trip. Because the patient had been recovering well with a tea made from the roots of "black crowhop," Washburn suggested that the patient continue with the home remedy. Later Washburn consulted his *materia medica* and found that the common name of *Cimicifuga* is "Black Crowhop" or "Black Cohosh." The folk remedy was the same as the prescription drug![65]

Had he been more observant, Washburn believed that he could have reported on the use of tannic acid for the treatment of burns long before the medical profession acknowledged this treatment. The members of the South Mountain community had traditionally used oak balls and oak leaves for wounds and burns; burns were common because women's clothes often caught fire near the flames around the wash pots. The oak leaves and balls were rich in tannic acid.[66]

Tobacco as a "remedy." Tobacco use was an important part of folk medicine that survived the passing of most other rituals. A "little snuff on a broom straw" placed in the mouth was the treatment of choice for nausea. To muster the strength for the final push in childbirth, midwives often "quilled" the mother-to-be. With quilling, the midwife placed the snuff on one end of a straw and

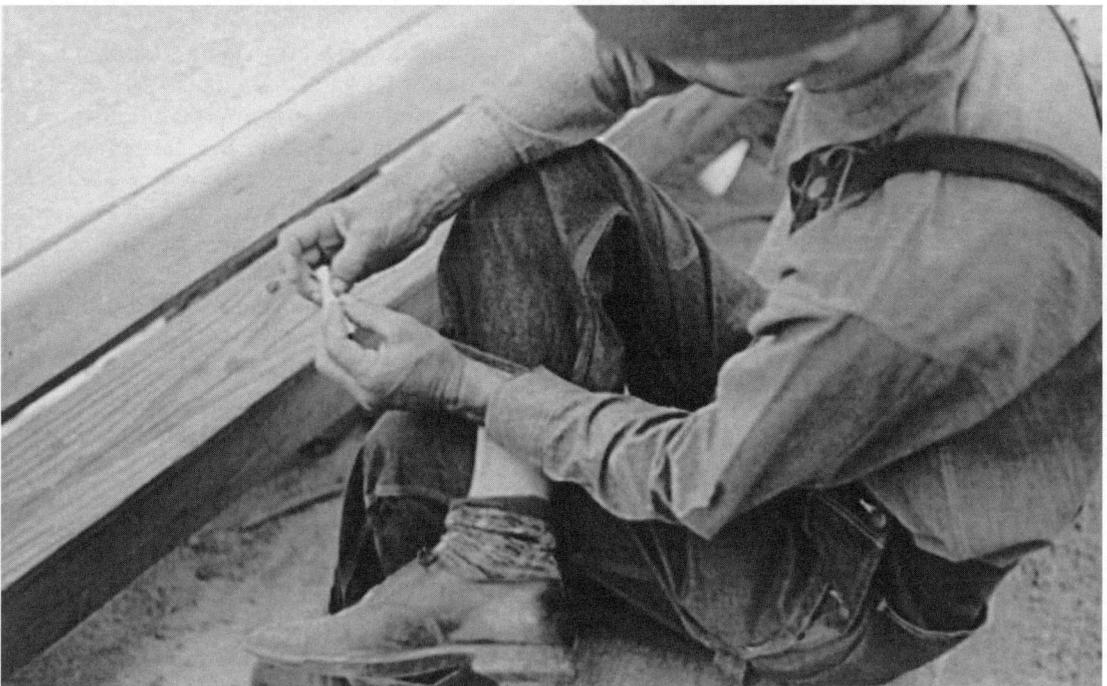

Rolling a cigarette, Irwinville Farms, Georgia, May 1938. Photograph by John Vachon, Farm Security Administration.

blew it into the nostril of the woman at the right time; the great sneeze that resulted from the woman was almost always accompanied by the birth of the child. Midwives practiced quilling well into the 1930s.[67] Washburn and many other doctors, however, condemned this practice that often resulted in the tearing of the mother during childbirth.[68]

During the decade of the 1930s rural people — especially those in the South — were able to buy cloth bags of loose, cut tobacco for cigarettes; they could "roll their own." The cost of these bags of tobacco was usually five cents.[69] Plugs of tobacco and powdered tobacco (snuff) accounted for the "lumped lip or swollen jaw" that travelers often noted in the rural South. Chewing tobacco and snuff "defined rural southerners"; urban Americans were beginning to exchange pipes, cigars, snuff, and chewing tobacco for cigarettes.[70]

A "pinch" of moistened tobacco or snuff (perhaps directly from the mouth of the "dipper") was the accepted treatment for bee stings and painful insect bites. Children ran to the tobacco user as soon as the sting occurred in order to secure the treatment.

The *Modern Household Encyclopedia* of 1948 still maintained that tobacco was the treatment of choice for the sting. The first aid advice included applying "a little tobacco moistened with water."[71] Not surprisingly, the American Red Cross in their 1957 manual made no mention of treating insect stings and bites with tobacco.[72] Although those who were more affluent tended to condemn the use of tobacco by the poor, there were compelling reasons for the tobacco use. Tobacco was more than a "pernicious habit"; it was many Southerners' "drug of choice."[73]

Tobacco dulled the pain of hunger and aching teeth and gums, while providing a pleasant, gratifying sensation in the mouth.[74]

Alcohol as a remedy. Although alcohol was a long-standing treatment for illnesses and was even paid for by the government to administer to women in labor, Prohibition made its use illegal. Many people still had the item in their homes, however, "for medicinal purposes."

A resolution from the American Med-

ical Association during a term of President Woodrow Wilson renounced whiskey for medicinal purposes. The statement declared that "alcohol as a drug can be eliminated from the pharmacoepia without in any degree crippling the efficiency of the doctors armamentarium."[75]

The use of alcohol as a household remedy remained common in the 1930s for colds, women's complaints, "lung involvement," and high blood pressure — despite ... Prohibition.76

The health of African Americans in Georgia. The lack of hospitals, doctors, and nursing care accounted for a higher death rate for African Americans. Although the life expectancy for the nation was 58.1 for males and 61.6 for females,[77] the "life expectancy of black men and women in Georgia was less than fifty years."[78] Georgia had significantly fewer doctors per capita than the nation as a whole. Of these Georgia doctors, almost half practiced in the Atlanta area, which left the rest of the state with an acute shortage of both doctors and dentists. With the segregated hospitals and with few African American doctors, African Americans in Georgia were often without the medical care that they needed and deserved.[79]

Margaret Mitchell, author of *Gone with the Wind* and Georgia resident, was aware of the medical needs — particularly of African Americans — in the state, particularly during the 1930s. She secretly provided financial help to more than twenty African Americans who were Morehouse graduates and who wanted to pursue a medical education. In addition, Margaret Mitchell "stimulated the building of a hospital in Atlanta for its middle-class black citizens."[80]

Mitchell sent a check and a letter to Hughes Spalding, Sr., who was just beginning to plan the development of a public unit for African Americans at St. Joseph's Hospital. Mitchell knew of the need for hospital facilities for African Americans; she herself had struggled to find a hospital willing to accept Carrie Mitchell Holbrook, her dying laundress. She recommended to Spalding that he study the possibility of establishing a private hospital for African American patients.

The result of Mitchell's letter and donation was the construction of the Hughes Spalding Pavilion. After being hit by an off-duty cab,

Mitchell died in Grady Hospital, which did have a unit for African Americans at the time of her death.[81] Spalding gave her full credit after her death for her work for others.[82] There is more about Margaret Mitchell's work, life, and death in chapter seven, "Entertainment."

Disease among African Americans— and other Georgians— persisted during the 1930s. The state, however, began to make great gains in its treatment and prevention of disease among African Americans and all Georgians during this time.

Soul food. The African Americans in Georgia had some distinct recipes. Their fare— called soul food— is "the brilliant masterpiece that derived from want."[83] The epitome of soul food is its use of greens, beans, and parts of the pig, chicken, or cow rejected "at the plantation house"; some of these "rejected parts" include pig feet, pig knuckles, chicken feet, pig ears, pig snouts, hog jaws, tripe, fish heads, and chicken heads. Cyber Palate remarks that these foods added to corn might constitute the major part of the diet of many African Americans.[84] Hush puppies, Hoppin' John, black-eyed peas, grits, and cracklin' bread with chitlins or fatback were common menu items. Interestingly enough, much of this diet does not differ greatly from the "white diet" of most of the Southerners that Kirby scorns in his discussion of the causes of pellagra.[85]

Soul food usually requires few cooking vessels, which makes the preparation easier and helps prevent a large capital outlay for many cooking vessels. In conclusion,

> ... [s]oul food, like all inspired cuisine, is greater than the sum of its parts. African and West Indian cooks and their offspring were unafraid of hot spices. Chiles figure boldly; Tabasco sauce is as prevalent as salt in soul kitchens. The variety of soul food is astonishing: chitlins or chitterlings, pig's intestines served boiled or fried in a batter; mess o' greens, or greens (most likely collard or mustard greens) cooked with salt pork until soft and delicious; red beans and rice; barbeque ribs slow-cooked long over an outdoor fire pit; sweet potato and peanut croquettes; cornbread— stuffed turkey with giblet gravy, and corn fritters— an endless feast.[86]

Purloo, perloo, perlou, perlew, pilau, or *pirlou* is another popular dish among many African Americans— and other Georgians. Rice, meat, and any available vegetables are cooked together in one vessel. Whether it is called *perlou, pirlou, perloo, purloo,* or *perlew,* the dish is the same; the cook combines shrimp, meats, sausage, game, vegetables, rice, "really anything you have in the pantry."[87] Harriet Ross Colquitt gives a recipe for Rice Bird Pilau in her *Savannah Cook Book:*

> Stew one dozen rice birds [head included] in a quart of water, until thoroughly done, seasoning them to taste with red pepper and salt. When done, remove birds and sprinkle one pint of rice in the water in which they were cooked. Boil fifteen minutes, then drain off water, stir in the birds, and steam until the rice is dry and grainy. And when the pie is opened ... even if the birds don't sing, you will have to admit that the dish is fit to set before a King![88]

Jimmy Carter particularly enjoyed purloo. He wrote of the dish in his *An Hour Before Daylight.* He described purloo as a

> ... thick stew built around the meat of some wild animal, most usually squirrel, rabbit, or raccoon. In what was a rare banquet, the flavor of the meat was preserved and greatly magnified by cooking it to pieces in a big pot that contained corn, meal, onions, Irish potatoes, squash, okra, peppers, and almost anything else available that didn't have too strong a flavor of its own. Sometimes several families would assemble and contribute ingredients. Whenever anyone asked the hosts what was in their particular concoction, they brought an expected round of laughter by responding, "If I tell you, you might not eat it!"[89]

Summary. The federal photographs help to tell the story of the health of Georgians. These photographers tell it all with their images of doctors; clinics; inoculations; the raising of milk cows, chickens, and other animals; the crowded doctor's offices, the midwives, and the house calls; the farming; the use of tobacco; the poor health and the untidiness of some subjects; the pride and the immaculate homes of others; the cured meat in the smokehouses; the jeweled jars of jellies, vegetables, and jams on the shelves; the varied cookery across the state; the canneries; and the dignity of the people— whether rich or poor, young or old, employed or unemployed.

Housing

In the 1930s, housing for Georgia residents varied considerably from one area of the state to another. The type of available housing usually depended both on the region of the state in which one resided and on one's occupation.

I. Georgia Mill Villages

Lewis Hine was one of the first photographers to use his camera as a documentary tool. Before 1920 his studio advertised Hine as a "Social Photographer." About 1920 he changed the advertisement to read "Interpretive Photography." This new advertisement emphasized a "more artistic approach to his imagemaking."[1]

Hine's photographic recordings of work and the social conditions surrounding the work often elicited emotional responses from the viewer. Hired by the National Child Labor Committee, Hine focused on the social and work problems, including child labor and the housing of the workers, which, of course, impacted the child.

Lewis Wickes Hine photographed labor conditions— particularly child labor —for the National Child Labor Committee. He also supplied captions for the photographs, many of which he made in Georgia. More about Hine's work, especially that in Georgia, and examples of his photographs, which had influenced federal photographer Roy Stryker, are in chapter two, "Population" and Appendix, "The Federal Photographers in Georgia During the Great Depression."

Mill village housing. In 1913 Lewis W. Hine accompanied his photograph of the mill village in Lindale, Georgia, with a comment that the housing accommodations neglected nothing — except the children. The Lindale village seemed a good example of comfortable housing for mill employees. One observer remarked that even at their worst, a company home was built better and was far more comfortable than the usual mountain home.[2]

Hine was not reluctant to photograph desirable mill village houses, undesirable mill housing, and isolated, inadequate housing. Unfortunately, inadequate housing persisted in Georgia well into the 1930s. Federal photographers documented both adequate and inadequate housing in the state during the Great Depression. Their record of the time remains.

Advantages of mill villages. The village houses were sometimes neat, modern residences on paved streets. Electricity and running water sometimes characterized the facilities. Some rural families hoped to leave the farms and move to a mill village where the houses had indoor bathrooms and electric lights.

When the mill owners built the villages, they did not intend the houses as a source of income. Rather, the construction of the homes was a necessity. In the early days, the mills were sometimes in remote places because they had to be near a power source, which in the early

The original caption for this April 1913 photograph reads: "Housing conditions, Lindale, Georgia. Not a thing neglected, except the child. Massachusetts Mills." Photograph by Lewis Wickes Hine, National Child Labor Committee.

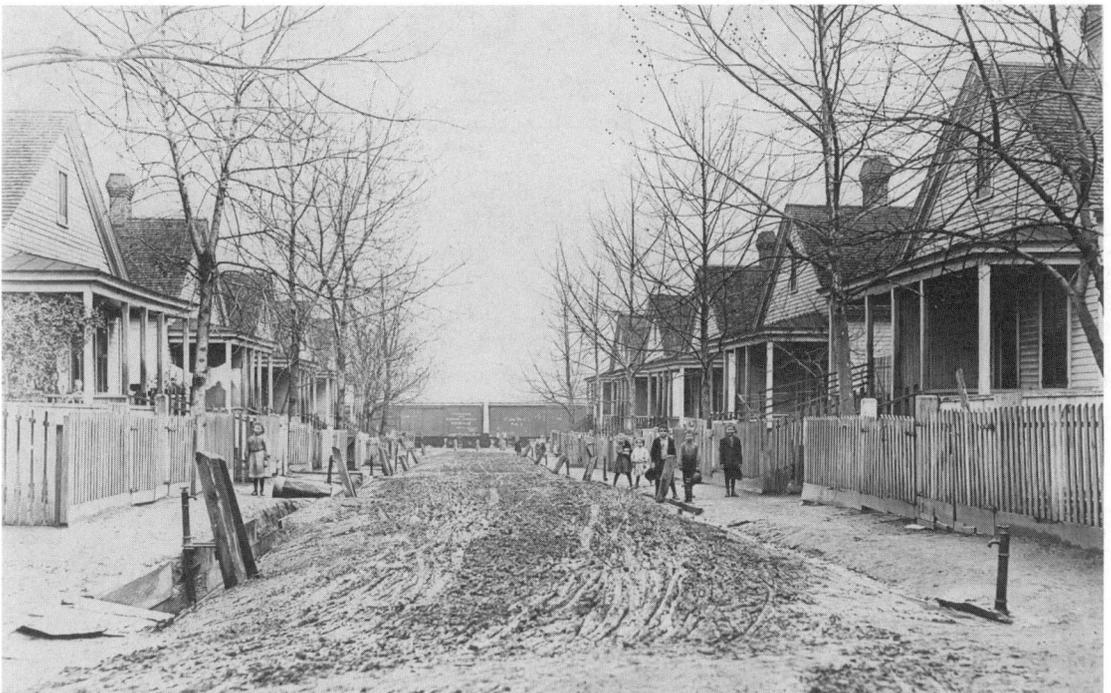

The original caption for this January 1909 photograph reads: "A typical street scene in Gregtown where the employees in King Mill live. The Secretary of Associated Charities said this is the most degraded part of Augusta, [Georgia]." Photograph by Lewis Wickes Hine, National Child Labor Committee.

The original caption for this January 1909 photograph reads: "Some of the workers in the Rome (Ga.) Hosiery Mill live in shacks like these." Photograph by Lewis Wickes Hine, National Child Labor Committee.

days was hydroelectric power. With transportation a problem for many prospective mill workers, the owners constructed homes for employees near their place of employment.

Some paternalistic mill owners were sincere in their day-to-day care of and concern for the workers and their families. When a reporter asked W.D. Anderson of the Bibb Manufacturing Company, Macon, Georgia, what his company made, Anderson responded quickly, "We make at Bibb, American citizens, and run a cotton mill to do it."[3]

George Tindall remarked that the company stores, which supposedly were the only place employees were to shop and which charged exorbitant prices, were a highly exaggerated feature of the mill villages. He also observed that most of the workers could move, despite arguments to the contrary, if the facilities were not suitable.[4]

Mill owners professed to give their laborers paternal treatment by providing the workers with electricity, indoor plumbing, low rents, inexpensive coal, credit at the village stores, buildings for schools and churches, and — in one mill village — even toilet paper when the tenants clogged the indoor commodes with the newspapers they had used.[5] Many mill families were grateful for these benefits, took pride in the village, and helped improve the appearance of their streets and houses.[6]

Disadvantages of mill villages. Not all mill homes were desirable, however. Tindall quotes Frank Tannenbaum, author of *Darker Phases of the South,* as remarking that it was better to have to scratch the soil with one's nails and live on the farm than to live in the mill villages and work in the factories.[7]

Some workers thought that the company

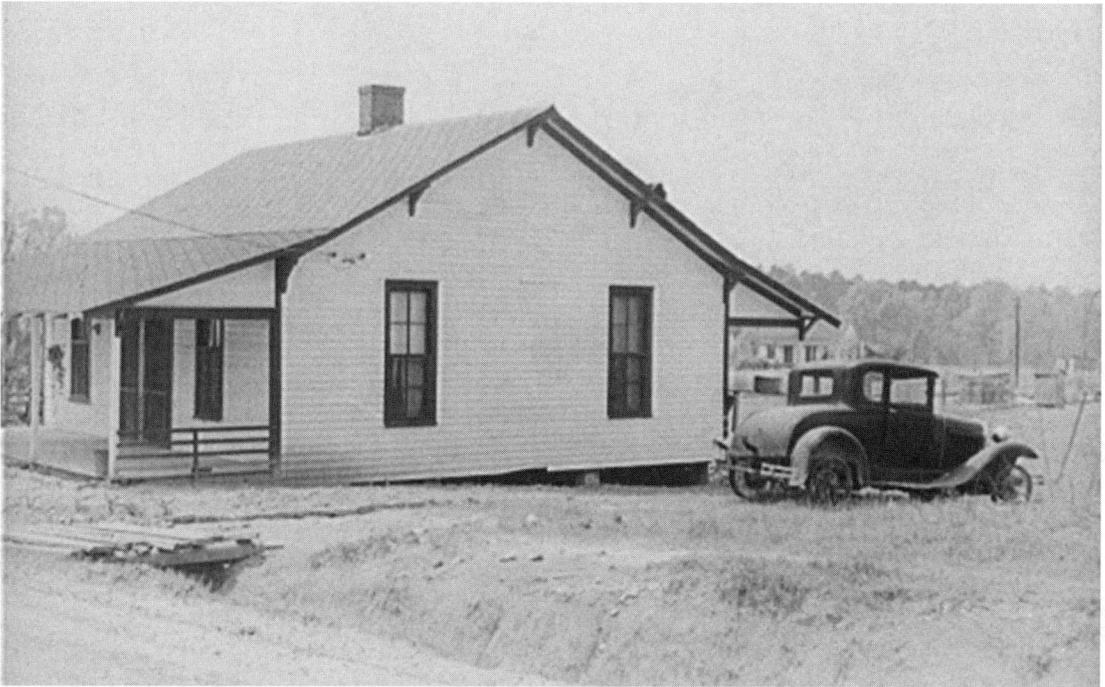

Mill village house near Atlanta, Georgia, May 1939. Photograph by Marion Post Wolcott, Farm Security Administration.

over-regulated their lives. For instance, many mill managers influenced strongly the hiring of the mill village preachers, teachers, doctors, storekeepers, and, of course, the mill workers themselves. Employers sometimes set village standards for behavior: required church attendance, stipulated purchases only at the village store where the owners set the interest rates, and requested the employment of the entire family. In some areas the mill village housing was substandard.[8]

The house rent varied from place to place. Typically, mill houses rented (before the days of electricity) for 25 cents a month per room. With electricity, the rent jumped to 50 cents per room per week. This rent could cut deeply into the average wage of $9.00 per week.[9]

Many mill villages were undesirable places to live. Inferiorly built mill homes—constructed in the early 1900s for $300 for a three-room house or $600 for a six-room house[10]—were often dully painted or not painted at all. The cottages were sometimes flimsy and even perched on stilts that rested on slanting lots

served by roads. Running water and electricity were not always available.[11]

Coleman notes what was, for some mill workers, another disadvantage: many textile mills paid their workers in scrip, which is contrary to Tindall's remarks in this chapter. Georgia workers who received scrip could redeem the pay only at the company store, where prices were high. The store often advanced a worker's supplies against future wages; this practice — along with deducting rent from the paycheck before the worker received the scrip — caused many workers to fall farther and farther behind in debt.[12]

Despite the mill owners' professed desire to have a safe, social atmosphere in the village, many workers considered the mill village an undesirable family environment. To workers who had previously lived in isolated rural areas, this close contact with others and the differences in ways of life contributed to their dissatisfaction.

"The passing of the mill village." After 1934 in many states, the mill villages, long a part of the scene around cotton textile mills,

began to "pass," or die.[13] High maintenance costs, improved roads that allowed workers to travel longer distances to work, and the difficulty in rationalizing the subsidized housing for certain workers and not for others helped some owners make the decision no longer to sponsor the mill village. Minimum wage legislation forced some plant owners to spend increased money on worker pay; many mill owners found they could not pay the required wages and furnish housing at a discount to factory workers.

To cut their losses, the companies began to sell the housing, often giving employees the first option to buy. Selling the houses, which the mills had often provided at a minimum cost, enabled the employers to raise the wages of the mill workers according to law; the selling of the houses, however, affected the lives of the workers and their families.

When new buyers of the textile industries and the villages did not personally know the residents of the villages, it was easier for them to make the decision to sell the mill housing.[14]

Many textile employees faced difficulty in securing adequate housing at a price they could pay. In the *Passing of the Mill Village* Harriet Herring describes the selling of these homes as a "death."[15]

Kenneth Coleman notes that by 1940, 60 percent of the mill workers in Georgia still lived in the company-owned houses. He also mentions that, by 1940, the use of scrip had declined along with work hours and drab houses; checks and houses with a more pleasing appearance became more common.[16]

II. Rural Homes in Georgia During the 1930s

Rural homes, in contrast to most mill village houses, were often without electricity, running water, or indoor bathrooms. More than half of the 3 million farmhouses surveyed in 1930 in 14 Southern states were unpainted; boards weathered by the elements gave a distinct color to the countryside. More than a

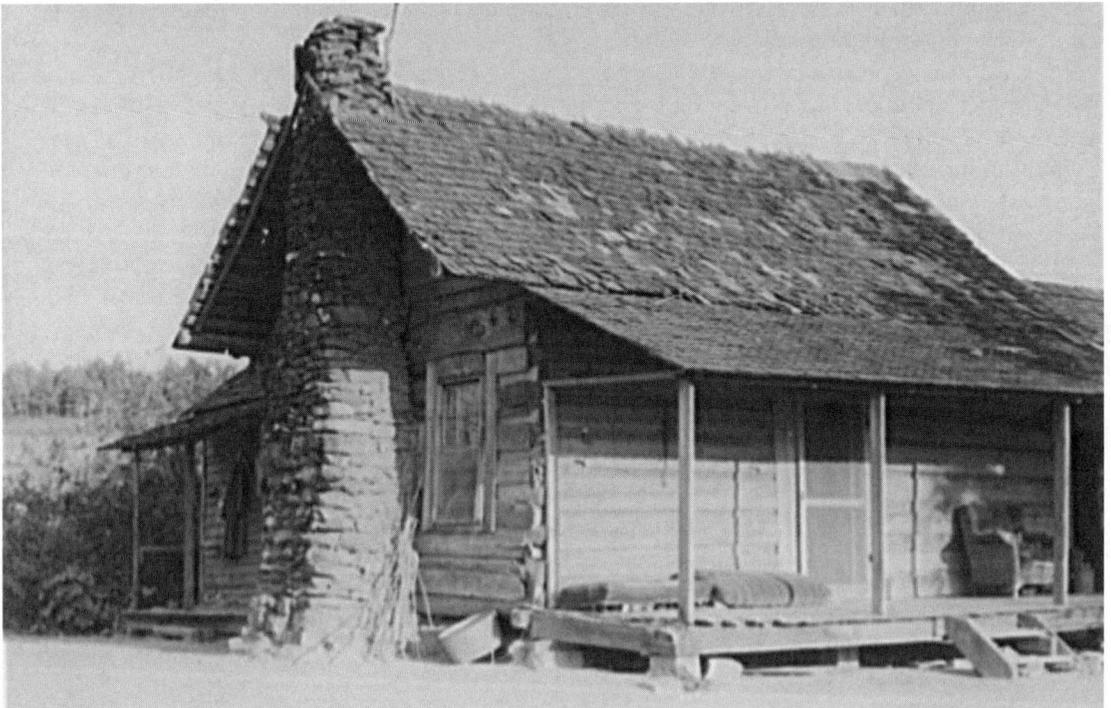

A house near Hartwell, Georgia, occupied by a sharecropper for seven years, July 1937. Photograph by Dorothea Lange, Farm Security Administration.

third of the rural houses did not have screens; the open windows and doors allowed mosquitoes to enter and increased the chances of malaria and other diseases carried by insects. Only 5.7 percent had running water. The National Emergency Council described these rural homes as being old, of little value, and in need of repair.[17]

Some rural homes were small but well-kept; it was evident that their owners took great personal pride in them. By contrast, other rural homes were two-story residences on vast acreage. The building materials varied, but wood, stone, and brick were common on the Georgia countryside. In remote mountain areas of Appalachia, the houses were usually heated by a fireplace, were almost never painted, typically had no toilets or running water inside, and usually had at least two people occupying each room. Mountain cabins often had ceilings and inside walls paneled with tongue-and-groove boards.[18]

III. Electrification of Georgia Homes

The electrification of Georgia did not begin with the Rural Electrification Administration of the 1930s. In 1883 Atlanta had become one of the first cities in Georgia to receive electric lighting. To show their backing of the project, the citizens themselves raised $3,500 in a stock offering and formed the Georgia Electric Light Company of Atlanta. The franchise for this company read:

> ... [to] serve patrons from a central station, or from isolated plants, electric lights for stores, dwellings, machine shops, depots, inside and out, or to introduce said lights wherever desired.[19]

That same year the new company contracted with Southern Light Company of New York to purchase an electric light plant of 45 lights for $8,500. In 1884 the company built a 940 kilowatt generating plant on Marietta and Spring streets and installed 22 electric streetlights. By 1889 the major use of the power was to operate 800 streetlights and to operate electric streetcars.

By 1897 there was a new steam generating plant on Davis Street that provided lighting for street illumination for 10 square miles; the plant served 400 customers. By 1904 Georgia Railway and Electric Company had contracted with Atlanta Gas Light Company and had purchased all the output from Morgan Smith's hydroelectric plant on the Chattahoochee River.

Smith's site went by the name Morgan Falls and was one of the largest hydroelectric plants of its time; Morgan Falls could generate 17,000 kilowatts. As a precaution, however, coal plants were on standby as generators. In addition, Georgia Railway and Electric Company installed a 6,000 horsepower gas engine at the Davis Street Plant and connected it to a 2,000-kilowatt generator to use if necessary. The gas unit could take the full load within two minutes. The installed storage batteries could take over to reduce the delay.

The years 1911 to 1925. In 1911 Georgia Railway and Electric Company acquired several more utilities. Among these new utilities was Atlanta Water and Electric Power Company. In 1912, Georgia Railway and Power's new hydroelectric plant at Tallulah Falls connected with the substation at Boulevard in Atlanta by a 100-mile transmission line with 110,000 volts. This was one of the first outdoor high voltage substations. By 1914, the Georgia Railway and Power Company was able to produce 94,200 kilowatts with its three hydro and two seam electric generating plants.

More hydro units at Tallulah Falls opened later. Interestingly, Tallulah Falls sold the first power that it generated not to Georgia Railway and Electric Company but to Southern Power Company, which later became Duke Power Company. The Tallulah Falls plant was able to generate 72,000 kilowatts of electricity.

Through a transmission line from Rome, Georgia, to Gasden, Alabama, Georgia made its first interconnection with the Alabama Power Company. This interconnection began a network that would embrace seven major electric systems in five southeastern states. This cooperation would benefit all parties.[20]

The year 1925. Georgia and the Southern states felt the pinch of the upcoming depression

long before the rest of the nation. The 1920s brought decreased power usage because of the slowdown of Georgia industries. The year 1925 was particularly devastating to the power companies and to Georgians. The summer of 1925 brought a record-breaking drought; the dry spell resulted in both a low stream flow and a long duration of the low flow period. As a result of the drought, hydroelectric power was less effective. The long dry spell reduced the electrical production from the hydroelectric plants by nearly 60 percent. Georgia had to purchase power from neighboring states. Never again would hydroelectric power be the primary generation mix for Georgia Railway and Power Company. The drought underlined the importance of bringing auxiliary steam stations into full service.

The year 1926. In 1926 Georgia Railway and Power Company became a part of the holding company of Southeastern Power and Light Company. Georgia Railway and Power Company took the new name of Georgia Power Company during the consolidation; it now served about half the state.

The year 1927. The year 1927 saw the merging of more utilities with Georgia Power. Some of these companies included Athens Railway and Electric Company and Rome Railway and Light Company. Georgia Power now served 130 cities and communities. It had 5,000 miles of lines for transmitting and distributing power in 300,000 square miles. The company employed 4,000 workers—a decided increase from the 35 employees of thirty years before. It now served 62,734 customers who paid 7.6 cents per kilowatt hour for their power. The average consumption for a year in 1927 was about half of what customers in 2000 consume in two weeks; power consumers in 1927 used about 481 kilowatt hours.

By the end of 1927 Southeastern Power and Light Company—consisting of Alabama Power, Gulf Power, Georgia Power, Mississippi and South Carolina Power—merged with Commonwealth Power, which included Central Illinois Light, Consumers Power Company, Pennsylvania Power Company, Ohio Edison, and Southern Indiana Gas and Electric. The new venture was the Commonwealth and Southern Corporation. Its function was to pool capital funds for construction, to use more advantageously the expertise of the employees, and to provide more reliable service.

Belt tightening. With the fall of the stock market in 1929, the demand for more power both from increasing industrial growth and from a rapid population growth did not come to Georgia. Mergers became necessary. By 1929 the cities of Macon and Augusta had merged with Georgia Power Company. Georgia Power used both coal- and gas-burning units at Plant Atkinson. By the close of 1930 the price of electricity had dropped to 5.7 cents per kilowatt-hour; this price was a decided decrease from the 7.6 cents of 1927.[21] Power companies began to cut expenditures. For example, Georgia Power did not construct another plant after the Atkinson plant (1929) for ten more years.[22] The other major utilities in the state also faced hard times and competition. The industry and power companies faced a slowdown.

Electricity for the mill villages. Many textile workers in isolated villages without electrical wiring began to request electrical power from the mill owners and from the power companies. Maynor described the views of the Southern Power officials; these views were often shared by other power companies across the Southern states:

At first, they [Southern Power officials] found requests by textile executives to provide power to the homes in their mill villages more of an irritant than a market.

Then, too, the rural dwellers—those who made most or a great part of their living from the farm — were a hard group to convince that electricity in any form was not a force of the devil himself.... Representatives ... began cultivating the farmer's interest in earnest by the 1920s. But most rural dwellers made their livings from the land just as their fathers and grandfathers before them had done, and they saw little reason to put in some modern paraphernalia that they neither understood nor trusted. Anyway, electricity was a fearful force, and life was hard enough for a farmer without worrying about built-in lightning running loose in his house and barn....

Yet new markets were waiting to be tapped, and after some experience in providing residential power service as a courtesy, Southern Power Company officials began to see where these potential markets were, and they went after them.[23]

Farmers left in the dark. Many Georgia farmers and their families in the first two decades of the twentieth century were "left in the dark" by the power companies. The companies had decided that they could not afford to build miles of electric line to serve a handful of customers in the rural areas. Rural Georgians certainly could not afford to pay to have the lines run to them. As a result, as late as the 1930s only one in ten of the rural homes had electric service.[24]

Power companies target the farms, homes, cities, and small businesses. With the "vacuum left by the closing or production cutbacks of large industries,"[25] power companies began to target the farms, the isolated mill villages, the rural homes, the small towns, and the small businesses that they had not previously "wooed." Advertisements and consultants from the companies even gave counsel and advice to potential customers on how electricity could help them.

The companies stressed the affordability of the new energy source in its promotions and advertisements. One power company included this quotation in one of its publications:

> One typical attitude is reflected in the expression of one housewife who exclaimed, "It's such a relief to not feel that you should turn off the lights behind you every time you leave a room, and to be able to plug in any appliance that you want to use anywhere in the house...."[26]

Of the nine South Atlantic states, only two states—West Virginia and South Carolina—exceeded Georgia in the production of electric power in 1920. By 1930, however, Georgia ranked sixth; other states were far surpassing Georgia's production—even if Georgia had increased its production from 595,000,000 kilowatt-hours to 937,000,00 kilowatt-hours.[27]

The Rural Electrification Administration (1935). On August 26, 1935, President Roosevelt asked that the administrator of the Rural Electrification Administration (REA) write to him requesting bids to begin operations by direct labor or bids for construction to begin its work. Through the REA, work began; many areas of the state of Georgia received electricity.[28]

The cost of signing up with REA was just five dollars. To justify running the line, however, there had to be at least three customers per mile. Without identifying the area or individual, an employee of a power company reported an unusual event. A farmer came in to pay his five dollars and to sign up for electric service. He found, however, that he was not eligible because "his house was too far from the right of way." A few days later he returned and waved his money. He had moved his house.[29]

Farms and electricity. Electricity had been slow in coming to some rural areas. However, as the power companies and the federally-sponsored REA brought electricity to the farms, things began to change drastically in the nation and in Georgia. Farmers began using electricity for everything: curing hay in the barn, milking cows, warming new baby chicks. When farmers who used electricity found their farm productivity began to increase, advertisers were quick to point out the connection. This was the beginning of "agribusiness." Not all farmers, however, had access to electricity during the lean years of the 1930s.[30]

Objections to the REA. Some people objected to the Rural Electrification Administration. Maynor describes the typical views of these opponents:

> When the Depression struck and times were critical, the progressives put on a strong punch for federal intervention in the things businesses and industries had been operating without extensive governmental influence. Now, the drive for socialization was one, and those who clung to the foundations of American free enterprise traditions found themselves enduring the heat of the political kitchens.[31]

Electrification at the end of the Great Depression. At the beginning of the Great Depression (1930), Georgia ranked sixth among the nine South Atlantic states in the production of electric power. In 1940 Georgia's rank among the South Atlantic states was still sixth although its kilowatt-production hours had increased to 1,613,000,000.[32]

It was in the 1950s and after, however, before some residents of the state saw the coming of the power lines and were able to pack

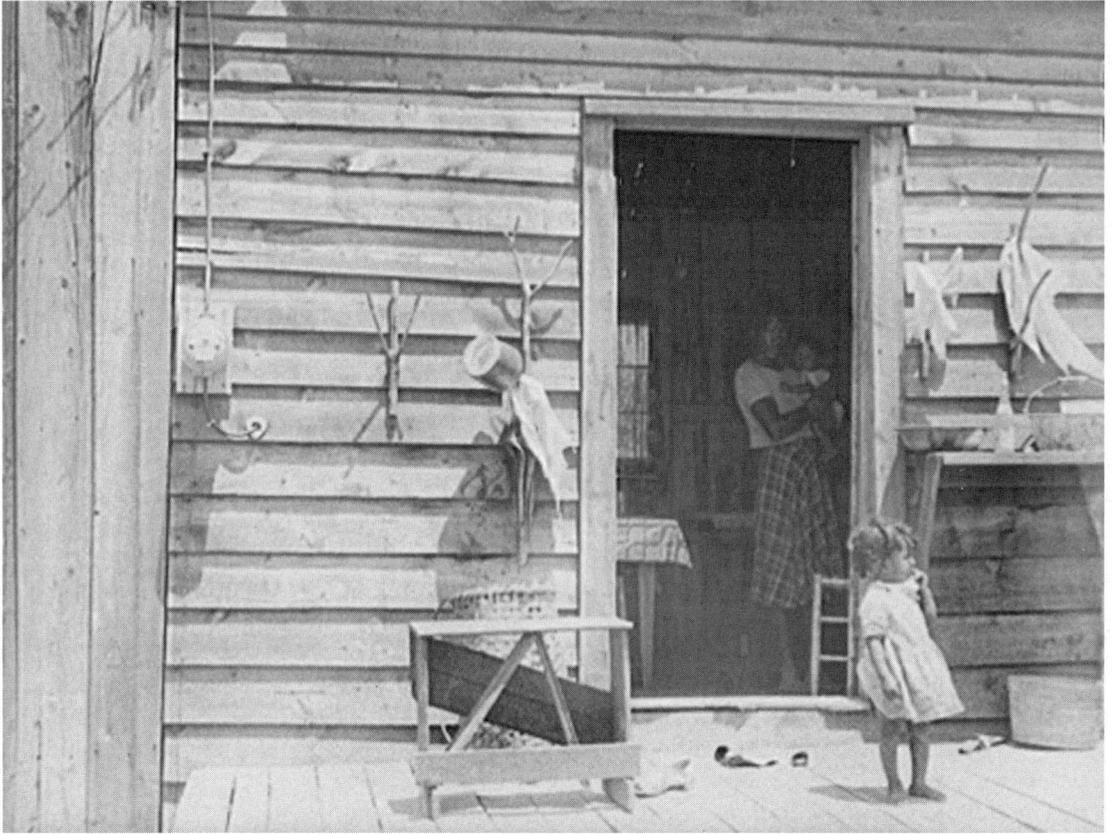

"Negro" tenant farmer's house showing REA (Rural Electrification Administration) electric meter on the wall, May 1941. Greene County, Georgia. Photograph by Jack Delano, Farm Security Administration.

away their kerosene lamps for antique collectors of future decades.

IV. Government Assistance with Housing

President Franklin Delano Roosevelt expressed his concerns about the housing situation in the Southern states. Southern housing varied considerably in quality.

Homeownership. Georgia had the lowest home ownership rate in the nation in 1920 (30.9 percent); it had claimed this "distinction" again in 1930 (30.6 percent). Like many other Southern states, Georgia had begun to feel the bite of "hard times" long before the 1930s.

The rest of the nation, too, experienced the hurt that the Great Depression could give.

The home ownership rate in the United States dropped to its lowest level of the century — 44 percent in 1940 — as a result of the Great Depression.

Despite the help of the federal government, the home ownership rate for Georgia in 1940 was 30.8 percent. This was an increase over Georgia's home ownership percentage in the year 1930, but it was not a percentage equal to the slightly higher pre–Great Depression home ownership rate of 1920 (30.9 percent).[33]

After his election to the presidency in November of 1932 and his subsequent inauguration, Franklin Delano Roosevelt continued to consider the housing problems that Americans — particularly those in the South — were facing. With little farm work available, landless farmers often did not own a home; like many city dwellers, they often had to depend on a landlord to furnish their quarters

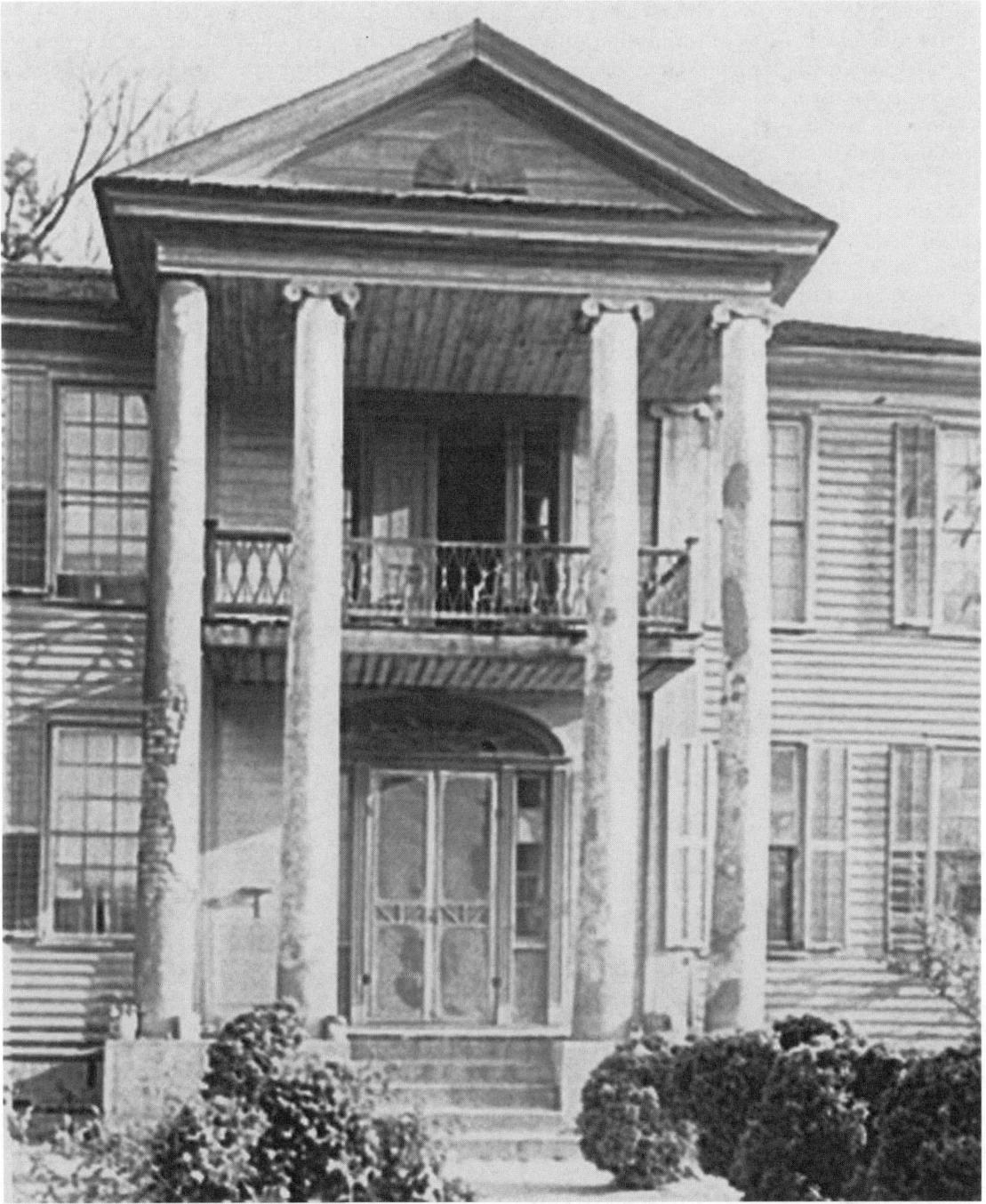

Jefferson Hall, a Greene County antebellum house near Union Point, Greene County, Georgia, May 1941. Photograph by Jack Delano, Farm Security Administration.

and often paid dearly for the substandard conditions. Some of these people saw no way ever to own a home or land. The situation of some of them, however, would change in the days to come with the help of some significant government programs.

Federal Emergency Relief Administration. Beginning in 1933 the Federal Emergency

Relief Administration (FERA) spent some of its monies on rural rehabilitation and the resettlement of farmers. Georgia residents reaped some of the benefits that FERA had to offer. One federal project was the remodeling of the Irwinville courthouse, built in 1883. The Irwinville Court House was in use until 1910, when the county seat moved to Ocilla. During the Great Depression, funds from the Farm Security Administration helped to remodel the old courthouse into apartments for settlers.[34] Several housing projects in Georgia resulted from federal funds.[35] Two other housing projects using FERA funds were the Irwinville Farms and the Pine Mountain Valley Projects.

Pine Mountain Valley Project. Coleman noted that the New Deal stimulated soil conservation measures, helped reduce the growing number of small farms, and decreased the rising rate of tenancy. Coleman observed that the New Deal programs forced marginal farmers and many tenants off the land; he emphasized that the programs helped primarily the top third of the farmers. Coleman did not believe that the New Deal helped the tenants and noted that they "suffered more severely. As large farmers curtailed production, they no longer needed as many laborers and consequently dismissed many tenants." Coleman noted, however, that the New Dealers did resettle some people on individual farms and also established four model farm communities: Pine Mountain Valley, Irwinville, Wolf Creek, and Briar Patch.[36]

Of these the most important was at Pine Mountain, a project especially close to the heart of President Roosevelt, who owned a farm in the vicinity. The original plan rested upon a utopian vision that included decent homes, gardens for subsistence, recreational and cultural opportunities, and employment in cooperative agriculture and industrial enterprises. Such a planned

Grady Watson moved from a shack in Irwinville to this home and farm unit in Irwinville Farms rural resettlement project. This view shows the Federal Relief Administration (FERA) house and the "Bryan" barn, June 1936. Photograph by Carl Mydans, Farm Security Administration.

A new house in Wolf Creek Farms, Georgia, in September 1935. Photograph by Arthur Rothstein, Farm Security Administration.

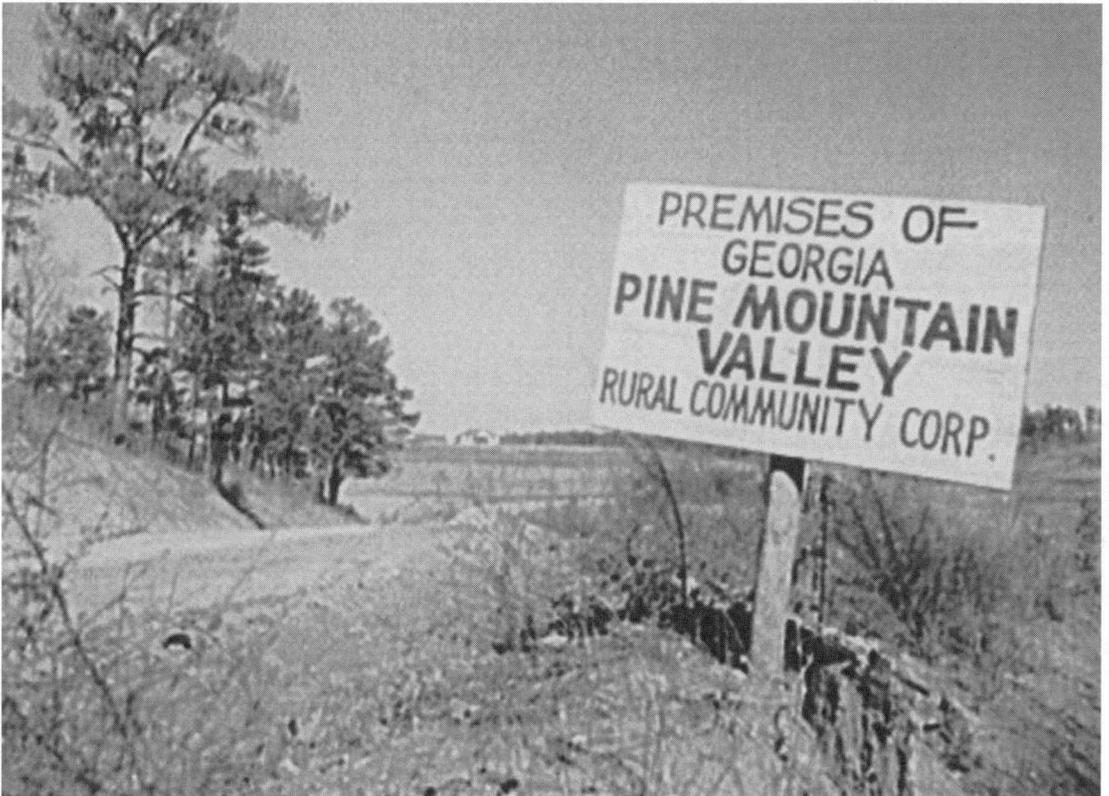

Sign for the Pine Mountain Valley, Georgia, model farm community, 1938. Photograph by Barbara Wright, Farm Security Administration.

community would offer people from both the cities and the country a way to escape from poverty by engaging in cooperative methods of self-support. Unfortunately, Pine Mountain, like the other New Deal communities, never fulfilled the goals of its founders. Plans for a diversified agricultural system did not materialize, and industrial operations remained small and unsuccessful.[37]

Unified Farm Program. Greene County, Georgia, became an experimental site for the Unified Farm Program; officials—local, state, and federal—worked to provide loans to needy applicants. The purpose of the funds was to help the rural, landless, poor.[38]

Subsistence homesteading. Subsistence homesteading was a plan some Georgians were able to try. The intention of subsistence homesteading was to settle a family on a plot of land so that the family could grow its own food and make many of its goods; in addition, in some families an adult would receive a part-time paid job. In Jasper County, Georgia, 50 units comprised the Piedmont Homesteads. Each unit in this farm community cost about $12,993—for a total cost of $649,650.88.[39]

LC-USW3-038933-E. LIBRARY OF CONGRESS, PRINTS AND PHOTOGRAPHS DIVISION, FSA-OWI COLLECTION

A resident of Pine Mountain Valley, Georgia, in 1938. Photograph by Barbara Wright, Farm Security Administration.

Piedmont Homesteads, a FSA (Farm Security Administration) project near Edenton, Georgia, around June 1936. Photograph by Carl Mydans, Farm Security Administration.

Techwood and University Homes. The very first federal slum clearance project inaugurated by the New Deal was in Atlanta. In September 1933 Harold L. Ickes, administrator of the Public Works Administration, symbolically blasted a hut on the future sites of the two segregated housing projects in Atlanta.

One of the huts was at the future site for "Techwood Homes," a white project that would open in August of 1936 with 2,124 rooms. The Techwood area was close to the Georgia Tech Campus and Peachtree Street. The other hut was at the future site of the "University Homes for Negroes," which would open in 1937 and would contain 2,342 rooms.[40]

The Public Works Administration began a construction program which involved thousands of Atlantans. Employed Georgians worked on both sewer and public housing projects. The PWA constructed in Atlanta the first federal housing projects: Techwood and University Homes.

Charles F. Palmer suggested these housing projects. The Atlanta businessman saw the project as a way to provide low-cost housing for deserving workers and at the same time as a way to eliminate some of the slums. A federal study by the WPA described "Techwood Flats" as a neighborhood that "had steadily disintegrated. Never been a better class residential section, it had reached the nadir of poverty, wretchedness, and dilapidation."[41] President Roosevelt dedicated Techwood on November 19, 1935; over 50,000 attended his speech at Grant Field on the campus of Georgia Tech. Atlantans had already submitted applications for other housing projects by this time.[42]

The Techwood Home District is historically significant in that it was the first federally funded public housing in the United States to reach the actual construction stage and represents the federal and local governments' first attempts, in a social/humanitarian way to eradicate slum housing on a grand scale. In addition, this district is significant in terms of its planning....

Replacing about thirteen blocks of one of the worst slum areas of Atlanta, this twenty-five acre federal housing project was built between the

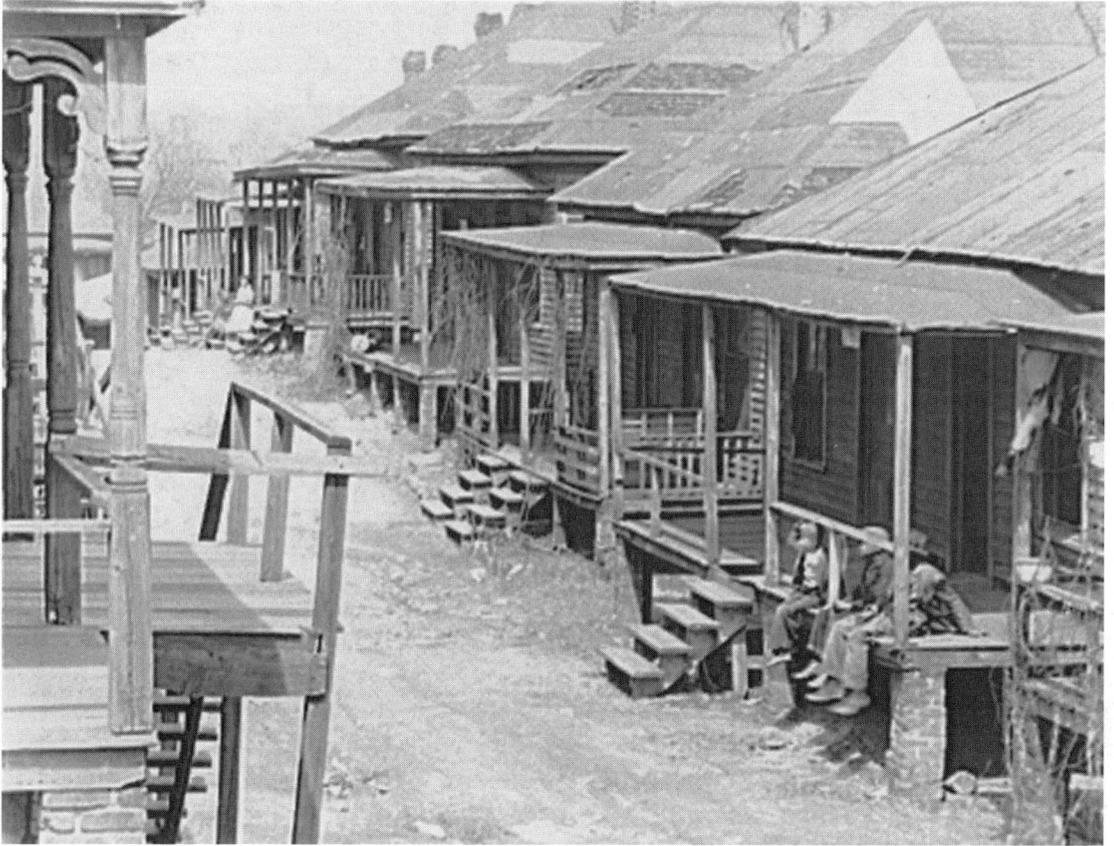

"Negro houses," Atlanta, Georgia, March 1936. Photograph by Walker Evans, Farm Security Administration.

years 1934 and 1935.... As the first project to go into construction under the direction of the Housing Division of the Public Works Administration (PWA), Techwood served as an experiment and proving ground in both planning and in the writing of specifications.... This project probably still remains the "best" public housing project in the United States.[43]

Before the 1996 Olympics in Atlanta, however, the tenants would be relocated and much of Techwood Homes would be torn down.[44]

The University Homes area, or "Beaver Slide," was close to Atlanta University, Clark, Morehouse, Morris Brown, and Spelman colleges. The PWA approved the University Homes development for African Americans after the president of Atlanta University (John Hope) and Charles Palmer took their plan to President Franklin Delano Roosevelt in Washington.

The Resettlement Administration. In order to move farmers to better land, to provide advice, and to help with their necessary housing and equipment needs, President Roosevelt used money from the Federal Emergency Relief Appropriation to create the Resettlement Administration (RA), which was "to administer rehabilitation and resettlement projects for the relief of farm areas."[45] The RA, during its short life, established 200 planned communities—many in the rural South—to enable the poor to become home and land owners. The RA resettled 10,000 people into planned communities and encouraged cooperation among the residents. Sixty of the 200 communities were farm settlements and 13 of the communities were for African Americans, who bought 92,000 acres in the 13 communities. One of these thirteen communities was in Georgia: Flint River Farms (1937).[46]

Flint River Farms, Georgia. To create the farm settlements, the RA purchased large tracts of high quality land and subdivided them into about 100 tracts of 50–100 acres. The RA built homes, buildings, and barns to help provide the purchaser with an income and "a line of work"; the agency leased and later sold the farms to approved families.[47] In addition to providing decent housing, the communities provided self governance opportunities, educational programs, and some measure of economic independence. In the midst of each federal settlement the RA built a community center, a cooperative cotton gin, a school, and a medical clinic. "Some Americans, particularly those in poorer and rural areas, encountered physicians not in home visits or private offices, but at clinics. At federal and state-funded clinics, physicians and nurses provided care for those whose class, race, or geographical location limited their access to physicians."[48]

Federal photographers and the Resettlement Administration (RA). Rexford Tugwell, the director of the Resettlement Administration (RA), realized that the federal organization was a tempting target for conservative critics. To help alleviate the anticipated criticism and to make a permanent record, Tugwell brought to the historical section of the RA a group of photographers headed by Roy Stryker; some of these photographers would later become a part of the Farm Security Administration. Using filmed images, the professionals would publicize both rural and urban life, conditions during the Depression, and America itself. Some of these photographers traveled through Georgia and depicted the rural and urban life, migrants, mill villages, city life, housing projects and farms, and resettlement housing.

Results of the Resettlement Administration (RA). Of the 500,000 families in America the Resettlement Administration (RA) intended

Jesse Stubs' Flint River Farms home and pecan grove, a cash crop, May 1939. Photograph by Marion Post Wolcott, Farm Security Administration.

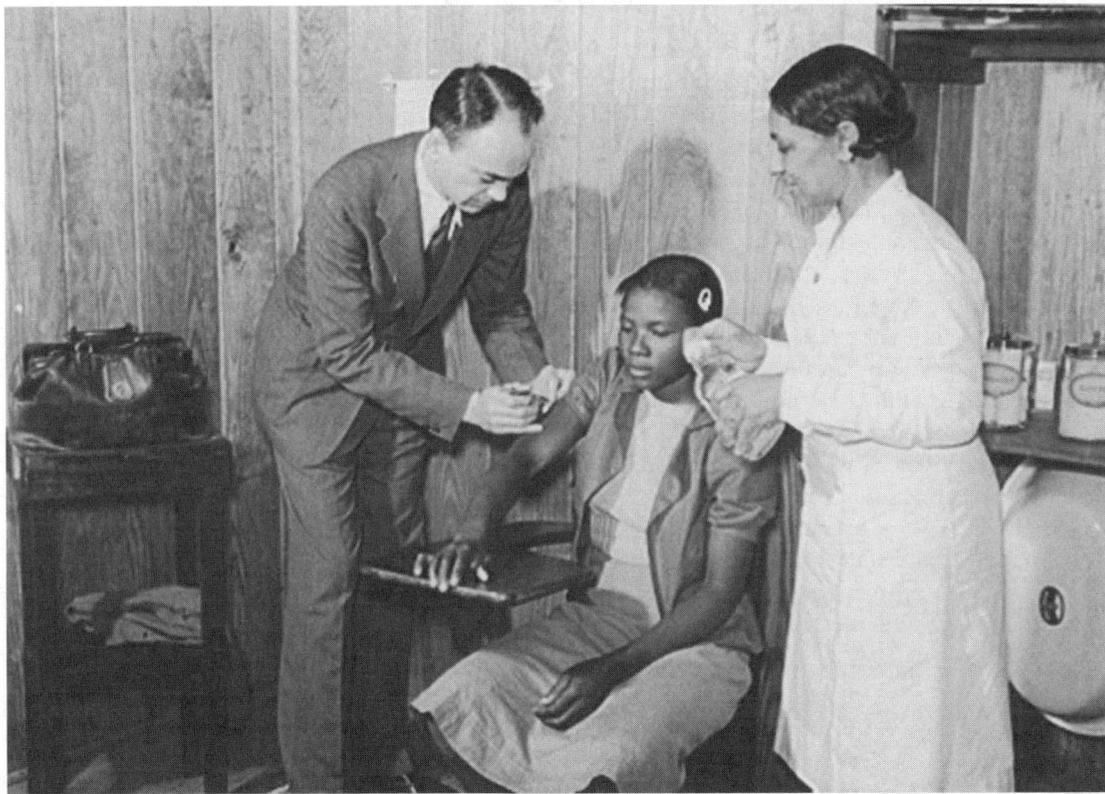

Dr. Thomas M. Adams, one of the cooperative medical plan members, with project nurse Lillie May McCormick. He gives a typhoid shot to Beatrice Loftly in the Flint River Farms health clinic, May 1939. Photograph by Marion Post Wolcott, Farm Security Administration.

to aid, less than 1 percent actually received help.[49] The RA reversed traditional land policy and gave excessive supervision to the clients. Some units failed before the RA "died" because of their small size, the formidable cost, and the many cooperative activities for individualistic families.[50]

Farm Security Administration and housing. After the abolition in 1937 of the RA, the Farm Security Administration (FSA) assumed many of the duties that the RA had been performing.[51] It was through the Farm Security Administration of 1937 that the federal government was able to extend financial aid to a selected number of tenants. By obtaining the aid, many tenants became landowners. Within the United States Department of Agriculture, the FSA helped to implement the provisions of the Bankhead-Jones Tenant Act (1937). The FSA administered long-term loans to share-croppers and tenants, loaned money to rural

cooperatives, and operated migrant worker camps.[52] As a result of the FSA, many tenants and sharecroppers were able to borrow the money necessary for a home of their own.

V. *Photographing Other Types of Housing*

In addition to the previously discussed housing types, federal photographers were able to document other types of housing in Georgia. Those who came to Georgia photographed Wolf Creek Farms; Hazelhurst Farms; rehabilitation clients' homes; railroad work crew houses; Newton D. Baker Village, a new defense housing project under the housing authority of Columbus, Georgia (near Fort Benning); and even the temporary homes of the construction workers.

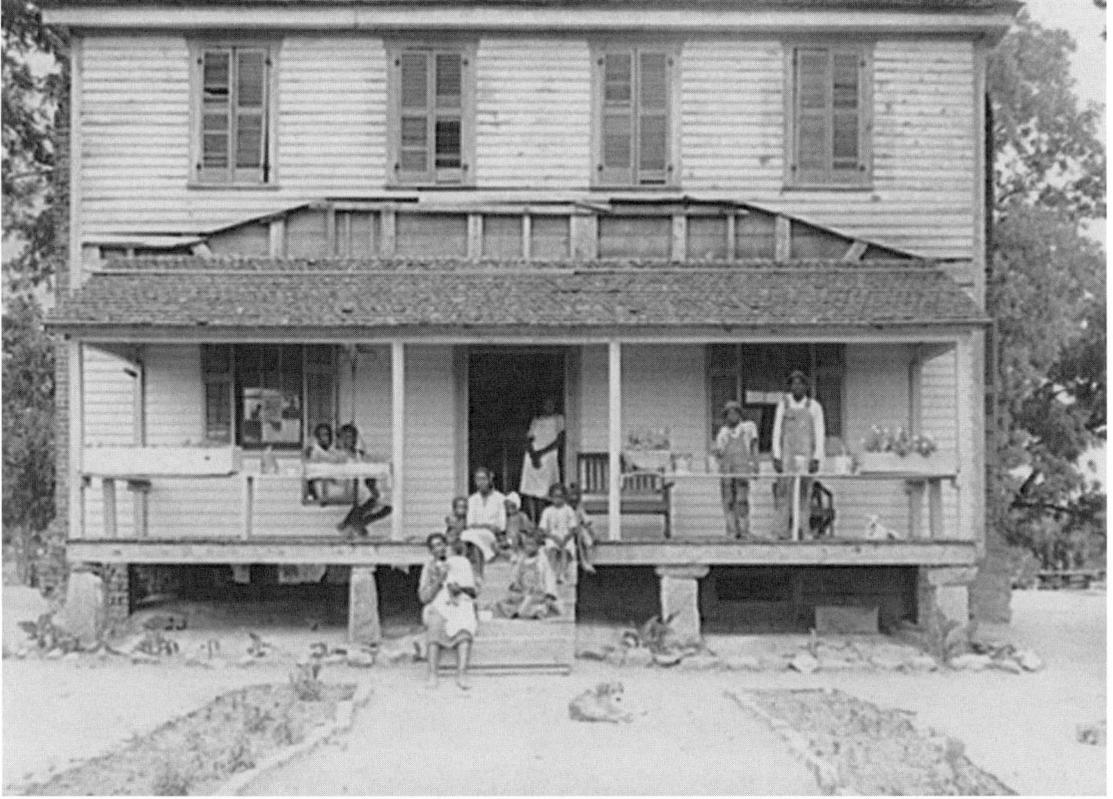

An old plantation house in Greene County, Georgia, occupied by a black FSA (Farm Security Administration) family, June 1941. Photograph by Jack Delano, Farm Security Administration.

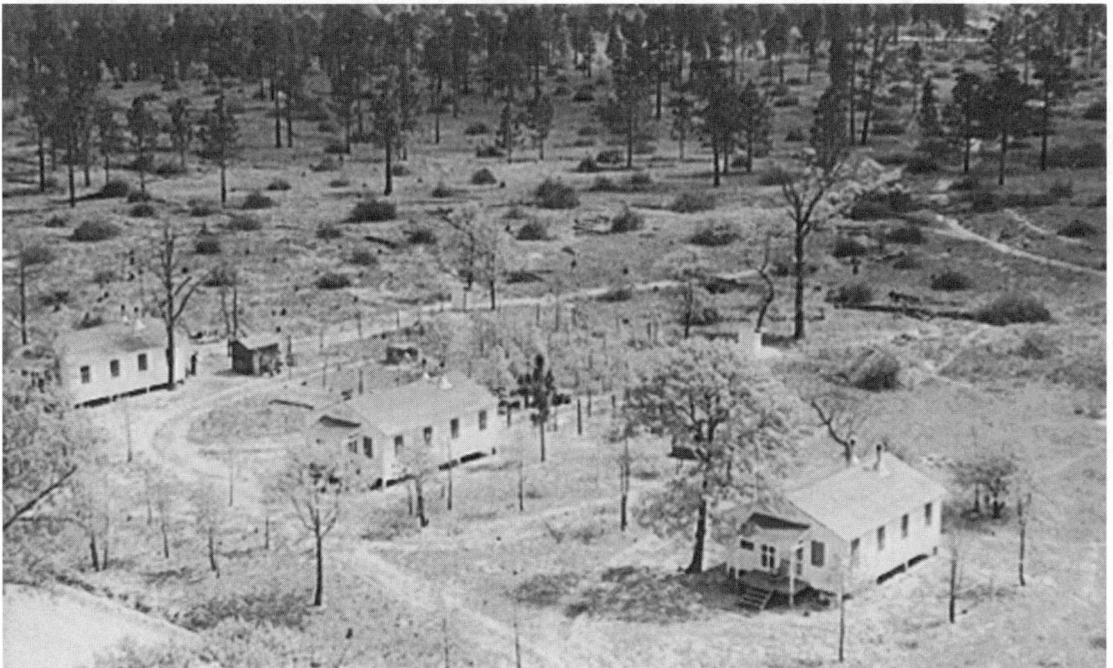

Prefabricated houses at Hazlehurst Farms Inc., showing both cleared and uncleared land in April 1941. Photograph by Jack Delano, Farm Security Administration.

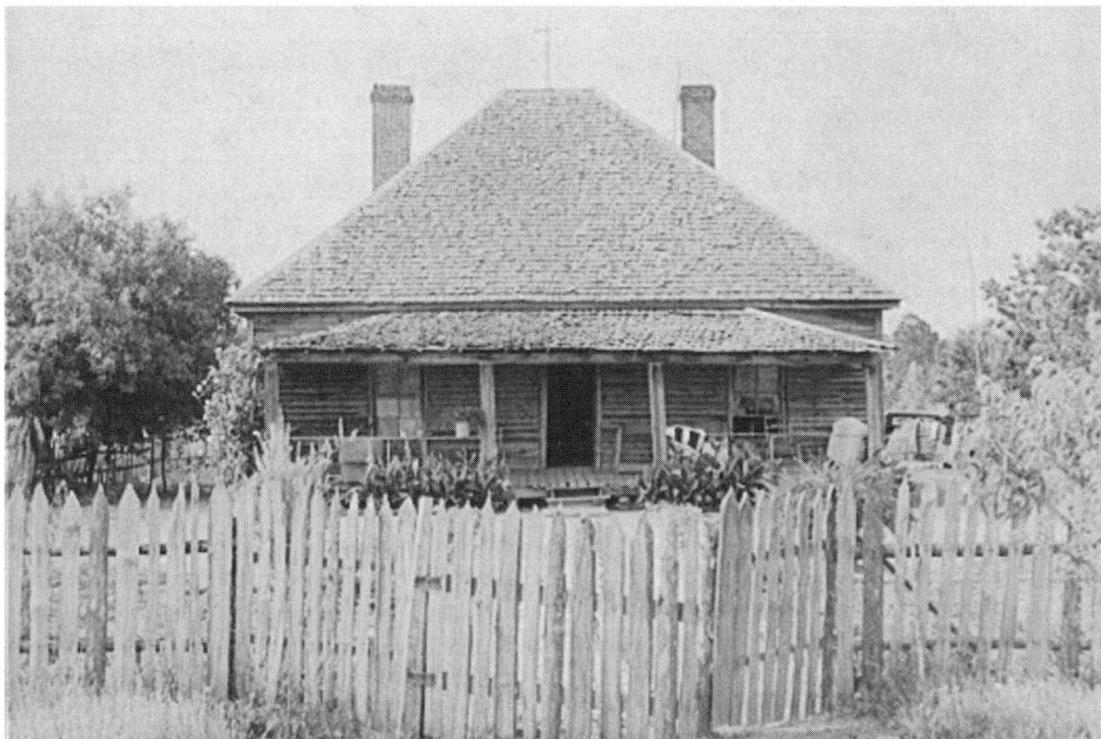

Rehabilitation client's house in Greene County, Georgia, spring 1939. Photograph by Marion Post Wolcott, Farm Security Administration.

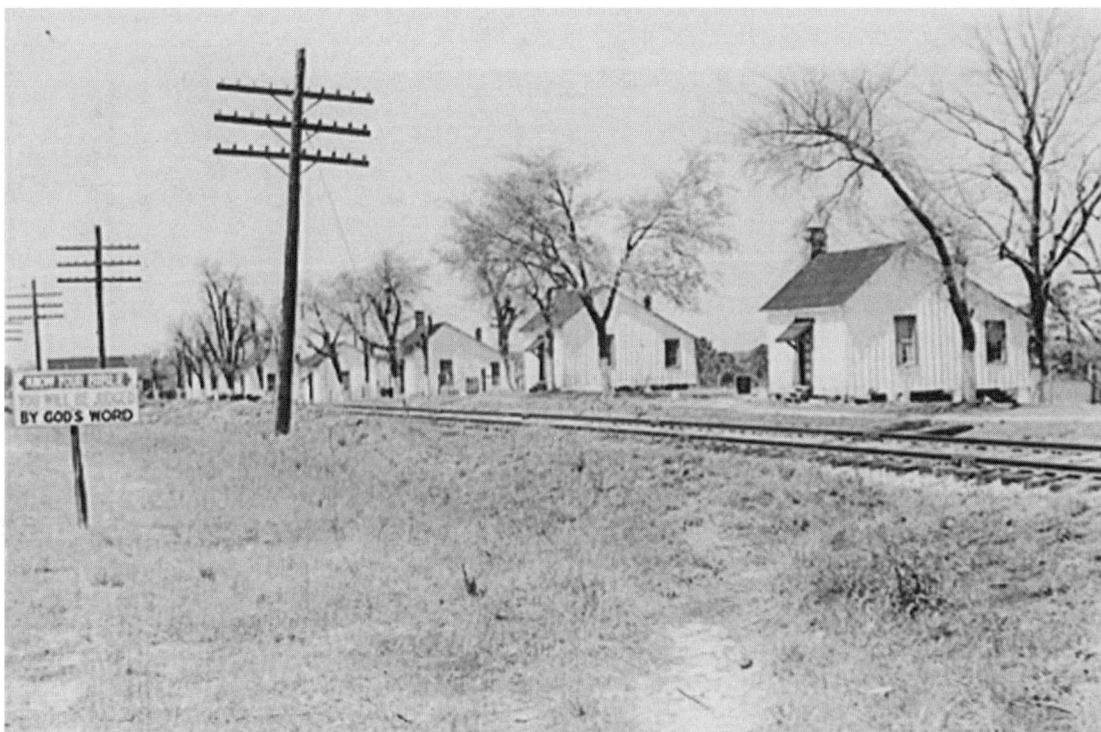

Railroad work crew houses near Madison, Georgia, May 1939. Photograph by Marion Post Wolcott, Farm Security Administration.

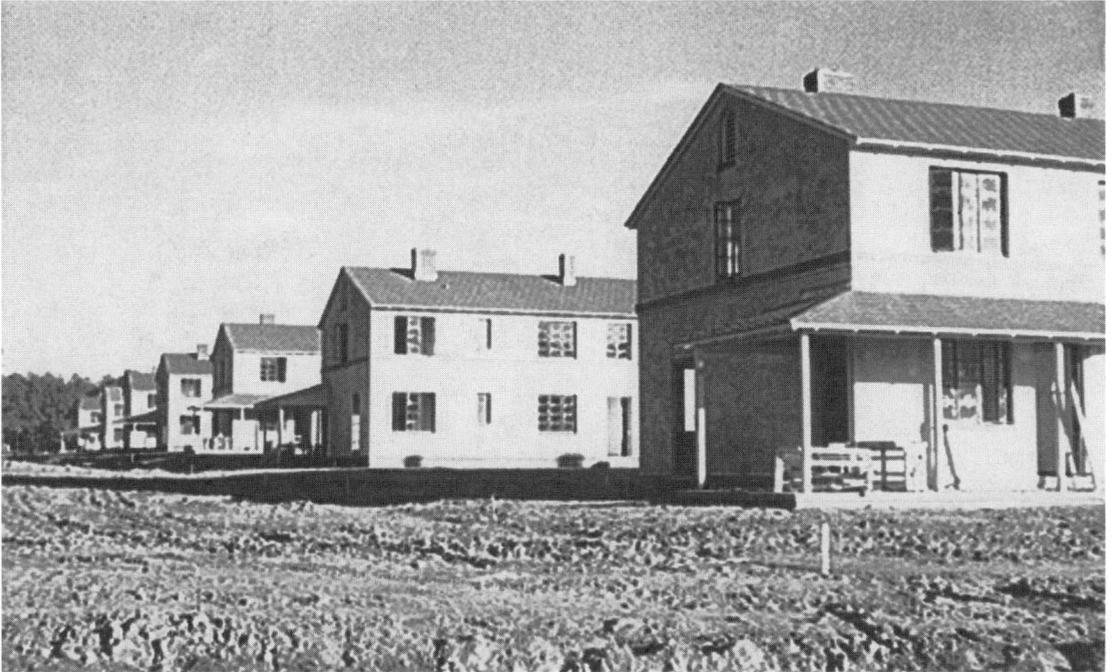

Newton D. Baker Village, a defense housing project under construction by the housing authority of Columbus, Georgia, near Fort Benning, April 1941. Photograph by Marion Post Wolcott, Farm Security Administration.

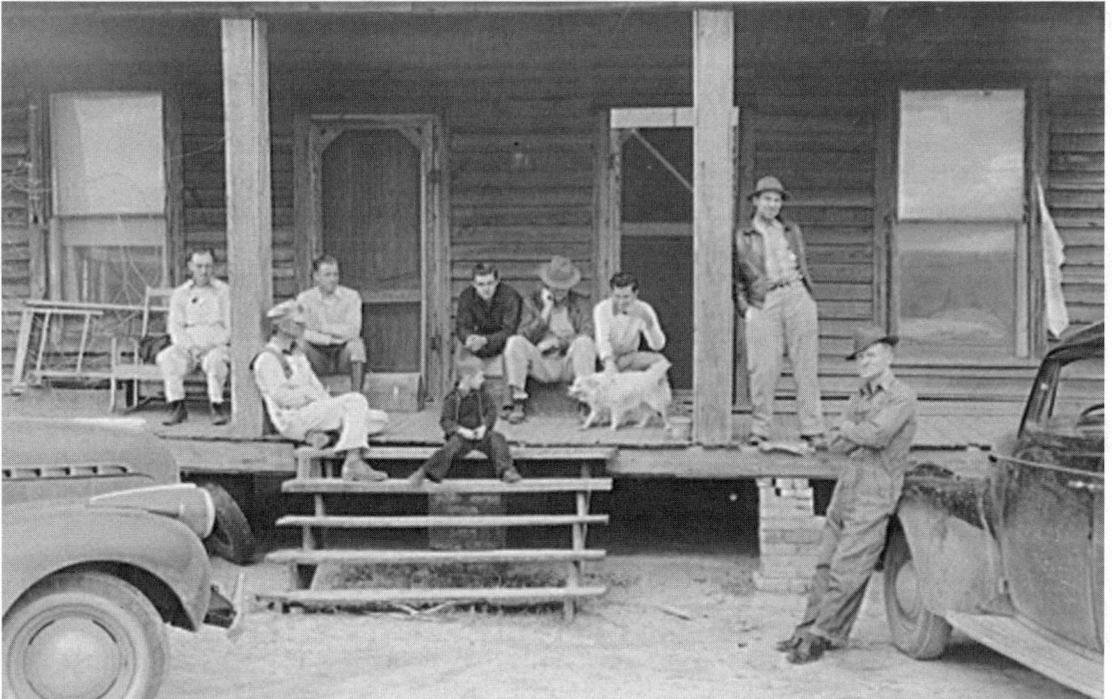

Construction workers on the porch of a local boarding house on a highway near Fort Benning, Columbus, Georgia. They were employed by Belair Construction building the defense housing project, December 1940. Photograph by Marion Post Wolcott. Farm Security Administration.

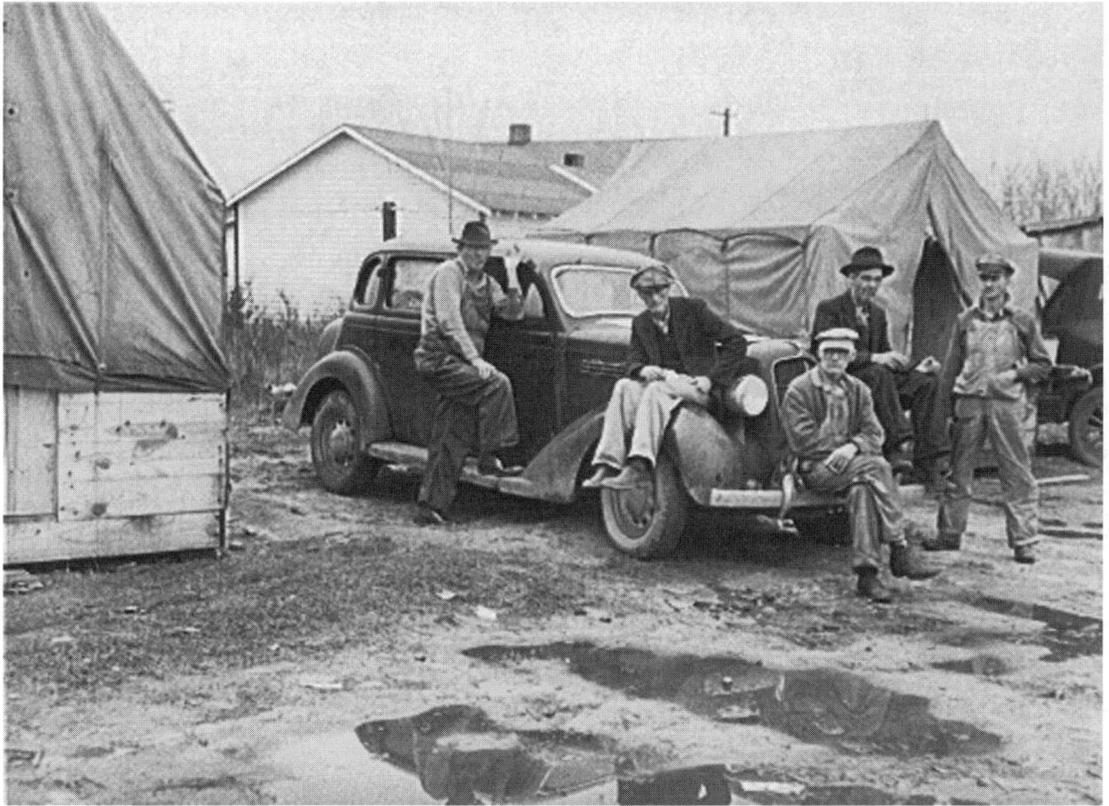

Construction workers William Allen Jones, Paul Knight, J. F. Goza, C.D. Brownless and B. I. Juhan in front of their tents near Fort Benning, Columbus, Georgia. For space only in W. T. Mullis' backyard they paid two dollars a week. Jones and Knight were working at Fort Benning. The others worked for the Williams Construction Company, building foundations for new barracks but got laid off for an indefinite time a couple of weeks before this photograph (December 1940). They all came from Stone Mountain, Atlanta, Georgia, where they worked on WPA (Works Progress Administration). Some had been here one month. One said, "There's something crooked in this here job — some men have worked every day seven days a week and others get no work at all. It's a dirty shame and the government ought to know about these conditions and see what goes on. It's awful bad." Photograph by Marion Post Wolcott, Farm Security Administration.

Migrant workers. Migrant workers in Georgia — as in other states—faced different housing problems. In each of the places where they worked, migrant workers had to find their own housing, live in their own vehicles or tents, or use the housing their employer provided. The provided dwellings were often

> ... built of a single thickness of rough boards, without window sash or screens. The galvanized iron roof epitomizes the South's place in the nation."[53]

Sometimes as many as thirty-five people slept in a "warehouse." These landless workers moved from one area to another with the mat-

uration of the crops. The families sought better dwellings and better working conditions.[54]

Photographer Jack Delano's letter to Roy Stryker (received July 2, 1940) describes the typical housing problems of the migrants:

> Housing for the transients is the chief problem. Some of the farmers have been able to furnish the migrants with warehouses or barns to stay in, but most of the negroes just have no place to stay at all. So at night you find them asleep in box cars, on potato sacks, in the potato graders, or out in the open....
> Last night I tried to get some pictures of the boxcar sleepers. If you had been here at 2 A.M. you would have seen 3 scared figures in the darkness— (myself and two boys carrying flashbulbs)—

quietly opening the door of the door of a box car and seeing exactly this ■, me pointing the camera in the general direction of loud snoring, setting off the flash then running like hell!

Tomorrow, I am going out to a house occupied by some transients about eleven miles from here. They're lucky to have a house but there are thirty seven of them staying in 3 rooms and an attic! I gave one of them a five the other day to get to talk to him and went up to the house. They think I'm a "pretty right guy" so I ought to be able to get some pictures there.[55]

Federal experiments in rural and suburban housing. It was 1934 before the first important federal efforts in low-income rural housing started in the United States. The government began to set up homestead projects and resettlement communities to provide a new start for the landless; the Resettlement Administration (RA), the Farm Security Administration (FSA), and other agencies tried a great many experiments in these communities. For

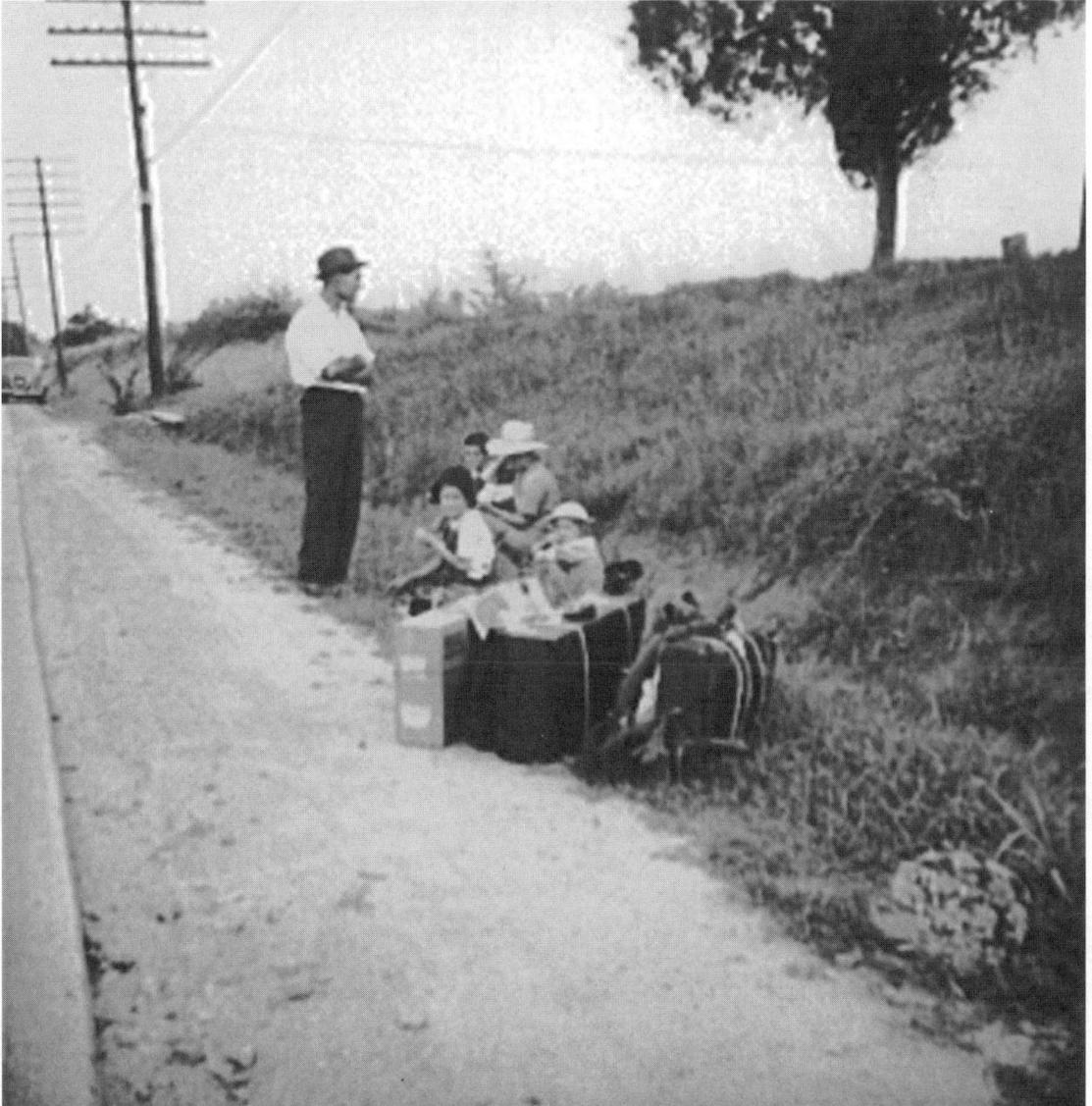

A hitchhiking family waiting along the highway in Macon, Georgia. The father repaired sewing machines, lawn mowers, etc. He was leaving Macon, where he needed a twenty-five-dollar license for such work and going back to Alabama in July 1937. Photograph by Dorothea Lange, Farm Security Administration.

instance, some federal agencies constructed houses—in addition to the conventional frame houses—of various experimental materials: prefabricated houses, mud houses, rammed earth houses, adobe houses, cotton houses, and steel houses.

Multiple dwellings, duplexes, and single houses were some of the experiments in the three "greenbelt towns": Washington, D.C.; Milwaukee, Wisconsin; and Cincinnati, Ohio. Other communities followed suit.[56]

When the decentralized housing program began in November 1937, there were only 46 housing authorities in the country. By creating local housing authorities, 68 communities were able to enter the public housing movement by 1939. The total number of local housing authorities was 289 in that year.

Smaller cities were joining the trend. There were 24 participating cities with a population of 25,000 or below in 1938; by 1939 the participating number had increased to 48—double that of the previous year. These small communities represented 27 percent of the cities with United States Housing Authority (USHA) commitments.

The year 1939 may well be considered one of the most significant in the contemporary social history of the United States. For in that year the slums of the nation began to decrease as the principles of public housing were transformed into the reality of projects.[57]

Late in 1939 more than a dozen states made efforts through their county housing authorities to rehouse rural families who were living in unfit structures. Designed primarily for rural families in Indiana, Illinois, Mississippi, and Georgia, the funds made it possible to provide the housing at charges the families could pay and to permit the leasing or sale of these better homes to the occupants.

As of December 31, 1939, a total of 12,000 substandard structures had been eliminated in 35 of the 155 communities participating in the

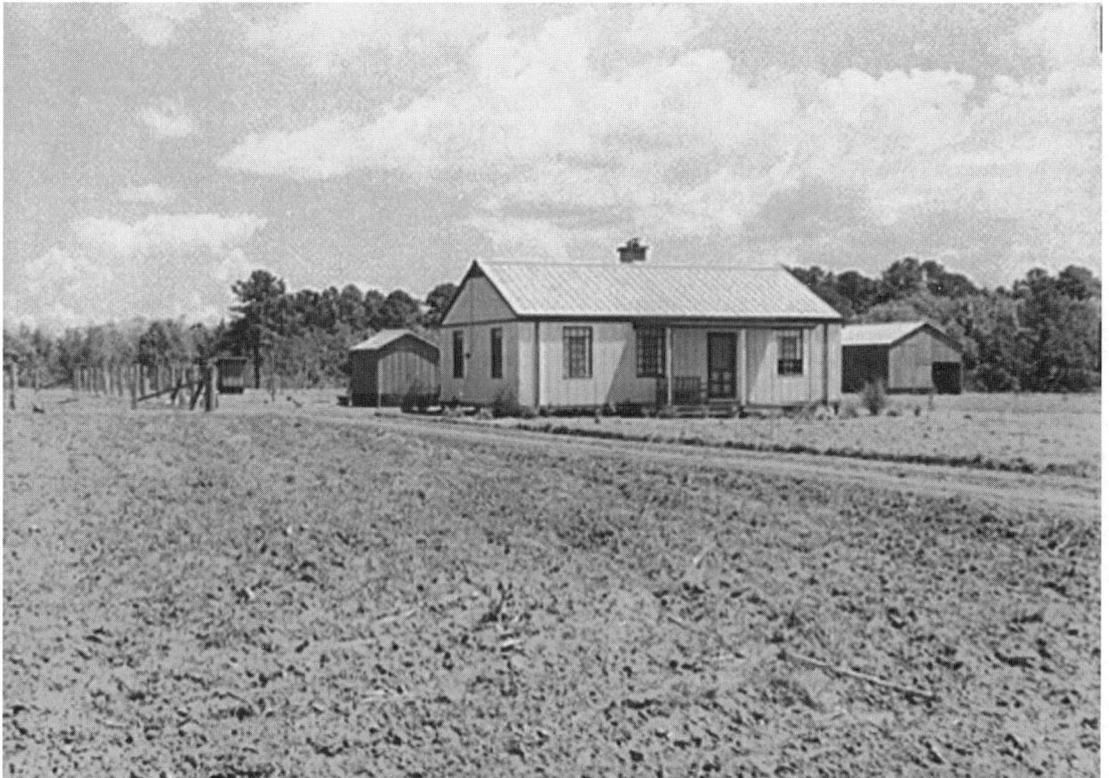

LC-USF34-051651-D. LIBRARY OF CONGRESS, PRINTS AND PHOTOGRAPHS DIVISION, FSA–OWI COLLECTION

Steel house operated by Larry Hall, May 1939, Flint River Farms, Georgia. Photograph by Marion Post Wolcott, Farm Security Administration.

slum clearance and low-rent housing programs. More funds from the United States Housing Authority made it possible for other local housing authorities to make major commitments to eliminate substandard housing in their area for the coming year (1940).

In 1939, the rents in the newly opened projects were below the average rent of the slum dwellings in the same communities; the rents were lower than the public expected. For example, at the Sunset Homes Project in Augusta, Georgia, the rent was $8.99 per month — well below the projected estimate of $13.25 per month.[58]

Harold S. Buttenheim, president of the Citizens' Housing Council of New York City, challenged:

> Whatever may be the present dangers to the United States from abroad, the major peril at home is the fertile soil of our city slums for the propagation of ideas hostile to our free institutions. And our most burdensome public costs are those resulting from idle man-power, idle machinery, and idle money. The result we can least afford is that of failing to build and maintain the virile citizenship and the good life that our abundant resources make possible.... The movement for better housing and neighborhood conditions must go forward.[59]

More legislation awaited approval in the decade to come.

Summary. In summary, the housing across the state of Georgia during the 1930s is best described as varied. The mill villages, the railroad crew housing, the fine Southern homes, the rural homes with electricity, the growing cities with their crowded houses and multifamily dwellings, the slum housing, the tents of the migrants, steel houses, and the shacks in both urban and rural areas are indicative of the many types of dwellings in Georgia during the Great Depression. The home ownership rate in the United States dropped to its lowest level of the century — 44 percent in 1940 — as a result of the Great Depression.[60]

Labor

Even though the general public is most familiar with labor stirrings during the Great Depression, the Georgia labor movement actually had its origin long before the 1930s.

I. Georgia Labor in the 1880s

In the 1880s a rapid increase in the industrial and agricultural workers in the state of Georgia paralleled closely a similar increase in employment in the nation. The Knights of Labor tried to achieve a toehold in the textile industry in Georgia in the 1880s. The organization was, however, largely unsuccessful.[1]

II. Georgia Labor in the 1890s

The increase in employment opportunities in Georgia and the nation as a whole continued until about 1893, when a brief depression affected the whole country. By the end of the decade of 1890s, however, the period of depression had ended. A heavy demand for industrial workers in Georgia and the nation continued from about 1900 until about 1920 — with the period during World War I demanding the most employees. It would be 1939 before Georgia regained the production peak it had achieved in 1919.[2] Labor unions, however, did not really begin to develop in Georgia until the 1890s. Skilled workers in building, in metal, in printing, and in railroad operations

were most likely to band together.[3] Textile workers participated in some local strikes in the 1890s and just after the turn of the century. These strikes were primarily efforts to resist integration.

A strike in 1895. One of the earliest strikes in Georgia occurred in 1895. This strike was not for wages or hours but to resist integration. At a cotton factory in Atlanta, Georgia, the management hired twenty African Americans and put them to work near the white employees. The 1400 white employees struck. Management settled the strike by removing the twenty recently hired workers.

III. Labor in Georgia from 1900 until the End of World War I

A strike of trainmen on the Central of Georgia Railroad occurred in 1909 when some African American firemen received employment. To settle the strike on the Central of Georgia, a board of arbitration decided that African Americans should have (1) the same pay as the white workers and (2) the same opportunities of employment as the white workers.[4]

Effect of World War I on unionization. With the advent of World War I, the focus of the nation veered from labor and toward the threat from beyond. The United States was no longer an island; cooperation with other nations had become a necessity. The prosperity

and the demand for industrial workers continued, particularly throughout the period of the war. The threat from abroad discouraged unionization.[5]

IV. Georgia Labor in 1919

Georgia in 1919 was a magnet to outside industrialists. Like most of the South, the state represented a good, cheap labor market to industries across the United States. Women and children, who commanded lower wages, were available for employment. In addition, Georgia had some hydroelectric power and also some enterprising power companies.[6] Georgia was also an appealing state to businesses because it did not have organized labor. John Golden, international president of the United Textile Workers, in a flyer (February 3, 1919), described the position toward unions of Frederick B. Gordon, president of the Columbus Manufacturing Company, Columbus, Georgia. Golden noted that Gordon had called himself "the Moses" who had the sacred mission of destroying trade unions in Southern states.[7]

Gordon quoted Golden as saying:

> And this is my prophecy: That the industrial South as a whole will never, while the country remains a republic, allow itself to be bound hand and foot, and virtually gagged politically, as is the industrial North today, by that "THING" that seeks to stab in the heart that inherent right of selective employment belonging to every individual firm or corporation in this country — that unholy, foreign-born, un–American, socialistic, despotic THING, know as LABOR UNIONISM.[8]

During 1919, union activities increased. In Columbus, Georgia, 7,000 workers joined the union activities as they sought a reduction of the fifty-five hour work week. The death of a worker occurred. Serious disorders and the temporary reduction of the influence of the union resulted. Then, union activism seemed to shift to North Carolina.

V. Georgia Labor from 1920 until 1926

In the 1920s the economy began to falter. There were several important reasons for the problems with the economy. Some Georgia banks had invested in real estate in Florida. With the collapse of the land boom in 1926, however, the Georgia banks that had been speculating heavily finally failed. Other events affected Georgia and the nation's economy. The sudden postwar price drop for commodities and the competition, boll weevils, and inclement weather impacted the agricultural workers. The poor economy impacted the industrialists also. This segment of the economy was, however, not as greatly affected as the rural population.[9]

Although all parts of the nation and all occupations did not foresee the retreat of prosperity, the recession immediately affected unionism, the workers, and the textile industry of the South and of Georgia. Union recruitment slowed. Only 30 additional unions began in the entire South over the next 12 months.[10]

Textile workers in 1921. Textile owners felt the lack of prosperity. As the demand for textile products declined (especially with shorter skirts and skimpier clothing), many owners and managers began to shorten employees' hours and reduce their workers' wages. Morale was especially low for textile workers in the South, where they had no organized bargaining power.

Low wages for the Southern laborer. The laborers in the South received wages that — even during the postwar boom of 1919 — were below that of most of the rest of the nation. The average annual wage in the South in 1919 was 73.9 percent of that in the rest of the nation. The average annual wage in the South during the first three decades of the 1900s was only 60 to 70 percent of that in the rest of the nation.[11]

The average wage of a male loom fixer was $42.88 for a full week in 1920; it was $21.41 in 1922, and $22.21 in 1928. A female weaver's salary for a full week declined from $26.56 in 1920 to $19.59 in 1922 to $19.37 for a full week in 1928. Because full-time work was not always available, the actual take-home salary for a male loom fixer was $18.38 for a week in the year 1928. The female weaver actually took home an average of $12.05 for a week in 1928. The five other standard occupations for mill

workers in 1928 averaged less than $10; a male frame spinner brought $6.76.[12]

The employment of Georgia youth in the 1920s. Unfortunately for the youth and the state, not all Georgia young people were able to take advantage of an education in the 1920s. This disadvantage for the youth of the state was a boon to employers intent on profits.[13]

Efficiency experts and stretch-outs. Many factory owners, seeking to get the most from their employees, brought in efficiency experts. Frank and Lillian Evelyn Gilbreth, who lived in Charleston, South Carolina, and whose children told of their experiences in *Cheaper by the Dozen*, were a frequently-sought team nationwide. Often the textile employees saw these consultants as hastening the pace of their job, increasing the work, and reducing the number of workers— actions that the workers dubbed "a stretch-out."[14]

Changes in mill ownership. Entrepreneurs in other parts of the country had begun to buy many of the Southern textile mills. Because these new owners often did not change their residences to be near the mills, they did not know their employees as individual people and frequently did not take a personal interest in the workers. These new owners chose often to sell the houses in the mill villages; this decrease in mill housing was to many workers a "death." While such distance of separation had a downside, a positive consequence was that the paternalism many textile workers disdained began to decline. Chapter five, "Housing," includes more information on the "passing" of the mill village.

Labor unions. After the end of World War I, craft unions and other groups of American workers across the nation began to renew their recruiting activities and to organize for improved working conditions. Georgia was a site for the activities of these organizations, which involved many different Georgia industries.[15]

Textile unions in the 1920s. Some scattered strikes hit the South during the 1920s. By the end of 1921 most textile strikes themselves had ended, but much worker dissatisfaction remained. The gap between textile owners and textile workers widened. Mill owners often maintained the reduced wages for the workers. A male loom fixer, for example, who had made $32.50 a week in 1920 made only $21.41 in 1922.[16]

Reasons for resistance to unionization. Despite the many dissatisfactions that workers had in their employment, Georgia workers were resistant to the development of strong labor unions. There were several reasons for their resistance. One was the rural tradition of many of the laborers; this rural tradition of subsistence and depending on one's family alone made it difficult for most of the workers to embrace permanent organization and unionization. Another reason for the resistance was that many of the workers were "loners" and not group-oriented; again, because many of them came from a rural background, they were accustomed to independence and "making do" on their own. Another reason that unionization was so difficult to achieve was the workers' suspicion of the outside organizers.

Many textile workers hoped for a paternalistic working environment. They wanted their employers to appreciate their jobs and their job performance. They preferred to defer to the "knowledge" of the owners and to give less thought to themselves. A predominant focus of the many of the religions in Georgia was the hereafter and not the here and now. Most churches stressed others and not one's self. A literal interpretation on the scriptures (fundamentalism) resulted in disinterest in labor unions.

Prominent traits of many of the Georgia workers were "ingrained individualism, apathy, poverty." The mill villages did not welcome the union organizers; sometimes open hostility and even violence met the union representatives who tried to solicit members.[17] Although most of the men would not admit it, they often had a fear of their "boss." When the housing for one's family and the wages that paid for the food and necessities of the household were at stake, many male workers were hesitant to "get involved."

For whatever reason or combination of reasons, however, unionization in Georgia was slow.

Strikes in 1921. The mills began to "cut back" even further in the late 1920s and in the early months of 1921; managers lowered wages— often as much as 50 percent. Workers became even more embittered. Even though union officials promptly advised against a walkout, on June 1, 1921, a neighboring state tried striking.

Approximately 9,000 North Carolina textile workers left their jobs. Because there was little need to reopen in a depressed economy, the mill managers merely waited for the union efforts to collapse. The North Carolina State Militia finally came to Kannapolis and Concord to protect the "scabs"—those who returned to work while fellow workers, family, and friends tried to continue the protests.[18]

> By the end of 1921 the upthrust of unionism was over. In not a single case had it brought an important union recognition, and the feeble locals soon disappeared. Failure of a railroad shopmen's strike in 1922 left that group largely unorganized. The other craft unions, which had shared in the growth, felt the severe impact of open-shop organizations that proliferated across the country after the war.[19]

Postwar prosperity had built the unions; the slump of 1920 and 1921 destroyed the unions in the state and nation. Dissatisfaction with working conditions and with wages continued to fester among the workers.[20]

Employers had typically resisted collective bargaining, the establishment of labor unions, wage controls, and increases in wages—which they often paternally insisted were high enough for the workers and enabled the businesses to compete successfully nationally. The rigid antiunion views of many employers, the hostility of management, the indifference of state government and the general public, the inconsistency of federal support, and the large number of unskilled workers in the state resulted in the slow development of a labor movement in Georgia—and much of the South.

The employees recognized that the power of many of the companies was extended far beyond the walls of the business. The influence of the managers extended to the villages, the company-owned stores, the churches, and sometimes the schools, the teachers, the sheriffs, the guards, and even the company spies who reported back to them on the words and actions of their workforce.[21]

VI. Labor and Unionization in 1927

In 1926 the Georgia state federation had commenced reviving and reinvigorating local labor organizations. The AFL took over and expanded the program in 1928. Neighboring states also began to work to strengthen the unions.[22] In 1927 the average earnings for workers in the South were $571 for workers in cotton, $747 for workers in timber and lumber, and $823 for workers in Southern industries.[23] The South was experiencing "a bad time" long in advance of the Great Depression.

VII. Wages, Working Conditions, and the Labor Movement in 1928

The highest-paid mill worker was the loom fixer—always a male. In the South he earned in 1928 only $22.20, a reduction from the $32.50 of 1920. Because full-time work was not always available, however, he usually took home only $18.38. The female weaver with only part-time work usually earned $12.05. The male frame spinner usually earned only $6.76 with the reduced hours. Five other standard workers earned less than $10 in the same year.[24]

The average hourly earning in cotton goods ranged from 20 cents an hour to 39.9 cents per hour, depending on the skills of the worker. Salaries for workers in hosiery and underwear production were the highest: 22.6 cents per hour to 65.5 cents per hour. Sawmills paid 21.9 cents to 83.1 cents an hour. Foundries and machine shops paid from 28.5 cents per hour to 79.4 cents per hour. Regional differentials tended to decrease at the higher levels of skilled labor; the differences disappeared altogether for blacksmiths, machinists, and bricklayers.[25]

The workweek in the textile industry. In 1928 the textile industry hired more workers than any other industry. The average workweek for a textile worker was usually ten or eleven hours per day for five days with a five-hour day on Saturday; the workweek, then, was fifty-five to sixty hours per week. Despite these low wages and long hours, managers began to increase the work even further for the employees—when the mills were running.

The class structure in Georgia. A social hierarchy—long implied—began to solidify in the state. Those outside the mill environment began to increase their scorn of the "Lintheads." To increase the hierarchy even more, the mill managers tended to alienate themselves from the workers whose wages they cut, whose hours they managed, whose work they increased in the stretch-out, and whose jobs they controlled.[26]

VIII. Georgia Labor between 1929 and 1930

William Green, president of the American Federation of Labor and a professed enemy of Communism, explained astutely the reason why the South sometimes gave the Communists an opportunity to act. He said:

> These southern workers know nothing about the philosophy of communism; they do not know what it means. It is all Greek to them, but in their hour of distress, when they are rebelling against conditions, they accept support and help of anyone who extends the friendly hand.[27]

Communism within the state in 1930. Reports of Communism in Georgia were flagrant in 1930. The state became a focal point for Communist activity. In May of 1930 the police arrested on insurrection charges six Communists. Angelo Herndon came to Atlanta in the summer of 1932. Herndon was a

> ... Negro Communist sent into Atlanta to organize a demonstration of the unemployed, was arrested, convicted of insurrection under a law of 1866, and sentenced to from eighteen to twenty years. His defense attorney, Benjamin J. Davis, Jr., son of Georgia's Republican national committeeman, later asserted that he had been turned to-

ward communism himself by the bigotry of a judge who addressed him as "nigger." After a protracted litigation Herndon finally won his freedom in 1937 with a ruling by the United States Supreme Court that the Georgia law violated the Fourteenth Amendment guarantee of due process.[28]

Child workers. In Georgia the proportion of children under sixteen declined from 18.7 percent in 1918 to 3.4 percent in 1919. Georgia's percentage compared favorably with Connecticut (4.8 percent), Massachusetts (5.8 percent), and Rhode Island (6 percent): "By 1931 all the Southern states forbade factory labor by children under fourteen and night work under sixteen; most set an eight-hour limit for all under sixteen."[29]

Unionization prior to the 1930s. The unionization of workers in Georgia had failed prior to the 1930s. Only 3.2 percent of the workers in the industry in Georgia were union members. Most of the 3.2 percent were residents of the Atlanta area.[30]

New Deal programs. The New Deal programs of the 1930s impacted agriculture in Georgia, but the programs affected industry very little. Although the aims of the New Deal programs had been to raise wages, increase employment, and reduce working hours, Southern workers believed the codes usually benefited employers, the nation's largest businesses, and primarily those states that were heavily industrialized. Most Georgia industries were so small that they could not—or would not—pay the wages the NRA codes recommended. Without the power to enforce the codes, the NRA affected Georgia workers very little.[31] Industry in Georgia grew slowly between 1890 and 1940. Likewise, the urban population grew slowly but steadily so that the 14 percent in 1890 became 34.4 percent by 1940.[32]

IX. Georgia Labor in the Early 1930s

The 1930s echoed with worker dissatisfaction, hostile management, reduced wages, decreased workers, and increased duties ("the stretch-out"). As was true in 1928, Communists

sought to exert their influence on union locals.[33]

Satisfaction among some textile workers in the early 1930s. There were two sides to the labor controversy of the early 1930s. Many workers favored the family environment of the mill village; they liked the fact that if a family moved to the provided housing, there would normally be a job for everyone. These same workers liked the fact that the mill owners sometimes distributed "free" coal and "free" electricity to those in the mill village. Renters in the villages usually considered the cost of their housing — 25¢ to 50¢ a room per week or per month — to be reasonable. Some residents were pleased with the many conduct rules: no drinking, no gambling, required church attendance, and no fights; they saw the rules as keeping their community safe and pleasant for themselves and their families. Some textile employees believed that if things became too bad in one plant, they could seek employment elsewhere.[34]

Dissatisfaction among some textile workers in the early 1930s. Other workers expressed dissatisfaction. Their gripes were many. Stretch-outs, discrimination, reduced wages, and long hours heightened unhappiness. The whole city — often even the doctor's office and the company store — seemed to belong to the mill owners. Those who worked in the mills faced a building filled with dust and cotton fibers; this atmosphere made the workers prone to respiratory ailments. The machinery needed constant attention, and during the stretch-outs the number of machines for which one was responsible became more and more. Disgruntled workers viewed the mill owners' "paternalism" as excessive control.[35]

Women textile workers. Laws to protect women workers in the South lagged behind other parts of the country, and the women comprised more than a third of the work force. Few women could muster strength for work at home after a long day in the mill. By 1931 Georgia had set limits for the number of hours per day that women could work, but that limit was nine to twelve hours a day for the labor of women in manufacturing; there was no law against night work for women in the mills.[36]

These textile workers needed courage to "buck the system," but some did so. This time before the proposed strike was "an even of hope — and despair."[37]

African-American women across the nation fared much worse than other women: "Nine out of ten agricultural laborers, and two-thirds of domestic servants were black."[38] Labor unions did not usually represent these occupations.

African Americans in the unions. African Americans worked as operatives in Georgia lumber mills, but less often in hosiery and textile manufacturing plants. African American on most streets were cleaners, seamstresses or tailors, occasionally restaurateurs, and barbers or beauticians. Plumbers, painters, brick masons, and other skilled trades in which African Americans worked were not usually unionized occupations.[39] Generally, no African-American women or men could work in the textile plants as spinners, weavers, or loom fixers. African-American women could work only as domestics for the mill workers, and African-American men could generally participate in textile work only outside the mill or as custodians within the building.[40]

X. *Georgia Labor in 1933 and 1934*

The United Textile Workers of America (UTW) in 1933 had barely 15,000 members across the nation and seemed to have failed in organizing workers in the South. Eighteen months later, however, the UTW boasted 300,000 members and locals in 208 cities, towns, and villages.[41]

August and September of 1934. Violence swept the textile districts from New England through the South during August and September of 1934. The strike involved 400,000 workers, with 200,000 from the South. The United Textile Workers claimed only to want the mill owners to honor the Cotton Textile Code, an NRA code signed in July of 1933. The UTW asked for the additional wages, the collective-bargaining provisions, and the work sharing

Badge of a Union Steward in the United Textile Workers Union, 1930s.

that representatives of the mills and the workers had earlier to honor. The UTW talked about striking, but there were decided logistical problems of organizing a strike that stretched through twenty states.[42]

> In 1934 the worst textile strike in Georgia's history swept across the state as flying squadrons of striking emissaries in trucks raced from one cotton mill town to another to force workers to quit their jobs. Governor Talmadge called out the state troops, armed them with tear gas bombs and machine guns, and arrested many of the strike agitators and lodged them in concentration camps. LaGrange and Manchester were storm centers.[43]

For the first few days some strikers—many of whom were women—reported the activities as "fun." By the end of the week, however, the activities became less joyful. There were no paychecks, and there was little backing from the union or the governor. Workers began to fear for their jobs, their homes, their families, and their lives.

Federal officials ineptly tried to resolve the dispute. Blood flowed.[44] Two people—a union sympathizer and a deputy—died in Trion, Georgia, on September 5, 1934. Still the strike persisted. When six or seven workers died in the sister strike at Honea Path, South Carolina, no church would house the funerals. Some textile workers from Georgia showed their support of their sibling workers by joining the 10,000 people who attended the services.[45]

The end of the strike of '34. Governor

Eugene Talmadge responded by calling out 3,700 Georgia National Guardsmen, the

> ... largest peacetime mobilization of national guardsmen in the history of the state. The guardsmen formed their own "flying squadrons" and arrested hundreds of organizers and pickets as a way to force the mills open and provide security.[46]

Near Fort McPherson in Georgia, the guardsmen encountered a group of pickets, the *Atlanta Constitution* reported on September 14, 1934. The next day the *Atlanta Constitution* reported that a group of 128 pickets—both men and women—were detained in Newnan, Georgia. By September 19, 1934, the *Atlanta Constitution* was able to report that 10,000 textile employees were back at work.[47] The broken backbone of the textile union in Georgia was evident after 1934 throughout the state as the union activities dissipated.[48] The union finally halted the strike. "We won't have our people going up against machine guns," a union official announced.[49]

After the strike of '34. Many Georgia workers were grateful for any governmental help. Union members generally welcomed the passage of the New Deal Legislation (1933–1945) and particularly the Wagner Act (1935), which had some of the same purposes as 7-a. Workers believed that the Wagner Act might help them in ways that 7-a had not. The Supreme Court in 1935 struck down the NRA. Many union members believed that in the uprising of '34 they had received no support from Section 7-a of the National Industrial Recovery Act (NIRA). Section 7-a should have granted them the right to bargain collectively, prevented discrimination against union members, ensured union rights within the companies, and prevented the discharge of workers for union activity. It had not.[50]

President Franklin Delano Roosevelt urged employers to rehire the strikers without retaliation, but many workers lived in fear of vengeance for their joining the union. Employers felt rage toward these people who had expressed such hatred toward them; they secretly felt fear toward the new, threatening fiend: the union.[51] Even the administration "found itself bamboozled and irritated by the labor eruptions of Roosevelt's first term.... It moved only

hesitantly and ineffectively to channel the accelerating momentum of labor militancy."[52]

The Communist *Daily Worker*, American publications like *The Nation* and *Social Research,* and newspapers across the country covered the Georgia strikes and analyzed the actions in this Southern state.

XI. Examples of Georgia Unionization after 1935

The United Auto Workers (UAW), founded in May 1935 in Detroit, Michigan, was under the auspices of the American Federation of Labor (AFL). Since its 1881 founding by Samuel Gompers, the AFL had as its main focus the small craft unions.[53]

In 1935 at its convention, a caucus of industrial unions assembled. Led by John L. Lewis, this group of industrial unions formed the Congress of Industrial Organizations (CIO) within one year. This CIO was separate from the AFL and included the United Auto Workers Union (UAW). The UAW was one of the first of the major unions to organize African American workers. This inclusion increased the support necessary to win recognition through election. There was, however, still prejudice within its members.[54]

The first sit-down strike of the UAW was in Atlanta, Georgia, in 1936 in a General Motors plant. In November of 1936 workers at the Lakewood General Motors plant and the Fisher Body plants went on strike. The beginning of the action was a "sit-down strike"; members of the UAW Local 34 refused to leave the plants and remained on site. After management assured the workers that the plant would not reopen until they completed their negotiations, the workers left the site.[55]

Other strikes followed, but union organization in the Ford Motor Company came much later — in 1941. Ford had vowed that "The UAW will organize Ford over my dead body." It was 1941 before Ford agreed to a collective bargaining agreement with the UAW.[56]

New Deal Legislation and the Wagner Act. Many Georgia workers had hoped for governmental help. Union members had generally welcomed the passage of the New Deal Legislation (1933–1945) and particularly the Wagner Act (1935), which had some of the same purposes as 7-a. Later, workers believed that the Wagner Act might help them in ways that 7-a had not. The Supreme Court in 1935 struck down the NRA.

1937. New Deal legislation foreshadowed more effective communication with labor in Georgia, the discontinuation of using state troops in strikes, employing collective bargaining instead of violent strikes, less open strife, and the decline of "paternalism" in Southern industry. Georgians, however, were not unanimous in their opinions about unionization and New Deal legislation. While many employers believed that unionization, collective bargaining, and New Deal legislation would help improve relations between labor and management, others viewed the legislation as government intrusion. Some employers tried to disregard the new legislation and found themselves in violation of federal law and in danger of disciplinary action.

In 1937 John L. Lewis and the Committee on Industrial Organization (CIO) sought to increase the unionization of the South, particularly the textile industry. His work was not, however, highly successful in Georgia at the time.[57] Even billboards seemed to indicate the concerns of the time.

1939. Douglas Flamming used the 1939 strike at Crown Cotton Mills in Dalton, Georgia, as an example of the division among Georgians on the subject of unions. Just after the Dalton strike, antiunion workers actually brought suit against the state of Georgia for their lost wages while workers were on strike.[58]

1941. In 1941 the town of Greensboro in Greene County, Georgia, achieved some adverse publicity; its workers went on strike for higher wages. The Mary-Leila Cotton Mill was the site of the 1941 strike. Federal photographer Jack Delano was in Georgia at the time of a 1941 strike. He was able to capture images of the pickets, many of whom were women. Their signs—captured on Delano's images—read "We'll hold this line till Hell freezes over," "We want a contract," and "More money means better living conditions."

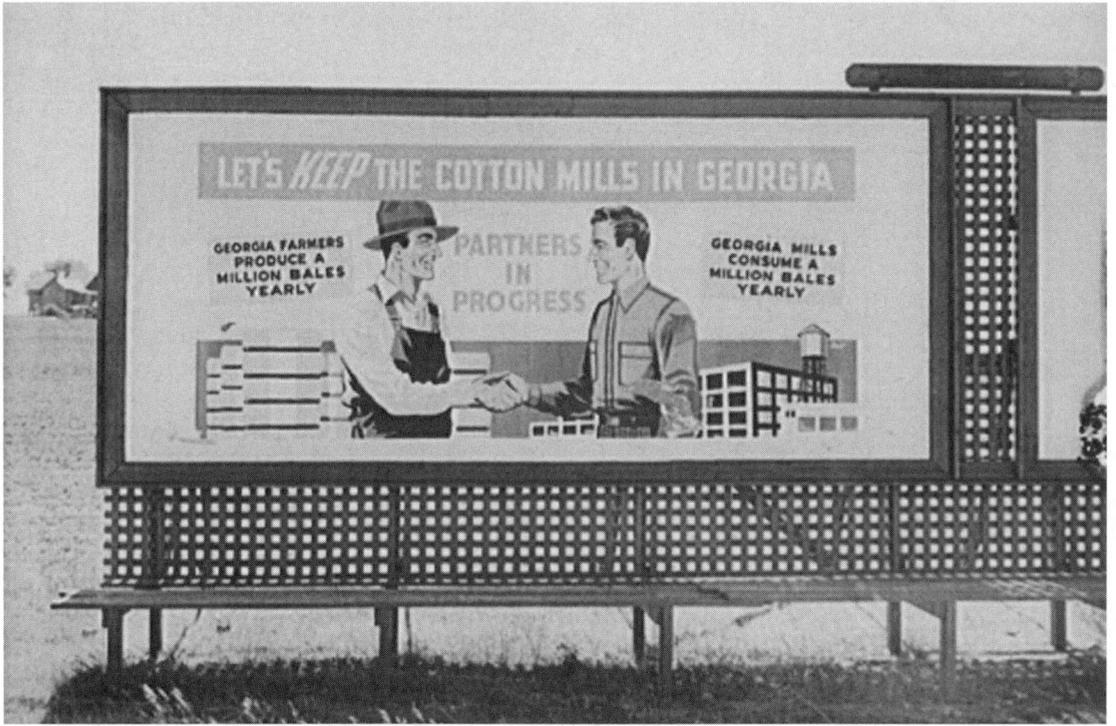

Signboards along Georgia highways indicated the attitude and anxiety of manufacturers and mill owners, March 1939. Photograph by Marion Post Wolcott, Farm Security Administration.

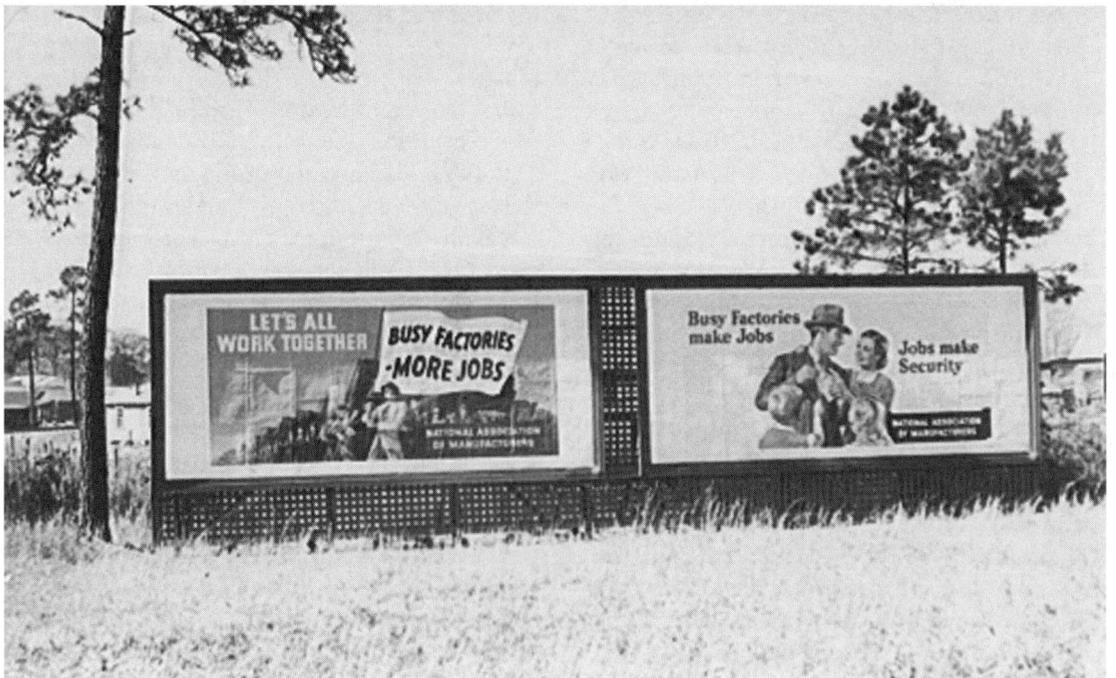

Highway signs by lumber planing mill in Cairo, Georgia, March 1939. Photograph by Marion Post Wolcott, Farm Security Administration.

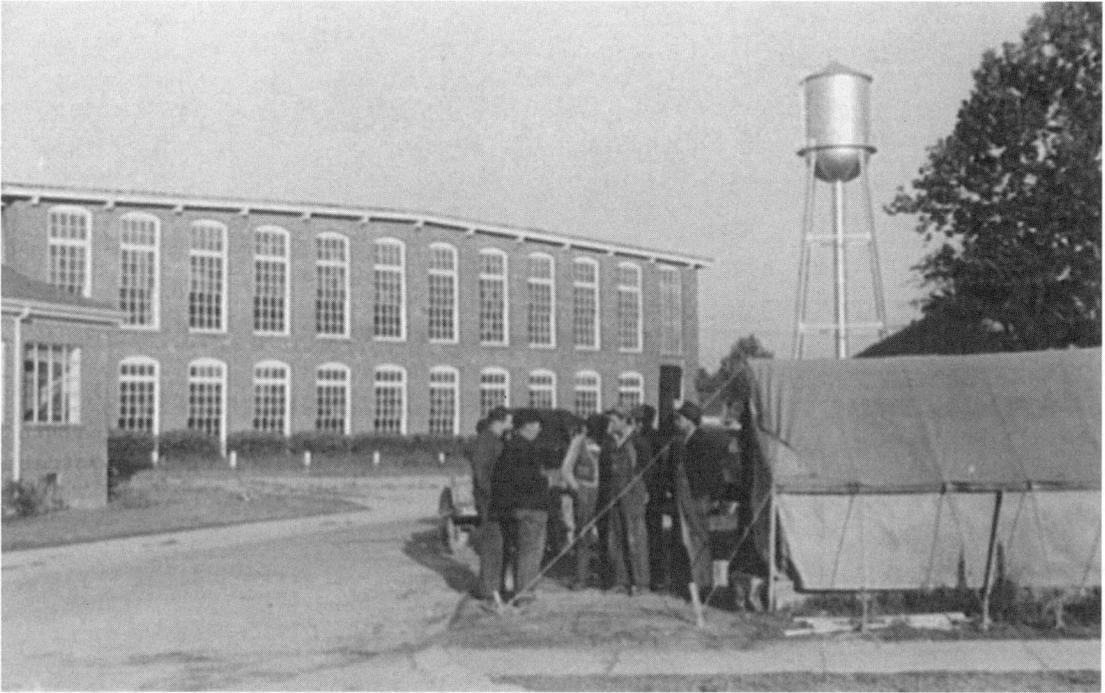

A mill in Greensboro, Green County, Georgia, May 1941. Photograph by Jack Delano, Farm Security Administration.

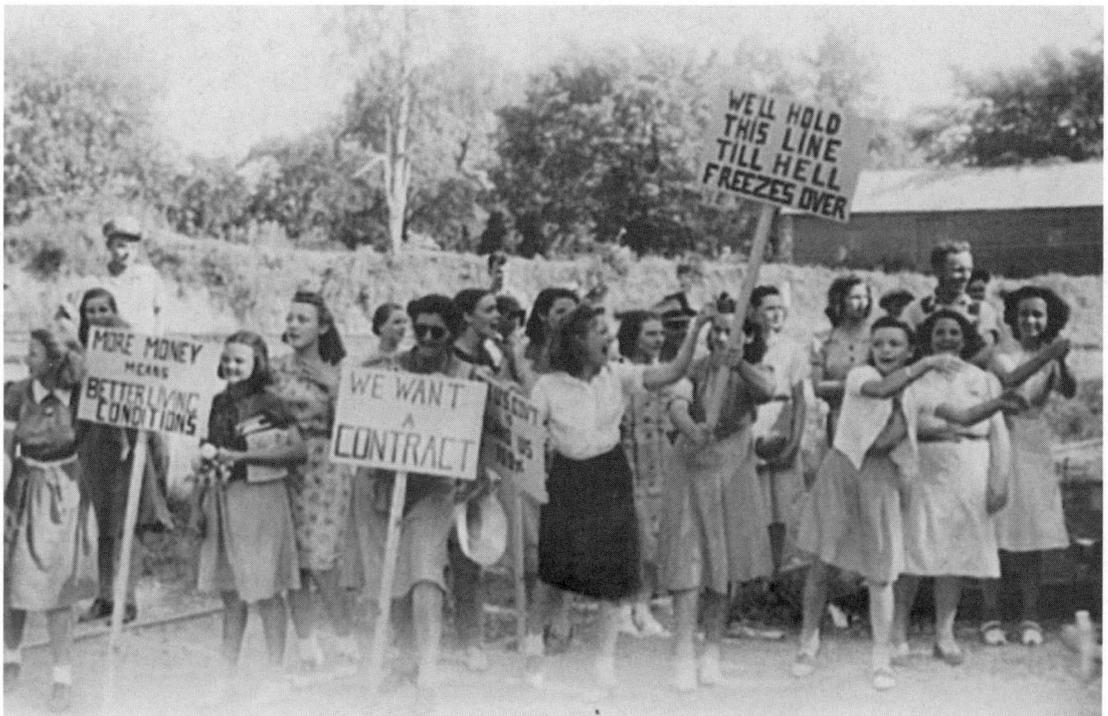

CIO pickets jeering at few workers who were entering a mill in Greensboro, Greene County, Georgia, May 1941. Photograph by Jack Delano, Farm Security Administration.

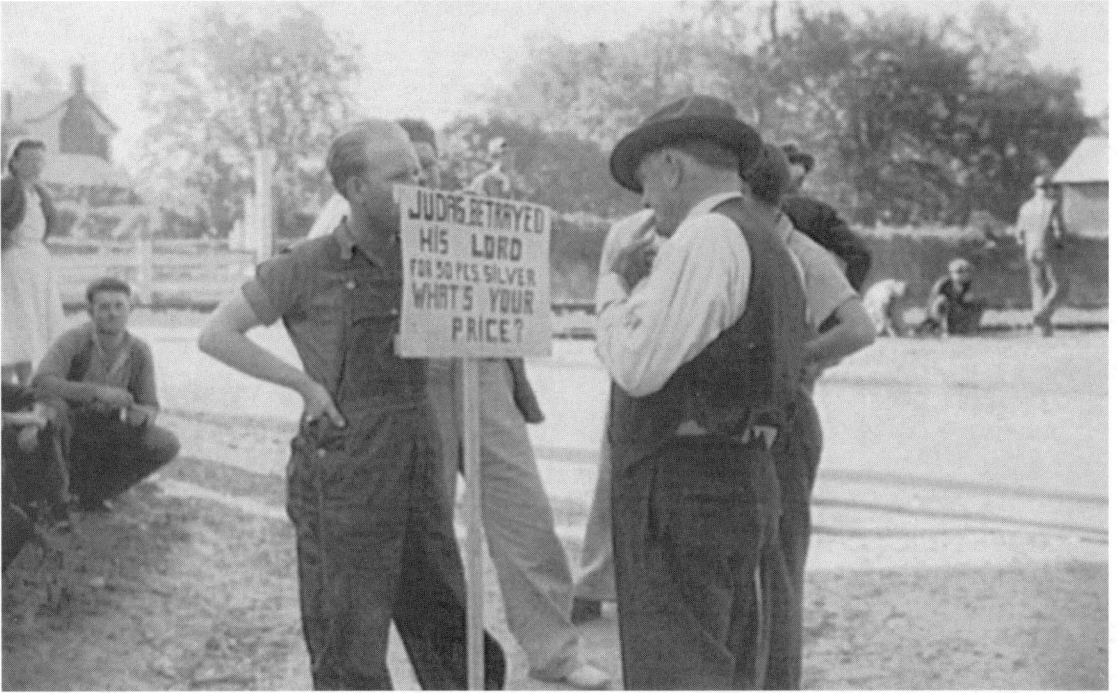

Greensboro chief of police reading a CIO picket sign at a textile mill in Greensboro, Greene County, Georgia, May 1941. Photograph by Jack Delano, Farm Security Administration.

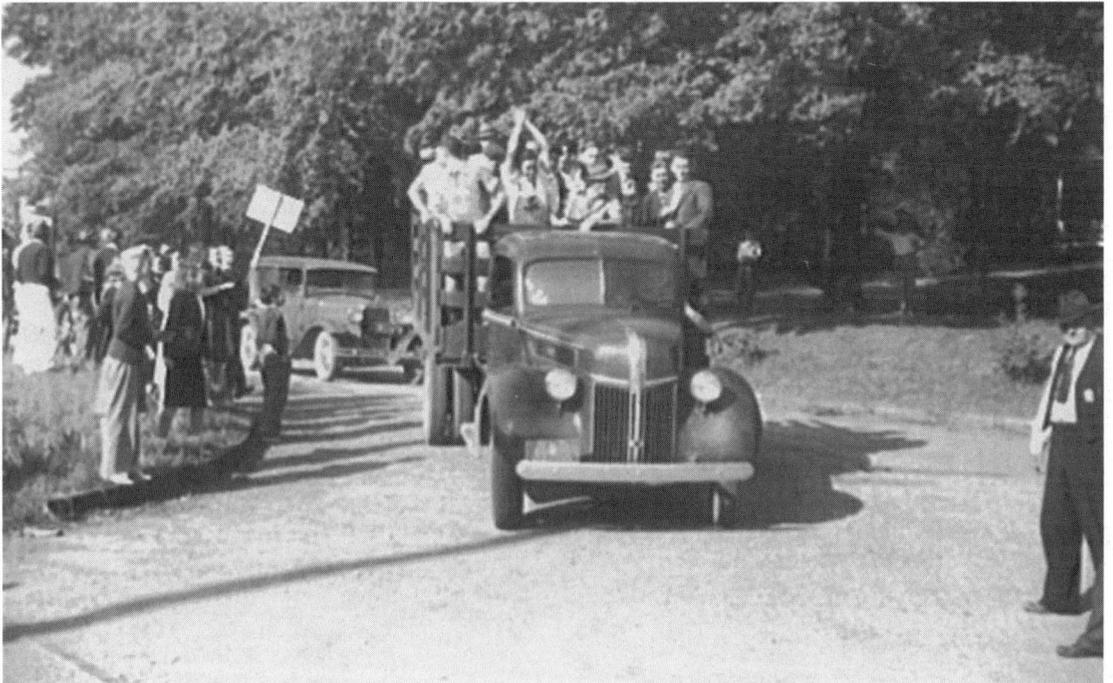

Mill workers who lived largely in rural areas cross a CIO picket line at a textile mill in May 1941 in Greensboro, Georgia. The lockout, which lasted about three months, ended in a signed contract. Photograph by Jack Delano, Farm Security Administration.

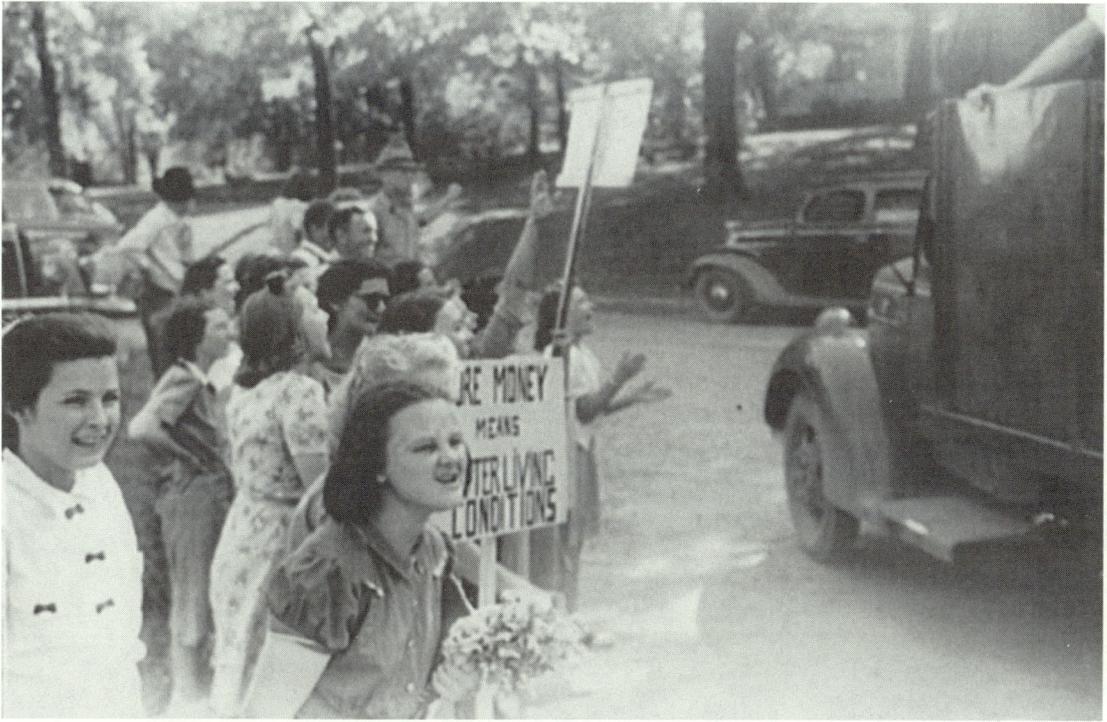

CIO pickets jeer at a few workers who were entering a Greensboro, Georgia, mill in May 1941. Photograph by Jack Delano, Farm Security Administration.

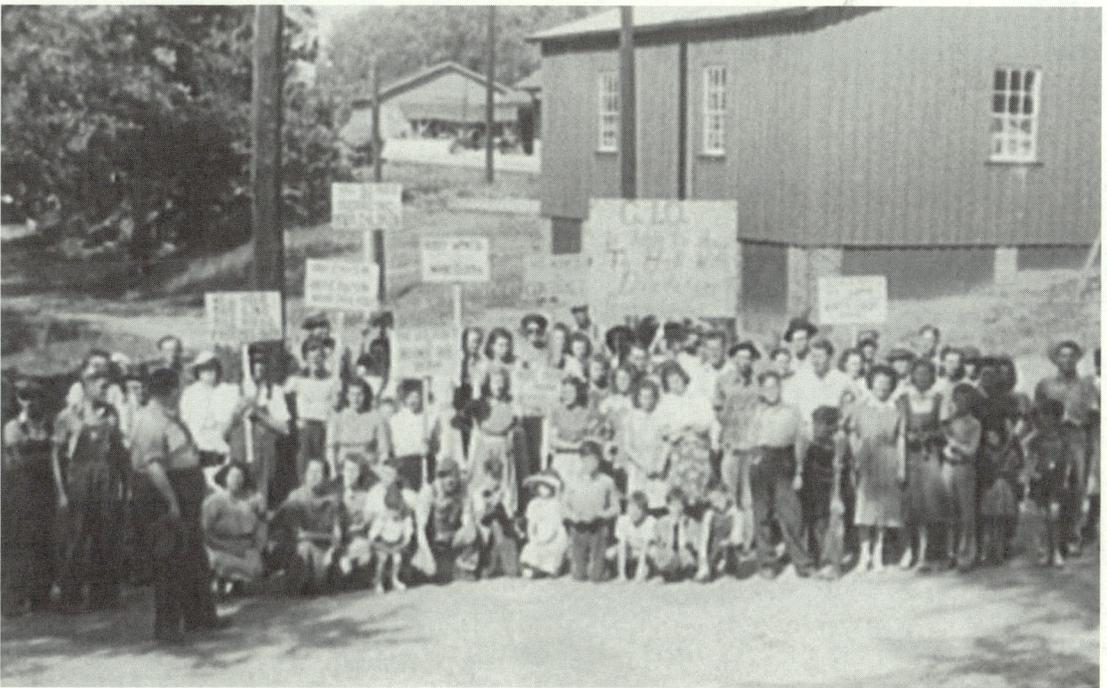

CIO pickets outside a mill in Greensboro pose for a picture, May 1941. Photograph by Jack Delano, Farm Security Administration.

The Chief of Police of Greensboro, Georgia, talked with the pickets. Delano captured the Police Chief reading the sign that said, "Judas betrayed his Lord for 50 Pieces of silver. What's your price?" Delano photographed mill workers in a truck breaking through the picket line. The arrival of the strike-breakers ("scabs") was met with jeers from the CIO pickets— even the women, and the pickets posed openly for Jack Delano to photograph them.

Although this strike was settled after three months, this would not be the only strike during the early 1940s— even though the nation went to war. In 1942, for example, there were 2,970 walkouts, which idled 840,000 workers. Some of them were mine workers who were protesting the declining safety conditions in mines already dangerous for workers. The federal government responded with the 1943 Smith-Connally Act, which restricted the union and made it more difficult for workers to strike. The tensions continued into the next decades.[59]

Summary. In summary, the first four decades of the 1900s in Georgia mirror a rapidly fluctuating unionization. The number of agricultural laborers increased and exhibited little unionization; textile workers continued to debate the pros and cons of unionization. There was a perpetuation of agricultural products in the state. Photographs from Stryker's collections and from the newspapers of the time reflect these directions in labor in the state of Georgia.

CHAPTER SEVEN

Entertainment

Any study of Georgia during the Great Depression would be incomplete without some attention to the mental health of its people, the state's most valuable resource. Relaxation is important to the health of individuals. Even during—what were for many—the difficult times of the Great Depression, Georgians needed opportunities for the release that they required.

The health education books of the 1930s emphasized particularly the importance of mental hygiene. Paul Witty and Charles Skinner emphasized that the goal of adulthood is "...wholesome, sane, co-operative living, with adequate release through aesthetic experience and creative activities."[1]

With the hard work, the disappointments, the "stretch-outs," the limited budgets, the strikes, the unemployment, the poor health, the inadequate diets, and the problems in education and housing, recreational activities that cost a great deal of time or money were prohibitive for many families and individuals; yet, relaxation from the stresses of everyday life was advisable. For some this relaxation was available at home; others preferred a chair at a local store or park.

With Atlanta as a cultural center, many were able to take advantage of some of the finer aesthetic and creative experiences that life had to offer. The federal government even helped to provide some artistic activities that were accessible for all economic groups; the New Deal art, for instance, that enabled the masses to view murals on the walls of federal buildings,

like the post office, gave some relief to artists who were hard-pressed during the economic decline, and enabled the general population to experience the arts—even though they might not be able to visit a museum. Exactly which aesthetic experiences and creative activities were most meaningful and possible varied, however, from individual to individual, from area to area and from time to time.

I. Entertainment: At Home, the Park, the Local Store, or the Local "Filling Station"

Many families—because of finances, limited time, social customs, and religious beliefs—did not engage in many leisure activities. Often they spent any "off" time sleeping and resting for the next workday—if work was there for them.

Parlor games: Monopoly. In 1934 Charles B. Darrow presented a game called Monopoly to the executives at Parker Brothers. The company rejected his game; Darrow decided to produce 5,000 copies of it on his own and take them to Philadelphia department stores. The volume of sales was so great that Darrow decided to go back to Parker Brothers for help with increased production; the company not only helped him mass produce the game but also helped with marketing Monopoly nationally. In 1935, the first year of the national marketing of Monopoly,

The Treasure of Little Orphan Annie *was a game made in 1934. Louise Hunt remembers that the game was available upon the submission of* "the thin aluminum seal from inside the lid of a can of Ovaltine."

the board game became the best-selling game in America.[2] It is especially interesting that the public was intrigued with a financial game during a time of economic hardship.

Parlor games: Board games. From the store windows and shelves some expensive parlor board games like The *Wizard of Oz* beckoned — often in vain — to child consumers of the 1930s. Many families had to use their limited funds for the bare necessities — not for what most would consider a nonessential "toy." Other games — such as *The Treasure of Little Orphan Annie* — were available for free upon the submission of "the thin aluminum seal from inside the lid of a can of Ovaltine."[3]

Parlor games: Picture puzzles. As an indication of the support many people had for Franklin Delano Roosevelt, many items related to him were available for purchase. Photographs, chimney flue covers, cups, and even picture puzzles carried his full-color portrait. This particular puzzle (dated 1933) remains in

the author's collection — with all the pieces still intact. The full color puzzle may have been a source of enjoyment to the children or the entire family on a quiet afternoon or night.

Parlor games: View Masters. Before the days of television, many families of the thirties enjoyed vicarious travel through the View Master. The picture wheels allowed the viewers to see the world from their living room. The popular View Masters were much like the more cumbersome stereopticons of an earlier time. View Masters survived the Great Depression and after to occupy a place in toy boxes 75 years later.[4]

Other parlor games. A major appeal of parlor games was that after the one-time cost, the family had an entertaining way to spend many evenings together. For those who could afford the initial purchase, a game of dominoes, Parcheesi, Chinese Checkers, Pick-Up Sticks, Tiddlywinks, or Backgammon could create camaraderie and challenge for young

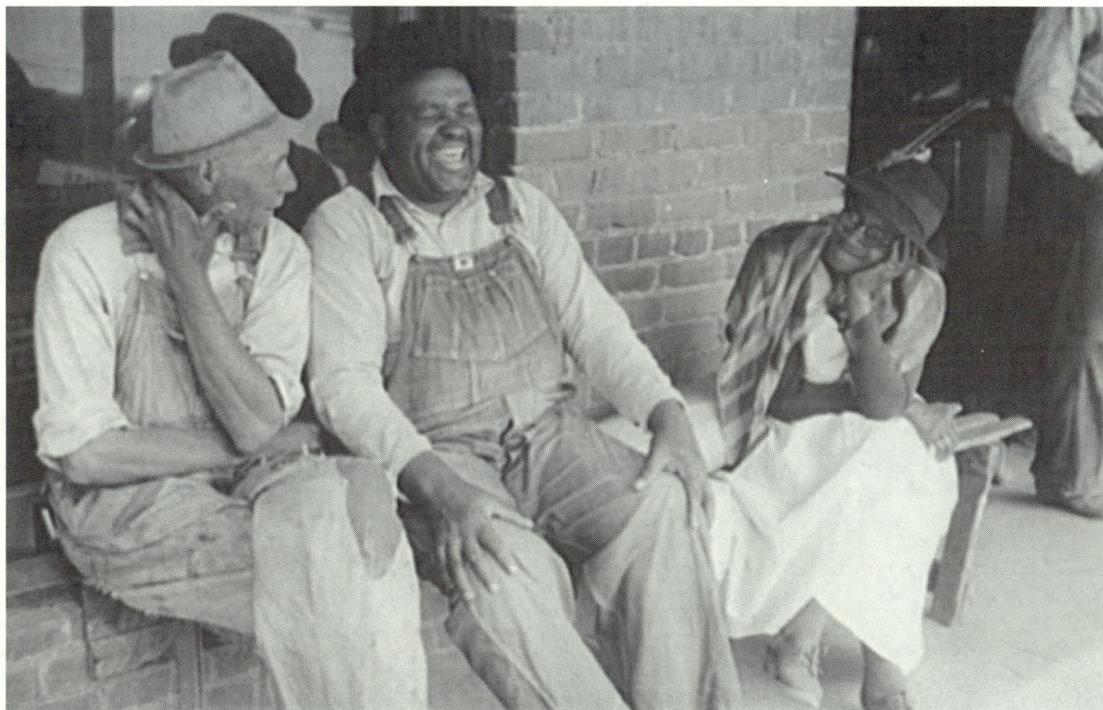

Saturday afternoon in Franklin, Heard County, Georgia, April-May 1941. Photograph by Jack Delano, Farm Security Administration.

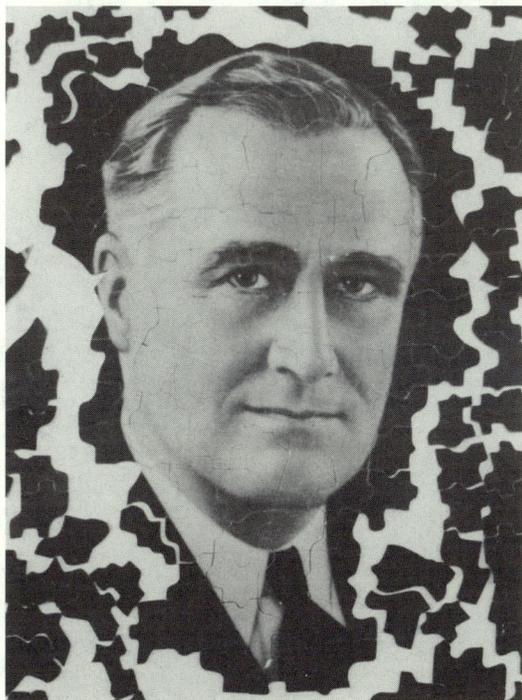

This is a photograph of a 1933 portrait puzzle of President Franklin Delano Roosevelt. The puzzle, in its original red, white, and blue striped box, reads, "New Deal Picture Puzzle of President Roosevelt."

and old alike. Even the families that could not afford a "store bought" game might still play a game of checkers.

Parlor games: Checkers. Making a checker board out of cardboard with squares carefully shaded with a pencil or crayon was the first step in constructing a game of checkers. Bottle caps — label up for red, label down for black — were the only other materials needed for an evening of entertainment. The worn, homemade board — scarred from players' smacking the caps on the cardboard in frustration or to emphasize an important move — became a treasured part of many homes, even after the family was able to buy a manufactured board. Checker games were also a part of the gatherings at local parks, general stores, and filling stations.

The bench or chair at the park, the "filling station," or the general store. Many times inviting benches or chairs became

gathering places for visiting with friends or for a friendly game of checkers or dominoes. A covered porch or shade tree in summer or a potbellied stove in winter might provide additional comfort for the group.

Discussions— sometimes heated —centered about the New Deal, political candidates, federal legislation, local laws, crops, prices and wages, the weather, the church, and other pertinent topics.

> The stores of the southern countryside quickly became the heartbeat and pulse of a good portion of American business. In their own community, they were centers of every sort of neighborhood activity. Everything of importance that ever happened either occurred at the store or was reported there immediately.... When he wished to "cuss" the government or to complain to the Lord because of the perfidy of politics and weather conditions, there was no place like ... the store....
>
> As one old-timer boasted, his store was where we put clothes on anything that had a back to wear them between the cradle and the grave, crowded their feet into something to keep them off the ground, and rammed food down everything that had a gullet to swallow it.[5]

Card games. Card games like Rook, Canasta, Hearts, and rummy were popular — except in those families which considered games with cards and dice to be evil.

Old Maid. The card game Old Maid for children, more than 100 years old, was still popular during the Great Depression. A 1930s edition of the game reflected Prohibition and included "speakeasy" characters like "Da Cops," "Da Moll," and "Da Entertainers"; the Old Maid in this version wore a '30s-style gown with a fan and flowers pinned to her bodice and wore rouge and long, dangling earrings.[6]

Bridge. Some women had time for a bridge club membership. The meeting of the group was often a social event scheduled weeks in advance. Members wore "proper" attire to the meeting; the hostess would welcome her guests into her spotless, decorated home where she had set up card tables for the other women. A highlight of the meeting was the complete meal, the buffet, or the refreshments— the more unusual the better — that the hostess had prepared for her visitors.

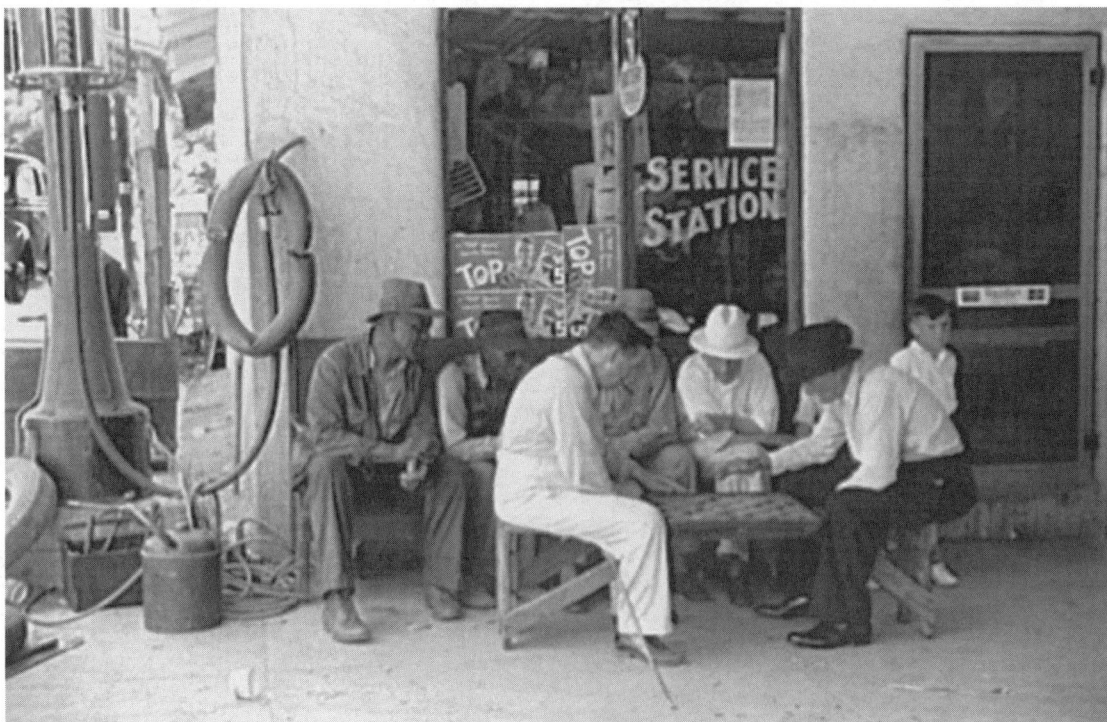

Playing checkers outside a service station on a Saturday afternoon in Greensboro, Greene County, Georgia, June 1939. Photograph by Marion Post Wolcott, Farm Security Administration.

The White Plains bridge club of Greene County, Georgia, October 1941. Photograph by Jack Delano, Farm Security Administration.

Poker. A Saturday night poker game for the men (or, less likely, women), however, might be a quite different affair from the bridge club. The dress might be less formal, and the food and beverages not as artistically served. The men's or women's poker game and the women's bridge club had the same hoped-for outcomes: entertainment and a gathering of friends and family. (A profit from the game was illegal in many areas.)

"Store-bought" toys in the 1930s. Some more affluent families were able to purchase model trains— some of which were electric in houses that had wiring. The Lionel brand was particularly popular. Model trees, model trucks, and water tanks sometimes added interest to the scene.

Also popular during the 1930s were several available construction sets: erector sets, Lincoln Logs, Tootsie Toys, and Tinker Toys. Many Georgia children, however, would receive no new toys, puzzles, or games in the hard times of the 1930s.

Homemade toys in the 1930s. The 1929 Stock Market Crash made toys a luxury for many children of the 1930s, but most young people could enjoy any free time by using their imaginations and any item available —from sticks to discarded tires. Many children passed many happy moments with homemade devices. Making shadows on the wall with lamp-light, making string designs, threading and twirling buttons on a string, constructing and playing with rag dolls, making dolls from twigs and leaves, developing wooden toys, and devising "tea sets" from acorn caps and bits of broken dishes were activities that could be played inside — and outdoors. The cost of the paraphernalia associated with theses leisure activities was minimal, but the fun was optimal and enduring.

Collections. Many young people began a special hobby of collections. The collections varied from person to person, but very often the item collected was one that was inexpensive or free. Some young people collected bottle caps from the local grocery store. Some collected the cigar bands that they found on the roadsides. Rocks and insects were other collectibles to some children. Baseball cards from bubblegum packs and comic books were also popular articles for those who had the money to

A farm boy of Irwinville Farms, Georgia, May 1938. Photograph by John Vachon, Farm Security Administration.

purchase them. In certain areas of Georgia arrowheads were numerous and were treasured items; Jimmy Carter and his father frequently found Indian artifacts near their home in Plains, Georgia.[7] Campaign buttons, matchbook covers, medallions promoting the New Deal, and marbles were other inexpensive yet pleasurable items.

Some psychologists argue that the reason one begins a collection is to gain control over things—especially at a time in one's life when life seems out of control. "Out of control" might very well describe the lives of many children — and adults— during the Great Depression and may account for the collections that were so popular.

II. Oral games, riddles, stories, and ballads.

Without the television sets and the video players that would prove popular in the next fifty years, many families entertained each other

These three "New Deal" medallions read on the obverse side "Onward America." On the reverse side are an eagle and the words "We do our part." The 32 mm medallion and the 23 mm medallion are made of aluminum; the 25.5 medallion is from green fiber. The Century of Progress World's Fair in Chicago distributed bronze versions of these medals. These medallions bearing the image of President Franklin Delano Roosevelt were items that children and adults alike collected.

with games, riddles, stories, and ballads. The origins of many of these oral games, riddles, stories, ballads and rhymes were an earlier time and place.

Oral games. Many of the oral games that Georgians played during the 1930s were common throughout the South, but probably date from an earlier time. One of these finger plays was the "Handstack" or "Club-fist" game; the author learned the game from her mother, Nell Burns (who grew up during the Great Depression). Nell had learned the game from her mother, Ella Turner (1887–1980); Ella had learned "The Handstack Game" or "Club-fist Game" from her grandfather, who reared her.

The Handstack or Club-Fist Game

Directions: The players—two, three, or more—make a "handstack." To achieve this tower, the first makes a fist with the right hand with the thumb extended upward. The second player grasps the first player's thumb with a fist and extends a thumb for the next player. The stack continues with all the players alternating their hands.

The last player to have a remaining hand asks the question, "Knock it off, take it off, or let the crows peck it off?" The player whose hand is on the top of the stack makes a choice as to how the questioning player will remove the hand. If the player chooses the option to have the fist "knocked off," the questioner strikes the fist to remove it; the questioner lifts the fist off the stack if the player chooses, "Take it off." The option to "Let the crows peck it off" results in the questioner using both hands to "nibble" at the fist until its owner voluntarily removes it from the pile.

After the first fist is off the pile, the questioning player gives the choice to the next person who has a fist on the stack. The game continues until only one fist remains. The questioning person asks the only person with a remaining fist on the pile the following questions—and the other player must respond to the questions in the prescribed manner. The rhyme "Whatcha Got There?" follows.

Whatcha Got There?

Questioning player: Whatcha got there? (The player is addressing the last person with a remaining fist.)
Remaining player: Bread and cheese.

Questioning player: Where's my share?
Remaining player: In the woods.

Questioning player: Where are the woods?
Remaining player: The fire burned them.

Questioning player: Where's the fire?
Remaining player: Water quenched it.

Questioning player: Where's the water?
Remaining player: Ox drank it.

Questioning player: Where's the ox?
Remaining player: Butcher killed it.

Questioning player: Where's the butcher?
Remaining player: Rope hung him.

Questioning player: Where's the rope?
Remaining player: Rat gnawed it.

Questioning player: Where's the rat?
Remaining player: Hammer killed it

Questioning player: Where's the hammer?
Remaining player: Behind the kitchen door cracking walnuts. The first person who shows his/her teeth gets a _____.

The remaining player decides the punishment for smiling and showing teeth. Usually the "punishment" is physical: a pinch, a hair pull, or a poke. The players try to make funny faces to get one of the others to laugh and show teeth. After one player laughs and receives the punishment, the game continues with a different person's fist on the bottom of the stack and with a different questioner. (Note: The game is played with good humor. Although it hints at violence, the players—frequently siblings—play with camaraderie and even at times have the participation of adult family members.)

Outdoor yard games. After "laying by" (after the crops were planted, thinned, hoed, and the families were waiting for the crops to mature before harvest), rural children in particular had more free time for play than before the farm work decreased. Like their urban counterparts, they might enjoy a game of hide-and-seek. Sometimes the one who was "It" counted to 25 or 50 before seeking those who were hiding. Children might use a poem to give the ones who were hiding the chance to seek shelter. The author learned the following rhyme from her mother. The chant was typical of the 1930s, but the rhyme itself dates back much earlier.

Hide and Seek Rhyme
A bushel of wheat, a bushel of rye.
All not ready, holler "I."

(If "It" hears shouts of "I," "It" gives the hiding players more time — and tries — to determine the direction from which the voices came. "It" waits

a second or two before chanting the rest of the rhyme.)

> A bushel of wheat, a bushel of clover.
> All not ready, can't hide over.[8]

Riddles. The author learned the rhyme/riddle "As I Was Going to St. Ives" from her mother, Nell Price Burns (1923–1998). Nell had learned the rhyme from her mother, Ella Turner Daves (1887–1980), whose grandfather had taught her the rhyme. The rhyme was a favorite throughout the South and even in Europe, where it probably originated.

The Opies, who collected traditional literature, date a similar rhyme from the 1700s.[9]

As I Was Going to St. Ives

> As I was going to St. Ives,
> I met a man with seven wives.
> Each wife had seven sacks.
> Each sack had seven cats.
> Each cat had seven kits.
> Kits, cats, sacks, and wives.
> How many were going to St. Ives? (Answer: one)[10]

Jokes, riddles, and games like "I Spy" were entertaining diversions as a family sat around the fireplace, rested on a cotton sheet in the field at midday, made a long trip, or sat on a porch in the cool of the evening.

Parables, fables, fairy tales, myths, legends, and folktales. Many Georgia families had their own family storyteller who could capture the attention of an audience. This storyteller often told parables (stories which are realistic and have morals), fables (stories with morals which are not realistic and often have animals as main characters), fairy tales (stories which always have the element of magic — but not necessarily fairies), myths (stories to explain things which the teller does not understand), and legends (stories — usually exaggerated — about real people, places, and things).[11]

An important purpose of this folklore was entertainment, but it also had the "practical application" of keeping the children working in the fields or preparing food for canning or drying — like snapping peanuts or breaking beans. The oral tales could make the drudgery of many tasks more enjoyable. As folklore collector Richard Chase observes, these tales reinforce

... "keeping the kids on the job" for such community tasks as stringing beans for canning, or threading them up to make the dried pods called "leather britches." Mrs. R.M. Ward tells us: "We would all get down around a sheet full of dry beans and start in to shelling 'em. Mon-roe would tell the kids one of them tales and they'd work for life!"[12]

Folktales. Folktales are stories told in the language of the people. Families around the fireplaces in Georgia shared the stories of Br'er Fox, Br'er Bear, and Br'er Rabbit from memory. Other families retold these or similar stories that their own families had told through the years. The foremost Georgia collector of African American tales in the local dialect was Joel Chandler Harris (1848–1908).

Joel Chandler Harris: Collector of African-American folktales. Harris, an Atlanta resident, was the collector who introduced "Americans to the basic patterns and rhythms of southern African-American speech."[13] Harris's writings — told in the language of the African Americans — shared with his readers the memorable character Uncle Remus, and "the age-old wisdom by which the enslaved secretly outwit their masters," and a new literary tradition: folk poems, folk tales and proverbs of the slaves. When he was a child, Harris had associated with the slaves and listened to the storytelling of such aged and colorful slaves as "Uncle" George Terrell and "Uncle" Bob Capers. It was their gift for story-telling that Harris tried to capture on paper.[14]

Joel Chandler Harris: His life. Born in Eatonton, Georgia, Joel Chandler Harris, his wife, and their children spent the years from 1876 until his death in Atlanta. Their home there — the Wren's Nest — is still open to the public. The Victorian Queen Anne style house is the oldest house museum in Atlanta.

Joel Chandler Harris and his writings — which included such varied works as biographies, stories for children, and many articles — were important to the city, state, and nation. James Weldon Johnson, the influential African-American author and songwriter, stated in 1921 that "the *Uncle Remus Tales* constitute the greatest body of folklore that America has produced."[15]

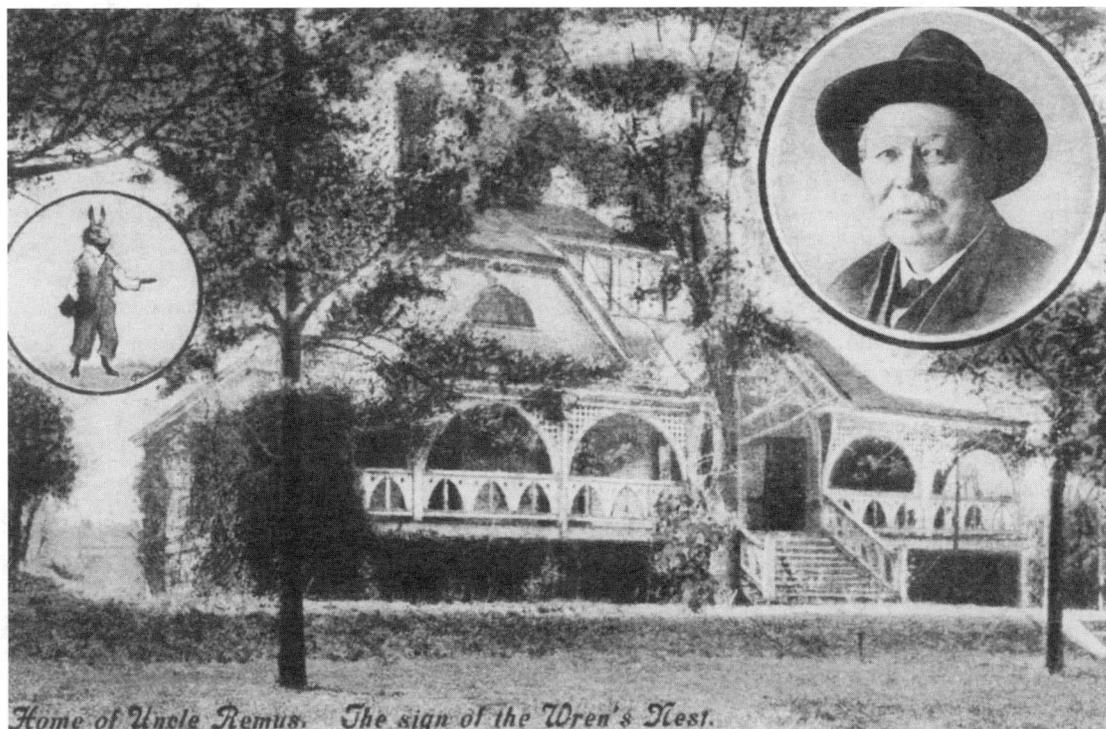

This postcard shows a portrait of Joel Chandler Harris, a sketch of Br'er Rabbit, and the home of Harris and his family; the home was called "The Wren's Nest" because when a wren built its home in the mailbox, Harris put up another box rather than disturb her.

Some critics protested the fact that a non–African American attempted to preserve the heritage of the African-American people. Others were more kind to the one who "composed a national literature that used localism to describe the universal."[16] Georgia poet Frank L. Stanton perhaps summed up Harris's accomplishments best: Joel Chandler Harris "made the lowly cabin-fires light the far windows of the world."[17]

Song of the South (based on Harris's work). The release of the Walt Disney feature *Song of the South* based on Harris's works came in 1946. The film mixed animation and live action. James Baskett portrayed Uncle Remus. Baskett was the very first live actor that Disney ever hired. For his performance, Baskett earned an Honorary Academy Award:

> To James Baskett for his able and heartwarming characterization of Uncle Remus, friend and storyteller to the children of the world in Walt Disney's *Song of the South.*[18]

James Baskett received a nomination for the best Actor or Best Supporting Actor. He was the first African-American man and the first Disney actor to receive an acting award, but it was a non-competitive award.[19]

The song "Zip-A-Dee-Doo-Dah" that Baskett sang in *Song of the South* won an Academy Award for the best song. The composer of the song was Georgian Johnny Mercer, discussed later in this chapter. Disney never released the film *Song of the South* on video in the United States. The film, based on the works of Georgia author Joel Chandler Harris, received much criticism. Its images of the "happy," subservient African Americans were distasteful to some viewers. The beginning and ending music in the style of spirituals and work songs were objectionable to some members of the audience. Some critics noted that the time of the movie was unclear; they complained that the film neglected to indicate whether the African Americans were workers or slaves. Others pointed out the minstrel tradition of the Uncle Remus character and observed that Toby — the

African-American child — did not attend the birthday party of Johnny (his white playmate) and even seems to serve Johnny. The National Association for the Advancement of Colored People has no current position on *Song of the South*.[20] Disney is planning a re-release of the film in movie theaters in 2008 — the first theatrical re-release since the 1970s.

Family stories. Listening to stories about the family and their experiences was a long-remembered tradition in many homes. David Wilson (1973) gives a memory from his childhood:

> Probably my earliest memories are of the times when the power would go out and we would have to get down the kerosine [sic] lamps. My grandmother always used these times to the best advantage by telling ghost stories— or "booger" tales. I don't remember the tales as such, but I can remember the lamp that lighted only her face as she recalled the choicest horrors of her childhood.
>
> That the people of these mountains should have a rich supply of "haint" tales is not at all surprising. They had conquered the land — but only in a small area around their doors. No matter how friendly the woods seemed in daylight, there were noises and mysterious lights there at night that were hard to ignore if you were out there all alone.[21]

Music in the parlor. Music from a Victrola — hand-cranked for those without electricity — or from radios, which might be operated by batteries or by electricity, was something not all families enjoyed. Those who possessed the spring-wound Victrola no longer had to provide their own entertainment.

For other entertainment, some family members might pull out a harmonica, a Jew's harp, a fiddle, or a banjo and join a group at the piano; in other families the musician might take the harmonica, mandolin, autoharp, or other instrument to the porch and play the music there for all to hear. "Playing the spoons" or "beating ham bone" was another rhythmic activity that some Georgians might willingly demonstrate for family or friends.

Voices lifted in song around a piano or a pump organ were frequently a memorable part of the gatherings of many families— especially on Sunday afternoons. Singing was particularly likely in those families that did not approve of sinful games of cards or games like Parcheesi in which one rolled dice. Neighbor-

ing families taking their Sunday afternoon constitutionals could hear these songs through open windows. Hymns and ballads were popular songs for the day.

Some family members might have had piano lessons; others might play the piano "by ear." Many families learned to "harmonize" in their singing.[22] In some homes, the individuals sang the hymns from memory or from a hymnal — often with "shaped notes." A later section in this chapter gives more information on shape note singing.

III. Radio in the 1930s

On March 15, 1922, the Department of Commerce issued a license for the first radio station in the South. That license went to WSB in Atlanta, Georgia; the slogan for the station's call letters was "Welcome South, Brother." Founded by the *Atlanta Journal*, WSB's first broadcast was the *Light Cavalry Overture* played for 1,000 radio receivers in the Atlanta area.[23] At first the station could broadcast only weather bulletins, but it received full license later that year. An affiliate of NBC, WSB was the first station to play the trademark three-tone NBC chimes.[24]

The purchase of a radio. *The Sears Roebuck Catalog of the Thirties* indicates that the cost of a radio "for the home" could be as inexpensive as $19.95; for $24.95 one could purchase a model on which the user could "push a button and there's your station." A table model that was vertical or horizontal was $24.95; a console was $29.95.[25] The prices— $19.95, $24.95, and $29.95 — must, however, be compared to other items. On a "Depression Shopping List for 1932 to 1934" a wing chair was $39.00, a '29 Ford automobile was $57.50, and a mahogany coffee table was $10.75.[26] It is not surprising that many Georgians did not have a radio during the Great Depression.

Music on the radio. Music was an important part of the listening of the families that had a radio. Some of the "hit" songs of the 1930s included songs about money. These tunes included "I Found a Million Dollar Baby," "Pennies from Heaven," "With Plenty of Money and You,"

In the evening Mrs. L. Smith of Carroll County, Georgia, plays a few hymns at the organ, April 1941. Photograph by Jack Delano, Farm Security Administration.

and — the song many associated with the decade — "Brother, Can You Spare Me a Dime."[27]

The Grand Ole Opry. *The Grand Ole Opry* became the longest continuously running radio show in the nation. Begun in 1925, the Saturday night program entered the homes of many families across the country.[28]

Popular radio music shows. Popular musical shows from the 1930s included *Paul Whiteman, Kate Smith,* and *Benny Goodman.* The audience for the *Lucky Strike Hit Parade* was enormous, with "40,000,000 or 50,000,000 addicted."[29]

Johnny Mercer. Johnny Mercer, the "Bard from Savannah," was born on November 18, 1909. He was one of the best-known American lyricists. He won an Academy Award four times for his work and received a total of 13 nominations. He had thirteen Top 10 Hits, including four in the Number #1 spot. In the summer of 1933, his "Lazy Bones" with Hoagy Carmichael remained a #1 smash for four weeks. Later Don Redman and Mildred Bailey also recorded the song and reached the Top Ten with it. Johnny Mercer took a job with Paul Whiteman, who had the Kraft radio program with Al Jolson. He wrote a song a week for the show and also sang duets.

In 1934 Rudy Vallee recorded Mercer's and Gordon Jenkins's "P.S. I Love You." It became a #4 hit for the Hilltoppers (1953) and a successful song for Tom T. Hall in the mid–1980s. Mercer's 1935 song "Eeny, Meeny Miney Mo" (written with Matty Malneck) was a #7 hit for Benny Goodman. Fred Astaire had a #4 hit when he and Mercer worked together on "I'm Building Up to an Awful Let Down." In 1936 Bing Crosby put Mercer's "I'm an Old Cowhand from the Rio Grande" in a film. Crosby's recording (with Tommy Dorsey) was a #2 hit. "Goody Goody" gave Benny Goodman a #1 hit 1936.

Mercer's "Jeepers Creepers" brought Johnny his first of 18 Academy Award nominations and was a #1 smash hit for Al Donohue (5 weeks). In 1938 Dick Powell introduced Mercer's "You Must Have Been a Beautiful Baby"; the song was a #1 hit for 2 weeks for Powell, later a #8 hit for Tommy Dorsey, and a #5 hit for Bobby Darin several decades later.

In 1971 Johnny Mercer was among the original members in the Songwriter's Hall of Fame. He died in California in 1976.[30] All his hits and compositions and the names of all those with whom he worked are too numerous to list here, and his success continued into the next decades. Interestingly, Mercer won an Academy Award for "Zip-A-Dee-Doo-Dah," in the movie *Song of the South*, based on the work of Joel Chandler Harris, another Georgian.

Radio drama. Although electricity and radio were not a part of everyone's life, radio was a source of entertainment and discussion throughout the week for many. Charley McCarthy seemed like a real person — not a dummy — to Sunday night listeners across the nation. Many women wondered with their friends if *Our Gal Sunday* "from a mining town in the West" would be able to "find happiness as the wife of a wealthy and titled Englishman."[31] *The Green Hornet, The Shadow,* and *One Man's Family* were other characters — and programs — that were popular with radio audiences of the decade.

Radio shows for children included *Little Orphan Annie.* Annie advocated capitalism; she herself proved capable of selling products as she pitched the drink called Ovaltine to her listeners.[32] She encouraged young children in the radio audience to "send in the thin alumi num seal from under the lid of a can of Ovaltine" for free premiums.[33] Little Orphan Annie had many "gifts" available with the seals from the can. Perhaps the most popular was the decoder pin; at the end of each radio show Annie gave a secret message that listeners could decipher — if they had the decoder.[34] However, her board game, equipped with its own spinner and pictured earlier, must have brought fun to the lives of those fortunate enough to be able to afford the can of Ovaltine and the radio, which carried details of how to order the "free" gifts.

Amos 'n' Andy. Although Annie and her dog, Sandy, were popular, the most popular radio characters were two men whom everyone knew by first name. After they began their radio broadcast,

> ... [e]very weekday evening from 7:00 to 7:15 P.M., telephone use all over the country dropped 50 percent, car thieves had an easy time on empty

streets, and many movie theaters shut off their projects to pipe in our radio while some 30 million Americans — including President Roosevelt — tuned in to *Amos 'n' Andy....* Such devotion to a comedy serial — created in black-voice by a pair of white vaudevillians, Freeman Gosden and Charles Correll — was typical of radio audiences in the '30s. The big box in the living room was everybody's ticket to adventure, laughter, sweet music and romance.

People listened for the openers of their favorite shows the way little children listened for the sound of father's car in the driveway.[35]

Some radio programs of the time, however, were not strictly entertaining.

Fireside Chats. President Franklin Delano Roosevelt hoped that he could calm the American people — and generate support for his programs — by speaking directly to them during the worst economic slump in history. He gave the first of his talks — about the bank holiday — when the people were the most discouraged. Because the people who trusted Roosevelt began to use the banks again, Roosevelt recognized the success of the radio and decided to employ it again and again.[36]

Through the radio, President Roosevelt entered the homes of the American people. He often gave the talks when things seemed worse for the general population. His soothing chats were at night; it seemed he recognized that working people had time to listen after the work in the fields or factories was over for the day. He talked about the banks, the new federal programs, and important news. A common feeling was that it "was a special time in our house when the President visited with us by radio. We talked about it for days afterward."[37]

1. Roosevelt gave a total of fourteen "Fireside Chats" during the 1930s. He spoke
2. On the Bank Crisis on Sunday, March 12, 1933;
3. Outlining the New Deal Program on Sunday, May 7, 1933;
4. On the Purposes and Foundations of the Recovery Program, on Monday, July 24, 1933;
5. On the Currency Situation on Sunday, October 22, 1933;
6. Review[ing] the Achievements of the Seventy-third Congress;
7. On Moving Forward to Greater Freedom and Greater Security on Sunday, September 30, 1934;
8. On the Works Relief Program on Sunday, April 28, 1935;
9. On Drought Conditions on Sunday, September 6, 1936;
10. On the Reorganization of the Judiciary on Tuesday, March 9, 1937;
11. On Legislation to Be Recommended to the Extraordinary Session of the Congress on Tuesday, October 12, 1937;
12. On the Unemployment of the Census on Sunday, November 14, 1937;
13. On Economic Conditions on Thursday, April 14, 1938;
14. On Party Primaries on Friday, June 24, 1939;
15. On the European War on Sunday, September 3, 1939.[38]

Sports on the radio. Through radio broadcasts, Georgia families could participate in sports events across the nation. Many listeners heard

> ... Lou Gehrig when the great ballplayer, dying of amyotrophic lateral sclerosis, said in a low, clear voice before 60,000 at Yankee Stadium, "I consider myself the luckiest man on the face of the earth."[39]

Listeners also participated vicariously in the rematch between Joe Louis — "The Brown Bomber" — and Max Schmeling, a German heavyweight who had taken the title of heavyweight champion from him in 1936. Adolph Hitler tried to use this outcome as evidence of both Aryan supremacy and German supremacy over Americans. "President Roosevelt had told Louis in 1938, 'Joe, we're depending on those muscles for America.'" In 1938 Joe won the match. "Never has any fight carried more symbolic weight than Louis-Schmeling on June 22, 1938."[40] More and more different sports were broadcast as time passed. Sports events became a part of the listening activities of families across the state.

Advent of television. After television arrived, however, the big radio shows of the 1930s and the silver screen became less popular for the masses. The first television demonstration in the Southeast was from Rich's Department Store in Atlanta in 1939.[41]

After the big radio shows had departed, the performers were long remembered with affection complete with their signature tunes and sayings:

"Thanks for the Memory"— Bob Hope;
"When the Blue of the Night Meets the Gold of the Day"— Bing Crosby;
"Inka-Dinka-Doo"— Jimmy Durante;
"Wanna buy a duck?"— Joe Penner;
"Vas you d'ere, Sharley?"— Jack Pearl;
The squeals of Baby Snooks— Fanny Brice[42]

IV. Outdoor Entertainment

Just as parents of today do, parents of the 1930s encouraged their children to "go outside and play." Oftentimes the children played something as simple as tag or hide-and-seek that required no special gear—just an occasional rhyme or chant. Kick-the-can, jump rope, and stickball (softball with a stick) were important games to the young—whether rural or urban—during the 1930s; none of these outdoor games required any expensive equipment. Most rural children had their own outdoor equipment—and often it was not "store bought."

Outdoor equipment for entertainment and recreation. Slingshots made from a forked stick, some rubber from an old tire, and an acorn or chinaberry for ammunition kept children occupied for hours and also made them proficient with their aim. Old horseshoes removed from an animal were set aside and saved from year-to-year for the game of horseshoes.

Although bicycles, skates, scooters, and Radio Flyer Wagons might have been a part of many children's lives during the 1930s, all children did not have these possessions. The creek, haymows, and barn rafters became their playground equipment. Many children attempted to construct their own stilts, sleds, bean shooters, and wagons when time and materials permitted. Open fields and woods formed the playgrounds for many rural children and adults.

Hunting and fishing. Fishing and hunting for sport and for food were a part of the lives of young and old in rural areas across the state. The Outer Banks were popular places to hunt and fish for game, but residents of rural areas regularly hunted and fished near their home out of necessity—not just for sport. Chapter one, "Water, Soil, and Industries Based on Natural Resources," includes additional data on hunting and fishing in the state.

Cockfighting. Eliot Wigginton devotes a whole chapter to cockfighting in his *Foxfire 8*. The 103-page chapter gives many details of the sport that is now illegal in most states across the nation. In 2007, a college basketball team — the University of South Carolina — still has a fighting gamecock, with metal spurs, as its mascot. The residents of the Georgia mountains were quick to share with interviewers for *Foxfire 8* their experiences with this bloody fight to the death.

The sport seems to have been around since 1400 B.C. in China. Henry VIII (1569) declared the sport illegal, but other rulers revived it. In this country, George Washington attended matches; he stated that in the same day he once attended both a church vestry meeting and a cockfight. At the White House, Andrew Jackson had a pit for cock fights. Wigginton sums up cockfighting in the Georgia mountains in this way:

> How cockfighting first came into the mountains is open to speculation. There is little doubt, however, that many of the early immigrants were devotees of the sport already, having practiced it in other places. And it is safe to assume that many of those who practiced here then, as now, did so in a world removed from the high-powered, highly financed, intensely well-orchestrated and supervised events that were the Kentucky Derbies of the chicken world. For most of them, in fact, it was and still is a sport practiced in a rather informal manner and setting.[43]

Local baseball and softball teams. Textile mills, industries, towns, churches, schools, and communities often had their own softball and baseball teams. Games against other industrial and community teams were important local events for workers and for management. Mills pitted both their women's and men's teams against other mills. Mills, in fact, were five times more likely to sponsor and support baseball teams than insurance policies for their workers.[44] Mill officials saw the teams as in no way threatening the power relationships between employee and employer. The team provided release and achievement for the worker and immersed the village into the mill system. Some companies rewarded players

generously for their efforts: "Baseball was the biggest thing — next to the churches."[45] Church teams and civic teams increased the competition in the local areas. Local residents discussed the winner of the games for weeks.

College and high school sports. The selection of a high school or college team in the state to support was a common practice for residents in the state and the South; even high school dropouts identified with a high school and a college team and with its wins — and losses. The high school or college team an individual boosted was usually that in the immediate geographical area — or the winning team at the time. The important high school and local teams provided much pleasure to their fans. Much good-natured "ribbing" occurred among the supporters.

V. Notable Books and Authors of the 1930s

All the publications of the 1930s did not meet all the stylistic criteria for enduring literature; many publications were merely designed to sell. The comic strips in the newspapers, the comic books, and the Big Little Books — though popular — may not become literary classics, but they were certainly popular and may become collectibles.

Big Little Books. The Whitman Publishing Company of Racine, Wisconsin, introduced Big Little Books (BLB) in 1932. These books — popular with adults and children alike — usually had the standard dimensions of 3⅝" × 4½" × 1½". The squat, 400-page cubes of print and pictures called Big Little Books sold for a dime. The first BLB was *The Adventures of Dick Tracy* (1932). It preceded the first true comic book by a year. Bill Hillman, however, is quick to note that Whitman set the standards for similar books by other publishers, such as Dell, Fawcett, and Goldsmith.[46]

Little Orphan Annie. Little Orphan Annie in comic strips, in weekly radio shows, in paper dolls, on watches, and in Big Little Books encouraged the children and the "Depression-ridden" adults with her faith in "good old capitalism." Her standard "Leapin' Lizards" amused

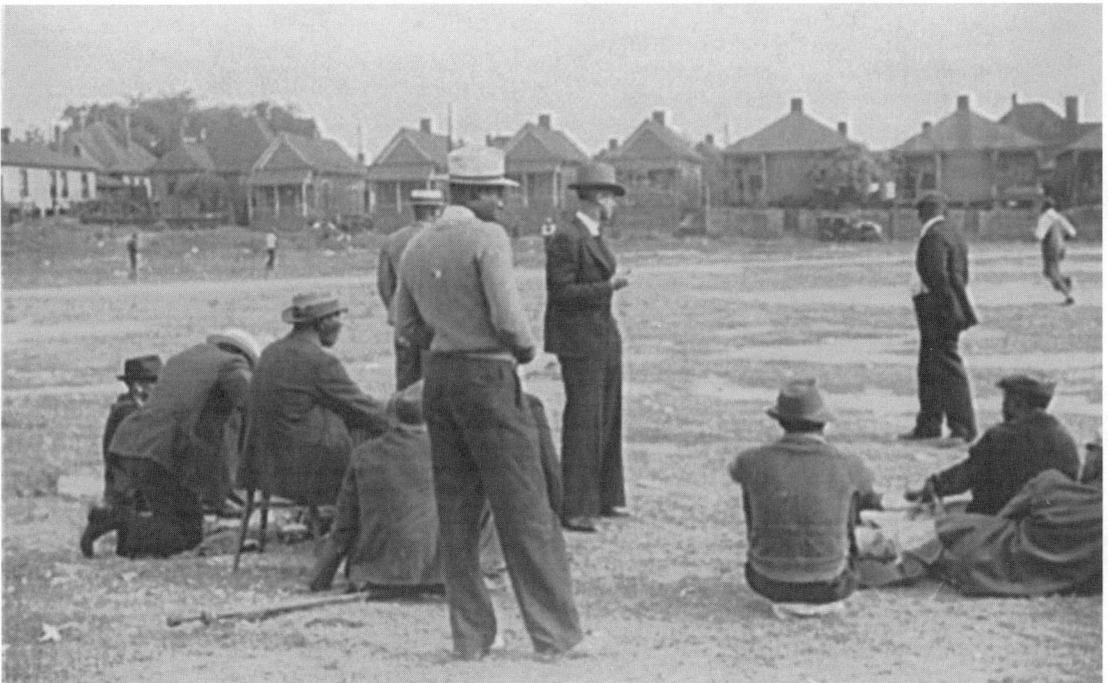

Watching a baseball game in Atlanta, Georgia, May 1939. Photograph by Marion Post Wolcott, Farm Security Administration.

her reading and radio audience.[47] Her optimistic comments about the economy encouraged those who read or listened.

Engel van Wiseman Books. An interesting series similar to the Big Little Books appeared in the 1930s. The Engel van Wiseman Book Corporation of New York produced 23 titles under the trademark Five Star Library series. The series began in the last half of 1934 and ended near the end of 1935. The 160-page books came entirely from motion pictures; a black-and-white photograph from the motion picture alternated with a page of text. The covers were hardboard and the spines were soft. One of these books was *The Fighting President;* the life of Franklin Delano Roosevelt formed the basis of the book.[48]

Tarzan and other heroes. By the end of the 1930s, Edgar Rice Burroughs' character of Tarzan had become the hero "of 21 fast-selling novels, a deftly drawn comic strip, a 15-minute daily radio serial and 16 movies."[49] Johnny Weismuller in the title role of some of the Tarzan movies

> ... enlarged the American vocabulary with the line "Me Tarzan, you Jane" and also introduced his fearful jungle yodel, a mixture of five sounds that included his own scream, a soprano singing high C and a recording of a hyena's howl played backwards.[50]

In addition to the character of Tarzan, the heroes Dick Tracy, Flash Gordon, Jack Armstrong, Buck Rogers, the Green Hornet, the Lone Ranger, and Tom Mix appeared in the Big Little Books, in some radio programs, and even in movies of the decade.

Participation books. Participation books — pop-up books, cut-out books, and paper dolls of Shirley Temple, Buck Rogers, and even President Roosevelt — were popular and still remain as collector's items. Some Georgia children who could afford them even amused themselves with paper dolls featuring English royalty. The overseas idols of Princess Elizabeth and Princess Margaret Rose were important to the toy chests of some American girls whose families could afford the purchase. Those without paper dolls might make their own by cutting folded newspapers into paper dolls or using Crayola crayons to draw and color their own.

Repetition of authors and books on the decade's bestselling list. An interesting feature of the decade of the 1930s was the repetition of authors and titles on the best-selling lists of fiction for each year of the decade. Authors who repeatedly appeared were Thomas Wolfe, Edna Ferber, Pearl Buck, Lloyd C. Douglas, A.J. Cronin, Hervey Allen, Margaret Mitchell, James Hilton, Charles Morgan, Walter D. Edmonds, Daphne du Maurier, Ellen Glasgow, John Steinbeck, Warwick Deeping, Mazo de la Roche, Sinclair Lewis, Rachel Field, Louis Bromfield, and Marjorie Kinnan Rawlings. *The Good Earth, Anthony Adverse, Rebecca,* and *Gone With the Wind* appeared as the number one best sellers two years in a row. The film industry made many of these books into films.[51]

Two important books about the Georgia prison system by Georgians. Already discussed in Chapter one, "Water, Soil, and Industries Based on Natural Resources," were two books Georgians wrote about the Georgia prison system after having experienced it themselves. *I Am a Fugitive from the Georgia Chain Gang* by Robert E. Burns and *Georgia Nigger* by John L. Spivak became popular books. The two books and the Warner Brothers movie helped bring about change in the Georgia prison system. It was these books and the movie that helped establish the image of sheriffs and prison wardens in the South as mean, dull-witted power abusers. The image still abounds in movies, television, and books about the South.[52]

Published first in *True Detective Mysteries* in January 1932, Burns's book, *I Am a Fugitive from the Georgia Chain Gang*, became the Hollywood movie *I Am a Fugitive from the Chain Gang.* (Warner Brothers removed the word *Georgia* from the movie title after some protests about the images depicted — from Georgians especially.)[53]

Nick Roddick examined the films of the period after the Wall Street crash and before America's entry into World War II:

> More than any other studio, Warners reflected these immense changes in American society. Gangster films ... portrayed not just the criminals but the social background to crime. Biographies

The covers of the popular Little Orphan Annie: The Big Little Book *and* The Fighting President, *which was part of the "Five Star Library Series: Engel van Wiseman Publishing."*

like *The Story of Louis Pasteur* endorsed the merit of individual enterprise.... Nick Roddick looks at these and many other films of the period to show how Warners worked as a film studio with a distinctive sense of the public mood.[54]

Margaret Mitchell and *Gone with the Wind*. Born in Atlanta in 1900, Margaret Mitchell could recite the battles of the Civil War in order before she was eight. There were three main reasons for her interest in history.

Margaret's love of history. First, Margaret had an old Civil War veteran as her favorite horseback-riding companion while her brother was in school. The two were joined by other Civil War veterans on occasion. These men talked about the Civil War constantly. Sometimes they would argue about which battle was the most important and why certain battles were won — or lost. Margaret listened.

Second, Margaret learned about the Civil War from Atlantans. Margaret, Stephens, and her parents often visited older people who had no one else to call on them; these people talked about the war while the Mitchells were there. Again Margaret listened.

A third reason for Margaret's interest was the travels around the Atlanta area; as the Mitchells traveled in Atlanta, the children heard the history of each section. A favorite local trip for Margaret was to view "The Battle of Atlanta," the largest circular painting in the world; from an early age she could locate in the scene the Union's bald eagle mascot named "Old Abe," General Sherman, and General John "Blackjack" Logan.[55]

The life of Margaret as a writer. After attending Smith College for one year, Margaret returned home to help her father after her mother's death. After a failed marriage, Margaret became the first female reporter to gather and write hard news items for the *Atlanta Journal*.[56]

On July 4, 1925, Margaret married John Marsh and they moved into Apartment #1 of the Crescent Apartments, once the home owned by Cornelius Sheehan. The couple lived in their 650-square-foot apartment from 1925 through 1932. During this time, Margaret sprained her ankle and became unable to work; she finally gave up her job. She wore a cast for a long time and spent several weeks in bed with traction on the injured limb. When

GASTON PHOTOGRAPH SERVICE. AUTHOR'S COLLECTION.

This postcard shows a portion of the "Battle of Atlanta," particularly the battle around the Troup Hurt House. This painting was one that Margaret Mitchell viewed many times as a child.

In 1925, Margaret Mitchell and her husband John Marsh moved into apartment #1 of the Crescent Apartments in Atlanta, Georgia. The house — now called the Margaret Mitchell House and located at 990 Peachtree Street — is open to visitors. Photograph by Ben Dashwood.

COURTESY ANNE NETTLES STANFORD, MARGARET MITCHELL HOUSE AND MUSEUM, ATLANTA, GEORGIA

arthritis set in, she found herself unable to walk. In April of 1926 the doctors removed her tonsils to perhaps relieve the infection that might have been affecting the healing of her ankle. For three years she was on crutches. During this time, in Apartment #1, Margaret wrote most of *Gone with the Wind*, which took her ten years to complete.

The publication of Gone with the Wind. In early 1935 the directors at Macmillan Publishing Company in New York decided to send editors across the nation to find new writers. In April 1935, the vice president and editor-in-chief, Harold Latham, made his first stop in Atlanta. It was here that Mitchell presented him with the manuscript for the novel that would become *Gone with the Wind*.[57] Within six months of its release in June 1936, *Gone with the Wind* had sold a million copies. With the money and with her own hard work, Margaret Mitchell was able to help her community, her state, and the nation in many ways.

Mitchell's altruism. Much of Mitchell's donations and charitable work was in secret. To help to remedy the problem of inadequate health care, she secretly sent 50 African American students to medical school. No one — not even the students — knew their sponsor for many years; some never found out Margaret Mitchell had been the one who had helped them. One of these students whose tuition Margaret paid was Otis Smith, the first African American to practice pediatrics in the state of Georgia.

Margaret quietly contributed money and support to help start a private hospital for African Americans: the Hughes Spalding Pavilion at Grady Hospital. She helped her laundress find the hospital care she needed. Margaret supported efforts to integrate the Atlanta police force. She testified before Congress in support of an international copyright law.

Anonymously, she tried to help single mothers by providing them with money for permanents and clothes when they applied for jobs. She started a fund for poor patients at Grady Hospital and made donations to the Atlanta

Margaret Mitchell wrote most of the manuscript of Gone with the Wind *in this room of apartment #1. The couple lived in this 650-square-foot apartment from 1925 through 1932. Photograph by Freddie Bennet.*

Historical Society and to the library in Fayetteville, Georgia. Margaret provided toys, clothes, and other necessities for young girls at the Florence Crittendon Home and paid for the medical expenses at the Sisters of Mercy at St. Joseph's Hospital. She was quick to respond to any need she saw — even a stray cat in the neighborhood. Margaret quietly helped during World War II — even launching a campaign that raised $65 million dollars for two cruisers and a destroyer.[58] Margaret Mitchell's good works continued until August 11, 1949, when a speeding taxicab struck her and injured her severely. She died on August 16, 1949, and her burial was in Oakland Cemetery in Atlanta.[59]

Margaret was able to help others — even after her death. She left sums to the Atlanta Historical Society and to the library in Fayetteville, Georgia. The City of Atlanta established the Margaret Mitchell Council, a traffic safety board that later became the Georgia Safety Council. The council developed stricter rules for granting and withdrawing driving licenses and encouraged the state to look at the driving records of taxi drivers and to consider changing the laws for convicted drunk drivers. Other states and cities began to follow suit — because of Margaret Mitchell, a little woman with a big book.

With 6 million copies of her book sold by 1949 and translations in 27 languages, the 1037-page book *Gone with the Wind* and its author had become cultural forces that will entertain and teach for years to come. Bookstores on every continent sell more than 250,000 copies each year of *Gone with the Wind*. The motion picture is still available on video.

VI. Movies of the 1930s

Movies were important to people during the Great Depression. They began to be interested in the lives of the stars. One of these stars in which they were interested was Carole Lombard — the wife of Clark Gable.

In the early 1930s, Hollywood was providing America with an image of itself on a scale and with a degree of apparent precision which no culture had previously known. Not only did the average twice-weekly visit to a movie theatre by an American family provide that family with fictionalised reports on the more dramatic events of recent American history such as gang wars, prohibition, newspaper scandals and the birth of the aviation industry. It also gave them a regular view of other families apparently just like them facing day-to-day emotional and social problems not unrelated to theirs.[60]

One of the films which gave the population — particularly Georgians — hope was *Gone with the Wind*.

Gone with the Wind. Despite what most people believe, the filming of *Gone with the Wind* was in California, except for a few scenes showing the fields and the gardens of the Wilkes' plantation. Visitors to Georgia are surprised to find that there is no Tara Plantation.

Premiere. The movie *Gone with the Wind* is almost four hours long. It opened first in the Loew Theatre in Atlanta on Friday, December 15, 1939. Clark Gable and many of the stars were in the audience. Publicity across the nation heralded the movie as "The Greatest Motion Picture Ever Made." Tickets for the premiere were $10.00; all of the 2,051 seats in the Loew Theatre sold out immediately.

Clark Gable addressed the audience at the Loew Theatre before the showing and told them that it was not his night. He told them that it was Margaret Mitchell's night and Atlanta's night. Interestingly, a chorus which performed at the premiere included Martin Luther King, Jr., who was born in Atlanta, Georgia, and attended school there. After the premiere, the prices for the movie ranged from 75 cents to $1.10.

Awards. The movie *Gone with the Wind* — like the book — set records. The movie and its cast won eight Oscars at the Academy Awards ceremony in February of 1940; the committee issued ten Oscar statuettes to those involved with the production.

Sidney Howard won the Oscar posthumously for Best Screenplay. Victor Fleming accepted the Best Picture Award for *Gone with the Wind;* Fleming's film *The Wizard of Oz* also had a nomination for the Best Picture Award the same year. Victor Fleming won a second Academy Award: Best Director for the film *Gone*

The movie program for Gone with the Wind *sold for 25 cents in theatres showing the film. These programs sell from $50 to $250 today.*

with the Wind. Vivien Leigh won the award for Best Actress for her performance as Scarlett O'Hara. For her role as Mammy, supporting actress Hattie McDaniel became the first African American to win an Oscar. Ernest Haller and Ray Rennahan won the Oscar for Best Cinematography and both Hal Kern and James Newcom won the Oscar for Best Film Editing. Lyle Wheeler won the award for Best Art Direction. Jack Cosgrove won the Special Technical Achievement Award. William Cameron Menzies received a special award for Outstanding Achievement in the Use of Color. David O. Selznick received the Irving Thalberg Memorial Award for Most Consistent High Level of Production.

Four thousand four hundred people participated in the making of the great film. Interestingly, Clark Gable, the star whom the public associates quickly with the production, came away without an award.[61]

Kitty Foyle. *Kitty Foyle*, a book on the best-selling list in 1939, depicted a working woman. The movie based on the book won an Academy Award in 1940, and Ginger Rogers won an Academy Award in 1940 for her portrayal of the "white collar" female employee. The image of the working woman was changing.

The Three Little Pigs. Walt Disney produced *The Three Little Pigs* in 1932. The cartoon impacted the public extraordinarily. Many people saw this film as a Walt Disney's comment on the Great Depression. Its hit tune was "Who's Afraid of the Big Bad Wolf?" The song and the movie itself seemed to be a symbol of the only thing that Americans had to fear: fear itself.[62]

Snow White. In 1934 Disney began work on *Snow White*, the first feature-length cartoon. The musical score of *Snow White*—like the song "Who's Afraid of the Big Bad Wolf?" from *The Three Little Pigs*—encouraged Americans, suggested the joy of working and predicted a bright future: "Some Day My Prince Will Come," "Heigh Ho, Heigh Ho, It's Off to Work We Go," and "Whistle While You Work." Radio City Music Hall—far from the Georgia countryside—showed the movie also. One report was that after the engagement of the movie, the management reupholstered all the seats because "so many children were terrified by Snow White's wicked stepmother that the seats were thoroughly drenched after each performance."[63]

Walt Disney's name/productions appeared eleven times on the list of Academy Award winners during the decade of the 1930s. The entertainment he provided was popular during the Great Depression—for those who could "spare a dime." Disney's success surprised many people. Financiers had been reluctant to lend him the two million dollars he had needed to produce the 80-minute animated feature *Snow White*. The prediction of these sponsors had been that the public would not pay to sit through an animated fairy tale. Their predictions were in error. The movie broke all previous attendance records, was translated into ten languages, and grossed over eight million dollars at the time.[64]

The community movie house. Interestingly enough, some of the same books that were best sellers appeared in the movies of the decade. *The Good Earth, Anthony Adverse, Rebecca,* and *Gone with the Wind* were among those best sellers that also became movies shown in the local communities.

The community movie house was a popular place for people to forget their own problems; most movie theatres in the 1930s were changing from projecting only silent films to offering movies with sound. In some areas of the state where no movie houses existed, entrepreneurs set up tents and chairs for their audience. For 25 cents a ticket (10 cents for children) one could forget troubles and cares in a theater—if one had the money for admittance. Movie houses in Georgia in the 1930s were segregated. African Americans sat in the balcony, and the white patrons sat on the main floor. It would be some thirty years before this practice would end. Some movie houses even began to offer premiums to moviegoers; by giving one item of dinnerware per person per movie some theaters secured repeat viewers as families tried to get a "whole set" of dishes.

The serial. To many moviegoers, the serial was as important as the main feature; this twenty-minute adventure appeared on the screen between the cartoons and the feature film.

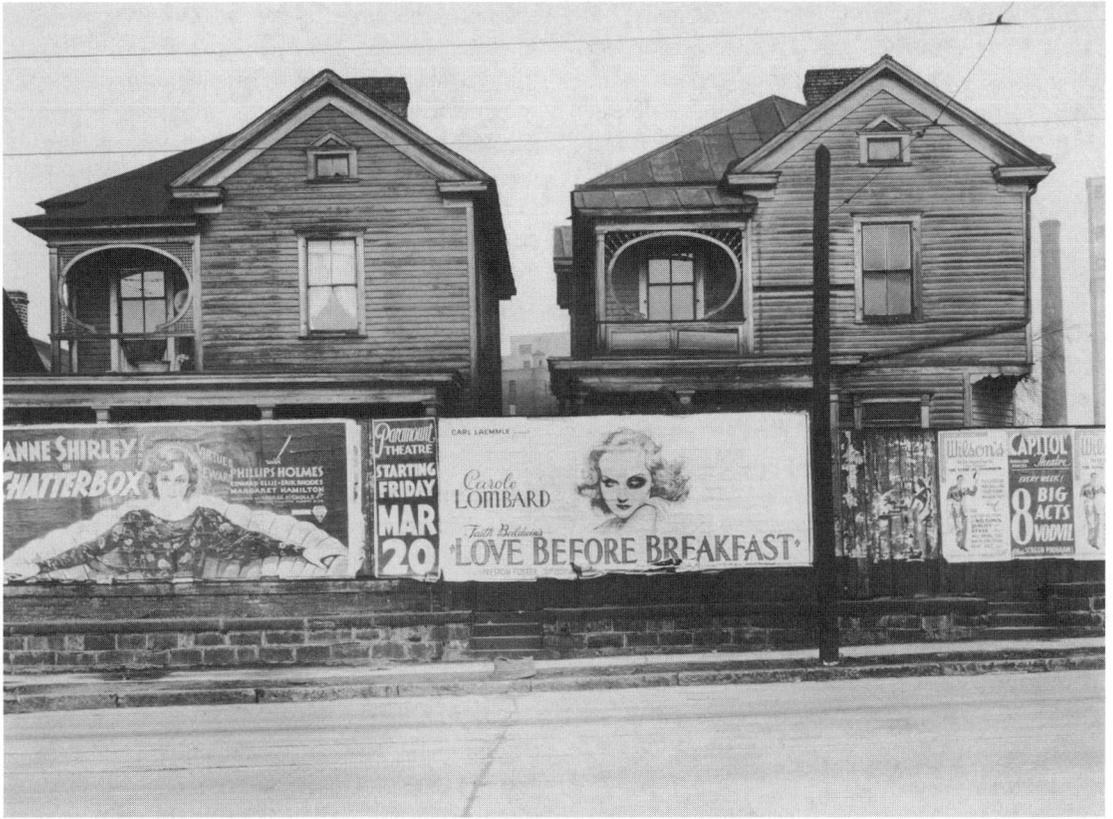

Frame houses and billboards in Atlanta, March 1936. Photograph by Walker Evans, Farm Security Adminis-tration.

A serial had from ten to fifteen weekly chapters; each chapter ended as a cliffhanger. The captured audience would return the next week to see what would happen. Some of the stars of the serials of the 1930s were Rin-Tin-Tin, Buster Crabbe, Mickey Rooney, Dick Tracy, Tom Mix, Zorro, the Green Hornet, Flash Gordon, Jackie Cooper, Mandrake the Magician, the Shadow, Terry and the Pirates, Red Ryder, the Lone Ranger, Bela Lugosi, and Clyde Beatty.[65]

Short subjects. David Niven, a star of the 1930s and afterwards, describes a visit to the theatre during the era of the Great Depression:

> In the late Thirties the twice-weekly program presented by most theatres consisted of a newsreel, a cartoon, a short, the second feature, and the first feature. The whole show lasted for a bunnumbing, four hours, but as a result, Hollywood was booming.[66]

Oliver Norvell Hardy. One of the stars of "the shorts" was a native of Harlem, Georgia.

Born on January 18, 1892, Norvell Hardy moved with his mother and four siblings to Milledgeville, Georgia, where his mother managed the Baldwin Hotel after his father's death in November of 1892. Norvell changed his name to his father's name — Oliver Norvell Hardy — as soon as he turned 18.

Oliver was the projectionist and manager of Milledgeville's first movie house: the Electric Theatre (1910). He performed regularly on the stage in the movie house. Oliver attended the Atlanta Conservatory of Music, Georgia Military College, and the University of Georgia. In 1913 he joined a newly established film colony located in Jacksonville, Florida; in 1918 he moved to Hollywood.

Oliver accidentally teamed with Stan Laurel, from England. Together the two made 107 movies, and won an Oscar for Short Film in 1932 for "The Music Box." Oliver died in 1957 after making more than 100 films, but his

memory is alive at the Laurel and Hardy Museum in Harlem, Georgia. The museum opened in 2002 and gives tribute to the comedy team of Laurel and Hardy.[67] This team gave the Americans who could afford movie admission a laugh during "hard times." The names Laurel and Hardy were known throughout the nation along with names of other selected short subject film actors like The Three Stooges, Larry, Curly, and Moe.

VII. The Place of the School, Church, and Community in Leisure Activities

The school and church were vital to the emotional health of most Georgians. Without unlimited funds for recreation and leisure during the Great Depression, the people depended on the activities of the local churches and schools to provide wholesome, inexpensive entertainment for young and old alike.

School events. The schools—one room or larger—formed a place to gather, socialize, and enjoy certain events that the school sponsored. Basketball, baseball, football, plays, elocution programs, suppers, exhibits, spelling bees, graduations, honors recognition events, glee club programs, and debate exhibits were some of the popular events that the community flocked to see.

Churches. Although the schools were important, very often it was the churches that served as the centers of the community.

> All through the South, of course, the church is an important social and cultural force, its sociability running the gamut of church-going, baptizings, funeralizings, brush-arbor revivals, all-day singings with dinner on the grounds, church suppers, singing schools and conventions.[68]

Waldrep, too, notes that church was important, "the social reality, uncontested at the institutional center of mill village life."[69]

In times of celebration like weddings and christenings, the people of the area congregated in the church. Likewise, in times of trouble the church was the center of the community where the people came for comfort and for prayer. During times of drought or times of flooding, for instance, it was not unusual to find the people of a community gathering to pray with others about their problems.

The list of social events sponsored by the

Funeral of a nineteen-year-old black sawmill worker in Heard County, Georgia, in April or May 1941. Photograph by Jack Delano, Farm Security Administration.

church included revivals (sometimes held in tents), hayrides, ice cream socials, schools for children, choir practices, chicken pie dinners, bazaars, watermelon slicings, church softball games—which might pit one denomination against another—and the ever-popular "community sings."

Revivals. Although the annual revival at their church was an event to look forward to, many families attended the revivals at other churches also. Women could socialize with family, friends, and acquaintances and exhibit their culinary skills at the dinner that usually followed the closing Sunday service. In addition to the revivals held in the churches themselves, there were "tent meetings" across the state during the months when outside services were feasible. Road signs reminded people to "Be Ye Ready."

Shape note singing. Shape note singing is an early American form of notation for untrained choirs and singers. The method uses four different shapes of notes. The shape indicates the position of the note on the scale. Singing schools and traveling teachers of the shape method promoted the method. William Walker's *Southern Harmony* songbook with shape notes sold 600,000 copies; it was perhaps the most popular songbook ever printed. No other editions replaced the original 1835 and 1854 editions; many depression-era families used a copy of the hymnal handed down from an earlier generation. Through the WPA, a photo-reproduction of the 1854 edition was made possible.[70]

Community socials. In rural areas the community often banded together to achieve things that would not always have been possible for a family alone. Barn raisings, corn shuckings (sometimes called corn huskings), house buildings, and quilting parties brought adults and children together for work—and play.

It was not unusual for families to go to a

A "community sing" in a black church in Union Point, Greene County, Georgia, October 1941. Photograph by Jack Delano, Farm Security Administration.

Religious signs along a Georgia highway, May 1939. Photograph by Marion Post Wolcott, Farm Security Administration.

This handwritten sample of shaped notes was the work of an unidentified scholar of the singing schools.

Picnic at Irwinville Farms, Spring 1939. Photograph by Marion Post Wolcott, Farm Security Administration.

neighbor's home and help with shelling peas, breaking beans, or husking corn after an abundant harvest. With many hands working, the task moved quickly — plus the neighbors were able to socialize, something that they were often unable to do during the regular workday. A bonus was that the neighbors would come to your home to assist you on a future evening. Although many families might not have more materially than the family that they were assisting, the camaraderie in times of trouble strengthened community ties and provided aid to those with problems. When deaths and birth occurred, neighbors were there.

Civic groups. There were some civic groups that were important to individuals with special interests. The Farm Bureau attempted to organize those in agriculture. Insurance groups, like the Woodmen of the World, met periodically and provided some social events for their members, as well as insurance coverage. Fraternal orders, country clubs, Home Demonstration Clubs, and other church and civic groups provided social occasions and a

means to achieve common goals for members of the community. The veterans of World War I, the Veterans of Foreign Wars, and the American Legion also met and planned events — like memorial events and parades.

The National Youth Administration, the Boy Scouts, and the Girl Scouts were popular organizations for the young people.

Juliette Gordon Low, the Girl Scouts, and her Savannah, Georgia, birthplace. The founder of the Girl Scouts was Juliette Gordon Low. Juliette Magill Kinzie Gordon (nicknamed Daisy) was born on October 31, 1860, in Savannah, Georgia. She was the second of six children. Juliette Low's childhood in the large English Regency house was happy even though the Civil War years caused considerable disruption to the family. Always interested in the arts, "Daisy" wrote, sketched, painted, sculpted, and acted. Her pets were many and varied, from a pet cow to exotic parrots.

Low received her education at Miss Emmet's School in Morristown, New Jersey; the Virginia Female Institute; Edgehill Academy in Keswick Station, Virginia; and Mesdemoiselles

Charbonniers, a French finishing school in New York City.

During her youth, she suffered from chronic ear infections. By 1886 because of problems with her treatment, she was almost deaf in one ear. At her wedding on December 21, 1886, a grain of rice entered her ear. When a doctor tried to remove the rice grain, he punctured her eardrum and damaged the nerves. As a result of the accident and the infection that followed, Juliette became totally deaf in that ear.

Although Juliette and her husband lived abroad, Juliette returned to the United States to help her mother, Nellie Gordon, organize a convalescent hospital for those sick or wounded during the Spanish American War. When her work was complete, Juliette returned to England; after her husband's 1905 death, Juliette searched for another way to use her life meaningfully.

After meeting Sir Robert Baden-Powell, founder of the Boy Scouts and the Girl Guides, she started Girl Guide companies in Scotland and England before returning home to Savannah. While visiting her parents in this Savannah house, she announced to her cousin by phone, "I've got something for the girls of Savannah, and all of America, and all the world, and we're going to start it tonight!" On March 12, 1912, eighteen girls held their first official meeting.

Juliette died from cancer in 1927; her grave is in Savannah's Laurel Grove Cemetery. The Gordon House was recognized as significant architecturally during the nineteenth century. During the depression, it was included as part of the Historic American Building survey, one of the federal works projects established during the depression. The original survey, which is housed at the Library of Congress has been updated through the years. The Girl Scouts of the United States of America bought the Gordon House from the family in 1953 to be used as a memorial to Juliette Gordon Low, as a program center for Girl Scouts, and as a historic house museum open to the general public. In 1965 it was designated as Savannah's first National Historic Landmark.[71]

National Youth Administration. Created by executive order on June 26, 1935, the National Youth Administration (NYA) was a part of the Works Progress Administration. The intent of the program was to help the American youth who were enduring special hardship. The number of Georgia youths aided by the NYA was second only to the number of Texas youths who benefited from the NYA. About two million students in the nation received an average of $6.00 per month.[72] Mary McLeod Bethune headed the NYA's "negro division."[73]

Many other clubs, groups, political parties, and civic organizations served as social associations. Some of these assemblies were able, as a unit, to achieve success in their goals to help others and improve the community, state, and nation.

Parades. Civic groups, schools, churches, and local merchants often worked together to arrange parades for towns and communities. Parades were important events in most towns and communities. Often the planners scheduled the event on a holiday when more people could attend. Rich and poor alike lined the streets to enjoy the sights and sounds of the decorated trucks, cars, flatbeds, and marchers.

Clubhouses and community centers. Some towns, housing projects, and cities had community centers or clubhouses available for family reunions, community events, and socials. Some mill villages also had a room or building available to the residents for their meeting and social events. Sometimes the tables and chairs would be pushed aside for music and dancing. All areas, however, did not condone the activity of dancing.

Food. Much of the community entertainment centered around food. Church bazaars and dinners, chicken pie suppers, fish frys, ice cream socials, community watermelon feasts, oyster roasts, potluck socials, club luncheons and teas, kudzu and ramp festivals, Brunswick stew suppers, and barbecues were occasions that the whole family could enjoy. The decade of the 1930s is often depicted as the era of "fake food."

Radish roses, sugar cubes painted with flowers, topiary salads and citrus baskets added flair to plates.

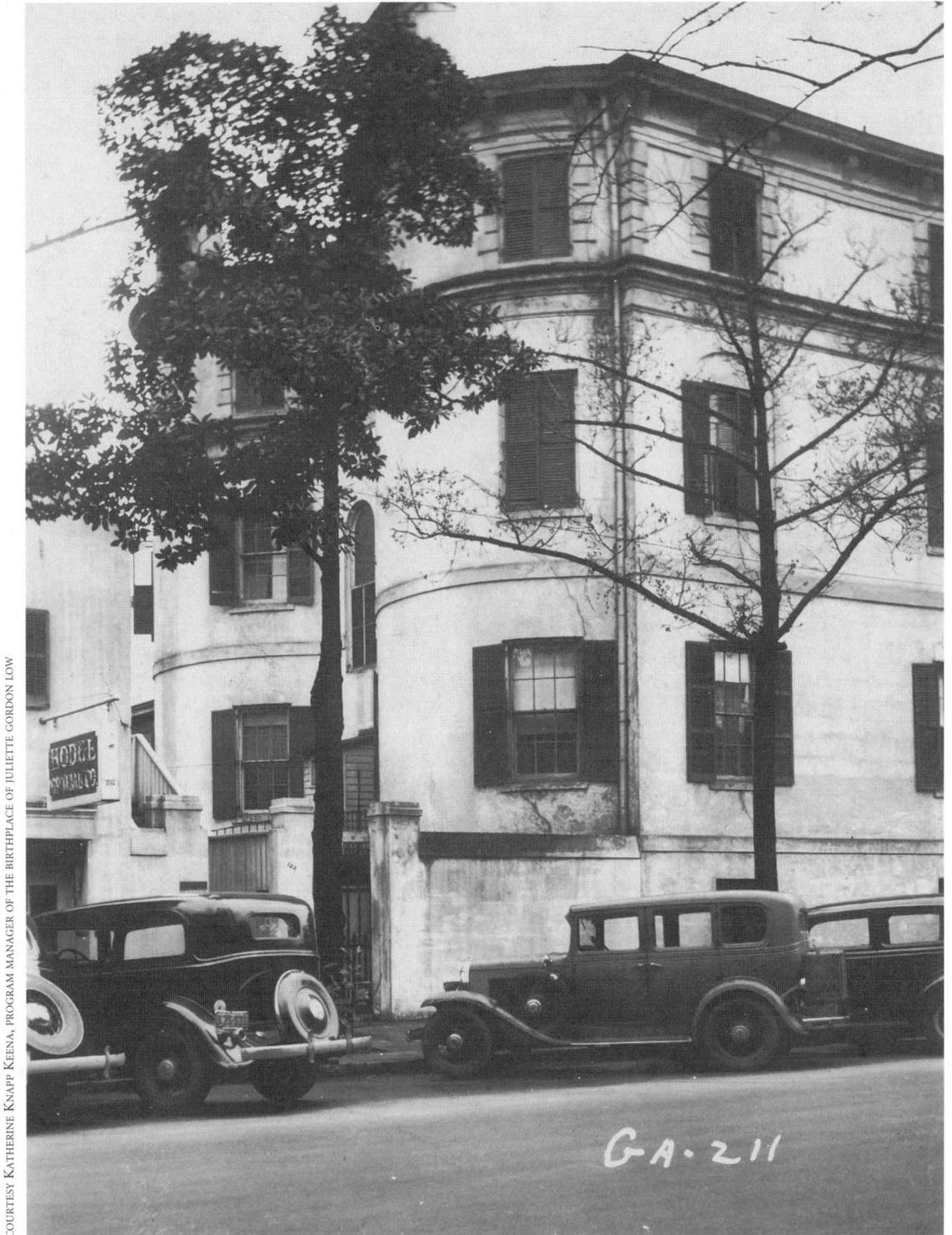

The birthplace of Juliette Gordon Low was part of the first Historic American Building Survey (HABS) of the Library of Congress and was a WPA project. This is the rear of Low's birthplace 10 East Oglethorpe Avenue, Savannah.

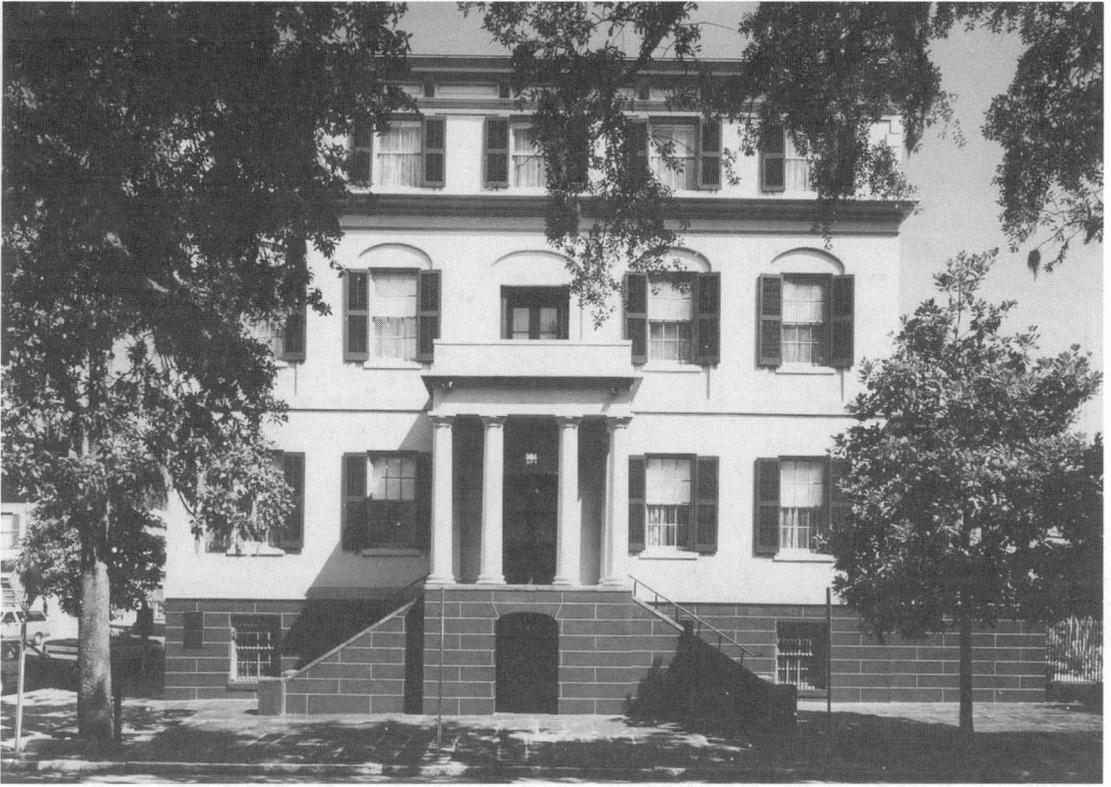

The front exterior of the birthplace of Juliette Gordon Low, 10 East Ogelethope Avenue, Savannah.

County, state, and regional FSA (Farm Security Administration) and NYA (National Youth Administration) luncheon and meetings were held at Crawfordville Farms, Georgia, in May 1939. Photograph by Marion Post Wolcott, Farm Security Administration.

Portrait of Dr. Mary McLeod Bethune, president and founder of the Bethune-Cookman College at Daytona Beach, Florida. Washington, D.C., January 1943. Photograph by Gordon Parks, Farm Security Administration.

The crowning glory of the club luncheon was the sandwich loaf, made with at least two types of breads and fillings, then "frosted" to look like a cake. Food disguises were a hallmark of the period. The 1934 edition of the *Boston Cooking-School Cook Book* told cooks how to form mushrooms out of cream cheese, to make an Indian salad that resembled a feather headdress and to fashion a bunny salad from a canned pear half.

It also was the era of the Mystery Cake, which contained canned tomato soup; pigs in blankets (made with Bisquick [introduced in 1931]); and Burning Bush, an appetizer of cream cheese balls wrapped in chipped dried beef and stuck into a whole eggplant with toothpicks.[74]

Marshmallows were a popular food during the 1930s; a recipe that combined the marshmallows in a "food disguise" was sure to be a hit. Such a recipe was "Sweet Potato-Marshmallow Surprise." The cook shaped cooked, mashed sweet potatoes around a marshmallow; after rolling the balls in crushed Post Toasties, the chef baked the balls until browned but not long enough to melt the marshmallows.[75]

Group on steps of community auditorium with county doctor, project manager, and nurse on May Day–Health Day in Irwinville Farms, Georgia, May 1939. Photograph by Marion Post Wolcott, Farm Security Administration.

Food companies were hard at work during the Great Depression developing food products that would tempt the consumer. Some of the new products were Hormel's Spam (1937), Bird's Eye's "frosted" [frozen] foods (1930), the Good Humor Bar (1930), the Toll House Inn's cookies (1930), Bisquick (1931), Ritz Crackers (1934), Campbell's Cream of Mushroom Soup (1933), Gallo's wines (1933), Girl Scout Cookies (1934), Pepperidge Farm Loaf (1935), and Nestle's Chocolate Chips (1939). The Toll House Inn developed a new recipe: Toll House Cookies (1937).[76] The Divan Parisien Restaurant in New York City also created a new dish: Chicken Divan.[77]

Sue Dawson notes:

Mr. Herbert Hoover
says that now's the time to buy,
so let's have another cup of coffee
and let's have another piece of pie.[78]

Food was important to those who did not have it and to those who did.

VIII. Dancing

Many in the religious community opposed dancing, but it was very much a part of the culture of some Georgia areas. The types of dancing varied. In rural areas, Maypole dancing, folk-dancing, and square dancing were particularly popular. Many areas continued the 1920s dances, like the Charleston. Some "modern thinking" areas began the swing dance that quickly became a national craze: the Big Apple. Created in 1937 by Lee David and John Redmond, the dance was unique.

Danced in a circle by a group, the Big Apple is led by one who calls the steps, as in a Virginia reel. The fundamental step is a hop similar to the Lindy Hop. In the words of *Variety*, "it requires a lot of floating power and fannying." In groups or singly, the dancers follow the caller and combine such steps as the Black Bottom, "shag," Suzi-Q, Charleston, "truckin'," as well as old square-dance turns like London Bridge, and a formation which resembles an Indian Rain Dance. The Big Apple invariably ends upon a somewhat reverent note, with everybody leaning back and raising his arms heavenward. This movement is called "Praise Allah." Through it all, the "caller" shouts continuously — "Truck to the right.... Reverse it.... To the left.... Stomp that right foot.... Swing it."[79]

Cafè society. Even though most of the country and state were foundering in the Great Depression, the cafè society was trying to keep up appearances. Others tried to copy their fashions and their dances, like the Lambeth

May queen and maypole dance at May Day–Health Day festivities in Irwinville Farms, Georgia, May 1939. Photograph by Marion Post Wolcott, Farm Security Administration.

Walk, which originated in England in 1938 and ended in shouts of "Oy!" Americans in New York and small towns alike adopted the dance.[80]

Dance marathons. One of the fads of the 1930s was the dance marathon. The object of the event was to determine which dance couple could remain on the floor the longest. At a time when money was scarce, many young people were eager to compete for the prize money.

Street dances and square dances. Frequently communities and groups continued to enjoy the square dance. Some small towns held street dances in the early fall and warm spring and summer months; the officials would close many streets for the events. At this time dancing took priority over traffic patterns.

IX. Fairs, Circuses, Recreation Parks, and Traveling Entertainment

Seasonal entertainment in Georgia included fairs and circuses, which made their yearly visits to the state. Posters heralded the upcoming events that were popular occasions for young and old alike. Usually the traveling trains or trucks arrived in rural communities in the fall after the laborers had picked the cotton and harvested the other crops. The amusement owners wanted to be sure that their arrival coincided with a time when the people had some money to spend.

Exhibit halls. For visitors who did not have a great deal of pocket money, the joy of visiting the exhibit halls—usually free—was

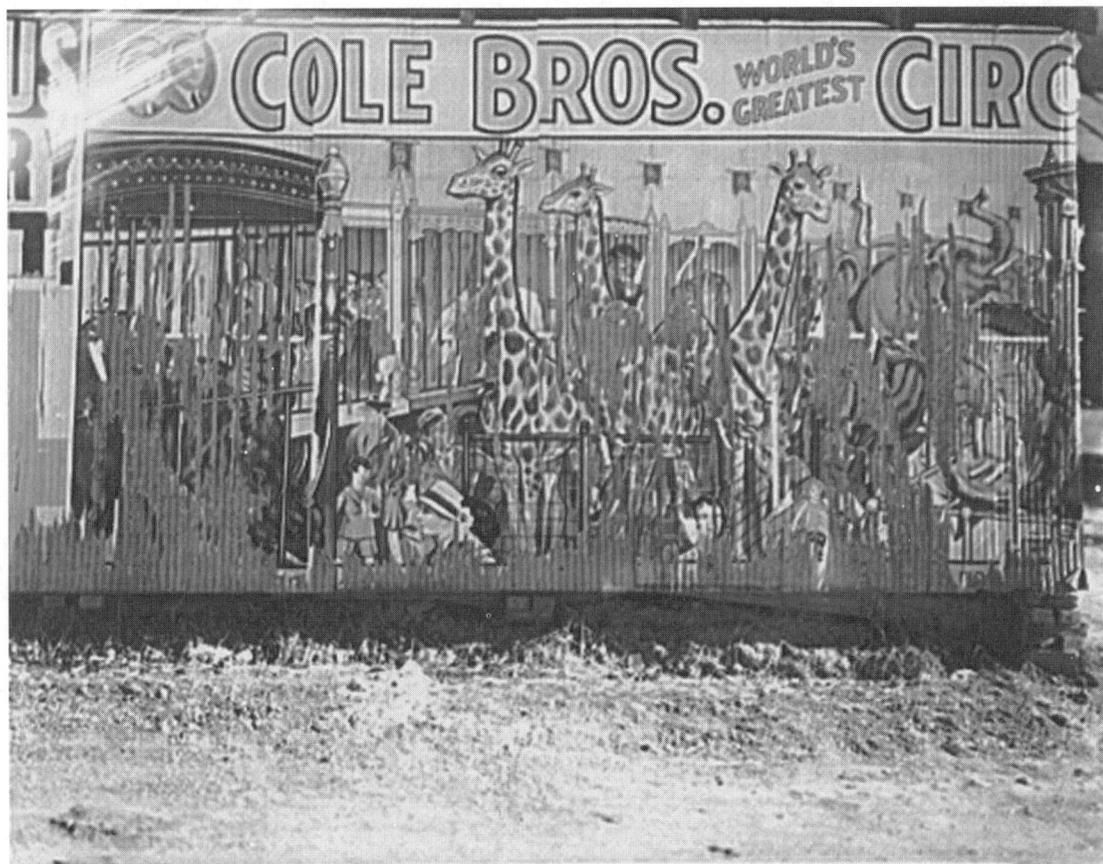

A circus poster photographed in the southeastern U.S. between 1935 and 1942. Photograph by Jack Delano, Farm Security Administration.

a treat, especially to those whose lives had recently been filled primarily with work. The advertisements and the anticipation of the upcoming fair or traveling circus brought happiness to many hearts — young and old.

The exhibit halls of the fairs featured the products of the farms, the food preparation and conservation of the families, and the other displays and handiwork of the residents. Usually there was no charge for this exhibit. Embroidery, quilting, tatting, knitting, darning, and stitchery of all kinds were necessary tasks in many households. The women and girls often included friends and relatives in the quilting and other handwork activities to make the work a social event. Some women entered their crafts in the county fair to exhibit their proficiency — and in hopes of getting a ribbon and the accompanying monetary award.

Walking the midway and visiting the shows. Even to those who did not have the money for entering the tents, walking the midway was a treat that young and old alike enjoyed. Visitors saw people they had not seen

in some time; those from neighboring communities often attended. Past residents even timed their community visits to correspond with the arrival of the fair or circus.

Midway shows were available to those who had the necessary coins to enter the advertised "spectaculars." Those who could not afford to "step inside" contented themselves with looking at the billboards and enjoying the free preview given outside just before the "show inside began." Odd animals and people — either real or contrived — were a feature of some of these sideshows.

Rides and the smells of cotton candy and frying potatoes reached the nostrils of those who arrived. The sounds of screams from the rides, the enticements of workers inviting fairgoers to try their luck at the booths, and the calls of "B-6" from the bingo booths filled the air. The actual sights would not be lasting, however, for the travelers would remove their displays and would be gone within a few days. On the last night of the visit, typically, the fairs and circuses had a fireworks display. The

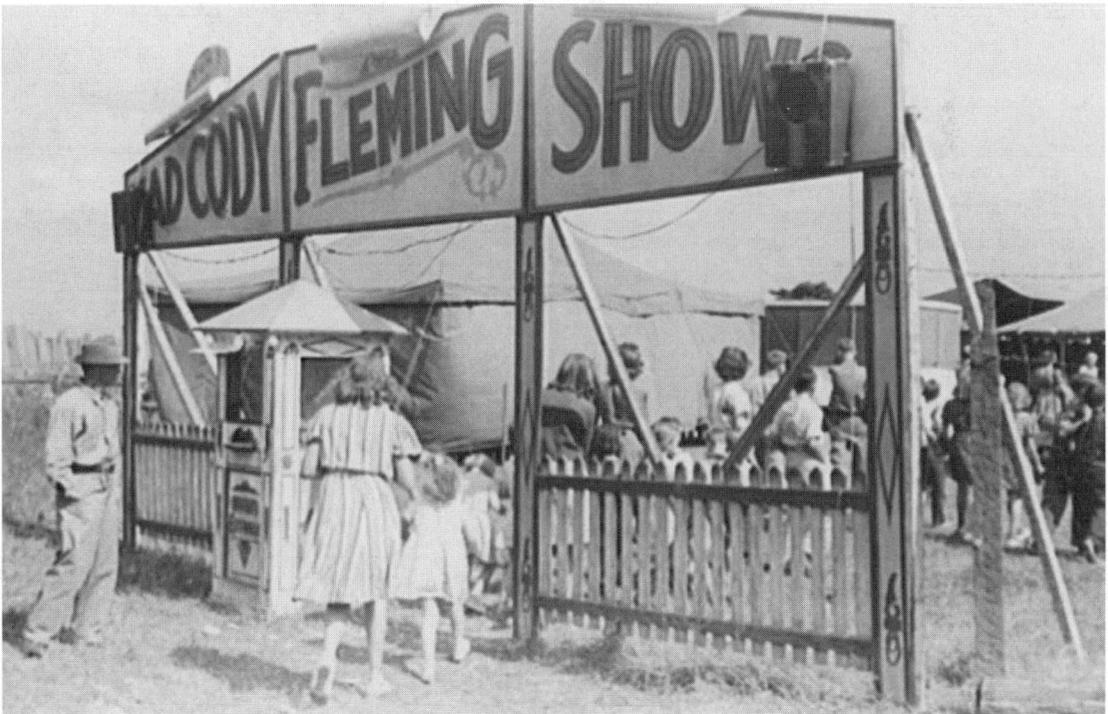

Entrance to the Greene County fair, Greensboro, Georgia, October 1941. Photograph by Walker Evans, Farm Security Administration.

exhibit marked the end of the fair or circus until the next season — and ensured that the audience would stay until the last possible moment and increase the profits of the sponsors.

Chicago Fair (1933) and New York World's Fair (1939). Some Georgians were able to visit a fair unlike any of the local county fairs. Even during the hard times of the 1930s, many Georgians were able to travel outside the perimeters of the state for memorable occasions of the decade. Two such events were the Chicago World's Fair of 1933 and the New York World's Fair of 1939 — "the biggest, giddiest, costliest and most ambitious international exposition" ever put on up to that time.[81]

X. Holidays

Georgia residents observed — even during "hard times" — holidays, such as Christmas, Hanukkah, the Fourth of July, Thanksgiving, and New Year's Day. During the 1930s the New Year's Shoot was a still-celebrated custom that German-speaking settlers brought to the New World. At the stroke of midnight, residents would fire their weapons in the air to welcome the New Year.[82] To ensure good luck the whole year, the New Year's Day menu of most Georgians included black-eyed peas and turnip greens, often cooked with fatback, side meat, or hog jowl for seasoning. Cooking two or more vegetables together — like corn and tomatoes to make succotash, black-eyed peas and rice to make "hoppin' John," and corn, limas, tomatoes and okra to make soup — was a common Georgia practice.

For most family members, homemade presents or none at all were the rule in many households during the Great Depression. An apple, a stick of peppermint candy, an orange, and some walnuts formed the Christmas presents for many children in Georgia. Homemade valentines made from paper colored with crayons and pasted with flour-and-water glue marked Valentine's Day. Most classrooms reeked of paste the day before the holiday. Easter was typically celebrated with eggs colored with homemade dye. Some teachers allowed the students to bring a boiled egg for an "egg cracking" contest to see who would have the strongest egg. Sometimes someone would bring a guinea egg, which was exceptionally hard, to make things interesting.

XI. Fine Arts in Georgia

Critic H.L. Mencken referred to the South as a "Sahara of the fine arts."[83] Mencken's statement would not have been true if he had considered the fine arts in Georgia — and Atlanta in particular — during the 1930s. There are many examples, but a few follow.

High Museum of Art. Atlanta housed the High Museum of Art, the leading art museum in the Southeastern United States. Founded in 1905 as the Atlanta Art Association, it received its first permanent home in the late 1920s with the donation of the High family home on Peachtree Street.[84]

Atlanta Cyclorama. The Atlanta Cyclorama is an example of an art form that started in America when artists created examples of scenes Americans might never see for themselves. The "Battle of Atlanta" opened for display in Michigan in 1887. Sold and ending up with a traveling circus, the painting glorified the defeat of Atlanta. When Atlantans would not pay to see their defeat, the circus declared bankruptcy. The animals became the cornerstone of Zoo Atlanta, a part of Grant Park. The painting was housed next door. The city of Atlanta gradually took control of the painting; the *Battle of Atlanta* had been an important part of the historical information of Margaret Mitchell. The city added a diorama to the exhibit in the 1930s.[85]

Clark Gable, a popular story goes, visited the Cyclorama in Atlanta during the celebrations surrounding the opening of the film *Gone With the Wind.* The legend states that Gable declared that the only way the painting could be more magnificent would be if the display included Gable himself. The management added Gable's features to one of the features in the diorama.[86] The painting, advertised (2007) as the largest in the world,[87] is currently only 42 feet high and 358 feet long; it was originally 60 feet high and 360 feet long.[88]

Federally-assisted art and culture in Georgia. The federal government, through its work programs during the Great Depression, was also subsidizing some artists during the Great Depression. For instance, these artists painted murals or prepared sculptures for post offices and federal buildings. Some of this federal art produced during the 1930s in Georgia included:

The British Come to See Augusta by Maurice Glickman (Ashburn, Georgia);

Products of Grady County by Paul L. Gill (Cairo, Georgia);

Arrival of the Atlanta and West Point Railroad by Jack McMillen (College Park, Georgia);

Northern Georgia by Charles Trumbo (Cornelia, Georgia);

Last Indian Troubles in Randolph County — 1836 by Carlo Ciampaglia (Cuthbert, Georgia);

Dogwoods and Azaleas by Paul Rohland (Decatur, Georgia);

Georgia Lumberman Receiving Mail by Star Route Wagon by Arthur E. Schmatz (Eastman, Georgia);

Morgan Raiders by Daniel Boza (Gainesville, Georgia);

The Burning of Greensborough by Carson Davenport (Greensboro, Georgia);

Cotton Picking in Georgia by Carson Davenport (Greensboro, Georgia);

A Letter by Orlin E. Clayton (Hartwell, Georgia);

George Oglethorpe Concludes a Treaty of Amity and Peace with the Creek Indians — May 18, 1733 by David Hutchison (Jesup, Georgia);

Turpentine and Cotton by Oliver M. Baker (McRae, Georgia);

Early Monticello by Beata Beach Porter (Monticello, Georgia);

Georgia Countryside by Doris Lee (Summerville, Georgia);

Experimenting with the First Model of the Cotton Gin by Edna Reindel (Swainsboro, Georgia);

Cantaloupe Industry by Chester J. Tingler (Sylvester, Georgia);

Weighing Cotton by Marion Sanford (Winder, Georgia).[89]

Federal photographers began recording images of the population and the resources of the United States during the Great Depression. These photographs, the drama, and the programs that the federal work legislation brought to auditoriums and schools across the nation are other examples of the culture in Georgia during the 1930s.[90]

Public libraries in Georgia. With the beginning of the Great Depression especially, library development in Georgia had almost halted. Most of Georgia's counties were without library service; there seemed no way to remedy the situation without state or federal aid. In 1934 a bright spot appeared on the horizon with the beginning of the first bookmobile service in Georgia. The bookmobiles were "makeshift" at best, but they were better than nothing.[91] In 1939 the first commercially built bookmobile in Georgia began to serve Bibb County.

For fourteen years the Georgia legislature had repeatedly defeated bills to allow county support of existing municipal libraries, to extend the service of libraries countywide, and to establish public library service in areas without the benefits. The Georgia legislature in 1935 at last passed legislation to enhance library service. This service was sorely needed because of the large number of rural residents without access to books.

The federal government and Georgia libraries. The same year (1935) President Franklin Delano Roosevelt created the Works Progress Administration (WPA). One function of the WPA was to fund personnel and to pay for library services, such as technical assistance, to Georgia and the rest of the nation. The actions of the WPA helped establish a "real" bookmobile service for needed sections of the state. Georgia took the initiative in some areas of library service. The Georgia Library Commission, in cooperation with the national planning efforts of the American Library Association, prepared and published the first major statewide plan for public libraries.

WPA assistance for libraries continued from 1936 to 1943, at which time more than 100 Georgia libraries were receiving WPA assistance. During this period, the state received approximately $1.4 million for its libraries.

Other actions were bringing books to

Georgians. The Georgia Department of Education set up a School Library Division in 1936; this section operated within its School Library Division. The following year (1937) the Free Textbook Bill included funds from the state for school library service; the same year, the state legislature passed a law providing for the certification of public librarians.

In 1938, the attorney general made a ruling that helped the school libraries. The decision allowed surplus funds from those provided for free textbooks to be used for school library materials. The state's first regional library system came into being in 1940 as a result of a WPA demonstration. The system served Clark, Oconee, and Oglethorpe counties. Its base was Athens. With increased public interest and WPA assistance until 1943, Georgia's library system continued to expand and improve.[92]

These free books were an important source of entertainment and education during the "hard times" of the Great Depression. Segregation, however, prohibited all Georgians from participating.

Georgia and the Federal Theatre Project. The federal government had another plan for taking the arts to places that might not have ready access to the arts—especially the theatre — and for helping those in the arts who might not otherwise find employment during the difficult thirties. It established the Federal Theatre Project (FTP) as a part of the Works Progress Administration. Hallie Flanagan served as the national director.[93] She reported that Harry Hopkins, administrator of the Works Progress Administration, saw the relief rolls in the summer of 1935 and believed that unemployed theatrical people could get just as hungry as other people and that their talents were worth conserving.[94]

> In order to provide professional and technical direction for a nationwide program under the Federal Theatre Project (FTP), the United States was divided into several theater regions and a Regional Director of the Federal Theatre Project was appointed for each of these regions. This appointed director would act as a representative, in that region, for the Federal Director of Theatre Projects in Washington.
>
> The Regional Director, with the cooperation of

existing Works Progress Administration officials in his region, directed the functions of the FTP, and approved all appointments to superintendence positions in the theater projects in his region.[95]

Among the general listing of plays that were tentatively approved by the National Play Policy Board was *Br'er Rabbit and the Tar Baby, based on Harris's work.*[96] One of the theater regions was the Southern Region, which included the states of Alabama, Florida, Georgia, Louisiana, Mississippi, and Tennessee.[97]

The Federal Theatre Project Collection at Princeton University Library contains bulletins, reports, play programs, and other materials of the FTP. The materials for Georgia indicate that the programs included:

Journey's End: R.C. Sherriff, 1/24/1938;

High Tor: Maxwell Anderson, Fall 1938;

Lost Horizons: Harry Segal and John Hayden, Fall 1938;

The Best Cure: Belmont-Ashton, 12/28/1938;

The Man of Destiny: G.B. Shaw, 3/15/1939;

Androcles and the Lion;

The Fireman's Flame: John Van Antwerp, 4/25/1939.[98]

At its peak the FTP employed 12,700 people, nine out of ten of whom came from relief rolls and about 50 percent of whom were actors, who worked in 40 cities in 22 states— including Georgia — and who toured even into rural areas. The board, which consisted of the regional directors; the city directors of New York, Chicago, and Los Angeles; the national director; the deputy national director; and an associate director, decided on plays, policies, fund allocation, opening and closing of projects, and employment and dismissal and was important to the FTP.

The programs of the FTP fell into eight major categories: classical plays, entertainment theatre (Gilbert and Sullivan, for instance), youth theatre, dance theatre, new American plays, black theatre, research and experimentation, and radio. Of the 25,000,000 people who had seen a production at the time that Hallie made her report, 65 percent reported that they had never before seen a play with living actors; the respondents indicated also that they hoped to continue to go to plays. Hallie

indicated that the FTP was the theatre of the American people.[99]

"Underprivileged" groups—schools, playgrounds, Civilian Conservation Corps Camps, reformatories, homes for the aged, hospitals, prisons—could see the productions without charge; this was 65 percent of those who viewed the productions. The remaining group (35 percent) paid from 5¢ to $1.10, depending on locality, the production, and the discretion of the local director. Hallie was also able to report that gifts from sponsors were extensive.[100] The subgroups under the FTP expanded to about 30 and even included a motion picture unit. An intangible, immeasurable quality that the audience experienced was *possibility.*[101]

XII. *Opera and Other Musical Programs*

A rich variety of sights and cultural programs dotted the state, including many annual events.

The opera and other musical programs. The Metropolitan Opera began touring Atlanta and the South in 1910. The Metropolitan tour drew to Atlanta audiences from all over the South and became a weeklong spring event, popular with the socially elite. Opera stars like Enrico Caruso and Arturo Toscanini occupied Atlanta's stages. Eventually, the week at the Met began to draw an international celebrity crowd. Atlanta's visits were regular — except during the Great Depression and wartime — until 1986 when the company ceased its tours.

Atlanta's Music Festival Association supported the construction of the Atlanta Municipal Auditorium and the installation of a seventy-seven stop Austin organ. The Atlanta Music Club (1915) enriched the city's musical life. The club helped to establish the Atlanta Symphony Orchestra (1923) and the Choral Guild of Atlanta (1939).

An informal Website reports a local legend. Evidently, the wealthiest socialites in Atlanta would attend the first act of the Metropolitan event and leave at intermission for an evening of parties. Eager young people would stand outside the theatre in hopes of receiving the partially used tickets and catching the remainder of the show.[102]

XIII. *Popular Attractions*

Some Georgia cities had permanent recreation parks. Local lakes and pools for swimming and fishing provided inexpensive fun for Georgia residents. In addition, traveling exhibits—which included "crime shows," agricultural exhibits, and "freak shows" [genuine and fake]—toured the state; some people took advantage of these traveling shows as a form of amusement.

Piedmont Park in Atlanta. Georgians have been visiting Piedmont Park in Atlanta since 1895—for various purposes. The original purpose of the purchased land was to build a horse racing track. Later, the park was the site of the Cotton States International Exposition of 1895; Victor Herbert entertained at the event. In 1904 the Atlanta City Council purchased the grounds for a park, which is still an important site.

Monuments, national parks, and state parks. Georgia is rich in monuments, historic sites, national parks, and state parks and also was in the thirties. Chapter one, "Water, Soil, and Industries Based on Natural Resources," gives further information on some of the places—including Chattahoochee National Forest—for visitors to see.

Kennesaw Mountain National Battlefield. The Department of the Interior transferred the Kennesaw Mountain National Battlefield Park to the National Park System in 1933. The Battlefield is a 2,888-acre site that preserves a battleground from the Atlanta Campaign of the Civil War. During the campaign 67,000 troops lost their lives. Georgians who had the means enjoyed a trip to the site to learn more of their state's history.[103]

Chickamauga and Chattanooga National Military Park, Fort Frederica National Monument, Fort Pulaski, and Andersonville. Chickamauga and Chattanooga National Military Park was the first and largest of the four national

The Drayton Hall, near Summerville, South Carolina, in June or July 1936, was the last of eighteen similar Georgian homes which Union troops burned after the Civil War. This house remained untouched because it housed patients ill with smallpox and the troops dared not enter the grounds for fear of their own health. Its construction was about 1740 and represents typical Georgian architecture. Photograph by Carl Mydans, Farm Security Administration.

military parks. The other three — Shiloh, Gettysburg, and Vicksburg — are other national sites that visitors can still tour.

On St. Simons Island, discussed in chapter one, "Water, Soil, and Industries Based on the Natural Resources," is the Fort Frederica National Monument. This island contains the ruins of an eighteenth century English military post.

Other historic sites are the Fort Pulaski National Monument, which is near Savannah and which contains the restored walls of a Confederate stronghold, and Andersonville, the site of the Andersonville Prison during the Civil War. Drayton Hall was another site for visitors with an interest in history.

The Georgia State Park System. The Georgia State Park System includes the Hard Labor Creek State Park in north-central Georgia and the Franklin D. Roosevelt State Park in western Georgia. Vogel State Park, discussed in chapter one, "Water, Soil, and Industries

Based on the Natural Resources," has a museum — one of two in the nation — dedicated to the Civilian Conservation Corps.

The Indian Springs State Park in north-central Georgia is the site of a mineral spring that the Creek Indians once used. The Chehaw State Park in southwestern Georgia was once occupied by Chehaw Indians. The Etowah Indian Mounds is the site of two large mounds and other remains of an Indian village. One of the mounds covers almost three acres and is one of the largest Indian mounds known in the United States.

Tourist attractions. Lighthouses, the Georgia beaches, shopping opportunities in Atlanta, the barrier islands, museums, swimming pools, city parks, national parks and battlefields, and state parks were only a few of the attractions that drew visitors to the state. Even those who had no money for long vacations or overnight trips might sometimes take a day

trip to the coast, the rivers, the mountains, or the streams to enjoy a brief respite from the problems of the Great Depression. Many city dwellers sought the rivers, lakes, ocean, and woods for a retreat from a busy urban life. Some farmers allowed out-of-state hunters the use of their land — and even their dogs—for a fee.

Stone Mountain. Georgia's Stone Mountain has long been a site of interest to travelers and local residents alike. Its prominent natural feature — exposed granite — extends 1,686 feet above sea level. Chapter one, "Water, Soil, and Industries Based on Natural Resources," contains further information about Stone Mountain itself. One of the reasons for visitors to Stone Mountain just after the turn of the century was, of course, a view of the mountain itself and hiking, but a new project brought further interest. This project that required —for various reasons— more than half a century to complete was the carving of Stone Mountain. The finished carving is 90 feet tall and 190 feet wide and is 400 feet above the ground; its frame is three acres— 360 feet square. The largest sculpture in the world, the carving is cut into the world's largest exposed mass of granite.[104]

History of the carving. In 1909, Mrs. Helen C. Plane, a charter member of the United Daughters of the Confederacy (UDC), conceived the idea of a Confederate Monument on the side of Stone Mountain. She suggested, as Atlanta chapter president, an image of Robert E. Lee.

In 1915 the UDC consulted Gutzon Borglum, who had recently finished the statue of Abraham Lincoln; he made sketches of Confederate leaders who might be included on the final carving. He thought only one such image "would be like a postage stamp stuck on a barn."[105] Samuel Venable, the owner of the mountain, deeded (in 1916) the face of Stone Mountain and ten acres adjoining the mountain to the UDC. Venable included a provision that the property must be returned if there was not a complete carving in twelve years.

World War I caused a pause in the activities. In 1923 Borglum announced that his designs were complete and that he was ready to

begin. After several failed attempts to sketch the image on the mountainside and after several disagreements with the committee, Borglum left Georgia shortly after completing the head of Lee (with a hat) and before his twelve-year contract was due to expire; before leaving, however, he destroyed his sketches and his models. He did, however, accomplish one significant monument: the design of a Confederate half-dollar, the sales of which would benefit the carving. His next position was to help with Mt. Rushmore in South Dakota.

Augustus Lukeman went to work in 1925. He knew he would have to work at top speed to finish the work before the 1928 expiration of the contract between Venable and the UDC. Lukeman had the curving face of the mountain blasted away and Borglum's work removed. His sketch was of three mounted, hatless men: General Robert E. Lee, President Jefferson Davis, and Lieutenant General Stonewall Jackson.

The coins that Borglum designed were selling quickly. The income from them would be sufficient to pay for the rest of the monument. On April 9, 1928, Lukeman unveiled his work: the faces of Lee and Davis, an outline of Lee's horse, blocked out figures of Lee and Davis. On May 20, however, the Venables reclaimed the property. Thirty years later (1958) Georgia purchased the mountain and 3200 acres of surrounding land and sponsored a competition for artists who wanted to complete the work. They chose Walker Kirtland Hancock to serve as consultant. The dedication of the completed carving on Stone Mountain finally came on May 9, 1970.[106]

XIV. Bobby Jones and the Masters Golf Tournament

Robert Tyre "Bobby" Jones was born on March 17, 1902, to Clara Thomas and Robert Purmedus Jones, Esquire, on March 17, 1902. He and his family spent every summer at a summer home near the East Lake Country Club. It was here that Bobby learned to play golf. After winning many regional competitions, Bobby — as a

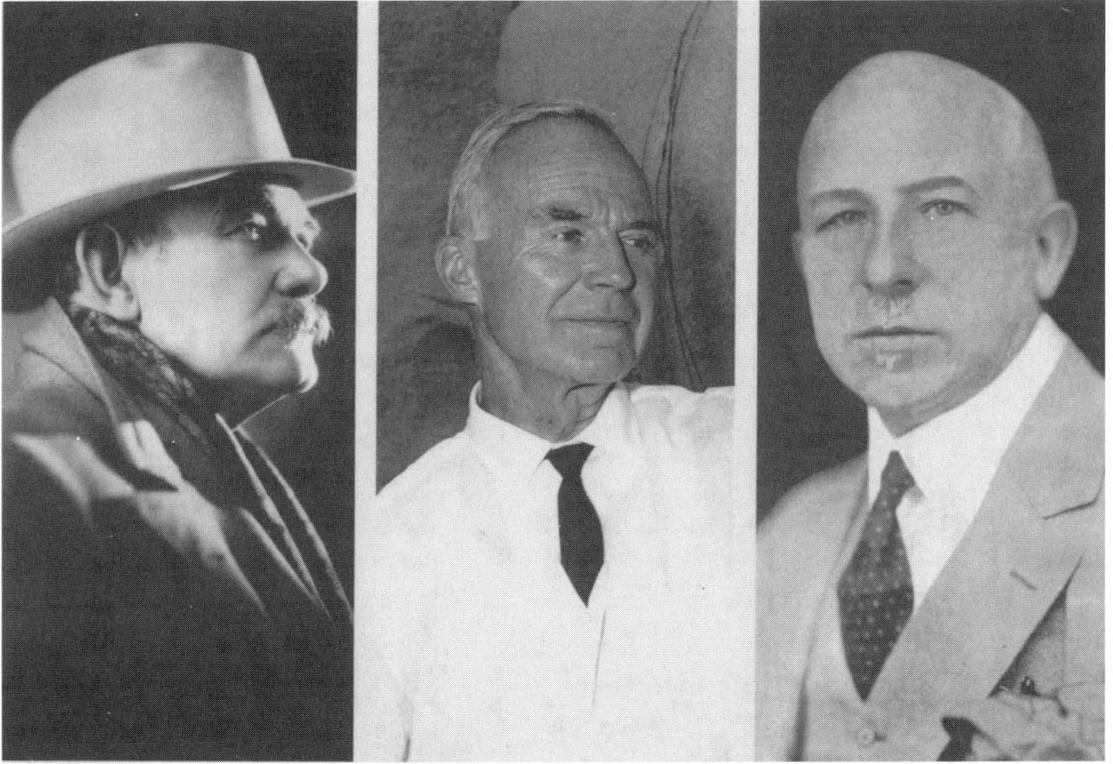

A postcard showing Gutzon Borglum, Augustus Lukeman, and Walker Hancock.

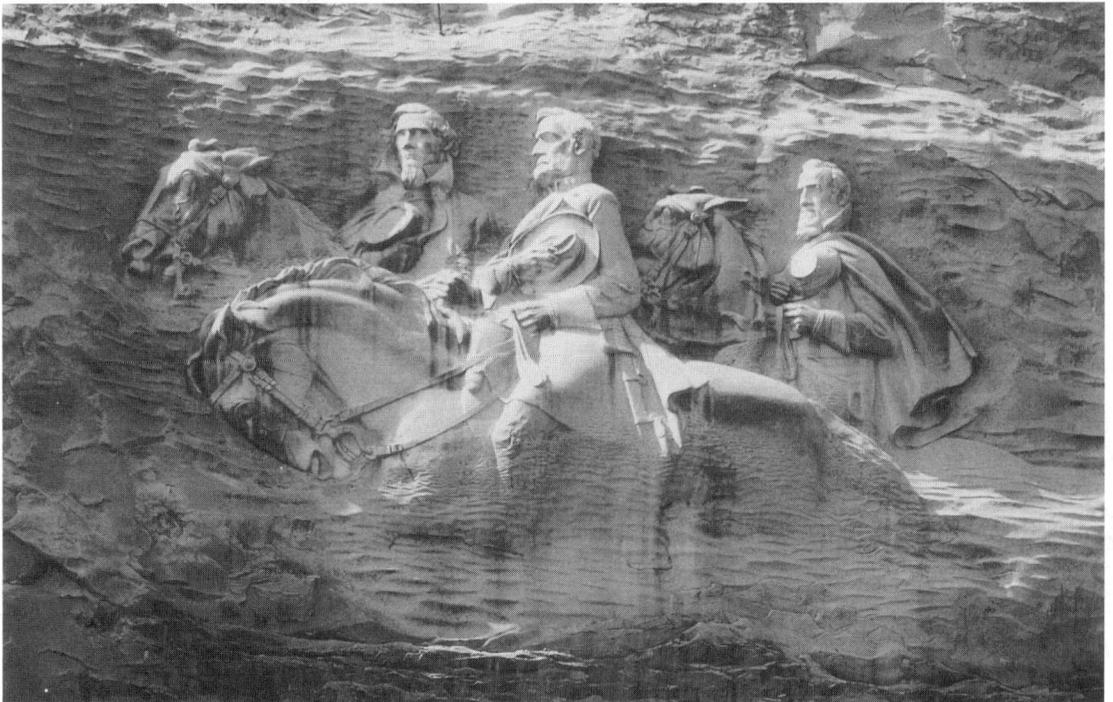

The final carving at Stone Mountain consists of Confederate President Jefferson Davis, General Robert E. Lee, and General Stonewall Jackson; their hats are off in tribute. Vice President Spiro Agnew gave the main dedication address on May 9, 1970. Photograph by Jim Duane.

fourteen-year-old — entered his first national competition: the U.S. Amateur at the Merlon Cricket Club near Philadelphia. He won two matches before elimination in the third round.

Over time, Bobby had his losses and his failures. Finally, in 1930, he won "The Grand Slam." He was the first man to win in one season all four major titles: the British Amateur, the British Open, the U.S. Open, and the U.S. Amateur. Two months later he announced his retirement. He was 28 years old. Jones retired from competition with 13 majors, and his record would hold for more than 40 years.[107]

The Masters. Bobby did not retire from the golf world or from public life. He filmed two series of golf instructional shorts. This work in 1931 and 1933 earned him about $250,000.

After signing with A.G. Spalding and Brothers, Bobby Jones designed and endorsed a line of golf clubs. He wrote hundreds of articles and several books about golf. He also wrote two autobiographical books: *Down the Fairway*, with O.B. Keeler (1927), and *Golf Is My Game* (1960).

Jones' outstanding retirement project was the creation in Augusta of the Augusta National Golf Club and the Masters, the annual invitational tournament generated by the Augusta National Golf Club. First played in 1934 when times were hard, the Masters became recognized as one of the four major tournaments in golf. Each year until 1948 Bobby came out of retirement to participate in the Masters. The Masters brought many visitors to Georgia even during the 1930s. More than seven decades later the event captures television audiences across the country and continues to be one of Georgia's and the nation's premiere sporting event.

Illness and achievement. In 1948 at the age of 46, Bobby developed a rare spinal disease; this affliction of syringomyelia forced Jones into a wheelchair. His final trip to the Masters was in 1968. Jones died on December 18, 1971, at age sixty-nine.

Bobby always put his wife and three children first. He presented a model of perseverance and character and did not complain about his problems. "His handling of his illness, the memory of his competitive career, and his Masters Tournament established Jones as one of sport's most outstanding and admirable heroes. In 1963 he was one of the first three professional athletes inducted into the Georgia Sports Hall of Fame."[108]

Summary. Although times were lean during the 1930s, many Georgians were able to draw on their own inner strength and promote their own mental health through taking some time for entertainment — as elaborate as a cross-state trip or as simple as a walk beside a local stream to enjoy the peace of one of Georgia's rivers.

Federal Photography in Georgia

Rexford Tugwell came to Washington in 1933 from Columbia University. As an initial part of President Franklin Delano Roosevelt's "Brain Trust," Tugwell assumed the role of assistant secretary of agriculture after Roosevelt created the Agricultural Adjustment Administration (AAA).

As a teacher at Columbia University, Tugwell had worked closely with student Roy Emerson Stryker. Stryker was a World War I veteran; born on November 5, 1893, he had spent his early years on a farm in Montrose, Colorado. Stryker — at Tugwell's suggestion — remained at Columbia as an instructor in economics. Tugwell asked Stryker to assist him on a book and Stryker agreed. Tugwell also offered Stryker a choice of helping to locate the illustrations for the book titled *American Economic Life* for a salary or of serving as joint author. Stryker selected becoming a joint author with his mentor.[1]

It was during the period that Stryker worked with Tugwell to select the photographs for *American Economic Life* that he became familiar with the work of photographers of the time. He found that most contemporary photographers were not depicting social movements or economic problems. They were, instead, searching for "abstract beauty."[2] Stryker found Lewis Wickes Hine to be a notable exception.

Influence of Lewis Wickes Hine on

Oil painting of Administrator Tugwell by Boris Deutsch, created between 1935 and 1942.

Stryker and Tugwell. Lewis Wickes Hine had worked with the National Child Labor Committee to document the adverse conditions of children at work. (Examples of his work are in chapter two, "Population," and chapter five,

"Housing.") The director of the National Child Labor Committee was adamant that before Hine there was no emotional response or emotional recognition in photographs. In 1929 the director described him as "the first person to focus the camera intelligently, sympathetically, and effectively on social work problems."[3] Hine and his work impacted Stryker and Tugwell, and they ended up using Hine's work for almost a fourth of the more than 200 illustrations in *American Economic Life*.[4]

I. Roy Emerson Stryker in Washington and Beyond

During the summer of 1934 Stryker took a part-time job with Tugwell at the information division of the Agricultural Adjustment Administration (AAA). There Stryker found a wealth of photographs maintained by the Department of Agriculture. He was intrigued! Stryker was developing a profound interest in photography. In the fall of 1934 he returned to his teaching job at Columbia and began compiling a picture book on agriculture of the period. Stryker hired former Columbia student Arthur Rothstein to help him with the work.[5]

Tugwell and the Resettlement Administration (RA). Rexford Tugwell believed that the emergency relief measures prior to 1934 had not helped America's rural residents— the poorest residents in the nation. He and others helped convince Roosevelt to form the Resettlement Administration (RA), an independent agency. Because Tugwell had served effectively as assistant secretary of agriculture and because the Resettlement Administration had a tie with the Department of Agriculture, Tugwell received the position of administrator of the RA. The Resettlement Administration offered grants and loans to small farmers and tenants for "rehabilitation purposes"; also, as the name implies, the Resettlement Administration resettled and assisted the poorest farmers. In addition, the RA organized rural cooperatives and constructed greenbelt towns, which were actually three communities in the suburbs meant to serve as models for the rest of the nation.[6]

Tugwell, Stryker, and the Resettlement Administration (RA). Tugwell called on Stryker for assistance again. In July of 1935 Roy Stryker took the position as chief of the Information Division of the Resettlement Administration. The purpose of this division was

> ...to prepare finished reports by a battery of economists, sociologists, statisticians, photographers, and other specialists. In fact, it produced and maintained a file of still photographs and supplied copies of the pictures for news releases, put out a variety of internal and external publications, and prepared a wide range of exhibits.[7]

In December of 1936 the Resettlement Administration became a part of the Department of Agriculture. Tugwell's resignation came about this same time.

The Farm Security Administration (FSA). After its change to the Department of Agriculture, the Resettlement Administration became the Farm Security Administration (FSA). Stryker continued in his section that took the title "Historical Section." While Stryker headed the section, he had varying numbers— depending on the budget — of photographers working for him. (Interestingly enough, however, Stryker would never hire Hine.) Stryker often gave the photographers (who totaled about 20 over an 8-year period) specific instructions, but he also told them to "photograph what caught their interest, even if it had no direct connection to the agency or its mandate." Stryker "envisioned a pictorial record of America."[8]

During a five-month period in 1936 Stryker distributed 965 pictures for publication. *Time, Fortune, Today, Literary Digest,* and *Business Week* used these federal photographs. Two of his exhibits appeared at the Democratic National Convention of 1936 and the Museum of Modern Art. By 1940 the Historical

Opposite: *Self portrait, in shadow, of Lewis Wickes Hine. Hine's caption for this August 1908 photograph: "John Howell, an Indianapolis newsboy make $.75 some days. Begins at 6 a.m., Sundays. (Lives at 215 W. Michigan Street)." Photograph by Lewis Wickes Hine, National Child Labor Committee.*

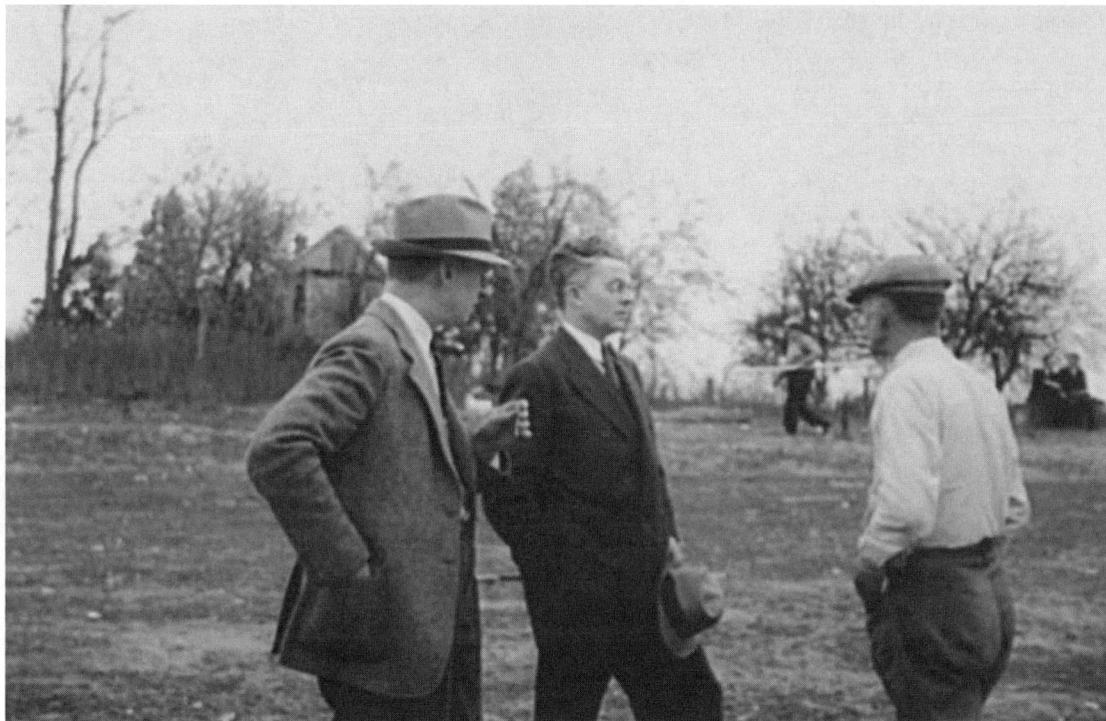

John Carter, Roy Stryker, and Major Lewis of the Resettlement Administration at the Berwyn Project of Suburban Resettlement, Prince George's County, Maryland, November 1935. Photograph by Carl Mydans, Farm Security Administration.

Section was distributing 1406 photographs per month.[9]

Organizing the photographs. Organizing and filing the tremendous number of photographs required much planning. John Vachon, a federal employee who would later photograph Georgia, worked hard to organize the photographs. The system he used was to try to keep the files in a series as the photographs were taken; for instance, he placed together all of a photographer's pictures done at one time on one subject (for example, all photos done on Greene County, Georgia). Stryker's section began to provide more guidance to the user of the photographs by increasing the descriptive phrases on the file.

In 1942 Paul Vanderbilt became a part of the organization. He began to reorganize the file so that one could locate the photographs also by subject. There is one collection for the original lots; there are 1580 lots by states with about 49 photographs in each lot. Then Vanderbilt developed a vertical file classification

system with 88,000 prints. On the back of each print is a lot number which Vanderbilt called the "bridge" between the files.[10] The collection of 130,000 photographs was in good hands with Paul Vanderbilt, but there was another danger.[11] The photographers and Stryker began to wonder if the government would destroy the files.

The Office of War Information (OWI). With the coming of World War II, the government tried to change the direction of Stryker's section. A budget reduction occurred in 1942, and the Farm Security Administration struggled. Stryker and Will Alexander, head of the Farm Security Administration, decided that this was no longer the best place for photographic documentation. A logical location would be the Office of War Information (OWI). Associate director Milton Eisenhower established within the OWI a Bureau of Publications and Graphics, directed by Stryker. With him, Stryker brought his files and his photographers.

At the OWI Stryker did not have a great deal of administrative freedom. Stryker wrote Dorothea Lange, a federal photographer who had visited Georgia, that his position was not "editorial director" but "administrative operator"; he saw the organization now as a service where he hunted photographs, ran the lab, and maintained files.[12]

Protecting the photograph collection. Stryker did manage, however, to incorporate the News Bureau file, formerly the Division of Information, into his own files. In July of 1943 Stryker made plans to protect these files by writing directly to Jonathan Daniels, administrative assistant to the president.

The 130,000 photographs in this office contained not only the record of the war's impact on the domestic scene — the small town, the city, the farm, and the people — but also the record of the land, the efforts of RA and the FSA, and other valuable pictographic information of the 1930s. These images were in one place.

If the Office of War Information were to tell completely both here and abroad the story of America at war, Stryker considered the oldest pictures to be as valuable as the most recent. Stryker feared that this coverage, conceived and produced as an unbroken continuity, was in danger of being dispersed to various locations. The nation's preoccupation with the war, in Stryker's opinion, threatened the preservation of current and past materials. To Stryker, the dismemberment of the files would be fatal for a live, active record. He believed that out of America at peace grew the strength of America at war. He viewed the nation's prewar soil and people as the same soil and people that were helping to fight the war.

Stryker believed it was possible to preserve the record intact and still make it available to the OWI and other war agencies for current use. He believed by transferring the custody of the file to the Library of Congress with instructions to place it on loan to the OWI for the duration of the war, the records could be kept intact and safe. This transfer would not mean additional expense to the library, would preserve the whole record, and would not hinder proper use by the Office of War Information.[13]

Daniels agreed with Stryker's transfer plans. Stryker began to prepare to change his place of employment and to ensure the transfer of the federal images.

A summary of Stryker's work with the federal government. Between 1935 and 1943 Roy Emerson Stryker directed the photographic section of the federal government after finding and becoming intrigued with the first photographs in the files of the AAA. Through these eight years that Stryker worked as director, the purpose of the photographic section remained the same: to document the nation through photography.

Some of the photographs moved through several government agencies. First, Stryker had found the photographs in the files of the AAA. Stryker worked as director of a part of the Resettlement Administration (RA) in 1935. In 1937 the section (still headed by Stryker) became a part of a second agency: the Farm Security Administration (FSA). In 1942 Stryker and his section became a part of still another agency: the Domestic Operations Branch of the Office of War Information (OWI).

In July of 1943 Stryker began to make arrangements for the preservation of the photographic files and to prepare for his future and that of his staff. The Library of Congress agreed to Stryker's request that the Library assume custody of his files. In September Stryker — along with several of the section's photographers — left the federal government but continued their photographic documentation of the nation through a new source: Standard Oil Company.

Fewer than twenty photographers were involved with Stryker and his dreams through the years Stryker served the government. Some photographers worked with him only a few months, like Barbara Wright, but some stayed for five or six years. Women like the renowned Dorothea Lange and Marion Post Wolcott worked with Stryker, as did such noted photographers as Walker Evans, Arthur Rothstein, Jack Delano, Carl Mydans, John Vachon, and Ben Shahn. (All of these photographers recorded images from Georgia.)

Stryker directed the work of all who worked with him on photography to make

sure the documentation was historically and sociologically sound; yet Stryker gave them the freedom to photograph that which they found aesthetically pleasing. He wanted never to compromise the standards of these camera artists. For these historical, sociological, and aesthetic reasons, the immense collection is priceless today.[14]

Stryker and Standard Oil. In September of 1943 Stryker resigned from the OWI. Stryker (and those photographers he took with him) continued the American photographic survey at Standard Oil Company.[15]

At Standard Oil, Stryker had much more administrative control over the documentary photographs than at the OWI. Stryker planned on a group of 25,000 photographs, but by the time the end of the project in 1949, he had amassed 68,000 photographs.[16] This collection "was the largest photographic documentation project ever undertaken in America by anyone other than the federal government."[17]

From Standard Oil to Pittsburgh Photographic Library. Stryker left Standard Oil in 1950 — after seven years— to become director of Pittsburgh Photographic Library (PPL).[18] Stryker resigned from PPL in 1952, but he helped in the transfer of the materials in 1960 when the collection moved from the PPL to the Carnegie Library of Pittsburgh.

Assessment of the photographic collection in the 1960s and 1970s. Tugwell in 1965 described the federal photographs as an "art form." By using documentary photographs, the FSA helped make reform "legitimate."[19]

Hurley states that

> ... [t]he photographs that his [Stryker's] staff had taken had begun a new trend in American aesthetics. They had taught that a picture could be beautiful and still possess a social conscience. The pictures had helped to galvanize public opinion behind programs to aid the rural poor (at least for awhile), and they had recorded the texture and "feel" of life in the 1930s in a way that no other project had done.[20]

Walker Evans, one of the federal photographers and one who recorded scenes in Georgia referred to the collection to which he had contributed as

> ... [a] pure record and not propaganda. The value and, if you like, even the propaganda value for the government lies in the record itself which in the long run will prove an intelligent and farsighted thing to have done. NO POLITICS whatever.[21]

Stange — whose work Daniel and others call a "revolutionist analysis"[22]—claims the files are lacking the

> ... resolution of art and the particularity of documentary. The project stands today as a compelling and enduring monument to the cultural prestige of liberal reformers, but the acclaim it is granted reveals the extent to which central institutions and communications modes have diminished the authority of artistic and political perceptions and installed in their place the devalued currency of instrumental discourse.[23]

In 1973 Stryker referred to his files as a "serious tool of communication."[24] Lawrence Levine seems to agree. He reminds the "reader" of the photographs to remember that human beings adapt to forces and frequently rise above them by actively participating. In other words, an individual can be both reactive and proactive. Statistics alone may not tell the reader enough. Photographs can help to tell the whole story.[25]

Stryker at Jones & McLaughlin Steel and afterward. Stryker next served Jones & McLaughlin Steel Corporation on a documentation project. He continued to accept consulting jobs and to conduct seminars at the University of Missouri. In the 1960s he returned to the West. Stryker died on September 27, 1975.[26] As for the irreplaceable federal photographic files, however, they became a part of the Library of Congress in 1944 and 1946. They remain there even today for the use of patrons interested in reconstructing this time in history.

Federal photographs in *this book*. The Stryker photographs help to tell the whole story — the story of the work in people's lives and their recreation; their pleasures and their pains; their despair and their dignity; their victories and their victims. Because Stryker included many kinds of photographs, the serious student has evidence of the soundness of his collection and of the complexity of the subjects— especially the Georgians who were often poor

but just as often proud. One can interpret the photographs, then, and supplement them with other evidence. The photographs are the "creators" and the "creation" of the Great Depression. They—like the recreational movies of the time—are not a means of escape but a way of reaffirming traditional values.[27]

Through the years, Roy Stryker met and worked with more than a score of photographers at the Agricultural Adjustment Administration (AAA), the Resettlement Administration (RA), the Farm Security Administration (FSA), and the Office of War Information (OWI). This section focuses, however, on the federal photographers who visited for some time in the "Peach State" during the Great Depression.

II. Arthur Rothstein (1914–1983)

After Roy E. Stryker assumed his position of chief of the Historical Section in the Division of Information of the Resettlement Administration (Contract of July 1, 1935),[28]

twenty-one-year-old Arthur Rothstein began working with Stryker on July 10, 1935. Rothstein, one of Stryker's students at Columbia University, had originally wanted to go to medical school, but "it didn't break right for him."[29] He would serve five years with Stryker.

1935 assignment. Because Rothstein had no professional photographic experience, he spent his first weeks trying to prepare for his work as a photographer. He practiced using the camera and studied intently the photographs on file. Stryker noted the scarcity of photographs of tenant farmers and gave Rothstein his first assignment: to record on film any evicted farmers who would relocate through the Resettlement Administration. Rothstein's travels in search of his subjects included the state of Georgia, where he recorded people and scenes in 1935 and 1937. His work ably filled the gap and produced some photographs of these impoverished farmers.[30]

Controversy in North Dakota. Rothstein took on another assignment in May of 1936. He went to North Dakota to document the drought there. In the southwest corner of the

A possible self-portrait of Arthur Rothstein, FSA (Farm Security Administration) photographer, July 1938.

state, Rothstein came upon a scene that was compelling to him as a photographer. A skull from a dead steer lay bleaching on the parched land. No shade trees or green vegetation were in sight on the dry, alkali flats. Rothstein began to photograph the skull from several angles; he moved the skull to achieve just the shadowing he wanted. Next, Rothstein placed the skull on a knoll near scrubgrass and a cactus. The result was a photograph suggesting that overgrazing had created a desolate environment.

The photographs of the "drought" received much public acclaim. President Roosevelt decided to make a trip to the area to see the situation firsthand. While he was on the train, however, copies of the August 27, 1936, *Evening Forum* of Fargo appeared throughout the cars. In the *Forum* (p. 6) was an article charging Rothstein and the RA with fakery and fabrication. Roosevelt's opponents — particularly the Republican Party — leaped with enthusiasm upon the article and charged that the programs of the Resettlement Administration were a sham. Stryker was on vacation, and his assistant Edward Locke answered the press "hesitantly and meekly."[31]

Levity concerning Dakota. Concern filled the federal offices as stories and rumors escalated. Meanwhile, Stryker and those with whom he worked tried to alleviate the tension. On August 29, 1936, Ed Locke wrote a humorous letter to Stryker to add some levity to the situation.

> ... They will probably try to get in touch with you if this matter goes any further, so if you still have that ... skull hide it.... Stick close to my story.[32]

President Roosevelt speaking at Bismarck, North Dakota, in August 1936. (Tugwell is beside Roosevelt.) Photograph by Arthur Rothstein, Farm Security Administration.

A photograph of Edwin Locke taken between 1935 and 1942.

C.B. Baldwin, assistant administrator of the Resettlement Administration, jokingly completed on October 23, 1936, a requisition form to Roy Emerson Stryker asking for a skull; the order specified "teeth in article as mandatory requirement of acceptance of included article." The fictitious order form with the purchase number 1,895,553,144,378,222 (and the fictitious stock number 111,111,222,222, and the fictitious price of $4 billion) contained the added description that the teeth in the skull must contain "no dental work."[33] C.B. Baldwin attached to the requisition a memorandum containing the following comical comments:

It is felt by officials of the RA that, because of the value from the publicity angle which has accrued from the article requisitioned, every effort should be made to have as many of them [skulls] available as possible. I shall appreciate your cooperation in making it possible for me to have one of them.

I should prefer one with the weathered surface so that no question of its authenticity could possibly arise. May I also request that teeth be included.

It is not felt that the alkali background is essential, since from all reports these backgrounds have been more than plentiful this season, and again I do not want the manufactured effect.[34]

Baldwin received a memorandum from the finance and control division in reply. It stated:

The Finance and Control Division has fully considered the advisability of encumbering the attached requisition against the allotment of AD Staff. Possible objections were: that the furnishing of such material, setting it up artistically on desks, etc., might be considered more properly as a project of the Special Skulls Division; that since the Information Division has publicly acquired such a reputation in the handling of such material, and a precedent has already been established for purchasing such items from allotments of the Information Division, the encumbrance should be made against the Division.

However, it was finally decided to make the charge to AD-1 on the ground that the possession of such items have a future value to the AD Staff in that hollow skulls provide an appropriate reminder and a lasting memorial to the accomplishments of the Information Division. [35]

Rothstein's reputation. Rothstein's popularity dropped. Opponents looked for other things to criticize. They observed that he often took county agents and administrators with him on his tours of an area. They suggested that this tactic created cooperation from his subjects that might not have already been there. His opponents declared that Rothstein set up unrealistic settings with both people and places.[36] Some photographers criticized Rothstein for not photographing literal truths and for not using "absolute veracity"; other photographers emphasized that he had portrayed the essential truth.[37] Rothstein himself explained that he sometimes directed his subjects much as a motion picture director moves and directs the actions of the players.[38]

Tugwell's resignation. The public scrutinized the work of Rothstein, of Tugwell, and of the RA. Tugwell resigned late in 1936 shortly after the reelection of Franklin Roosevelt. Following Tugwell's resignation, the Resettlement Administration quietly became a part of the Farm Security Administration (FSA).[39]

Rothstein continued his work with the FSA despite the controversy surrounding him. Fleischhauer's evaluation of Rothstein's subsequent work noted that he kept his eye for balance and mood, sought to give his subjects dignity while he captured them in their everyday duties, did not portray them as victims, and was able to give even the most uncomfortable, squalid homes a certain attractiveness.[40]

Rothstein and Georgia. Rothstein visited Georgia in 1935, 1936, 1937, and 1942 for purposes of photography. The perceptive viewer of photographs of Georgia taken during the Great Depression may be able to identify Rothstein's photographs of people — particularly children. His signature is evident in the poignant pictures of the poor who project dignity, of mothers and children seemingly deliberately posed, and of agents and administrators with the "little people." Though controversial, these subjects often bolstered support for the works of the Farm Security Administration. His photographic collection from Georgia focuses not only people but also on objects: a wild hog trap, slaughtered bulls, barrels of turpentine, cotton bales, harrows, wagon wheels, and other significant articles.

After his federal work, Rothstein, a New York native, served in the United States Army from 1943 through 1946 and in the China-Burma Theater; he received the Army Commendation Medal. Upon his discharge, he went to work at *Look,* where he served until 1971 as technical director of photography and as director of photography. In 1947 he married Grace Goodman. They had four children.[41]

Rothstein authored ten books and served on the faculty of the Graduate School of Journalism at Columbia University from 1961 to 1971. He worked for one year with *Infinity* magazine before serving as photographer and administrator with *Parade.*[42] Rothstein died in 1985 at the age of 71.

III. Carl Mydans (1907–2004)

Carl Mydans studied journalism at Boston University and went to work as a reporter for the *American Banker.* After his photographic work brought him to the attention of the Suburban Resettlement Administration, twenty-eight-year-old Mydans went to work with the federal government in 1935. Later, Tugwell's Resettlement Administration subsumed the Suburban Resettlement Administration, and Stryker headed the photographic project for which Mydans worked.[43]

Mydans and Georgia. Carl Mydans traveled to Georgia in 1935 to record its scenes and people. Mydans returned to the state in 1936 to record more images of Georgia and its people — from Okefenokee Swamp to housing areas. His photographs included a waterwheel at a Georgia grist mill and even catfish fishing. Shortly after his 1936 trip to Georgia, Mydans left the Resettlement Administration.[44]

Paramount, World War II, and prisoners of war. On November 21, 1936, Stryker reported in a letter to Dorothea Lange, another photographer in his division, that Mydans "has left us to go to Hollywood to do candid photographs for the Paramount Company."[45] Later Mydans and three other photographer helped to launch *Life.* He remained with *Life* until 1972, when the magazine temporarily closed, and returned in 1978 when it began operation again.[46]

Mydans covered major news events throughout the world for *Life*; he and his wife worked together. He photographed England preparing for attack, the Finnish campaign against Russia, France at war, and General Patton. Mydans and his wife, Shelley — a former researcher with *Life* — were both captives of the Japanese in the Philippines; after 21 months in prison, their captors released them in exchange for Japanese prisoners.[47]

The couple wrote a fictionalized report of their life in prison in *The Open City.* A review for the book stated that *The Open City* was

> ... a novelized account of life in Manila (Santo Tomas camp). The author and her husband, photographers for *Life* magazine, were imprisoned at Santo Tomas for ... months, before they were repatriated....[48]

The most recognizable photograph that Mydans made during World War II was that of General Douglas MacArthur wading ashore on January 9, 1945, on his return to Luzon. Mydans was also with MacArthur on the *Missouri* when Japan formally surrendered in Tokyo harbor. He remained in Fukui, Japan, as head of the Time-Life Bureau. In 1948 when the 7.3 magnitude earthquake hit, he managed to escape his building. He ran back, however,

Carl Mydans, Farm Security Administration photographer, holding a camera, standing with his foot on the running board of a Treasury Department Procurement Division Fuel Yard truck in Washington, D.C., ca. 1935. Photograph by Carl Mydans, Farm Security Administration.

to remove his cameras and documented the sights of the area where 5,000 people died.[49]

Achievements and awards. Carl Mydans received, among other awards, the *U.S. Camera* Gold Achievement Award. He completed photojournalistic assignments with *Time, Fortune, Smithsonian Magazine*, and many other recognizable journals.[50] *Life* reported at a celebration of Mydans' birthday in May of 1997 that Mydans and *Life* had been linked for six decades. The article noted that Carl had even met his wife, Shelley, at the office Christmas party. In 1997 Mydans at ninety was still regularly coming to the *Life* offices, was working on his memoirs, and was still married to Shelley.[51] Of all the FSA photographers to have visited Georgia on assignment during the Great Depression, Mydans was the last one surviving. At the time of his death, he left behind his son, Seth, a correspondent for the *New York Times,* a daughter, and two grandchildren. His wife, Shelley Smith Mydans, had predeceased him by two years.[52]

IV. Dorothea Lange (1895–1965)

Dorothea Lange was born in New Jersey in 1895. Her childhood was not easy. Her father left the family when Dorothea was just a child, and at the age of seven she had polio, which left her with a limp. Dorothea, however, caused some of her own problems because she often cut school. She spent stolen days wandering through the city and making notes on what she saw. By the time she was 18, she knew she wanted to record with a camera.[53]

Early use of the camera. Dorothea went to California and set up a studio in 1919. She became well-known in the area as a portrait photographer because of her interest in people and in preserving their images.

Lange and social issues. Lange became increasingly interested in social issues during the 1930s; she recorded the sights she saw. In 1934 she exhibited her photographs of unemployment, hunger, and despair in San Francisco. Even though her photographs were not always appealing, they told of true life.

Paul Taylor, a sociologist and economist, was impressed with her work. The two began to document the living conditions of the migrant worker on film for books, magazine articles, and exhibits. The work of this team (who had become husband and wife) encouraged all Americans to demand improvements in the lives of their people.

Lange and the Resettlement Administration. The Resettlement Administration hired Dorothea Lange as a photographer on September 19, 1935. Preferring to work out of her Berkeley home, Lange remained in California and did not move to Washington.[54]

Stryker dubbed Dorothea Lange "the matriarch" of the RA's photography unit. Her photographs helped to bolster support for the work of the federal government.[55] The best-known photographic work of all the depression years is Lange's Migrant Mother. This image of the migrant woman holding her infant inside a tent in California is a documentary masterpiece; a print from her work is on display at the Museum of Modern Art.[56]

Lange and Georgia. Lange photographed many other scenes and many other people of the depression era. She successfully captured both Georgians and Georgia scenes with her camera, especially in 1937. In Georgia, she recorded "Cabins in the corn," graphic scenes of erosion, the field workers—young and old, Georgia homes, and homeless families. Her photograph of the hitchhiking family is a character study that evokes strong emotion in the viewer.

Stryker's termination of Lange. Stryker found it necessary to terminate Lange. He later explained:

> Last July the budget committee presented me with the cold facts of how much money I would have to spend on personnel.... I am sure that I did what anyone in my place would have done. I selected for termination the person who would give me the least cooperation in the job that is laid before me....[57]

Jonathan Garst wrote to Stryker on November 21, 1939, to suggest that Stryker "retain her on a W.A.E. basis. This will give her an official relationship and occasionally you can use her to great advantage." Garst explained, "Paul Taylor

Dorothea Lange, Resettlement Administration photographer, in California in February 1936.

is apparently still violently in love with Dorothea Lange and takes her problems very much to heart." Garst also stated that "the Taylors are hard up."[58] Stryker responded on November 30, 1939, that he appreciated "the spirit in which you and Walter Packard have presented your feelings in the matter of Dorothea's termination...."[59] He went on to say that he did not

> ... believe that there is much that can be done regarding the situation now.... I think I appreciate as fully as anyone, perhaps more so, the contribution which Dorothea has made to the photographic file of the FSA, and certainly to the presentation of the migrant problem to the people of this country. I know that judgments of art are highly subjective. And yet subjective or not, I had a decision to make. I made it to the best of my ability.[60]

Lange and the War Relocation Authorities. The War Relocation Authority hired Dorothea Lange in the early 1940s to document the lives of the Japanese aliens and the Japanese-Americans whom the United States government forced to live in relocation camps. Because her photographs show the difficult lives of these prisoners, the public did not see many of her photographs until after the war.

Lange's illness, final contributions, and death. Lange became seriously ill in 1945. She had to halt her next project: photographing the United Nations Conference of 1945. Her illness lasted several years. When Dorothea was finally able to work again in 1951, she focused her camera on portraits of family life; several of her assignments were for *Life*. Although Dorothea found in 1964 that she had cancer, she did not stop her work. She designed an exhibit of her photographs, planned for a center for documentary photography, and recorded a study of the country women of

America. Dorothea died in 1965, but her photographs remain. They are a reminder of people, places, and events of another era.[61]

V. Walker Evans (1903–1975)

Walker Evans was born in 1903 to a prosperous St. Louis family. Shortly after his birth, the family moved to an exclusive suburb on Chicago's North Shore where his father worked as an advertising copywriter. Walker attended private schools. In 1915 his family moved to Ohio.

After attending Loomis School, Phillips Academy, and Williams College in Williamston, Massachusetts, Walker worked at night for several years in the map room of the New York Public Library. After spending a year in Paris where he used a vest-pocket camera, Walker arrived in New York in 1927. He took odd jobs, and in 1928 he began his career in photography. Some of his photographs appeared in the book *The Bridge* (1930), a poem by Hart Crane. Other collaborations followed.[62]

Evans's federal appointment. Evans's federal appointment to work with the chief of the Historical Section began on September 24, 1935, shortly after Lange's September 19, 1935, appointment. Evans's position was "an emergency appointment for such period of time as your services may be required on emergency work and funds are available therefore, but not to extend beyond June 30, 1937."[63]

Evans's duties were:

> Under the general supervision of the Chief of the Historical Section with wide latitude for the exercise of independent judgment and decision of Senior Information Specialist to carry out special assignments in the field; collect, compile and create photographic material to illustrate factual and interpretive news releases and other informational material upon all problems, progress and activities of the Resettlement Administration. To supervise a small group of assistants from time to time depending on the importance and size of the assignment, and other related tasks.[64]

Stryker seemed very pleased to have Evans. In his letter to Professor Carman at Columbia University on October 11, 1935, Stryker explains:

> Mr. Walker Evans, who is soon to join our staff as a special photographer, will be in New York some time next week. I would very much like to have him call and talk to you. In my mind Mr. Evans is one of the best photographers in this country for the job of photographically documenting American history. It is very likely that we might get him to work for us for a year. I am very anxious that he talk with you to give you some conception of his ideas for the use of the camera as a device for recording American history. I wish to goodness that we had money enough to hire him this year and let him devote his entire time to making a photographic record of the agricultural material. Incidentally, he will do some of this anyway, but I wish we could put him on that job and nothing else.[65]

Evans's request for a letter of authorization on February 7, 1936, indicates that he is planning a trip by common carrier from Washington to New Orleans and that he will return to Washington. His travel carried him to various points within the states of Louisiana, Mississippi, Alabama, Georgia, South Georgia, North Carolina, Virginia, West Virginia, Kentucky, and Tennessee. The dates of the planned trip were from February 8, 1936, to April 8, 1936.[66] He also did some photography in Georgia in 1941.

Let Us Now Praise Famous Men **(1930).** Walker Evans joined James Agee of *Fortune* to photograph tenant faming in the South — a project that Stryker had earlier noted he would have liked to have had Evans complete for him. After *Fortune* rejected the collaborative effort of Evans and Agee, their work appeared in print as the book *Let Us Now Praise Famous Men* (1941, 1962). The work was well-received. One critic called it "a classic work of the 1930s."[67] The Museum of Modern Art held its first one-man show devoted to Evans's photography in 1938.

Evans's life during the next three decades. In 1941 Walker Evans married Jane Ninas. He held a Guggenheim Fellowship for the years 1940, 1941, and 1959, and was staff writer at *Time* from 1943 until 1945. He moved to *Fortune* as staff photographer and assistant editor. Evans remained there for 20 years; he published 40 portfolios and photographic essays during that time. For several years he used a hidden camera to photograph subway riders

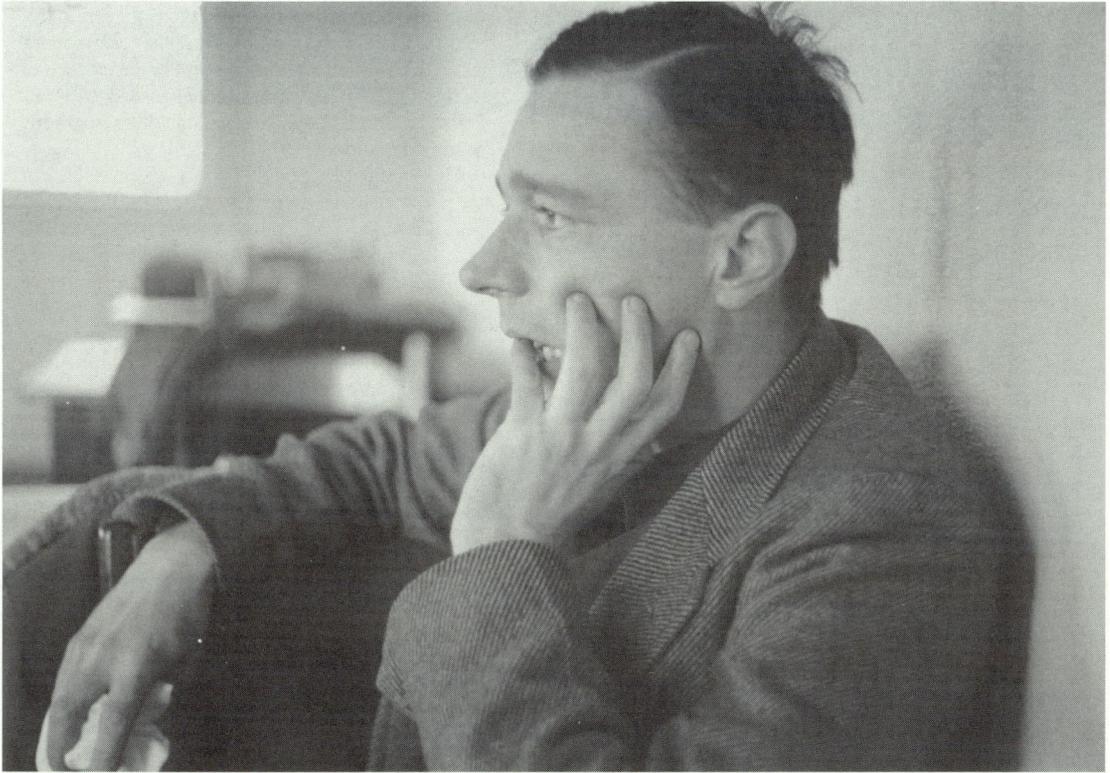

Walker Evans, February 1937. Photograph by Edwin Locke, Farm Security Administration.

in New York; these photographs appear in *Many Are Called* (1966).

After his divorce from Jane Ninas in 1955, he married Isabella Boeschenstein von Steiger in 1960. They divorced in 1972.

Evans retired from *Fortune* in 1965, but he remained active. He joined Yale University School of Art and Architecture as the first professor of graphic arts. The Museum of Modern Art (1971) held a major retrospective of his work as an original artist. After his 1972 retirement from Yale, he spent years as artist-in-residence at Dartmouth College.

Walker Evans's work with photographs spanned almost half a century. Most people associate him with black-and-white photography, but he also worked with color film. While living in Old Lyme, Connecticut, in his later years, he used polychromatic images almost exclusively. After Walker became intrigued with the SX-70 Polaroid Color Camera, he used it constantly. He continued to work quite actively with photography until a

fall in 1974 resulted in a break in his collarbone. His death came on April 10, 1975, in New Haven, Connecticut.

VI. Marion Post Wolcott (1910–1990)

Born in 1910, Marion Post attended the Edgewood School in Greenwich, Connecticut (1925 until 1927); the New School for Social Research in New York (1928 until 1929); New York University (1929 until 1930); and the University of Vienna (1930 until 1932). She took her B.A. from the University of Vienna.[68]

Beginning photography. In 1932 and 1933 Marion visited abroad. She took her first roll of film just before returning to America and became interested in photography. After her return to the states, she studied photography informally with Ralph Steiner in New York in 1935. Shortly thereafter she began to serve

as a freelance photographer in New York. Her first major photographic assignments came when she agreed to make photographs for the book *People of the Cumberlands* (1937) and for the *Philadelphia Evening Bulletin* (1937).[69]

Marion Post's work with the federal government (1938–1940). On July 14, 1938, Roy Emerson Stryker wrote to tell Marion Post that the FSA had approved her application for employment. Her photographic scenes of the South — especially Georgia — remain as a testament to her work with the government. A letter from Raleigh, North Carolina, on the Saturday before Christmas of 1938 gave her impressions of the South:

> It's amazing even tho this isn't the deep south the pace is entirely different. It takes so much longer to get anything done, buy anything, have extra keys made or get something fixed, or pack the car. Their whole attitude is different and you'd think the "Xmas rush" might stimulate them a little, but not a chance.[70]

After her visit to North Carolina, Post wrote again on Christmas Day about the South from her post in Columbia, South Carolina:[71]

> You should see all these Southern towns, decked out fit to kill, with more lights and decorations and junk than you could find in the 5th Avenue big 5 & 10 cent store. The houses too. But ... all the fire crackers, everywhere, all the time, day & nite. Especially every time I'm ready to check the camera. I jump like I'd been shot, time after time. Can't get used to it, especially if I'm concentrating on something. I wish that they'd celebrate and have a decent meal in one of the restaurants, just for a change....
>
> So far I've been mostly dashing around from one tenant purchase farm to another, with one idiot or another (in their own way, of course), and from cancer to syphilis — my malaria jobs haven't come thru yet.... The days are so short now that I get impatient. This afternoon it got very cloudy, I'm hoping it won't last and will be clear again tomorrow so that I can get some of the same, & also do a little color work.[72]

On July 5, 1939, Marion wrote again to Roy, on her way from Savannah, Georgia, to New York:

> The P.H. [Public Health] jobs are cleaned up as well as possible. They certainly are a pain in the neck, and I don't mean neck either. I still haven't recovered from the mass of Savannah mosquito and red bug bites I got. The ... mosquitoes we were trying to photograph in the insectary wouldn't feed off anyone else so I had to pose and the next morning my arm was so swollen and blue I couldn't use it. I was actually sick from it, among other things, for days.
>
> No need to tell you I'll be glad to get back — if only to get rid of my athlete's foot — no it's really not bad, and at least not as *extensive* as S...'s was (according to Arthur's report to me last fall) — if S ... makes any complaints about these jobs we'll just ask him how his athlete's foot is!
>
> I'll also be glad of a rest from the daily and eternal questions whether I'm Emily Post or Margaret Bourke-White, followed by disappointed looks — or what that "thing" around my neck is, and how I ever learned to be a photographer, if I'm all alone, not frightened and if my mother doesn't worry about me, and *how* I find my way. In general, I'm most tired of the strain of continually adjusting to new people, making conversation, getting acquainted, being polite and diplomatic when necessary.
>
> In particular I'm sick of people telling me that the cabin or room costs the same for one as it does for two, of listening to people, or the "call" girl make love in the adjoining room. Or of hearing every one's bath room habits, hangovers, and fights thru the ventilator. And even the sight of hotel bedroom furniture, the feel of clean sheets, the nuisance of digging into the bottom of a suitcase, of choosing a restaurant and food to eat.
>
> I'm not going to try to do textile towns on the way up — it's absolutely the wrong time of year, much too pretty and everything covered with much trees and shrubbery and gardens, etc. And it can't be rushed thru too fast....[73]

Marion sometimes found that photographing and empathizing with Southerners was difficult. Her January 12, 1939, letter about her trip from North Carolina to Columbia, South Carolina, to Georgia to Florida read:

> During those few short days in that part of the swampy lowlands, I found most of the people very suspicious, quite unfriendly. It was practically impossible to do anything about it, especially because of the cold weather. To them very cold and unusually windy. They just get in their huts or shacks, and build a little fire, and close the wooden window and door and hug their arms close to them, waiting till it gets warm again. And they won't let a stranger inside. Often they wouldn't even let me photograph the outside of the house. I tried every different line I could think of. And carried small bribes and food along with me. Along the bigger roads, they were very commercialized — immediately asked for money, and

no nickels or dimes, or food either, real money. And, even then they'd just stand up in front like stiffs and not move until you snapped it and left. Well — it's worth doing and I now know a lot of roads and places not to go up, and a few I'd like to go back to.... Most of the people who would talk at all, said more or less the same thing — that they didn't like for us strangers to come bothering around because they mostly played "dirty tricks" on them or brought bad luck. They never would say specifically what or how, but several said got things "tookin' from them" — but what? They haven't got anything! And many times, a neighbor or relative from nearby, who had seen the car stop, would come over — I thought only out of curiosity — but they said whenever a strange car or person comes by and stops "too long" they come around to see if their friends needs any help — "that's the onliest ways we could get along." "We don't ask for nothin' and times is hard but as long as we're not abothered none we're satisfied." Some said they didn't understand why I was riding around in that kind of country and roads all alone: A couple thought I was a gypsy — (maybe others did too) because my hair was so "long and heavy" and I had a bandanna-scarf on my head and bright colored dress and coat. All of which I remedied immediately, but it

Marion Post Wolcott with Rolleiflex and Speed Graphic in hand, Montgomery County, Maryland, January 1940. Photograph by Arthur Rothstein, Farm Security Administration.

didn't seem to help. All the things in the car seemed to awe them, too.... Suddenly, when I was going quite fast on a not too wide road, the rubber casing on one of my tires (a new one) just ripped almost completely off and for a couple of seconds, it sounded and looked as if me and my little Leica and ... Plymouth full of all that junk were going straight, or rather cockeyed, to.... But the car finally decided to stay right end up and on the road and we got stopped. It was worse than any blowout I've ever had, and almost caused a very serious accident with another car. For once I was very lucky.[74]

Stryker responded on January 13, 1939, to Marion's letter:

What a ... of a time you are having! I am certainly glad that your mix-up with the bad tire didn't end more disastrously. It is particularly upsetting to know that this happened with a practically brand-new tire. Those of us who drive on old, slick tires can expect such things, but with new material, you feel safe.

I am glad that you have now learned that you can't depend on the wiles of femininity when you are in the wilds of the South. Colorful bandannas and brightly colored dresses, etc. aren't part of our photographers' equipment. The closer you keep to what the great back-country recognizes as the normal dress for women, the better you are going to succeed as a photographer.... I know this will probably make you mad, but I can tell you another thing — that slacks aren't part of your attire when you are in the back-country. You are a woman, and "a woman can't never be a man"![75]

Marriage. Marion married government official Lee Wolcott in 1941, reared four children, and traveled with her husband to Virginia, New Mexico, Iran, and California. Marion Post Wolcott died in Santa Barbara in 1990.[76]

Subjects. Marion Post Wolcott provided a variety of images of Georgia in the 1930s. She documented health care services on film; she photographed people at work and enjoying their leisure. Some examples of her work are included in chapter two and chapter seven: "Playing checkers outside a service station on a Saturday afternoon," "Farmer who comes to town on Saturday afternoon to sell his chickens from door to door," and "Saturday afternoon in Franklin, Heard County, Georgia." She photographed also a variety of housing types in the state; chapter five shows some of these various types.

Awards. Before her death in California on November 24, 1990, Marion exhibited yearly — except for 1989 — in individual exhibits. Her awards include the Dorothea Lange Award in 1986; the Lifetime Achievement Award, the California Museum of Photography, Riverside, California, 1990; the Lifetime Achievement Award, Society of Photographic Educators, 1991; and the 1990 Sprague Award from the National Press Photographers' Association. Her many photographs for the federal government are among her gifts to future generations.

VII. John Vachon (1914–1975)

Vachon was born in Minnesota in 1914. After his wife, Penny, died, Vachon took responsibility for their three children, Brian, Ann, and Gale. He later married Francoise Fourestier, and they had two children, Christine and Michael.

John F. Vachon, Farm Security Administration photographer, 1942.

Vachon and the Farm Security Administration. The Farm Security Administration hired Vachon as a messenger in 1936. Later during his employment (1937) he began to write captions on, mount, and file the photographs by such federal photographers as Walker Evans, Dorothea Lange, and Carl Mydans.[77]

Vachon said that as he worked with the files, he "became captivated by the images."

> About that time Roy Stryker decided he would like to mold a photographer in his own image. He put a camera in my hand, breathed upon me, and told me to see what I could do (but only on weekends, of course).[78]

Roy Stryker, Walker Evans, and Arthur Rothstein trained him well. Vachon soon became a junior photographer. After traveling with Rothstein, as a photographer, he at last took his first solo trip: to North Carolina (April 1938) and to Georgia (May 1938).

Vachon and Georgia. In Georgia, Vachon photographed — among other things — the cultivation of tobacco, railway stations, small children working and playing on the farms, health workers, Southerners relaxing with their tobacco, schools, and farming techniques. His subjects varied from place to place within the state.

Office of War Information (OWI) and other employment. Vachon went with Stryker both to the Office of War Information in 1942–43 and to the Standard Oil Company in 1943. He served on the *Jersey Standard* from 1945 to 47.

In 1947 Vachon went to *Life*. He worked one year as staff photographer with *Life* before going to *Look* (1948–1971). In 1968 Vachon worked with Stryker and Rothstein to produce the book *Just Before the War*. His next work was as a freelance photographer from 1971 until 1975; in 1973 he was the recipient of the Guggenheim Fellowship.[79] In 1975 John Vachon served as visiting lecturer of photography at the Minneapolis Art Institute.

Lasting memories. John Vachon's death came on April 20, 1975, in New York. This was 10 days after the death of his friend and fellow federal photographer, Walker Evans.

The New York Public Library, the Museum of Modern Art in New York, the George Eastman House in Rochester, and the Library of Congress in Washington — to name only a few repositories — hold his collections.[80]

VIII. *Jack Delano (1914–1997)*

Delano had been born Jack Ovcharov in Kiev, Russia, in 1914. He received his education at the Settlement Music School in Philadelphia from 1925 to 1933. Delano attended the Pennsylvania Academy of Fine Arts until 1937.[81] While traveling in Europe in 1936–37, he took his first photographs.

Work as a federal photographer, particularly in Georgia. In 1937 Delano went to work with the federal government and remained there until 1939.[82] He made many of his photographs of Georgia in 1940 and 1941. He shows a wide array of people in a variety of roles. Delano's many photographs vary and a selection of them appear in this book: a spring

Portrait of Jack Delano, Office of War Information photographer, taken between 1935 and 1945.

box; a migratory worker washing her clothes; erosion; relics from the past; a pasture; a hosiery mill — inside and out; the tobacco shelf in a store; clay eaters; turpentine workers; convicts; a wagonload of cotton; "v.d. clinics"; welfare workers; inside a home with portrait of FDR on the wall; pickets during a strike; a ferry; a funeral; a ferry; erosion; recreation: at the store, at the organ, and at the bridge club; a meeting with the county agent; and a pasture.

In 1940 Delano married Irene Esser and they had two children. He was serving as a freelance photographer at the time. On May 6, 1940, he returned to the federal staff of Roy Stryker.[83] Delano and his wife wrote to Stryker on March 28, 1941, from "the South." Delano described their reactions to the region and its people:

> Haya! This is greetings from two would-be southerners. What a place the "south" is— it's got us ga-ga but we like it....
> Both Irene and I are finding it pretty easy to get along with people down here and to get accustomed to Southern ways. Our technique of not trying to be southerners but acting like naive Yankees seems to work quite well and people become friendly out of sheer sympathy for our ignorance.... Although we wouldn't like to spend the rest of our lives here, what we have seen of the South so far fascinates us and I sure hope to be able to do some intensive work here. This sure seems like the most tortured, primitive, poverty stricken (economically and socially) and wasted area I've ever seen. Yet the potentialities are so great that one doesn't leave disgusted with it but feels rather that the South must come out of it even tho it has so many strikes against it.... [84]

Delano, the military, Puerto Rico, and other professions. In 1943 Delano began serving with the United States Army Corps of Engineers. In 1946 he received his discharge with the rank of captain, moved to Puerto Rico, and served as photographer for the Puerto Rican government. He became director of Motion Picture Services (1947–1953); an independent film maker (1953–1957); director of programming for Puerto Rican Educational Television (1957–1964); general manager of the Puerto Rican Government Radio and Television Service; an independent photographer, filmmaker, book illustrator, and graphics consultant; and a music teacher (1969–1979).[85]

Memorial to Delano. Delano died in 1997 as an octogenarian. The Library of Congress, the New York Public Library, the George Eastman House, the University of Kentucky, and the Institute of Puerto Rican Culture in San Juan house his works.[86]

IX. Esther Bubley

The hiring of Esther Bubley. In 1943 the photographic section of the Farm Security Administration hired Esther Bubley (1921–1998) just at the time of its transfer to the Office of War Information. Her most important assignment with the federal government was a Greyhound bus journey across the South. Bubley made 445 pictures chronicling the trip and the terminals from Louisville, Kentucky, to Memphis, Tennessee.

Bubley in Rome, Georgia. Although these photographs were not all from the Great Depression era, one image (shown on page 82 of this book) from Rome, Georgia (1943), was especially germane. This particular photograph captures a sign reading "Colored" in a bus terminal, which was typical of the thirties, the decades before, and many years thereafter. The sign emphasized the segregation in Georgia — and the nation — at the time.

Bubley in World War II. Bubley covered the home front during World War II. She documented the housing shortage in the nation's capital, women who were filling "men's" jobs, rationing, and the increased reliance on bus travel necessitated by the war. After the war, she followed Stryker to the Standard Oil Company (New Jersey).[87]

Stryker's summary of Bubley and her work. Although Bubley was not an official federal photographer for the Farm Security Administration during the Great Depression, Stryker commented on her and on her work during an oral interview:

> Esther Bubley came down at the behest, at the recommendation of Edward Steichen. We had no place as a photographer so she worked in the laboratory for a while. By this time we were O.W.I. You see we had become O.W.I. at the last. So there were photographers who were never Farm Security people who did work on the Farm Security file, or

who were on the payroll of Farm Security as Farm Security. Esther was one of these and she came down and worked in the laboratory and worked around, and about the time, shortly before I left she went out and did several jobs and some very interesting jobs. She did a trip on a bus.... She was there a short time, and what she did was very good.[88]

Bubley's later work and life. In New York, Bubley developed a brilliant freelance career photographing for *Life* and the *Ladies' Home Journal* and working for corporate clients who were publishing high quality general interest magazines. Bubley was a skilled industrial photographer, creating powerful compositions under technically challenging conditions, and a perceptive "people photographer," achieving an uncanny intimacy with her subjects. Edward Steichen was so impressed with her images of an emergency tracheotomy that he hung her contact sheets on the wall in an exhibition at MoMA. By the late 1960s Bubley had had enough of travel, and the picture magazines were in decline. She curtailed her assignments and concentrated on

COURTESY JEAN BUBLEY

Esther Bubley photographing the Esso refinery in Aruba, 1957. Bubley was on assignment for Pepsi-Cola International, and her images appeared in the eight-page photo-essay, "Aruba, Pipeline of the World," in the January 1958 issue of Panorama, *Pepsi's magazine for their international bottlers.*

projects of personal interest; she produced several children's books and a book of macro photography of plants. She finally published images taken in 1952 of a now-famous Charlie Parker/Norman Granz jazz session. Esther Bubley died in New York of cancer at age 77.[89]

X. Barbara Wright

Although Barbara Wright was not a full-time employee of the Farm Security Administration, she contributed "miscellaneous lots of photographs" to the federal files. Among these photographs are several that the author used in this publication and include — among others — a Pine Mountain Valley sign (1938), a Georgia sawmill (1940), and photographs of Mary McLeod Bethune and the NYA.

Barbara photographed people and scenes in Finland as well as in the United States. One of the photographs in Lot 2223 was one of Barbara Wright.

Roy Stryker summed up Barbara Wright in this way: "Barbara Wright was a girl around town, a strangely erratic brilliant gal who worked for us for a little while and ... she was all right."[90] Certainly the images in this collection substantiates Stryker's summary.

XI. Summary

In summary, the works of the photographers — Arthur Rothstein, Carl Mydans, Dorothea Lange, Walker Evans, Marion Post Wolcott, John Vachon, John Delano, Esther Bubley, Barbara Wright — who came to Georgia remain. They form a record of the state and its people during an important period in the nation's past — the era of the Great Depression.

Notes

Preface

1. Roosevelt's letter to the Members of the Conference on Economic Conditions in the South, National Emergency Council, p. 1.
2. Ibid., 3.
3. Ibid., 1.
4. Ibid., 3.
5. "The Thirties, with Love: A Working Outline," p. 2, Stryker Papers, Series II. B.
6. Ibid.

Introduction

1. http://www.georgiaencyclopedia.org/nge/Article.jsp?id=h-3223.
2. "World War I Statistics" from Georgia Department of Veteran Services and U.S. Department of Veteran Affairs.
3. Kurian, 30, 267; Donovan, 32, 158.
4. Davis, "A Short History of the Model T Automobile," *North Carolina During the Great Depression*, 3–4.
5. http://www.slcatlanta.org/Publications/EconDev/AutoSouth/GAAuto.pdf.
6. http://www.ourgeorgiahistory.com/year/1917.
7. http://georgiaencyclopedia.org/nge/Article.jsp?id=h-643.
8. Coleman, 306.
9. http://www.georgiaencyclopedia.org/nge/Article.jsp?id=h-643.
10. http://ngeorgia.com/facts/population.html.
11. Coleman, 263.
12. http://ga.water.usgs.gov/publications/ofr00-380.pdf.
13. Coleman, 263.
14. http://www.ars.usda.gov/is/AR/archive/feb03/boll0203.htm.
15. http://insects.tamu.edu/fieldguide/bimg198.html.

16. Coulter, 431.
17. http://memory.loc.gov/egi-bin/query/D?wpa:2:/temp/~ammem_5Wkkk::
18. http://www.uic.edu/educ/betpu/historyGIS/greatmigration/gmdocs/boll_weevil_song.html.
19. http://www.ars.usda.gov/is/AR/archive/feb03/boll0203.htm.
20. Bell, 28–29.
21. McElvaine, *The Great Depression*, 46.
22. Biles, 120.
23. McElvaine, *Down and Out*, 18; *This Fabulous Century*, vol. 4, 25.
24. McElvaine, *The Great Depression*, 38.
25. McElvaine, *Down and Out*, 20.
26. *Farm Journal*, 15.
27. Chitwood, 765.
28. *This Fabulous Century*, vol. 4, 25.
29. Chitwood, 765.
30. Jennings, 154–155.
31. *This Fabulous Century*, vol. 4, 23.
32. Davis, Anita Price. *North Carolina During the Great Depression.* Jefferson, NC: McFarland, 2003. pp. 8, 238–239.

Chapter One

1. http://www.netstate.com/states/intro/ga_intro.htm.
2. Ibid.
3. *Merit Students Encyclopedia*, vol. 7, 569–572.
4. http://www.cviog.uga.edu/Projects/gainfo/FDRarticle4.htm.
5. Hepburn, 41–50; *Merit*, 569–671; Coleman, 2–5; http://www.goodwine.com/chris/georgia1.htm.
6. Ibid.
7. Ibid.
8. Carter, 13.
9. Hepburn, 41–50; *Merit*, 569–671; Coleman, 2–5; http://www.goodwine.com/chris/georgia1.htm.

10. http://www.tybeelighthouse.org.

11. http://sip.armstrong.edu/Tybee/FortScreven.html; http://sip.armstrong.edu/Tybee/TybeeLightStation.html.

12. http://www.fws.gov/wassaw/history.htm.

13. Hepburn, 107; http://www.sherpaguides.com/georgia/coast/northern_coast/skidaway_island.html.

14. http://www.sherpaguides.com/georgia/coast/northern_coast/ossabaw_island.html; http://www.ossabawisland.org/history.htm.

15. http:// seaturtle.sdsmt.edu/015hist.html.

16. http://www.fws.gov/blackbeardisland/history.htm.

17. http://www.bansemer.com/georgia_lighthouses/sapelo_island_lighthouse.html.

18. http://www.fes.gov/wolfisland/.

19. http://www.littlestsimonisland.com/timeline/1908/.

20. http://www.littlestsimonisland.com/bandits; http://www.littlestsimonisland.com/timeline/1900s/.

21. http://www.storesonline.com/site/539680/page/123265.

22. http://www.goldenislesinfo.com/history.html.

23. http://www.bgivb.com/interesting/index.cfm?action=history.

24. Mary Louise Hunt, 12-29-06 interview; http://www.goldenislesinfo.com/history.html.

25. Hepburn, 41–50, 54–70; http://www.travel.howstuffworks.com/barrier-island.htm; http://www.jekyllislandhistory.com/jekyllclub.html.

26. http://www.promotega.org/fdr05004/cumberland.htm.

27. http://www.nps.gov/cuis; *Merit*, 569–671; www.glc.k12.ga.us/passwd/trc/ttools/attach/bckgrnd/may/geo_bari.pdf; Coleman, 2–5.

28. http://www.georgiaencyclopedia.org/nge/Article.jsp?id=h-1299.

29. Ibid.

30. Ibid.

31. *The Public Papers and Addresses of Franklin D. Roosevelt*, 122–123.

32. Ibid.

33. Public No. 17, 73d Congress; 48 Stat. 58; *The Public Papers and Addresses of Franklin D. Roosevelt*, 122–123.

34. *Merit*, vol. 7, 569–570; Hepburn, 37–40.

35. http://blueridgemountains.com/lake_blue_ridge.html.

36. http://www.greatlakesofgeorgia.com/hartwell/history.asp.

37. *Merit*, 576.

38. http://www.georgiaencyclopedia.org/nge/Article.jsp?path=/Folklife/Foodways&id=h-555.

39. Adapted from http://www.members.cox.net/jjschnebel/brunstew.html.

40. http://www.srwmd.state.fl.us/water+data/springs/what+is+a+spring.htm.

41. http://www.georgiaencyclopedia.org/nge/Article.jsp?id=h-767&pid+s-53; http://www.georgiaencyclopedia.org/nge/Article.jsp?id=h-1101; Hepburn, 27.

42. *Merit*, 571–573; Hepburn, 40–44; http://goodwine.com/chris/georgia1.htm.

43. Anna Tutt, "Blacks in Appalachia," in *Foxfire 8*, 26.

44. *Merit*, 571–573; Hepburn, 40–44; http://goodwine.com/chris/georgia1.htm.

45. National Emergency Council, 3

46. Ibid., 9.

47. *Merit*, 571–573; Hepburn, 40–44; http://goodwine.com/chris/georgia1.htm.

48. http://www2.census.gov.prod2/decennial/documents/03337983v2p2ch06.pdf.

49. http://fisher.lib.virginia.edu/cgi-local/censusbib/census/cen.pl.

50. Hepburn, 25–26.

51. Daniel, *Breaking the Land*, 175–176.

52. Jenkins, "Po'Boy," "Let Me Tell You About This Mule," in *Foxfire 8*, 491–492.

53. Ibid., 501–502.

54. http://www2.census.gov.prod2/decennial/documents/03337983v2p2ch06.pdf.

55. Hepburn, 29.

56. Raper, vi.

57. *Rural Worlds Lost*, 140.

58. Ibid., 66.

59. Ibid., 66, 140.

60. Daniel, *Breaking the Land*, 5.

61. Hepburn, 16–17.

62. Ibid.

63. Carter, 52.

64. Daniel, *Breaking the Land*, 292.

65. Smithsonian Folkways, audiotape *Field to Factory*.

66. Henderson, A-6.

67. Lefler, 1963, 580–582.

68. http://www.cptr.ua.edu/kudzu/.

69. Hepburn, 61–62.

70. http://www.cptr.ua.edu/kudzu.

71. Ibid.

72. Saloutos, 28.

73. http://www.georgiaencyclopedia.org/nge/Article.jsp?id=h-942.

74. *The Public Papers and Addresses of Franklin D. Roosevelt*, II, 68–70.

75. Ibid., 80–81.

76. Ibid., 107.

77. Ibid., 110.

78. Merrill, 122.

79. Time-Life Editors, *This Fabulous Century, 1930–1940*, 131.

80. Bradley, 53.

81. Merrill, 122.

82. Time-Life Editors, *This Fabulous Century, 1930–1940*, 131.

83. http://www.marist.edu/summerscholars/96/ndccc.htm.

84. Merrill, 123.

85. http://www.ourgeorgiahistory.com/history101/gahistory11.html.

86. http://www.georgiaencyclopedia.org/nge/Article.jsp?id=h-2733.

87. http://ngeorgia.com/feature/ccc.html.

88. *The Public Papers and Addresses of Franklin D. Roosevelt*, II, 68–69.

89. Ibid., 74.

90. Taylor, 240.

91. Biles, 40.

92. Taylor, 238.

93. Walker, 4.

94. Powell, 616; Lefler, 1954 edition, 582.

95. Taylor, 238.

96. Griffin, 526; McElvaine, *Down and Out*, 27.

97. McElvaine, *Down and Out*, 27.

98. Tindall, 403–404.

99. *Roosevelt's New Deal*, 2.

100. "A Presidential Statement on Signing the Soil Conservation and Domestic Allotment Act, March 1, 1936," *The Public Papers and Addresses of Franklin D. Roosevelt*, V, 95, 100.

101. Griffin, *The History of Old Tryon and Rutherford Counties*, 525.

102. "White House Statement and Letter on the Appointment of a Special Committee on FarmTenancy, November 17, 1936," *The Public Papers and Addresses of Franklin D. Roosevelt*, V, 590–591.

103. Note added to "White House Statement and Letter on the Appointment of a Special Committee on Farm Tenancy, November 17, 1936," *The Public Papers and Addresses of Franklin D. Roosevelt*, V, 590–593.

104. Lefler, 1963 edition, 582.

105. http://www.fisher.lib.virginia.edu/collections/stats/histcensus/php/newlong2.php.

106. Ibid.

107. http://www.encarta.msn.com/sidebar_461500343/1938_Georgia.html.

108. Coleman, 270.

109. Ibid., 269.

110. http://www.georgiaencyclopedia.org/nge/Article.jsp?id=h-828.

111. *Smoky Mountains Magazine*.

112. Ibid.

113. Ibid.

114. *These Are Our Lives*, 301.

115. http://www.georgiaencyclopedia.org/nge/ArticlePrintable.jsp?id=h-2580.

116. "(Good Old) Mountain Dew," www.bobdylanroots.com/good.html.

117. "(Good Old) Mountain Dew," www.bobdylanroots.com/good.html.

118. Coleman, 267.

119. Heimann, 109.

120. Kirby, 191.

121. Ibid., 192.

122. Ibid., 191.

123. Ibid.

124. Parramore, *Express Lanes,*15.

125. Powell, 485–486.

126. http://www.netstate.com/states/intro/ga_intro.htm.

127. Carter, 55.

128. Coleman, 267; http://www.georgiapecans.org/trivia.html.

129. Coleman, 267.

130. McMichael, 327–328; http://www.hts.gatech.edu/south/georgia/butts/butind31.htm; http://www.georgiapecans.org/trivia.html.

131. Coleman, 267.

132. Ibid.

133. Ibid., 274.

134. Ibid., 267.

135. http://www.netstate.com/states/intro/ga_intro.htm.

136. www.census.gov/prod/www/abs/decennial/1930.htm.

137. http://encarta.msn.com/sidebar_461500343/1938_Georgia.html.

138. http://www.egaonline.com/home/industry/granite.shtml.

139. Ibid.

140. http://www.georgiaencyclopedia.org/nge/Multimedia.jsp?id=m-8361.

141. http://www.davidpride.com/USA/DC/DC_177.htm.

142. http://www.cagrnweb.com/quarries/states/ga-structs_and_monuments.html; http://www.pickenscountyga.com/history.htm.

143. http://encarta.msn.com/sidebar_461500343/1938_Georgia.html.

144. http://www.alumnifriends.mines.edu/fun_stuff/kaolin_mining/; http://goodwine.com/chris/georgia1.htm.

145. http://encarta.msn.com/sidebar_461500343/1938_Georgia.html.

146. http://a-s.clayton.edu/rosenburg/smith.htm.

147. http://www.whitedirt.com.

148. Ibid.

149. Carter, 53–54.

150. Coleman, 267.

151. http://www.claxtonfruitcake.com/page.php?page=story.

152. http://www.georgiafruitcakecompany.com/Articles/9.html.

153. Coleman, 267.

154. http://www.georgiaencyclopedia.org/nge/Article.jsp?path=/Folklife/Foodways&id=h-1854.

155. Courtesy of the Coca-Cola Company.

156. Petretti, 5–6.

157. http://www.georgiaencyclopedia.org/nge/Article.jsp?id=h-1854.

158. http://www.citydirectory,com/Overview/history/history6.htm.

159. Ibid.

160. http://www.cr.nps.gov/nr/travrl/atlanta/for.htm.

161. http://clubs.hemmings.com/clubsites/chevytalk/GMhistory/1930onplantcodes.html.

162. http://www.cr.nps.gov/nr/travrl/atlanta/for.htm.

163. http://www2.census.gov.prod/www/abs/decennial/1930/htm. cuments/2938777v3ch03.pdf.

164. http://www2.census.gov.prod2/decennial/doc uments/03337983v2p2ch06.pdf.
165. http://www2.census.gov.prod2/decennial/doc uments/33973538v2p2ch3.pdf.
166. Ibid.
167. http://www.bluebird.com/history.php.
168. http://www.westga.edu/~history/Banning mill/Banningtimeline.htm.
169. National Emergency Council, 58, 59–60.
170. Ibid.
171. Ibid.
172. Carter, 51–52.
173. http://www2.census.gov.prod2/decennial/do cuments/33973538v2p2ch3.pdf.
174. http://www.census.gov.prod/www/abs/decen nial/1930.htm.
175. http://www2.census.gov.prod2/decennial/doc uments/33973538v2p2ch3.pdf.
176. Hepburn, 26.
177. Hepburn, 31.

Chapter Two

1. National Emergency Council, Roosevelt's letter to the Members of the Conference on Economic Conditions in the South, National Emergency Council, 1.
2. http://www.brandywinesources.com/1901-1945/1938DOCReportontheSouth.htm; http://www.time.com/time/magazine/article/0,9171,759988,00.html; Fortson, 8, 12.
3. National Emergency Council, 1, 3; http://www.brandywinesources.com/1901-1945/1938DOC ReportontheSouth.htm.
4. National Emergency Council, 1.
5. Tindall, 599.
6. Ibid.
7. http://www.time.com/time/magazine/arti cle/0,9171,759988,00.html.
8. National Emergency Council, 5.
9. Ibid., 20.
10. Kurian, 16–17.
11. Smithsonian Folkways, *From Farm to Factory*.
12. Dodd and Dodd, 18–19.
13. Hepburn, 107–109.
14. Kurian, 16–17.
15. Hepburn, 106–107.
16. http://www2/census.gov/prod2/decennial/ documents/33973538v2p2ch3.pdf.
17. Taeuber, 377.
18. http://shs.westport.k12.ct.us/jwb/AP/TLdocs/ Comstock.htm.
19. http://www.pbs.org/wgbh/amex/pill/people events/e_comstock.html.
20. http://www.bookrags.com/history/America -1930s-lifestyles-and-social-trends/sub6.html.
21. Gordon, 330–331.
22. Schoen, 1–2.
23. Tone, 85–87.

24. Schoen, 15–16.
25. http://www.bookrags.com/history/America-1930s-lifestyles-and-social-trends/sub6.html; Reed, 265–267.
26. Wharton, 463–465.
27. http://www.hsph.harvard.edu?organizations/ healthnet/WoC/reproductive/schoen.html.
28. http://www.pbs.org/wgbh/amex/pill/people events/e_comstock.html; http://www.webmd.com/ content/article/12/1687_51143.
29. Schoen, 14.
30. Ibid., 27.
31. http://www2.census.gov.prod2/decennial/ documents/33973538v2p2ch3.pdf.
32. http://www.mste.uiuc.edu/malez/DATA/SO CIALSCIENCE/mortality_rates.html.
33. Fishback, 26; Coleman, 382.
34. Biles, 64.
35. Ibid.
36. Coulter, 437–438.
37. Ibid., 438–440.
38. Coleman, 314–315.
39. Coulter, 440–441, 446–447.
40. Biles, 65.
41. Address of President Franklin Delano Roosevelt, Barnesville, Georgia, August 11, 1938, http:// www.cviog.uga.edu/Projects/gainfo/FDRspeeches/ FDRspeech38-6.htm.
42. Coulter, 440–447.
43. http://www.ssa.gov/history/reports/ces/ces bookt6.html.
44. http://www.ourgeorgiahistory.com/history 101/gahistory11.html.
45. Hepburn, 32.
46. Coleman, 286.
47. Hepburn, 24.
48. Brundage, 105, 263.
49. Allen, 7.
50. Ibid., 204–205.
51. http://memory.loc.gov/ammem/ndlpedu/fea tures/timeline/depwwii/race/letter.html.
52. Hepburn, 24; http://pro.corbis.com/search/ ImageSet.aspx?typ=set&isuid=%7b07977dd3-5cee -46b3-8a9f-ba741cfe5f5}.
53. Hepburn, 24.
54. http://www.georgiaencyclopedia.org/nge/Arti cle.jsp?id=h-2730.
55. Lefler, 1963, 470.
56. http://www.georgiaencyclopedia.org/nge/Arti cle.jsp?id=h-2730; Dodd and Dodd, 18–19.
57. Ibid.
58. http://www.georgiaencyclopedia.org/nge/Arti cle.jsp?id=h-2730; Dodd and Dodd, 18–19; Biles, 109.
59. Ulys, p. 9, 11, 14, 21.
60. http://www.imdb.com/title/tt0034297/.
61. Thompson, 48.
62. Ibid., 73.
63. Ibid., vii.
64. Dodd and Dodd, 18–19.
65. Ibid.

66. http://newdeal.feri.org/works/wpa06.html.

67. http://www.usc.edu/schools/sppd/lusk/casden/research/data_folder/us_pcinc.pdf.

68. Coleman, 315–317.

69. Wecter, 181.

70. D. Rittner, "Great Depression Decal," http://egi.ebay.com/aw-cgi/Ebay[SAPI.dll/View Item&item.

71. McElvaine, *Down and Out*, 217.

72. Goldston, 104–105.

73. Coulter, 447.

74. Hepburn, 169.

75. Coleman, 317.

76. Time-Life Editors, *This Fabulous Century*, 1930–1940, 131.

77. http://www.answers.com/topic/georgia-state-united-states.

78. McElvaine, *Down and Out*, 6–7.

79. Ibid., 205.

80. Dodd and Dodd, 18–19.

81. http://www2/census.gov/prod2/decennial/documents/33973538v2p2ch3.pdf.

82. McCutcheon, 73.

83. Kurian, 46.

84. Donnermeyer, 1.

85. McCutcheon, 121–140.

86. McElvaine, *Down and Out*, 3.

87. Kurian, 158.

88. Coleman, 247.

89. Coulter 448–449; Coleman 247, 305, 285–286.

90. 9http://www.trouparchives.org/burns.html.

91. http://www.georgiaencyclopedia.org/nge/Article.jsp?id=h-793.

92. http://www.trouparchives.org/burns.html.

93. Ibid.

94. Ibid.

95. http://www.georgiaencyclopedia.org/nge/Article.jsp?id=h-793.

96. Hepburn, 232–233; Coleman, 382; http://www.trouparchives.org/burns.html.

97. http://www.georgiaencyclopedia.org/nge/Article.jsp?id=h-793.

98. Byerly, 11–12.

99. National Emergency Council, 41–42.

100. Byerly, 11–12.

101. http://www2.census.gov.prod2/decennial/documents/33973538v2p2ch3.pdf.

102. Jim Trelease, *Reading Aloud* (video) (Springfield, MA: Reading Tree Productions, 1993).

103. http://www2.census.gov.prod2/decennial/documents/33973538v2p2ch3.pdf.

104. Wecter, 25.

105. Ibid., 31–32.

106. Fisher, 138.

107. Wecter, 25–26.

108. Byerly, 76.

109. Walker, *All We Knew Was to Farm*, 34–35.

110. Walker, *Southern Women*, 6.

111. http://www.brumc.org/homemakers.htm.

112. Hunt.

113. Wecter, 27.

114. Davis.

115. Vertamae Grosvenor, "USA Rice Recipes," wysysiwyg://153/http://www.ricecafe.com/scshrimp.htm.

116. Wecter, 28, 30.

117. Walker, *Southern Women*, 2.

118. Wecter, 25–26.

119. Byerly, 75.

120. *Uprising of '34.*

121. Grim.

122. Walker, *Southern Women*, 2.

123. Ibid.

124. Byerly, 75.

125. Wecter, 27.

126. Ibid., 25.

127. Fisher, 7.

128. Ibid., 138.

129. Ibid.

130. http://lcweb2.loc.gov/pp/nclchtml/nclcback.html.

131. Kaplan as cited by http://lcweb2.loc.gov/pp/nclchtml/nclcback.html.

132. Coleman, 306.

133. Wecter, 181.

134. National Emergency Council, 41–42.

135. Byerly, 11–12.

136. Wormser, 48.

137. Ibid., 47.

138. Hepburn, 193.

139. Wormser, 48.

140. Wecter, 181.

141. Ibid., 182.

142. Wormser, 48–50.

143. Ibid., 51.

144. http://www.answers.com/topic/national-youth-administration-1.

145. http://www.georgiaencyclopedia.org/nge/Article.jsp?id=h-1733.

146. Wecter, 188.

147. http://www.youthtoday.org/youthtoday/aaDecJan2004/story2.html.

148. McElvaine, *Down and Out*, 6.

149. Ibid., 26.

150. Ibid., 4–6.

151. Ibid., 163.

152. Wecter, 181.

153. Ibid., 181.

154. "Roosevelt's New Deal," 8, http://www.liberarts.sfasu.edu/history/134-Unit%207B.html.

155. Hepburn, 232–233.

156. Barnwell, 15.

157. Glass, 84–85.

158. Wormser, 13.

159. Ibid., 118.

160. H.G. Jones, professor at University of North Carolina, interview/letters, 1996.

161. Courtesy of Mary Louise Hunt, 1-28-07.

162. Dixon.

163. Wormser, 118–119.

164. Ibid., 11.

165. Raper, 24.
166. Wolfe, 145.
167. Brokaw, xix.
168. Ibid., 6.

Chapter Three

1. Coleman, 120–121.
2. Ibid., 120–122.
3. Ibid., 121.
4. Ibid.
5. Coulter, 421–422; Coleman, 323–326.
6. Coulter, 421.
7. Ibid.
8. Coleman, 323–326.
9. Ibid.
10. Ibid., 325, 421.
11. Ibid., 323–326.
12. Ibid.
13. Coulter, 419–423.
14. http://www.georgiaencyclopedia.org/nge/Article.jsp?id=h-1425.
15. Coulter, 423; Coleman 325.
16. Coulter, 422–423.
17. Ibid., 422–424.
18. Ibid., 425–426.
19. Ibid.
20. http://www.gammonseminary.org/history.htm.
21. Coulter, 426–427.
22. Coleman, 330
23. Coulter, 425–426.
24. http://www.sreb.org/main/Publications/Roosevelt/1938.asp.
25. Ibid.
26. Hepburn, 192–193.
27. http://www.sreb.org/main/Publications/Roosevelt/1938.asp.
28. Hepburn, 192–193.
29. http://www.sreb.org/main/Publications/Roosevelt/1938.asp.
30. Hepburn, 193.
31. http://www.sreb.org/main/Publications/Roosevelt/1938.asp.
32. Coleman, 324–325.
33. Hepburn, 192–193.
34. Coulter, 421.
35. Coleman, 327.
36. *Statistical Abstract,* 104.
37. Raper, 237.
38. http://mgagnon.myweb.uga.edu/students/3090/04SP3090-Glover.htm.
39. Coleman, 324–325.
40. Ibid., 326.
41. Ibid., 328–329; http://www.time.com/time/magazine/printout/0,8816,929,00.html.
42. Wecter, 191.
43. Herring, 27–31.
44. Tindall, 323.

45. Wecter, 191; Hepburn, 192–193.
46. Coleman, 323–324.
47. Hepburn, 194–195.
48. Ibid., 193.
49. Wecter, 190.
50. http://www.georgiaencyclopedia.org/nge/Article.jsp?id=h-1425; Wecter, 190.
51. Coulter, 312.
52. http://fax.libs.uga.edu/LA262/1f/educational_survey_of_georgia_no_11.txt.
53. Ibid.
54. http://www.time.com/time/magazine/printout/0,8816,929,00.html.
55. Coleman, 315–316.
56. Hepburn 193, Lanier, 183–184.
57. Raper, 24.
58. http://www.bookrags.com/wiki/School_bus.
59. Tindall, 495.
60. Hepburn, 192–194.
61. Coleman, 327.
62. Hepburn, 192–194.
63. Coleman, 324–325.
64. Ibid., 327.
65. Ibid., 316–318.
66. Coulter, 441.
67. Coleman, 316–318.
68. Coulter, 441.
69. Coleman, 320–325.
70. Hepburn, 195.
71. Coulter, 441.
72. Ibid., 421.
73. http://www.time.com/time/printout/0,8816,753586,00.html.
74. Trelease.
75. Hepburn, 195.
76. Ibid., 195.
77. http://www.capolicycenter.org/Georgia/georgia3.html.
78. Coleman, 377.
79. http://www.capolicycenter.org/Georgia/georgia3.html.
80. Wecter, 191.
81. Coulter, 421.

Chapter Four

1. *Report on the Economic Condition of the South,* 29.
2. McElvaine, *The Great Depression,* 80.
3. Hepburn, 222.
4. Ibid., 222–224.
5. Ibid., 229–230.
6. Ibid., 230–231.
7. Coleman, 312.
8. Hepburn, 231–232.
9. Coleman, 312–314; Hepburn, 230–231.
10. Hepburn, 231.
11. Ibid.

12. Ibid.
13. Ibid., 232–233.
14. Ibid.
15. Kirby, 188.
16. Ibid.
17. Etheridge, 4–5.
18. Ibid., 5, 31.
19. Kirby, 188.
20. Etheridge, 72.
21. Ibid., 81.
22. Kraut, 1–6.
23. Etheridge, 145.
24. Kraut, 1–6.
25. Letter of Dr. Joseph Goldberger to Mary Goldberger, September 23, 1921, as cited by Etheridge, 170–171.
26. Henderson, A-1.
27. Ibid., A-1, A-6.
28. Etheridge, 153.
29. Ibid., 153–154.
30. Kraut, 1–6.
31. Etheridge, 208–209.
32. Ibid., 258.
33. Ibid., 209.
34. Henderson, A-6.
35. Carter, 52–53.
36. Turner, 549.
37. Centers for Disease Control and Prevention, "Fact Sheet: Hookworm Infection," 1.
38. Turner, 420.
39. Centers for Disease Control and Prevention, "Fact Sheet: Hookworm Infection," 1.
40. Davis, *North Carolina During the Great Depression,* 143–147.
41. Washburn, *A Country Doctor in the South Mountain,* 15–18.
42. Ibid., back cover.
43. Le Gloahec.
44. Coleman, 331.
45. Hepburn, 2.
46. http://www.sreb.org/main/Publications/Roosevelt/1938.asp.
47. Johnson, 50–52.
48. Coleman, 331.
49. http://www.pbs.org/wgbh/aso/databank/entries/dm52sa.html; "Polio History Timeline," http://www.pbs.org.
50. Parran, 1.
51. http://www.etg.nlm.nih.gov/project/m3w3/phs_history/phs_history_13_content.html.
52. Parran, 206.
53. Ibid., 204–205.
54. http://www.nlm.nih.gov/exhibition/phs_history/66.html.
55. http://www.time.com/time/magazine/printout/0,8816,882715,00.html.
56. http://newdeal.feri.org/survey/40b10.htm.
57. Ibid.
58. http://www2.state.ga.us/Departments/dhr/facstdg2.html.
59. http://www.georgia.gov/vgn/images/portal/cit_1210/1248428STCFACTSHEET.pdf.
60. Reed, 267.
61. http://www.georgiaencyclopedia.org/nge/Article.jsp?id=h-2549.
62. http://www.birthinthetradition.com/1.0bitt_hist.html.
63. Ibid.
64. http://www.birthinthetradition.com/1.0bitt_hist.html.
65. Washburn, *Country Doctor,* 18.
66. Ibid.
67. Kirby, 192.
68. Washburn, *Country Doctor,* 16.
69. Kirby, 191.
70. Ibid., 191.
71. de Both, 21.
72. American National Red Cross, 155.
73. Kirby, 191.
74. Ibid., 192.
75. Washburn, *As I Recall,* 172–173.
76. Ibid.
77. http://kclibrary.nhmccd.edu/decade30.html.
78. Carter, 53.
79. Coleman, 382.
80. Johnson and Pickens, xiv.
81. Davis, *Margaret Mitchell,* 26.
82. Johnson and Pickens, 14–15.
83. Cyber Palate LLC, "Soul Food," http://www.cuisinenet.com/glossary/soul.html.
84. Ibid.
85. Kirby, 188.
86. Cyber Palate.
87. Grosvenor.
88. Colquitt.
89. Carter, 78.

Chapter Five

1. http://www.getty.edu/art/gettyguide/artMakerDetails?maker=1601&page=1.
2. Tindall, 326.
3. Andrews, 195–196.
4. Tindall, 325–327.
5. Byerly, 12.
6. Parramore, *Express Lanes,* 32.
7. Tindall, 326.
8. Stoney.
9. Andrews, 195; Parramore, *Express Lanes,* 33.
10. Andrews, 195.
11. Byerly, 11–12.
12. Coleman, 269–270.
13. Herring, *Passing of the Mill Villages,* book jacket.
14. Glass, 84–85.
15. Herring, book jacket.
16. Coleman, 269–270.
17. National Emergency Council, 35.

18. Kirby, 178–179.
19. http://www.georgiapower.com/about/pdf/History.pdf.
20. Ibid.
21. Ibid.
22. Ibid.
23. Maynor, 67.
24. http://www.georgiaemc.com/pdfs/media_center_pdf/RuralElecHistory.pdf.
25. Maynor, 71.
26. Ibid.
27. http://www2.census.gov/prod2/statcomp/documents/1921-01.pdf.
28. "A Letter to Various Government Agencies on Allocation of Work Relief Funds," The Public Papers and Addresses of Franklin D, Roosevelt, IV, 344–345.
29. Bill Harris, "Radio Reaches Rural America: The Early Days of REA," http://www.radioremembered.org/.
30. Maynor, 68.
31. Ibid., 69.
32. http://www2.census.gov/prod2/statcomp/documents/1940-01.pdf.
33. http://www.census.gov/hhes/www/housing/census/historic/owner.html.
34. http://www.cviog.uga.edu/Projects/gainfo/courthouses/irwinoldCH.htm.
35. http://www.newdeallegacy.org/table_communities.html.
36. Coleman, 264; http://www.georgiaencyclopedia.org/nge/Article.jsp?id=h-2733.
37. Coleman, 265.
38. http://www.georgiaencyclopedia.org/nge/Article.jsp?id=h-2733&hl=y.
39. "Franklin Delano Roosevelt," http://www.ruraledu.org/site/c.beJMIZOCIrH/b.2125173/apps/nl/content.asp?content_id={2DB79154-73CD-42D8-9D96-46B7B658EE02}¬oc=1.
40. Tindall, 485.
41. http://www.cviog.uga.edu/Projects/gainfo/FDRarticle4.htm.
42. Ibid.
43. http://www.artery.org/Techwood.htm.
44. Ibid.
45. "Franklin Delano Roosevelt," http://www.ruraledu.org/site/c.beJMIZOCIrH/b.2125173/apps/nl/content.asp?content_id={2DB79154-73CD-42D8-9D96-46B7B658EE02}¬oc=1
46. Ibid.
47. Ibid.
48. http://www.ccat.sas.upenn.edu/goldenage/exp/ex_p2_20.htm.
49. McElvaine, The Great Depression, 301.
50. Badger, 208.
51. http://nwda-db.wsulibs.wsu.edu/findaid/ark:/80444/xv77296.
52. Ibid.
53. Raper, 21.
54. Roy Stryker Papers, I.
55. Ibid.
56. http://encarta.msn.com/sidebar_461501285/1939_housing_developments.html.
57. Ibid.
58. Ibid.
59. Ibid.
60. http://www.census.gov/hhes/www/housing/census/historic/owner.html.

Chapter Six

1. Draper, 5.
2. Coleman, 272–273.
3. Ibid.
4. Coulter 410–411.
5. Coleman, 273.
6. Tindall, 318.
7. Golden, 1.
8. Ibid.
9. Coleman, 272–273.
10. Tindall, 330–339.
11. Ibid., 318–319.
12. Ibid., 339.
13. Ibid., 322.
14. Davis and Hunt.
15. Draper, 5–6.
16. Tindall, 334–339.
17. Coleman, 272–273.
18. Tindall, 330–339.
19. Ibid., 338.
20. Ibid., 333–334.
21. Draper, 5.
22. Tindall, 341.
23. Ibid., 320.
24. Ibid., 339.
25. Ibid., 320.
26. Ibid., 340.
27. Draper, 28–29.
28. Ibid., 378.
29. Ibid., 323.
30. Coulter, 272.
31. Coleman, 273.
32. Coulter, 274.
33. Tindall, 390.
34. Ibid., 326–327.
35. Uprising of '34.
36. Tindall, 323–324.
37. Uprising of '34.
38. North Carolina: Guide, 54–55.
39. Uprising of '34.
40. Hapke, 7–8.
41. http://msit.gsu.edu/dhr/pullen/selections.asp?id=34strike.
42. Kennedy, 295–296.
43. Coulter, 439.
44. Kennedy, 295–296.
45. Uprising of '34.
46. http://msit.gsu.edu/dhr/pullen/selections.asp?id=34strike.

47. Ibid.
48. *Uprising of '34.*
49. Kennedy, 296.
50. *Uprising of '34.*
51. Kennedy, 296.
52. Ibid., 298.
53. http://www.answers.com/topic/united-auto-workers.
54. Ibid.
55. http://www.whatwhatwhat.com/Atlanta_history/gm_fisher.htm.
56. http:www.answers.com/topic/united-auto-workers.
57. Lefler, 1963 edition, 606–609.
58. http://www.press.uillinois.edu/epub/books/waldrep/08.html.
59. http://www.whatwhatwhat.com/Atlanta_history/gm_fisher.htm.

Chapter Seven

1. Witty and Skinner, 291.
2. Monopoly Companion.
3. Hunt.
4. http://www.yesterdayland.com/popopedia/shows/decades/toys 1930s.php.
5. Clark, 16.
6. Retro.
7. Carter, 96–97.
8. Davis, *Children's Literature Essentials,* 130–133.
9. Opie and Opie, 377.
10. Davis, *Children's Literature Essentials,* 83–84.
11. Ibid.
12. Chase, VIII.
13. http://www.uncleremus.com/bio.html.
14. Ibid.
15. http://www.cr.nps.gov/nr/travel/Atlanta/har.htm.
16. http://www2.gsu.edu/~wwwelf/eljch.html.
17. http://www.uncleremus.com/bio.html.
18. http://www.snopes.com/disney/films/sots.html.
19. http://www.filmsite.org/aa47.html.
20. http://www.infoplease.com/ipa/A0148372.html.
21. Wilson from Wigginton, *Foxfire 2,* 324.
22. Wilcox.
23. http://www.georgiaencyclopedia.org/nge/Article.jsp?id=h-2642.
24. http://www.answers.com/topic/wsb-am.
25. *Sears Roebuck Catalog of the Thirties,* 702.
26. Time-Life Editors, *This Fabulous Century,* 27
27. McCutcheon, 238–241.
28. "Grand Ole Opry Celebrates 75th Birthday," wysiwyg://238/http://www.theage.com.au/entertainment/2000Oct15.html.
29. Niven, 168.
30. http://www.johnnymercer.com/yesterday.html.

31. Time-Life Editors, *This Fabulous Century,* 130.
32. Ibid., 76.
33. Hunt, Louise.
34. Time-Life, *This Fabulous Century,* 76.
35. Ibid.,30.
36. Davis, Getty.
37. Bryon.
38. "Fireside Chats of Franklin D. Roosevelt."
39. Time-Life, *This Fabulous Century,* 30.
40. Kindred, Dave, "Joe Louis' Biggest Knockout," http://www.sportingnews.com/archives/sports 2000/moments/140271.html.
41. http://www.georgiaencyclopedia.org/nge/Article.jsp?id=h-2641.
42. Niven, 168.
43. Wigginton, *Foxfire 8,* 390.
44. Herring, *Welfare Work,* 352–352.
45. Waldrep, 24–25.
46. Hillman.
47. Time-Life, *This Fabulous Century,* 76.
48. "Five Star Library Series: Engel van Wiseman Publishing."
49. Time-Life, *This Fabulous Century,* 84.
50. Ibid.
51. "1930's Bestsellers," (No author) http://www.caderbooks.com/best30.html.
52. Griffin, 526; McElvaine, *Down and Out,* 27.
53. Ibid.
54. Roddick, back cover.
55. Davis, *Margaret Mitchell,* 7.
56. Ibid., 13–14.
57. Ibid., 19.
58. Ibid., 24–26.
59. Ibid., 28–31.
60. Roddick, 11.
61. Davis, *Margaret Mitchell,* 28-31.
62. Finch, 72.
63. Time-Life, *This Fabulous Century,* 203.
64. Finch, 451.
65. McCutcheon, 252–254; Time-Life, *This Fabulous Century,* 203; Finch, 72.
66. Niven, 16–17.
67. http://www.harlemga.org/museum.htm.
68. Botkin, 93.
69. Waldrep, 26.
70. Wilcox.
71. Keena, Katherine.
72. Wecter, 188.
73. http://www.youthtoday.org/youthtoday/aaDecJan2004/story2.html.
74. Dawson.
75. "Cioppino, Chicken Divan, Fake Food Were Big in '30s."
76. Dawson.
77. "Cioppino, Chicken Divan, Fake Food Were Big in '30s."
78. Dawson.
79. Time-Life, *This Fabulous Century,* 237.
80. Ibid.
81. Ibid., 268.

82. Ulys, 197–198; Botkin, 621–622.

83. Parramore, *Carolina Quest,* 464.

84. http://www.high.org/overview/about/history.aspx.

85. http://www.roadsidegeorgia.com/site/cyclorama.html.

86. http://enallexperts.com/e/a/at/Atlanta_cyclorama.htm.

87. http://www.atlantaga.gov/client_resources/government/planning/cdp/2004cdp-14artsandculturalaffairs.pdf.

88. http://www.roadsidegeorgia.com/site/cyclorama.html.

89. http://www.wpamurals.com/Georgia.htm.

90. http://www.georgiaencyclopedia.org/nge/Article.jsp?id=h-898&pid=s-52.

91. http://www.dekalb.public.lib.ga.us/about/decahist.htm.

92. http://www.georgialibraryhistoryproject.org/timeline.htm.

93. http://libweb.princeton.edu/libraries/firestone/rbsc/aids/tc015/.

94. http://lcweb2.loc.gov/cgi-bin/ampage?collID=ftadm&filename=farbf/00040002/ftadmin&db&recNum=1.

95. http://lcweb2.loc.gov/ammem/fedtp/ftwpa.html.

96. http://lcweb2.loc.gov/cgi-bin/ampage?collID=ftscript&filename=fpraf/09640037/ftscript.db&recNum=2.

97. http://lcweb2.loc.gov/ammem/fedtp/ftwpa.html.

98. http://libweb.princeton.edu/libraries/firestone/rbsc/aids/tc015/

99. http://lcweb2.loc.gov/cgi-bin/ampage?collID=ftscript&filename=fpraf/09640037/ftscript.db&recNum=1 (through 15).

100. http://lcweb2.loc.gov/cgi-bin/ampage?collID=ftadm&filename=farbf/00040002/ftadmin&db&recNum=13 (through 15).

101. http://lcweb2.loc.gov/ammem/fedtp/ftwpa.html; http://lcweb2.loc.gov/cgi-bin/ampage?collID=ftadm&filename=farbf/00040002/ftadm&db&recNum=13 (through 15).

102. http://www.georgiaencyclopedia.org/nge/Article.jsp?id=h-898&pid=s-52.

103. http://www.nps.gov/kemo/historyculture/index.htm.

104. Neal, 3.

105. Ibid.

106. Ibid., 9–45.

107. http://espn.go.com/sportscentury/features/00014123.html.

108. http://www.georgiaencyclopedia.org/nge/Article.jsp?id=h-468.

Appendix

1. Hurley, 12.

2. Ibid., 13.

3. Stange, 66.

4. Hurley, 13.

5. Ibid., 26–27.

6. Fleischhauer, 2–3.

7. Ibid., 3.

8. Ibid., 5.

9. Stange, 108.

10. Fleischhauer, 53.

11. Hurley, 166–168.

12. Stange, 133.

13. Hurley, 170.

14. Fleischhauer, vii–xi, 1–14.

15. Ibid., 5–7.

16. Stange, 142.

17. "The Photographers: Roy E. Stryker."

18. Stange, 145.

19. Ibid., 130.

20. Hurley, 173.

21. Fleischhauer, 61.

22. *Official Images*, xi.

23. Stange, 130–131.

24. Fleischhauer, 9.

25. Ibid., 15.

26. "The Photographers: Roy E. Stryker."

27. Fleischhauer, 24.

28. Contract of July 1, 1935, Stryker Papers, Series I.

29. Interview, p. 4, Stryker Papers, Series II. B.

30. Ibid.

31. Curtis, 69–78.

32. Letter from Ed Locke to Roy Stryker, August 29, 1936, Stryker Papers, Series I.

33. Fictitious requisition form from C.B. Baldwin to Roy Stryker, October 23, 1936, Stryker Papers, Series I.

34. Memo from C.B. Baldwin to Roy Stryker, October 23, 1936, Stryker Papers, Series I.

35. Memorandum from Finance and Control Division to C.B. Baldwin, in reply to requisition of October 23, 1936, Stryker Papers, Series I.

36. *Contemporary Authors*, NR, pp. 437–438.

37. *World History,* 379.

38. Curtis, 69–78.

39. Ibid., 122.

40. Fleischhauer, 146–149.

41. *Contemporary Authors*, NR, 437–438.

42. Evory, *Contemporary Authors*, NR, pp. 437–438.

43. http://www.nscds.pvt.k12.il.us/ncds/us/apushit/roosevelt/newdeal.html; *Encyclopedia*, 351–352.

44. Stryker Papers, Series I.

45. Ibid.

46. http://www.nscds.pvt.k12.il.us/ncds/us/apushit/roosevelt/newdeal.html; *Encyclopedia*, 351.

47. International Center of Photography, *Encyclopedia of Photography*, 351.

48. James, *Book Review Digest*, 514.

49. http://www.boston.com/news/globe/obituaries/articles/2004/08/18/carl_mydans_97_celebrated_chronicler_of_20th_century_10928042441.

50. International Center of Photography, *Encyclopedia of Photography,* 351.

51. "May," *Life* (May, 1997), 40–46.

52. http://www.boston.com/news/globe/obituaries/articles/2004/08/18/carl_mydans_97_celebrated_chronicler_of_20th_century_10928042441.

53. Davis, *Focus on Women,* 62.

54. Ibid.

55. Fleischhauer, 115–117; 160–163.

56. Curtis, 67.

57. Roy Stryker Papers, I.

58. Ibid.

59. Ibid.

60. Ibid.

61. Davis, *Focus on Women,* 62.

62. Trachtenberg, 235.

63. Contract of September 16, 1935, Stryker Papers, Series I.

64. September 16, 1935, letter to Miss McKinney of the Division of Information, Stryker Papers, Series I.

65. Letter of October 11, 1935, Stryker Papers, Series I.

66. Request for letter of Authorization, February 7, 1936, Stryker Papers, Series I.

67. Trachtenberg, 2.

68. Walsh, "Marion Post Wolcott," *Contemporary Photographers,* 2.

69. Rosenblum, 326.

70. Roy Stryker Papers, I.

71. Ibid.

72. Ibid.

73. Ibid.

74. Ibid.

75. Ibid.

76. Rosenblum, 326.

77. Walsh, "John Vachon" in *Contemporary Photographers,* 1.

78. Ibid., 2.

79. Ibid., 179–180.

80. Ibid.

81. Ibid., 189–190.

82. Ibid.

83. "Letter from Stryker to Delano," 3-28-40, Roy Stryker Papers, I.

84. Roy Stryker Papers, I.

85. Walsh, 189–190.

86. Ibid.

87. Marien, 287–290.

88. "Roy Stryker Oral History Interview Conducted by Richard Doud," http://artarchives.si.edu/collections.oralhistories/transcripts/stryke65.htm.

89. Jean Bubley, niece of Esther Bubley.

90. http://www.aaa.si.edu/collections/oralhistories/transcripts/stryke65.htm.

Bibliography

Address by President Franklin Delano Roosevelt, Barnesville, Georgia, on August 11, 1938. http://www.cviog.uga.edu/Projects/gainfo/FDRspeeches/FDRspeech38-6.htm.

Allen, James, Hilton Als, Congressman John Lewis, and Leon F. Litwack. *Without Sanctuary: Lynching Photography in America*. Santa Fe, NM: Twin Palms Publishers, 2000.

American National Red Cross. *First Aid Textbook*. Washington, DC: American National Red Cross, 1957.

Andrew, Mildred Gwin. *The Men and the Mills: A History of the Southern Textile Industry*. Macon, GA: Mercer University Press, 1987.

Atlanta Constitutio, September 19, 1934.

Badger, Anthony. *Prosperity Road*. Chapel Hill, NC: University of North Carolina Press, 1980.

Barnwell, Mildred Gwin. *Faces We See*. Gastonia, NC: Southern Combed Yarn Spinners Association, 1939.

Biles, Roger. *The South and the New Deal*. Lexington, KY: University of Kentucky Press, 1994.

Billings, Henry. *All Down the Valley*. New York: Viking Press, 1952.

Botkin, B.A. *A Treasury of Southern Folklore*. New York: Bonanza Books, 1949.

Bradley, James, with Ron Powers. *Flags of Our Fathers*. New York: Bantam Books, 2000.

Brokaw, Tom. *The Greatest Generation*. New York: Random House, 1998.

Brundage, W. Fitzhugh. *Lynching in the New South: Georgia and Virginia, 1880–1930*. Urbana and Chicago: University of Illinois Press, 1993.

Bryon (No first name). "The New Deal Program." http://web54.sd54.k12.il.us/schools/keller/newdeal/chats.htm

Bubley, Jean. Niece of Esther Bubley.

Byerly, Victoria. *Hard Times Cotton Mill Girls*. Ithaca, NY: Cornell University, 1986.

Carter, Jimmy. *An Hour Before Daylight: Memories of a Rural Boyhood*. New York: Simon and Schuster, 2001.

Centers for Disease Control and Prevention. "Fact Sheet: Hookworm Infection." http://www.cdc.gov/ncidod/dpd/parasites/hookworm/factsht_hookworm.htm

Chase, R. *The Jack Tales*. Boston: Houghton Mifflin, 1943.

Chitwood, Oliver Perry, Frank Lawrence Owsley, and H.C. Nixon. *The United States from Colony to World Power*. New York: D. Van Nostrand, 1953.

"Cioppino, Chicken Divan, Fake Food Were Big in '30s." http://www.dispatch.com/news/newsfea99/century/food/rec15fod.html

Clark, Thomas D. *Pills, Petticoats, and Plows*. Norman: University of Oklahoma Press, 1944.

Coleman, Kenneth, general ed., Numan V. Bartley, William F. Holmes, F.N. Boney, Phinizy Spalding, and Charles E. Wynes. *A History of Georgia*. 2nd ed. Athens: University of Georgia Press, 1977.

Colquitt, Harriet Ross. *Savannah Cook Book: A Collection of Old-Fashioned Receipts from Colonial Kitchens*. New York: Farrar and Rhinehart, 1933, as cited by http://www.cookbkjj.com/bookhtml/000998.html

Corbitt, David Leroy. *Addresses, Letters and Papers of Clyde Roark Hoey, Governor of NC*. Raleigh: Council of State, 1944.

Coulter, E. Merton. *Georgia: A Short History*. Chapel Hill: University of North Carolina Press, 1933, 1947, 1960.

Curtis, James. *Mind's Eye, Mind's Truth*. Philadelphia: Temple University Press, 1989.

Cyber Palate LLC. "Soul Food." http://www.cuisinenet.com/glossary/soul.html

Daniel, Pete. *Breaking the Land: The Transforma-*

tion of Cotton, Tobacco, and Rice Cultures Since 1880. Champaign: University of Illinois Press, 1985.

Daniel, Pete, Merry Foresta, Maren Stange, and Sally Stein. *Official Images: New Deal Photography.* Washington, DC: Smithsonian, 1987.

Davis, Anita P. *Margaret Mitchell: A Link to Atlanta and the World (A Teacher's Guide to the Author of "Gone with the Wind").* Atlanta: Atlanta Historical Society, 2006.

Davis, Anita Price. *Children's Literature Essentials.* Boston: American Press, 2000.

_____. *North Carolina During the Great Depression: A Documentary Portrait of a Decade.* Jefferson, NC: McFarland, 2003.

_____, and Marla J. Selvidge. *Focus on Women.* Huntington Beach, California: Teacher Created Materials, 1995.

Davis, Anita Price, and Mary Louise Hunt. "Women on U.S. Postage Stamps." Jefferson, NC: McFarland, forthcoming.

Davis, Getty Mrs. Oral. Interview, September, 28, 1996.

Dawson, Sue. "Depression Forced Cooks to Economize Creatively." http://www.dispatch.com/news/food/food99/ food0915/rec30.html

de Both, Jessie. *Modern Household Encyclopedia.* Chicago: J.G. Ferguson and Associates, 1946.

Dixon, Leon. National Bicycle History Archive of America. E-mail of January 28, 2007, from Old Bicycle@aol.com: http://www.nbhaa.com

Dodd, Donald B., and Wynelle S. Dodd. *Historical Statistics of the South, 1790–1970.* University of Alabama Press, 1973.

Donnermeyer, Joseph F. "Crime and Violence in Rural Communities." http://www.ncrel.org/sdrs/areas/issues/envrnmnt/drugfree/v1donner.htm

Donovan, Frank Robert. *Wheels for a Nation.* New York: Crowell, 1965.

Etheridge, Elizabeth W. *The Butterfly Caste: A Social History of Pellagra in the South.* Westport, CT: Greenwood, 1972.

Evory, Ann. *Contemporary Authors.* Vol. 6, New Revision Series. Detroit: Gale Research, 1995.

Farm Journal. December 1931, p. 15.

Federal Writers' Project: Works Progress Administration. *North Carolina: A Guide to the Old North State.* Chapel Hill: University of North Carolina Press, 1939.

Federal Writers' Project: Works Progress Administration. *These Are Our Lives: As Told by the People and Written by Members of the Federal Writers' Project of the Works Progress Administration in North Carolina, Tennessee, and Georgia.* Chapel Hill: University of North Carolina Press, 1939.

Finch, Christopher. *The Art of Walt Disney from Mickey Mouse to the Magic Kingdom.* New York: Abradale Press and Harry A. Abrams, 1973.

"Fireside Chats of Franklin D. Roosevelt." http://www.mhree.org/fdr/fdr.html

Fishback, Price V., Michael R. Haines, and Shawn Kantor. *Births, Deaths, and New Deal Relief During the Great Depression.* Cambridge, MA: National Bureau of Economic Research, 2005.

Fisher, Andrea. *Let Us Now Praise Famous Women.* New York: Pandora, 1987.

Five Star Library Series. Engel van Wiseman Publishing. (No author). http://www.biglittlebooks.com/englev.html

Fleischhauer, Carl, and Beverly W. Brannan. *Documenting America, 1935–1943.* Berkeley: University of California Press, 1988.

Fortson, Judge Blanton. "Agriculture Under the Federal Recovery Program." An address delivered before the Georgia League of Women Voters in Atlanta and broadcast over radio station WSB on August 17, 1935.

"Franklin Delano Roosevelt (Chief New Deal Agencies During Roosevelt's Administrations 1933–1945)." *Compton's Encyclopedia,* January 1, 1994. http://www.nscds.pvt.k12.il.us/ncds/us/apushit/roosevelt/newdeal.html

Golden, John. "Textile Workers, Organize for the Eight Hour Day, February 3, 1919." Flyer.

Goldston, Robert. *The Great Depression.* New York: Ballantine Books, 1968.

"(Good Old) Mountain Dew." In "A Portrait of the Artist as a Young Man." http://www.members.nbci.com/elstongunn/good.html

Gordon, Linda. *Woman's Body, Woman's Right: A Social History of Birth Control in America.* New York: Grossman Publishers, 1976.

Griffin, Clarence. *The History of Old Tryon and Rutherford Counties.* Spartanburg, SC: Reprint Company, Publishers, 1977.

Grim, Valerie. Oral Presentation on March 2, 1999, at Converse College, Spartanburg, SC.

Grosvenor, Vertamae. "USA Rice Recipes." wysy siwyg://153/http:// www.ricecafe.com/scshrimp.htm

Hapke, Laura. *Daughters of the Great Depression: Women, Work and Fiction in the American 1930s.* Athens: University of Georgia Press, 1995.

Harris, Bill. "Radio Reaches Rural America: The Early Days of REA." wysiwyg://redir_frame .24? http://www.radioremembered.org/

Heimann, Robert K. *Tobacco and Americans.* New York: McGraw-Hill, 1960.

Henderson, Gary. "Disease of the Poor." *Spartanburg Herald-Journal,* April 8, 2001, pp. A-1, A-6.

Hensley, Donald R., Jr. "Tap Lines, Southeastern

RR History and Photographs." www.taplines. net

Hepburn, Lawrence R. *Contemporary Georgia.* Athens: University of Georgia Press, 1987.

Herring, Harriet L. *Passing of the Mill Village.* Chapel Hill: University of North Carolina Press, 1949.

_____. *Welfare Work in Mill Villages.* Chapel Hill: University of North Carolina Press, 1929.

Hillman, Bill. "Big Little Books." http://www. geocities.com/Hollywood/Boulevard/6643 erb mot44.html

Hunt, Mary Louise. (Former Georgia resident.) Interviewed on March 8, 1998; December 29, 2006; January 28, 2007.

Hurley, F. Jack. *Portrait of a Decade: Roy Stryker and the Development of Documentary Photography in the Thirties.* Baton Rouge: Louisiana State University Press, 1972.

International Center of Photography. *Encyclopedia of Photography.* New York: Crown, 1984.

James, Mertice M., and Dorothy Brown. *The Book Review Digest.* 41st Annual Collection. New York: H.W. Wilson, 1945.

Jennings, Peter, and Todd Brewster. *The Century.* New York: Doubleday, 1998.

"Joe Louis." http://www.dyboislc.com/ShadesOf Black/JoeLouis.html

Johnson, Bruce. *A History of the Grove Park Inn.* Asheville: Grove Park Inn, 1991.

Johnson, Ira Joe, and William G. Pickens. *Benjamin E. Mays and Margaret Mitchell: A Unique Legacy in Medicine.* Winter Park, FL: FOUR-G Publishers, 1996.

Kaplan, Daile, ed. *Photo Story: Selected Letters and Photographs of Lewis W. Hine.* Washington: Smithsonian Institution Press, 1992, as cited at http://lcweb2.loc.gov/pp/nclchtml/nclcback. html

Keena, Katherine Knapp. Program Manager of the birthplace of Juliette Gordon Low, who was the founder of the Girl Scouts, National Historic Landmark, 10 East Oglethorpe Avenue, Savannah, Georgia 31401. www.girlscouts.org/birth place

Kennedy, David M. *Freedom from Fear.* New York: Oxford University Press, 1999.

Kindred, Davis. "Joe Louis' Biggest Knockout." http://www.sportingnews.com/archives/sports2 000/moments/140271.html

King, Spencer, Jr. "Georgia." Vol. 7. *Merit Students Encyclopedia.* Old Tappan, New Jersey: Crowell-Collier Encyclopedia Corporation, 1969: 568–593.

Kirby, Jack Temple. *Rural Worlds Lost: The American South, 1920–1960.* Baton Rouge: Louisiana State University Press, 1987.

Kraut, Alan. "Dr. Joseph Goldberger and the War on Pellagra." http://www.nih.gov/od/museum/ exhibits/goldberger/full-text.html

Kurian, George Thomas. *Datapedia of the United States: 1790–2000.* Lanham, MD: Bernan Press, 1994.

Lanier, Ruby J. *Blanford Barnard Dougherty, Mountain Educator.* Durham: Duke University Press, 1974.

Lefler, Hugh Talmage, and Albert Ray Newsome. *NORTH CAROLINA: The History of a Southern State.* Chapel Hill: University of North Carolina Press, 1954, 1963, 1973.

Le Gloahec, John. Benjamin E. Washburn Papers, 1905 (1913–1939)–1960. http://www.rockefeller. edu/archive.ctr/rf_bew.html

Marien, Mary Warner. *Photography: A Cultural History.* New York: Harry N. Abrams, 2002.

"May." *Life.* May 1997: 40–46.

Maynor, Joe. *Duke Power: The First Seventy-five Years.* Charlotte: Delmar, 1979.

McCutcheon, Marc. *Everyday Life from Prohibition through World War II.* Cincinnati: Writer's Digest Books, 1995.

McElvaine, Robert S. *Down and Out in the Great Depression.* Chapel Hill: University of North Carolina Press, 1983.

_____. *The Great Depression: America, 1929–1941.* New York: Times Books, 1984.

McMichael, Lois. *History of Butts County, Georgia, 1825–1976.* Atlanta: Cherokee Publishing, 1988.

Merrill, Perry. *Roosevelt's Forest Army: A History of the Civilian Conservation Corps, 1933–1942.* Montpelier, VT: Perry H. Merrill, Publisher, 1981.

Monopoly Companion. "History: The Monopoly Story." http://www.monopoly.com/history/history.htm

National Emergency Council. *Report on Economic Conditions of the South.* Washington, DC: U.S. Government Printing Office, 1938.

Neal, Willard. *Georgia's Stone Mountain.* 46-page booklet, n.d., n.p.

Niven, David. *Bring on the Empty Horses.* New York: Putnam's, 1975.

Opie, Iona, and Peter Opie. *The Oxford Dictionary of Nursery Rhymes.* Oxford: Clarendon Press, 1951.

Parran, Thomas, and R.A. Vonderlehr. *Plain Words about Venereal Disease.* New York: Reynal and Hitchcock, 1941.

Parramore, Thomas C. *Carolina Quest.* Englewood Cliffs, NJ: Prentice-Hall, 1978.

_____. *Express Lanes and Country Roads: The Way We Lived in North Carolina, 1920–1970.* Chapel Hill: University of North Carolina Press, 1983.

Pettreti, Allan. *Warman's Coca-Cola® Field Guide.* Iola, Wisconsin: KP Books, 2005.

"The Photographers: Roy E. Stryker." www.elpgh. org/exhibit/photog14.html

"Polio History Timeline." www.pbs.org

Powell, William S. *NC Through Four Centuries.* Chapel Hill: University of North Carolina Press, 1989.

Raper, Arthur Franklin, and Ira DeA. Reid. *Sharecroppers All.* Chapel Hill: University of North Carolina Press, 1941.

Reed, James. *From Private Vice to Public Virtue.* New York: Basic Books, 1978.

Retro. "Old Maid: Retro Style." http://www.retro active.com/hawaii/oldmaid1.html

Rittner, D. "Great Depression Decal." http:/egi. ebay.com/aw-cgi/Ebay[SAPI.dll/View Item&item

Roddick, Nick. *A New Deal in Entertainment: Warner Brothers in the 1930s.* London: British Film Institute, 1983.

Roosevelt, Franklin. *The Public Papers and Addresses of Franklin D. Roosevelt.* Vols. 1–5. New York: Random House, 1938

"Roosevelt's New Deal." http:// www.libarts.sfasu. edu/history/134-Unit%207B.html

Rosenblum, Naomi. *A History of Women Photographers.* New York: Abbeville Press, 1994.

"Roy Stryker Oral History Interview Conducted by Richard Doud." http://artarchives.si.edu/ collections.oralhistories/transcripts/stryke65.htm

Saloutos, Theodore. *The American Farmer and the New Deal.* Ames: Iowa State University Press, 1982.

Schoen, Johanna. "Fighting for Child Health: Race, Birth Control, and the State in the Jim Crow South." http://www.hsph.harvard.edu? organizations/healthnet/WoC/reproductive/sch oen.html

Sears Roebuck Catalog of the Thirties. Franklin Square, NY: Nostalgia, 1978.

Smithsonian Folkways. *From Farm to Factory.* Washington, DC: Smithsonian Institution, 1994.

Smoky Mountains Magazine. wysiwyg://161/http:/ /smokymtns.com/dew2.htm

Stange, Maren. "Symbols of Ideal Life: Technology, Mass Media, and the FSA Photography Project." *Prospects* 11 (1986): 81–104.

Stoney, George, (producer) and Judith Helfand (director). *Uprising of '34.* New York: First Run/ Icarrus Films, 1995.

Stryker (Roy) Papers. Series I: Correspondence, 1924–1972. Louisville, KY: University of Louisville Photographic Archives.

_____. Series II: Professional Activities, 1912–1971. Louisville, KY: University of Louisville Photographic Archives.

_____. Part A. Personal Papers and Awards, 1912–1969. Louisville, KY: University of Louisville Photographic Archives.

_____. Part B. Writings by Stryker, 1936–1963. Louisville, KY: University of Louisville Photographic Archives.

Taeuber, Karl E. "Birth and Death Rates." In *The World Book Encyclopedia.* Chicago: World Book, 1989.

Taylor, Mildred. *Let the Circle Be Unbroken.* New York: Dial, 1981.

Thompson, Bertha, as told to Dr. Ben L. Reitman. *Boxcar Bertha: An Autobiography.* New York: Amok Press, 1988.

Time-Life Editors. *This Fabulous Century, 1930–1940.* New York: Time-Life Books, 1969.

Tindall, George Brown. *The Emergence of the New South, 1913–1945.* N.p.: Louisiana State University Press and the Littlefield Fund for Southern History of the University of Texas, 1967.

Tone, Andrea. *Devices and Desires: A History of Contraceptives in America.* New York: Hill and Wang, 2001.

Trachtenberg, Alan. "Walker Evans." In *Dictionary of American Biography.* Supplement 9: *1971–1975.* New York: Scribner's, 1994. http:// galenet.com/serlet/BioRC/hits

Trelease, Jim. *Reading Aloud.* (Video.) Springfield, MA: Reading Tree Productions, 1993.

Turner, C.E. *Personal and Community Health.* St. Louis: C.V. Mosby, 1956.

Tutt, Anna. "Blacks in Appalachia." In *Foxfire 8.* Edited by Eliot Wigginton and Margie Bennett. Garden City, New York: Anchor Press/Doubleday, 1968.

Ullman, Morris B. *Statistical Abstract of the United States: 1940.* Washington, DC: U.S. Department of Commerce, 1940.

Ulys, Errol Lincoln. *Riding the Rails: Teenagers on the Move During the Great Depression.* New York: TV Books, 1999.

Waldrep, G.C., III. *Southern Workers and the Search for Community.* Urbana and Chicago: University of Illinois Press, 2000.

Walker, Melissa. *All We Knew Was to Farm: Rural Women in the Upcountry South, 1919–1941.* Baltimore: Johns Hopkins University Press, 2000.

_____. "Southern Women in the Twentieth Century South." A paper presented at the Southern Women in the Twenty-First Century Symposium. Spartanburg, SC: Converse College, March 6, 2001.

Walsh, George, et. al. *Contemporary Photographers.* New York: St. Martin's Press, 1982.

Washburn, Benjamin Earle. *As I Recall.* New York: Rockefeller Foundation, 1960.

_____. *A Country Doctor in the South Mountains.*

Spindale, NC: Spindale Press, 1944 (Third printing, 1974).

Watkins, Robert M. Photographer, Forest City, North Carolina.

Wecter, Dixon. *The Age of the Great Depression: 1929–1941.* New York: Macmillan, 1948.

Wharton, Don. "Birth Control: The Case for the State." *Atlantic Monthly* (October 1939): 463–466.

Wigginton, Eliot. *Foxfire 2: Ghost Stories, Spring Wild Plant Foods, Spinning and Weaving, Mid-wifing, Burial Customs, Corn Shuckin's, Wagon Making and More Affairs of Plain Living.* Garden City, NY: Anchor Press/Doubleday, 1973.

_____, and Margie Bennett. *Foxfire 8.* Garden City, NY: Anchor Press/Doubleday, 1984.

Wilcox, Glenn C. Introduction to the 4th edition of *The Southern Harmony and Musical Composition.* http://www.apadrecordings.com/south arm.htm.

Witty, Paul A., and Charles E. Skinner. *Mental Hygiene in Modern Education.* New York: Farrar and Rinehart, 1939.

Online Sources

http://www.alumnifriends.mines.edu/fun_stuff/kaolin_mining/

http://www.answers.com/topic/united-auto-workers

http://www.answers.com/topic/wsb-am

http://www.ars.usda.gov/is/AR/archive/feb03/boll0203.htm

http://a-s.clayton.edu/rosenburg/smith.htm

http://www.atlantaga.gov/client_resources/government/planning/cdp/2004cdp-14artsandculturalaffairs.pdf

http://www.bansemer.com/georgia_lighthouses/sapelo_island_lighthouse.html

http://www.bgivb.com/interesting/index.cfm?action=history

http://www.birthinthetradition.com/1.0bitt_hist.html

http://blueridgemountains.com/lake_blue_ridge.html

http://www.bobdylanroots.com/good.html

http://www.bookrags.com/history/America-1930s-lifestyles-and-social-trends/sub6.html

http://www.brandywinesources.com/1901-1945/1938DOCReportontheSouth.htm

http://www.brumc.org/homemakers.htm

http://www.caderbooks.com/best30.html

http://www.cagrnweb.com/quarries/states/ga-structs_and_monuments.html

http://www.ccat.sas.upenn.edu/goldenage/exp/ex_p2_20.htm

http://www2.census.gov.prod2/decennial/documents/03337983v2psch06.pdf

http://www2.census.gov.prod2/decennial/documents/2938777v3ch03.pdf

http://www2.census.gov.prod2/decennial/documents/33973538v2p2ch3.pdf

http://www.census.gov/hhes/www/housing/census/historic/owner.html

www.census.gov/prod/www/abs/decennial/1930.htm

http://www2.census.gov/prod2/statcomp/documents/1921–01.pdf

http://www2.census.gov/prod2/statcomp/documents/1931–01.pdf

http://www2.census.gov/prod2/statcomp/documents/1940–01.pdf

http://www.city-directory,com/Overview/history/history6.htm

http://www.claxtonfruitcake.com/page.php?page=story

http://clubs.hemmings.com/clubsites/chevytalk/GMhistory/1930onplantcodes.html

http://www.cptr.ua.edu/kudzu

http://www.cr.nps.gov/nr/travel/Atlanta/har.htm

http://www.cr.nps.gov/nr/travrl/atlanta/for.htm

http://www.cviog.uga.edu/Projects/gainfo/FDRarticle4.htm

http://www.cviog.uga.edu/Projects/gainfo/FDRspeeches/FDRspeech38–6.htm

http://www.davidpride.com/USA/DC/DC_177.htm

http://www.dekalb.public.lib.ga.us/about/decahist.htm

http://www.egaonline.com/home/industry/granite.shtml

http://en.wikipedia.org/wiki/Atlanta_Opera

http://enallexperts.com/e/a/at/Atlanta_cyclorama.htm

http://encarta.msn.com/sidebar_461500343/1938_Georgia.html

http://encarta.msn.com/sidebar_461501285/1939_housing_developments.html

http://espn.go.com/sportscentury/features/00014123.html

http://www.etg.nlm.nih.gov/project/m3w3/phs_history/phs_history_13_content.html

http://www.filmsite.org/aa47.html

http://fisher.lib.virginia.edu/cgi-local/census bib/census/cen.pl

http://fisher.lib.virginia.edu/collections/stats/hist census/php/newlong2.php

http://www.fws.gov/blackbeardisland/history.htm

http://www.fws.gov/wassaw/history.htm

http://ga.water.usgs.gov/publications/ofr00–380.pdf

http://www.gammonseminary.org/history.htm

http://www.georgia.gov/vgn/images/portalcit_1210/1248428STCFACTSHEET.pdf

http://www.georgiaencyclopedia.org/nge/Article.js
p?id+h-2642

http://www.georgiaencyclopedia.org/nge/Article.js
p?id=h1101

http://www.georgiaencyclopedia.org/nge/Article.js
p?id=h1299

http://www.georgiaencyclopedia.org/nge/Article.js
p?id=h-1425

http://www.georgiaencyclopedia.org/nge/Article.js
p?id=h1854

http://www.georgiaencyclopedia.org/nge/Article.js
p?id=h-2549

http://www.georgiaencyclopedia.org/nge/Article.js
p?id=h-2730

http://www.georgiaencyclopedia.org/nge/Article.js
p?id=h-2733

http://www.georgiaencyclopedia.org/nge/Article.js
p?id=h-3223

http://www.georgiaencyclopedia.org/nge/Article.js
p?id=h-468

http://www.georgiaencyclopedia.org/nge/Article.js
p?id=h-767&pid+s-53

http://www.georgiaencyclopedia.org/nge/Article.js
p?id=h-793

http://www.georgiaencyclopedia.org/nge/Article.js
p?id=h-828

http://www.georgiaencyclopedia.org/nge/Article.js
p?id=h-898&pid=s-52

http://www.georgiaencyclopedia.org/nge/Article.js
p?id=h-942

http://www.georgiaencyclopedia.org/nge/Article.js
p?path=/Folklife/Foodways&id=h-555

http://www.georgiaencyclopedia.org/nge/Article.js
p?path=/Folklife/Foodways&id=h-1854

http://www.georgiaencyclopedia.org/nge/Multi
media.jsp?id=m-8361

http://www.georgiafruitcakecompany.com/Arti
cles/9.html

http://www.georgialibraryhistoryproject.org/time
line.htm

http://www.georgiapecans.org/trivia.html

http://www.getty.edu/art/gettyguide/artMakerDe
tails?maker=1601&page=1

http://www.girlscouts.org/who_we_are/birthplace/

http://www.girlscouts.org/who_we_are/history/low
_biography/

www.glc.k12.ga.us/passwd/trc/ttools/attach/bck
grnd/may/geo_bari.pdf

http://goldenislesinfo.com/history.html

http://goodwine.com/chris/georgia1.htm

http://www.greatlakesofgeorgia.com/hartwell/hi
story.asp

http://www2.gsu.edu/~wwwelf/eljch.html

http://www.high.org/overview/about/history.aspx

http://www.hts.gatech.edu/south/georgia/butts/
butind31.htm

http://www.imdb.com/title/tt0034297/

http://www.infoplease.com/ipa/A0148372.html

http://insects.tamu.edu/fieldguide/bimg198.html

http://www.jekyllislandhistory.com/jekyllclub.html

http://www.johnnymercer.com/yesterday.html

http://kclibrary.nhmccd.edu/decade30.html

http://lcweb2.loc.gov/ammem/fedtp/ftwpa.html

http://lcweb2.loc.gov/cgi-bin/ampage?collID
=ftadm&filename=farbf/00040002/ftadmin&db
&recNum=1 (the numbers range from 1 to 15)

http://lcweb2.loc.gov/cgi-bin/ampage?collID
=ftscript&filename=fpraf/09640037/ftscript.db
&recNum=2

http://lcweb2.loc.gov/pp/nclchtml/nclcback.html

http://libweb.princeton.edu/libraries/firestone/rbs
c/aids/tc015/

http://www.littlestsimonisland.com/bandits

http://www.littlestsimonisland.com/timeline/1900s/

http://www.littlestsimonisland.com/timeline/1908/

http://www.marist.edu/summerscholars/96/ndccc.
htm

http://members.cox.net/jjschnebel/brunstew.html

http://memory.loc.gov/ammem/ndlpedu/features/
timeline/depwwii/race/letter.html

http://memory.loc.gov/egi-bin/query/D?wpa:2:/
temp/~ammem_5Wkkk::

http://www.mste.uiuc.edu/malez/DATA/SOCIAL
SCIENCE/mortality_rates.html

http://www.netstate.com/states/intro/ga_intro.htm

http://newdeal.feri.org/works/wpa06.html

http://ngeorgia.com/facts/population.html

http://ngeorgia.com/feature/ccc.html

http://www.nps.gov/appa/

http://www.nps.gov/cuis

http://www.nps.gov/kemo/historyculture/index.htm

http://nwda-db.wsulibs.wsu.edu/findaid/ark:/
80444/xv77296

http://www.ossabawisland.org/history.htm

http://www.ourgeorgiahistory.com/history101/gahi
story11.html

http://ourgeorgiahistory.com/year/1917

http://www.pbs.org/wgbh/amex/pill/people
events/e_comstock.html

http://www.pickenscountyga.com/history.htm

http://pro.corbis.com/search/ImageSet.aspx?typ=
set&isuid=%7b07977dd3–5cee-46b3–8a9f-ba
741cfe5f5}

http://www.promotega.org/fdr05004/cumberland.
htm

http://www.roadsidegeorgia.com/site/cyclorama.
html

http://www.ruraledu.org/site/c.beJMIZOCIrH/b.2
125173/apps/nl/content.asp?content_id={2DB7
9154–73CD-42D8–9D96–46B7B658EE02}&
notoc=1

http://seaturtle.sdsmt.edu/015hist.html

http://www.sherpaguides.com/georgia/coast/north
ern_coast/ossabaw_island.html

http://www.sherpaguides.com/georgia/coast/north ern_coast/skidaway_island.html

http://shs.westport.k12.ct.us/jwb/AP/TLdocs/Com stock.htm

http://sip.armstrong.edu/Tybee/FortScreven.html

http://sip.armstrong.edu/Tybee/TybeeLightSta tion.html

http://www.slcatlanta.org/Publications/EconDev/ AutoSouth/GAAuto.pdf

http://www.snopes.com/disney/films/sots.html

http://www.sportingnews.com/archives/sports200 0/moments/140271.html

http://www.sreb.org/main/Publications/Roose velt/1938.asp

http://www.srwmd.state.fl.us/water+data/springs/ what+is+a+spring.htm

http://www.ssa.gov/history/reports/ces/cesbook t6.html

http://www2.state.ga.us/Departments/dhr/facs tdg2.htm

http://www.storesonline.com/site/539680/page/12 3265

http://www.time.com/time/magazine/article/ 0,9171,759988,00.html

http://www.time.com/time/magazine/printout/ 0,8816,882715,00.html

http://www.time.com/time/magazine/printout/ 0,8816,929,00.html

http://travel.howstuffworks.com/barrier-island. htm

http://www.trouparchives.org/burns.html

http://www.uic.edu/educ/betpu/historyGIS/great migration/gmdocs/boll_weevil_song.html

http://www.uncleremus.com/bio.html

http://www.usc.edu/schools/sppd/lusk/casden/re search/data_folder/us_pcinc.pdf

http://www.webmd.com/content/article/12/1687 _51143

http://www.westga.edu/~history/Banningmill/Ban ningtimeline.htm

http://www.whitedirt.com

http://www.wpamurals.com/Georgia.htm

http://www.yesterdayland.com/popopedia/shows/ decades/toys 1930s.php

http://www.youthtoday.org/youthtoday/aaDec Jan2004/story2.html

Index